Rembrandt's Journey

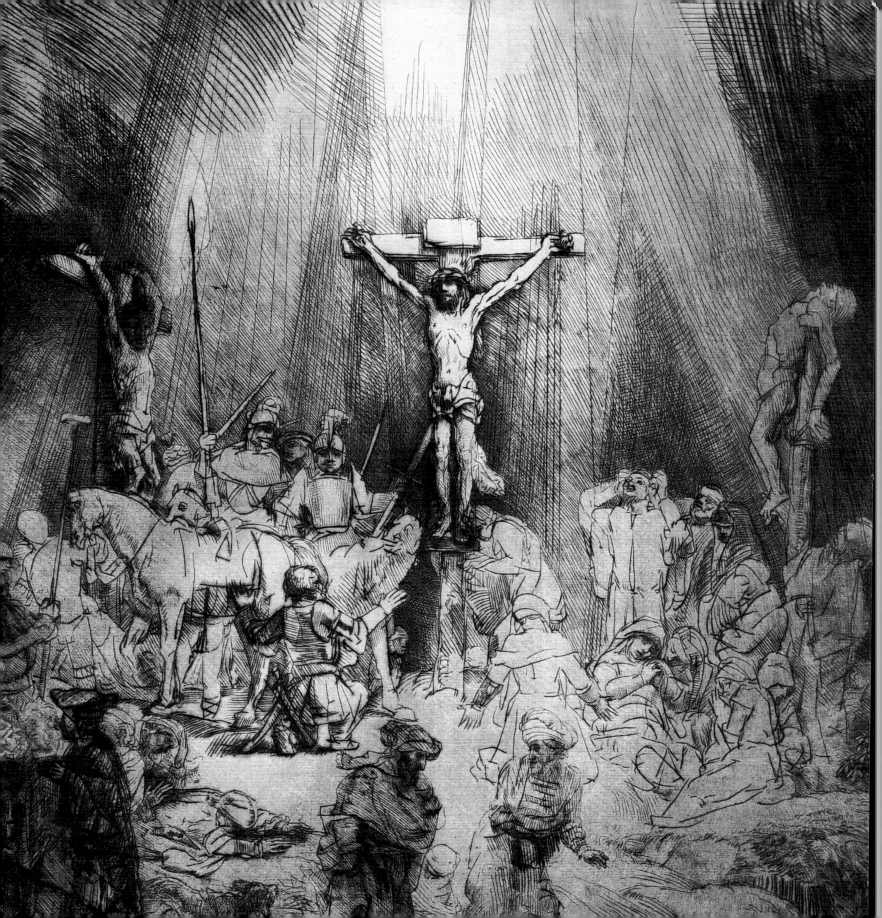

REMBRANDT'S JOURNEY

PAINTER · DRAFTSMAN · ETCHER

CLIFFORD S. ACKLEY

IN COLLABORATION WITH RONNI BAER,
THOMAS E. RASSIEUR, AND WILLIAM W. ROBINSON

MFA PUBLICATIONS
A DIVISION OF THE MUSEUM OF FINE ARTS, BOSTON

MFA PUBLICATIONS
a division of the Museum of Fine Arts, Boston
465 Huntington Avenue
Boston, Massachusetts 02115
Tel. 617 369 3438 Fax 617 369 3459
www.mfa-publications.org

This book was published to accompany the exhibition *Rembrandt's Journey: Painter · Draftsman · Etcher,* organized by the Museum of Fine Arts, Boston, and The Art Institute of Chicago. The exhibition was supported by an indemnity from the Federal Council on the Arts and the Humanities.

Museum of Fine Arts, Boston
October 26, 2003–January 18, 2004

The Art Institute of Chicago
February 14, 2004–May 9, 2004

Merrill Lynch
Generous support for this publication
was provided by Merrill Lynch.

ISBN 0-87846-677-0 hardcover
ISBN 0-87846-678-9 softcover
Library of Congress Control Number: 2003107349

SECOND PRINTING
Printed in England

Book design by Christopher Kuntze
Composed in Zapf Renaissance type by Avanda Peters
Manuscript edited by Emiko K. Usui
Copyedited and proofread by Denise Bergman

Printed and bound at Balding + Mansell, Norwich, England

Trade distribution:
Distributed Art Publishers / D. A. P.
155 Sixth Avenue, 2nd floor
New York, New York 10013
Tel. 212 627 1999 Fax 212 627 9484

Frontispiece: *Christ Crucified between Two Thieves*, 1653 (detail of no. 168)

CONTENTS

CATALOGUE ENTRIES

DIRECTORS' FOREWORD

The exhibition *Rembrandt's Journey: Painter ·Draftsman · Etcher* takes us on a voyage through the varied terrain of the evolving work of a tirelessly inventive artist. Rembrandt is the greatest among a legion of seventeenth-century Dutch artists, but he is also—due to his humanity and the immediacy of his touch with brush, pen, or etching needle—our contemporary as well.

Rembrandt's extraordinary self-portraits still convey a vivid sense of direct personal encounter. A unique combination of startling candor and protean role-playing, they epitomize his unrivaled ability to combine keen observation with soaring leaps of the imagination. His religious subjects have a dramatic invention and psychological penetration that make them accessible to viewers no matter what their religious faith or philosophical beliefs. Rembrandt's vision reshaped our ideas about the expressive potential of his three media—painting, drawing, and etching—and reinvented the genres of portraiture, landscape, and the nude.

It has been several decades since the United States has seen a major loan exhibition that surveyed the unfolding of Rembrandt's work in all three media. Both the Museum of Fine Arts, Boston, and The Art Institute of Chicago, co-organizers of this exhibition, have in the last few years through gift and purchase made major acquisitions of Rembrandt etchings and copper plates that have given new depth and meaning to their Rembrandt collections and that are featured here. The exhibition is further enriched by outstandingly important loans from around the world.

We are grateful to our generous sponsors: in Boston, Merrill Lynch, and in Chicago, the Abbott Laboratories Fund, for making it possible to share Rembrandt's diverse vision of human experience and spirituality with a broad audience.

Malcolm Rogers
Ann and Graham Gund Director
Museum of Fine Arts, Boston

James N. Wood
Director and President
The Art Institute of Chicago

ACKNOWLEDGMENTS

Rembrandt's Journey was originally conceived by Clifford Ackley as a major survey of Rembrandt's varied production as an etcher. The Museum of Fine Arts had organized the exhibitions *Rembrandt: Experimental Etcher* in 1969 and *Printmaking in the Age of Rembrandt* in 1980 but neither of these exhibitions had dealt with the full range and development of Rembrandt the printmaker. Early in the discussion of the project Boston's director Malcolm Rogers proposed that Rembrandt paintings be added to the mix and it was agreed that the role of Rembrandt's third medium, drawing, would also be expanded. At that point Ronni Baer was brought into the project to negotiate the painting loans and to write an essay on the oil sketches, and William Robinson of the Fogg Art Museum was engaged as an expert advisor on the drawings. A new member of the staff of the Department of Prints, Drawings, and Photographs, Thomas Rassieur, with his extensive experience with Rembrandt prints in the major European collections, was also made part of the exhibition team.

This exhibition would not have been possible without the large number of generous loans of significant Rembrandt works from public art institutions. In Amsterdam, at the Rijksmuseum, we are very indebted to Jan Piet Filedt Kok and, in the Rijksprentenkabinet, to Peter Schatborn, Ger Luijten, Huigen Leeflang, and Cindy van Weele. At the Rembrandt House we wish to thank Ed de Heer and Bob van den Boogert. In Berlin, Jan Kelch of the Gemäldegalerie of the Staatliche Museen was of great assistance, as were Alexander Dückers and Holm Bevers of the Kupferstichkabinett. In Boston at the Isabella Stewart Gardner Museum, Alan Chong made things possible. In Cambridge, England, at the Fitzwilliam Museum, we are indebted to Duncan Robinson, David Scrase, and Craig Hartley. In Cambridge, Massachusetts, at the Harvard University Art Museums, Fogg Art Museum, we would like to thank James Cuno, Marjorie Cohn, and William Robinson. At the Cleveland Museum of Art we are grateful to Charles Venable, Diane DeGrazia, and Carter Foster. In Copenhagen, at the Statens Museum for Kunst, we are indebted to Chris Fischer and Jan Garff. At The Detroit Institute of Arts, we recognize the generosity of Graham W. J. Beal and George Keyes. In Dublin, at the National Gallery, we are in the debt of Raymond Keaveney. In Glasgow at the Hunterian Art Gallery, University of Glasgow, Mungo Campbell and Peter Black were of great assistance. In Haarlem, at the Teylers Museum we wish to thank Carel van Tuyll van Serooskerken. In Hanover, New Hampshire, at the Hood Art Museum, Dartmouth College, Barton Thurber was very helpful. In Kassel, at the Staatliche Museum, we are in the debt of Bernhard Schnackenburg. In London, at the British Museum, Antony Griffiths and Martin Royalton-Kisch extended themselves. At the National Gallery, Neil MacGregor, David Jaffé, and Axel Rüger generously agreed to the loans. In Los Angeles, at The J. Paul Getty Museum, Scott Schaefer and Lee Hendrix facilitated the loans. In Moscow, at the Pushkin Museum, Irina Antonova and Natalia Markova were extremely generous and helpful. In New York, at The Metropolitan Museum, we are thankful to Walter Liedtke, George Goldner, and Nadine Orenstein. At the Pierpont Morgan Library we are indebted to Cara Denison, Egbert Haverkamp-Begemann, and Jan Leja. In Paris, at the Institut Néerlandais, the Frits Lugt Collection, we are grateful to Mària van Berge-Gerbaud and Hans Buijs. In Poughkeepsie, New York, at the Frances Lehman Loeb Art Center, Vassar College, James Mundy and Patricia Phagan came to our assistance. In Rotterdam, at the Museum Boijmans-van Beuningen, we would like to thank Chris Dercon, Guido Jansen, and Jeroen Giltaij. At the St. Louis Art Museum, Brent Benjamin and Francesca Consagra deserve our gratitude. In St. Petersburg, at The State Hermitage Museum, we recognize the generous assistance of Mikhail Piotrovsky, Vladimir Matveyev, and Irina Sokolova. In Washington, D.C., at the National Gallery of Art, we wish to thank Alan Shestack, Arthur Wheelock, Andrew Robison, Peter Parshall, and Gregory Jecmen.

Certain collections from which no loans were requested were nevertheless closely studied in preparation for this project. In Amsterdam, we are indebted to Jan Six of the Six Collection. In Paris, at the Bibliothèque Nationale, we are grateful to Gisèle Lambert and Maxim Préaud. At the Dutuit Collection of the Petit Palais we would like to thank Sophie de Bussierre. At the Rothschild Collection of the Louvre, Pierrette Jean-Richard was most accommodating. In Vienna, at the Albertina, Marianne Bisanz-Prakken was very helpful.

A number of private collectors provided essential loans: Maida and George Abrams, The Aurora Art Fund

(courtesy of Stiebel, Ltd.), S. William Pelletier, James M. and Melinda A. Rabb, Alan and Marianne Schwartz, and a private collection through Sotheby's, Japan. In addition to the above, we are indebted to several other collectors who wished to remain anonymous.

Many scholars of Rembrandt have been of assistance in answering the organizers' inquiries. Some of those who have been particularly helpful are Paul Crenshaw, Stephanie Dickey, Egbert Haverkamp-Begemann, Erik Hinterding, Peter Schatborn, Ernst van de Wetering, Elizabeth Wyckoff, and Michael Zell. We would like to thank Annewies van den Hoek for kind assistance with Dutch translation. Certain knowledgeable art dealers have also been very helpful with information: Adrian Eeles, Armin Kunz, Robert M. Light, Lutz Riester, Helmut Rumbler, and Nicholas Stogdon.

The co-organizers, The Museum of Fine Arts, Boston, and The Art Institute of Chicago, have, of course, made substantial loan commitments to the exhibition and their staffs have of necessity been closely and deeply involved in the evolution of this complex project. At the Museum of Fine Arts, Boston, we would like to mention first of all Kate Harper, special research assistant for the exhibition, whose dedication to the project has been an inspiration to us all. The entire Department of Prints, Drawings, and Photographs has been affected by this consuming project. We would like to mention in particular Joanna Karlgaard, whose attention to loan forms, photo orders, and labels has been essential. Patrick Murphy provided welcome assistance in the early stages of the development of the project. Stephanie Stepanek and Sue Reed were helpful with proofreading and advice. In the Department of the Art of Europe, Chris Atkins was of invaluable help to Ronni Baer in preparing for the exhibition. George Shackelford, Tracey Albainy, Frederick Ilchman, Lien de Keukelaere, and the entire staff of the department also lent their support and advice. In the Paper Conservation Laboratory we are indebted to Roy Perkinson, Deborah La Camera, and Kimberly Nichols, but in particular to Annette Manick, whose careful examination and restoration of Rembrandt prints in the collection were critical for the final selection of the exhibition. Gail English and Sarah Gurney ensured that the Museum's Rembrandts as well as a number of loans were appropriately matted and framed. In Paintings Conservation Jim Wright and Rhona MacBeth

provided essential information and support, as did Andrew Haines for framing. In Museum Learning and Public Programs we are grateful for the contributions of Gilian Shallcross, Barbara Martin, and Lois Solomon. In the Administration, we gratefully acknowledge director Malcolm Rogers, who challenged us to expand the scope of the exhibition, and we recognize the able coordination provided by Katie Getchell and Jennifer Bose, and in External Relations the fundraising assistance of Patricia Jacoby, William McAvoy, and Jennifer Cooper. In Public Relations we would like to acknowledge the enthusiastic support of Dawn Griffin, Kelly Gifford, and Lisa Colli. Registrar Pat Loiko, as ever, made the impossible possible. The photographers Tom Lang, John Woolf, David Matthews, and media coordinator Nicole Crawford fulfilled our often difficult demands. Publisher Mark Polizzotti and his team of Terry McAweeney, production manager, editor Emiko Usui, copyeditor Denise Bergman, and book designer Christopher Kuntze gave proper form to a very complex publication. Jim Armbruster provided the installation design and Janet O'Donoghue the graphic design. David Geldart and the utility teams and shops gave the exhibition its final physical form.

At our co-organizing institution, The Art Institute of Chicago, we are indebted to director James Wood, to Douglas Druick and Martha Wolff, and in particular to Suzanne McCullagh whose devotion kept the flame alive. In Administration, Dorothy Schroeder provided essential coordination, and in Development we are grateful to Alice DuBose and Lisa Key, in Paper Conservation to Margo McFarland, in Public Affairs to Eileen Harakal, in Education to Mary Sue Glosser and Jeffrey Nigro, in Design to Lyn Delliquadri and Joseph Cochand and, above all, to Registrars Mary Solt and Therese Peskowits. William Caddick of the Physical Plant and Anders Nyberg of Visitor Services provided essential support.

We would also like to thank certain friends and family members who were particularly patient and supportive during the stress and strain of *Rembrandt's Journey*: Steven, Jake, and Jane Elmets, Daan MacGillavry, Elke Oberthaler, John Powell, Rosemary Wilson, Joan and Jim Wright, and Howard and Katherine Yezerski.

THE AUTHORS

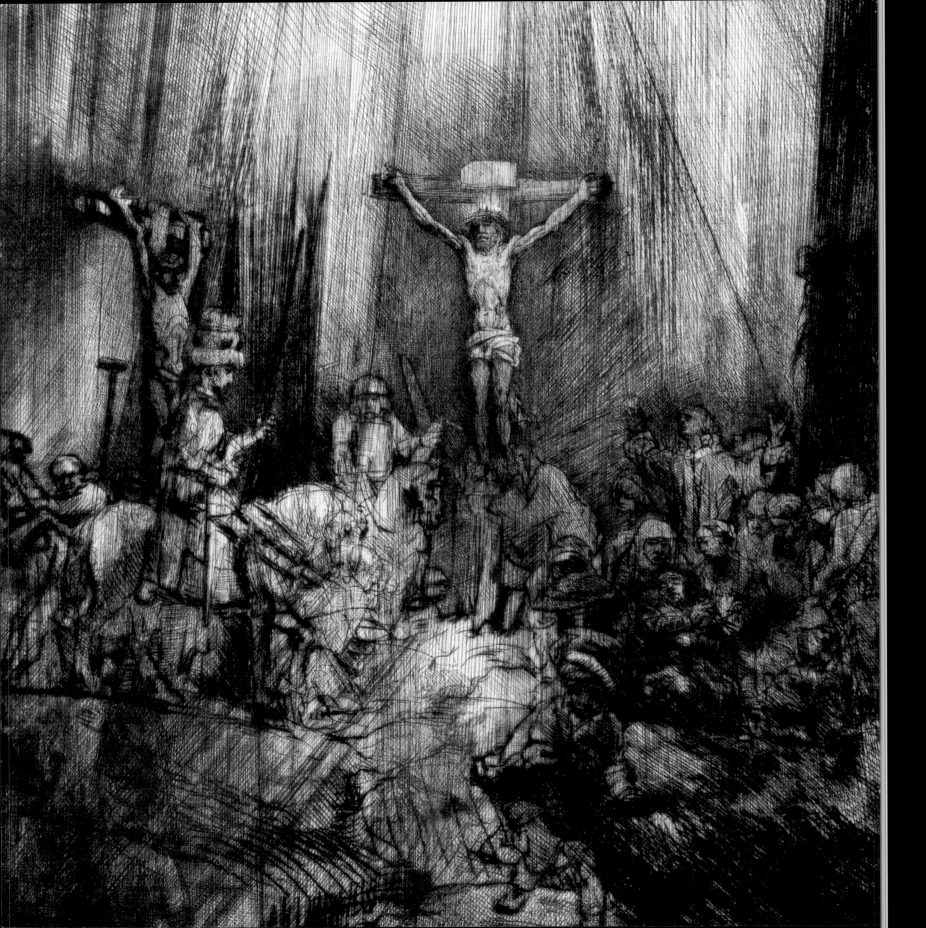

INTRODUCTION
Rembrandt's Artistic Journey

Clifford S. Ackley

Rembrandt's Journey: Painter · Draftsman · Etcher surveys the unfolding of Rembrandt van Rijn's art from his early years in Leiden to his later Amsterdam years, using as an organizing framework or armature the artist's extraordinarily diverse and profoundly expressive work in printmaking. Works are grouped by theme rather than by medium or strict chronology, so as to better illuminate the evolution of Rembrandt's art with regard to style and content, and, so as to explore certain themes that Rembrandt repeatedly returned to over time, always with a new perspective. The thematic groups shuttle back and forth in time but nevertheless follow an overarching chronological trajectory spanning Rembrandt's artistic career. The exhibition and catalogue encompass some 20 paintings, 30 drawings, and 150 etchings and copper etching plates ranging in date from about 1626 to 1661.[1]

In selecting the works there has been a special emphasis on Rembrandt the storyteller, the inventive illustrator of biblical narratives from the Old and New Testaments. Other recurrent themes are self-portraiture and the image of the artist, portraiture and fantasy portraits, scenes from everyday life, erotic love, landscape, and the nude. Rembrandt produced three major bodies of work in his three media of painting, drawing, and etching. Any one of the three taken alone would suffice to ensure his fame and continuing influence. In this exhibition the three media are sometimes closely interrelated (see *Christ's Passion*, nos. 40–46, or *Joseph Telling His Dreams*, nos. 50–53). In other instances they are presented as three independent but complementary bodies of work that closely parallel one another in their development. Many of the works have been selected with a strong consciousness of aspects of Rembrandt's art that have a particular appeal to the modern eye: spontaneity of execution, economy of suggestion (as opposed to detailed description) and a shared sense of the artist's process of making the work, of choices and changes of mind. The decision to include large numbers of oil sketches, works that are virtually drawings with oil paint, was made in part with such modern sensibilities in mind. On the other hand, certain works were deliberately chosen as examples of the refined, highly meticulous craftsmanship of which Rembrandt was also capable (the 1647 etched portrait of Jan Six, no. 74, for example). Among the leading characteristics of Rembrandt as an artist are the remarkable changes in his art over time and his deliberate use of different modes—sketchy versus highly finished, pale tonalities versus profound depth of shadow—during the same period and in the same medium. Of course one of the most typical Rembrandt works in any medium is the single image, whether painting, oil sketch, drawing, or etching, that deliberately includes within itself varying degrees of finish and unfinish. There is, for example, still a lively range of opinion as to whether certain Rembrandt etchings (and some paintings) are finished or unfinished.

Rembrandt is one of the rare artists who combines an original literary gift with a highly original visual inventiveness. His lively mixture of moods from low comedy to tragedy has a Shakespearean truth to the variety of life experience. A fresh, keen observation of human psychology and body language, supported by a dedication to drawing from life, means that Rembrandt's biblical narratives have a human dimension and a psychological and physiological truth that a sensitive viewer can respond to even if they don't share a belief in the deeper religious meaning of the events depicted. The challenge for Rembrandt—as for every visual artist turning texts into pictures—was to find visual equivalents for psychological and spiritual states. In the 1630s he is prone to express the spiritual through physical action (*Christ Driving the Moneychangers from the Temple*, no. 151, or *The Angel Appearing to the Shepherds,* no. 39). Even his representation of divine light is more explosive and dynamic at this time. By the 1650s his narrative subjects are characterized by a new serenity and stability of structure; physical action is stilled. The symbolic dialogue of darkness and light now assumes an expressive role equal to or greater than that of the human actors.

The three essays that precede the catalogue entries explore different facets of the exhibition: Rembrandt the dramatist's expressive use of gesture and body language, the function and meaning of Rembrandt's oil sketches, and the way in which Rembrandt in his prints allows us

to participate vicariously in the creative process. See the Chronology for an outline of significant events in Rembrandt's life and artistic career.

Who Was/Is Rembrandt?

In 1628 an art-loving lawyer from Utrecht, Aernout van Buchell (or Buchelius) made a few notes in Latin on the Leiden art scene. One of them reads in translation: "The Leiden miller's son is highly, if prematurely, esteemed."[2] This slightly cool comment is the first drop of ink to be spilled concerning seventeenth-century Holland's most famous artist. Today that initial drop has become a raging torrent of words that continues to attempt to define who Rembrandt van Rijn was and is as man and artist.

Rembrandt's beginnings as the son of a miller seemed embarrassingly humble to a number of early writers. The cultivated virtuoso of arts and letters Constantijn Huygens, secretary to the stadholder Frederik Hendrik at the court in The Hague, visited Rembrandt and his friendly rival and possible studio-mate Jan Lievens in Leiden about 1628–29. To Huygens, it was all the more reason for an outburst of nationalistic pride that a young Dutchman, a "beardless boy" of such modest origin, should already have accomplished so much (specifically the profoundly original emotive expressiveness of the figure of the repentant Judas in Rembrandt's painting *Judas Returning the Thirty Pieces of Silver*, 1629, Private Collection, England) without having made the voyage to Italy.[3] Rembrandt's relatives were indeed millers, but quite prosperous ones who were able to send the boy to the Latin school and to enroll him at the University, even though he appears to have left the latter almost immediately to pursue his passion for drawing and painting.

A long period of apprenticeship to a Leiden painter of hell scenes, Jacob van Swanenburgh, was followed by a brief but influential apprenticeship to the highly successful Amsterdam painter of histories from the Bible and classical antiquity, Pieter Lastman. Both teachers had spent time in Italy. After his move to Amsterdam in 1633 Rembrandt began signing himself simply but grandly "Rembrandt," appointing himself a member of the exclusive club of celebrated Italian Renaissance artists known only by their first names: Leonardo, Raphael, Titian, and Michelangelo.

Rembrandt is not only the most famous seventeenth-century Dutch artist then and now, he is also the best documented. That said, it is surprising to discover how little we actually know. The documents in question are mostly impersonal legal and financial ones that require a good deal of reading between the lines. Rembrandt was a great artist but was evidently not a very good businessman. The insolvency and enforced sale of his property brought on by his inability to pay for his fine house in the Breestraat was a disaster for him but a boon for us. If his possessions had not been inventoried for sale in 1656, we would have far less information about Rembrandt's extensive collections of art and rarities. In fact his irrepressible desire to spend large sums on art may have significantly contributed to his financial difficulties.

Rembrandt's collection of other artists' work was not just an art collection; it was also a reference collection for his own use and a teaching collection for use by his pupils. Huygens and other early writers criticized Rembrandt for not making the Italian journey to complete his artistic education, but Rembrandt and Lievens replied to Huygens that they were too busy to make the journey, and that besides they could see sufficient Italian art in Holland. Rembrandt's extensive print collection, which undoubtedly also reflects his love of the medium that he was to revolutionize and redefine, also functioned—before the age of photomechanical reproduction—as a kind of "museum without walls." He owned in the form of prints a virtual survey of European art history from the Renaissance on, including an extensive collection of original prints by the Northern masters Albrecht Dürer and Lucas van Leyden and engravings and woodcuts by or after the Italian masters Mantegna, Raphael, and Titian. These were his equivalents for the reproductions and postcards one sees tacked up on studio walls today.

Rembrandt also collected picturesque and exotic clothing and weapons for use in his historical pictures in order to more imaginatively and colorfully evoke the ancient Bible lands. In his early *Samson* painting from Berlin (no. 11) Samson's dagger is a perfect representation of a Javanese *kris*, undoubtedly one of the imported curios that Rembrandt owned. He also drew on Japanese paper exquisite copies of Indian miniature paintings in order to gain inspiration for costume and custom in his depictions of biblical antiquity (see no. 143).

Rembrandt was accused by early writers such as the well-traveled German painter Joachim von Sandrart (1675) and Rembrandt's first biographer Arnold Houbraken (1718) of being money-mad, of taking on large numbers of pupils at high fees, or of manufacturing for gain unfinished proofs and variants of his prints to feed the appetite of collectors avid to possess such unique rarities from his hand.[4] Some modern historians have sought to counter the Romantic legend of Rembrandt the creative genius by stressing the economic and social factors that motivated him. Artists are of course frequently

spurred on by gain and social approval, as Rembrandt undoubtedly was with his highly successful portrait commissions during the early Amsterdam years. However, restlessly inventive artists such as Rembrandt are equally motivated by creative exploration of new imagery and the potential latent in traditional media.

We have an abundance of pictures by Rembrandt but very few authentic texts from his hand. An amusing example is the laconic note on a sketch sheet included here: "a little child with an old jacket on his head" (see no. 100). Historians have endlessly scrutinized and debated the meaning of a single expressive phrase found in one of the seven formal diplomatic letters that Rembrandt wrote from 1636 to 1639 to the stadholder's secretary, Constantijn Huygens, regarding the completion, delivery, and payment for the prestigious series of Passion of Christ paintings commissioned by the court in The Hague. In a letter of January 12, 1639, Rembrandt explains that in the *Entombment* and *Resurrection* paintings he had attempted to express "the greatest and most natural *emotion*" (or *movement*, depending on which historian's interpretation you endorse).[5] The debate about the different readings of the phrase seem somewhat academic since in both Dutch and English the meaning of the word *emotion* is grounded in the idea of movement. Certainly for Rembrandt, who was so skilled in indicating the inner emotions through the outward movements of the body, the two concepts must have been essentially identical.

A number of seventeenth-century Dutch artists made self-portraits in considerable numbers but none pursued self-portraiture throughout their careers in three different media with the intensity, variety of conception, and inventiveness of Rembrandt. In the Leiden years, for example, Rembrandt's drawn, etched, and painted self-portraits (nos. 12–17) speak to his fascination with the expression of the emotions, his interest in role-playing, and his ambition to make his image as well as his name known. Collectively the self-portraits are radical in that they suggest that one individual can potentially contain many selves. Chronologically arranged, they constitute an unprecedentedly candid record of time's slow erosion. It is difficult to imagine the modern self-portrait (Vincent van Gogh, Max Beckmann) without the precedent of Rembrandt.

Each era forms its own image of Rembrandt. In his time Rembrandt was overtaken by the rising tide of classicizing taste that modeled itself on Italian and French art and the sculpture of classical antiquity. Rules of ideal beauty and proportion were elevated above what was seen as Rembrandt's wrong-headed individualism and slavish devotion to nature. While Rembrandt's sophisti-cation in the use of color and of light and shadow was admired, his rough, sculptural manner of painting and his tonal, nonlinear approach to drawing were held in contempt. Smooth surfaces and clearly defined contours were the guiding values of the classicizing trend. Rembrandt, with his shockingly or touchingly real nudes observed directly from nature and which followed no rules of ideal beauty or proportion, was branded the "leading heretic of art."[6] What was originally a negative label was to become later, during the Romantic period when individualism was acclaimed as the principal attribute of the true artist, a badge of honor. Criticized for consorting later in life with humble folk, Rembrandt was reported in the writings of the French critic Roger de Piles (1699) and by Arnold Houbraken (1718) to have said, "When I wish to refresh my spirit, it is not honor I seek but liberty."[7]

Modern historians have sought to objectify and demystify Rembrandt, by combating the Romantic image of the genius that rose above the pack and seeking to place Rembrandt more firmly in a seventeenth-century Dutch context. Part of this laudable effort is the new connoisseurship devoted to pruning from the collected paintings and drawings of Rembrandt works by his many contemporary pupils and followers as well as copies and imitations by later artists. The Amsterdam-based Rembrandt Research Project's team of Dutch scholars began its investigation into the paintings in 1969. Three impressively thorough volumes have been published and two more are slated to appear. Over the decades certain of the opinions published there have begun to be subject to reconsideration and revision because it has been discovered that Rembrandt was not always the perfectly consistent, logical Dutchman he was originally anticipated to be. In the process the image of Rembrandt's workshop practice and of the artists in his circle has been enormously strengthened and clarified. Rembrandt's distinctive style carried many artists with him the way Picasso and Braque carried other artists to new heights during the Cubist era of the early twentieth century.

Although there is no official team for the investigation of the connoisseurship of drawings, in recent years scholars such as Peter Schatborn in Amsterdam and Martin Royalton-Kisch in London have been thoughtfully refining the image of Rembrandt the draftsman. A group of some seventy-five drawings documented by authentic signatures or inscriptions or, more frequently, by their relationship to securely attributed works in other media, has served as the unofficial core for the construction of this newly clarified but still controversial body of authentic drawings. For example, Rembrandt's drawings of the

female nude from the late 1650s and early 1660s were once thought to exist in much greater numbers. Now we know that many of them were made by pupils drawing from the same model alongside their teacher. We are fortunate to have in the exhibition the Chicago nude drawing, one of the three or four drawings from the nude model still securely attributed to Rembrandt (no. 200).

Rembrandt on Paper

The learned Florentine abbot Filippo Baldinucci, who published in 1686 a history of the art of printmaking and its principal practitioners, included in his book only one seventeenth-century Dutch printmaker: Rembrandt. He based his account on Rembrandt prints he had seen and on contact with a Danish artist who had studied with Rembrandt, Bernhard Keil. Baldinucci reported that Rembrandt was held in such high esteem that a drawing in which little or nothing could be seen was sold at auction for a very high price. He also described Rembrandt's bizarrely original style of etching in which a deep, powerful, and picturesque chiaroscuro was achieved with irregular scratches and hatchings. Certain areas were intensely black, and in other areas Rembrandt permitted the white of the paper to play. Sometimes there was only a patch of shadow or a single stroke and nothing more.[8]

This radical, suggestive use of blank paper as light and space is still one of the most striking characteristics of Rembrandt's drawings and prints. In the drawings it has sometimes resulted in later hands adding conventional passages of shading with wash in order to "complete" the drawing. The prints in their turn have sometimes been mutilated by having "excess" blank paper trimmed away.

Samuel van Hoogstraten, Rembrandt's pupil, noted in 1678 that printmakers are the "heralds and trumpeters" of the artist's fame, and prints the "messengers and interpreters" of works distant in space and time.[9] This was certainly the case for Rembrandt. Baldinucci in Italy knew only two Rembrandt portrait paintings, but was clearly thoroughly conversant with the prints. In 1660 the aristocratic Sicilian collector Don Antonio Ruffo asked the North Italian painter Guercino (Giovanni Francesco Barbieri) to paint a pendant to the *Aristotle* portrait that he had commissioned from Rembrandt (now in The Metropolitan Museum of Art, New York). Guercino replied, "I have seen various of his works in prints which have come to our region; they are very beautiful in execution, engraved with good taste, and done in a fine manner, so that one can assume that his

painted work must likewise be of complete exquisiteness and perfection. I sincerely consider him a great artist."[10]

Rembrandt essentially redefined the expressive potential of printmaking by applying the painterly, draftsmanly freedom of drawing and painting to printmaking. Some Rembrandt etchings consist of a few pale, whispery lines while others are profoundly black, velvety, asystematic webs and meshes of line in which Rembrandt anticipates the new mechanical tonal method of printmaking, mezzotint (see Materials and Techniques). There is an extraordinary range of scale, tonality, use of line, and subject matter in the etchings that speaks of an artist of restless sensibility always eager to try something new. This quality is particularly visible beginning in the late 1640s in the many individual impressions of prints that are essentially unique variants with regard to choice of support (white European paper, oatmeal paper, Japanese paper, or vellum), inking, or fundamental changes to the image etched into the plate. Later large-scale works such as "The Three Crosses" (nos. 168–170) or *Christ Presented to the People* (nos. 173, 174) combine an extraordinary freedom of execution—the image being boldly scratched directly into the copper with a sharp point—with an imposing breadth of conception. Like certain of Rembrandt's late drawings, such prints might very well be described as "monumental sketches."

Some Notes on the Connoisseurship of Prints

There has been a conscientious effort to include here good, fine, or outstanding early impressions of Rembrandt's prints. By this we intend impressions printed during Rembrandt's lifetime while the etching plate was still in his possession and was in optimum condition before repeated pressure of printing had worn down the soft copper. This means also that the paper of the individual impression is in good, if not pristine, condition and has not been excessively mended or bleached. Whenever possible we have attempted to include untrimmed impressions with the full platemark and a margin of extra paper. The inky platemark in early Rembrandt impressions often acts as an expressive frame for the total composition, and the blank paper of the margin also serves to set off the image. The paper of the original margins was often trimmed away when the prints were pasted into albums by early collectors. Such mounting also often resulted in damage to the corners or edges of prints when they were removed at a later date. Over time collectors have added their stamps or inscriptions to the prints, lending a history and a pedigree to the individual impression. These marks are often placed dis-

creetly on the back of the sheet but also sometimes quite conspicuously on the front of the sheet within the image itself. For example, in the impression of Rembrandt's *Self-Portrait with Saskia* reproduced here (no. 58), the early nineteenth-century collector Edward Utterson placed his *EU* monogram in the image in such an annoyingly clever way that Rembrandt appears to be making a drawing of Utterson's stamp!

Accidental stains, tears, and mending of holes can of course destroy the effect of the passages of blank paper that originally suggested light and atmosphere in Rembrandt's prints, particularly in the landscape etchings where untouched paper plays such a critical role. Just as retouching by later hands is a problem with drawings, so is later deceptive retouching of impressions of prints with brush or chalk to make them appear richer, finer, and earlier than they actually are. Such "improvements" are particularly a problem with prints from the later 1640s and 1650s that are often dependent for their effect on strong passages of drypoint burr. Platemarks are also frequently deceptively retouched to make them "inkier."

Signed limited editions of prints are a relatively modern phenomenon dating from the end of the nineteenth century. In Rembrandt's time plates were not generally retired or destroyed but were acquired by publishers who reworked them, often thereby altering the artist's original intentions if wear from the pressure of repeated printing had not already done so.

Recent research in the United States and The Netherlands on the watermarks in the European papers Rembrandt used to print his etchings is helping to determine which impressions were printed while the plates were still in his possession. It appears from the evidence of watermarks that Rembrandt's early plates were often reprinted later in his workshop in new "editions." Certain subtle effects in Rembrandt's etchings are so fugitive that one even begins to discriminate the "finer" and "lesser" among lifetime impressions. Rembrandt's later tendency to treat each impression as a unique work means that the question of which is the superior of several early impressions becomes a highly subjective one. Do you want more or less drypoint burr? Do you want it printed on Japanese paper, on oatmeal paper, or on white European paper? Do you want it printed with a tone of ink? If so, with what pattern of inking? Of course the real pleasure for the aficionado of such later Rembrandt prints consists in comparing one variant impression with another, and thereby participating in the artist's creative process.

Homage to Rembrandt

Prior to Picasso in our time no painter had, like Rembrandt, produced such an extensive and diverse body of prints over the course of a long artistic career. Picasso himself paid homage to Rembrandt in five etchings of 1934 in which the image of an aged Rembrandt, composed of baroque curlicues, is shown consorting with beautiful young women.[11] It is singularly appropriate that it was a Rembrandt-like etching accident that led Picasso to create the image of Rembrandt on the plate reproduced here (fig. 1). Picasso's dealer, Daniel-Henry Kahnweiler, recorded the artist's account of the etching's creation in his diary: "It was another case of the cracking etching ground. I had a plate on which this accident occurred. I said to myself: it's ruined, I'm going to do any old thing on it. I began to scribble. It became Rembrandt. This began to amuse me and I continued with it. I even made another one, with his turban, his furs, and that elephant eye of his, you know. Now I'm working this plate further to get blacks like his; you don't get that in one try."[12] The Picasso etching is a doubly fitting homage to the older artist because it is a perfect example of the kind of seemingly casual, but calculatedly artful, etched sketch plate that Rembrandt did so much to foster (see nos. 27, 104).

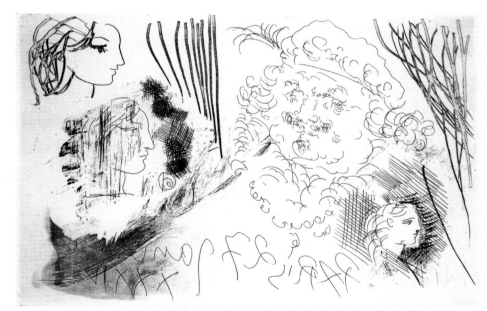

Fig. 1. Pablo Picasso, Spanish (worked in France), 1881–1973, *Sheet of Studies: Rembrandt and Heads of Women*, 1934, etching, 13.3 × 21.2 cm (5¼ × 8⅜ in.), Museum of Fine Arts, Boston, Lee M. Friedman Fund and Gift of William A. Coolidge.

One of the difficult to define but essential and profoundly appealing qualities later artists have acknowledged in Rembrandt might be categorized as "Rembrandt's humanity." To quote the late-nineteenth-century painter and printmaker Odilon Redon, an artist with a thorough understanding of the symbolic power of black and white, "No one master has painted drama as Rembrandt did. Everything, even the smallest sketches, involve[s] the human heart."[13] David Hockney, a leading painter and printmaker of our own time, wrote, "Sometimes certain sensitive individuals, such as Rembrandt, cross the line, transcending mere naturalism to produce paintings that not only depict exterior reality but also reveal inner truths."[14]

NOTES

1. Today a rough estimate of Rembrandt's surviving authentic works in these three media might number approximately 300 paintings, 1,000 drawings, and 290 etchings. Walter Liedtke in "Rembrandt and the Rembrandt Style in the Seventeenth Century" in Liedtke et al. 1995, 2: 4, proposed the figure of approximately 300 paintings. Peter Schatborn in "Rembrandt Tekenaar" in Van Berge-Gerbaud 1997 estimated on the basis of the drawing albums in Rembrandt's 1656 inventory and the inventories of other artists of the time that there might originally have been 1,500–2,000 drawings.

2. As cited in Slive 1953, 8.

3. See Huygens's Latin memoir of his youth as translated in Chong et al. 2000, 134–36.

4. See Joachim von Sandrart's evaluation of Rembrandt in *L'Academia Todesca della architectura, scultura et pittura: oder Teutsche Academie der edlen Bau-, Bild- und Mahlerey-Künste*, (Nuremberg, 1675), as reprinted in Slive 1953, 209 and Houbraken 1718–21, 1: 271–72.

5. *Docs.* 1979, 1639/2. The celebrated phrase is "die meeste ende die naetuereelste beweechgelickheijt."

6. In Andries Pels's poem attacking Rembrandt from the classicizing position (in *Gebruik en misbruik des toneels*, 1681, as reprinted in Slive 1953, 210), the relevant phrase is "de eerste ketter in De Schilderkunst" (the foremost heretic in painting).

7. See the biography of Rembrandt in Roger de Piles, *Abregé de la vie des peintres avec des réflexions sur leurs ouvrages, et un traité du peintre parfait, de la connaissance des desseins et de l'utilité des estampes*, Paris, 1699, as reprinted in Slive 1953, 217–18; and Houbraken 1718–21, 1: 273.

8. See Slive 1953, 104–115 (chapter 7, "Filippo Baldinucci"). The description of Baldinucci's account of Rembrandt's technique in his *Cominciamento, e progresso dell'arte dell'intagliare in rame, colle vite di molti de' più eccellenti maestri della stessa professione*, 1686, is based on Slive's paraphrase of the text.

9. Van Hoogstraten 1678, 196. The relevant phrases are "lofblazers en trompetters" and "boden en tolken."

10. Guercino's Italian text as translated in Haak 1969, 240.

11. Geiser 1986, nos. 405–406, 413–414, and 420.

12. Kahnweiler as cited by Janie Cohen in "Picasso's Dialogue with Rembrandt's Art," in Cohen and Rose-de Viejo 2000, 82.

13. Redon 1986, 66.

14. Hockney 2000, 184.

REMBRANDT AS ACTOR AND DRAMATIST
Gesture and Body Language in the Biblical Etchings

Clifford S. Ackley

If one wants to be acclaimed in this most noble aspect of art [the depiction of the human passions],
one must completely transform oneself into an actor.

Learn now, oh youthful painter, this most artistic role-playing.

SAMUEL VAN HOOGSTRATEN
Introduction to the Noble School of Painting, 1678[1]

From his time to our time the painter and etcher Rembrandt van Rijn has been widely recognized for his skill in depicting emotion, particularly in paintings, drawings, and etchings that illustrate stories from the Old and New Testaments. About 1628–29 when the cultivated gentleman-connoisseur Constantijn Huygens, secretary to the stadholder Frederik Hendrik at the court in The Hague, visited Rembrandt and his friendly rival and possible studio-mate Jan Lievens in their birth city of Leiden, he singled out Rembrandt for his greater surety of judgment and liveliness in the expression of emotion. Huygens demonstrated Rembrandt's mastery of the latter quality through his highly rhetorical "rave review" of Rembrandt's new painting of *Judas Returning the Thirty Pieces of Silver* (1629, Private Collection, England), concentrating on Judas's remorse as expressed not only by his facial expression but also by the gestures of the traitorous disciple's hands and body.[2] In his treatise on the practice and theory of painting of 1678, Samuel van Hoogstraten (Rembrandt's pupil from about 1642/43 to 1647), when discussing the special qualities that distinguished great master painters, associated Rembrandt with the "expression of the emotions."[3]

Rembrandt clearly had an unusual ability to imaginatively and empathetically project himself into various roles in biblical narratives, giving familiar stories a new psychological depth and human meaning.[4] In this he was undoubtedly abetted by his dedication to drawing the human face and figure from life, whether his own or a hired model's. Early on in his career, Rembrandt, judging from the evidence of his painted and etched self-portraits from around 1628, appears to have used the mirror to practice facial expressions (disgruntlement, outrage, surprise). Hoogstraten in his treatise advised the young artist to use the mirror to study expression, becoming at once both "actor and audience."[5] Later, Rembrandt set

himself and his many pupils the challenge of making drawn variations on biblical histories, not necessarily as preparatory studies but rather as a means of limbering up the imaginative faculties in order to arrive at fresh takes on familiar stories (see *Inventing Religious Compositions: Drawings of the 1650s,* nos. 175–79).[6] Rembrandt may in a sense be compared to a great actor, theater director, or dramatist, who through insight and experience give new life or a more nuanced dimension to well-known texts or themes.

Over the years, while looking closely at or "reading" Rembrandt's etched biblical narratives, I began to realize that it was not only through careful observation of facial expressions that Rembrandt brought new meaning to his etched biblical subjects; he also enlivened them through inventive hand gestures and the movements and stance of the entire body. The challenge for Rembrandt, as for all painters of literary subjects, or, today, for filmmakers translating a novel into film, was that inner emotions and psychological subtleties had to be transformed into visible outward signs and physical actions. Rembrandt, who was conversant with the Amsterdam theater of his time and made drawings of some of its actors in costume, sometimes made use of conventional histrionic gestures in early paintings and prints. In more instances, however, he exhibited a special gift for fresh insights into human psychology and for what one might characterize as dramatic or literary invention, abilities rivaled by few visual artists of his time or, for that matter, any other.[7]

In his 1638 etching *Adam and Eve* (no. 95) Rembrandt used the fall from innocence of the first family of humankind as a pretext to explore in sly, low comic terms the eternal sparring match between man and woman.[8] Earlier artists, such as Albrecht Dürer in his engraving of 1504, had used the subject as an opportunity to pres-

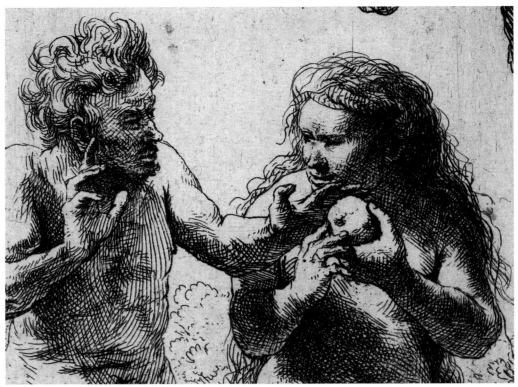

Fig. 2. *Adam and Eve*, 1638, etching, no. 95 (detail).

ent an image of human perfection, but Rembrandt's Adam and Eve are wonderfully earthy, imperfect figures whose bodies seem already to be experiencing the effects of the fall that introduced into the world Sin, Desire, Shame, and Death. Eve is definitely the sturdier, more resolute figure. With a sublimely crafty, calculating expression she offers the fatal apple to a wary Adam. She holds the tempting fruit out above her bosom like a surrogate breast. We are presented with a virtual ballet or pantomime of hand gestures (fig. 2).[9] Eve with both hands caressingly presents the sensuous fruit. The twitching fingers of Adam's right hand appear to be engaged in desperate signing, enumerating his anxieties, while his other hand, tantalized, hovers just above the proffered apple.

Eve stands erect at the very center of the composition, shadows flirting with her naked torso, concealing and revealing the fertile belly that is to be the cradle of the human race. Adam's shoulders are tensely hunched, his face pinched with fear and hesitation, his hair standing on end. Eve's coiffure reveals a primal touch of fashion, a striped headband that pulls her flowing locks back from her brow. Their very stance (fig. 3) is indicative of

Fig. 3. *Adam and Eve*, 1638, etching, no. 95 (detail).

Fig. 4. *Abraham Casting out Hagar and Ishmael,* 1637, etching and drypoint, no. 66 (detail).

Fig. 5. *Abraham Casting out Hagar and Ishmael,* 1637, etching and drypoint, no. 66 (detail).

their relationship: Eve's feet are firmly planted on level ground, while Adam stands knock-kneed, his feet having an uncertain purchase on uneven ground.

Yet another Old Testament domestic drama revolves around the nomadic patriarch Abraham, father of the Jewish nation, and his two families. The small, finely drawn etching of *Abraham Casting out Hagar and Ishmael,* 1637 (no. 66), is one of the most elaborately choreographed and psychologically nuanced of Rembrandt's etched narratives. Abraham's aged and barren wife Sarah had given Abraham her Egyptian maidservant, Hagar, as a concubine. But when a child, Ishmael, was born to Hagar the relationship between the women became strained. Then, when Ishmael was half-grown, God intervened and announced to the ninety-nine-year-old Abraham and the incredulous ninety-year-old Sarah that they would conceive a child together. That miraculous child of their old age was Isaac. Since Sarah feared that Isaac's inheritance might have to be shared, she asked Abraham to send Hagar and Ishmael away. God reassured the distressed Abraham, informing him that Ishmael would also be the father of a great people: Ishmael was to become the founder of the Muslim nation.

This carefully orchestrated scene of departure, in which the pivotal figure of Abraham is pulled in two directions at once, can be divided between those smugly, gloatingly in possession within the house at left, and the newly dispossessed, faceless ones at right who are being cast out into the wilderness to fend for themselves. Abraham literally has one foot *inside* (on the doorstep) and one foot *outside* the house (fig. 4). He looks toward the departing Hagar and Ishmael with longing and regret. As has been noted, his left hand simultaneously dismisses and blesses the valiant small figure of Ishmael,

who seems girded for whatever the future may bring (fig. 5).[10] The victors, those in full possession at left (fig. 6) are filled with a spiteful *schadenfreude*: Sarah leans, cackling with pleasure, on the windowsill while a plump, sly, almost sinister, small Isaac peeps through the half-open leaf of the Dutch door. Faintly smiling, the family dog

Fig. 6. *Abraham Casting out Hagar and Ishmael,* 1637, etching and drypoint, no. 66 (detail).

descends the steps. At lower left even the ornate jardiniere seems to break into a grin.

After having provided Abraham and Sarah with the precious son of their old age, God tested Abraham's faith and obedience by asking him to sacrifice his son as a burnt offering on a far mountaintop. In his 1645 etching of *Abraham and Isaac*, father and son have arrived at the mountaintop (no. 67). There is a pot of coals for the fire and a bundle of firewood that Isaac, the intended sacrifice, has carried to the site. At this point a puzzled and somewhat perturbed Isaac asks his father, "Where is the lamb for the sacrifice?" Abraham, full of faith, replies that God will provide one. In Rembrandt's etching Abraham gazes firmly down into his son's face and emphatically points toward God in heaven (fig. 7). Isaac, his expression partly masked and made ambiguous by shadow, does not meet his father's gaze and appears to gravely ponder his father's answer. Abraham's steadfast conviction is represented by his firm stance in the center of the composition, while Isaac's uncertainty and dawning sense of unease is subtly represented by the large bundle of firewood that leans heavily against him and threatens to push him off balance. Isaac's figure tips slightly backwards, his left foot insecurely planted (fig. 8). Immediately behind him opens the abyss, the sheer drop down the mountainside.

Rembrandt's etching of *Abraham's Sacrifice* from ten years later (no. 68) shows us the next episode in the narrative: Abraham's attempted sacrifice of his son is interrupted by an angel of the Lord who informs Abraham that he need not slay his son because he had now proven his faith and obedience. God provides a substitute sacrifice, a ram whose horns are caught in a thicket.

In the text from the book of Genesis the angel calls out from heaven but Rembrandt has translated the angel's intervention into much more literal and physical terms. The figures of the angel, Abraham, and Isaac are locked together in a complex embrace, like a monumental sculpture group on a pedestal. All action is arrested, frozen in time. The dialogue of hands is remarkably expressive (fig. 9). Abraham's left hand has a firm grip on the knife while the angel forcefully pinions both of Abraham's arms. Abraham's right hand acts as a compassionate blindfold for Isaac, shielding his eyes from the sight of the terrible knife. Abraham himself, his eye sockets darkened as if blind, seems not yet to see, only to hear, the angel.[11]

In characteristic fashion Rembrandt includes within the single image details that allude to events that both precede and follow the central action. On the side of the mountain, gazing off into space, indifferent to the miracle, we see the pack mule and servants that have accompanied Abraham and Isaac on their journey to the place of sacrifice (fig. 10). At left, barely visible under the curve of the angel's wing is the substitute sacrifice, the arched back of the ram with its horns tangled in the thicket.

A small, intensely intimate etching of about 1645 shows the elderly patriarch Jacob, son of Isaac, in loving, silent communication with his beloved youngest son Benjamin (nos. 64, 65). Jacob clung more closely to Benjamin because he believed that his other favorite son, Joseph, was dead. Joseph's herdsman brothers had tricked Jacob into believing that Joseph had been slain by wild beasts, whereas in reality they had sold the boy to slavers who sold him again in Egypt (for the Joseph story see nos. 50–53).

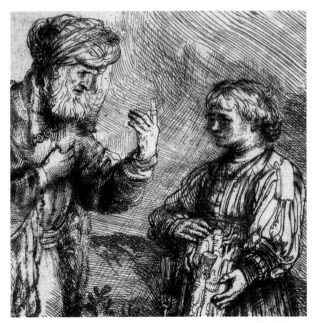

Fig. 7. *Abraham and Isaac*, 1645, etching and drypoint, no. 67 (detail).

Fig. 8. *Abraham and Isaac*, 1645, etching and drypoint, no. 67 (detail).

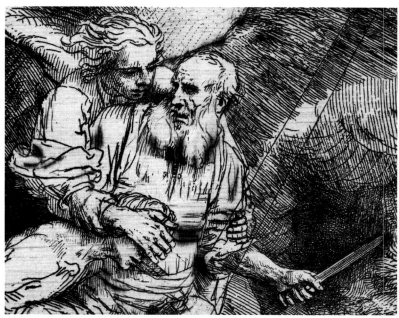

Fig. 9. *Abraham's Sacrifice,* 1655, etching and drypoint, no. 68 (detail).

Fig. 10. *Abraham's Sacrifice,* 1655, etching and drypoint, no. 68 (detail).

Given the disparity in ages, the father and son in the etching might understandably be mistaken for grandfather and grandchild. Jacob sits proudly erect and directs a level look at the viewer as if to capture our attention and to command us to share his pride in his son (fig. 11). Cradled protectively between his father's knees, the smiling child is serenely unaware of the viewer: his small booted feet, casually placed one upon another, are framed by the large, firmly planted feet of the old man (fig. 12).

The silent dialogue of hands and play with visual metaphor in this etching is one of the most quietly original in all of Rembrandt's work. Secure within his father's love, the child hangs on the paternal knee, his right hand

Fig. 11. *Jacob Caressing Benjamin,* about 1637, etching, no. 64 (detail).

Fig. 12. *Jacob Caressing Benjamin,* about 1637, etching, no. 64 (detail).

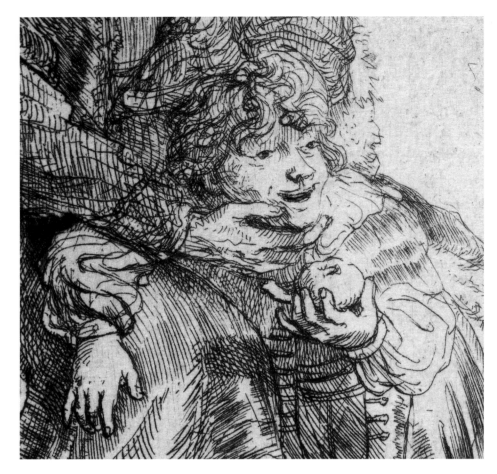

Fig. 13. *Jacob Caressing Benjamin,* about 1637, etching, no. 64 (detail).

fully relaxed. The father's large hands caress the boy's round head, fondling his chin and ruffling his locks, while the boy's fingers unconsciously caress the orb of an apple (fig. 13).

About a decade later (1654), the episode of the thirteen-year-old truant Jesus, who ran away from his parents in Jerusalem during Passover in order to debate matters of religion with the learned doctors in the temple, provided Rembrandt with the opportunity to further investigate the dynamics of family life (fig. 14 and no. 166). The etching and drypoint shows the youngster in the custody of his parents on the road returning to Nazareth after Mary and Joseph had discovered him in the temple at the end of three days of anxious searching. Mary's posture radiates disappointment: she walks hunched over, her eyes cast down. Jesus looks up at her as if to ask, "What's wrong, Mother?" His hand lightly clasps her open one. Joseph's expression is less easily interpreted, his features shadowed by his hat brim, but his whole bodily attitude is that of one marching firmly

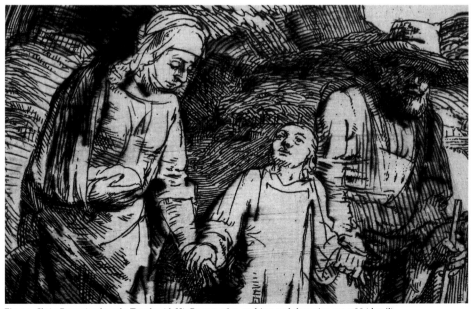

Fig. 14. *Christ Returning from the Temple with His Parents,* 1654, etching and drypoint, no. 166 (detail).

Fig. 15. *Christ Returning from the Temple with His Parents,* 1654, etching and drypoint, no. 166 (detail).

Fig. 16. *Joseph Telling His Dreams,* 1638, etching, no. 52 (detail).

ahead with little time for excuses. He holds the errant boy's hand in an iron grip to ensure that there will be no more unauthorized excursions on the latter's part. The family dog scurrying alongside serves as an anxious spectator to the domestic drama (fig. 15).

Dogs and small children are appealing subsidiary figures that Rembrandt often used to give a more vivid sense of everyday reality or easier accessibility to his etched religious narratives. Sometimes, as above, they are active participants in or spectators to the action. On other occasions, such as the dog grooming itself in the foreground by the fire in the 1638 etching of *Joseph Telling His Dreams* (fig. 16 and no. 52), or the child with its back to Christ doodling in the sand in the 1652 etching of *Christ Preaching* (fig. 17 and nos. 136, 137), such lively vignettes function as a relief or foil to the solemnity of the central event.

Groups of listeners who appear to be absorbed in or comment on the action are an integral part of many of Rembrandt's etched religious narratives. Houbraken in 1718 noted Rembrandt's particular gift for such passages when he talked about the figures of the listening throng in Rembrandt's monochrome oil sketch of about 1634, once owned by Jan Six and now in Berlin, the *John the Baptist Preaching* (see fig. 32, p. 35): "marvelous because of the naturalism with which the listeners' features have been imagined."[12] We have a fine example of this in a detail from the right background of the densely packed

Fig. 17. *Christ Preaching* ("La Petite Tombe"), about 1652, etching and drypoint on Japanese paper, no. 137 (detail).

Fig. 18. *Joseph Telling His Dreams,* 1638, etching, no. 52 (detail).

Fig. 19. *Christ Disputing with the Doctors,* 1654, etching, no. 165 (detail).

small etching of 1638 representing *Joseph Telling His Dreams* (fig. 18 and no. 52), in which Joseph's older herdsman brothers flock together to exchange views regarding Joseph's prophetic dream, their faces smirking or pinched with doubt and distrust. The scene is so over-crowded that we glimpse only the fingertips of an addi-tional offstage brother with whom another is conversing. A later example of such an audience, from 1654, is a detail of the learned doctors in the gallery listening to the the-ological debate between the young Jesus and the rabbis in the etching of *Christ Disputing with the Doctors* (fig. 19 and no. 165). With a few economical strokes, Rembrandt suggests four different physiognomies with varied head-gear, their succinctly described expressions evoking a broad spectrum of states of mind: attentiveness, skepti-cism, and boredom. When one looks at the whole image, these listeners tucked into a corner of the plate do not immediately capture our attention, but they embody the nearly subliminal level of detail that gives additional psychological depth and veracity to Rembrandt's imag-ined group narratives.

In certain instances Rembrandt magnified, or expand-ed the reach of, a gesture or bodily movement by allow-ing light to throw a shadow or silhouette of it onto an adjacent surface. In *Christ Preaching* ("The Hundred Guilder Print") of about 1648 (no. 135), one of the most original, eloquent, and moving passages is that of the woman to the right below Christ who beseeches his aid with upraised arms and prayerfully folded hands (see fig. 20). The translucent shadow of her profile and of her imploring hands is cast onto the bright field of Christ's robe: her earnest petition is visually one with the figure of Christ himself. In the 1651 etching of *The Blindness of Tobit* (no. 132), the old man fumblingly seeks the door of the room in order to greet his returning son, Tobias. His blindness is made more poignant by the emphatic shad-ow that precedes him and which, falling on the wrong spot on the wall, underlines that he is about to miss his intended goal. In the monumental drypoint of 1655, *Christ Presented to the People* (nos. 173, 174), the vehement gesture of an isolated priestly figure at lower right (fig. 21), who appears to be demanding Christ's execution, dramatically reverberates in its ghostly shadow thrown on the blank face of the platform on which Christ stands to be judged.

Rembrandt's etched *Descent from the Cross* (no. 158) of

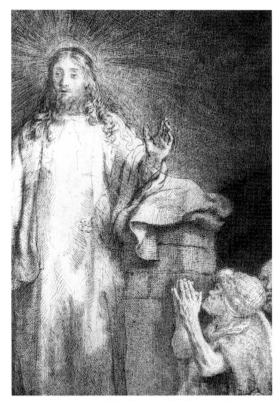

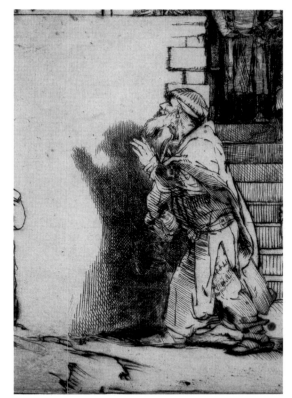

Fig. 20. *Christ Preaching* ("The Hundred Guilder Print"), about 1649, etching and drypoint, B. 74, II, Harvard University Art Museums, Fogg Art Museum, Gray Collection of Engravings Fund and Alpheus Hyatt Fund (detail).

Fig. 21. *Christ Presented to the People*, 1655, drypoint, B. 76, V, Museum of Fine Arts, Boston, Harvey D. Parker Collection (detail).

one year earlier is part of a group of four plates of vertical format and identical dimensions presenting key episodes from the life or Passion of Christ (the others being *The Presentation in the Temple, The Entombment*, and *Christ at Emmaus*). Rembrandt had painted the subject in 1633 (Munich, Alte Pinakothek) as part of the series of Passion pictures commissioned by the court at The Hague. In 1642 Rembrandt had also etched a sketchlike *Descent* that is delicate in line and pale in tonality (no. 42). The 1654 etching presents a close-up of the action with only the base of the cross visible and, like the painted version, with a dramatic nocturnal setting. The Munich painting is illuminated by a heavenly spotlight but the present etching is illuminated by artificial light. In his representations in all media of *The Descent from the Cross* and *The Entombment* Rembrandt revealed his interest in reexperiencing these tragic events in great imaginative detail, particularly with respect to the physical engineering required to deal with the slack, dead weight of Christ's body. In the 1654 etching the realistic details of the removal of Christ's body from the cross are enhanced dramatically by being picked out of the profound darkness by the light of a flaring torch.

As with the etching of *Abraham's Sacrifice* discussed above, Rembrandt suggests within the single image a sequence of events in time. A sling or slide of cloth wound around the cross's upright has been used, with the help of a ladder, to lower Christ's body. The horizontal of Christ's body parallels and echoes the bier on which he is soon to be laid on the ground below. Joseph of Arimathea, a wealthy follower of Christ who provided a tomb for Christ's burial, spreads a linen shroud over the stretcherlike bier. A series of vividly imagined details give authenticity and continuity to this chain of actual and implied actions (fig. 22). Behind the cross a workman appears to be tapping out with a hammer the spike that still secures Christ's right foot. Physical suspense is provided by the full weight of Christ's body being received by a small man with powerful upper torso but short legs, who stands at the very edge of a steep drop. One of the most expressive if eerie details of this descent into darkness is the man who reaches up out of the

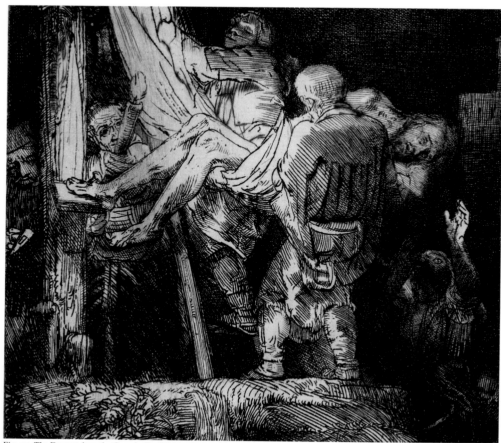

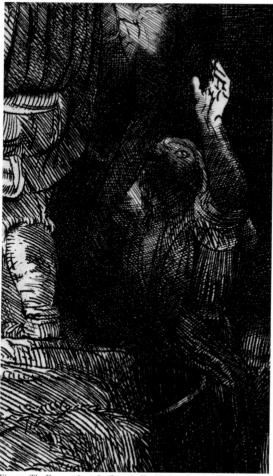

Fig. 22. *The Descent from the Cross by Torchlight*, 1654, etching with drypoint, no. 158 (detail).

Fig. 23. *The Descent from the Cross by Torchlight*, 1654, etching with drypoint, no. 158 (detail).

gloom to assist with the lowering of Christ's body (fig. 23). His one visible hand flickers flamelike in the dark and only one catlike eye is visible in a face mysteriously masked by shadow.

About the same time (1653–55), a surprising shift from the relative serenity and clarity of the first three states of the imposing drypoint representing Christ's crucifixion, "The Three Crosses," to the dissonant, shadowy chaos of the radically revised fourth state of that plate (nos. 168–170) resulted in dramatic changes to the bodily postures and gestures of the participants. If we compare the group of Christ's family and followers gathered to the right of his cross as seen in an impression of the second state (fig. 23) with the same figures as seen in an impression of the fourth state (fig. 24) one might understandably believe that one was looking at impressions from two different plates. In the fourth state the figure of the

Magdalene, relatively unchanged in drawing but heavily obscured by shadow, still bends to embrace Christ's feet as she did in the first three states, but most of the other followers are radically rethought and redrawn. In the second state we can still discern the figures of individual mourners with considerable clarity. They are drawn with an almost classical economy and harmony of contour. Mary is given a beautiful, youthful face. Gestures, whether Mary's hands clasped in sorrow or, to the left, a kneeling woman's outstretched arms, have an almost conventional rhetorical character. More original gestures such as John's—his fists tensely pressed to his temples—are still emotionally contained. What a difference when we reencounter this group of mourners in the fourth state! Faces are boldly redrawn with a blunt, masklike harshness. The mother of Christ has sunk down into another woman's arms and seems to thrash and roll

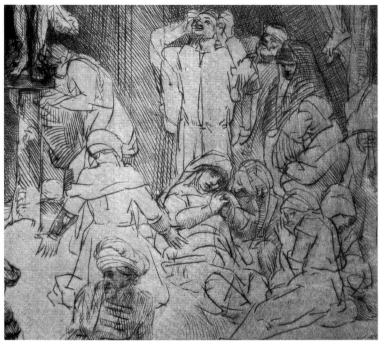

Fig. 24. *Christ Crucified between Two Thieves* ("The Three Crosses"), second state, 1653–55, drypoint, no. 168 (detail).

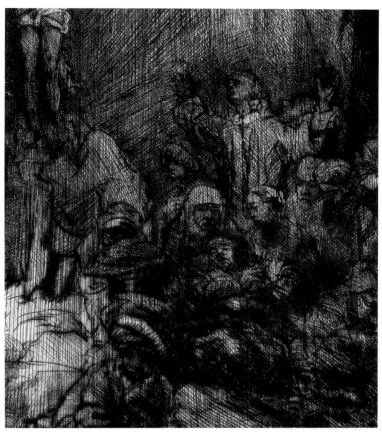

Fig. 25. *Christ Crucified between Two Thieves* ("The Three Crosses"), fourth state, 1653–55, drypoint, no. 170 (detail).

about, her face aged and distorted by grief. John's figure has been moved to the right and he flings out his arms in a forcefully exaggerated gesture of despair. Light and shadow are now the principal actors: radiating, ricocheting streaks of animate shadow crisscross the scene, shattering solid forms into flickering fragments.

In closing, it is appropriate to quote Arnold Houbraken, who in 1718 published the first full-fledged artistic biography of Rembrandt and who had studied with Rembrandt's pupil Samuel van Hoogstraten, regarding Rembrandt's unique abilities in depicting human emotions: "[which] stem from thoughtful consideration of the various passions...[revealed through] the distinctive movements of the body."[13]

NOTES

1. Van Hoogstraten 1678, 109, "Wilmen nu eer inleggen in dit alleredelste deel der konst, zoo moetmen zich zelven geheel in een toneelspeeler hervormen," and, "Leer nu, o Schilderjeugt, deze allerkonstlichste rol speelen." The translations from the Dutch in this essay are the author's but I would like to thank Annewies van den Hoek for her kind assistance.

2. For the account of Rembrandt and Lievens in Huygens's Latin memoir of his youth, see Worp 1891, 106–136 (with Latin and Dutch); the more recent Dutch translation by C. L. Heesakkers in Huygens 1987; and Alan Chong's English translation in Chong et al. 2000, 134–36.

3. Van Hoogstraten 1678, 75, "Rembrand op de lijdingen des gemoeds...."

4. Van Hoogstraten 1678, 109, notes that the young artist who wishes to learn to express the passions in his art may wish to study his own personal experiences, pleasant and unpleasant, so as to learn firsthand what inner feelings and outer gestures are associated with such emotions: "Zoo moogt gy ook, als u eenigen druk overkomen is, u met de kunst troosten, en als u iets behaeglijx voorkomt, zoo is 't tijdt,

dat gy aenmerkt wat innerlijke gevoelicheden en uiterlijke bewegingen deeze lijdingen veroorzaken."

5. Van Hoogstraten 1678, 110, "om te gelijk vertooner en aenschouwer te zijn."

6. Van Hoogstraten 1678, 191–92. In this chapter on drawing Hoogstraten advises the young artist to draw many "histories" from the imagination.

7. For Rembrandt and the theater of his time, see the article by Ben Albach 1979, 2–32. The painter Karel van Mander in his treatise, *The Foundation of the Noble Liberal Art of Painting* (*Den Grondt der edel vry Schilder-const*), published in 1604, when discussing the representation of the feelings or emotions (*Affecten*, chapter 6, sections 5 and 6) recommends close observation of the external evidence of emotive states from life rather than slavishly following the formulaic rules for expressing emotion laid down by stage performers; see Van Mander [1604] 1973, 1: 158.

8. Rembrandt rarely made preparatory drawings for his biblical etchings but two preliminary sketches exist for the Adam and Eve etching. They are reproduced and discussed in White 1999, 38–39, and figs. 44–45. The first (Philadelphia, Private Collection) shows the pair seated with Eve higher than Adam. Adam appears hysterical with fright as Eve holds out the apple. The second sheet (Leiden, Print Room) has two studies. Adam and Eve are now standing and their gestures are roughly comparable to those in the etching but Adam is taller than Eve.

9. Van Hoogstraten 1678, 117–18, likens the gestures of the hands to a universal language that can convey the most varied actions and emotions: desire, refusal, joy, sadness, recognition, fear, etc.: "wat de handen belangt, door dezelve worden voornementlijk alle daden ofte doeningen uitgewerkt, ja der zelver beweegingen zijn byna by een algemeene spraeke te vergelijken. Ze begeeren en belooven, zy vragen, zy weygeren, zy betoonen vreugde, droefheit, leetwezen, erkentenis, vreeze en gruwel . . ."

10. Tümpel 1970, no. 6.

11. See Rosenberg 1964, 176, "the angel remains unseen by the patriarch" and "the father himself has not yet fully grasped the significance of this blessed visitation. As he listens, inwardly, to the unknown voice, the stamp of suffering still marks his features."

12. Houbraken 1718–21, 1: 261 "verwonderlyk om de natuurlyke verbeeldingen der toeluisterende wezentrekken . . ."

13. Houbraken 1718–21, 1: 258, "'t welk ontspruit uit aandagtige bedenkingen der menigerhande Hartstochten . . . uit de onderscheidentlyke beweginge der lichamen zig vertoonen."

REMBRANDT'S OIL SKETCHES

Ronni Baer

While Rembrandt may well be among the most beloved artists in history, and his paintings among the most studied, his oil sketches remain little known. One reason is that defining a Rembrandt oil sketch is an elusive exercise. For the purposes of this essay, we will consider them to be the roughly worked paintings, usually small in scale and often monochromatic, that appear to have been made preparatory to another work. Oil sketches are, perhaps, the smallest "category" of his art; only about ten of his paintings can be so classified. The majority are history subjects. Several evince a complicated working process that included laying a flexible support onto a more rigid one. Fresh, direct, and intimate as any drawing but materially more solid, the oil sketches exhibit the marks of the artist's hand more obviously than many of Rembrandt's other works and show a fertile and questing mind at work. They raise issues of Rembrandt's aspirations, fueled by his models of professional status and technical wizardry (Jan Lievens, Anthony van Dyck, Peter Paul Rubens, Titian). Furthermore, they illustrate the complex pattern of artistic exchange between Italy and the northern Netherlands on the one hand, and Antwerp and the northern Netherlands on the other. They are linked to the historical appreciation for the unfinished and, simultaneously, appeal to the contemporary taste for artistic process and an aesthetic of sketchiness.

Though Rembrandt was a tireless draftsman, he made few compositional drawings. There are drawings, finished to a high degree but not complete, that were intended to work out the position or gesture of a figure, or the play of light on drapery. Other of his drawn sketches are very loose, with unresolved details. His oil sketches, however, are most closely related to the few full-size, highly finished and complete drawings that were incised for transfer to etching plates: *Diana at the Bath* of about 1630–31 (no. 196); *Bust of a Man with a Flowing Beard* of about 1631; *Portrait of Cornelis Claesz. Anslo* of 1641; and *Jan Six* of 1647 (no. 74).[1] While many of the oil sketches cannot be related to other (known) works, it seems that they, like these finished drawings, might have been largely intended as models for prints. They were apparently not used by the young artists in Rembrandt's studio as part of workshop practice, nor, with the possible exception of *The Concord of the State* (fig. 33, p. 37), were they likely submitted to a patron for approval.

Rembrandt varied his technique in his oil studies. Among the biblical subjects, *Joseph Telling His Dreams* (no. 51) is broadly painted; *Ecce Homo* (*Christ before Pilate*; no. 48) is close to drawing; *The Entombment* (no. 46) is decidedly "sketchy"; while the *Lamentation at the Foot of the Cross* (no. 44) presents a combination of broadly applied paint and finely delineated details. These works show an extraordinary range for so circumscribed a type of painting, but invariably Rembrandt is preoccupied with the illumination of the scene, the arrangement of light and shadow in the composition. Their execution calls to mind Constantijn Huygens's 1629 statement about Rembrandt's "sure touch and liveliness of emotions," and how "[he] devotes all his loving concentration to a small painting, achieving on that modest scale a result which one would seek in vain in the largest pieces of others. . . . In what we are accustomed to calling history pieces, [Lievens], his astonishing talent notwithstanding, is unlikely to match Rembrandt's vivid invention."[2] The summarily painted oil sketches reveal the "sure touch" admired by Huygens, as well as Rembrandt's unrivaled ability to "vividly" describe gestures, facial expressions, and body language on a very small scale indeed.

It has recently been observed that Rembrandt gave new impetus to the appreciation of visible process in a work of art.[3] This applies not only to his drawings and prints, but to his oil sketches as well. By virtue of their small size and relatively rough execution, these studies draw attention to the paint itself and the way it is applied, even more than to the personages and action depicted. Unusually apparent in them is the use of thick pigment and the changes, or *pentimenti*, that are part of the creative process. As his sketch plates and numerous drawings evoke the artist's mental processes and allude to his virtuoso abilities, so, too, do his oil sketches.

Rembrandt and the Italian Roots of the Oil Sketch

The oil sketch had been developed as a category of painting in Italy long before Rembrandt turned his hand to it. It was first used in late sixteenth-century Venice, in studios, like that of Tintoretto, responsible for producing large works, painting cycles, or decorative ensembles. Brush and oil became an alternative to preparatory pen and wash drawings, to aid assistants in executing

complicated commissions or to give the patron an idea of the finished work. It was precisely at this time that light began to take on a more important role, ordering space and organizing the image so that the composition could be apprehended as a whole (rather than primarily read in its separate parts). Chiaroscuro, or the contrast of light and shadow, would now establish the value structure of a painting rather than merely suggest the plasticity of individual figures. Rembrandt's small studies of biblical subjects show how well the artist assimilated the Italian precedent of using light and dark to organize a composition.

Although Rembrandt did not choose to travel to Italy, he would have had ample opportunity to see Venetian paintings in Leiden and Amsterdam collections.[4] He felt that a trip south was unnecessary, reportedly explaining that "the best Italian paintings of the genre most appreciated and collected these days by kings and princes north of the Alps are to be found outside Italy. What is scattered around in that country and only to be traced by dint of considerable effort, can be found in abundance and even in surfeit here."[5] Indeed, many collections at that time were well known and documented, but what is not clear from surviving descriptions is whether any of the Italian works Rembrandt might have seen in Holland was an oil sketch. The only possible candidate is the "Head of a woman with neck and breast naked" by Palma il Vecchio, seen by Van Mander in the house of a certain Van der Muelen (sic) in Leiden.

The gulf between the apparent appreciation for Italian paintings in Holland and proof of Rembrandt's direct knowledge of Venetian oil sketches thus remains. Nevertheless, we can suggest possible bridges, mostly centered on Amsterdam. The painter Dirck Barendsz. (1534–1592) was in Rome and Venice from about 1555 to 1562, and is credited with introducing to the northern Netherlands the strong colors and rapid, sketchy brushwork associated with the Venetian style of painting.[6] While in Amsterdam, Barendsz. made forty chiaroscuro oil sketches depicting scenes from the Passion which were used as designs for prints.[7]

One prominent painter with direct ties to Rembrandt was his teacher Pieter Lastman (1583–1633), who visited Rome and Venice between 1602 and 1607. His ability to transform the monumental figures and grand conceptions of his Italian predecessors and counterparts into cabinet-sized history paintings made him the ideal teacher for ambitious young artists. Lastman's monogrammed oil sketch of *The Sacrifice of Isaac* (fig. 26), dated about 1612, is a finished grisaille that may have served him as a study for a larger work. It was certainly the

point of departure for Rembrandt's painting of 1635, now in The Hermitage, St. Petersburg.[8]

David with the Head of Goliath before Saul: Rembrandt and Lastman

Rembrandt's first known oil sketch, *David with the Head of Goliath before Saul* (fig. 27), is painted on panel and signed and dated 1627. Artists did not generally sign modelli or studies, but Rembrandt was different; this is the first of several sketches that bear his signature. The small painting, made while Rembrandt was still in his native Leiden, is such an anomaly among his oil sketches that one might question its designation as one. It is unusual in its use of bright, local color and appears to be unrelated to any of his known prints, drawings, or paintings. Only its reduced scale and cursory execution argue for including it among the artist's oil sketches.

David with the Head of Goliath before Saul is reminiscent of two of Rembrandt's other early history paintings: *The Stoning of St. Stephen* of 1625 and the *History Painting* of 1626.[9] The expansive horizontal format and general relation of figures to architecture are shared by the three works. Furthermore, the mounted horseman in *St. Stephen* and the kneeling supplicant in *History Painting* are taken over in the oil sketch, where they occupy analogous positions and perform similar functions. These resemblances, and the fact that, despite its size and execution, *David with the Head of Goliath before Saul* is a fully realized picture, suggest that Rembrandt might have here used the oil sketch, for the only time in his work, either as a study for a larger painting (perhaps never realized) or as an autonomous work of art.

The loose, free touch and thick application of paint do not hide the significant artistic strides Rembrandt

Fig. 26. Pieter Lastman (Dutch, 1583–1633), *Sacrifice of Isaac*, about 1612, grisaille in oil on panel, 40 × 32 cm (15¾ × 12½ in.), Museum het Rembrandthuis, Amsterdam, on loan from The Netherlands Institute for Cultural Heritage.

Fig. 27. *David with the Head of Goliath before Saul*, 1627, oil on panel, Br. 448, Corpus A9, 27.5 × 39.5 cm (10⅞ × 15½ in.), Kunstmuseum, Öffentliche Kunstsammlung Basel, Basel.

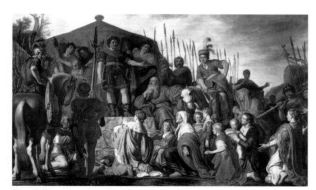

Fig. 28. Pieter Lastman (Dutch, 1583–1633), *Coriolanus and the Roman Women*, 1625, oil on panel, 81 × 132 cm (31⅞ × 52 in.), Trinity College, Dublin, reproduced by kind permission of the Board of the College.

made in the course of a year or two. It is possible that he was adopting the experimental medium and technique of Jan Lievens (1607–1674), another former Lastman pupil and child prodigy with whom Rembrandt worked extremely closely during his Leiden years.[10] It is sure that Rembrandt was also looking at Peter Paul Rubens (1577–1640). As has long been noted, Rubens's *Adoration of the Magi* now in the Musée des Beaux-Arts, Lyon, was the source for the figures of Saul and the trainbearer(s). Rembrandt would have known the composition through Lucas Vorsterman's print of 1621 or an anonymous engraving after Vorsterman.[11]

Around the time Rembrandt entered his Amsterdam studio, Pieter Lastman completed his painting of *Coriolanus and the Roman Women*, whose structure and detailing would inspire the younger artist in his early history paintings (fig. 28).[12] Very different, however, are the two painters' approach to light: Rembrandt uses stronger contrasts between light and dark, while Lastman's composition is more evenly—though not uniformly—lit. Rembrandt's color is in a higher key, his figures are smaller in proportion to the space they occupy, and the evocation of atmosphere is stronger.

Lastman's solution for the organization of his complex composition harmonized with Karel van Mander's prescriptions in his treatise on the theory of painting, *Den grondt der edel vry schilder-const* (Foundations of the noble liberal art of painting). The market stall was the suggested model: the figures should be placed according to their role and importance; the corners should be filled with figures or architecture that draw attention toward the middle of the picture; small groups should be used to order the action; and close attention should be paid to telling details.[13] Rembrandt, too, followed this advice: the center of his composition, bathed in light, is dominated by Saul, Abner, and David; the seated

pikesman and mounted archer (who is closely related to Lastman's similarly placed horseman) serve as *repoussoirs*; the two trainbearers exchange conspiratorial glances, intimately linking them; and Saul's regal garments and Goliath's huge sword are iconographically important.

As for the arcane subject, a *David Receiving the Head of Goliath* by Lastman figured in a sale of 7 March 1731, though we have no record of its appearance.[14] Whether Rembrandt was inspired to emulate Lastman's artistic solution, or was spurred by it to revise it critically, the young artist found it crucial to enter into dialogue with his teacher. Throughout his career, Rembrandt measured his artistic standing and goals against others, whether he saw them as role models, rivals, or paragons.

Bust of an Old Man: Rembrandt and the Flemish Tradition

Bust of an Old Man (no. 31), signed and dated 1633, is the smallest known painting by Rembrandt.[15] The painting is a *tronie*, intended as a character study rather than a portrait of a specific individual. There was a market for these works, but they could also be used as models for figures in genre and history paintings. While in Leiden, both Rembrandt and Lievens made several drawn, etched, and painted studies of such old men.[16] The fact that this oil sketch, so clearly related to his youthful work, dates to the year Rembrandt settled definitively in Amsterdam makes its style and subject seem somewhat nostalgic.

For this oil sketch, Rembrandt used a loaded brush and broad strokes to capture the old man's tousled hair, unruly beard, intense expression, and the fall of light on his body. This rough technique, like the compositional type, reflects Rembrandt's interest in Flemish painting. From about 1553 to 1565, the Antwerp artist Frans Floris (1519–1570) executed numerous oil sketches on panel of life-size imaginary study heads. Floris used these works both to study the fall of light and shadow and to experiment with expression and carriage. They also had a practical function. Floris established a thriving workshop, organized along the lines of those he had seen during a stay in Italy, and employed assistants to carry out an increasing number of commissions. Van Mander reported that after the artist had sketched a composition with chalk, he would direct his students to insert the heads from studies he had previously painted "as he had always a good many of them painted on panel in his studio."[17]

Rubens, too, reverted to the Italian model and reintroduced the practice of using study heads. Dating before 1620, these sketches on panel were made at a time when

the commissions produced by Rubens's busy workshop did not have to be executed entirely by the master's hand. Later, when his pictorial abilities were fully mature and he carried any number of physiognomic images in his head, Rubens dispensed with such "patterns."[18]

Head studies by Anthony van Dyck (1599–1641), based on nature rather than fantasy, offered excellent examples of the single-figure *tronie* painted in the rough manner (fig. 29).[19] Van Dyck sojourned in The Hague during the winter of 1631–32, where he made oil sketches for a projected series of etched and engraved portraits of illustrious men (called the *Iconography*). These included Jan Lievens, who was one of Van Dyck's early followers in Holland, and Constantijn Huygens, who could have met the Flemish artist in London as early as 1620. That both Dutch men, so closely connected to Rembrandt, had contact with Van Dyck during his stay in Holland provides circumstantial evidence of Rembrandt's exposure to the Flemish artist, one that would ultimately be important to his production of portrait prints.[20] Another possible connection between Rembrandt and Van Dyck would have been through the former's reproductive printmaker, Johannes van Vliet, who was in Antwerp in 1632.

A further link between Rembrandt and the art of Antwerp was Hendrick van Uylenburgh. When he arrived in Amsterdam, Rembrandt resided with Uylenburgh and later married his first cousin, Saskia. Uylenburgh, who presumably trained as a painter in Poland before coming to Amsterdam and setting up as an art dealer, had been responsible for shipping twelve paintings of apostles by Van Dyck to the King of Poland in 1620. His continued contact with the Flemish art world may have been an important stimulus to his young lodger.[21]

Joseph Telling His Dreams and Ecce Homo: Rembrandt, Reproductive Printmaking, and the Tradition of Grisaille Painting

Rembrandt's second oil sketch of an Old Testament subject, signed and dated 163(?), depicts Joseph recounting the second of his dreams to his family (no. 51).[22] As with many of his oil sketches, there is no way to know for certain for what purpose the sketch was made. Despite the fact that it is painted on paper, no reproductive print after it exists (although the possibility cannot be excluded that Rembrandt intended for it to be etched or engraved). Clearly, the artist used it to study the disposition of light and dark, organizing the composition around a brightly lit center held by the young protagonist, intently leaning toward his father.

An unusual group of independent drawings related to the painting provide a provocative glimpse into the way the oil sketch and 1638 etching of the subject (no. 52) evolved. Rembrandt appropriated one of his early red chalk studies (no. 50) for the figure of Jacob in the oil sketch. He then apparently revised the sketch's compositional arrangement in a faint chalk drawing on the verso of another work. In pen, ink, and wash, he drew the figure of a seated woman reading a book, not present in the oil sketch but anchoring the right corner of the print, and a turbaned man (no. 53). The latter is an elaborated study of the barely sketched-in brother standing beyond Joseph in the oil sketch who hovers directly above him in the later etching. The artist also recorded a puppy curled in his kennel (no. 54), a domestic detail he incorporated into the oil sketch. Rembrandt pilfered his own work, made drawn observations of the world around him, and thought out loud in pen and ink to arrive at and then revise a composition that best expressed the drama inherent in the biblical story of sibling rivalry.

This oil sketch is an example of a grisaille, a monochrome painting. Largely owing to its lack of color, it appears to be more cursorily executed than *David with the Head of Goliath before Saul*. By removing the distraction of color, the focus is not only on the arrangement of light and shadow but also on the artist's confidence with the brush.

Historically, work in grisaille can be traced from courtly manuscript illumination to the decoration of the closed shutters of altarpieces (in imitation of sculpture), to a wide-ranging interest in monochromy beginning in the late fifteenth century, to the small works produced on their return to the north by the Netherlandish Romanists, influenced by the grisaille murals they saw in Italy. The oil sketch became a practical tool in the north by the mid-sixteenth century with the growth of professional printmakers.[23] Original drawings and, gradually, oil sketches were a necessity in the developing division of labor between design and execution. What more appropriate way to prepare a print, normally executed in tones of black, white, and gray, than with a monochrome painting, where the relative strengths of the lights and darks can be worked out?

In Holland, several artists born in the generation before Rembrandt painted oil sketches, some evidently as experiments, others as models for prints. These were artists associated with Dutch mannerism, working in the centers of Haarlem and Utrecht. Karel van Mander (1548–1606), apprenticed to an artist in Ghent before journeying to Italy and elsewhere, finally settled in Haarlem. Among the first works he painted there was a grisaille tondo panel depicting *The Deluge*, now in the

Fig. 29. Anthony van Dyck (Flemish, 1599–1641), *Head*, about 1616, oil on paper laid on canvas, 57 × 41.4 cm (22½ × 16¼ in.), Bayerische Staatsgemälde-sammlungen, Alte Pinakothek, Munich.

Frans Hals Museum, Haarlem. In 1599, his compatriot, Hendrick Goltzius (1558–1617), who had gone to Italy to further his artistic training, painted a grisaille on paper, *Without Ceres and Bacchus, Venus Would Freeze*, later engraved but originally made as a finished work.[24] Cornelis Cornelisz van Haarlem (1562–1638), who studied in Antwerp, made at least one oil sketch on paper and several grisailles on panel to be engraved by Jan Muller and Jacob Matham.[25] In Utrecht, Abraham Bloemaert (1566–1651), whose father set him to copy work by Frans Floris, made oil sketches as designs for prints as well as monochrome paintings in shades of gray, brown, and pink.[26]

In Rembrandt's immediate milieu, Jan Lievens also painted a few oil sketches.[27] Among them are a grisaille on panel of *The Capture of Samson*, from about 1627–28 (fig. 54, p. 77), which has often been attributed to Rembrandt and, in any case, relates to Rembrandt's own early depiction of the subject (no. 11). Lievens also painted a grisaille on paper of *St. Jerome*, 1631, now in the Lakenhal, Leiden, most likely for his own print of the subject.

Ecce Homo (*Christ before Pilate*; no. 48), dated 1634, is the single oil sketch of a narrative by Rembrandt that was definitely made to be reproduced as a print. The etching of the subject (no. 49), the same size as the sketch and reproducing the composition in mirror image, is signed *Rembrandt f.* and dated 1635 in the first state and 1636 in the third. The technique of the sketch—drawn outlines over relatively broadly painted tones of yellowish brown—resembles those preparatory designs made by Rubens for reproductive engravers working after his compositions. The fact that the outlines of the sketch are indented also relates it to the elaborate full-scale drawings made by both Rubens and Rembrandt for transfer to the copper plate. From both a stylistic and technical viewpoint, the print of *Ecce Homo* has been largely attributed to Johannes van Vliet, whose dated plates after Rembrandt were published between 1631 and 1635.[28]

It seems likely that Rembrandt contracted the execution of the plate to Van Vliet in Leiden, giving him the specially prepared grisaille as his model. Van Vliet began working on the commission and sent trial proofs to Rembrandt in Amsterdam for his assessment. On one of the proofs, Rembrandt evidently made corrections in brown oil paint before sending it back to Leiden.[29] Using this retouched proof, Van Vliet finished the print and sent the plate to Amsterdam. Rembrandt made a few final corrections on the plate (his hand can be seen in much of the drypoint work on the print), signed it, and began printing an edition.[30]

It was during the 1630s that Rembrandt decided to publicize his work through reproductive prints. He may have adopted this practice in conscious emulation of Rubens, who, in turn, may have had the models of Raphael and Titian in mind. Rubens attached great importance to the reproductive engravings made after his work, leading him to acquire privileges, a form of copyright, so that the unauthorized reproduction of his prints would be a punishable offence. Only in this plate and the *Descent from the Cross* (fig. 30)—the two largest, most "Flemish" etchings associated with his work—did Rembrandt claim the "privilege" of copyright.

The *Descent from the Cross*, also largely the work of Johannes van Vliet, was published by Hendrick van Uylenburgh. It reproduces Rembrandt's painting of the subject that probably entered Frederik Hendrik's collection through the intervention of Huygens. It was the artist's response to the great *Descent from the Cross* by Rubens in Antwerp Cathedral—known to Rembrandt, appropriately enough, through the engraving after it by Lucas Vorsterman. While in his earlier works Rembrandt adopted individual motifs from Vorsterman's reproductive engravings after Rubens, he now adapted whole compositions, translating them into his own idiom.[31] Furthermore, to have a major painting commissioned for the court was a milestone for the ambitious young Rembrandt, and one to which he may well have wanted to attract attention. What better way than to have its image disseminated in print form, after the practice of the most seasoned and successful painter-courtier known to him—Rubens?

The Entombment: Rembrandt and Courtly Aspirations

The *Entombment* sketch (no. 46), a moving depiction of Christ's burial, is remarkable both for the energy of its paint application and for its lack of definition. The range of darks, from almost pitch black to a creamy brownish gray, is relieved only by the lead white and ochre yellow on the figures illuminated most directly by the candle. Many details of costume and form have been suppressed; Rembrandt summarily blocked in the postures of the faithful carrying Christ's body to the tomb, and captured the quiet atmosphere of intense spirituality through the use of impastoed, broad brushwork. Only the features of Nicodemus cradling Christ's head and Joseph of Arimathea tugging the shroud have been more fully described.

Rembrandt was interested in exploring the effects of artificial light throughout his career. He was exposed to the practice during his earliest apprenticeship with Jacob van Swanenburg, whose scenes of hell evinced a fascination with painted fire. He had an opportunity to

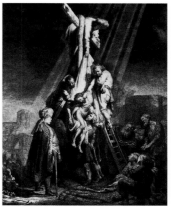

Fig. 30. Rembrandt and Johannes van Vliet (Dutch, about 1610–after 1635), *Descent from the Cross*, 1633, second plate, etching, B. 81, 53 × 41 cm (20⅞ × 16⅛ in.), Rijksmuseum, Amsterdam.

develop it further when Caravaggio's influence came north with the group of Utrecht artists who returned home from extended stays in Rome. It was also characteristic of a strain of Venetian painting exemplified by the work of the Bassani.[32]

The sketch is a variant of the large, fully realized *Entombment of Christ* that Rembrandt painted for the stadholder Frederik Hendrik (fig. 31); the big painting is clearly related to the small sketch but is not entirely dependent upon it. Rembrandt's paintings of the *Descent from the Cross* and the *Elevation of the Cross* were delivered to the court in 1633, the first in a sequence of scenes from the Passion of Christ that Rembrandt executed for Frederik Hendrik. The *Ascension* followed in 1636, and in 1639 the *Resurrection* and the *Entombment* were sent to The Hague. According to a letter Rembrandt wrote to Huygens dated February 1636, the *Entombment* was more than half done. Therefore, the time elapsed between the execution of the oil sketch, on stylistic grounds dated between 1633 and 1635, and advanced work on the painting must not have been great. Nevertheless, for the final work Rembrandt radically changed the format of the painting, adjusting the placement of several of the figures and relocating them onto different planes. The lit lantern and glimpse of sky in the background make the painting a less mysterious evocation of palpable sadness and grief and heighten the presentational and meditative aspects of the scene.

The Passion paintings were not the first works by the artist to enter Frederik Hendrik's collection. Through the offices of Constantijn Huygens, it seems that Rembrandt's *Samson and Delilah* and *Simeon in the Temple* had been acquired for the prince by 1632.[33] The artist was also commissioned to paint the *Portrait of Amalia van Solms* (Musée Jacquemart-André), Frederik Hendrik's wife, in that year, and it is possible that other paintings by the artist were owned by the stadholder as well.[34] Furthermore, two paintings that early entered the collection of Charles I of England, a *Self-Portrait* (Liverpool) and an *Old Woman* (Windsor Castle), are linked to Frederik Hendrik's court in The Hague via the English diplomat Sir Robert Kerr, who visited the city in 1629.

Both Gary Schwartz and Simon Schama have made the case for Huygens's machinations on behalf of Rembrandt at court and of Rembrandt's own ambitions to be a court artist.[35] It is clear that the example of Rubens, not only as an artistic source for compositions and motifs, but also as one of Frederik Hendrik's favorite painters and as a diplomat and courtier, motivated him.[36] Rubens had brought north the values of the Italian Renaissance tradition of the noble painter, a status most famously achieved by Titian, who came to stand for the highest professional and social aspirations of the artist.[37] Whereas

Rembrandt consciously alluded to the art of Rubens, acknowledging and discharging a debt to him (*imitatio*), he struggled to emulate and ultimately surpass Titian (*aemulatio*), the greatest of the Venetian artists.[38] In many ways, Rembrandt modeled his artistic biography on that of Titian.

As they are for Titian, the sketchy, the unfinished, and the display of artistic choice and process are important components of Rembrandt's art.[39] This is obvious in the sketch plates he prepared as etchings, as well as in the number of prints that, because of their inking and choice of paper, are unique examples rather than true multiples. (Similarly, the fact that a number of impressions of the unfinished plates of the *Iconography* were printed suggests that contemporary connoisseurs appreciated the aesthetic value of Van Dyck's unfinished portraits.[40]) The taste for the unfinished can be traced back to Pliny, who claimed that in such works, the artist's thought process is made visible. The idea was picked up by Vasari, who opined that the creative furor evident in drawings—and, by extension, sketches—is dimmed if the execution of a finished work requires prolonged effort. By associating the incomplete work with a burst of artistic creativity, Vasari accentuated the connection between an artist's sketch and his intellectual activity, making the painter's inspiration comparable to that of the poet. Baldinucci described the *macchia* (spot, stain) as "done with extraordinary facility and with such harmony and freshness that it almost looks as if it had appeared all by itself on the paper or the canvas."[41]

The ideas of speed and economy are implicit in this definition of *macchia*, the touch associated with sketches since Leonardo. Such spontaneity and apparent effortlessness, connected to the idea of *sprezzatura* as extrapolated by the Venetian critic Lodovico Dolce (1508–1568) from Castiglione's *Il libro del cortegiano*, was viewed as the true manifestation of an artist's genius.[42] Vasari saw Titian's technique as devolving from his method of painting directly on the canvas, without first making preparatory drawings, so that tonal and color values take precedence over form. Such an approach concealed the effort that went into making a painting.[43] Since many of Rembrandt's oil sketches are only peripherally related to other of his works of art, it is tempting to see him as laying claim to this artistic heritage or buying into this artistic *topos* in a work like *The Entombment*.

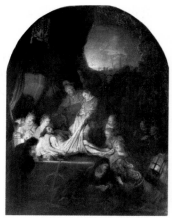

Fig. 31. *The Entombment of Christ*, completed 1639, oil on canvas, Br. 560, Corpus A126, 92.5 × 68.9 cm (36⅜ × 27⅛ in.), Bayerische Staatsgemäldesammlungen, Alte Pinakothek, Munich.

St. John the Baptist Preaching and Lamentation: Rembrandt's Working Method

The oil sketch of *St. John the Baptist Preaching* from 1634 (fig. 32) had a complicated genesis. At an early stage, the central piece of canvas had a small strip attached to the

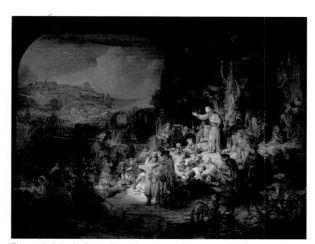

Fig. 32. *St. John the Baptist Preaching*, 1634, oil on canvas laid on panel, Br. 555, Corpus A106, 62 × 80 cm (24⅜ × 31½ in.), Staatliche Museen zu Berlin, Preussischer Kulturbesitz, Gemäldegalerie.

right edge. That canvas was subsequently attached to a larger panel, and a second canvas the size of the panel laid over it. A window revealing the original canvas was then cut into the second canvas and the surplus canvas from this second piece (corresponding to the area of the original composition) was discarded, resulting in the alignment of the old and new canvases on the panel. Rembrandt was then free to enlarge and elaborate his composition on the peripheral unpainted parts of the new canvas. Only after this point was the painting given its black surround.

In its original format, the size of the sketch was the same as the *Descent from the Cross* and *Ecce Homo*, so it has been suggested that it, too, was originally intended as the model for an etching. At what point Rembrandt abandoned this project, if indeed it was meant as a preparatory work, is unknown. The grisaille was acquired by Jan Six, in whose 1658 inventory it is mentioned, so it was certainly appreciated and probably considered an independent work by that time.[44]

Rembrandt's use of light in this very finished oil sketch is dramatic and expressive. It is most striking in the original part of the canvas, which features a broad swath of warm light extending out from the gesticulating John in an elongated ellipse. The foremost plane, which extends up into the foreground of the original canvas, is in deep shadow; the blocky figures at right are drawn in bold, dark strokes. The column with the emperor's bust, reminiscent of the same feature in *Ecce Homo*, delimits the "stage" on which the drama unfolds, and separates it from the sweeping landscape beyond.

A composition by Pieter Lastman (known today through a drawn copy of the lost painting) was the point of departure for Rembrandt's sketch.[45] Rembrandt elab-

orated on the small aqueduct in the center background of Lastman's composition, transforming it into an imposing double-arched bridge. The breadth of conception of both the landscape and its architecture anticipates that of painted biblical narratives like *The Visitation* of 1640 (no. 69). Furthermore, Rembrandt adopted from his teacher the gesture and placement of John on an elevation on the right side of the composition and the idea of depicting the range of reactions of various types of people.

One of the most striking aspects of Rembrandt's painting is the assemblage of what has been described as "the entire population of the world"—figures who, by their exotic headgear, costumes, and ethnic types appear to be, among other nationalities, Japanese, Indian, Egyptian, and Turkish. While in the Bible the populace is described in the context of baptism, Rembrandt here presents them attending to John's preaching. The three debating Jewish sages just leaving the pool of light with their backs turned to Christ's messenger may well represent the "vipers" alluded to in the text of the gospel.

The artist has remembered the lessons he learned from Lastman and Van Mander in terms of using small groups to order the action and including telling details to enliven the scene. He has depicted an array of postures and captured the varying degrees of attentiveness among the listeners—a mother cradling her child and a man sprawled on the ground listen raptly to John's words, a woman behind the departing Pharisees quiets her crying baby, listeners more critical of what they hear cock their heads, others are distracted or, as is the case with the man leaning his head on his hand at John's feet, asleep. The concomitant emotional range—individuals who are bored, angry, indifferent, or spiritually moved—is also striking and contributes to the immediacy of the image. These were the qualities that struck the artist's contemporaries.[46] Rembrandt was alert to the unfolding of daily life and the minutiae of his surroundings, which he explored in many of his genre drawings and sketch plates. In fact, he made a number of studies of individual figures and groups, which he incorporated into this work.[47] The enormous range and various foibles of humanity are the real subjects of this painting; such a crowd—the people to whom Christ would be Savior—was later the focus of the great "Hundred Guilder Print" (no. 135) and *Christ Preaching* ("La Petite Tombe"; nos. 136, 137).

Ernst van de Wetering has recently suggested that most of these oil sketches of biblical subjects were preparatory for a planned series of monumental prints on the Life of Christ.[48] This has been the only concerted attempt to explain the purpose for which these small paintings were made. He ingeniously accounts for the

apparent incongruity of the Old Testament subject of *Joseph Telling His Dreams* by interpreting it as a prefiguration of the way the faithful would worship Christ after the Resurrection. In fact, he believes that the series reflects Mennonite beliefs and was likely initiated by Hendrick van Uylenburgh, a prominent member of the sect.

Like *St. John the Baptist Preaching*, the *Lamentation at the Foot of the Cross* (no. 44), dated about 1634–35, is made up of a complex and intricate piecing together of components. Rembrandt originally painted the subject as a grisaille on paper. He then cut out sections, leaving an irregularly shaped piece of paper, which he laid onto a slightly larger canvas. After reworking the composition so that it covered the canvas, more canvas was added at the top and bottom, transforming the painting from a horizontal to a vertical format. It is presumed that neither this step, nor the subsequent laying of the canvas onto an oak panel, was carried out by Rembrandt.[49]

There may have been a practical dimension to the difficulties Rembrandt experienced while making the *Lamentation* oil sketch. The scene depicted is not one described in the Bible. Rather, the artist has conflated three scenes from the Passion: the Deposition (the men on the ladders have taken the body of Christ from the cross), the Lamentation (the lit figures in the foreground), and an allusion to the Entombment (if the figures on horseback in the right distance represent the encounter between Pilate and Joseph of Arimathea in which the latter requested permission to bury the body of Christ). This iconographic complexity—one need think only of Rembrandt's incorporation of several episodes of Matthew 19 into "The Hundred Guilder Print" (no. 135)—may have resulted in the experimental nature of the image's evolution and appearance.[50]

A drawing in the British Museum, London (no. 43), which itself has something of the character of an oil sketch, is closely related to the *Lamentation* in the National Gallery. It, too, shows that Rembrandt made many drastic alterations to it. The artist clearly went to work on both of these compositions directly, without the aid of preparatory drawings. He apparently regarded them as works in progress; certain features from one were incorporated in the other and vice-versa, as Rembrandt worked out his ideas. He did not use the oil sketch here to give initial form to another work of art.[51] Rather, these two works document working stages, modifications in a conception as Rembrandt wrestled with its ultimate form, in much the way that the successive states of his prints record the artist's continual adjustment of the image in his mind's eye.

An inscription by Jonathan Richardson the Younger on the back of the British Museum drawing reads: "Rembrant has labour'd this study for the lower part of his famous descent from the Cross graved by Picart & had so often changed his mind in the disposition of the clair obscur, which was his Point here, that my Father & I counted I think seventeen pieces of paper."[52] This note was copied by Sir Joshua Reynolds and pasted onto the back of the National Gallery painting, which he briefly owned. In both the *Lamentation* and the British Museum drawing, the central grouping at the foot of the cross receives the most illumination. The group of onlookers in the drawing is brightly lit whereas the comparable group in the sketch is largely in shadow. The body of the "good thief," both by its placement within the composition and by its lighting, is a secondary focus of the painting, but only his feet are apparent in the related drawing. So indeed, the artist was rehearsing his options for the distribution of light and shade in these works in addition to exploring other pictorial concerns.

Among the most important of these is Rembrandt's attention to the human drama being played out across the picture space. He adeptly uses postures, facial expressions, and gestures to communicate the range and depth of the emotion of the scene. At the right edge of the painting, an elderly man, hands clasped, fervently looks up at the cross. His body is largely in shadow; his face and hands are rendered in daubs of white paint that stand out strongly against his dark surroundings. To the front of him, the lifeless body of Christ, head tilted back and arms limp at his side, lies across his mother's lap, while Mary Magdalene embraces his feet. A bearded and balding man (and not, as is usually the case, the young St. John) bears the weight of the swooning Virgin Mary, who receives the solicitous ministrations of two women and a man, their faces marked by concern. Other, shadowed people at the left edge of the picture look on, their features, stances, and gestures expressive of pity and grief. Rembrandt orchestrates moments of quiet movement—head hung with handkerchief held up to eyes, palms raised in pity, neck craned to see, arms reaching out to help, hands clasped in supplication or prayer—to keep the eye moving among the figures.

The idea of keeping changes obvious, so that the working process actually becomes part of the work of art, recalls Vasari's observation that "Titian's pictures are often repainted, gone over and retouched repeatedly, so that the work involved is evident."[53] Van Mander believed that Titian worked out his compositions directly on the canvas, a method deemed appropriate only for experienced masters. It is known that Rembrandt, too,

rarely prepared his paintings with the aid of drawings. The few sheets that can be directly associated with finished pictures quite often turn out to have been executed during the painting process, when the artist was contemplating a radical change to a composition. The revisions evident in his painted work would have signaled that the artist was "overflowing with inventions." Such *pentimenti*, then, intimately connected to the concept of *sprezzatura*, were signs of spontaneity that marked Rembrandt, like his paragon Titian, as a bold master with a fertile imagination. Rembrandt's contemporaries might have seen the sheer number of drawings and etchings that he made during his lifetime in the same light as his *pentimenti*, that is, as evidence of the creative furor that marks painters and poets of genius.[54]

The Concord of the State: Rembrandt and Allegory

The Concord of the State (fig. 33) is the only one of Rembrandt's oil sketches that represents an allegory, a type of subject relatively rare in the artist's oeuvre. Unlike his etched book illustrations for *Piedra Gloriosa* (see figs. 72, 73, p. 210), it is apparently not dependent on a text. It is also not on the order of his "divided images" that contrast observed nature and symbolic representations (as in, for example, "The Walker" [no. 181] or *The Hog* [no. 76]). Nor does it rely on pictorial tradition (as does *The Young Couple and Death* [no. 90]). It lacks the metaphorical dimension of etchings like *The Goldsmith* (no. 89) or *The Phoenix* (no. 172). There are a few paintings that have allegorical components (*Night Watch*, Br. 410; *Girl with Dead Peacocks*, Br. 456), but this is the only work with clear political overtones.

In conception *The Concord of the State* is most like the illustration Rembrandt made for Herckmans's *Der Zee-Vaert Lof* (fig. 80, p. 255). In the print, the *Ship of Fortune* sets off behind an emperor, whose open-armed gesture signifies the beginning of peace, essential to Holland's seaborne mercantile trade. In style, the oil sketch most closely resembles *St. John the Baptist Preaching* (fig. 32). Much of the composition is articulated by the brush almost as a pen would be used; that is, details of form, facial features, and costume are drawn in black over a broadly brushed earth-colored ground layer. Lights and darks are applied with some impasto over the same ground. The cursory execution of the background figures recalls the rabble in *Ecce Homo*. The allegorical depiction, though, lacks the human drama that animates Rembrandt's biblical narratives.

The panel, which is generally dated 1635–40, is much larger than any of Rembrandt's other oil sketches. In fact,

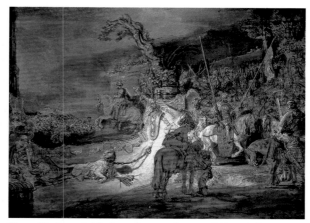

Fig. 33. *The Concord of the State*, 1635–40, oil on panel, Br. 476, Corpus A135, 74.6 × 101 cm (29⅜ × 39¾ in.), Museum Boijmans van Beuningen, Rotterdam.

it is not referred to in the artist's inventory of 1656 as either a sketch or a grisaille, but rather simply by its title. Although its meaning and function have long been debated, recent research has suggested that the sketch was likely commissioned by a member of the Orangist party (possibly Maurits Huygens, Constantijn's brother) to exhort the Amsterdam regents to unite with the Orangists rather than negotiate peace with Spain prematurely.[55] If this were indeed the case, it would be the only instance of a work of this nature being commissioned from Rembrandt. While it would have served the usual function of providing the model for a print, the sketch might also have satisfied the demands of the patron eager to see the form the work would take—quite a rarity in Dutch production practice.

Ephraim Bueno and Lieven Willemsz. van Coppenol: Rembrandt and the Oil Sketch Portrait

Rembrandt's portrait oil sketches postdate the last of his narratives by many years. The first of them depicts Ephraim Bueno (no. 73), a physician and writer from a prominent Portuguese Jewish family. He was no doubt introduced to the artist by Menasseh ben Israel, Rembrandt's friend and patron and the proprietor of a local Jewish printing house. The sketch panel dates to about 1647, the date that appears on Rembrandt's etching of the sitter (no. 72). For the print, the artist took the painted sketch as his model and extended the image in all directions.

Rembrandt's oil sketch is a muted composition in black, white, gray, and flesh tones. The use of color sets his portrait sketches apart from the grisaille preparations artists usually made as models for portrait prints.[56] Perhaps Rembrandt exploited color to enhance the

animation of the sitter; it certainly contributes to the impression of warmth and affection for Bueno that characterize the painting.

Portrait prints often depicted eminent public figures. Such commissions may have been intended to disseminate information about the sitter or to consolidate his social standing. For example, Bueno's image could have belonged to a series of portraits of Dutch Sephardic physicians, who were highly esteemed figures both in and beyond the Jewish community.[57] Rembrandt's portrait prints, however, tended to depict men with whom he had a personal association. Michael Zell has demonstrated that many of these etchings were probably distributed as gifts or conceived as tokens of friendship.[58] Indeed, the intimate nature of the depiction and the fact that no caption accompanies Bueno's print, despite the space left for one on the plate, imply that it had a very limited circulation.

Jan Lievens, too, produced an etching of this sitter (fig. 34). In it, Bueno is seated in a chair, hat in hand, looking steadily at the viewer. Unlike Rembrandt's more casual and meditative depiction, Lievens's Bueno adopts a conventional studio pose. Furthermore, the etching bears an identifying caption. Hans Schneider dated Lievens's etching after Rembrandt's based on the sitter's apparent age.[59] Perhaps Bueno commissioned Lievens's image, much more in keeping with the other official portraits of the Dutch Sephardic physicians, for distribution and reserved Rembrandt's for his own personal use.[60]

Lievens's print shows him working in the grand Van Dyckian manner. As Stephanie Dickey astutely observed, despite the obvious differences between Rembrandt's and Lievens's characterizations of the sitter, these were "the only painter-etchers of their generation who embraced this genre as a vehicle for personal expression, producing etchings from their own designs that were valued by collectors not only for the identity of the sitter, but for that of the artist."[61]

In fact, Rembrandt may have had Van Dyck's *Iconography* in mind when he chose to make such an oil sketch in preparation for his portrait etching. The most obvious difference between the projects, of course, is that Van Dyck's sketches were used by professional printmakers, whereas Rembrandt, by this time, etched and printed his own plates.

In about 1658, more than a decade after his oil sketch of Ephraim Bueno, Rembrandt painted Lieven Willemsz. van Coppenol, a Mennonite writing master and former school teacher (fig. 35). The sketch, painted in black, white, flesh color, and touches of red, was made in preparation for the artist's last and largest portrait etching (fig. 36).[62] In the sketch, Rembrandt took into account the fact that the image would be reversed when printed and gave the calligrapher a quill pen in his left hand. As one might expect, the X-ray of the oil sketch reveals *pentimenti* in the sitter's hand and collar.[63] These changes and dendrochronological evidence argue for the authenticity of the sketch, even while the condition makes it qualitatively difficult to ascribe to Rembrandt.[64]

Unlike the Bueno print, the "Large Coppenol" was clearly made for wide distribution; the sitter intended to trumpet his talent with a pen. As a calligrapher, Coppenol sent examples of his work to prominent literary figures of the day, soliciting panegyrics from them. He then took these verses and wrote them in his best hand under the printed likenesses of himself. This explains the unusually large margin that has been left at the bottom of the prints.[65]

Coppenol commissioned another portrait print of himself during the same period from Cornelis Visscher (1629–58; fig. 37). Visscher depicts Coppenol with a slightly quizzical or amused expression and draws attention to the elegance of the sitter's apparel. Rembrandt, on the other hand, produced a more concentrated image, depicting a more focused, serious man of purpose with his prominent empty sheet of paper ready to receive the calligrapher's mark.

Critical Fortune of the Sketches

There is scant direct evidence of the attitudes of early commentators toward Rembrandt's oil sketches. Both Samuel van Hoogstraten (1678) and Arnold Houbraken (1718–21) discuss *St. John the Baptist Preaching*, but neither treats it as a sketch, as a preparatory work, or as otherwise unfinished.[66] Filippo Baldinucci (1686) and Houbraken mentioned Rembrandt's use of impasto, the former attributing it to the artist's slow working method, the latter to his speed.[67] Gerard de Lairesse (1707) specifically criticized Rembrandt's use of impasto and his rough way of working,[68] although he admitted that, "at the proper distance, the strong brush strokes and the impasto vanish, the whole blends and one gets the effect one would desire to have."[69] Although this was the first defense of Rembrandt's use of free brushwork and heavy impasto, Lairesse was actually referring to aspects of the artist's late style rather than the quite different sketchy qualities of the small oils under discussion. More generally, Lairesse advises artists to start with free sketches ("ruwe en lugtige schets"), especially as an aid in determining the disposition of light. It is understood

Fig. 34. Jan Lievens (Dutch, 1607–1674), *Ephraim Bonus*, after 1644, etching, Hollstein 20, 33.3 × 26.1 cm (13⅛ × 10¼ in.), Museum Boijmans van Beuningen, Rotterdam.

Fig. 35. *Lieven van Coppenol*, about 1658, oil on panel, Br. 291, 36.6 × 28.9 cm (14⅜ × 11⅜ in.), The Metropolitan Museum of Art, New York, Bequest of Mary Stillman Harkness.

that the sketch here is a preparatory step in the artistic process; he makes no specific mention of Rembrandt or his oil sketches in this context.

Baldinucci reported that a drawing by Rembrandt, in which "little or nothing could be seen," was sold at auction for thirty scudi. This is the first written proof that Rembrandt's shorthand drawings were appreciated and sought after by some of his contemporaries. But the comment also indicates that neither the biographer nor his informant, Bernhard Keil, who worked in Rembrandt's studio from about 1642 until 1644, placed much value upon his rapid sketches.[70]

Houbraken complained about Rembrandt's lack of finish, both in his paintings and in his etchings. Especially disturbing to him was the contrast between carefully finished details and the rest, "smeared as with a rough painter's brush."[71] He explained that Rembrandt's resistance to finish was due to his impatience as he grew older, his predilection for alteration, his fecklessness, and his whimsical and capricious character.[72] He appreciated the artist's power of invention as it was expressed in his numerous graphic sketches; while he marveled at the wealth of facial expressions, attitudes, and costumes he found in these works, he made no mention of Rembrandt's technique.[73] So how is it that we have come to admire so much these small works in oil?

The Taste for Oil Sketches

Beginning in the late 1960s, an interest in early oil sketches began to manifest itself in the form of exhibitions devoted to the subject. In one focused on Baroque oil sketches, the collector who had amassed the works wrote, "The Baroque sketch is an art for our times, it is relevant and modern. Since the Impressionists we have grown to love the apparently incomplete, the *non finito*, leaving it to the imagination of the beholder to add the final touches. . . . It is an autonomous work of art in which the enthralling moment of creation is caught and held."[74] In the introduction to the catalogue of another exhibition, entitled *Masters of the Loaded Brush*, the eminent art historian Rudolph Wittkower described "the modern spontaneity and freshness of vision and touch" he saw in these works.[75] How did the modern viewer become accustomed to looking at art that is summarily executed and grow to value the qualities in painting implied by Wittkower's words?

A taste for oil sketches is first reflected in the history of collecting. Of the ten oil sketches by Rembrandt discussed in this essay, more than half were either owned by fellow painters, his connoisseur friends, or retained by the artist himself.[76] This corresponds with what we know about the early collectors of oil sketches by Pieter Bruegel (1525/30–1569), Goltzius, and Adriaen van de Venne (1589–1662), to name but a few.[77]

As we have seen, in the sixteenth century the brilliant brushwork associated with *sprezzatura* "became the overt mark of the painter's skill and the appreciation of such a mark testified to a connoisseur's sensitivity."[78] This development paralleled the nascent taste of Venetian amateurs for drawings, which grew to the point that a regular traffic in these sheets was established by the second half of the sixteenth century.[79] Early on, the freedom and boldness of drawings was linked by connoisseurs to Pliny's admiration for the unfinished and Vasari's idea that a sketch is done in a sort of "fire of inspiration." By the seventeenth century, "this idea [had] seeped down to the level of the layman."[80] The Englishman Roger North, executor of the estate of the artist Peter Lely, remarked that "drawings are observed to have more of the spirit and force of art than finished paintings, for they come from either flow of fancy or depth of study."[81] Roger de Piles, the late seventeenth-century French amateur painter, engraver, theorist, and critic, owned a number of Rembrandt drawings, which he felt had more liveliness than his etchings.[82]

Among early collectors, Cardinal Leopoldo de' Medici (1617–1675) and his nephew Grand Prince Ferdinando (1664–1713) greatly admired both drawings and oil sketches, two types of art that appealed to the same taste.[83] Leopoldo, largely through the efforts of his agent Paolo del Sera in Venice, avidly amassed oil sketches, forming a collection that must have had a great impact on the taste of connoisseurs in Florence.[84] Ferdinando, too, collected *modelli* of pictures painted for other patrons before this was a common practice. He enjoyed watching artists at work and discussing with them the actual painting procedure.[85] In the course of the seventeenth century, patrons not only conversed about art with painters but amateurs discussed issues of connoisseurship among themselves. They debated how to distinguish hands stylistically, and the criteria they used became more and more subtly differentiated.[86] This focus on reading and interpreting the individual marks of a specific artist deviated from the more typical interest in his choice of subject matter.

Eighteenth-century critics began to call into question the idea of art in the service of illusion. The quest to replicate the visible world was generally dependent on the finish of a painting. This step away from the primacy of the imitation of nature boded well for the popularity of the sketch aesthetic. Still, it was the connoisseur's purview to both recognize the artist's hand and judge

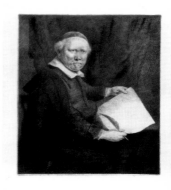

Fig. 36. *Lieven van Coppenol: The larger plate*, about 1658, etching, drypoint, and burin, B. 283, 34.2 × 29.1 cm (13⅜ × 11⅜ in.), National Gallery of Victoria, Melbourne, Everard Studley Miller Bequest.

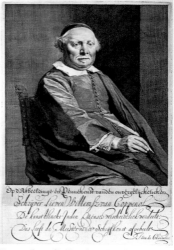

Fig. 37. Cornelis Visscher (Dutch, 1629–1658), *Lieven van Coppenol*, 1658, engraving, 29.3 × 23.3 cm (11½ × 9⅛ in.), Rijksmuseum, Amsterdam.

the painting's aesthetic value. Drawings and sketches, skillfully left unfinished by the artist, could only be understood by the cognoscenti.[87] On a related front, the execution of a painting began to be associated with the "effect of the feelings that moved the artist in painting."[88] The artist's touch, most purely manifested when he first picked up a brush or pencil, was seen as expressive of both his genius—a concept that found its definition in the course of the century—and his enthusiasm. According to the French writer, philosopher, and critic Denis Diderot in his review of the *Salon of 1765*: "A sketch ordinarily has a fire that a painting does not. It is the heated moment for the artist, the purest verve, without any admixture of the artifice that reflection puts on everything; it is the soul of the painter spreading itself freely on the canvas I see in the painting something pronounced; how many things do I imagine in the sketch that are scarcely delineated there."[89] For Diderot, the sketch reflected the pure and spontaneous conception of the artist, untainted by artifice, which also demanded on the part of the viewer an engagement with the object to an unprecedented degree. As Mary Sheriff observed, "It was not a large step [from here] for the painter to bring aspects of the sketch into the finished work."[90]

The painter Eugène Delacroix (1798–1863) required that his finished pictures retain the general effect and movement of a first sketch. On 24 April 1854 he wrote, "What makes the sketch so excellently suited to express the idea is not the suppression of the details but their complete subordination to the great overall design. So the greatest difficulty is to sustain that elimination of detail in the painting." In his view, painting should display the creative process that takes place in the artist's studio. Despite the public's budding interest in painters at work, they found it difficult to accept the evidence of process in Delacroix's work, and he was roundly criticized for exhibiting paintings that were deemed to look like painted sketches.[91] The criticisms of improvisation and facileness leveled at his work—"He threw buckets of paint onto canvases, he painted with a drunken broom"—were actually belied by the prodigious number of drawings, studies, and sketches found in his studio after his death, signs of his "daily, indefatigable labor." In a review of an exhibition of his work held in Paris in 1864, the year after Delacroix died, Henri de la Madelène wrote, "The sketch is Delacroix's triumph. No one had a livelier hand for capturing genius's blazing ideas in rapid lines. His burning brush seems to fly across the canvas, and the composition comes together all at once, without hesitation, without cooling off, as palpitating as life. . . . The finished work, slowly painted,

deeply studied, adds only material perfection to this miraculous first impulse."[92]

Not all critics shared this enthusiasm for the explicit exploitation of sketchiness in definitive works. In 1833, the critic A. Jal wrote, "Sketches (*pochades*) can only live for a limited time. People are already getting tired of these palette-samples that catch the eye but have no appeal to reason or taste: they are like solar prisms that shine and dazzle but elude formal analysis, leaving no more trace in the memory than a burst of fireworks." He, like other early-nineteenth-century critics, failed to see a relationship between the freshness and immediacy of the effect and the sketchy brushwork, between the expressive significance of the subject and that of the execution.[93] Charles Baudelaire's review of the Salon of 1859 reflected prevailing ideas about the sketch as belonging to the studio or private realm of the artist, whereas the finished work was that appropriate to the public sphere. While admiring the pastel studies of Eugène Boudin (1824–1898), the writer found it unacceptable that the artist might be exhibiting his mere "notes" as pictures. In so doing, he risked exposing his method and his mental processes, undermining the viewer's appreciation of the finished work. Even as late as 1880, R. Balzé opined, "However skilful the touch, it should not be apparent, since it stands in the way of illusion and immobilizes everything. It shows us the method instead of the object, the hand instead of the brain. Where do you see the touch in nature?"[94]

However, by the 1820s, the Barbizon artists — Camille Corot (1796–1875), Théodore Rousseau (1812–1867), and Charles-François Daubigny (1817–1878), among others — were painting routinely from nature and used the sketch as the primary means to observe and transcribe natural phenomena. The sketch allowed them to train their eye and hand to capture fleeting effects of light and atmosphere. These artists were moving toward the idea of directness as being as important as what was captured. A critic like Théophile Thoré began to understand that a sketchy application of paint created a certain desirable effect. About Corot he wrote, "His half-finished manner has at least the merit of producing a harmonious ensemble and a striking impression. Instead of analysing a feature, one feels an impression."[95] As Albert Boime observed, "Thoré ushered in a revolutionary attitude within the traditional framework; his critique shifted from admiraton of the qualities of the finished work to those of the sketch. . . . He praised, on the one hand, the aesthetic qualities of the sketch—composition, ensemble and effect; and, on the other, its theoretically inferred attributes—originality, spontaneity and sincerity."[96]

The shift in the association of sketchiness with the artist's private endeavors to an acceptable public execution that solicited the involvement of the viewer was one of the fundamental results of looking at Impressionist paintings. In 1874, the critic Philippe Burty wrote about the Impressionist painters, "The chief object of these gentlemen . . . was to present their works almost as in the same conditions as in the studio. . . . They feel that their style of painting, whether by simplicity of design, or by simplicity of tone, or by simplicity of composition, looks like a challenge or a caricature when placed side by side with works conceived under the pre-occupation of mannered design."[97] The attempt of these artists to make their works look as rapidly painted as their fleeting subjects achieved a symbiotic link between style and subject.[98] The exploratory and private nature of the sketch was abandoned by Claude Monet (1840–1926) and his compatriots when they signed, sold, and exhibited their large, broadly executed paintings.

Other events hastened the exposure of both artists and the public to sketchy painting. For example, numerous plein-air sketches by the Barbizon masters and compositional studies by artists like Delacroix and Henri Regnault came onto the market when these painters died in the 1860s and 1870s. Furthermore, the La Caze bequest to the Louvre in 1869 featured free and loosely painted works by Van Dyck, Rubens, Hals, and Ribera, just in time for Manet and Renoir to see them.[99]

The unfinished and spontaneous, qualities valued by Vincent van Gogh (1853–1890), figure in a letter he wrote to his friend the painter Emile Bernard from Arles in April 1888, describing his working method: "I hit the canvas with irregular touches of the brush, which I leave as they are. Patches of thickly laid-on color, spots of canvas left uncovered, here and there portions that are left absolutely unfinished, repetitions, savageries; in short, I am inclined to think that the result is so disquieting and irritating as to be a godsend to those people who have fixed preconceived ideas about technique."[100] And in February of 1873, Edgar Degas (1834–1917) had written to the artist James Tissot about his work on the subject of cotton merchants, "I am preparing another less complicated and more spontaneous, better art . . ."[101] Clearly the topic was one that fully engaged artists at this time, but the sketch asthetic had not yet won acceptance by the general public by the end of the nineteenth century.

Reminiscent of the Romantic attitude, the Post-Impressionists added to the mix, in Roger Fry's words, the use of the Impressionists' "discoveries . . . to express emotions which the objects themselves evoked."[102] The Impressionist quest for optical immediacy was replaced in their minds and in their work by the "expressionist" devotion to emotional urgency. By the same token, in order for the image to be an "expression," it needed to move away from mimesis and tended, therefore, towards abstraction.

By the mid-twentieth century, many of the ideas surrounding the sketch aesthetic became manifest in the art of the Abstract Expressionists. The question of finish, the importance of gesture both as the mark of an individual and as an indication of process, and the appearance of spontaneity were all bound together in the modern quest for self-expression. The idea of the sketch as preliminary or preparatory to another work was dead, but the sketch aesthetic was finally triumphant. As the critic Harold Rosenberg wrote in 1952, "A sketch is the preliminary form of an image the mind is trying to grasp. To work from sketches arouses the suspicion that the artist still regards the canvas as a place where the mind records its contents—rather than itself the 'mind' through which the painter thinks by changing a surface with paint. If a painting is an action, the sketch is one action, the painting that follows it another. The second cannot be 'better' or more complete than the first. There is just as much significance in their difference as in their similarity."[103] The current popularity of Impressionist exhibitions and the fact that Abstract Expressionist art is now part of the art historical canon attest to the acceptance of the sketch aesthetic as does the burgeoning interest in how paintings were made.

The critic and art historian Donald Kuspit has recently written, "Painting at its best is the space of individuality and spontaneity, and as such affords the possibility of an original psychic act."[104] In light of these words the current appreciation of Rembrandt's oil sketches can best be understood. The modern viewer is no longer as concerned with the original purpose or intent of an oil sketch as s/he is with the insight it might give to the artist's creative process, to the appearance of spontaneity that has come to be associated with pure invention, to the individual marks that signal Rembrandt's genius. Like the self-portrait with which Rembrandt's name is indissolubly linked, the sketch is assumed to represent not only an artist's freest stylistic expression but also a window onto his soul.

NOTES

I would like to thank George T. M. Shackelford and Frederick Ilchman for discussing with me various observations recorded here. For her early assistance in researching the topic, I would also like to acknowledge Lien de Keukelaere. This essay could not have been written without the thoughtful advice and resourceful help of Chris Atkins.

1. According to Lydia de Pauw-de Veen, in the seventeenth century, it was impossible to determine whether the Dutch word *schets*, found repeatedly in inventories, referred to a painting or to a drawing; see De Pauw-de Veen 1969, 97. *Diana at the Bath* (no. 196) is B. 201; *Bust of a Man with a Flowing Beard* is B. 291; *Portrait of Cornelis Claesz. Anslo* is B. 271; *Portrait of Jan Six* (no. 74) is B. 285.

2. Huygens, as in Vogelaar et al. 1991, 132–33. Huygens was secretary to the stadholder, Frederik Hendrik, and one of Rembrandt's earliest admirers and patrons.

3. Peter Parshall, "Unfinished Business: The Problem of Resolution in Printmaking," in Parshall et al. 2001, 24.

4. There were works by the Venetians, Palma il Vecchio and Palma il Giovane, in collections in Leiden and Amsterdam by 1604. Lucas van Uffel, who spent about fifteen years in Venice, returned to Amsterdam about 1630 with numerous Italian paintings. Meijer *Amsterdam* 1991, 79, mentions Titian among the artists collected by Van Uffel. The extensive Reynst collection, much of it derived from that of Andrea Vendramin, who died in Venice in 1629, featured paintings attributed to Bellini, Titian, Tintoretto, and Veronese, among others, many of which had been bought by Jan (who lived in Venice) and sent to his brother, Gerard (who lived in Amsterdam) in the 1630s; see Logan 1979, 87; Meijer *Amsterdam* 1991, 384. According to Clark 1966, 102, the Vendramin collection was brought to Amsterdam in the 1640s and the sale was handled by Hendrik van Uylenburgh, with whom Rembrandt was closely associated. The Vendramin collection at that point also included works by Giorgione, Paris Bordone, both the Palmas, Schiavone, and other Venetians. Rembrandt himself would eventually own drawings by, and prints after, many important Italian artists, as well as paintings attributed to the Venetians, Bassano, Palma il Vecchio, and Giorgione. His patron, Jan Six, went to Italy in 1640/41 and formed an important collection of Italian paintings, much of it by various masters of the sixteenth-century Venetian school.

5. Huygens, as in Vogelaar et al. 1991, 134.

6. His painting also shows evidence of his familiarity with the art of Pieter Aertsen, another Amsterdam native, and Frans Floris, two masters known to have produced oil sketches. For Aertsen, see Filedt Kok et al. 1986, n. 296; for Floris, see p. 31.

7. Wouter Kloek, "Dirck Barendsz.," in Turner 1996, 3: 230–31. Only part of the print series was executed; see below, note 23.

8. Br. 498; Corpus A108.

9. The former is in the Musée des Beaux-Arts, Lyon (Br. 531A; Corpus A1), and the latter, whose subject still eludes us, is in the Stedelijk Museum de Lakenhal, Leiden (Br. 460; Corpus A6).

10. Bernard Schnackenburg, "Young Rembrandt's 'Rough Manner': A painting style and its sources," in Van de Wetering and Schnackenburg et al. 2001, 104, quotes Hoogstraten's comment that Lievens was "expert in seeking wonders in smeared pigments, varnishes and oils" and suggests that Lievens's technical innovations are the source for the *David* sketch's "variegated bright colors of thickened impasto . . . applied in an extremely broad manner that pulls the forms together, but they are also rubbed away so as to blend with the surroundings."

11. The anonymous engraving is reproduced in *Corpus* 1982–89, 1: 136, fig. 7. Rubens, who sought malleable young artists to reproduce his paintings in print, found in Lucas Vorsterman an engraver who could approximate his painterly technique in a linear medium.

12. Rembrandt studied with Lastman for six months in the 1620s, although the exact dates are unknown.

13. Broos 1975–76; *Corpus* 1982–89 1: A9; Tümpel and Schatborn et al. 1991, 125–27; Van de Wetering et al. 2001, 45–49, 138–41.

14. Chu 1987, 215. Lastman often was a pioneer in painting subjects that had previously been represented only in the graphic arts, and tended to be interested in scenes of recognition, the apparition of divine or heavenly beings, and, as here, meetings between important personages and their inferiors. For Lastman's subject matter, see Christian Tümpel, "Pieter Lastman and Rembrandt," in Astrid Tümpel and Schatborn et al. 1991, 54–84.

15. Because the sitter's wrist but no hand has been depicted, it may be that the work is a fragment (the paper support limits technical confirmation). It has further been suggested that the sketch was intended for an *album amicorum*, a bound collection of writings, autographs, and art work assembled by the owner from his friends and acquaintances. However, its relatively high relief would have made it difficult to incorporate into a closed book. See *Corpus* 1982–89, 2: 353; Blankert et al. 1997, 115.

16. In Rembrandt's case, see, for example, the chalk drawing of an old man in Stockholm (Ben. 38), the etched *Bust of an Old Bearded Man* (B. 260), and the small painting on panel in Innsbruck (Corpus A29). For Lievens, see the chalk drawing of an old man in a private collection, The Hague (Schneider and Ekkart 1973, SZ LXXII), the etched *Bust of an Old Man in Profile* (B. 22), and his painted panel of a *Bearded Old Man* in Braunschweig (Sumowski 1983–95, 3: n. 1263).

17. Van Mander (1604, 242v) as in Held 1980 1: 597.

18. Rubens was the most prolific painter of oil sketches in the seventeenth century. In his studio, he not only employed them as models (guiding assistants in the various stages of work or as templates for reproductive engravers) but also used them to manipulate his own figural or compositional ideas. In addition, the sketches would have been used to give his patrons an idea of the form their commissions would take. The fact that he stopped making sketches of study heads after 1620 implies that Rubens's workshop procedures had evolved into something more fluid and less methodical; see Held 1980 1: 6.

19. Schnackenburg, "Young Rembrandt's 'Rough Manner,'" in Van de Wetering and Schnackenburg et al. 2001. While the pictorial type is one Van Dyck would have encountered in Rubens's workshop, the execution he favored differs from his master's relatively smooth application of paint. Van Dyck's adoption of the rough style for many of his expressive head studies seems to be rooted in his own contact with Venetian art, both through his teacher Hendrick van Balen, and through the Venetian paintings and reproductive prints he might have seen in Flanders and London. Jacob Jordaens (1593–1678), the third in the triumvirate of great seventeenth-century Flemish painters, made rough head studies as well.

20. Dickey 2001.

21. Lammertse 2002.

22. The last digit of the date is missing. The sketch is painted on paper laid down on cardboard. In addition to the Bible, Rembrandt may have known the story through Flavius Josephus's *Of the Antiquities of the Jews*, a history that supplemented the biblical text and enhanced the established iconographic tradition; see Wheelock 1995, 314.

23. Examples are numerous. Grisailles dated 1574 by Anthonie Block-landt (1533/4–1583), served as designs for Philip Galle's engravings of the Four Evangelists. As mentioned above, Dirck Barendsz.'s monochrome oil studies on paper of about 1580 provided the models for Jan Sadeler's five engravings of scenes from the Passion. Otto van Veen (1556–1629), who apprenticed in Leiden with Isaac Claesz. van Swanenburgh, a former pupil of Frans Floris, enjoyed an extended stay in Italy. On his return to Antwerp, he brought back the practice of preparing paintings and engravings with quick, small brunailles (brown monochromes). Rubens, who apprenticed with Van Veen between about 1594 and 1600, made monochrome oil sketches for the title pages of books, biblical narratives, small sculpture, and architectural surrounds that were eventually engraved by professional printmakers. Rubens's collaborator, Van Dyck, also experimented with etchings, wash drawings, and oil studies as models for reproductive

engravers. See Filedt Kok et al. 1986, 303 no. 371.1–4,; Stampfle 1991, nos. 113–215; Held 1980, nos. 265–66, 289, 303–06, 419–20; Depauw and Luijten et al. 1999, 81–87.

24. British Museum, London (inv. no. 1861.8.10.14). The popularity of grisaille painting at this time could have been partially due to Goltzius's recent introduction of the chiaroscuro woodcut to the northern Netherlands.

25. Van Thiel 1999, 447, no. WO1, and 413–15, no. MP1-5.

26. For Bloemaert's oil sketches, see Roethlisberger 1993, 1: 39, figs. 53, 57, nos. 24, 27; figs. 683–92, 702–25, 752–54, and no. 564.

27. In the 1674 inventory of Lievens's estate, ten works are listed as "sketches."

28. The draughtsmanship, moiré technique, and unfinished appearance of the first state of the print all point to Van Vliet's work; see Martin Royalton-Kisch, "Van Vliet: Rembrandt's Printmaker," in Schuckman, Royalton-Kisch, and Hinterding 1996, 10. Dickey 2001, 293, observed that Van Vliet's method of working up the etching plate from back to front, leaving a reserve in the first state for the foreground, was used by Rembrandt only in the *Goldweigher* of 1639, but was typical of Van Dyck and Rubens. Erik Hinterding has convincingly shown that the fruitful collaboration begun in Leiden between Rembrandt and Van Vliet did not end when the former went to live and work in Amsterdam; see his "Rembrandt and Van Vliet: The Watermarks," in Schuckman, Royalton-Kisch, and Hinterding 1996, 25–26.

29. The changes include the diminution of the canopy above Christ, the silhouetting of the figures below, the darkening of the crowd area, and the added emphasis given to the contours of the architecture. In sum, they convey revised information to the printmaker; see Royalton-Kisch, "Van Vliet," in Schuckman, Royalton-Kisch, and Hinterding 1996, 11. The retouched proof is in the British Museum, London. Rubens is also reported to have intervened in the production of prints after his work; Baudouin 1991, 46: "Only rarely did [the artists who made prints after Rubens's compositions] reach the same heights in their engravings after other compositions than those of the great master. This proves the importance of Rubens's personal involvement in the execution of those prints. His hand can be detected . . . in the corrections he personally made to the proofs or the first states."

30. For the "production process" of the print, see Hinterding "Rembrandt and Van Vliet," in Schuckman, Royalton-Kisch, and Hinterding 1996, 26.

31. While Rubens's great Baroque machine emphasized the divine nature of Christ, Rembrandt's more restrained depiction focuses on Christ as the tortured man who endured unimaginable pain on the cross. For other Rembrandt paintings based on Rubens's art, see Schama 1999, 286ff.

32. Rembrandt's inventory (number 54) included "Een brandent leger vanden oude Bassan" (A 'burning camp' by the elder Bassano).

33. "Een stuxken schilderie, daer Sampson het hayr wert affgesneden, door Jan Lievensz. tot Leyden gemaeckt," mentioned in the 1632 inventory of the stadholder's collection, is probably to be identified with Rembrandt's painting in Berlin (Lievens's oil sketch was apparently still in the artist's collection in 1674 and his relatively large panel in Amsterdam would not correspond to the description since it features life-size half-length figures). Confusion between the works of Rembrandt and Lievens was not rare, even during their lifetimes. It cannot be determined whether the second painting—listed in the inventory as "Een Symeon in den tempel, Christus in sijne armen houdende, door Rembrandts oft Jan Lievensz. gedaen"—is the one in The Hague or in Hamburg; see Drossaers 1930, 203 (49) and 205 (64).

34. Schwartz 1985, 69.

35. Schama 1999, 27–35; Schwartz 1985, 67–71.

36. At the time, Rubens was special envoy from the King of Spain to the King of England, charged with negotiating a peace treaty between the two countries.

37. David Rosand, "Titian's Dutch Disciple," in Clark et al. 2000, 10.

38. See Berger 2000, 429, for the distinction between the two terms; see 484 for the observation that, in the open brushwork of his broad, late style, "Rembrandt made Titian and Venetian painting a matter of the look of his art without actually applying his paint or building up his images as the Venetians did." Rembrandt's admiration for Titian's art is apparent in his own collection. His inventory (no. 216) lists "Een [boeck] seer groot met meest alle de wercken van Titian" (One very large [book], with almost all the work of Titian.); this clearly refers to prints by and after the Italian master. See, too, Van de Wetering 1997, 169.

39. According to Haverkamp-Begemann 1967, 111–12, "Rembrandt expressed himself fully in the unfinished, fragmentary and variable state of a work of art The unfinished and the sketch were goals for Rembrandt, while for Rubens they were steps towards completion of a work of art." Many of Rembrandt's late paintings, like those of Titian, were considered unfinished by contemporary critics; according to Houbraken 1718–21, 1: 259, Rembrandt is memorably quoted as saying that "a work [of art] is finished when an artist realizes his intentions."

40. Koerner and Zell 1999, 5.

41. Held 1963, 87.

42. Fehl 1997, 9, defined *sprezzatura* as "the courtier's noble disdain of unworthy effort, of untoward eagerness." Berger 2000, 97, distinguishes four characteristics or aspects of *sprezzatura*: the ability to show that one is not showing effort ("sprezzatura of nonchalance"); enticing an audience to imagine a greater reality behind what is presented ("sprezzatura of conspicuously false modesty"); the attitude of disdain or scorn for easy mastery ("sprezzatura for maintaining class boundaries"); and disguising what one thinks or feels behind a mask of reticence ("sprezzatura of suspicion").

43. Held 1980 2: 7; Van de Wetering 1997, 162.

44. This synopsis is based on *Master and Workshop: Paintings* 1991, 180.

45. Tümpel "Peter Lastman and Rembrandt," in Astrid Tümpel and Schatborn et al. 1991, 74–77 and fig. 25.

46. Van Hoogstraten 1678; Houbraken 1718–21. The former's appreciation was marred, however, by the artist's breach in decorum: "one also saw a dog mounting a bitch in a scandalous manner. Say if you will that this can happen and is natural, I say that it is an abhorrent indecency in the circumstances of this story"

47. See, for example, Ben. 140, 141, 142.

48. See Ernst van de Wetering, "Remarks on Rembrandt's Oil-Sketches for Etchings," in Amsterdam/London 2000, 50–56.

49. Bomford et al. 1988, 66. The later additions correspond roughly to the area that extends above Christ's cross, the two standing figures at the left edge of the composition, and the strip of canvas below the feet of the swooning Virgin.

50. While some of the figures and groupings in the sketch are related to passages in the etching of the *Descent from the Cross* of 1642 (B. 82, no. 42) and the oval plate of *Christ Crucified between Two Thieves* of about 1641 (B. 79), the artist has here complicated his task by enlarging his iconographic scope.

51. However, the fact that the "good thief" is placed on the right facing Christ's cross goes against pictorial tradition and has led some scholars to argue that the grisaille was made as a design—in reverse—for an etching; see Bomford et al. 1988, 69–70.

52. For Richardson, Sr.'s early appreciation for Rembrandt's art, see Gibson-Wood 2003, 158–59.

53. Rosand in Clark et al. 2000, 15.

54. Van de Wetering 1997, 166–67; Stacey Sell, "'Quick to Invent and Copious to Express': Rembrandt's Sketch Plates," in Parshall et al. 2001, 66.

55. Van de Wetering in Amsterdam/London 2000, 57.

56. Rubens employed color in his oil sketches for portrait paintings (Held 1980, 1: nos. 292–94) but his sole undisputed portrait oil sketch for a print is a grisaille (Held 1980, 1: no. 295). Van Dyck's sketches for the *Iconography* are also monochromatic. Only Hals apparently made color portrait *modelli* for engravers to use; see, for example, Slive 1970–74, no. 207.

57. Zell 2002, 20.

58. Koerner and Zell 1999, 7.

59. Schneider and Ekkart 1973, 266–67.

60. My thanks to Michael Zell and Chris Atkins for discussing these portrait prints with me. The contrast between public and private presentations of the self are explored in Smith 1982, 167; Loughman and Montias 2000, 45–46.

61. Dickey 2001, 299. She continues, "The implied presence of a single motivating genius is the central factor that distinguishes Van Dyck's *Iconography* from other portrait print series."

62. Rembrandt etched two versions of the sitter. The smaller one shows Coppenol at his writing desk accompanied by his grandson (no. 210). The oil sketch under discussion (fig. 35) is the same size as the larger print (fig. 36), of which it is a mirror-image.

63. This is also true for the X-ray of the oil sketch of Bueno (no. 73).

64. And in fact the attribution of the sketch to Rembrandt has not always been secure; see Liedtke et al. 1995, 2: 120 and Van de Wetering in Amsterdam/London 2000, 58, 60.

65. Amsterdam/London 2000, 354.

66. See note 46 above. Houbraken simply describes it as "in 't graauw geschildert."

67. Slive 1953, 184–85.

68. Slive 1953, 163–64. He admonished artists to work evenly and smoothly in order to achieve illusion by art, "not daubing."

69. Slive 1953, 119.

70. Slive 1953, 110–11.

71. Slive 1953, 179.

72. Slive 1953, 182.

73. Slive 1953, 178.

74. Rossacher 1968, unpaginated.

75. Wittkower 1967, xv.

76. By 1669, *Joseph Telling His Dreams* was in the collection of Rembrandt's friend, the Amsterdam artist, Ferdinand Bol. *Ecce Homo*, mentioned in Rembrandt's inventory of 1656, was already in the 1680 inventory of the Amsterdam artist, Jan van de Cappelle. *St. John the Baptist Preaching* was in the collection of Jan Six by 1658. Mention of works we can identify with *The Entombment*, *Lamentation*, and *The Concord of the State* figure in Rembrandt's inventory of 1656 (the *Lamentation* was later owned by Sir Joshua Reynolds). No early provenance is known for Rembrandt's other four oil sketches.

77. According to Grossman 1952, 224–25, Bruegel painted the monochromatic *Woman Taken in Adultery* for himself and the *Death of the Virgin* for his friend Abraham Ortelius, the great geographer and antiquary. In seventeenth-century Holland, the monochrome manner in painting, like that of Adriaen van de Venne and Jan van Goyen, was appreciated by an elevated intellectual and social milieu, including Constantijn Huygens; see Westermann 1999, 239.

78. Rosand in Clark et al. 2000, 16.

79. Held 1963, 78.

80. Held 1963, 86.

81. As in Koerner and Zell 1999, 6. Lely, a connoisseur with a large and diverse collection, owned, among other works by Van Dyck, seven impressions of his unfinished etchings for the *Iconography*, at least one of his sketchbooks, a *modello* for the *Garter Procession*, and thirty-seven oil sketches for the *Iconography*. On Lely's collection, see Dethloff 2003.

82. Held 1963, 86.

83. Leopoldo most likely kept his drawings and oil sketches together, apart from finished works; see Gallerie di Firenze 1952, 5–6.

84. Wittkower 1967, xxiv. See, too, Goldberg 1983, 57–58.

85. Haskell 1980, 233.

86. Wittkower 1967, xxiii; Honig 1998, 202–7.

87. Sheriff 1990, 134.

88. Sheriff 1990, 120.

89. As in Sheriff 1990, 142.

90. Sheriff 1990, 143.

91. Bätschmann 1997, 103–7.

92. As in Jobert 1998, 305.

93. Boime 1971, 92.

94. Balzé, 1880, 10, as in Boime 1971, 93.

95. Boime 1971, 96.

96. Boime 1971, 96.

97. Berson 1996, 10.

98. Brettell 2001, 17.

99. Brettell 2001, 36–44.

100. Chipp 1968, 32.

101. Degas 1947, 29.

102. Werenskiold 1984, 19.

103. Rosenberg 1990, 77. It is entertaining to read early reviews of Pollock's work from *Time Magazine*. The tone in the 1 December 1947 issue is slightly incredulous and ridiculing; the brief note reproduces paintings by Pollock and Hans Hofmann and a sculpture by David Smith under the heading, "The Best?" On 20 November 1950, under the title "Chaos, Damn It!", we are informed that "Jackson Pollock's abstractions stump experts as well as laymen. Laymen wonder what to look for . . . ; experts wonder what on earth to say about the artist." On 19 December 1955, it was determined that "The Champ"'s one big contribution to the "slosh-and-spatter school of postwar art" was inventing "a new kind of decoration, astonishingly vehement." The notice includes responses by the critics, who "retreated into a prose that rivaled [Pollock's] own gaudy drippings." Among them, the acknowledgment from the *New York Herald Tribune*, which stated firmly that "whether or not you like Pollock's painting . . . one must admit the potency of his process."

104. Kuspit 2000, 3.

LOOKING OVER REMBRANDT'S SHOULDER
The Printmaker at Work

Thomas E. Rassieur

The opportunity to watch a famous artist at work is an exciting event, a privilege. Art lovers have been looking over the shoulders of great artists for centuries. Alexander the Great is said to have eagerly watched Apelles as he painted. Emperor Maximilian I watched Albrecht Dürer at work. One can imagine that close attention from powerful figures had its price for the artists. They had to endure the disruption of their concentration, revelation of trade secrets, exposure of failed attempts, and loss of the element of surprise when unveiling astonishing works. The hero of Dutch art in the generation before Rembrandt, Hendrick Goltzius, chose not to make such sacrifices and guarded the secrecy of his unfinished projects.[1] More recently, popular films, such as Hans Namuth's of Jackson Pollock and Henri-Georges Clouzot's of Picasso, have been able to simulate the studio visit for a mass audience without intruding excessively into the artist's domain.

Long before the advent of film, however, Rembrandt appears to have desired to share the experience of making art by transforming the role of impressions taken from unfinished copper etching plates.[2] Such trial proofs had long served as aids in the process of developing and completing printing plates, but Rembrandt took the unusual step of printing extra impressions of his works-in-progress, apparently for the enjoyment of others. Moreover, his unconventional, often improvisational approach to printmaking resulted in completed prints that invite the viewer to imagine the process of their creation. Whereas the celebrated printmakers before him had aspired to systematic, mechanical perfection, Rembrandt instead let his hand move freely, allowing us to trace its unpredictable path with our eyes. If he changed his mind while working on an image, he would often leave his discarded first thoughts in plain view. Initially, this was true of etchings that he seems to have made as private exercises, but as time went on he grew more willing to share evidence of self-criticism in prints made for circulation. Eventually, the superimposition of multiple ideas within certain images became so pronounced that they might be considered manifestos of his artistic freedom. Impatience and inventive risk-taking sometimes led to mishaps that

left their marks on his prints, but instead of discarding the botched work or taking pains to correct problems, he often chose to present the experience of partial failure as one that was attendant to brilliant achievement. In the later 1640s, once he had acquired fame and a degree of fortune, Rembrandt extended his exploration of the artistic potential of his etchings beyond the completion of the copper plates. By varying both the papers on which he printed and the distribution of ink on the plate, he created multiple interpretations of his prints. In so doing he allowed others to experience the many potentialities—equally valid solutions to artistic challenges—that he found within a given image.

The Basics of Rembrandt's Techniques

Before looking over Rembrandt's shoulder, it may be helpful to review a few aspects of three related printmaking techniques: engraving, etching, and drypoint. An engraving is made by incising lines into the surface of a polished copper plate with a sharp tool called a burin, essentially a square shaft of steel having one end cut on the diagonal to make a sharp, diamond-shaped tip, and the other end set into a handle that can be cradled in the palm of the hand. Applying pressure through the palm, the engraver forces the tip into the surface of the plate so that it removes a sliver of copper and leaves behind an incised line. Once all the lines of the image have been cut, the printer—sometimes the same person as the engraver but often not—rubs ink into the plate and then carefully wipes clean the surface, leaving the ink in the incisions. Next, the printer places the plate on the press, covers it with a sheet of dampened paper and a protective felt blanket and then, turning the long spokes of the handle, cranks the sandwich of copper, paper, and felt through the press (see fig. 38). The rollers exert tremendous pressure, forcing the paper down into the grooves to pick up the ink. Once through the press to the other side, the felt can be lifted and the paper peeled away from the plate. If all went well, a mirror image of the incised design will appear in black ink on the white paper. Then the plate can be inked and printed again.

Fig. 38. Jan Luyken (Dutch, 1649–1712) and Caspar Luyken (Dutch, 1672–1708), *De Plaat-drucker* (The Copper Plate Printer), 1694, page 62, *Spiegel Van't Menschelyk Bedryf* (Mirror of Human Professions) by Nicolaus Visscher, Amsterdam, illustrated book, 21 × 16 × 2.5 cm (8¼ × 6⁵⁄₁₆ × 1 in.), Collection of Arthur Vershbow (detail).

Etching developed as a substitute for engraving. It uses chemistry to avoid the mechanical demands of handling the burin. First, the artist coats the plate with a protective layer of waxy varnish, called the ground. He then uses a needle set into a narrow stick of wood (so that it resembles a pencil) to scratch through the ground, thereby exposing the copper as he draws the lines of his design. Next, the plate is exposed to acid, which eats away or "bites" at the copper wherever the needle scratches have exposed it. After sufficient biting, the lines become grooves comparable to those incised by the burin in the engraving process. Once the ground has been removed, the plate can be inked, wiped, and printed in the manner described for engraved plates.

For an artist such as Rembrandt, who was trained to draw and paint rather than to work in metal, etching holds a major advantage over engraving: the action of holding the needle and scratching the ground closely approximates the manner of drawing with a pen, while the handling of the burin is a craft quite foreign to those not specifically trained in the discipline.[3] Not only is the grip required for the burin unusual, but also the force required to cut the copper far exceeds that which is needed to scratch through a waxy ground. With etching, an artist can pick up the needle and immediately work with a degree of confidence, which is just what Rembrandt did.

As a beginner printmaker, Rembrandt relied on etching, using engraving primarily as a means of touching up plates when etched lines had bitten poorly or some area needed deeper shading. Over time, he developed an increasing interest in a third technique, drypoint. A cross between engraving and etching, drypoint involves the use of a needle that can be held like the one used for etching, but the artist uses it to scratch directly into the surface of the plate, and thus produces lines directly rather than through the intervention of acid. Because the tool does not cut as cleanly as a burin, it can raise a more pronounced burr of metal along the lines. When the plate is inked and wiped, the burr prevents the complete removal of ink from the surface. In printing, this surplus ink spreads onto the paper. If the amount of burr is small, the line will be slightly softened. Larger amounts can produce dramatic, rich, and velvety lines similar in appearance to those made by ink applied with a broad-nib pen or wash applied with a brush—both techniques favored by Rembrandt. The amount of burr depends on several factors, such as the force applied and the angle at which the artist holds the needle. In printmaking ter-minology, the inky halo produced by the metal burr of copper is itself known as "burr." Though earlier artists, such as Albrecht Dürer, sometimes employed rich drypoint burr (see fig. 78, p. 222), Rembrandt was the first printmaker to exploit fully its dramatic potential on a sustained basis.

When Rembrandt began his career, the available guides to etching, particularly those in Dutch, contained basic information but little detail.[4] Printmaking procedures had not yet been standardized, and know-how was shared largely as an oral tradition. If Rembrandt did have access to a published guide, it was most likely to have been Gerard ter Brugghen's *Verlichtery Kunst-Boeck* (Illustrated Art Book) of 1616.[5] It was not until 1645 that the first comprehensive treatise on etching and engraving was published by the French printmaker, Abraham Bosse.[6] Bosse's book was extremely influential, but by the time it appeared, Rembrandt was already quite experienced and probably felt little need to consult it. He may even have reacted against its prescriptive voice. When checked against the appearance of Rembrandt's prints, certain comments in Ter Brugghen's and Bosse's guides reveal how the artist adhered to common practice in some cases and steered a quite different course in others. When he departed from the norm, it was sometimes a matter of casualness, but often such independence arose from the pursuit of a unique artistic vision.

The Copper Plates

Information about Rembrandt's some 290 copper plates comes from two sources, the impressions taken from those 290 and the eighty-one original plates that have survived.[7] Several of his surviving plates are illustrated and discussed in this volume (nos. 6, 65, 83, 130, 144, and 182). Rembrandt purchased new plates, for those that already bore an etched or engraved image usually cost more.[8] In only two known instances did he reuse plates previously worked by other printmakers: the first was his frugal recycling of an out-of-date mathematical diagram no longer having commercial value;[9] the second and far more interesting case was his appropriation, during the early 1650s, of a plate bearing the image of *Tobias and the Angel* (no. 114), etched and engraved many years earlier by Hercules Segers, the other great improvisational printmaker of seventeenth-century Holland. Rembrandt scraped away some of Segers's work and then added his own etching and drypoint, transforming the plate into *The Flight into Egypt* (no. 115). The result was a dialogue be-

tween two artists whose temperaments overlapped. Apart from this remarkable episode, Rembrandt's plates began as ordinary pieces of copper hammered flat. His treatment of the plates, however, was extraordinary, as evidenced by the impressions printed from the plates while they were still in Rembrandt's hands. Unfortunately, over centuries of intermittent use, nearly all of the plates have become worn, and many have been subject to further etching and engraving by later owners—often publishers—attempting to wring additional impressions from weakening lines.

Even while they were still in his possession, some of Rembrandt's plates wore to a degree that seriously compromised their ability to produce the effects he originally intended. His drypoints were especially susceptible to such wear, because their copper burr was so fragile. In *St. Francis Praying beneath a Tree* (no. 149), for example, the burr plays a pivotal role in creating the dramatic and changeable light that gives the image its visual fascination and spiritual depth. Impressions printed on a seventeenth-century paper—possibly still during Rembrandt's lifetime—show a considerable loss of burr (fig. 39). Despite the plate's ongoing capacity to record the spontaneity of his draftsmanship, it has lost the greater part of its magic.

We know that Rembrandt destroyed some of his own plates. He cut up the plate of *The Flight into Egypt*, for example, and made a self-portrait on one of the fragments.[10] He also reused plates on which he had made false starts or tested ideas. When turned on its side, the first state of *Three Heads of Women, one lightly etched*, which included only one head at that stage, bears a sketch of a timber ceiling (fig. 40). Perhaps Rembrandt made a beginning on a subject such as the Nativity or the Death of the Virgin, but stopped without finishing the image. Later, he transformed it into a sketch plate with the addition of the two further head studies. His informal approach to the composition may have been stimulated by the reuse of cast-off copper.[11]

Despite varying degrees of degradation, the surviving copper plates have a talismanic ability to summon Rembrandt's creative spirit. They were prized in Rembrandt's own time and they are highly sought after today, but the plates did not always enjoy an exalted status. When Alvin-Beaumont, the Paris art dealer who last published a nearly complete set of the surviving plates, tried to sell his set in the 1920s and 1930s, he found no buyer for over fifteen years. He finally sold the plates to Robert Lee Humber, an American living in Paris. Humber entrusted them to the North Carolina Museum of Art, but his heirs sold them in the early

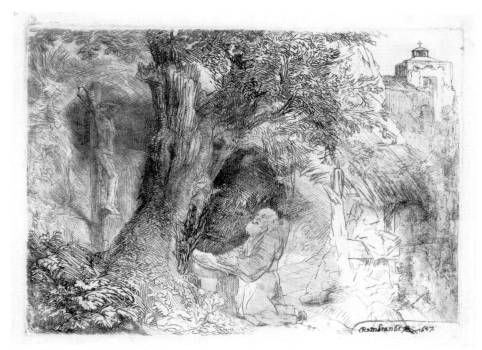

Fig. 39. *Saint Francis Praying beneath a Tree*, 1657, drypoint, etching, and engraving, B. 107, A, 18 × 23.8 cm (17 1/16 × 9 3/8 in.), Museum of Fine Arts, Boston, Harvey D. Parker Collection.

1990s. This time, promotion by dealers in England and America generated considerable enthusiasm, and the plates sold quickly at substantial prices. They are now widely dispersed in public and private collections.[12]

One plate discovered within the past decade, *Abraham Entertaining the Angels* (no. 144), stands apart from the eighty others that are known.[13] Rather than enduring the wear and alteration brought on by hundreds of years of use, this plate was fortuitously retired when another artist used the back as a support for a painting (see fig. 75, p. 218). Despite some damage caused by its having been nailed into a frame, it comes closer than any of the others to showing us what Rembrandt's plates looked like when they were still fairly new. The grooves are deep and have sharply defined edges. The lines on the other plates tend to be much shallower and to have softer, more rounded edges; thus they will not hold as much ink as those on the *Abraham* plate, explaining in part why early impressions of Rembrandt's prints are preferable to later ones. Only when the plates were fresh enough to hold all the ink that the artist intended them to bear would they print with the full strength and balance that he envisioned. Although the *Abraham* plate is the closest to its original condition, even it lacks the drypoint burr that produced the rich lines seen in early impressions (no. 142).

Rembrandt was apparently interested in his own cre-

Fig. 40. *Three Heads of Women, one lightly etched*, about 1637, etching, B. 367, I, 12.7 × 10.3 cm (5 × 4 1/16 in.), Rijksmuseum, Amsterdam.

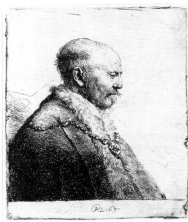

Fig. 41. *The Artist's Mother: Head only, full face,* 1628, etching with additions in black chalk, B. 352, I, 8.5 × 7.7 cm (3⅜ × 3¹/₁₆ in.), Rijksmuseum, Amsterdam.

Fig. 42. *The Artist's Mother: Head only, full face,* 1628, etching, B. 352 II, 6.2 × 6.5 cm (2⁷/₁₆ × 2⁹/₁₆ in.), Museum of Fine Arts, Boston, Harvey D. Parker Collection.

Fig. 43. *Bald Man in Profile,* 1630, etching, B. 292, I, 11.8 × 9.7 cm (4⅝ × 3³/₁₆ in.), Rijksmuseum, Amsterdam.

Fig. 44. *Bald Man in Profile,* 1630, etching, B. 292, II, 11.8 × 9.7 cm (4⅝ × 3³/₁₆ in.), Rijksmuseum, Amsterdam.

ative processes, for he saved trial impressions of his prints even before his fame had increased to the point where others sought his unfinished work. These impressions reveal that he often began to draw with his etching needle without having first fully planned the shape, size, or position of the image on the plate. We also know that he was sometimes inclined to cut down his plates after drawing on them. The final outcome was thus unpredictable. This flexible, improvisational approach, one that was more pronounced at the beginning of his career but occasionally recurred in his mature work, distinguishes Rembrandt from all earlier printmakers.

Rembrandt often began to etch a small study in the middle of a relatively large plate, as in the case of his *Head of an Elderly Woman* (figs. 41, 42), the subject of which is traditionally identified as his mother. On an early impression, he used black chalk to sketch an idea for further development of the image that would have included her upper body. In the end however, he cut away more than an inch of the copper plate, cropping it just below the woman's chin to create a strikingly eccentric composition.[14] On other plates that began as single heads, such as his *Bald Man in Profile* (figs. 43, 44), he chose not to cut the plate and proceeded to etch the sitter's upper body. Or, he could go in yet another direction: one head might be followed by others until the copper was covered with etched studies, as occurred in the plate featuring three studies of the same bald old man as that of the plate above (no. 29). A number of Rembrandt's small prints were originally etched together on larger plates that were later divided.[15] Because he sometimes cut his plates after having begun to draw, Rembrandt often did not bother to smooth the edges of the copper until he was satisfied with the image. For example, the irregular inky marks printed by rough plate edges appear in early impressions of *Jupiter and Antiope* (no. 98) and *The Hog* (no. 76). The marks suggest that Rembrandt used a serrated tool, such as a toothed chisel, to cut the copper. When he was ready to print impressions in larger quantities, he would file the edges until they were fairly smooth.

Whatever Rembrandt hoped to do with his printing plates, every etching began with the mundane exercise of polishing the copper. In its final stages this task was accomplished with the use of a mild abrasive. Bosse recommended charcoal carefully prepared to avoid any grit.[16] As a young man Rembrandt had difficulties with the task. Either too impatient to complete the job or too inexperienced to choose a sufficiently fine-grained abrasive, he left countless scratches on his plates. Those in his early rendition of *The Rest on the Flight into Egypt* were thick enough to cast a curtain of shadow over the sunlit scene (no. 8). The effect was so pronounced that it prompted Rembrandt to burnish away certain scratches to create highlights. He soon became vigilant about polishing his plates, but he would remember the potential of surface abrasion as a way to add atmosphere. In the 1650s, fine scratches added considerably to the haziness of the damp air in the *Clump of Trees with a Vista* (no. 192) and to the symbolic darkness of *The Blindness of Tobit* (no. 132).

Applying the Etching Ground

Once he had polished the plate, Rembrandt was almost ready to apply the etching ground, the acid-resistant coating through which he would scratch his design. But first he needed to clean the copper thoroughly. Any

smudges of dirt or grease could impair the adhesion of the ground. As a beginner, Rembrandt apparently did not always clean his plates with adequate care. *Peter and John at the Gate of the Temple* (no. 10) shows the disastrous consequences. Irregular black stripes made up of countless black dots mar the image. The streaky quality of the damage suggests that perhaps Rembrandt wiped the plate with a grimy rag before applying the ground. The residue allowed acid to penetrate the ground and corrode the copper surface, and then every etched pit held a speck of ink that was ultimately transferred to the paper. Fortunately, Rembrandt learned from such failure, and after a short while he began to clean his plates properly.

The recipe that the etcher uses for his ground is critical to the success of his work. In 1660, the English printmaker Alexander Brown published a varnish recipe and asserted that it was the only one used by Rembrandt:

The Ground of Rinebrant of Rine: Take half an ounce of Expoltum burnt of amber one ounce, of Virgins Wax half an ounce, of Mastick, then take the Mastick and Expoltum, and beat them severally very fine in a Mortar; this being done, take a new earthen Pot and set it upon a Charcole fire, then put the Virgins Wax into it and melt it, then shake into it the Mastick and Expoltum by degrees, stirring the Wax about till they be throughly mingled, then pour it forth into fair water and make a Ball of it, and use it as before-mentioned, but be sure you do not heat the Plate too hot when you lay the ground on it, and lay your black ground very thin, and the white ground upon it. This is the only way of Rinebrant.[17]

This recipe produces a dark chocolate-colored ground.[18] According to Brown, a thin coat would have been applied to the copper and then covered with a second layer of white ground: "A white Ground: Take of Wax one ounce, Rosin two ounces, melt them together, add thereto a quarter ounce of *Venice* Cereus [sic] finely ground."[19] Most etchers used a dark ground and would blacken it with candle smoke to make it darker still, so that the scratches left by their etching needles would appear clearly in copper red against it.[20] A light-colored surface would have been advantageous, however, for then Rembrandt could transfer a design to a plate by coating the back of the drawing with chalk or paint, and then placing it on the plate and scoring the outlines of the design with a stylus. The sheet would thus act like carbon paper, leaving the traced outlines on the plate's white, coated surface. Colored coatings on the back of some surviving Rembrandt drawings tell us that they were transferred to plates using this method, but their number is very small.[21]

There is no proof for Brown's claim that Rembrandt used the recipe, but Samuel van Hoogstraten, Rembrandt's onetime student, provides a measure of corroboration when describing his own use of a two-layer, white-over-dark ground.[22] Van Hoogstraten does not provide a complete recipe, but he cites the same ingredients as those in Brown's recipe for the dark layer, and a mixture of lead white and egg whites for the white layer. If Rembrandt did make frequent use of a white layer as Brown's text suggests, he may have attached greater value to its paperlike white color, against which the exposed lines of copper would read like strokes of red chalk. Rembrandt, the painter who assigned printmaking an exceptionally central role in his artistic life, may have adapted his etching materials to make them as similar as possible to those he was most familiar with since childhood.

After mixing the ground and cleaning the plate, Rembrandt could proceed to the ground's application. To do so, he had to warm the plate in order to allow the ground to flow over the surface and then dry. Overheating would dry the ground too quickly, crackling or crazing the coating. Bosse's treatise suggests that the best way to heat a plate is to place it face up on a grate with embers arranged around the periphery of the base.[23] This method would circulate warm air beneath the plate without subjecting it to direct exposure. Rembrandt was not so methodical as Bosse. His impatience or his adventurous artistic spirit appears to have sometimes led him to place his plates directly over the coals. Several of his etchings have weblike patterns of lines caused by acid biting the copper through a crackled ground. A prominent example is *The Windmill,* in which the crackling is most pronounced at the very center of the plate (no. 119 and fig. 45).[24]

When he wanted to, Rembrandt was able to apply his ground in a very thin and even coat. Ter Brugghen's

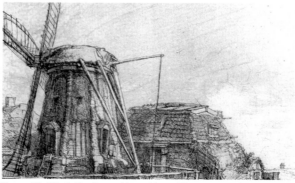

Fig. 45. *The Windmill,* 1641, etching with crackle pattern, etched granular tone, and burnishing, no. 119 (detail).

book recommended smoothing the ground over the plate as thinly and evenly as possible, in order to make fine, clean etchings.[25] Rembrandt may have followed such prescriptions for minutely detailed etchings, such as *Abraham Casting out Hagar and Ishmael* (no. 66); or for etchings especially meaningful to his social ambitions, such as his 1639 self-portrait (no. 81) and his portrait of Jan Six (no. 74); or for particularly intimate works, such as the *Sleeping Puppy* (no. 55). In preparing etchings for which he anticipated wider circulation, Rembrandt may have applied the ground more thickly so that it would stand up to the longer acid bite required for making deep, strong lines that would hold up during long press runs. The deeply bitten lines of certain religious prints of the 1650s, such as *Christ Disputing with the Doctors* (no. 165) or *Abraham Entertaining the Angels* (nos. 142, 144), suggest that Rembrandt had learned from experience that the finely etched lines of his earlier religious prints were all too subject to wear.

The Stroke of the Etching Needle

Rembrandt's manner of handling his etching needle varied considerably over the course of his career. If we were present to observe his earliest encounters with it, we would see his enthusiasm, impatience, and intense determination. As a beginner working on *The Circumcision* (no. 7), his hand flew over the plate in speedy zigzags, scrawling arcs, and staccato jabs. Yet, when he came to details of central importance, such as the hands of the operating priest or the face of the child, he slowed down (fig. 46). Here he drew with concentrated precision, carefully placing short lines to articulate complex structures and human emotion.

Apparently, the young Rembrandt was sometimes frustrated by his inability to make revisions in etching with the same improvisational spontaneity possible in drawing. When he wanted to make changes to *The Small Lion Hunt* (no. 105), for example, he chose neither to engrave with a burin nor to prepare the plate for etching. Instead, he scraped and scratched directly into the copper—with what, we cannot say. He used this relatively crude technique to darken many areas of the plate so that by contrast the lions would be bathed in blinding light. In a few places, such as the foreleg of the pouncing lion and the shoulder of the foreground hunter, he abraded the plate in a specific direction to improve the definition of the form as well as the sense of movement (fig. 47).

By 1628, when Rembrandt first dated his prints, he had developed a far more subtle stroke. This advance

is readily seen in his portrait of an old woman traditionally identified as his mother (no. 21). He used a fine, sharp etching needle to make the delicate, layered web of closely spaced lines that convincingly depicts the structure, features, and textures of the woman's head. He drew small details with freely arranged flicks and tiny curved strokes. Then he selectively shaded over these areas with small areas of parallel lines (as on her chin) or with zigzags (as on her cap and shoulder). The crude scratching seen in *The Small Lion Hunt* had already evolved into a more assured use of drypoint as a quick means of adding supplementary detail (as in the cursorily defined veil descending from her cap to her shoulder).

The relatively large *Self-Portrait* of 1629 (no. 13) reveals that the development of Rembrandt's vocabulary of etching strokes did not follow a single path. Much of the self-portrait was drawn with unusual, broad double lines that appear to have been made with a quill pen or some sort of double-pronged tool that simulated the action of a split nib. Perhaps Rembrandt was searching for a technique that would allow him to etch exactly as he drew on paper, or perhaps he simply wanted to make etchings that had lively, inflected lines like those in pen drawings. Rembrandt did not pursue this particular draftsmanlike technique any further, but he did continue to explore more than one technical approach at any given moment of his career.

In the mature works of about a decade later, we find Rembrandt varying his handling of needles and burins to convey a wide range of abstract qualities such as intelligence and emotion. Three prints from 1639 form a capsule survey of how he matched the motion of his hand to the thoughts in his mind. The extremely fine etched strokes and closely modulated tonal control of his *Self-Portrait Leaning on a Stone Sill* (no. 81) mirror the

Fig. 46. *The Circumcision,* 1626, etching, no. 7 (detail).

Fig. 47. *The Small Lion Hunt, with two lions,* late 1620s, etching, no. 105 (detail).

gentlemanly refinement and self-possession that he hoped others would see in his person. By contrast, in the highly charged *Death of the Virgin* (no. 70), great sweeping strokes in the floor, ceiling, vapors, and drapery give expression to the inner turmoil of the mourners. For his personal commentary on the beauty and frailty of human life, *The Young Couple and Death* (no. 90), Rembrandt chose to work in drypoint, not as a means of making minor corrections, but as the primary technique for the entire image. The poetically delicate lines may have been a conscious metaphor of love's fleeting pleasures.[26] With these works Rembrandt showed that he had attained full command of his art, and yet he would soon be searching for new means of expression.

Into the Acid

Etching, the workhorse of Rembrandt's printmaking techniques, required acid to eat away at, or "bite," the exposed copper. In the seventeenth century there were two principal methods of applying acid to the plate. One involved making a little wax dam around the edges of the plate to form a tray that would hold the acid. The other called for placing the plate in an inclined wooden tray and repeatedly pouring acid over it.

Rembrandt probably used the wax dam method early in his career. Sometimes irregular blank edges around an etching reveal that the wax masked the outermost parts of the image. At the left edge of *The Flight into Egypt* (no. 9), for example, the lopped-off ends of many of the zigzag strokes indicate that they may have been masked. In many cases, however, we do not see masked areas at the edges, possibly because Rembrandt trimmed his copper plates after they had been bitten. He may have continued to use the wax dam method for many years, at least occasionally, for the edges of his *Self-Portrait* (no. 82) of about 1642 appear to have been masked in such a manner.

As the acid bit, it was advisable to agitate the bath now and then with a feather, in order to disperse the bubbles created by the chemical action. If allowed to sit undisturbed, the bubbles would hinder contact between the acid and the plate, causing little spots of insufficient biting. Rembrandt seems to have sometimes exploited the bubbles to produce desirable effects, such as the night sky in *The Flight into Egypt* (no. 109). Here he probably exposed the plate directly to acid as a second operation after having cleaned the varnish from the plate following the initial biting. He tipped the plate slightly so that the acid would cover only the upper half of the plate. The overall exposure corroded the surface except where bubbles formed, leaving little white stars scattered through the sky. The corrosion also darkened Joseph's upper body but not Mary's. Rembrandt may have masked her figure with a bit of varnish, or perhaps he scraped and burnished away some of the corrosion after the acid had bitten the plate.

Bosse's printmaking treatise of 1645 suggested pouring the acid over the inclined plate.[27] Rembrandt may already have adopted this method by then. His later plates tend to have neater edges than his earlier ones, and we see the line work going nearer to the perimeter instead of the many truncated strokes produced by masking. When there are blank spots at the edges of his later plates, they seem to have been produced by the masking effect of something more fluid than wax. For example, there are irregular gaps in the shaded areas near the edges of *The Virgin and Child with the Cat and Snake* (no. 164), as well as on the edges of other etchings from the 1654 Childhood of Christ series. This appearance suggests that Rembrandt applied a coat of varnish to the back and sides of his plates to protect them from the flowing acid, but also that he was sometimes less than meticulous.

After biting the plates Rembrandt would have had to rinse them in water and clean off the ground before he could print. Many of his plates, especially those from his early career, bear scratches. It is difficult to determine whether specific scratches occurred during the polishing of the plates before the application of the ground, or in the process of removing the ground. With each of these steps the impatient young artist ran the risk of blemishing his plates.

Rembrandt often varied the strength of his lines during the 1630s, generally making foreground lines heavier and background ones lighter by using a technique called "stopping out."[28] He would start to bite the plate but interrupt the process while the grooves were still fairly shallow. After rinsing and drying the plate, he applied a coat of varnish to the areas that he wanted to remain light. He then resumed biting, continuing to deepen and broaden the grooves that remained exposed. The deeper, wider grooves in the plate ultimately held more ink and thus made bolder lines when printed. With this method the artist could produce as many zones of varying darkness as he desired. At first Rembrandt's use of stop-out produced broad schematic divisions, such as the lightly etched upper left quadrant of *The Presentation in the Temple* of 1630 (no. 1), but with time he became adept at graduating his stop-outs to achieve smoother transitions, such as those in his

Abraham Casting out Hagar and Ishmael of 1637 (no. 66). Despite his mastery of the technique, Rembrandt seems to have largely abandoned it in the 1640s, thereafter favoring a more uniform single bite augmented with drypoint.[29]

Etched Granular Tone

Rembrandt was a key participant in a broad trend among seventeenth-century Dutch printmakers: the quest for printed tone.[30] A number of other artists sought ways of printing tone through mechanical methods such as extremely fine engraving, stippling with a needle, or the new technique of mezzotint, pioneered in the 1640s and perfected in the 1660s.[31] In the 1630s, Rembrandt began to investigate ways to add tonal effects to his prints that did not rely on linear strokes of the needle or burin. He appears to have been one of the few printmakers to find a chemically based method of imparting repeatable tonal effects to his plates.[32]

Accidents such as the one that defaced his early *Peter and John at the Gate of the Temple* (no. 10) may have opened Rembrandt's eyes to the possibility of using corrosion rather than strokes of the needle to vary the tonality of his prints.[33] If acid is allowed to come into contact with the smooth surface of the copper plate, it corrodes the surface, opening up tiny irregularities. When inked and printed, each of these irregularities captures and transfers a minute speck of ink to the paper. Rembrandt purposefully bathed the plate for his 1633 *Flight into Egypt* (no. 109) in acid in order to corrode its surface. In 1634 he seems to have employed corrosive action to increase the depth of shadow in the closely worked foliage of his *Angel Appearing to the Shepherds* (no. 39). The lines are so closely spaced that they obscure most clues as to how he performed the process, but close inspection reveals that the plate surface was locally covered with countless tiny pits.

By the early 1640s, Rembrandt was no longer relying on an acid bath to pit the surface of the copper. Instead, he seems to have applied his corrosive agent with a brush or a rag. He may have made a paste of such material that would stay in place when applied. Long striated bands of speckles—referred to here as etched granular tone or bitten tone[34]—mute many of the figures in *The Presentation in the Temple*, while adding variety to the atmospheric lighting of the dusky interior scene (no. 2 and fig. 48). We can trace the path of Rembrandt's brush as he applied his corrosive mixture. He then took up a blunt tool and slightly burnished the newborn child, making him the brightest point in

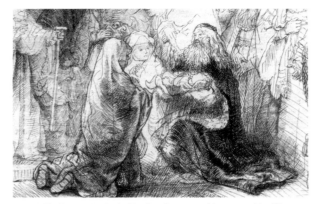

Fig. 48. *The Presentation in the Temple*, 1639–40, etching, no. 2 (detail).

the image in direct contrast to the aged, black-robed Simeon who recognized the arrival of the Messiah.

A great swath of etched granular tone sweeps across the sky of Rembrandt's 1641 *Windmill*, a plate mentioned above for its prominent crackled ground (no. 119). In the broad, free application of the corrosive agent one senses the artist's excitement about its potential as a painterly extension of his printmaking techniques. The resulting mottled gray tone lends the landscape a feeling of thick, damp air. We can again see him working with a burnishing tool to smooth the plate. He polished his copper plate just above the horizon to create the effect of clear air below low-hanging fog.

Rembrandt nearly mastered the controlled use of granular tone that same year. Close inspection of *The Angel Departing from the Family of Tobias* (no. 134 and fig. 49) reveals that he could selectively add bitten tone to his etchings with the same degree of precision with which he could apply ink wash to a drawing using a fine brush. The woman standing in the center, Tobit's wife Anna, wears a cloak that is shaded on the outside but has a brightly lined interior. Rembrandt appears to have determined the exact placement of tone for the shaded area in a two-step process, but exactly what this process was is not clear. He may have first applied his corrosive compound and then burnished corroded areas to obtain highlights. Another possibility is that he applied a resistant varnish to the places that he wanted to remain uncorroded and afterwards applied the compound.

In 1718, Arnold Houbraken touched on aspects of Rembrandt's unusual treatment of his plates:

He also had a way of his own of working his etched plates afterwards and completing them, which he would never let his pupils see; which is also not to be understood in which way it is done; thus the invention (even as with the knowl-

Fig. 49. *The Angel Departing from the Family of Tobias*, 1641, etching and drypoint, no. 134 (detail).

edge of coloring glass as Dirk and Wouter Crabeth of Gouda did it) is descended in the grave with the inventor.[35]

Though he regarded Rembrandt's process as a lost secret, Houbraken's comparison to glass coloring suggests that he may have considered Rembrandt's proprietary process chemical in nature. On the same page of his text, Houbraken went on to state:

One discovers also in the portrait of Sylvius that it is in the same way first roughly etched; the tender light shadows and the strong [ones] are brought in later and are nobly and delicately handled as it can be done in mezzotint.[36]

Houbraken's remarks apparently refer to Rembrandt's 1646 portrait of *Jan Cornelis Sylvius* (no. 71 and fig. 50), where the use of granular bitten tone in the sitter's face and hands is a marvel of subtlety and control.[37] Rembrandt also allowed his chemical process to roughen the surface of the plate beyond the oval window through which the preacher appears to lean. When printed, this roughness produced a perfect equivalent to the granular texture that one would expect of a weathered, antique marble funerary monument. Houbraken evidently understood that Rembrandt's work occurred in stages and that the granular tone was added after the lines had been etched. His comparison of the granular tone to mezzotint—the modish printmaking technique of the eighteenth century—suggests recognition of Rembrandt's ability to add tonal nuances well beyond the capability of the etching needle.

In the 1650s, Rembrandt continued to work with the surface texture of his copper plates, but the irregularities that he employed were so fine that one would not tend to describe them as granular. In *The Descent from the Cross by Torchlight* of 1654 (no. 158), only two places on the surface appear to have been completely polished: the upraised hand near Christ's shoulder and the standing figure at right. These select areas are brighter than the remainder of the image. In other areas, even on the flame of the torch, the print has a slightly gray tone. This distribution of light and tone holds true from one impression to another.[38] Rembrandt appears to have used the same technique for his *Woman Bathing Her Feet at a Brook* of 1658 (no. 197). Here the area of the woman's cap was polished smooth on the copper plate and in printed impressions appears bright compared to the light gray tone that pervades the rest of the image. How he achieved his effect remains unknown. He may have ever-so-slightly roughened the surface of a polished plate with a quick acid rinse, or he may have burnished specific parts of the plate with extra care.

Drypoint

About 1640, Rembrandt expanded his use of drypoint. Previously used for small touch-ups or the delicate rendering of a complete image, it now became his principal means of adding strong accents to his prints and also provided much of his shading. Many of the drypoint strokes themselves assumed a bold individual character. A vivid example of drypoint used in this manner is *The Triumph of Mordecai* (no. 108). At the right side of the print, the figures are rendered primarily as etched outlines with relatively little modeling and just a few touches of drypoint. Increasingly, as one scans toward the left side, the figures become dramatically accented with velvety drypoint lines. Rembrandt bore down hard on his needle to raise a pronounced burr that would capture, and then print, a rich charge of ink. He emphatically scored the main outlines of figures, such as those of the kneeling soldier in the lower corner, giving the shadows on and around them a depth that causes highlights to shine with greater brilliance. Velvet, fur, hair, and beards were given a new sensuosity unequaled in his earlier work, and the shadows on the architecture became soft and deep.[39] In drypoint, Rembrandt had found at last a solution to the problem that he had failed to solve with the double-pronged tool used for his *Self-Portrait* of 1629 (no. 13). He now had a versatile printmaking technique that could match the density of color and breadth of line produced by charcoal or ink applied with a brush or broad-nib pen.

In his elaborate 1643 *Landscape with the Three Trees* (no. 121), Rembrandt integrated an array of printmaking techniques, combining precise calculation and uninhibited impulse. With the etching needle he drew the expansive plain reaching from the watery bank to the city in the distance. Long, nearly parallel, horizontal lines crossed by countless little vertical flicks become hedgerows and canals marking the limits of pastures and fields. Amid those horizontal lines, Rembrandt seems to have brushed on narrow streaks of corrosive paste to produce modulated bands of granular bitten tone. The result is an active play of light that accentuates the great distance visible across the plain. We imagine scattered sunshine breaking through the roiling clouds above and striking the varied textures of the fields below. Taking up the drypoint needle, Rembrandt delicately enveloped in deeper shadow the lovers in the foliage of the embankment. In sharp contrast to his careful control of man's cultivated domain, Rembrandt seems to have unleashed the full force of nature as he created the sky. With broad, scrawling rhythmic freedom, he etched the turbulent clouds and

Fig. 50. *Jan Cornelis Sylvius*, 1646, etching, drypoint, and engraving, no. 71 (detail).

then, guided by a straightedge, slashed the sharp diagonals with the drypoint needle.

Over the next few years Rembrandt's use of drypoint developed into a sumptuously painterly art, as well as a versatile one. At one extreme he used it for the high finish and subtle transitions of "The Hundred Guilder Print" (no. 135), and at the other for the sketchy immediacy of *Clump of Trees with a Vista* (no. 192). Greatly varied but closely regulated burr yielded an intricate arrangement of light and texture in *The French Bed* (no. 94). The sense of light filtering into the room and caressing the forms lends a sculptural dimensionality to the figures and convincing tactility to their surroundings.

Rembrandt seems to have had a habit of developing artistic ideas that he would then set aside for a long period of time. Suddenly when the moment was right, the idea would reemerge. The slashing, ruled diagonal drypoint in the *Three Trees*, for example, did not reappear in his work for a decade. Then in 1653, in his summa of the drypoint technique, "The Three Crosses" (nos. 168, 169), Rembrandt took out his straightedge and slashed the copper to create light and darkness that could only be heaven sent. When he went on to transform the image from baroque opera to expressionist lament (no. 170), Rembrandt gouged the plate even deeper. In redrawing the figures, he seems to have borne down with extra force to overcome the deeply rutted surface of the heavily worked copper. He drew with austere, powerful strokes to raise thick burr capable of standing out from the tangle of existing lines that would continue to print in subsequent impressions. Whereas Rembrandt's drawing practice often guided his efforts in printmaking, in this case the reverse might have been true: the concise, emphatic drypoint strokes that he used to rework this plate may have informed his late drawing style.

Rembrandt's portrait of *Thomas Haringh* (no. 207) probably followed closely after "The Three Crosses," and in it, the artist again shows his versatility in the handling of his printmaking tools as well as his ability to match technique and subject. In complete contrast to the bold handling of grand drama for the religious theme, this soulful drypoint likeness of an old man is executed with matchless delicacy and precision. Rembrandt recreated the wizened features with tiny, halting strokes suggestive of intricately wrinkled skin. In the clothing the burr is so fine and the strokes so closely spaced that they often lose their linear character to read as pure tone.

Choosing the Paper

For the first two decades of Rembrandt's printmaking career, he always used white European paper. So long as the quality was good, he appears to have regarded paper as a commodity, showing no preference for the product of any particular maker—watermarks (see Materials and Techniques) of many different makers are found in the papers that he used. About 1647, however, Rembrandt's attitude toward paper changed drastically when he obtained a quantity of it from Japan. Different in color, texture, and receptivity to ink, the Japanese paper opened new possibilities for varying the appearance of his prints. This discovery led Rembrandt to investigate other surfaces on which to print, and his findings began to change his work, even as he continued to use his customary European paper.

Only one documented instance of Rembrandt purchasing paper is known, and that occurred when he bought a substantial amount of blank paper at auction.[40] Normally he seems to have purchased paper in small quantities, using up most sheets of a given size before buying more.[41] This practice has produced a body of evidence akin to archeological strata—in theory, the use of a given type of paper, often identifiable by its watermark, represents a layer in time. Erik Hinterding has taken the lead in recording watermarks in Rembrandt's prints and in attempting to construct a chronology based on specifically datable examples.[42] The results of his research inform current understanding of many individual prints and also suggest broader trends in Rembrandt's printmaking.

Watermarks provide many clues about the ebb and flow of Rembrandt's overall printing activity. Rather than printing continuously from his plates or printing on demand when a customer requested a certain image, he appears to have printed a supply of a given print and to have sold the impressions over a period of years before reprinting.[43] Rembrandt's printing activity seems to have peaked when he needed money.[44] Furthermore, the creation of new images might have stimulated renewed interest in, and reprinting of, older ones of similar subjects, as his 1650s landscapes seem to have done for those of the 1640s.[45] In 1653, however, Rembrandt's reprinting of old plates ceased abruptly.[46] He appears to have lost control of them, and they may have left his hands altogether.[47] When they were next printed they appeared on papers not used by Rembrandt but characteristic of those used by Amsterdam printseller Clement de Jonghe.[48] After Rembrandt's bankruptcy, a shift occurred in his usage of European

paper: no longer working off a pile of uniform paper, he began to use scattered sheets of different types. Hinterding concluded that Rembrandt became something of an amateur, experimentally testing the effects of papers from different manufacturers.[49] While it is clear that in the later 1650s Rembrandt was no longer in charge of an organized commercial workshop turning out large quantities of prints, his long-term treatment of white European paper as a commodity and his reduced financial circumstances suggest that he became as much a scavenger as an experimenter.

Watermarks can also help to determine which states were created by Rembrandt and which resulted from the posthumous reworking of worn printing plates by other hands. Based on his identification of clear dates for particular watermarks, Hinterding concluded that many states formerly believed to be by Rembrandt are on papers that could have only been made after his death.[50] Only the first two states of *The Angel Departing from the Family of Tobias* (no. 134), for example, are on paper made within Rembrandt's lifetime, although three or four states had previously been catalogued as being by the artist.[51]

Accounts of the Dutch East India Company suggest that about four thousand sheets of paper were shipped from Japan to Amsterdam from 1644 to 1645.[52] The exotic commodity must have been much more expensive than ordinary European paper. More than any other artist, Rembrandt seized on the unfamiliar Japanese paper. By 1647, he had a supply in hand. That year he made an extraordinarily highly finished portrait of Jan Six (no. 74), a young aristocratic collector whose classically grounded play, *Medea,* had just or was about to premiere.[53] Rembrandt printed several impressions on his newly obtained Japanese paper. Tending toward golden and brownish tones, the paper varied in color more than typical European printing papers. It also varied in thickness, often having layers laminated together to give the paper extra body. Its smooth surface allowed the ink to bleed just a bit, causing closely placed lines to fuse together into areas of modulated tone. Rembrandt was apparently quite pleased with the result and went on to make Japanese paper his hallmark.[54]

After 1647, Rembrandt printed at least some impressions of each new plate on Japanese paper, which carried connotations of luxury and rarity for collectors. Moreover, the paper gave Rembrandt new variables, such as color and texture, with which to inflect his art. Numerous impressions on Japanese paper are featured in the present catalogue. The two impressions of *Christ*

Preaching (nos. 136 and 137) show the difference between impressions on European and Japanese paper. The one on European paper is sharp, with high contrast and a remarkable sense of space. That on Japanese paper is soft, muted, and full of moody atmosphere. They are both early impressions of remarkably high quality, yet different as vanilla and chocolate.

Japanese paper seems to have awakened Rembrandt to the artistic value of varying his supports. In 1647 or shortly thereafter, he tried materials that further broadened the range of color, luminosity, and texture of his prints. Over the next decade, he printed a few impressions of about ten plates on so-called "oatmeal" or "cartridge" paper, a sturdy, brownish European packing paper, made from the dense fibers that settled to the bottom of the papermaker's vat.[55] The result was a somewhat grainy, muted appearance. Impressions of *St. Jerome Reading in an Italian Landscape* on white paper tend to give the appearance of a hot sunny day, but those printed on oatmeal paper make the weather seem cool and overcast (no. 148).

More frequently—for some twenty plates—he used vellum, the sturdy polished skin of a lamb, kid, or calf familiar from old documents and illuminated manuscripts.[56] Its smooth white surface produced luminous impressions. The print most closely identified with Rembrandt's use of vellum is *Christ Crucified between Two Thieves* ("The Three Crosses," nos. 168–170)—fourteen of the nineteen known impressions of the first state are on vellum.[57] Included here is a rare and dramatic second-state impression on vellum (no. 169). The varied coloristic effects imparted by vellum are visible in one of the two second-state impressions of *The Entombment* (no. 156), for which Rembrandt wiped the plate more cleanly and evenly than he did for the impression on paper (no. 157). Unfortunately, few impressions on vellum retain their original appearance, due to warping, shrinkage, and discoloration.

Inking the Plate

In the seventeenth century the emerging specialty craft of ink making was oriented toward letterpress printing for books rather than toward copper plate printing, so Rembrandt probably used ink that was made by one of his assistants. In its most elemental form, printing ink was made from a mixture of carbon and heated oil. The Dutch tended to use linseed oil and often added resins to increase the viscosity.[58] Ter Brugghen's 1616 recipe called for this combination and recommended the dregs of white wine as a good source of carbon. The

multi-step preparation required separate heating and refinement of the ingredients, then mixing them together by grinding.[59]

Rembrandt was fairly conservative with respect to ink. Though he was fascinated by the prints of Hercules Segers, he did not follow the older artist's practice of using colored inks. Segers printed his *Tobias and the Angel* (no. 114) in green. In other prints, he used various colors, sometimes more than one for a single impression. Rembrandt limited himself to black.

After the etching ground had been removed, ink was applied to the plate with a dauber and gradually worked down into the grooves and pits that formed the image. During application, the plate was warmed to allow the ink to flow more freely. When the recesses were filled, the surface would be wiped clean with a piece of cloth, care being exercised to ensure that the ink was not wiped out of the lines. A final surface cleaning might be done with the side of the hand. The ink was usually stiff so that it would remain in the recesses when the plate surface was wiped.

Early on, Rembrandt mastered this procedure and went on to follow it fairly closely when printing impressions meant for distribution. But as usual, over time, his propensity for impatience and innovation emerged. Sometimes he would not wipe his plates completely clean. The first impressions printed from his early plates often have an overall grayish cast (see, for example, *Beggar in a High Cap, Leaning on a Stick*, no. 23). He seems not to have bothered to remove all of the ink from the surface of the plate when he simply wanted to check his progress on the image.

Throughout the 1630s and the first half of the 1640s, he or his assistants appear to have made a practice of wiping the plates clean to produce standardized prints of a high quality. Some plates, however, were so closely worked that they did not lend themselves to perfectly clean wiping. The differences between closely worked areas and more open spaces may be seen in the highly effective impression of his *St. Jerome (in a dark chamber)* of 1642 illustrated in this volume (no. 146). It has a considerable amount of ink in the minute spaces between the lines, but wherever larger, open spaces punctuate the network of lines, the plate surface is clean. The tiny white highlights on Jerome's coat are just large enough to have permitted the ink to be wiped away from the surface, but nearby, the extremely fine mesh of lines remains covered with a thin layer of ink.

About 1647—the same time that he started to expand beyond European paper to use Japanese paper and vellum—Rembrandt made a remarkable, purposeful change in his approach to printing: instead of wiping his plates nearly clean, he began to leave pronounced films of ink on the surface. This practice differs from the closely worked *St. Jerome (in a dark chamber)* in that he now left ink on relatively broad areas of smooth polished copper. Moreover, he could produce tonal effects by selectively wiping parts of the plate cleaner than others.[60] While earlier artists had used selective wiping, none did so as frequently and dramatically as Rembrandt.[61] In printing some impressions of *The Entombment* (no. 157), he nearly snuffed out the entire image with a dark film of ink, leaving only a small highlight to suggest the presence of an unseen lamp glowing softly behind one of the mourners. We can imagine the small arcing movement of his thumb as he picked out the clean spot.

Often Rembrandt's selective wiping was more complex than that of *The Entombment*. In the impression of *St. Francis Praying beneath a Tree* illustrated here as catalogue number 149, he provided extra guidance for our eyes and increased the mystery of the saint's experience by varying the thickness of the ink on the plate surface. A heavy film of ink blankets Francis's lower body, while his head and shoulder are more cleanly wiped and thus more brightly illuminated. Ink darkens the body of Christ on the crucifix except along its edge as though it is just catching the light of the breaking day. Any collector fortunate enough to possess this sheet knew full well that Rembrandt had thought carefully about this very impression and could imagine the artist's hands caressing the plate as he worked to draw out the full beauty of the image.

For other images, Rembrandt purposefully left a veil of ink on the plate but did not wipe it so specifically as he did *The Entombment* and *St. Francis*. A thin layer of ink added atmosphere and increased the play of subtle light by its slight modulations. Printed with a film of tone on warm-colored Japanese paper, the impression of *David in Prayer* in this volume as catalogue number 160 is remarkably evocative of the musician king's spiritual transport. The muted effect produced by this tonal veil is quite different from the more common, highly contrasted, and cleanly wiped impressions on white European paper. Christ's apprehension on the eve of his crucifixion is similarly heightened by the deep tones of *The Agony in the Garden* (no. 167), for which Rembrandt left a considerable amount of ink on the plate surface. The variations in density here, however, are not due to selective wiping. Instead they result from variation in the density of the drypoint burr. By controlling the pressure exerted by his hand as he wiped

the plate, Rembrandt dragged the full charge of ink held by any individual burred line onto nearby parts of the image.

In his large plates of the 1650s, Rembrandt often used selective wiping, to orchestrate broad areas of tone as well as for specific visual metaphors. In preparing to print catalogue number 168, a second-state impression of "The Three Crosses," he greatly varied the density of ink on the surface of the plate while avoiding abrupt and obvious transitions. He left a thick film around the plate's periphery, except at the upper center where he cleaned off a little more ink to enhance the sensation of light coming from above. He also wiped the central part of the image cleaner. A pool of light surrounds the kneeling centurion, an expression of the soldier's recognition of Christ's divinity. Christ's body is the most cleanly wiped area of the image, but Rembrandt left a slight film of ink to keep the highlight from breaking the somber mood. The expressive use of tonality is quite evident if one compares the dark tone of the crucified thieves to the illuminated body of Christ.

Awareness of Our Presence

Already by the early 1630s, Rembrandt seems to have recognized an audience that wanted to look over his shoulder. Over the years he developed new ways to cater to their desire. Sporadically at first and later quite regularly, Rembrandt printed unusually large numbers of impressions of his proof states, apparently with the intent of sharing them with collectors.[62] That same purpose may have inspired his decision in 1634 to cut down the plate of his theatrical quasi-self-portrait as an oriental potentate to a rather rough oval (compare no. 28 and fig. 51), for he printed many extra proof impressions before filing the edges down smooth. In 1635, he also printed numerous impressions from the half-finished plate of his fantasy portrait of Saskia as a biblical heroine (no. 61). Printing extra proofs would become a frequent practice in the late 1640s that would last through the 1650s.

In addition, we know that in 1636 Rembrandt began printing his sketch plates in greater numbers than he had in the period from 1630 to 1632. In 1636 and 1637 he made the three plates showing Saskia and other women in seemingly intimate poses arranged in informal compositions (for example, no. 60). These were followed by sketch plates showing a greater variety of subjects in even more casual compositions (see, for example, nos. 27, 104).

By the late 1630s, the concept of observing the artist's thought process may have been a subject of conversation among the collecting elite. In 1637, Franciscus Junius' scholarly work on classical art, *De Pictura Vetterum* (The Painting of the Ancients) was published in Amsterdam.[63] Based on ancient texts, this commentary was probably the most important discussion of art history since the 1624 re-issue of Van Mander's account of the lives of the great northern European artists.[64] Junius cited a telling passage from Pliny (XXXV.40.145):

> It is a rare thing and worthy of note that the final works of artists, their unfinished paintings . . . are held in higher admiration than their finished works, for in them the line drawings are left exposed and the plans of the artists can be seen. . . .[65]

Junius also dwelled at some length on the belief that Apelles was considered the greatest painter of antiquity, not because he was the most meticulous (there the laurels belonged to Protogenes), but because he knew when to stop.[66] Shortly after the book appeared Rembrandt invited art lovers into his atelier to watch him work when he created his most dramatically unfinished print, *The Artist Drawing from a Model* (no. 85). In his *Death of the Virgin* of 1639 (no. 70), he also left in plain view his discarded first thoughts for the configuration of the stage and the shape of the bed canopy.[67]

Throughout his career, Rembrandt unmistakably displayed both spontaneous creativity and meticulous perfectionism. After Junius' work appeared, this duality became even more pronounced. The *Artist Drawing from a Model*, with its abrupt transition between highly finished and barely outlined forms, contains both impulses, as does *The Triumph of Mordecai* (no. 108), with its gradual transition between the two. In 1642, he made both the sketchy *Descent from the Cross* (no. 42) and the closely worked *St. Jerome* (in a dark chamber; no. 146).

A great surge of innovation occured in the later 1640s. In portraits such as that of *Jan Six* (no. 74) and *Jan Asselijn* (no. 87), as well as in his unparalleled "The Hundred Guilder Print" (no. 135), Rembrandt tested several new ideas. In *Jan Six*, he took the illusion of light, space, and texture to levels never before achieved in etching. In "The Hundred Guilder Print," he appears to have repeatedly scraped and reworked the image, and in *Jan Asselijn*, he for the first time scraped away a major compositional element—the easel and painting—from one of his plates and left the area blank except for the roughened texture of the copper. In printing these plates, Rembrandt began to use the variety of papers that distinguished his later work. He printed all three on both European and Japanese paper. He also tried oatmeal paper and vellum for *Jan Asselijn*, and perhaps

Fig. 51. *Self-Portrait (with plumed cap and lowered sabre)*, 1634, etching, B. 23, II (oval state), 13 × 10.8 cm (5⅛ × 4¼ in.), Rijksmuseum, Amsterdam.

silk for "The Hundred Guilder Print."[68] *Jan Asselijn* and "The Hundred Guilder Print" are also among the first prints in which Rembrandt explored plate tone and selective wiping.

One wonders why at this stage Rembrandt began to change so many variables, in essence to begin to make nonstandard impressions. Although there is certainly no accounting for the innate creativity of a great artist, several factors, including his milieu, the awareness of new materials, and the practical experience of his own ongoing printmaking activity, may have come together to spark Rembrandt's imagination. With respect to the sitters for the portraits, Six and Asselijn were artistically minded—Six the poet-playwright and Asselijn the painter—and such patrons may have been sympathetic to Rembrandt's innovative risk-taking.

The availability of Japanese paper appears to have stimulated Rembrandt's renewed interest in the materiality of printmaking. His delight in the effect of the inking may have played a role in his decision to scrape clear the background of the Asselijn portrait to give his new interest an open field of play. Rembrandt's self-critical approach to "The Hundred Guilder Print" led him to rethink and rework the composition while working on the plate. His process of rethinking may have extended beyond the completion of the plate, perhaps heightening his interest in varying his papers and his inking.

Yet another factor that may have spurred Rembrandt's late 1640s departure from standardized printing was Bosse's 1645 treatise on printmaking. Rembrandt's practice often differed from Bosse's recommendations. One wonders if he might not have pointedly rejected formulaic notions of printmaking that Bosse proliferated (see fig. 52).

The climax of Rembrandt's printmaking career was his reinvention of the two large plates from the period 1653–55, *Christ Presented to the People* (nos. 173, 174) and "The Three Crosses" (nos. 168–170). They are executed completely in drypoint, an unusual choice for very large plates because the time invested in working them up would yield relatively few impressions before the burr wore away. Yet, drypoint gave Rembrandt's clients the most direct and tactile expression of his hand. He chose special supports, Japanese paper for *Christ Presented* and vellum for "The Three Crosses," and he printed many impressions with elaborate selective inking. When the burr was spent he redrew each of them. Some of the changes were radical, such as the removal of the crowd in *Christ Presented* and the violent slashing drypoint in "The Three Crosses."

Rembrandt thus presented his clients with impressions from the reworked plates that were in no way inferior to the first round of proofs, and he demonstrated his ability to create multiple interpretations of superb quality—technically, artistically, and spiritually. The impressions printed from these transformed, monumental plates laid down a serious artistic challenge, for they carried Rembrandt's work ever further from conventional norms of beauty and craftsmanship. The decision to work on a copper surface deeply rutted with the traces of his initial conception underscored his power to destroy as well as to create. He asserted full control of his art, pointing the way to both methods of and attitudes toward expression that would find full acceptance only in the era of artists such as Kirchner, Picasso, and Pollock.

In 1718, Arnold Houbraken cast a skeptical eye on Rembrandt's sale of variant states, criticizing as commercially driven "the device of light alterations or small and slight additions which he made in his prints, through which they were sold again as new."[69] He went on to mock those collectors whom he believed to have been duped by Rembrandt's tactics:

Indeed the desire was at that time so great that people were not held to be proper connoisseurs at all who did not have the little Juno with and without the crown [no. 158], the little Joseph with the white and the brown head [no. 52], and other of the same kind. Indeed, every one must have the *Woman by the stove* [no. 198], although one of his slightest, with and without the white cap and with and without the stove-key, which he allowed to be sold by his son Titus (as though too slight for him).[70]

Houbraken also thought that Rembrandt's habit of leaving artworks seemingly unfinished indicated a character flaw.[71] While he recognized that the great variety of expressions, poses, and costumes in Rembrandt's many preparatory sketches demonstrated the superiority of his creative powers,[72] Houbraken seems to have been unable to accept the open revelation of Rembrandt's creative processes in works meant for sale to collectors. Rembrandt and those contemporaries who sought his etchings apparently felt unconstrained by such rigid ideas about what art was ready for public consumption. Instead, the artist and his eager patrons relished negotiating new ways to satisfy the timeless desire to witness the process of artistic creation.

Fig. 52. Abraham Bosse, plate 8 from *Traicté des manieres graver en taille douce sur l'airin*, 1645, illustrated book, 13.3 × 8.2 cm (5¼ × 3¼ in.), Museum of Fine Arts, Boston, Gift of Sylvester R. Koehler.

NOTES

1. Van Mander [1604] 1973, fol. 285[v].

2. The classic study of Rembrandt's printmaking methods is White 1969. All later studies of Rembrandt's printmaking, including the present one,

owe White a great debt. White 1969, 7–8, draws the analogy between Clouzot's film and Rembrandt's states.

3. Seventeenth-century authors repeatedly commented on the accessibility of the technique of etching; see Ackley *Printmaking* 1981, xxi.

4. Van Gelder 1939 transcribes the available guides and discusses evidence of some that are no longer known.

5. Ter Brugghen 1616. The final three pages (fol. 25r–26r) contain etching recipes.

6. Bosse 1645.

7. Erik Hinterding traces the movement and use of the plates after they left Rembrandt's hands. He also catalogues nearly all of the surviving plates, giving their dimensions, weight, and an assessment of their present condition; see Hinterding *Copperplates* 1995.

8. Hinterding *Copperplates* 1995, 9–10.

9. He used the back of the plate for *The Return of the Prodigal Son* (B. 91). Such recycling was apparently not unusual. Like Rembrandt, Adrian van Ostade reused plates that had illustrated a mathematical text (B. 12, 25, 36, and 39). See Christie's Amsterdam sales catalogue for November 13, 1995.

10. The self-portrait is B. 5.

11. This notion is reinforced by the deep, irregular scoring on B. 366, as well as by the uncontrolled corrosion on B. 363.

12. Hinterding *Copperplates* 1995, 35–39. Humber owned seventy-seven Rembrandt plates. The count is sometimes confused by the presence of two other plates that historically have been grouped with the authentic Rembrandt plates. Bartsch catalogued both as being by Rembrandt, but now one is attributed to Ferdinand Bol (B. 295) and the other is considered the work of an unidentified student of Rembrandt (B. 344). Three other scattered plates have long been known: B. 281, 285, and 286.

13. Christie's London sold the plate on June 26, 1997, after discovering it in an English private collection. The plate is now in the collection of the National Gallery of Art, Washington.

14. He could also start with an eccentric composition and later cut the plate down so that no one would ever suspect that it had once been asymmetrical (see *Sleeping Puppy*, no. 55).

15. The *Sheet of Studies with Men's Heads* (B. 366) was cut into five separate plates. Other small prints by Rembrandt may have had similar beginnings. A later and more orderly manifestation of this practice was the production of the four illustrations for *La Piedra Gloriosa* on a single plate (B. 36, see figs. 72, 73, p. 210).

16. Bosse 1645, 14–15.

17. Brown 1660, 33. Expoltum is naturally occurring asphalt or bitumen, which at the time came from France, Tirol, and southern Germany. Virgins Wax is probably newly made beeswax that is white in color. Mastic is a pale, yellow natural resin from the *Pistacia lentiscus* shrub that occurs in southern Europe and northern Africa.

18. My thanks to Peter Scott of the printmaking faculty of the School of the Museum of Fine Arts for working with me on testing the recipe.

19. Brown 1660, 27. Ceruse is white lead pigment.

20. As recommended by both Ter Brugghen 1616, fol. 25v (see also Van Gelder 1939, 117) and Bosse 1645, 16, and pl. 1, lower section.

21. *Diana at the Bath* (Ben. 21, London, British Museum) has a black chalk coating on the back and *Portrait of Cornelis Claesz. Anslo* (Ben. 758, London, British Museum) has an ochre coating. Both are indented on the outlines.

22. Van Hoogstraten 1678, 196. Münz 1952, 2: 14, and White 1999, 6–7, apparently accepted as fact Brown's assertion that Rembrandt used the double ground.

23. Bosse 1645, 15–17, and pl. 2.

24. Other examples include B. 291 and 310.

25. "strijckt het over uwe heete schoone Plaet/ so dun ende so effen alst u mogelick is/ ende om geheel ende fijn schoon werck to maken ...," in Ter Brugghen 1616, 25v (see also Van Gelder 1939, 117).

26. His choice of drypoint may indicate familiarity with the work of the fifteenth-century printmaker known as The Master of the Housebook (or The Master of the Amsterdam Cabinet). This late medieval artist explored the theme of youth and death. He was also the most prolific practitioner of drypoint before Rembrandt.

27. Bosse 1645, 30–31, and pl. 6.

28. Bosse 1645, 32–36, and pl. 8.

29. Münz 1952, 2: 14–15, 19–21.

30. Clifford Ackley, "Printmaking in the Age of Rembrandt: The Quest for Printed Tone," in Ackley *Printmaking* 1981, xix–xxvi.

31. See Ackley *Printmaking* 1981, xxv.

32. In the 1650s, Jan van de Velde IV made a portrait of Oliver Cromwell using what appears to have been a form of aquatint; see Hind 1921, 397–99. Van de Velde had no immediate followers and the process was reinvented about a century later.

33. The disastrous failure of the first plate attempted for the collaborative print *The Descent from the Cross* (B. 81, I) would have been another such learning experience.

34. Ackley *Printmaking* 1981, xxiii. Etched granular tone came to be known as "sulphur tint" after Rovinski 1890, vii and xxx, identified it as such. The term "sulphur tint" is still widely used even though a number of other suggestions have been put forth as to how Rembrandt made it. The most plausible alternatives to the corrosive paste method suggested here are techniques involving a porous ground that acid could penetrate. For a review of the literature on this topic, see Rassieur 2001, 74–75.

35. "Hy had ook een eige wyze van zyne geetste platen naderhant te bewerken en op te maken: 't geen hy zyne leerlingen nooit liet zien; 't is ook niet te bedenken op wat wyze 't zelve gedaan is; dus is die vinding (even als de wetenschap van het Glas te koleuren, gelyk het Dirk en Wouter Crabet van Gouda hebben gedaan) met den uitvinder ten grave gedaalt," in Houbraken 1718–21, 1: 271. Translation based on Münz 1952, 2: 214, with corrections by Egbert Haverkamp-Begemann.

36. "Men ondekt ook aan het portretje van Sylvius, dat het op gelyke wyze eerst ruuw geetst is, de teedere tintelschaduwe en kragt daar naderhand is ingebragt, en zoo eel en zagt gehandelt, als door de schraapkonst kan gedaan worden," in Houbraken 1718–21, 1: 271. Translation based on Münz 1952, 2: 214, with corrections by Egbert Haverkamp-Begemann.

37. Ackley *Printmaking* 1981, xxiii, 150–51. In 1633, Rembrandt etched a portrait of Sylvius (B. 266), but Houbraken's remarks make much more sense when related to the 1646 portrait.

38. In printing some impressions Rembrandt left a film of tone that muted the hand and the standing figure, but in the clean-wiped impressions the distribution of light described here holds true. Rembrandt's practice of leaving extra ink on the plate for some impressions of his prints is discussed below.

39. For a description of a newly discovered proof state of *The Triumph of Mordecai*, see the Exhibition List, no. 108.

410. *Docs.* 1979, 1637/2, entry for 16 March. Hinterding diss. 2001, 44–45, suggests the lot contained one to three reams, roughly 500 to 1,500 sheets.

41. An exception is a large purchase of paper with a "Basilisk" watermark that Rembrandt used about 1640–41. This purchase and the attendant increase in Rembrandt's production of prints may have resulted from his purchase of an expensive house in 1639 and the decline in his production of paintings shortly thereafter; see Hinterding diss. 2001, 100–102, 160.

42. The analysis of the paper used for his prints is one of the most ac-

tive fields in Rembrandt research. Evidence about Rembrandt's European paper is based on analysis of watermarks. In 1981, American researchers began to gather a large sampling of the watermarks using beta-radiography, an accurate but slow technique; see Ash and Fletcher 1998, 11, 28. In 1988, Dutch researchers developed a much faster method of recording watermarks using low-power x-rays; see Laurentius 1996, 43. By 2001, the number of Rembrandt prints examined had reached some six thousand. Of these, some two thousand were found to have watermarks, over 1,700 of which were identifiable. Hinterding catalogued 640 different marks; see Hinterding diss. 2001, 38. Rembrandt prints often have no watermark because they are small enough to have been printed on fragments cut from larger sheets of paper, and a typical watermark covers only a fraction of the full sheet. The margins have also been trimmed from many impressions, resulting in further loss of watermark evidence. For a detailed discussion on the formats and division of paper, see Hinterding diss. 2001, 21–28.

43. Hinterding diss. 2001, 44–58.

44. About 1639 when he bought his large house and again in the early 1650s when he was in danger of losing it, Rembrandt bought paper in larger quantities and increased his production; see Hinterding diss. 2001, 14, 100–102, 123–26, 139. On Rembrandt's financial problems, see Crenshaw 2000.

45. Hinterding diss. 2001, 104.

46. Ibid., 126–27.

47. The plates did not appear in the 1656 bankruptcy inventory of Rembrandt's possessions. Hinterding once suggested that Rembrandt deviously hid the plates by placing them in someone else's care or by pawning them (Hinterding *Copperplates* 1995, 12) but later considered the possibility that he simply sold them (Hinterding diss. 2001, 142–44).

48. Watermark evidence suggests that De Jonghe printed and perhaps owned even more Rembrandt copper plates than appeared in the 1679 inventory of his estate; see Hofstede de Groot *Urkunden* 1906, 406–410; and Hinterding diss. 2001, 139–46.

49. Hinterding diss. 2001, 149–50.

50. For a preliminary list of posthumous states, see Hinterding diss. 2001, 511, appendix 5.

51. Biörklund and Barnard 1968, no. 41-G, lists three states as being by Rembrandt. White and Boon 1969, no. 43, lists four states before listing later publishers.

52. Hinterding diss. 2001, 114, note 335.

53. Rembrandt also made a print that served as a frontispiece for the publication of *Medea* (see no. 138).

54. When Rembrandt's Asian paper is thin and white or pale yellow it is sometimes referred to as "Chinese" paper. This may be a misnomer for a paper made in Japan but intended to resemble Chinese calligraphy paper; see Hinterding diss. 2001, 113. Van Breda 1997, 25–38, suggests that "Chinese" paper was made of bamboo and soft mitsumata fibers as opposed to the tough, lustrous gampi fibers used in the paper typically identified as Japanese. Whether Rembrandt distinguished between Japanese and "Chinese" paper, we do not know.

55. B. 104, 141, 218, 235, 237, 270, 272, 276, 277, 316. For the most part, he used oatmeal paper while his plates were still new, but in a couple of

cases scraps may have been used to print small plates from his youth (B. 141, 316). Despite its coarse appearance, oatmeal paper cost more than regular white paper; see Hinterding diss. 2001, 112. Early sources also speak of "Indian" (short for East Indian) paper, which is sometimes associated with yellowish paper containing scattered clusters of coarse fibers. Unfortunately, "Indian" paper is difficult to define, and some paper identified as such has proven to be a yellowish variant of European oatmeal paper; see Hinterding diss. 2001, 113, note 334.

56. B. 35, 36, 56, 69, 70, 76, 78, 86, 107, 111, 199, 200, 273, 274, 275, 276, 277, 282, 283, 304. As with oatmeal paper, he generally used vellum while his plates were still fresh, except for the reprinting of a few early efforts (B. 69, 111, 304).

57. Hinterding diss. 2001, 127–28.

58. Bloy 1967, 13–15. The French, typified by Bosse, tended to use walnut oil without the admixture of resins.

59. Ter Brugghen 1616, 25v–26r (see also Van Gelder 1939, 117–118). Ink containing lampblack (actually collected by hanging sheep skins over a fire built of resinous wood) was preferred for relief printing from woodblock prints. Lampblack is light and wooly. The heavier, grittier structure of the carbon from wine dregs allows for cleaner wiping of the plate; see Bloy 1967, 46.

60. The portrait of Jan Asselyn (no. 87), about 1647, is among the first plates in which Rembrandt used selective wiping.

61. Notably Albrecht Dürer used selective wiping in the 1510s, especially in plates such as B. 26 and 37.

62. Hinterding diss. 2001, 14. Unfinished states from very early in his career are quite scarce, no more than four impressions of each are now known. The pattern changes with his highly finished 1633 biblical print, *The Good Samaritan* (B. 90).

63. Junius 1991, 1: xiv.

64. Van Mander [1604] 1994–99, 3–4.

65. Junius 1991, 2: 44. See also 1: 164.

66. Junius 1991, 1: 287–89.

67. In 1639, Rembrandt also engaged in one of his less frequently used methods of offering a glimpse into his creative process. He may have customized individual impressions of his bravura *Self-Portrait Leaning on a Stone Sill* (no. 81) by drawing on them. On at least four of the first-state impressions, he drew black chalk elaborations, most notably of the architectural surroundings; yet, his further work on the plate was limited to small changes to the hat and hair. Early in his career, he had also added supplementary drawing to impressions of a self-portrait (B. 7).

68. White and Boon 1969, no. 74, records an impression of the second state on silk, but I have not been able to verify that it is an early impression.

69. Houbraken 1718–21, 1: 258 (English translation from Münz 1952, 2: 214).

70. Houbraken 1718–21, 1: 271 (English translation from Münz 1952, 2: 214).

71. Slive 1953, 180–83.

72. Slive 1953, 178.

Catalogue

The prints, drawings, and paintings are discussed in sixty-five thematic clusters. These clusters are arranged in an approximate chronological order. Works from different periods are, however, often grouped together in order to illuminate Rembrandt's changing conceptions of subject, style, and technique. Works are reproduced actual size unless otherwise indicated. With the exception of *Tobias and the Angel* (no. 114) by Hercules Segers, all works in the exhibition are by Rembrandt.

Titles are based on those of standard catalogues. The authors have sometimes revised the titles on the basis of subject matter.

Measurements are given in centimeters and inches, height before width. For prints, the measurements are those of the platemark (or the sheet if trimmed); for drawings, the size of the sheet; and for paintings the surface of the panel or canvas. Where precise measurements were unavailable, we have relied on published information.

Unless otherwise described, paper is European laid paper. Watermark information is based on Ash and Fletcher 1998 and Hinterding diss. 2001.

Both yellowish and white Asian papers are described here as Japanese (instead of "Chinese" to denote white Asian paper).

All Bible references come from *The Holy Bible Containing the Old and New Testaments: King James Version with Apocrypha*, ed. Robert Carroll and Stephen Prickett (Oxford: Oxford University Press, 1997), unless otherwise stated.

For all other bibliographic references, see References.

See Materials and Techniques for fuller information on technical terms relating to printmaking, drawing, and painting.

The authors are indicated by their initials following each entry:

CSA	Clifford S. Ackley
TER	Thomas E. Rassieur
SWR	Sue Welsh Reed
WWR	William W. Robinson

The identifying numbers for works in standard catalogues are abbreviated as listed below. Bartsch numbers are provided for prints, with an asterisk (*) to denote unpublished state changes (see Exhibition List). The drawings are referred to by Benesch numbers. Paintings are identified by Bredius numbers and, when available, Corpus numbers as well.

B. In reference to Rembrandt's prints: Adam Bartsch, *Catalogue raisonné de toutes les estampes qui forment l'oeuvre de Rembrandt et ceux de ses principaux imitateurs*, 2 vols. (Vienna: Blumauer, 1797).

In reference to prints by other artists: Adam Bartsch, *Le Peintre-graveur*, 21 vols. (Vienna, 1803–21).

Ben. Otto Benesch, *The Drawings of Rembrandt: Complete Edition in Six Volumes*, enlarged and ed. Eva Benesch (London: Phaidon Press, 1973).

Br. Abraham Bredius, *The Complete Edition of the Paintings of Rembrandt*, 3rd ed., ed. Horst Gerson (London: Phaidon Press, 1969).

Corpus Josua Bruyn, Bob Haak, Simon Levie, P. J. J. van Thiel, and Ernst van de Wetering, *A Corpus of Rembrandt Paintings*, 3 vols. (The Hague: Nijhoff Press, 1982–89).

Docs. Walter L. Strauss, and Marjon van der Meulen, eds., *The Rembrandt Documents* (New York: Abaris Books, 1979).

Holl. Hollstein, F. W. H., *Dutch and Flemish Etchings, Engravings, and Woodcuts, c. 1450–1700*, 58 vols. (Amsterdam: M. Hertzberger, 1949–87; Roosendaal: Koninklijke van Poll, 1988–94; Rotterdam: Sound and Vision, 1995–2001).

Holl. (German) Hollstein, F. W. H., *German Engravings, Etchings, and Woodcuts, c. 1450–1700*, 62 vols. to date (Amsterdam: M. Hertzberger 1954–87; Roosendaal: Koninklijke van Poll, 1988–94; Rotterdam: Sound and Vision, 1995–).

New Holl. The New Hollstein Dutch and Flemish Etchings, Engravings, and Woodcuts, 1450–1700, 12 vols. to date (Roosendaal: Koninklijke van Poll in cooperation with the Rijksprentenkabinet, Rijksmuseum, Amsterdam, 1993–94; Rotterdam: Sound and Vision in cooperation with the Rijksprentenkabinet, Rijksmuseum, Amsterdam, 1996–).

New Holl. (German) The New Hollstein German Engravings, Etchings, and Woodcuts, 1400–1700, 4 vols. to date (Rotterdam: Sound and Vision, 1996–).

1–3

The Presentation in the Temple

THREE DECADES

Over time, Rembrandt returned obsessively to certain biblical narratives, conceiving anew their format, setting, patterns of illumination, and expressive meaning. The three etched versions of *The Presentation in the Temple*, dating from 1630 (no. 1), 1639–41 (no. 2), and about 1654 (no. 3) are classic examples of such variations on a theme. The evangelist Luke (Luke 2:22–39) tells how Christ's parents brought the newborn child to the temple to be presented to the priest, God's representative. Jewish religious law required that first-born sons be brought to the Lord's temple thirty days after birth.[1] Luke relates that in Jerusalem there was an inspired holy man, Simeon, who had a revelation from the Holy Spirit that he would not die until he had seen the Messiah. Simeon is directed by the Holy Spirit to visit the Temple, where he intercepts Christ's parents, takes the child in his arms and offers up a song of praise to the Lord, stating that he can now depart in peace because "mine eyes have seen thy salvation." Simultaneously a pious elderly prophetess, Anna, happens upon the scene and shares in Simeon's moment of revelation.

The earliest etched *Presentation* is one of three highly finished, miniaturistic compositions dealing with episodes from the childhood of Christ, dated or datable in style and format to 1630 (see nos. 36–38). The interior is divided between an open, brightly lit space on the left and the crowded scene to the right of center, behind which a shadowy staircase leads upward to the high priest's throne in the depths of the temple. The principal figures are dramatically lit from the side but are very small in scale, and there are a number of lively visual incidents that draw the eye away from them. In the left middle distance, for example, a young girl stares curiously at the viewer. Even more surprisingly, at the far left the dark silhouette of a crippled beggar vanishes off the edge of the plate. Under these distracting circumstances, it is understandable that Rembrandt resorted to the rather obvious device of an angel who leans over Anna's shoulder and points in order to direct her attention (and ours) to the central event. The prominent beggar, one of a host of beggars and street people Rembrandt drew and etched in the later 1620s and early 1630s (see nos. 22–27) may in fact be an oblique allusion to Christ's future ministry to and healing of the poor and the sick. The focus here is not on Simeon's prayer of thanksgiving, but rather on a moment in Luke's narrative in which Simeon directly addresses Mary, the mother of Christ, predicting that

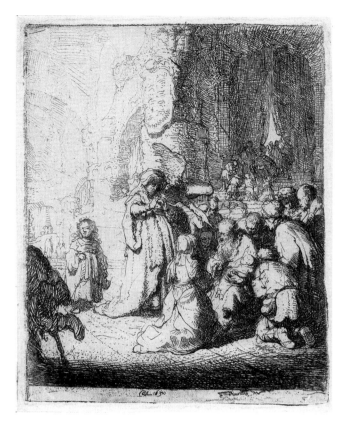

1

The Presentation in the Temple, 1630
Etching
B. 51, II
10.2 × 7.8 cm (4 × 3 1/16 in.)
Museum of Fine Arts, Boston
Katherine E. Bullard Fund in memory of Francis Bullard

her child will be the cause of much turmoil in Israel and that a "sword" will pierce her soul. An early Rembrandt painting in the Kunsthalle, Hamburg (about 1627–28), illustrates this same moment in the narrative and makes equally dramatic use of raking lighting and silhouette.[2]

In the second and undated etched *Presentation* of 1639–41 (no. 2), the image is not only much larger, but the principal figures are themselves larger in scale in relation to the space of the temple, and they are positioned closer to the viewer on the right-hand side of a raised, stage-like platform. As in many of Rembrandt's etchings of about 1639–41, the etched line is quite fine, and the prevailing tonality is a light middle gray. The shadowy depths of the temple are rendered by transparent webs of delicate cross-hatching. The interior is thronged with figures elaborately costumed in variations on the exotic garb Rembrandt invented to evoke the ancient Near East of the Bible. The arrangement of the principal figures is friezelike and defines the space of the horizontal composition, while the architecture itself is relatively vague and indeterminate. Diagonal rays of divine light focus our attention on Simeon holding the child while two doves of the Holy Spirit hover like an aureole above Anna's head.

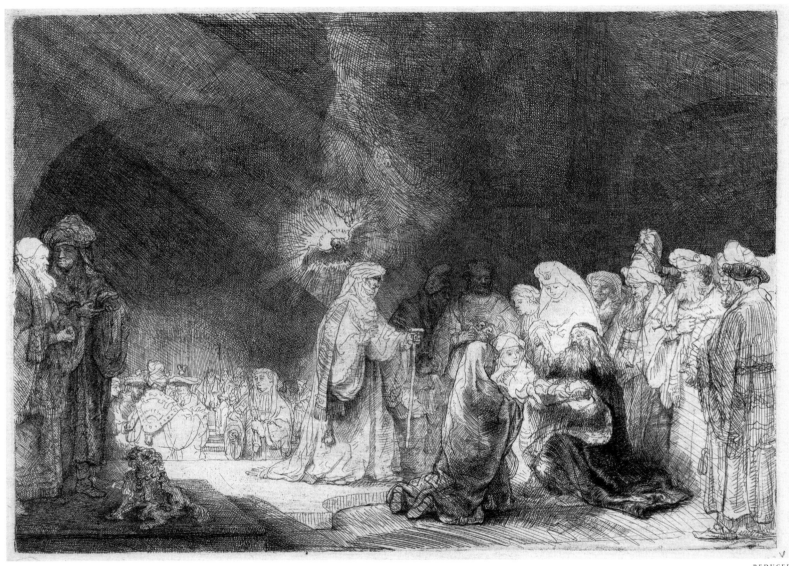

2

The Presentation in the Temple,
1639–41
Etching and drypoint
B. 49, II
21.2 × 29 cm (8⅜ × 11⁷⁄₁₆ in.)
Museum of Fine Arts, Boston
Katherine E. Bullard Fund in
memory of Francis Bullard

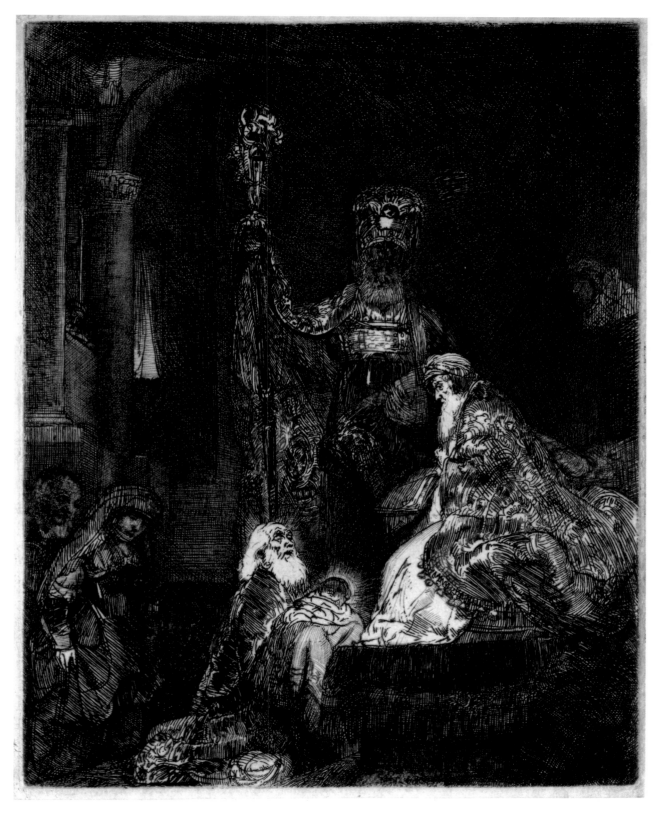

The Presentation in the Temple
(in the dark manner), 1654
Etching, drypoint, and engraving
B. 50, only state
21 × 16.2 cm (8¼ × 6⅜ in.)
National Gallery of Art,
Washington
Rosenwald Collection

As in the etching of *The Death of the Virgin* (no. 70) of 1639 or the celebrated etching of Christ preaching and healing, "The Hundred Guilder" print of the late 1640s (no. 135), some figures or parts of figures are only sketched in outline while others are more fully modeled and detailed. Rembrandt uses these degrees of finish to help us to better focus on the central event. In the first state or stage in the evolution of the plate, the figure of Simeon was relatively light in tone and he had no head covering. He was upstaged by the rich accents of dark drypoint on the figure of Joseph, who stands behind the kneeling figure of Mary and holds an offering of sacrificial doves above her head, echoing the doves of the Holy Spirit that hover above Anna. In the second and completed state seen here, Simeon's robe has been darkened and he wears a dark skullcap. Mary's figure has also been given increased visual weight by added etched work, while Joseph's figure has been lightened by the removal of drypoint burr. There is no longer any possible confusion as to where the center of spiritual meaning is located.

The third etched version of *The Presentation* (no. 3), traditionally and very appropriately described as "in the dark manner," is part of a group of four Life or Passion of Christ subjects of similar dimensions and vertical format, of which two are dated 1654 (see nos. 158–159). Here Simeon's prayer of thanksgiving is literally the center of things. In the immediate foreground Simeon, eyes closed in prayer, kneels before the seated high priest with the infant in his arms. Subordinated to the sideline shadows, Christ's parents incline their heads reverently at left, while Anna is now a vague silhouette peering down from the upper right. Simeon has removed his turban, and his head and white beard are the brightest accents in the enveloping darkness. The standing priest's ornate staff—like a great exclamation mark directed at Simeon's head—leaves us in no doubt as to the holy man's pivotal

role in this moment of divine revelation. As in so many of Rembrandt's biblical etchings from the 1650s, darkness and light are the principal actors here. The child's face is veiled with shadow, emphasizing the glow of his halo, but perhaps also hinting at the sacrificial death to come. The space of the interior is characteristically shallow and compressed as it is in many Rembrandt compositions of the 1650s. The central figure group of the two sumptuously costumed priests and Simeon with the child is tightly locked together in a stable pyramid to which the dimly seen details of the temple's interior architecture are merely appendages. The shimmer of the rich fabrics of the two priests' ceremonial garb is suggested with an economical linear shorthand rather than meticulously described.

Recently it has been pointed out that the conception of the subject is highly unusual, unconventionally combining the episode of Simeon's personal moment of revelation with the officiating priests of the temple to whom the child would normally have been presented. The priests' solemn, meditative gazes are focused on Simeon and the child. This conception has been interpreted in the light of Rembrandt's friendship with his neighbor, the Sephardic Amsterdam rabbi Menasseh ben Israel, whose mystical treatise *La Piedra Gloriosa* (The Miraculous Stone) Rembrandt illustrated with etchings a year later (see figs. 72, 73; p. 210). Menasseh ben Israel, as well as certain Protestant ministers of the time, sought to bring about reconciliation between the traditionally opposed Judaic and Christian traditions.[3] CSA

NOTES

1. Zell 2000, 496–521.

2. Br. 535; Corpus A12.

3. Zell 2000, 496–521.

4–6

Christel at Emmaus

EARLY AND LATE

Two versions of *Christ at Emmaus* (also known as *The Supper at Emmaus*), etched twenty years apart, illuminate the kind of creative revisions Rembrandt made when he returned to the same New Testament subject many years later. Luke (Luke 24:13–35) relates how, after Christ's miraculous resurrection from the dead and the discovery of his empty tomb, he joined two of his disciples who were traveling to the village of Emmaus outside Jerusalem, but they did not recognize him. As night fell, the disciples invited the stranger to stay with them at an inn. During their shared meal, as Christ broke bread, they experienced a flash of sudden recognition, but he shortly thereafter "vanished out of their sight."

The small 1634 etching (no. 4) is anecdotal and informal in conception, almost a vignette from everyday life. At left a traveler's stick and satchel lie on the floor and at right a mangy, undernourished dog begs for scraps from the table, while one of the disciples slices meat. There is a sense of action interrupted: Christ grasps the loaf of bread vigorously, and, in an explosive burst of light, reveals himself to his followers' startled eyes. The patterns of light and shadow are stark and dramatic in their contrasts.

The *Emmaus* of twenty years later (no. 5) is larger in scale and is part of the group of four vertical Life of Christ etchings from 1654 (nos. 154–159). The mood is quieter, more solemn, and formal: Christ faces us, seated behind a table elevated like an altar on a raised platform, the still center of the composition. The bread is already broken and Christ holds out the two halves in a ritualistic gesture reminiscent of the Last Supper with his apostles shortly before his arrest and crucifixion. On that occasion he commanded them to eat and drink the bread and wine that represented his body and his blood, the origin of the rite of communion.

In the earlier print, Rembrandt included in the shadows of the background a servant or innkeeper that he covered over with heavy shading in order to suppress his figure. Here the aproned innkeeper descending the steps in the immediate foreground directs our attention toward Christ. Even a dog is present as before but now less conspicuous, discreetly tucked in behind the innkeeper. But in spite of these homely details associated with the real world, a mood of mystic revelation prevails. The curtain that divided the space of the inn in the earlier print has become a stately canopy that frames the

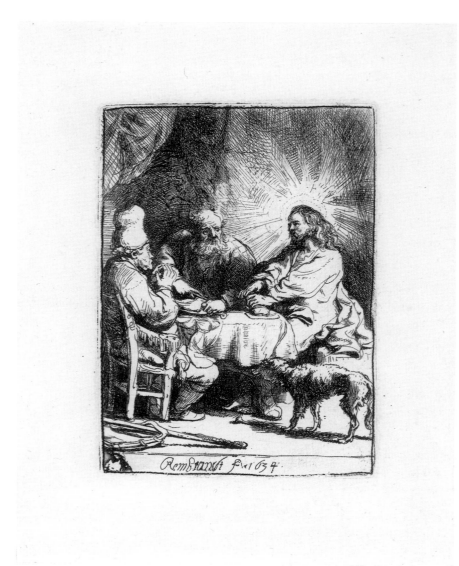

figure of Christ. It resembles a similar canopy that Rembrandt added to set off the figure of Christ in his free red chalk copy (Robert Lehman Collection, Metropolitan Museum of Art, New York) after an engraving of Leonardo's *Last Supper*.[1]

In the first state of the print seen here, the head and halo of Christ are lightly etched, ethereal, and insubstantial. We can readily believe that Christ is truly a spiritual being who is about to vanish away from his followers' sight. This feeling is enhanced by the image having been printed on a thin, pale, silken Japanese paper of a type that Rembrandt began to use in the later 1640s. A number of impressions of this state are printed on such paper. In the next state of the print, however,

4

Christ at Emmaus, 1634
Etching
B. 88, only state
10.2 × 7.4 cm (4 × 2^{15}/$_{16}$ in.)
Museum of Fine Arts, Boston
Katherine E. Bullard Fund in
memory of Francis Bullard

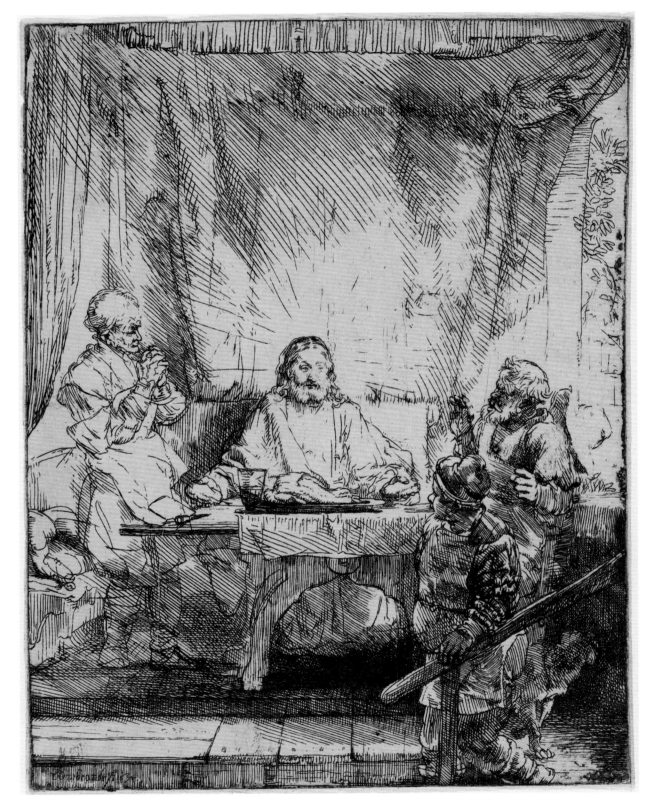

5
Christ at Emmaus, 1654
Etching on Japanese paper
B. 87, I
21 × 15.9 cm (8¼ × 6¼ in.)
Museum of Fine Arts, Boston
Gift of Mrs. Christopher
Tunnard in memory of W. G.
Russell Allen

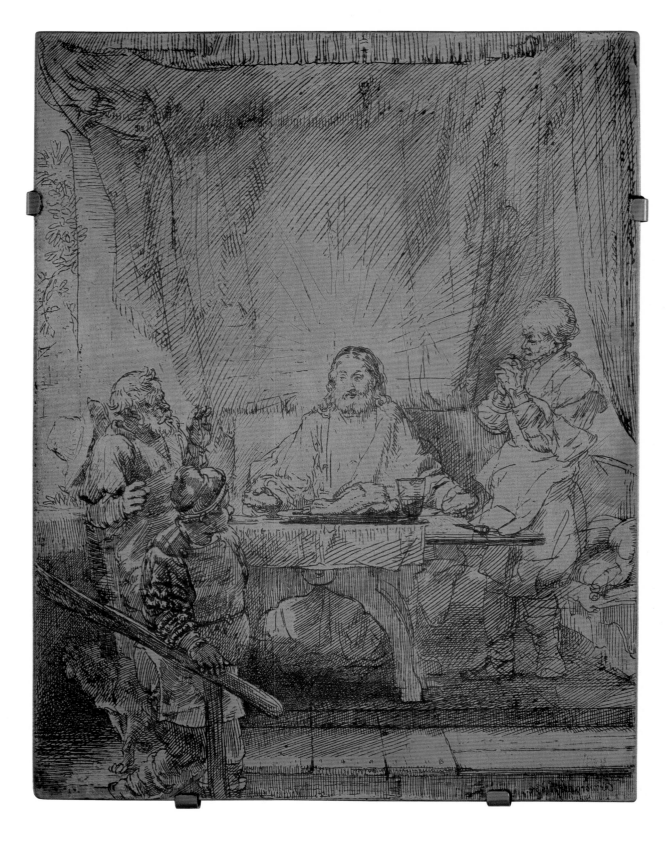

6

Christ at Emmaus, 1654
Copper etching plate
B. 87
21.3 × 16.3 cm (8⅜ × 6⁷⁄₁₆ in.)
The Art Institute of Chicago
The Clarence Buckingham
Collection

Rembrandt added significant work in drypoint that made the image more substantial and material rather than more spiritual and ethereal, completing the face of Christ and adding rays to his halo.

The copper plate for the 1654 *Emmaus* (no. 6) is one of the best preserved (least reworked) and most legible of the eighty-one surviving Rembrandt etching plates. Seventeenth-century printmakers and publishers had no concept of limited editions of prints, a relatively modern idea dating from the 1890s. Publishers reworked copper plates to give them longer lives, and thereby often distorted the artist's original intentions and meanings. A number of Rembrandt's plates left his hands in the second half of the 1650s in the wake of his bankruptcy proceedings. Erik Hinterding estimates that about 150 of Rembrandt's plates were in circulation and being reprinted by other hands in the late seventeenth century.[2] The juxtaposition here of copper printing plate and impression also reminds one of the inevitable reversal of the image that is such a challenge for the printmaker, who must visualize in advance the effect of the final printed image. CSA

NOTES

1. First half of the 1630s, Ben. 443. Reproduced in Liedtke et al. 1995, 2: 157, no. 56.

2. See Hinterding *Copperplates* 1995, 8.

7–10

Beginnings as an Etcher

1626–1628

By the time Rembrandt first dated his etching plates in 1628, he had already attained considerable technical competence. Although the source of his introduction to the alchemical mysteries of printmaking is not solidly documented, a plausible scenario is that, after brief contact with a professional print publisher's workshop, he then attempted to master the process on his own. He apparently took up etching about 1626 in Leiden after returning from his study with Pieter Lastman in Amsterdam. His excitement about this new outlet for his creativity radiates from the lines rapidly scrawled across the surface of his plates, but equally palpable is his frustration with the resulting prints. Among his first efforts are the four religious etchings seen here: *The Circumcision* (no. 7), *The Rest on the Flight into Egypt* (no. 8), *The Flight*

into Egypt (no. 9), and *Peter and John at the Gate of the Temple* (no. 10).[1] Religious subjects were not his exclusive interest at the time, but the relatively large scale of three of these etchings suggests that they held a special significance for him. Indeed they are the prelude to three decades of intense meditation on spiritual themes. He would return to each of these subjects—in some cases repeatedly—later in his career.

Three of these four prints show defects that testify to Rembrandt's inexperience—random scratches, bands of gritty etched specks, and unevenness in the printing. One however, *The Circumcision*, stands apart from the others. Despite the sketchy manner of drawing with the etching needle, this plate has a clean, finished appearance without noticeable technical flaws. An engraved borderline frames the image. Formal inscriptions identify Rembrandt as the etcher and Jan Pietersz. Berendrecht as the publisher. During his lifetime, Rembrandt's some 290 copper plates were rarely inscribed with a publisher's address.[2]

Berendrecht was an entrepreneurial Haarlem printer and publisher who encouraged painters to try their hand at etching.[3] The many changes seen in this third state of *The Circumcision* were apparently all made with an engraving tool by someone working for Berendrecht. In the working proof, first state (fig. 53), not only are the inscriptions and the borderlines absent, but the drawing on the plate also has a less finished appearance. The edges of the image are irregular, with intermittent blank areas. Some of the shadows, such as those on the rear wall to the left of the candle and the upper end of the stairway balustrade, are not yet as densely worked as they are in the completed third state. Details such as the sconce and the ceremonial staff are less emphatically defined. While the publisher may have seen the additions in the third state as enhancements, they tend to limit Rembrandt's original open rendering of space. They cause the background to press forward visually, crowding the central figure group.

Despite its shortcomings, *The Circumcision* reveals in the young Rembrandt the dynamic tension between explosive creativity and meticulous perfectionism that would energize his art throughout his career. Here, amid all the scrawling lines and loose rendering of details, he drew the central protagonists with focused economy. A few concise strokes fully describe the skilled hands of the officiating priest, or *mohel*. The child clenches his fists and knits his brow, responding to the pain but bearing it stoically.

Having received in Berendrecht's workshop his introduction to the art of etching, Rembrandt appears to have

Fig. 53. *The Circumcision*, 1626, etching, S. 398, I*, 21.4 × 16.2 cm (8⁷⁄₁₆ × 6³⁄₈ in.), Rijksmuseum, Amsterdam.

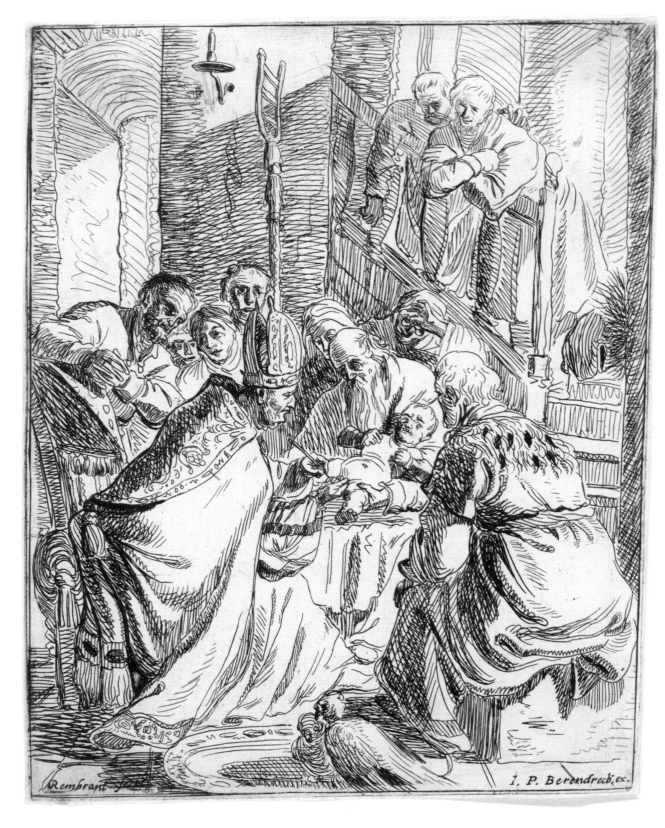

7
The Circumcision, 1626
Etching and engraving
S.398, III*
21.5 × 16.8 cm (8⁹⁄₁₆ × 6½ in.)
Courtesy of the Fogg Art
Museum, Harvard University
Art Museums, Cambridge,
Massachusetts
Gift of Belinda L. Randall from
the collection of John Witt
Randall

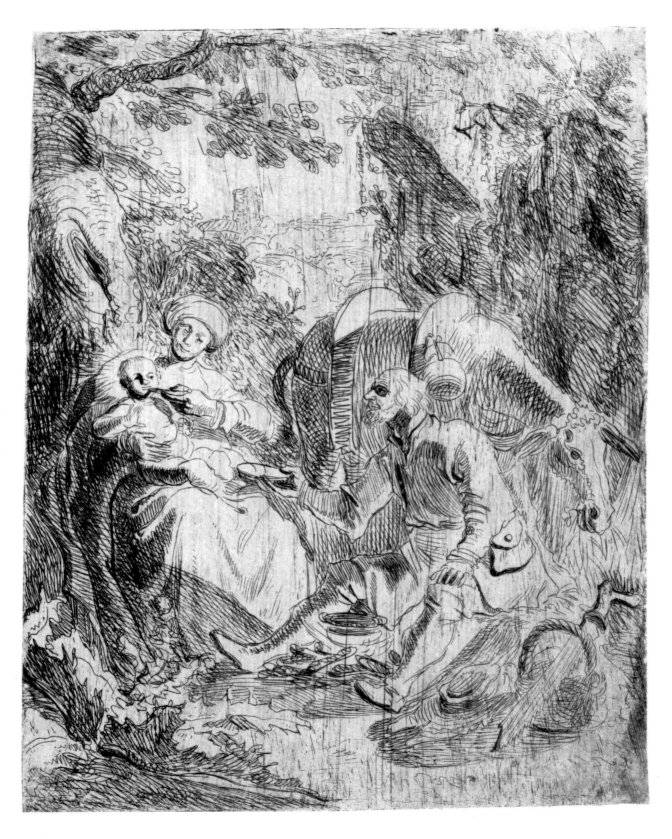

tried to duplicate the process on his own. In scale, style, and subject, *The Rest on the Flight into Egypt* (no. 8) is closely related to *The Circumcision,* and as such may well be Rembrandt's first independent etching.[4] Still groping his way toward an effective method of shading and modeling, he has expanded his repertoire of lines, squiggles, and hatching in order to convey the complex play of light required by his pictorial ambition. Again choosing a theme from the infancy of Christ, he shows the fleeing Holy Family enjoying a picnic rest stop in a shady glade. Joseph, his basket of carpentry tools by his side, holds out a bowl of food that he has warmed up on a small campfire. Mary spoon-feeds the radiant Christ child enthroned upon her lap.

When polishing the plate for *The Rest on the Flight into Egypt,* Rembrandt failed to exercise sufficient care. He left conspicuous scratches and pits in the copper.[5] These flaws retained ink and are clearly visible on the few impressions taken from the plate. No self-respecting professional printmaker would have tolerated such imperfection. Rembrandt then proceeded to make the most of a bad situation. He carefully burnished away many of the dense scratches on the mother and child, leaving the remaining scratches to cast a tone over the rest of the image. The resulting subtle sense of mystic illumination radiating from the child underscores his role as the "Light of the World." The scarcity of impressions—just three are known—suggests that Rembrandt resigned himself to the fact that the etching was not fit for wider circulation. Though he set the plate aside, Rembrandt's interest in this episode from Christ's early life resurfaced in the 1640s when he illustrated it in two etchings as well as a painting (nos. 110–112).

On a smaller plate he etched another image of the fleeing Holy Family, *The Flight into Egypt* (no. 9). Entering from the right, the travelers ascend a rise and veer around a massive gnarled tree. They pass from a light-filled landscape into a darker one. The resolute Joseph leads the way with Mary seated on the knobble-kneed donkey. Her face filled with apprehension, she holds the sleeping Christ child close in a protective embrace.

The broad bundles of zigzag lines record Rembrandt's furious scribbling with the etching needle. Some loose passages of engraved shading in the foreground supplement the etched lines. Nevertheless, as with *The Circumcision,* Rembrandt animated the central figures with telling details. Mary's maternal concern is indicated with great economy, and everything about the determined figure of Joseph, including his forward bent ear and pointed nose, propels him toward his goal.[6]

Rembrandt's sketchy handling of the needle in *The*

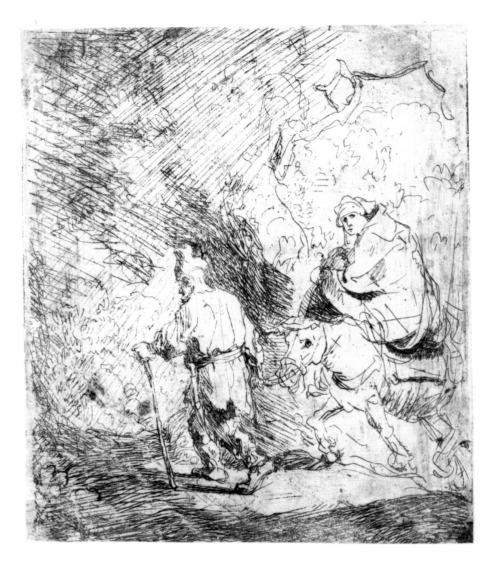

Flight into Egypt is less labored than in *The Circumcision* and *The Rest on the Flight into Egypt.* In the other two he appears to have attempted to organize the hatching that shades and models form, but here, flexible, unsystematic strokes of the needle enliven the figures. Though one can find a few scattered precedents for such informality of approach among Dutch etchers, Rembrandt was undoubtedly also aware of Italy's rich tradition of free and loosely handled etching.[7] Whether the stylistic echo of Italy was a conscious decision or whether it arose due to similarity of circumstance—painters trying out the unfamiliar medium of etching—is an open question.

The Flight into Egypt is known in only two impressions. Both of them are uneven in the printing. Rembrandt retouched one of them with pen and ink, presumably to plan improvements to the plate.[8] Whatever plans he had

9

The Flight into Egypt (a sketch), 1626
Etching and engraving
B. 54, I
Sheet: 14.6 × 12.2 cm (5¾ × 4¹³⁄₁₆ in.)
Rijksmuseum, Amsterdam

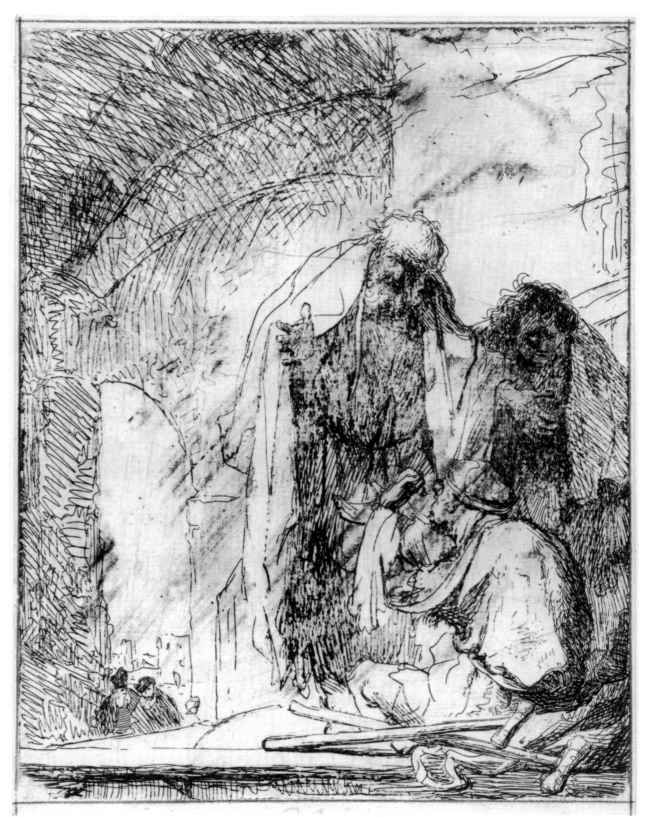

came to naught, for the next evidence we have of the plate is that he had cut it into pieces.[9] However, early failure did not deter Rembrandt, and *The Flight into Egypt* became a recurring theme throughout his career as an etcher.

Not all of Rembrandt's early religious prints focused on the infancy of Christ. *Peter and John at the Gate of the Temple* (no. 10) illustrates a passage from the Acts of the Apostles (Acts 3:1–8). A man lame with a congenital birth defect asked the apostles Peter and John for alms at the gate of the temple. Peter responded that he had no money but that he would give what he had. Invoking the name of Christ, he commanded the man to walk, and the crippled man found that his legs had been made strong.

Placing the temple threshold in the foreground, Rembrandt locates the viewer a step lower so that the apostles seem to loom above us and we identify more closely with the beggar's point of view. As would be the case in many of his prints, the action takes place on an elevated spot in the foreground, while the terrain drops away in the background.[10] Unfortunately the expressive impact of the figures and the grandeur of the space are nearly obliterated by the presence of distracting granular etched streaks. While drawing with his needle, Rembrandt appears to have made corrections to the cripple's sleeve and Peter's cloak, erasing misplaced lines with local application of supplementary dabs of wax or varnish on top of his original ground.[11] This added protection appears to have prevented the granular corrosion from pitting these areas, causing them to look like crude highlights.[12] Although Rembrandt evidently conceded defeat after pulling a few proofs (only four impressions are known), he learned from his mistakes and would later find ways to harness the effects that here seem to have occurred by accident (see "Looking over Rembrandt's Shoulder" essay).[13] He also returned to this subject toward the end of his career as an etcher (see no. 180, his last etching on a religious theme). TER

NOTES

1. Not all of these prints have always been recognized as part of Rembrandt's oeuvre, but most specialists have accepted them since the publication of White and Boon 1969. For a dissenting opinion, see Straten 2002, 167–77.

2. Hendrick Uylenburgh published one Rembrandt print, a collaboration, in the 1630s, *The Descent from the Cross* (B. 81, the second plate; see fig. 30, p. 33). Frans Carelse published the fifth state of B. 78, *Christ Crucified* ("The Three Crosses"), but whether this was in Rembrandt's lifetime remains unclear.

3. Wyckoff 1998, 139–93.

4. For the story of the Flight into Egypt, see nos. 109–115.

5. White 1999, 20, suggests that the scratches resulted from scraping to remove an earlier image from the copper.

6. Rembrandt may have borrowed the effective idea of showing Joseph from the back from a tiny woodcut in Albrecht Altdorfer's 1515 series, *The Fall and Redemption of Man* (B. 13). Münz 1952 2:91.

7. For a survey of Italian etching, see Reed and Wallace 1989. See also Orenstein 2001, 31–33. Orenstein also cites Italian etchers as an important precedent for Rembrandt's relaxed attitude toward the finish of his etchings.

8. Bibliothèque Nationale de France, Paris. He modified with pen and ink the mound at the lower right, the donkey's hind legs and right front hoof, Mary's turban, and the shading at the lower left. There is further retouching in gray wash, but it is not by Rembrandt.

9. He used one scrap of the copper to etch a small self-portrait (B. 5). The figure of Joseph was cut out and worked up as a single figure, but we do not know by whom.

10. Lucas van Leyden, whom Rembrandt collected, frequently employed this compositional device in his early engraved work, such as *The Raising of Lazarus* (B. 42) and *St. George Liberating the Princess* (B. 121).

11. The faint, scratchy outlines of his first draft are visible on the lame man's sleeve.

12. As is typical of surviving impressions of Rembrandt's earliest prints, this one has been touched up with brush and wash to strengthen weak lines and reduce unwanted bright spots caused by uneven biting and printing. The additions are most easily noticed in Peter's hand, John's face and cloak, and the outlines of the drapery. Ruled brown pen and ink borderlines also appear on several early prints, possibly indicating that they were once together in a now dispersed album or portfolio.

13. See also Rassieur 2001, 41–76.

11

Samson Betrayed by Delilah

1628–1630

The Old Testament Book of Judges tells the story of the Jewish superhero Samson, whose birth an angel of the Lord foretold, and whose mission on earth apparently was to use his strength to plague and punish the overlords of the Israelites, the Philistines. Samson showed a great weakness for foreign women, first marrying and divorcing one deceitful Philistine woman and then taking up with another, Delilah (Judges 16:4–31). The Philistine rulers offered Delilah money if she would share with them the secret of Samson's strength so that they could take him captive. Finally Delilah uncovered the secret: Samson's strength resided in his hair, which had remained uncut since birth. "She made him sleep upon her knees; and she called for a man, and she caused him to shave off the seven locks of his head...and his strength went from him." Captured, blinded, Samson was no

longer feared, but his hair grew again and so did his strength. On the occasion of a festival of their god Dagon, the Philistines gathered to celebrate Samson's capture and to mock him, but Samson, praying to God to give him strength, toppled the two pillars that supported the place of assembly, destroying himself and thousands of his enemies.

Samson Betrayed by Delilah is the first of several paintings Rembrandt produced on the theme of Samson and his women. Three large-scale paintings from the 1630s survive: *Samson Threatening His Father-in-Law*, 1635 (Berlin, Gemäldegalerie), *The Blinding of Samson*, 1636 (Frankfurt, Städelsches Kunstinstitut), and *Samson's Wedding Feast*, 1638 (Dresden, Gemäldegalerie).[1] This modestly scaled work, executed on one of the oak panels Rembrandt customarily used as supports for his paintings in Leiden during the 1620s, is relatively simple in its visual structure, but charged with dramatic and psychological tension. Samson's figure is totally absorbed into that of Delilah, his face buried in her body. Only his glossy, leonine locks are visible. The curtained bed and the drinking vessels at right allude to Delilah's methods of seduction and control. She turns her head, her glance a signal to the anxiously hovering Philistine with the shears, while her hands fondle and point to Samson's mane of hair. Another soldier, helmeted and armed with a sword, pokes his wary head through an open door behind the bed. The body language and facial expression of the man armed with the shears is a masterful study of the physical attributes of fear. The setting is simple, the color scheme almost monochromatic except for the blaze of light and color on the rich garments of Samson and Delilah, and, significantly, on the tensed arm holding the shears. The spareness of the setting and the bare planks of the floor remind one of the interior in the 1628 Boston *The Artist in His Studio* painting (no. 18).

The *Samson Betrayed* painting is monogrammed and dated 1628 on the step at left. Because the monogram is unusual, and the date considered surprisingly early for the style of the painting and because both were added after the paint was dry, the Rembrandt Research Project team chose to question both monogram and date, suggesting a broader range of dates, 1628–30.[2] The painting is related to a smaller monochrome oil sketch of the same subject in the Rijksmuseum, Amsterdam that was once attributed to Rembrandt and is now generally considered to be an early work of Jan Lievens (fig. 54). This oil sketch, which may have preceded the Rembrandt in its execution, is similar in overall conception but less nuanced, more caricatural, in its use of gesture and body language. In the Lievens painting the soldier with the shears has

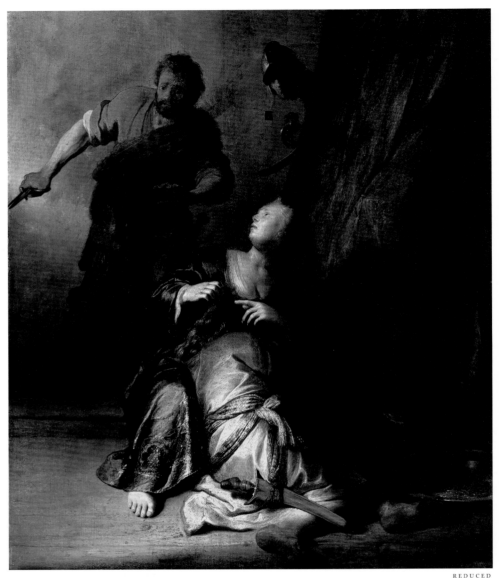

REDUCED

the features of Rembrandt himself, as seen in the small self-portrait etchings of about 1630 in which he was rehearsing various facial expressions in the mirror (see nos. 15–17). The complex relationship between these two works reflects the close and competitive relationship between the two young artists in their Leiden years that has often made it difficult for modern scholars to separate the work of one from the other.

Symbolic of the power of which Samson is about to be deprived, a sheathed dagger hangs from Samson's sash. This may be the first representation in the West of an authentic Javanese dagger, or *kris*, and is certainly one of the *Indiaens* weapons from Rembrandt's collec-

11

Samson Betrayed by Delilah,
1628–30
Oil on panel
Br. 489; Corpus A24
61.3 × 50.1 cm (24⅛ × 19¾ in.)
Staatliche Museen zu Berlin,
Preussischer Kulturbesitz,
Gemäldegalerie

tion of exotic curiosities.[3] As we know from inventories and from representations of artists' studios (see no. 85), Rembrandt and other painters of his time assembled collections of curious old or exotic weapons that proved useful as props or as inspiration for further invention when staging scenes from the Bible or earlier history and mythology. csa

NOTES

1. *Samson Threatening*: Br. 499; Corpus A109. *Blinding of Samson*: Br. 501; Corpus A116. *Samson's Wedding*: Br. 507; Corpus A123.

2. *Corpus* 1982–89, 1, 249–57.

3. See the inventory of Rembrandt's possessions in *Docs.* 1979, 1656/12, no. 313: "In the small studio, In the second bin, sixty pieces of Indian hand weapons, arrows, shafts, javelins and bows." A similar *kris* is employed to gouge Samson's eye in the Frankfurt painting. See also De Heer et al. 1999, 47, 71–72.

Fig. 54. Jan Lievens (Dutch, 1607–1674), *The Capture of Samson*, 1627–28, oil on panel, 27.5 × 23.5 cm (10¹³/₁₆ × 9¼ in.), Rijksmuseum, Amsterdam.

12–17
Early Self-Portraits
1628–1630

A number of seventeenth-century Dutch artists made self-portraits, but none pursued self-portraiture throughout their careers—in three different media—with the intensity, variety, and inventiveness that Rembrandt brought to the subject. In his Leiden years (1626–31) Rembrandt's drawn, etched, and painted self-portraits spoke to his interest in role-playing, his fascination with the expression of the emotions, and his ambition to make his image, as well as his name, known. Rembrandt even inserted his self-portrait into the crowd as witness and author in early narrative paintings on historical themes such as the so-called *Leiden History Painting* of 1626.[1] It is worth noting that his Leiden friend and competitor Jan Lievens, with whom he was involved in a lively, almost symbiotic exchange of artistic ideas, was not equally obsessed with the making of self-portrait images at this time.

There are two rare, drawn bust-length self-portraits from 1628 to 1629 that relate closely to the numerous "head and bust" self-portrait etchings that Rembrandt was producing from 1628 to 1631, one in the British Museum (fig. 55) and one in the Rijksmuseum (no. 12).[2] Both are modest in size and executed in a combination of fine underdrawing with quill pen and brown ink and bolder additions with brush and gray and black washes. In both, the artist's hair is conspicuously tousled and unruly and he wears a frogged jacket with military associations.[3] When one surveys Rembrandt's numerous self-portraits from the 1620s to the 1660s there are many more in which he is dressing up and playing a role in period or exotic costume, than ones in which he appears in contemporary street or studio dress. The London drawing makes use of dramatic side lighting and has a momentary expression with open mouth and raised eyebrows similar to the small 1630 etching included here (no. 16). Rembrandt's face in the Amsterdam drawing has a more conventional expression, but with a strong concentration on the fixed, penetrating gaze of the prominent eyes. Certain facial features—eyes, nose, mouth, and jaw line—have been more emphatically defined with heavier pen strokes.

The Amsterdam drawing relates closely in conception to the large, experimental, bust-length etched self-portrait of 1629 known in only two surviving impressions, one in Amsterdam (no. 13), and the other in London. In the etching Rembrandt's appearance is

Fig. 55. *Self-Portrait, with mouth open*, about 1628–29, pen and brown ink with gray wash, Ben. 53, 12.7 × 9.5 cm (5 × 3¾ in.), British Museum, London.

12

Self-Portrait, Bust, about 1628–29
Pen and brown ink, brown wash
and white watercolor
Ben. 54
12.7 × 9.4 cm (5 × 3¹¹/₁₆ in.)
Rijksmuseum, Amsterdam

somewhat tidier, more dignified, and he is more res-
olute in expression. He again wears a frogged military-
style jacket as in the two drawings, but one sees over his
left shoulder a pigtail of hair, a lovelock or *cadenette,* a
dandified, aristocratic affectation that Rembrandt him-
self was unlikely to have worn.[4] With its *RHL* mono-
gram and date in reverse, the 1629 etching is a bold ex-
periment that misfired, as with some of Rembrandt's
earliest etchings on religious themes (see, for example,
no. 10). In the Amsterdam drawing we have a sharp con-
trast between fine pen lines and bold slashes of wash; in
the print we see a parallel contrast between fine etched
lines and highly distinctive, broader etched lines cre-
ated with an unconventional double point such as a
split pen. The shallow troughs formed by these broad
etched marks did not retain the ink well and printed un-
evenly. Both surviving impressions consequently have
many passages of double-line work that have been filled
in by hand with ink.[5] The two impressions also show in

the blank areas a curious textile pattern that may have
resulted from off-printing of the felt blankets used to
pad the plate during the pressure of printing.[6] Failure or
not, the ambition, originality, and graphic invention vis-
ible here are unfailingly appealing to the modern eye.

The 1629 painted *Self-Portrait* from the Gardner Muse-
um (no. 14) is a much deeper excursion into role-play-
ing and fantasies of aristocratic distinction than the
etching of the same year. It is the most elaborately con-
ceived of the painted self-portraits that survive from the
period 1628–29, and is painted on a wooden panel that
had already been used for another painting or the begin-
nings of one, a practice frequently encountered in Rem-
brandt's early paintings.[7] The artist looks straight out at
us, lips parted, eyebrows raised, with a slightly expec-
tant expression. Already, at this early date, Rembrandt is
characteristically using shadow to veil the eyes or cor-
ners of the mouth, giving a greater sense of mobility or
a mysterious ambiguity to the facial features. The Gard-

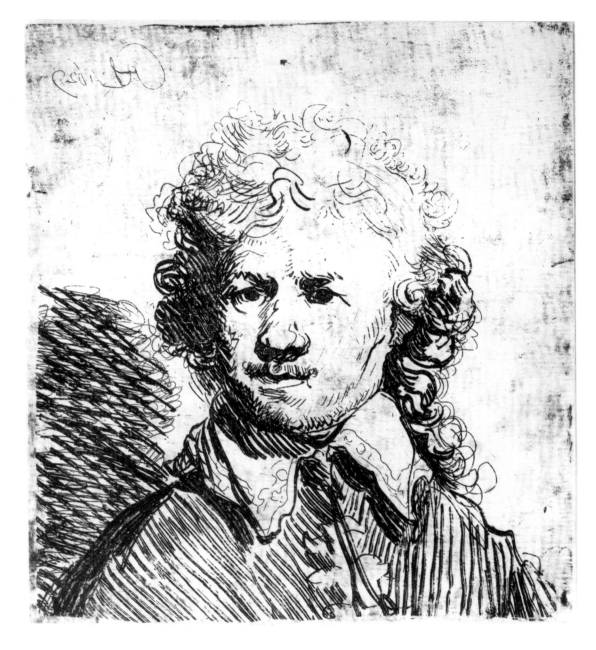

13

Self-Portrait (bare-headed, roughly etched), 1629
Etching, touched with pen in dark gray ink
B. 338, only state
17.4 × 15.5 cm (6⅞ × 6⅛ in.)
Rijksmuseum, Amsterdam

ner painting is all about refinement: idealization and elongation of the artist's sometimes coarse and plebian facial features, suavity of execution, and careful rendering of subtly contrasting textures in the artist's fantasized costume. The elegant color scheme employs understated grayed colors. The rather stylized ovoid profile of cloaked shoulders visible here was a decorative device that the early Lievens as well as the early Rembrandt used repeatedly, as may be seen in the Chicago Rembrandt painting of about 1631 of an *Old Man in a Gorget*

and Black Cap (no. 30). In such early fantasy portraits (whether self-portraits or images of anonymous models), Rembrandt often took advantage of the ornamental potential offered by the curving silhouettes of outsize ostrich plumes sprouting from headgear. The costume in the Gardner painting is an eclectic confection that vaguely suggests the sixteenth century: velvet cloak, gold chain, and plumed cap, but also an Oriental scarf.[8] The gold chain evokes memories of the chains awarded to artists by kings and emperors but does not precisely

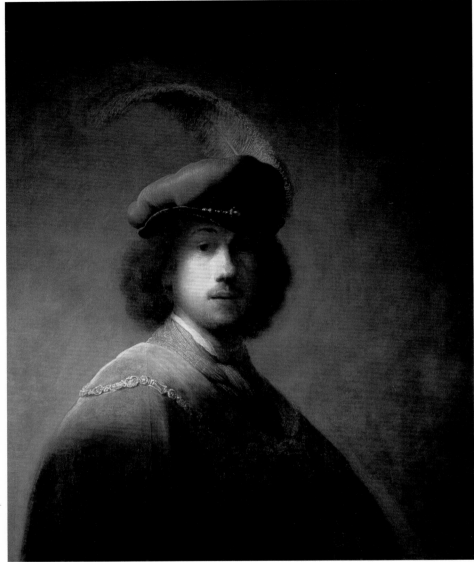

14

Self-Portrait, 1629
Oil on panel
Br. 8; Corpus A20
89.5 × 73.5 cm (35¼ × 28¹⁵/₁₆ in.)
The Isabella Stewart Gardner
Museum, Boston

REDUCED

resemble them. The total image nevertheless successful-
ly conveys the impression that the young artist and his
profession are noble in character and of high standing.
Since the early sixteenth century in Renaissance Italy
there had been in the world of arts and letters an ongo-
ing discussion about whether painting was merely a craft
or a more elevated, humanistic profession.

During the Leiden years, from about 1628 to 1631 but
particularly in 1630, Rembrandt etched about ten small,
almost postage stamp-size, head and bust self-portraits
in which the artist's features undergo surprising trans-
formations and express a great range of moods and emo-

tions. Some of these (nos. 15–17) employ the dramatic
side-lighting and high contrasts of light and shadow that
Rembrandt often used at this time and that relate in a
general way to the dramatic lighting employed by the
Dutch followers of the radical Roman realist Caravaggio
(1573–1610). These quirky, personal etched self-portraits
are without clear precedent in the history of self-por-
traiture, particularly in printmaking. Most modern
scholars have related them to the young Rembrandt's
passionate interest in the expression of human emotions.
The artist used himself as a cheap model, studying his
contorted features in the mirror as he pressed his lips

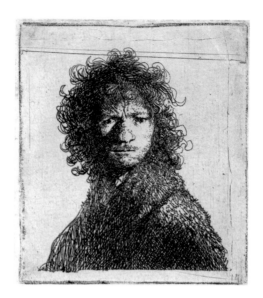

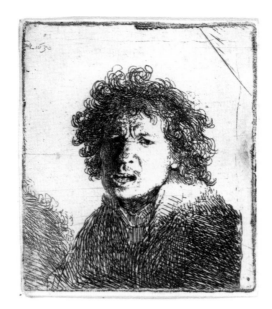

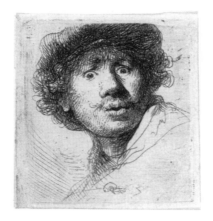

15
Self-Portrait (frowning, bust), 1630
Etching
B. 10, II
7.2 × 6 cm (2¹³⁄₁₆ × 2³⁄₈ in.)
National Gallery of Art, Washington
Rosenwald Collection

16
Self-Portrait (open-mouthed as if shouting), 1630
Etching
B. 13, II
7.3 × 6.2 cm (2⁷⁄₈ × 2⁷⁄₁₆ in.)
The Pierpont Morgan Library, New York

17
Self-Portrait in a Cap, 1630
Etching
B. 320, only state
5.1 × 4.6 cm (2 × 1¹³⁄₁₆ in.)
The Pierpont Morgan Library, New York

firmly together and frowned ferociously (no. 15), or brow corrugated and mouth agape, seemed to complain bitterly or to have cried out (no. 16). In both of the foregoing, the artist's hair, presented as a bristling, wooly corona dramatically framing the face, adds to the intensity of the effect. In another 1630 etching (no. 17) the artist's hair is partly covered with a cap and everything—contours of face, mouth, eyes—is rounded in surprise or wonder. In a frequently cited passage, Samuel van Hoogstraten, the Dutch painter who studied with Rembrandt from about 1642/43 to 1647, recommends to the young artist in his treatise of 1678 on the theory and practice of painting, *Introduction to the Noble School of Painting; or The Visible World,* use of a mirror to aid in the representation of the passions or emotions in order "to be at once performer and audience."[9] CSA

NOTES

1. Corpus A6, in the collection of the Lakenhal, Leiden. The historical subject has yet to be identified; see *Corpus* 1982–89, 1: 104–13.

2. Royalton-Kisch 1992, 28–29, no. 1, Schatborn 1985, 2–3, no. 1.

3. Mariéke de Winkel, "Costume in Rembrandt's Self-Portraits," in White and Buvelot et al. 1999, 61–62.

4. Ibid.

5. Whether by Rembrandt himself or by another, later, hand it is not possible to determine. Most likely it is the latter.

6. This pattern is also visible on a few other early impressions of early Rembrandt etchings. See, for example, the impression exhibited here of the beggar etching, no. 23.

7. See *Corpus* 1982–89, 1: 218–24. See also Chong et al. 2000, 93–94.

8. Mariéke de Winkel, "Costume in Rembrandt's Self-Portraits," in White and Buvelot et al. 1999, 61–62.

9. Van Hoogstraten 1678, 110: "om te gelijk vertooner en aenschouwer te zijn." For Van Hoogstraten, see Brusati 1995, 41.

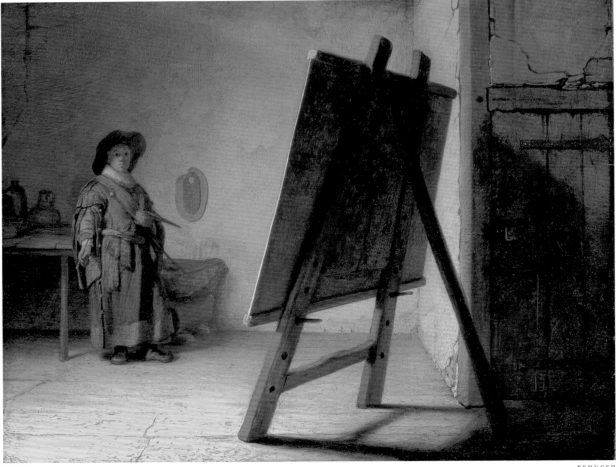

18

The Artist in His Studio, about 1628
Oil on panel
Br. 419; Corpus A18
24.8 × 31.7 cm (9¾ × 12½ in.)
Museum of Fine Arts, Boston
Zoe Oliver Sherman Fund in
memory of Lillie Oliver Poor

REDUCED

18–19
The Artist in the Studio

1628–EARLY 1630S

In the mid 1620s Rembrandt and Jan Lievens, the two young Leiden artists who had studied separately in Amsterdam with the painter of historical narratives, Pieter Lastman, returned to their hometown and set themselves up as independent artists.[1] From about 1625 until 1631 they were in close contact, influencing each other's art, sharing the same models, and perhaps even occupying the same studio space.[2] Two Rembrandt images of artists before the easel in their studios, one painted and one drawn, present us with tantalizingly suggestive and thought-provoking images of the relationship between artist and work.

The painting (no. 18) has in recent years, through frequent exhibition and reproduction, become virtually emblematic of the young Rembrandt and his art.[3] Small in dimension, the panel is large in conception. Striking in its stark simplicity, it focuses on the dramatic confrontation between the small figure of a youthful artist almost swallowed up in his bulky studio garb and a looming easel on which rests a large panel held rigid between wooden battens at top and bottom.[4] Given the prominent placement of the easel in the center foreground, and the heightening of its significance through the weight of shadow, one might say that the painting on the easel is the dominant player in the studio drama. The expression on the face of the artist with his prominent button eyes and raised eyebrows—anxious? questioning? challenged? thoughtful?—is made more ambiguous by the veil of shadow cast by his large hat. The artist is fully armed: he holds a brush at the ready in his right hand and in his left, a palette, several more brushes, and the *maulstick,* or "painting-stick," on which artists rested their hand to steady it when adding finer

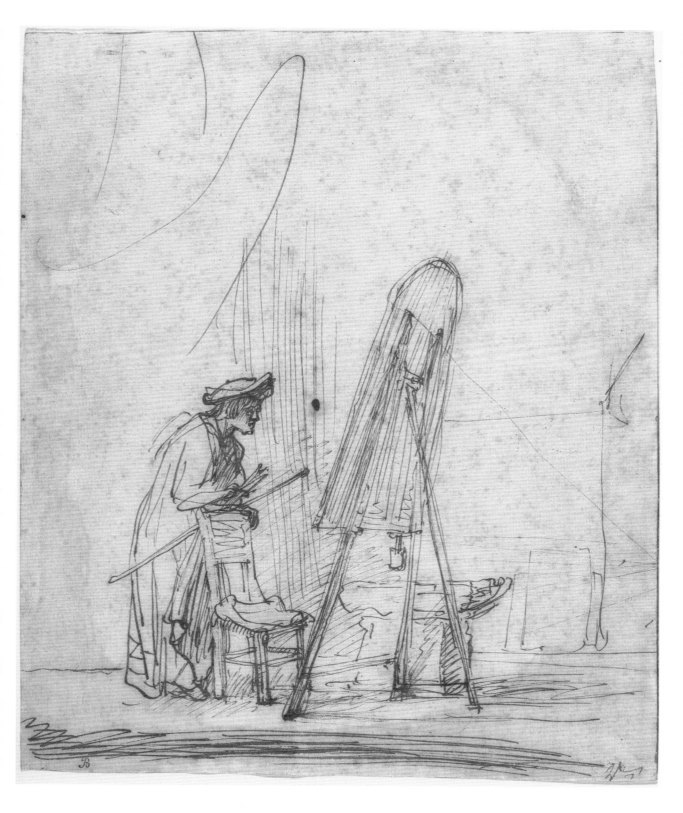

19
An Artist in His Studio, early to mid-
1630s
Pen and brown ink
Ben. 390
20.5 × 17 cm (8$\frac{1}{16}$ × 6$\frac{11}{16}$ in.)
The J. Paul Getty Museum,
Los Angeles

details. The room is sparsely furnished, almost spartan, contrasting with the customary picturesque litter of useful and symbolic props (exotic weapons, musical instruments, plaster casts) that are often to be seen in seventeenth-century Dutch representations of artists' studios. Two extra palettes hang on a nail above the large grinding stone where mineral pigments were pulverized and mixed with binding media to make the artist's paints. Behind the standing artist a crude table holds vessels that may contain the oils and varnishes essential to such manufacture. The bare, nearly impoverished character of the interior is emphasized by the attention given to details of cracked plaster and the rough, splintery floorboards that are so thickly rendered as to have an almost sculptural relief.

One of the questions frequently asked in connection with this appealing and provocative painting is who the youthful-appearing artist might be: Is he Rembrandt; is he the fourteen-year-old Gerrit Dou who began his apprenticeship with the twenty-two-year-old Rembrandt in 1628; or is he "The Young Artist," a metaphorical stand-in for Rembrandt himself? While the present author favors the last of these interpretations, the question is admittedly made more difficult by Rembrandt's propensity for constantly transforming his appearance in his self-portraits, changing his age or the shape of his face, and casting himself in various roles. An artist who studies his own features as obsessively as Rembrandt did in his early years inevitably ends up inventing faces that echo their own features, what one might call "semi-self-portraits."

Part of the appeal of this image is its air of mystery, created by Rembrandt's teasing device of not allowing us to see the front of the panel. We are encouraged to speculate about whether the young artist is confronting a blank slate or whether the easel holds a picture in progress. Is the artist intimidated by the task before him, standing back to examine what he has accomplished, or is he in the process of conceiving the work to be executed? Ernst van de Wetering has proposed the attractive theory that because Rembrandt was an artist who rarely used preparatory studies or underdrawing as a guide in his paintings, and who freely and directly worked out his compositions with the brush on the panel or canvas itself, what we see here is the artist conceiving the *idea* of the composition in his imagination before beginning work on the still-untouched field of the picture.[5] He further notes that when executing a painting, seventeenth-century Dutch artists customarily worked seated rather than standing and points to two worn depressions on the cross bar of the easel in the painting where feet must have rested. He therefore concludes that the artist must be *thinking* about the painting to be executed rather than in the process of *executing* it. However, the fact that the artist already has a palette and a battery of brushes in hand might encourage one to believe that the artist has already passed beyond the initial stage of roughing-in the composition in monochrome as Rembrandt customarily did, and has passed on to the stage of working in color. Whichever interpretation one favors, one nevertheless has a clear sense of a tense standoff between a somewhat daunted young artist and the ambitiously large panel that he confronts.

The interior space in the painting is unusual for Rembrandt in that it seems almost measurable. Most of Rembrandt's architectural spaces tend to be intuitive and imaginative ones, adjuncts to the figures rather than clearly defined cubes of space. This unusual spatial clarity has led Dutch scholars to attempt to relate the space to a certain-sized room on a particular floor of a typical Leiden house of the period or to investigate the possibility of a rare flirtation on the young Rembrandt's part with rational systems of perspective construction.[6] Study of the latter resulted in the observation that there was apparently one system of perspective for the room and another for the easel.[7] It appears that Rembrandt intuitively bent the rules of constructed perspective to his own expressive ends.

The pen drawing of an artist's studio (no. 19) shows an artist with palette, brushes, and maulstick leaning on the back of his comfortably cushioned painting chair and scrutinizing close up with narrowed eyes a painting with arched top that rests on an easel. The easel is of lighter construction than the one in the Boston painting and the painting appears to be a canvas. The artist wears a bulky (warm) enveloping garment similar to that in the Boston painting. A large grinding stone for preparing paints is placed near the easel. Light enters from the left and some cursive lines at the upper left suggest the sail-like shades that were sometimes used in seventeenth-century studios to control or direct the light. In the background at right are sketchy indications of walls and overlapping rectangles that may be pictures stacked against the wall. Some tenuous diagrammatic perspective lines recede from the easel into the distance at right.[8] These lines, apparently added after the rest of the drawing was completed, might have been made by Rembrandt or by another artist's hand in the course of instructing a student about perspective. The drawing is somewhat later in date than the Boston painting, relating in style in its thin, springy calligraphic pen line to Rembrandt drawings of the early to mid-1630s.

Ernst van de Wetering points out that the features of the artist (pointed face with knobbly chin) resemble not so much those of Rembrandt as those of his friend and colleague Jan Lievens. Comparison with Lievens's features in early portraits or self-portraits does indeed show a surprising correspondence.[9] Pursuing the possible Lievens identification, Van de Wetering quotes Samuel van Hoogstraten's statement in his 1678 treatise: "In the quest for wonders in the smeared-on paints, varnishes and oils Jan Lievens was completely at home."[10] He further suggests—based on Hoogstraten's didactic description of an imaginary (?) painting contest between three seventeenth-century painters who practiced three different methods of developing a painting—that Lievens, like Van Goyen in the painting contest, was the kind of painter who first dashed something down on the panel or canvas and then discovered the composition in these chance patterns. He believes that this is what the artist in the drawing is engaged in doing. Whether or not one accepts this very specific interpretation, there is no question that the artist in the drawing—Lievens or his stand-in—is seen in the act of intensely examining, questioning, or criticizing work already in progress. As with the Boston painting, the intense dialogue between the artist and his work, whether in a state of gestation or in the process of execution, lies at the heart of this image. CSA

NOTES

1. See Vogelaar et al. 1991 and Van de Wetering et al. 2001.

2. See Ernst van de Wetering, "De symbiose van Lievens en Rembrandt," in Vogelaar et al. 1991, 39–47.

3. It was, for example, the cover image for Wurfbain *Geschildert tot Leyden* 1976, Van de Wetering 1997, and Van de Wetering et al. 2001.

4. Ernst van de Wetering, "Leids schilders achter de ezels," in Wurfbain 1976, 21–31.

5. Ibid.

6. Ernst van de Wetering, "De symbiose van Lievens en Rembrandt," in Vogelaar et al. 1991, 43–44; and Couprie 1994, 69–96.

7. Ibid.

8. Goldner and Hendrix 1992, 240–42, no. 103.

9. See Ernst van de Wetering, "Leids schilders achter de ezels," in *Geschildert tot Leyden* 1976. For the young Lievens's facial features see the Lievens profile self-portrait in Copenhagen of about 1627 reproduced in Vogelaar et al. 1991, 13.

10. Van Hoogstraten 1678, 237–38: "in d'aangesmeerde verwen, vernissen en olyen wonderen te zoeken was Jan Lievens dapper thuis," discussed by Van de Wetering in Wurfbain 1976. As Van de Wetering points out, the remark about Lievens immediately follows the description of the painting contest.

20–21

An Elderly Woman (Rembrandt's Mother)

1628 AND EARLY 1630S

The elderly woman shown in these two prints has traditionally been identified as Rembrandt's mother. Rembrandt inscribed the smaller of the two (no. 20), a sketchy bust-length portrait, with the date 1628, the first year in which he dated his etchings. Comparison with some of his first etching trials (nos. 7–10) reveals Rembrandt's rapid progress as a student of printmaking techniques. The larger, highly finished etching (no. 21) shows the same woman wearing a black veil and sitting at a table. This plate is usually dated about 1631, the year in which Rembrandt introduced the seated three-quarter-length format into his repertoire of painted portraits.[1] Though differing in style, these two etchings share Rembrandt's life-long interest in depicting sitters wizened by old age, including his own image.

Although the name of the old woman shown in these two prints cannot be determined with certainty, her identification as Rembrandt's mother has a long tradition.[2] Neeltgen (Cornelia) Willemsdr. was born about 1568.[3] Her father was a baker in Noordwijk, a small coastal town north of Leiden. The family moved to Leiden where, in 1589, Neeltgen married Harmen Gerritsz. van Rijn, a well-established grain miller. His family name derived from the location of his great-grandfather's windmill, on the banks of the Rhine (Rijn) River across from Leiden. Neeltgen gave birth to at least ten children. Rembrandt was her youngest surviving son. Her husband died in 1630. Neeltgen lived until 1640 and died a wealthy woman.[4]

When Rembrandt returned from his studies in Amsterdam under Pieter Lastman, he established his own studio in Leiden. He may have followed the common practice among young painters of locating their first studios in properties owned by their parents.[5] In his early attempts to master likeness and the expression of emotion, Rembrandt used himself as a cheap and readily available model, studying his own features in a mirror. His mother may very well have been the female counterpart to his obsessive study of his own image. He made at least six etchings, a drawing, and three paintings of the woman seen here.[6] Other artists, including Jan Lievens, his friendly rival, and Gerrit Dou, his first pupil, portrayed her as well.

Perhaps as interesting as the question of whether or not this woman was Rembrandt's mother, is the fact that

her likeness was repeatedly placed before a public that in all likelihood cared little about who she was. There was a developing market for pictures of anonymous old women (and men)—in contrast to the long tradition of titillating pictures of coy young women. The interest in faces eroded by time closely parallels the taste for "the picturesque," including images of dilapidated farmhouses, ruins, ragged peasants, and beggars, all subjects depicted by Rembrandt. Modern historians attempting to account for the seventeenth-century Dutch taste for such humble subjects have cited widely divergent but not truly contradictory influences, including legends of artists of classical antiquity who were rewarded for depicting everyday life, as well as the marketability of images free of difficult religious or literary content.[7] In an era when death always seemed to hover near, the elderly were inevitably regarded as wonders of nature.

When he began to work on the 1628 plate (no. 20), Rembrandt seems not to have had a fixed plan for its finished appearance. The image may have evolved over three separate sessions. The first state shows that he began by etching the head and the drapery that cascades toward the lower right, probably while in the presence of the model. After printing a proof or two, he apparently regrounded the plate and etched her upper body as well as some fine details in her face. Finally, he scratched drypoint lines, such as the softly blurred ones that descend toward her shoulder like a veil, directly into the copper. Rembrandt's use of drypoint would later become a prominent characteristic of his work, but his early use of the technique in prints such as this one rarely receives notice.

Rembrandt's only other etching dated 1628 shows the head of the same woman (see fig. 42, p. 48). Here too, he appears to have started to work on the plate without having a clear idea of the outcome. He began by etching the woman's face and some of the shadows within her cap. Black chalk indications on a proof printed at this stage reveal that he considered showing the woman's upper body (fig. 41, p. 48). Instead, he radically trimmed his copper to produce a highly original composition so sharply cropped at bottom that the woman almost seems decapitated.

Although these are his first dated prints, Rembrandt reveals himself to be already a master of the medium and to have developed fresh, innovative ways of handling the etching needle. Instead of drawing with the broad, scrawling strokes that he used in his early biblical etchings (nos. 7–10), he modeled his forms with an array of extremely fine lines, dots, and flicks. In these two prints, he mapped every irregularity of the old woman's skin,

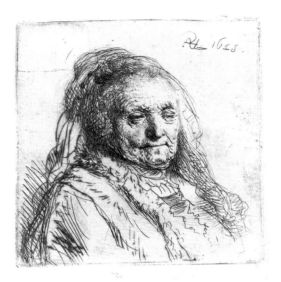

20
An Elderly Woman (Rembrandt's mother, head and bust), 1628
Etching and drypoint
B. 354, II
6.6 × 6.4 cm (2⅝ × 2⁹⁄₁₆ in.)
Hood Museum of Art, Dartmouth College, Hanover, New Hampshire
Gift of Jean K. Weil in memory of Adolf Weil, Jr., Class of 1935

combining the minute description of the old woman's facial features with a shorthand indication of her clothing. The vivid realism of her face thus is enhanced by the contrast with the scribbled sketchiness of her clothing. Conventional portrait engravers applied their talent toward the replication of fur, knots, and folds, but Rembrandt merely hints at the clothing and directs our attention to the woman's face.[8]

The larger print showing the old woman seated at a table has much more the character of a formal portrait and is brought to a high degree of finish throughout. The extreme refinement of the face and hands again suggests that Rembrandt etched these first. He also etched a preliminary sketch of the clothing that is still visible amid the more heavily etched lines and along the contours of her clothing to the right of her hands. The sketch probably had a rough minimal suggestiveness similar to that in the clothing of the 1628 etching. He completed the clothed body and the furniture in subsequent sessions. Their deeply etched lines required long exposure to the acid, so Rembrandt would have applied stop-out varnish to protect the delicate lines of her face and hands. He worked with great care in order to describe precisely the brocade of the cloak, the fur of the trim, and the silk of the sleeve. Through the flowing translucent black veil, we see the form of her cap.

Rembrandt's father died in 1630, so it is tempting to see the woman as being his widow dressed in mourning. In the seventeenth century, however, black veils were all-purpose luxury accessories worn by brides at their weddings and by fair-skinned women avoiding the summer sun. Black veils appear to have been coming into

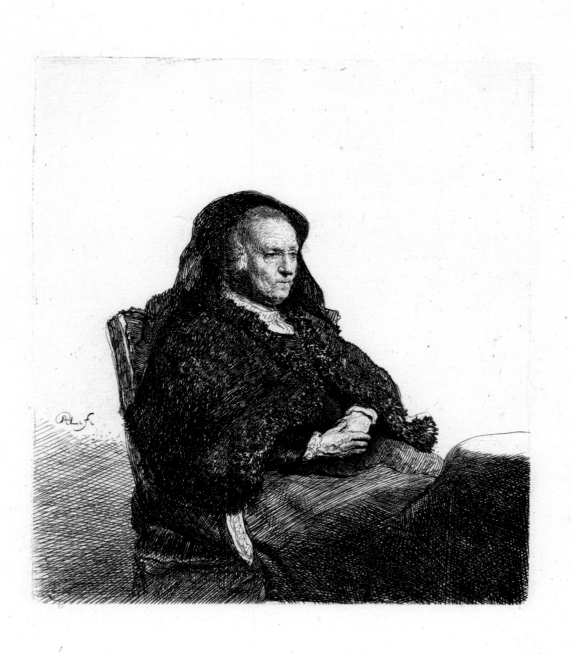

21

An Elderly Woman (Rembrandt's mother, seated at a table), about 1631
Etching and engraving
B. 343, II
14.8 × 13.1 cm (5^{13}/$_{16}$ × 5^{3}/$_{16}$ in.)
Museum of Fine Arts, Boston
Gift of Mrs. Horatio Greenough
Curtis in memory of her husband
Horatio Greenough Curtis

fashion as mourning dress among noble women, but they had not yet acquired that connotation among the broader public.[9] In this portrait the black veil's primary function may be to contrast with and enframe the gray tonality of her delicately etched facial features. Its contour also draws our attention to her heavy-lidded eyes. The luxurious quality of her clothing is matched by that of the carved chair with its tasseled velvet cushion. Rembrandt then seems to have engraved the finishing touches to the copper plate—long, deeply cut strokes of the burin in the tablecloth and short judicious strokes to perfect the shading of the woman's face. TER

NOTES

1. See Br. 146 and Br. 164. He painted a female portrait in this format in 1632, Br. 330.

2. The 1679 estate inventory of Amsterdam publisher Clement de Jonghe listed several dozen copperplates by Rembrandt, including one identified as "Rembrandt's Mother," but the notary misidentified many of Rembrandt's motifs. Bredius and De Roever 1890, 180–81. Hofstede de Groot *Urkunden* 1906, 406–10, notes that this plate could be any of several: B. 343, 348, 349, 351, 352, or 354. Bartsch identified five plates as Rembrandt's mother, B. 349, 351, 352, 353, and 354. B. 353 is no longer attributed to Rembrandt.

3. *Docs.* 1979, 1587/1. Neeltgen ("Little Nell") is a diminutive for Cornelia, her formal and seldom-used name.

4. *Docs.* 1979, 1513/1, 1581/2, 1622/1, 1630/1, 1640/8, 1640/9.

5. His teacher, Pieter Lastman, for example, established his first studio in his mother's home. Dudok van Heel, "Rembrandt: His life, his wife, the nursemaid, and the servant," in Williams et al. 2001, 21.

6. B. 343, 348, 349, 351, 352, 354, and possibly 355. Ben. 55. Br. 63, 69, and 70.

7. Mariët Westermann, "Making a Mark in Rembrandt's Leiden," in Chong et al. 2000, 45, notes explanations based on Pliny's account (*Natural History*, book 35.112) of the painter Peiraikos as well as the avoidance of obscure or difficult religious iconography.

8. Like his older Flemish contemporary Anthony van Dyck, Rembrandt may have looked to the somewhat loose treatment of clothing in portraits etched by Ottavio Leoni (1578–1630). Rembrandt's vocabulary is, however, far more casual than that of either Van Dyck or Leoni.

9. Marieke de Winkel, "Fashion or Fancy? Some interpretations of the dress of Rembrandt's women re-evaluated," in Williams et al. 2001, 58–61.

22–27
Street People and Beggars
LATE 1620S—EARLY 1630S

During the Leiden years, from about 1629 to 1631, Rembrandt etched a large number of small plates of varied dimensions representing street people and beggars. These were inspired in part by the internationally known and much-copied series of twenty-five beggar etchings by the Lorraine etcher Jacques Callot, first published in Nancy about 1622–23 (fig. 56). Even Rembrandt's chalk drawings of street figures from this time are marked by the style of the Callot etchings. The Rijksmuseum's rapid sketch, presumably drawn directly from life, of a man wearing a cap and leaning on a stick, is one of three Rembrandt black chalk drawings of such single street figures preserved in Amsterdam, all generally dated about 1629–30 (no. 22).[1] While the bold parallel shading lines and the decorative silhouette prompt comparisons with Callot's etchings, the distinctive angular rhythm of the chalk line does not. Rembrandt has clearly reconsidered certain passages in the drawing, going over them with firmer, sometimes sharper, chalk strokes. This layering of marks is particularly evident in the legs and gives the drawing a greater sense of immediacy, characteristically allowing the viewer to share in the process of its making.

The Amsterdam chalk sketches are closely related to the largest of Rembrandt's early beggar etchings, which also represents a street figure leaning on a stick (no. 23). It is seen here in an unusually early impression: the edges of the plate are still irregular and the platemark prints strongly, framing the image. There is an overall gray tone, partly resulting from the off-printed, accidental textile pattern also observable on the two surviving impressions of the early experimental self-portrait of 1629 (no. 13). The present etching, usually dated about 1629, is executed in a free, scribbly "drawing" manner not unlike the early failed experimental plate of *Peter and John at the Gate of the Temple* (no. 10) but technically more successful. The plate is in fact about as simple technically as a Rembrandt plate can be. The wiry line varies relatively little in width and the plate has been bitten with acid only once. On the left, however, there is clear evidence in the abrupt, clean interruption of the hatching lines at the right edge of the figure's shadow that the shadow's edge was stopped out or masked with wax or varnish before the plate was bitten. Indebted as it is to Callot in its overall conception, it could never be mistaken for one of the French master's etchings. Its casual,

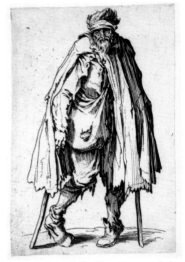

Fig. 56. Jacques Callot (French, 1592–1635), *Beggar on crutches with a wallet*, from the series *The Beggars (Les Gueux)*, 1620–23, etching, 13.7 × 8.8 cm (5⅜ × 3⁷/₁₆ in.), Museum of Fine Arts, Boston, Horatio Greenough Curtis Fund.

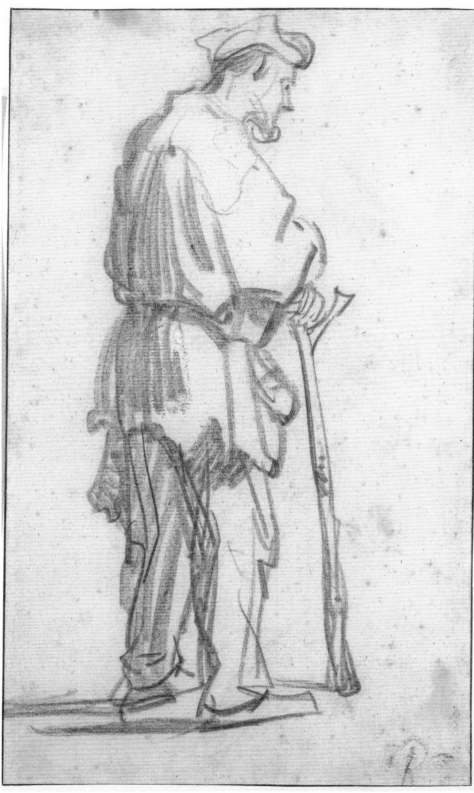

REDUCED

22

Standing Beggar, 1630
Black chalk, with white
watercolor
Ben. 30
29.4 × 17 cm (11^{9}/$_{16}$ × 6^{11}/$_{16}$ in.)
Rijksmuseum, Amsterdam

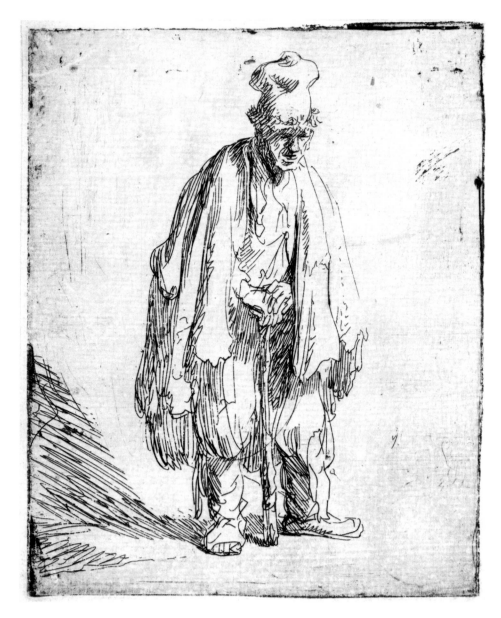

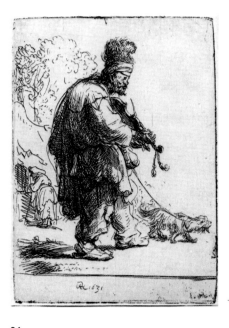

23

Beggar in a High Cap, Leaning on a Stick, about 1629
Etching
B. 162, only state
15.6 × 12 cm (6⅛ × 4¾ in.)
Rijksmuseum, Amsterdam

24

The Blind Fiddler, 1631
Etching
B. 138, I
7.8 × 5.3 cm (3¹/₁₆ × 2¹/₁₆ in.)
Teylers Museum, Haarlem

unsystematic use of line is totally at variance with Callot's crisp, stylized, thickening and thinning etched strokes that imitate the calligraphic vocabulary of traditional engraving.

We like to believe that we are more enlightened about urban social problems than the citizens of earlier times. Nevertheless, the average person approached on the street today by a beggar or panhandler is likely to feel great ambivalence, distrust, or even fear. This was certainly the case in seventeenth-century Europe. Beggars were often satirized and accused of using tricks and deception in order to evoke pity and to attract alms.

In seventeenth-century Amsterdam beggars were customarily sent to workhouses to get them off the street and to make them into more productive members of society.[2]

Some beggars and street people apparently eked out a living by providing music or by selling medical potions or poisons for the control of household pests (see *The Rat-Poison Peddler* of 1632, no. 139). Rembrandt's *Blind Fiddler* of 1631 (no. 24) is evidently such a street person who earned a marginal living by providing entertainment. He is seen in ornamental silhouette, with fur hat and shaggy seeing-eye dog, playing his fiddle as he strolls along.

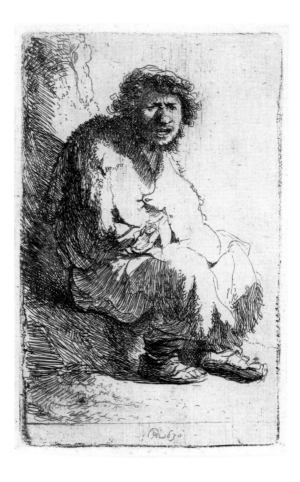

25

A Beggar Seated on a Bank (Self-Portrait),
1630
Etching
B. 174, only state
11.5 × 6.9 cm (4½ × 2¹¹⁄₁₆ in.)
Museum of Fine Arts, Boston
Katherine E. Bullard Fund in
memory of Francis Bullard

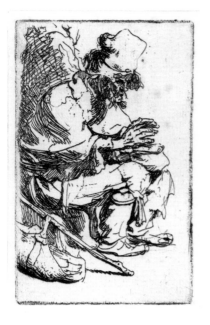

26

*Beggar Seated Warming His Hands at a
Chafing Dish,* about 1630
Etching
B. 173, II
7.7 × 4.6 cm (3¹⁄₁₆ × 1¹³⁄₁₆ in.)
Museum of Fine Arts, Boston
Katherine E. Bullard Fund in memory
of Francis Bullard

In the background his female companion solicits contributions at a cottage door. This beggar seems a picturesque figure, even endearing in an offbeat fashion rather than an object of fear and disgust. There is obviously a wide range of viewpoint and attitude to be experienced in Rembrandt's various etched beggars and street people early and late (see, for example, the quite dignified and sympathetic beggar family in the later etching of *Beggars at the Door,* 1648, no. 140).

A work that confronts the complicated relationship between what we know of historical seventeenth-century social attitudes and what Rembrandt depicts is the 1630 etching of *A Beggar Seated on a Bank* (no. 25), in which the beggar in the ragged cloak and scraggly beard, with open hand extended, has Rembrandt's own features. Its distinctive self-portrait character is made more vivid when it is compared with another etching of an anonymous beggar of about 1630 in which a seated vagabond

with stick and bundle warms his chilled hands over a dish of coals (no. 26). Rembrandt's expression, with contracted brow and open mouth, is similar to that seen in one of the small emotive self-portraits of the same year (no. 16). This extraordinary bit of role-playing need not necessarily be taken as signifying a Christ-like identification on Rembrandt's part with the beggar's lot, but should perhaps be viewed—Rembrandt had a robust sense of visual humor—as a good, if inside, joke. The twenty-four-year-old artist was not yet fully established and could use some financial assistance!

Another early, etched image in which Rembrandt associated, however loosely, his own image with depictions of beggars is the *Sheet of Studies* (no. 27) of about 1631–32. It is seen here in one of the very small number of early impressions before the irregular plate edges were trued up, the plate reduced in size, and the random, blobby etching accidents so seductive to the modern eye

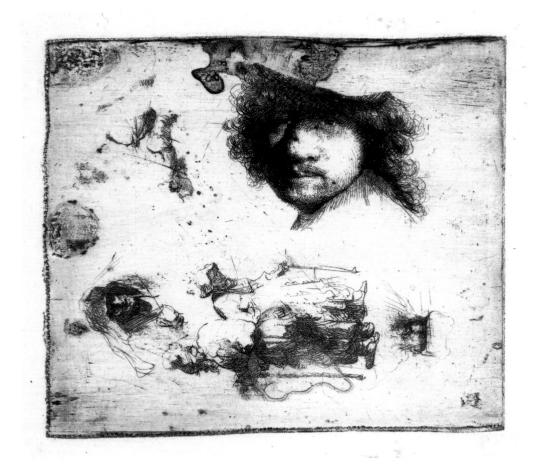

27
Sheet of Studies (with head of the artist), about 1631–32
Etching
B. 363, I
10.1 × 11.4 cm (4 × 4½ in.)
Rijksmuseum, Amsterdam

removed or toned down. Later impressions taken after these "improvements" would appear to be posthumous ones.[3] CSA

NOTES

1. Schatborn 1985, 4, no. 2.

2. For more on the attitude toward beggars in seventeenth-century Holland, see Ackley *Printmaking* 1981, 100, no. 60 (Droochsloot), and 117, no. 71 (Rembrandt); see also Amsterdam Historisch Museum 1965.

3. Amsterdam/London 2000, 117–18.

28–34
Head Studies and Fantasy Portraits
1630S

Rembrandt's obsession with the recording of the real world and his inventive fantasy were inextricably intertwined. Though seventeenth-century Dutch art is frequently and properly associated with the realistic documentation of daily life, artists and their patrons also relished imaginative caprice. As a young artist, Rembrandt created a cast of imaginary characters, pressing into service his own features as well as those of his models, especially picturesquely seamed and weathered old men. A tireless draftsman, he studied live models with unmatched intensity, and was thus able to endow his fantasy portraits with convincing lifelike presence. Rembrandt transformed objective studies from life into exotic images of

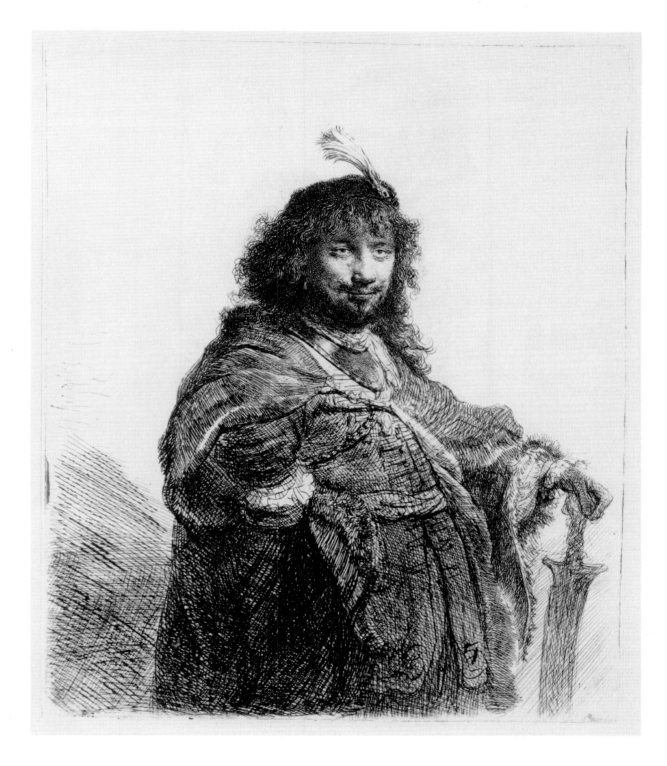

28

Self-Portrait (with plumed cap and lowered sabre), 1634
Etching
B. 23, I
19.7 × 16.2 cm (7¾ × 6⅜ in.)
Rijksmuseum, Amsterdam

oriental potentates, old soldiers, and venerable wise men. Some models posed for him repeatedly, but it appears that often their identities were not as important to collectors as the artistry of the maker.

With increasing frequency, scholars are using the seventeenth-century Dutch term *tronie* to refer to such fantasy portraits and character heads.[1] The use of this contemporary term in relation to Rembrandt and other artists gives one the illusion that one can thus better understand the pictures within an authentic seventeenth-century framework. Unfortunately, the term *tronie* meant no more than "face," "person," or "mug." When faced with the task of listing household contents, for example, notaries and auctioneers used it as a convenient means of rough description. They added modifiers to make the art objects more identifiable: laughing *tronie*, Turkish *tronie*, maiden *tronie*, and so forth. *Tronies* could also be portraits whose sitters were unknown at the time of the inventory. Perhaps it is just as appropriate to discuss such images using more accessible descriptive terms—fantasy portrait, head study—while acknowledging that it is often not possible to determine where objective study leaves off and fantasy begins.

Dutch East India Company ships returning from Asia to the international port city of Amsterdam brought with them curious artifacts and tales of adventure. By the early 1630s, the exotic splendors of Asia had already begun to fuel Rembrandt's imagination. In 1631, he painted a full-length self-portrait in oriental attire and in 1632 a three-quarter-length composition of an unidentified man wearing a jeweled turban and a bulky costume of silk, fur, and gold.[2] The 1634 etching, traditionally known as the *Self-Portrait (with plumed cap and lowered sabre),* may be considered the printed counterpart of these paintings (no. 28). Rembrandt's work is riddled with such "semi-self-portraits" that cast his more or less recognizable likeness in wide-ranging roles, from beggar to deity.[3] His mastery of disguise leaves in a quandary those who crave distinct categorization, for at times, as in this etching, it becomes almost impossible to know whether he served as his own model.[4] The broad nose, heavy eyelids, and wiry hair bear some resemblance to the artist, but if this is Rembrandt, he has taken the liberty of darkening his features, adding a mole by his nose, and smoothing out the usual vertical wrinkle of his brow. He may have begun the image as a finely rendered head study, but he soon moved beyond literal transcription, adorning the ear with an exotic pearl and the hair with the lovelock familiar from his Leiden period self-portraits. He imagined the figure with imposing girth, draped in silk and fur with a gathered sash traversing the bulky midriff. A

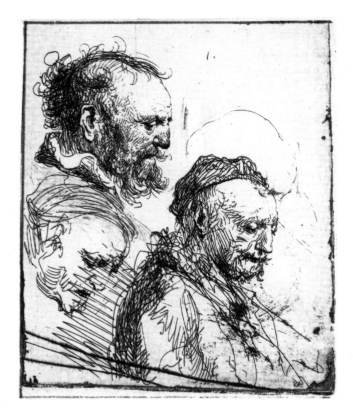

29
Three Studies of Old Men's Heads,
about 1630
Etching
B. 374, only state
10.5 × 8.4 cm (4⅛ × 3⁵⁄₁₆ in.)
Rijksmuseum, Amsterdam

jeweled plume, steel gorget, gold chain, and Asiatic sword proclaim his princely might. His right hand is positioned at his waist, his elbow thrust out at us in a posture familiar from aristocratically confident portraiture and images of martial potency.[5] Though Rembrandt used a similar posture in his 1636 painting of a *Standard-Bearer,*[6] here he may have been ultimately dissatisfied with his composition, or the plate may have been damaged. The first state of the print, shown here, is known in only four impressions. Before printing it in large numbers, Rembrandt cut the copper plate down to an oval bust and brought the costume to a level of finish more consistent with that of the head. Rembrandt pursued his interest in etching exotic fantasy portraits by producing a series of four bust-length works, two of which are dated 1635, based on prints by his friendly rival Jan Lievens.[7]

The ability to capture an animated likeness when drawing spontaneously with the etching needle was one of the distinctive talents of the young Rembrandt. His ability to animate the features of the man with the lowered sabre was the result of diligent practice working both before the mirror and while carefully observing models. A telling example of such determined practice survives in the form of an etching from about 1630, in which Rembrandt repeatedly sketched the head of a

balding old man with a beak nose, who also appears in several of his paintings and prints from this time (no. 29).[8] The studies vary in their degree of finish. Though usually described as showing three heads, the outline and eye of a fourth are discernible as well. With each successive draft, Rembrandt bore down on his subject, gradually refining his aim until he struck his target in the fully rendered head at the upper left. Yet even the rapid studies are drawn with stirring sensitivity, capturing in the deeply creased features an air of fatigue and encroaching melancholy. He seems to have used for this study an irregularly scored scrap of copper left over from some other etching project. The casual roughness of the presentation increases our sense of informal intimacy. We have the feeling that Rembrandt is allowing us to look over his shoulder while he works. Because only five impressions from the copper plate are known, Rembrandt appears to have regarded this as a private performance. Within a few years, however, he would etch more neatly prepared sketch plates for broader circulation (no. 60).[9]

About 1631, Rembrandt painted a fantasy portrait of the same model, now alert and erect in posture if no longer filled with the full vigor of youth (no. 30). He wears a broad black velvet beret with two large ostrich plumes, an earring with a large dangling pearl, a lustrous steel gorget, and an elaborately worked gold chain and medallion, the kind of evocative costume properties that Rembrandt combined and recombined in order to embellish his fantasy portraits and self-portraits. His pictures are so convincing that we can imagine the models dressing up to sit for their portraits. More likely, Rembrandt worked from draped dummies or lay figures when studying the clothing and accessories to which he also applied his highly creative imagination.

The gorget is an obvious reference to military service. The gold chain would not have been associated with wealth so much as with honor. Steely gray hair and deeply furrowed, care-worn features tell us that the man's victories have been hard won. Yet his mettle is suggested by the power of his spiral pose, which Rembrandt underscores by continuing it up into the curving plumes of the beret. The strong light entering from the left catches the pearl earring, reflects sharply off the gorget collar, and strongly illuminates the right side of the man's face while leaving the left side in transparent shadow. Rembrandt's varied brushwork enlivens the entire image. Short strokes, both broad and narrow, capture the textures of the face, while long strokes suggest the folds in his neck. The bold, broad, freely placed strokes of gray in the background allow the warm brown under-layer to

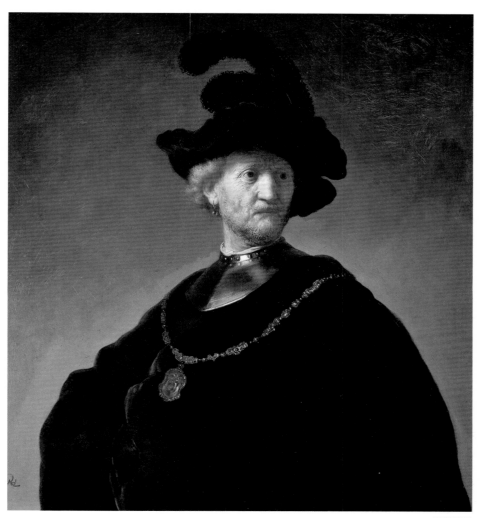

show through. Created by overlapping layers of paint, the glowing halo of light around the old man's body is a device still favored by portrait photographers who place an extra flash behind their subjects. Here it accentuates the active contour of the man's black velvet mantle. Economical touches of gray paint add sheen to the velvet, and together with the path of the chain, suggest the mass of the man's upper body. With this imposing painting, Rembrandt may have offered the burghers of Amsterdam a taste of his talent for the vivid portraiture that would soon be in great demand.

Rembrandt did not need to work on a large scale to demonstrate the powers of his brush. Not much bigger than a playing card, a tiny sketch executed in oil paints brushed onto paper is among the many studies that Rembrandt made of old men (no. 31). This 1633 painting is one of his smallest; yet it is in no sense miniaturistic.

30

Old Man in a Gorget and Black Cap, about 1631
Oil on panel
Br. 81; Corpus A42
83.1 × 75.7 cm (32^{11}/$_{16}$ × 29^{13}/$_{16}$ in.)
The Art Institute of Chicago
The Mr. and Mrs. W. W. Kimball Collection

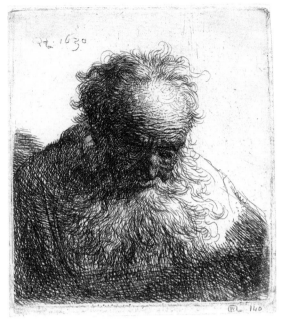

Fig. 57. *Bust of an Old Man with a Flowing Beard*, 1630, etching, B. 325, I, 9.1 × 7.6 cm (3⁹/₁₆ × 3 in.), Museum of Fine Arts, Boston, Harvey D. Parker Collection.

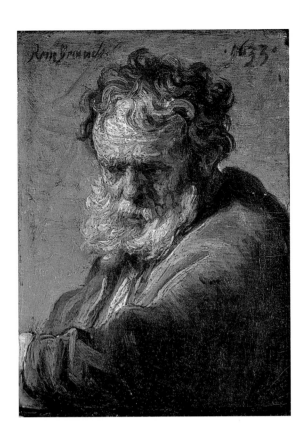

31
Bust of an Old Man, 1633
Oil on paper laid on panel
Br. 633; Corpus A74
10.6 × 7.2 cm (4³/₁₆ × 2¹³/₁₆ in.)
Private Collection

He wielded his brush with the same breadth and freedom that one would expect in much larger works by him. As a result, the painting brims with concentrated energy. The old man's strength of spirit seems to be expressed by his grizzled hair and cottony beard. Though he limited his palette to black, white, and ochre, Rembrandt creates from these few colors a broad range of tones, and varied his brush strokes to fill the tiny sheet with visual activity. The signed and dated work is as much about displaying the vigorous actions of the artist's hand as it is about venerable old age. Similarly his nearly two-dozen etchings of anonymous old men feature rapid movements of the hand that spun webs of fine lines into broad masses of light and shadow (fig. 57).

In contrast to the compressed intensity of the oil sketch, a beautifully preserved drawing of a *Seated Old Man* shows Rembrandt using the brush as a tool for suggestion rather than description (no. 32).[10] His liberal application of dark wash over a quick, precise preliminary drawing in pen and ink resonates with other drawings believed to date from about 1639. The model's head is in almost full profile, and he wears a fur hat with large flaps. His heavy-lidded eyes give him a somewhat withdrawn expression. He clasps the arm of his chair with his right hand and holds a cane in his left. Due to his advanced age and exotic dress, the sitter has traditionally been identified as a rabbi, but Rembrandt's fantasy may be reaching into the remote times and places to be found in some of the historicizing dramas staged in Amsterdam at that time.[11]

In a manner similar to his etching practice (see nos. 20, 28), Rembrandt made a careful pen and ink study of the man's head and rapidly sketched his body, using fine lines for both. With heavier strokes of the pen, he emphasized selected features, such as the hands and principal drapery contours. With the brush, he added washes of varying density to give volume to and shadow the man's figure, his clothing, and his surroundings. Employing a technique seldom seen in his drawings but often seen in his paintings and inherent in his use of the etching needle, Rembrandt scratched lines through passages of wash to define the sitter's collar and to adjust the light on his right forearm. Though at first glance his use of line and wash may appear nonchalant, closer inspection reveals

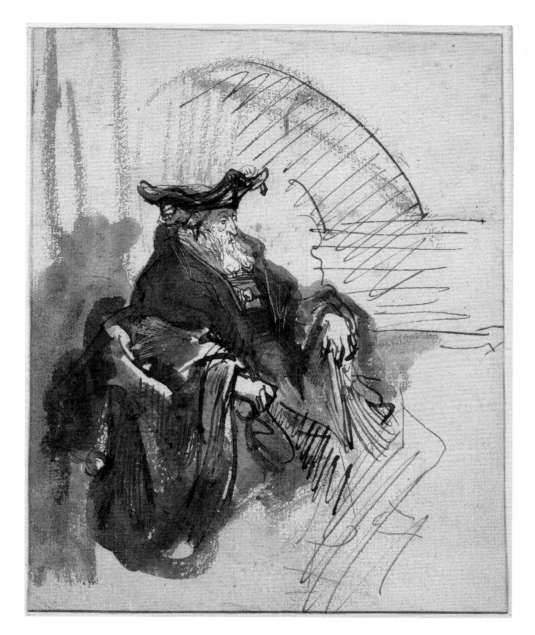

Seated Old Man, about 1639
Pen and brown ink, brown wash,
white watercolor, scoring
16.4 × 12.9 cm (6⁷/₁₆ × 5¹/₁₆ in.)
Collection Frits Lugt, Institut
Néerlandais, Paris

Rembrandt's precision and subtlety even while working at a fast pace. His gift for economy is visible in the cursory indications of the man's feet. A stroke or two of wash shades his forehead while his eyelids catch the light. Wash clearly indicates layered clothing as well as the man's bulging stomach, and a few broad strokes suggest his surroundings without fully defining them.

Until about a decade ago, this drawing was attributed to Salomon Koninck (1609–1656), largely on the basis of its similarity to one of his paintings. Koninck is not known to have worked directly with Rembrandt, but he often followed his lead in style and subject. Koninck apparently adapted this composition or a related work for his own use. In the recent critical study of drawings by Rembrandt and his circle, this is one of the rare instances of a well-known drawing being reassigned to Rembrandt.[12] Far more frequently, drawings long attributed to Rembrandt are reassigned to his followers.

The full beard, arched brow, flat cheekbones, and distinctive long, downward pointing nose suggest the possibility that the model shown seated in the drawing above posed again for a 1640 etching, *Old Man with a*

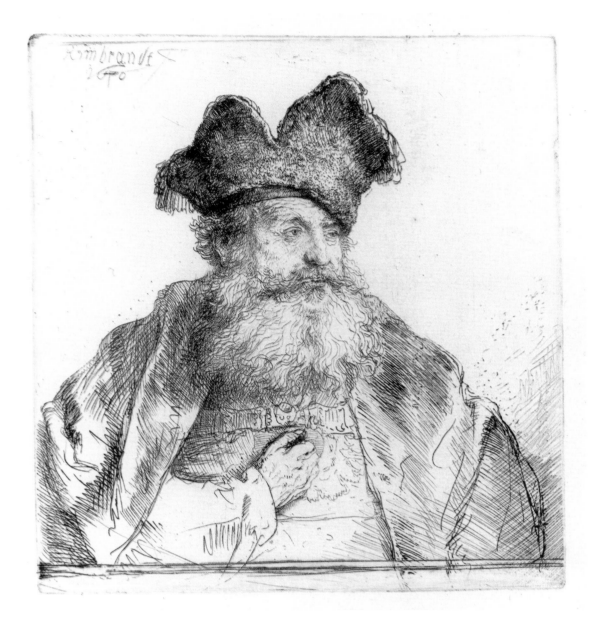

33
Old Man with a Divided Fur Cap, 1640
Etching and drypoint
B. 265, I
15.2 × 13.8 cm (6 × 5⁷/₁₆ in.)
The Fitzwilliam Museum, University
of Cambridge

Divided Fur Cap (no. 33). Among Rembrandt's fantasy portraits of old men, this is among the most fully developed. Shown in three-quarter profile from a low, close-up point of view, this patriarch could have stepped right from the pages of one of Rembrandt's beloved Bible stories. The cocked angle of his great fur hat accentuates his sharp-eyed gaze and sculptured features. Rembrandt's swift, confident handling of the needle is especially evident in the mantle covering the richly ornamented clothing. He added tiny, judicious strokes of drypoint with burr to throw the sparely drawn arm and hand into relief. Rembrandt's 1630s drawings of actors and his later print for the publication of the play *Medea* (no. 138) testify to his interest in the theater. The rhetorical bearing of this exotic figure invites the question as to whether this image too might be related to contemporary presentations on the stage.

A mid-1630s drawing, *Four Studies of Male Heads* (no. 34), recalls Rembrandt's etched sheet of four studies of one man's head (no. 29) in that both show the heads art-

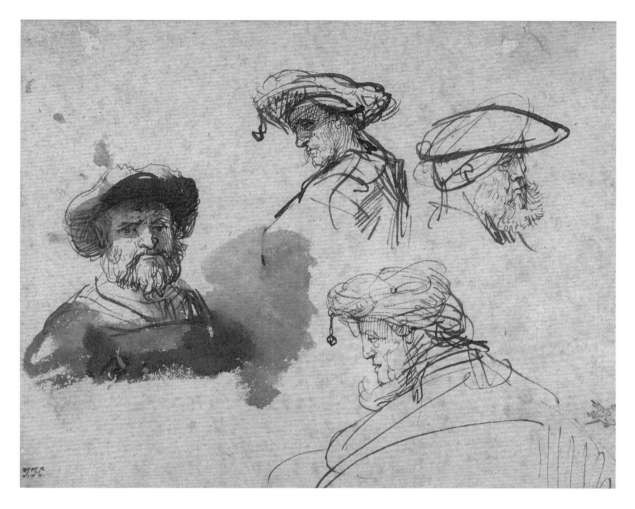

34

Four Studies of Male Heads,
mid-1630s
Pen and brown ink, brown
wash
Ben. 339
12.6 × 15.8 cm (4¹⁵⁄₁₆ × 6¼ in.)
Courtesy of the
Fogg Art Museum, Harvard
University Art Museums,
Cambridge, Massachusetts
Loan from Maida and George
Abrams

fully arranged and worked up to varying degrees of finish. In the present sheet, searching double contours in the headgear convey the sensation that Rembrandt made circular motions with his pen before accelerating into flourishes of zigzags and loops. The man at the upper right with an upswept beard is shown just to the top of his chest with no indication of his shoulders. Rembrandt tried two different solutions for the man's hat, settling on one with a bill over his forehead. The upper bodies of the other three figures are more completely suggested. At the center of the sheet are two turbaned men, the hulking lower one perhaps being the same model as the sketch to the right. Both turbaned men are drawn with supple, almost calligraphic lines. Despite the abbreviated handling, Rembrandt produced a remarkably concrete sense of the men's bodies. The figure at the left wears a beret or perhaps a turban. Freely and fully

modeled in a technique similar to the *Seated Old Man* drawing, the figure casts a strong shadow and persuades us of his presence. The adroit placement of wash allows a sliver of light to break the shadow on the darkened side of his face. Minute details, such as the specks of light around his left eye, greatly enhance his lively and arresting gaze. The combination of casual spontaneity and meticulous perfection typical of Rembrandt is also visible in the fine parallel pen strokes that shade the faces of all four of these rapidly sketched studies. Rembrandt drew many other sheets of similar studies, one of which is closely related in conception to the present example.[13] Though such sheets may have been used to instruct pupils in drawing technique,[14] there is also the distinct possibility that they were additionally—like the etched sketch plates—independent works, exercises for the artist's imagination. TER

NOTES

1. For a discussion of the term, including a survey of its history, see Dagmar Hirschfelder, "Portrait or Character Head? The Term *Tronie* and its meaning in the Seventeenth Century," in Van de Wetering et al. 2001, 82–90. Subcategories, such as "costume tronie" or "expressive tronie" are beginning to be introduced as well. See Bernhard Schnackenburg, "Young Rembrandt's 'Rough Manner,'" in Van de Wetering et al. 2001, 112–14.

2. *Self Portrait in Oriental Attire*, Paris, Musée du Petit Palais (Br. 16, Corpus A40), and *Man in Oriental Costume*, New York, Metropolitan Museum of Art (Br. 169, Corpus A48).

3. See for example *Christ before Pilate* (no. 49), *The Descent from the Cross* (B. 81), *The Ship of Fortune* (fig. 80, p. 255), *A Beggar Seated on a Bank (Self-Portrait)* (no. 25), and *The Artist Drawing from a Model* (no. 85).

4. For a summary of attempts to identify the sitter as a historical forebearer or contemporary of Rembrandt, see White and Boon 1969, 11, no. 23.

5. For example, Hendrick Goltzius's woodcut of *Mars, half-length* (B. 230) and his engraving of a *Standard-Bearer* (B. 125). See also Joaneath Spicer, "The Renaissance Elbow," in Bremmer and Roodenburgh 1991, 84–128.

6. Paris, private collection (Br. 433, Corpus A120).

7. The four *Oriental Heads* (B. 286–89). Rembrandt inscribed three of these with variations of the word "retouched" after his name. This notation is probably an acknowledgement of his use of Lieven's designs (B. 18, 20, 21, 26). His rethinking of the fourth image was so thorough that here he may have felt no need to acknowledge Lievens.

8. For example, etchings B. 292 and 304 and a painting in Innsbruck, Tiroler Landesmuseum Ferdinandeum (Br. 76, Corpus A29). This model was traditionally identified as Rembrandt's father, Harmen Gerritsz. van Rijn, who died in 1630, but he is probably someone else. He appears again in a seated portrait dated 1631 in the second state (B. 263). A Rembrandt drawing of a different old man is inscribed in a contemporary hand: Harman. Gerrits. van de Rhijn (Oxford, Ashmolean Museum; Ben. 56). This drawing is now often accepted as an authentic portrait of Rembrandt's father.

9. No. 60.

10. Van Berge-Gerbaud 1997, 9–10, no. 4.

11. For example, Joost van den Vondel's *Sofompaneas of Joseph in't hof*, performed in October 1638, and Abraham Kemp's *Van de moort van Sultan Osman*, performed in March 1639. See Schatborn and De Winkel 1996, 393.

12. For a Koninck attribution, see Sumowski 1979, 6: 3408–9, no. 1529. Koninck's painting, Turin, Galleria Sabauda (*Master and Workshop: Drawings and Etchings* 1991, 2:68, 1983–95, 3: 1648, no. 1124). For a Rembrandt attribution, see Peter Schatborn in *Master and Workshop: Drawings and Etchings* 1991, 2: 68, fig. 17c; and Schatborn 1995, 221–23.

13. Birmingham, Barber Institute of Fine Arts; Ben. 340.

14. Robinson 2002, 118.

35

Daniel and Cyrus before the Idol Bel

1633

A kind of mystery thriller featuring a high-stakes battle of wits, *Daniel and Cyrus before the Idol Bel* (no. 35) pits a virtuous young man against a corrupt gang of priests. In painting the tale, Rembrandt freely departed from the written version and from earlier visual renditions to underscore its psychological content. He created an image that allows viewers familiar with the story to exercise their own imaginations: the open-ended image invites them to speculate about the tale without being limited to the identification of a particular moment in the story, and the shadowy suggestiveness of the temple interior encourages viewers to imagine further splendors of exotic stuffs and rich metalwork. This small, jewel-like picture that might have adorned a collector's cabinet of art and rarities is broadly executed, but more finished than an oil sketch.

The Old Testament book of Daniel is sometimes supplemented with the apocryphal story of Bel (or Baal). Daniel, the expatriate Israelite prophet, was the treasured friend and advisor of Cyrus, the Persian king of Babylon. The Babylonians worshipped Bel, a colossal idol. Each day they brought Bel twelve bushels of flour, forty sheep and fifty gallons of wine. When Cyrus asked Daniel why he did not participate, he replied that he worshipped only the living God, not idols. Cyrus offered Bel's appetite as evidence of the idol's vitality, but Daniel laughed, pointing out that Bel was made of clay and bronze and could never eat anything. Angered, Cyrus summoned the seventy temple priests and laid down a challenge: if they could not explain who ate Bel's provisions they would die, but if they could show that Bel consumed them, then Daniel would be put to death. Daniel assented, and the priests told Cyrus to seal the chamber that night after the food had been laid out in order to prove that no one but Bel could have eaten it. After they departed and the food was in place, Daniel ordered his servants to scatter ashes in Cyrus's presence over the entire floor of the temple. After this was done, the door was closed, and Cyrus sealed it. In the morning, Cyrus broke the seal and opened the door. Seeing that the food was gone, Cyrus shouted Bel's praise. But once again Daniel laughed. Preventing Cyrus from entering, he pointed to the ash-strewn floor. Seeing the footprints of men, women, and children, Cyrus realized that he had been deceived by their entry through secret doors. Carrying out his threat, Cyrus had the priests as well as

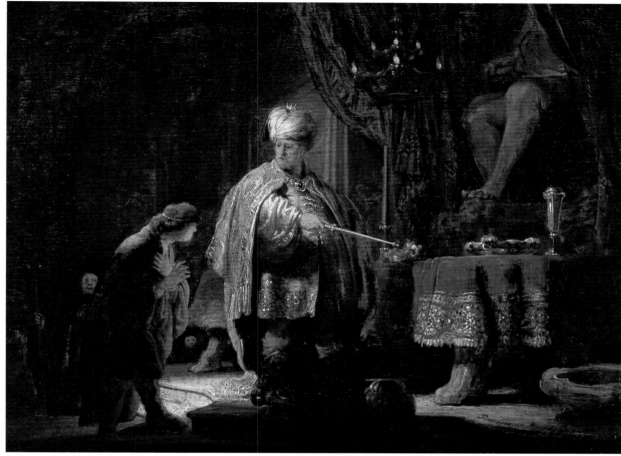

35
*Daniel and Cyrus before the Idol
Bel*, 1633
Oil on panel
Br. 491; Corpus A67
23.4 × 30.1 cm (9¼ × 11⅞ in.)
The J. Paul Getty Museum,
Los Angeles

REDUCED

their wives and children slain. He turned Bel over to Daniel who destroyed the idol and its temple.[1]

Few artists before Rembrandt had depicted this story. The best-known precedent would have been a 1565 series of Daniel prints designed by Maarten van Heemskerck.[2] Whereas Heemskeerck portrayed the scene as a cast of thousands in a vast space, Rembrandt distilled the story down to Daniel and Cyrus plus a couple of shadowy background figures who represent the priests. Rembrandt chose to focus on the psychological interaction between Daniel and Cyrus.

A band of light entering the murky chamber from the left directs the viewer's gaze from Daniel to Cyrus to the grand altar table at the idol's feet, richly draped in red. Cyrus turns to Daniel while pointing his glistening scepter toward the empty offering vessels. This could be any of several moments in the story: Cyrus defending Bel's vitality, Cyrus issuing the life-or-death challenge, or Cyrus believing that Daniel has been proven wrong.

Rembrandt emphasizes the danger of Daniel's posi-tion. Having to defend his beliefs against a much more powerful man, the modestly clad Daniel is shown in shadow on a lower step than Cyrus, whose opulent clothing glitters in the light. The text has a confident Daniel laughing at the absurdity of idolatry, but Rem-brandt portrays him as bending forward obsequiously, demonstrating his humility and perhaps also straining to assess the evidence before him. His gesture is guard-ed and tentative. Rembrandt has centered the narrative on the very real possibility that Daniel's beliefs could cost him his life. TER

NOTES

1. *Holy Bible* 1997, 177–78 (Apocrypha, Bel and the Dragon).

2. See New Holl. (*Maarten van Heemskerck*), part 1 nos. 226–35. Heemskerck made his drawings in 1564. Philips Galle engraved the plates published by Hieronymous Cock. The 1656 inventory of Rem-brandt's possessions indicates that he owned an album filled with all the works—in all likelihood prints and perhaps some drawings—of Heemskerck. *Docs.* 1979, 1656/12, no. 227.

36–38

The Childhood of Christ

1630

Three highly finished, miniaturistic etchings dated or datable to 1630 illustrate key episodes from the infancy and adolescence of Jesus.[1] The evangelist Luke refers briefly to the circumcising and naming of the child eight days after birth, but does not indicate where this took place (Luke 2:21). In the undated etching of the *Circumcision* from the 1630 Childhood of Christ group (no. 36), Rembrandt, following a centuries-old visual tradition, stages the event in a temple setting, as he had in *The Circumcision* print that is possibly his first etching (about 1626, no. 7). The fact that Mary, as well as Joseph, is present on the right, hands folded in prayer, is contrary to the Jewish tradition that required of a woman who had just given birth a long period of purification before entering the temple.[2]

In all three 1630 etchings Rembrandt was experimenting with varied configurations of space and light in order to evoke—even in such a small format—deep, illusionistic spaces of a grandeur appropriate to the events depicted. Here he has constructed with intertwining patterns of light and darkness, as well as a billowing cloud of incense, a spatial design that suggests the coiling spiral of a nautilus shell. It is typical of the startling combinations of Baroque pomposity and earthy realism that often characterize Rembrandt's art at this time that the tiny "pearl" at the center of this ornate, spiraling composition should be the head of the energetically squalling child.

The space of the 1630 *The Presentation in the Temple* (no. 37; see also the discussion of this etching under no. 1) is a double perspective divided into two halves cut at center by the great pillar before which Rembrandt placed Anna and the pointing angel: the space on the left recedes straight back, nearly whited-out by blinding daylight, while the right-hand space is a shadowy stairwell that ascends toward the throne of the high priest and a sliver of light visible through an opening in a draped archway. The space of the *Christ Disputing with the Doctors* (no. 38) pivots around an even more massive pillar or pier and is orchestrated by repeated circular rhythms.[3] At the far right, two distant figures, probably Christ's parents searching for their missing son, approach through a vaulted passageway. All three of the 1630 etched miniatures employ a dramatically darkened foreground to heighten the effect of their theatrical lighting. They are essentially tonal, nonlinear in con-

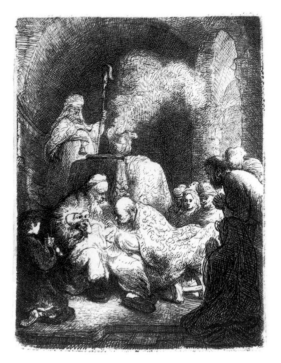

36
The Circumcision, 1630
Etching and drypoint
B. 48, only state
9 × 6.4 cm (3⁹⁄₁₆ × 2½ in.)
S. William Pelletier, Athens, Georgia

ception, using dense bundles and meshes of fine lines of varying strength (achieved by means of staged biting and rebiting of the plate with acid) to define broad masses of light and shadow.

Luke (Luke 2:41–51) tells the story of how Jesus, the wayward, disobedient twelve-year-old, escaped parental supervision in order to discuss religion with the learned doctors in the temple of Jerusalem. Christ and his parents had made their annual trip to Jerusalem for the Passover feast, but on the return journey the parents discovered that the boy was missing. After three days of searching, they found him engaged in a dialogue with the rabbis in the temple, amazing all present with his depth of understanding. When his parents questioned him as to why he had subjected them to so much anxiety, he impertinently answered that they should know that "I must be about my Father's business."

In the first state of *Christ Disputing with the Doctors* (no. 38) Jesus is a diminutive figure who stands, gesturing authoritatively, ringed about by the bulky seated figures of the teachers, who appear to listen attentively. Christ's figure is theatrically singled out by the beam of light that falls into the space from the upper left. In the second state, the shadows were strengthened to heighten their dramatic effect and to consolidate the mass of the group of rabbis at left. In the third state, Rembrandt made the radical decision to cut the copper plate down on three

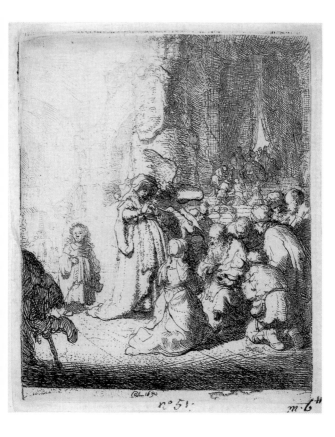

37
The Presentation in the Temple, 1630
Etching
B. 51, II
10.3 × 7.8 cm
(4¹/₁₆ × 3¹/₁₆ in.)
Thomas E. Rassieur
Collection

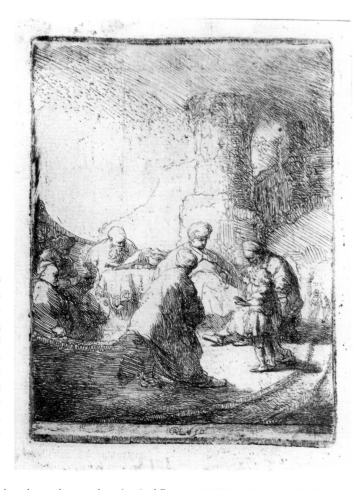

38
Christ Disputing with the Doctors, 1630
Etching
B. 66, I
10.8 × 7.8 cm
(4⁵/₁₆ × 3¹/₈ in.)
Lent by the
Trustees of the
British Museum,
London

sides (top, left, and bottom), reducing the open space at top and recomposing the doctors into a tighter group. There are now three rabbis behind the center table, the two added ones appearing to be engaged in a debate about what the precocious youngster is saying (fig. 58). In his early years as an etcher, Rembrandt frequently made changes to his plates by cropping them, cutting away strips of copper. He also did this with the 1630 *Presentation* discussed here (no. 37), but in that instance he merely removed a blank margin at the top of the plate rather than fundamentally rethinking the composition.[4]

Throughout his career Rembrandt had bursts of activity in which he pursued a particular subject in serial fashion, for example his many drawings and etchings of beggars and street people from the late 1620s and very early 1630s (see nos. 22–27). The three Childhood of Christ etchings of 1630 suggest a series in their approximate similarity of size, format, and conception, but were never actually issued as such. There are even two later, small, upright Childhood of Christ etchings that one might readily imagine as belonging to such a series, the twilight *Flight into Egypt* of 1633 (no. 109) and the nocturnal *Rest on the Flight* of 1644 (no. 110). CSA

NOTES

1. It is interesting to speculate about what may have inspired Rembrandt (other than his own active imagination) to execute these etched biblical miniatures, paintinglike in their tonal breadth and fullness of description. Some possible sources for Rembrandt, who was to become a dedicated print collector, are the virtuoso miniaturistic engravings of artists around Albrecht Dürer in Nuremberg in the first half of the sixteenth century (the so-called *Kleinmeister*, or "Little Masters," such as Hans Sebald Beham), the small devotional prints of the Wierix brothers in Antwerp (about 1600), the contemporary etched religious miniatures of the Lorraine printmaker Jacques Callot (died 1635), as well as small-scale illustrations in prayer books and bibles.

2. See Tümpel 1970, no. 44.

3. Ibid., no. 65. Tümpel notes that the organization of figures and space in this etching relates closely to the early Rembrandt painting, *Judas Returning the Thirty Pieces of Silver* (1629, Private collection, England, Corpus A15).

4. The beggar so radically cropped by the left edge of the plate tempts one to imagine a lost earlier state in which the composition extended further to the left, but that was probably not the case. For an example of radical cropping in a print by an earlier master known to Rembrandt, see Albrecht Dürer's early engraving (about 1496, B. 28) of the Prodigal Son dining in the barnyard among swine, in which a cow is cut in half by the left edge of the plate.

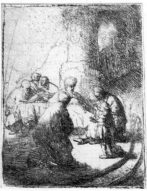

Fig. 58. *Christ Disputing with the Doctors: small plate*, 1630, etching, B. 66, III, 8.9 × 6.7 cm (3½ × 2⅝ in.), British Museum, London.

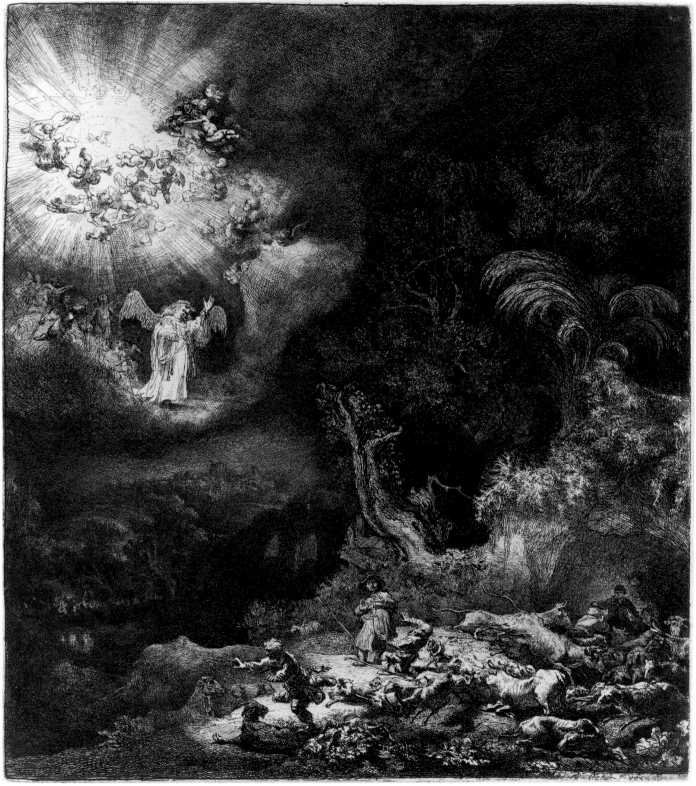

104 | THE ANGEL APPEARING TO THE SHEPHERDS

39

The Angel Appearing to the Shepherds

1634

The Angel Appearing to the Shepherds typifies Rembrandt's often frenetic, baroque compositions of the 1630s. An explosive blast of light in the night sky heralds the appearance of an angel announcing the birth of the Messiah. But the angel's admonition to "Be not afraid" has come too late, for the terrified herdsmen and their flocks run for cover or drop to their knees, stunned by the unexpected and wondrous vision. For centuries artists had illustrated this episode from the Gospel of Luke (Luke 2:8–14), but about 1600 it met with increasing popularity. The subject allowed Dutch printmakers to combine the familiar sight of herdsmen and flocks with visionary nocturnal effects. While adhering faithfully to the text, Rembrandt departed from artistic conventions by elevating our viewpoint rather than placing us on the ground near the shepherds. He envisions the event as a dynamic collision of heaven and earth.

Looking up, we see the angel standing on a cloud-bank that is as solid as a rocky ledge. Around the angel, untold numbers of cherubs emerge from the celestial mists. Above, many more tumble about like skydivers. At the very center of the blinding flash we can barely perceive the radiant dove of the Holy Spirit. Below, in a harsh raking light, we see the frightened men and their panicked beasts. The trees above the embankment seem equally agitated. But the distant landscape remains peaceful. The figures camping out around a fire on the opposite riverbank seem unaware of the commotion: the heavenly news is meant exclusively for the shepherds.

Surviving trial proofs reveal that Rembrandt first etched and drypointed on the plate a detailed compositional sketch.[1] In developing the plate, he first brought the dark diagonal band of landscape and sky that divides the two brightly lit zones to a high degree of finish. Full of quiet mystery and soft transitions, the landscape is inspired by fashions current during Rembrandt's childhood;[2] yet the rich deep blacks, extended tonal range, and nocturnal glow are virtually without precedent in his own prints. Close examination reveals that this is anything but a simple etching. Not only did he supplement etching with engraving, but much of the gray tone, such as that seen in the clouds, is produced by minute specks of ink printed from small pits etched into the surface of the copper plate. It appears that Rembrandt had already learned to create, intentionally and with a degree of control, passages of granular etched corrosion similar to that

which had accidentally marred earlier works such as *Peter and John at the Gate of the Temple* (no. 10). These gray tones optically alter our perception so that the areas where the blank paper shows through appear extraordinarily bright. The line work is equally unconventional. Irregularly drawn with needles of varying width and crisscrossing one another in an extraordinarily fine mesh, Rembrandt's lines achieve the depth and brilliance of engraving while avoiding its distracting and decorative systematic patterns. The success of this dazzling print initiated a quarter-century of exploration of nocturnal effects in his graphic art. Unfortunately, the extremely fine etched lines and the delicacy of the granular pitted passages caused the plate to break down quickly under the pressure of the printing press. Few impressions of this print convey the full tonal range and subtle nuances seen in the example shown here. TER

NOTES

1. London, British Museum, and Dresden, Kupferstichkabinett der Staatlichen Kunstsammlungen. Reproduced in Amsterdam/London 2000, 130, no. 21.

2. In the 1610s, Hendrick Goudt had translated a few of the small, dark, jewel-like paintings of Adam Elsheimer into subtle, glowing engravings (see Goudt's *Flight into Egypt*, fig. 70, p. 182.) Later in the same decade Jan van de Velde made some convincing night scenes in engraving and etching (reproduced in Ackley *Printmaking* 1981, 102, no. 61).

40–46

Christ's Passion

1630S AND 1640S

Drawings, etchings, and oil sketches from the mid-1630s to the mid-1640s that illustrate significant episodes in the narrative of Christ's Passion illuminate Rembrandt's commitment to imagining afresh these often-depicted events. The cycle of Christ's Passion, from the Last Supper with his apostles through his arrest, trial, crucifixion, burial, and resurrection is central to the Christian story. During the 1630s, from about 1633 to 1639, Rembrandt was occupied with the execution of five Passion paintings for the court of the stadholder, Frederik Hendrik, in the Hague. These were initially commissioned through Constantijn Huygens, Frederik's secretary, the art lover and humanist who so profoundly admired the young Rembrandt's work. In 1633 *The Raising of the Cross* and *The Descent from the Cross* were delivered, in 1636 *The Ascension,* and in 1639 *The Entombment* and *The*

facing page

39

The Angel Appearing to the Shepherds, 1634
Etching, engraving, and drypoint
B. 44, III
26.2 × 21.8 cm (10⅜ × 8⅝ in.)
The Pierpont Morgan Library, New York

Resurrection. These paintings are similar in size and share an upright, vertical format with arched top, and are today in the collection of the Alte Pinakothek, Munich. They were highly prestigious commissions but were not necessarily Rembrandt's happiest or most successful productions. In 1646 two paintings of episodes from the childhood of Christ were added to the group, an *Adoration of the Shepherds*, also in Munich, and a lost *Circumcision* known only from a copy in the museum in Braunschweig.[1]

In certain Rembrandt drawings of the 1630s, the speed and insistent curvilinear rhythms of the marks made with quill pen and brush are precise equivalents for the intensity of movement and emotion expressed. The Berlin drawing *Christ Carrying the Cross* (no. 40) is a superlative example. Christ bearing his own cross to his execution is mentioned only by the evangelist John (John 19:17). The other three evangelists refer to a certain Simon of Cyrene who was dragooned into carrying the cross for Christ. The pathos of Christ collapsing beneath the weight of the cross is part of a Catholic devotional tradition (the Stations of the Cross) in which the worshipper

is asked to reexperience Christ's sufferings step by step. It had a long pictorial tradition. The drawing, which appears to have been cut on all sides, particularly at top, is generally dated to the mid-1630s.[2] Extremely broad and suggestive in its execution, it provides significantly greater detail only at the two critical points of narrative and emotional focus: the head of Christ, and at right, the face of the collapsed and swooning Mary, his mother. She is the focus of three figures who support her, swoop to her aid, or fall back in consternation. A dark smudge of wash above the fallen figure of Mary, perhaps spontaneously dabbed on with a finger, insures that our eye gravitates to this crucial emotional center of the design. Luke (Luke 23:27) relates that "there followed him a great company of people, and of women, which also bewailed and lamented him." Behind Christ two cursorily sketched figures appear to struggle with the weight of the cross. Above them appear the remnants of a mounted horseman cut off by the top edge of the sheet.

In the left foreground a powerful and boldly rendered figure moves parallel to the fallen Christ and his attendant followers. Initially laid in in pen and then reworked

40
Christ Carrying the Cross, mid-1630s
Pen and brown ink, brown wash
Ben. 97
14.5 × 26 cm (5¹¹⁄₁₆ × 10¼ in.)
Staatliche Museen zu Berlin,
Preussischer Kulturbesitz,
Kupferstichkabinett

41
Calvary, mid-1630s
Pen and brown ink and brown
wash, touched with white
watercolor, with section replaced
and redrawn by Rembrandt
Ben. 108
21.8 × 17.9 cm (8⁹⁄₁₆ × 7¹⁄₁₆ in.)
Staatliche Museen zu Berlin,
Preussischer Kulturbesitz,
Kupferstichkabinett

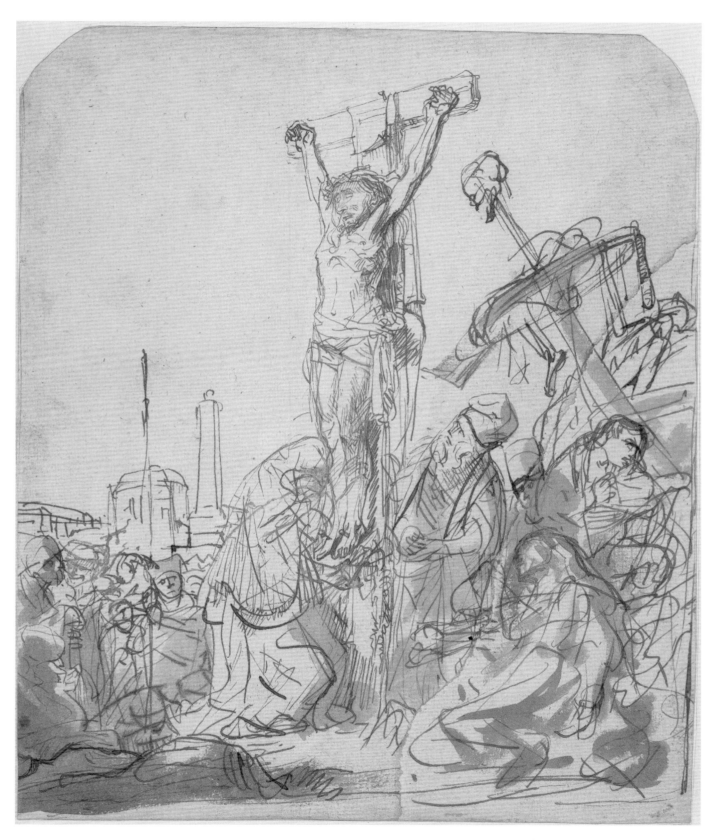

with the brush in a bold shorthand, the figure—possibly an executioner or workman—carries on his shoulder a spadelike tool and a basket.[3] This heavily trudging figure, and his trailing shadow with its deeper accent of black pigment, not only serve to create the space of the composition and to suggest the fall of light, but also lend to the halted procession a fatalistic sense of inevitable forward motion.

In the Berlin *Calvary* drawing from the mid-1630s (no. 41) Christ's cross is isolated: it rises above the surrounding tumult of mourning followers and curious onlookers like a devotional image. The crosses of the two thieves who were crucified to the left and right of him are not visible. Only Christ's figure is fully in focus and carefully rendered in detail. Though he has clearly expired, the final spear wound in his side, one still senses tension and strain in the pinioned arms and the bony ribcage. The stately buildings of Jerusalem are visible in the distance at left. Around the foot of the cross, the agitation and sorrow of Christ's followers is expressed not only by their postures and gestures but also in the chaotic tangle of the lines. At left a heavily draped Mary Magdalene bends in sorrow over Christ's pierced feet. To the right an older bearded man—most likely Joseph of Arimathea, a wealthy follower of Jesus who asked Pilate for the body so that he might provide a proper burial—looks up at Christ on the cross. To the right we see the collapsed body of the mother of Christ and behind her, the beloved disciple John into whose care he commended his mother (John 19:26–27) wringing his hands in despair. Behind them the bodies of executed criminals, one of them broken on a wheel, lend a macabre contemporary realism to this place of execution known as Calvary, or Golgotha, the "place of the skull" (John 19:17). Such wheels with the exposed bodies of malefactors that served as warnings to lawbreakers were common sights on the outskirts of seventeenth-century Dutch cities.

At the top corners a later hand has cut the sheet, creating the depressed arch shape that Rembrandt so often favored. But a more radical change was made by Rembrandt himself: at right, apparently dissatisfied with his initial ideas, the artist diagonally ripped away a sizeable piece of the sheet, replacing it with a new piece of paper and reworking the figures of Mary and John. This phase of rethinking involved the addition with the brush of impetuous broad strokes of darker wash over scribbled linework on the figure of the swooning Virgin and in the lower left foreground.

The removal of Christ's body from the cross after his execution by crucifixion, the subject traditionally known as the Descent from the Cross, is scarcely mentioned by

the evangelists. Luke, referring to Joseph of Arimathea's claiming of the body from Pilate, merely states (Luke 23:53): "And he took it down . . ." The pictorial tradition for this subject in the late Middle Ages, the Renaissance, and later is, however, a particularly vital one, offering artists not only an opportunity for pietistic expression but also a chance to display their inventiveness with the representation of the human body in action. For Rembrandt the most conspicuous treatment of the subject would have been the *Descent* that the internationally celebrated painter Peter Paul Rubens (1577–1640) painted in 1612 for an altarpiece for Antwerp Cathedral. This painting was reproduced under Rubens's direction in an engraving by Lucas Vorsterman in the 1620s.[4] The Descent

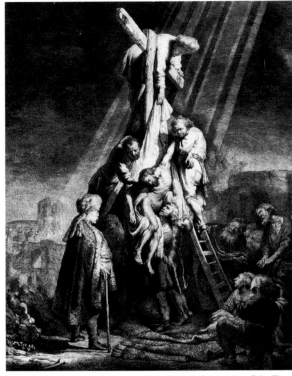

Fig. 59. *The Descent from the Cross*, 1633, etching and engraving, B.81, II, 52.6 × 41 cm (20¾ × 16⅛ in.), Museum of Fine Arts, Boston, Gift of Mrs. Lydia Evans Tunnard in memory of W. G. Russell Allen.

was, of course, one of the subjects Rembrandt painted for the court in The Hague. He also produced about the same time in 1633—most probably in collaboration with the Leiden etcher Johannes van Vliet, who had reproduced some of his early paintings as etchings—a large, densely worked etched and engraved plate that was a free variation on the painting (fig. 59). This printed "painting" meticulously translated into black and white may not appeal to modern taste, but it was quite popular in the seventeenth century and seems to have achieved Rembrandt's presumed goal of, like Rubens, making his painted work better known through a print.

The etching and drypoint of the *Descent* dated 1642 (no. 42) provides the maximum contrast with the elaborately worked-up collaborative *Descent* print of 1633. Except for the conventional diagonal rays of divine light falling into the scene from the left, it seems at first glance almost shockingly sketchlike and casual in its presentation of the sacred subject as a real event. One must observe, however, that even in the context of the grandiose pictorial rhetoric of the 1633 print Rembrandt was engaged in a brutally realistic way with the physical problem of dealing with the slackness and sagging weight of Christ's tortured and dead body: this was not

the ample, smooth, heroic musculature of Rubens's dead Christ. In the lightly etched 1642 print, one of Christ's arms hangs limply, already freed, while a workman on a freestanding ladder is impassively engaged in extracting the spike that still secures the other hand with a pair of large pincers. A cloth looped under Christ's arms and tugged on by men behind the cross supports the slack weight of Christ's body. The print is one of a number of etchings by Rembrandt executed in the period 1641–48, landscapes as well as figural subjects, that are lightly drawn and etched and take full advantage of the pictorial potential of the white of the paper. These etchings translate the openness, freedom, and power of suggestion of Rembrandt's drawings into the printed image. Here, as is particularly evident in this very early impression, the image is enriched by a light grayish film of ink left over the entire surface of the plate and by the unusual freshness of the drypoint burr in the foreground. These darker foreground details fortified with drypoint burr not only add greater spatial dimension but are central to the devotional and symbolic meaning of the subject: at left the fainting mother of Christ supported by another woman, at center a skull and bone, and at the right the crown of thorns on a salver.

One of the aspects of Rembrandt's art that is particularly appealing to the modern sensibility is his willingness to share with the viewer the visible traces of the artist's working process, whether transparently layered changes in his drawings or radical cropping or reworking of his copper plates in his etchings. We have already discussed how he tore off a corner of the Berlin *Calvary* drawing (no. 41) and replaced it with new work on new paper, but one of the most dramatic examples of Rembrandt's search for the most expressive solution is to be found in two closely intertwined works, the mixed media drawing in the British Museum, London (no. 43) and the monochrome oil sketch in the National Gallery, London (no. 44). Both represent Christ's followers lamenting or mourning over his body at the foot of the cross. The Lamentation as a subject is not directly taken from the evangelists' account of the events surrounding Christ's crucifixion, but is a devotional image with a strong pictorial tradition. It is usually staged around Christ's tomb rather than at the foot of the cross. Here Christ's limp body is sprawled across his mother's lap as in a devotional Pietà image, but it is a Pietà seen in a realistic narrative context. While several of Christ's followers seek to aid or comfort the unconscious Virgin, Mary Magdalene embraces Christ's feet.

It has been observed that one of Rembrandt's characteristic approaches to the depiction of biblical subjects

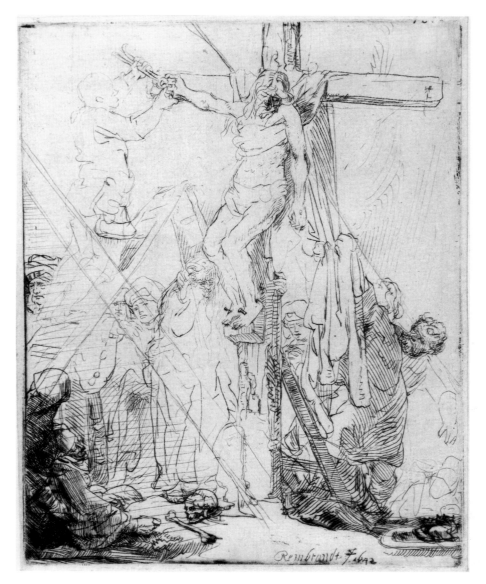

is to combine, as here, the narrative and the devotional in a single image. With specific reference to the National Gallery oil sketch, it has been suggested that within this one image, Rembrandt was alluding to three episodes from the Passion: the Descent from the Cross, the Lamentation and, possibly, the Entombment. In the right background, we see a figure who may be Joseph of Arimathea, head bowed, asking Pilate, who is mounted on horseback, for the body of Christ.[5] This almost medieval tendency to suggest different moments in the story in a single scene is a familiar aspect of Rembrandt's religious narratives.[6] It is a significant feature of Rembrandt the literary artist and dramatist. Rembrandt's stress on the emotional suffering of Christ's mother is,

42

Descent from the Cross (a sketch), 1642

Etching and drypoint

B. 82, only state

14.9 × 11.6 cm (5⅞ × 4⁹⁄₁₆ in.)

Lent by the Trustees of the British Museum, London

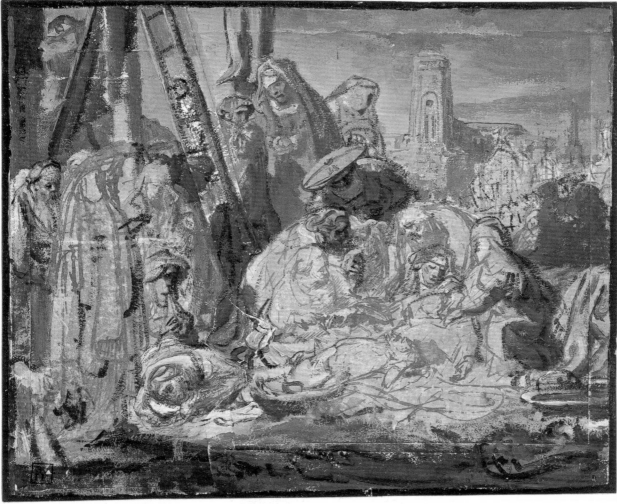

43

Lamentation at the Foot of the Cross,
1634–35
Pen and brown ink and brown
wash, red and perhaps some black
chalk, reworked in monochrome
oil paint; sheet made up of cut
sections of paper
Ben. 154
21.6 × 25.4 cm (8½ × 10 in.)
Lent by the Trustees of the British
Museum, London

as we have seen, a recurring theme of his dramatic inventions on the theme of Christ's Passion in this period.

Both drawing and oil sketch are today generally dated to the period 1634–35. Both were begun on paper and both involve the use of cutting or tearing of the sheet in order to facilitate rethinking and reworking of the composition. The oil sketch has a particularly complicated history: first a sketch was executed in oil on paper, next the sheet of paper was irregularly cut or torn and mounted on canvas and further worked up in oil by Rembrandt; and, lastly, additional pieces of canvas were added at top and bottom in Rembrandt's studio and mounted on the oak panel with rounded upper corners that we see today. These added strips of canvas were apparently prepared with a ground characteristically used by Rembrandt and then varnished in his studio but left blank. The final non-Rembrandt phase in the evolution of the work involved

the addition of new passages in oil paint by a coarser hand on the added strips at top and bottom and along the left edge (including the crossbar of the cross of the Good Thief facing us in the light at center and the whole figure of the Bad Thief in shadow at left). It is not clear whether these cruder additions from another hand were made in Rembrandt's studio or outside it, but they were in any case complete by 1730 when Bernard Picart made an etching reproducing the painting in its present state.

The drawing, executed in a combination of pen and wash in brown ink, red chalk, and gray and brown oil paint has a complex relationship with the National Gallery painting.[7] It began as a sketch in pen and ink, was extended by mounting on a slightly larger piece of paper, then recomposed by a zigzag cut through the left half from top to bottom and then remounted on a larger sheet of paper, the left piece lower than the right, and

a gap left between them. In the diagonal upper portion of this gap Rembrandt executed the ladder leaning against the right side of the cross.

The central figural groups in the two works are essentially the same but there are many variations in the auxiliary figures and in the city view in the distance. Those who have closely studied the dizzyingly complex relationship between the two works agree that there is an extremely complicated back-and-forth interchange between them in the course of their creation. For example, the ladder mentioned above, which fills the gap in the cut sheet of the drawing, corresponds in the oil sketch to a cutout in the original sheet of paper that accommodates the addition of the corresponding ladder. The distinctive churchlike tower in the drawing is no longer visible in the oil sketch but is detectable in the x-ray of the painting. Even when we imagine away the somewhat clumsy additions by the later hand, it is obvious that the oil sketch is a more finished work, whether with respect to its execution in a single medium, the spectrum of grayed colors that subtly suggest full color, or the powerful pool of light that bathes the central group.

It is speculated that a number of Rembrandt's oil sketches of the 1630s, in addition to the National Gallery, London's monochrome oil on paper sketch of 1634 (no. 48) that served as a model for the collaborative etching of 1635–36 (no. 49), may have been intended as models for similar collaborative reproductive prints.[8] This theory is currently popular, but there is no evidence that such prints were in fact carried out. The *Lamentation* drawing and oil sketch could equally well be considered to be studies for a Passion painting for the court in The Hague that was never executed. To complicate such speculations further there is the instance of the large finished drawing of *Christ and His Apostles* in the Teyler Museum, Haarlem, executed in a combination of drawing media—including a cut-out correction—that is fully signed and dated 1634. This drawing has also been proposed as a model for an etching, but is more probably a rare instance of a drawing treated as an independent work of art suitable for framing on the wall.[9]

The small signed, but not dated, etching of *Christ Carried to the Tomb* (no. 45) relates to the 1642 *Descent* etching discussed above in its sketchy execution, light tonality, and suggestive use of white paper, but it is more firmly structured and formal in its pictorial organization. It relates in style to prints from the period 1642 (*The Raising of Lazarus*, no. 129) to 1645 (*The Rest on the Flight*, no. 111) but the usually assigned date of about 1645 is probably correct. The subject is an original variation by Rem-

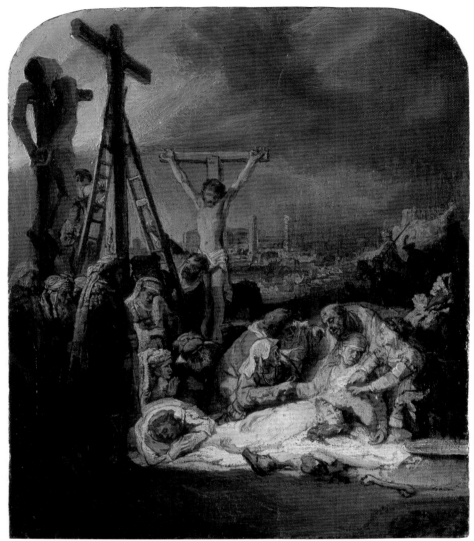

brandt on the traditional themes of the Lamentation and the Entombment. It shows a stately funeral procession of Christ's quietly sorrowing followers accompanying the stretcher with Christ's body to the cave at left. The compact, friezelike funeral cortège is inserted almost architecturally into the print's squarish format and its rationally constructed daylight landscape. Yet beneath the hushed formality of the scene Rembrandt's pragmatic imagination is ingeniously at work on the problem of transporting the dead weight of the body: the four stretcher bearers clutch strips of cloth that loop around their shoulders and pass under the stretcher to support it. At the left, in the mouth of the rocky tomb that was

44
Lamentation at the Foot of the Cross, 1634–35
Oil on cut paper, mounted on panel
Br. 565; Corpus A107
31.9 × 26.7 cm (12⁹⁄₁₆ × 10½ in.)
The National Gallery, London

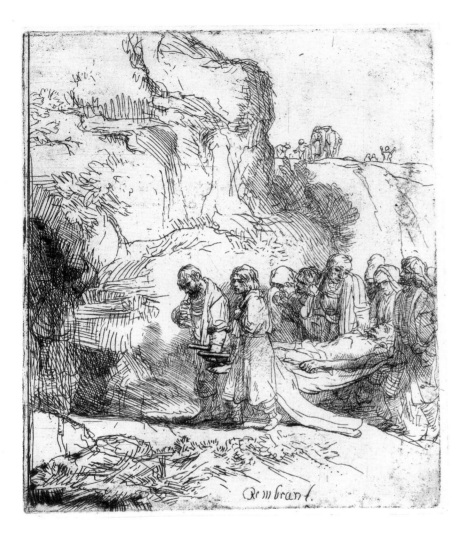

45

Christ Carried to the Tomb, 1645
Etching and drypoint
B. 84, only state
12.9 × 10.7 cm (5¹/₁₆ × 4³/₁₆ in.)
The Art Institute of Chicago
The Clarence Buckingham
Collection

provided by Christ's wealthy secret adherent, Joseph of Arimathea, Rembrandt originally drew figures of women mourners that he then half-obscured with heavy cross-hatching. A few touches of drypoint burr, visible only in early impressions, add weight and dimension to the foreground at lower left.

The Glasgow *Entombment,* a monochrome oil sketch on oak panel (no. 46) stands out among Rembrandt's oil sketches because of its extreme fluidity of execution. It is essentially a study of artificial illumination in profound darkness and like the 1654 *Entombment* etching (nos. 155–157) explores metaphorically as well as realistically the extinguishing of the bodily life of Christ, the "Light of the World." Generally dated in the 1630s, it is sometimes regarded as a stage in the evolution of the *Entombment* painting for Frederik Hendrik of 1636–39 (Alte Pinakothek, Munich) or even as a variation on that paint-

ing.[10] The Rembrandt Research Project's dating of it to 1633–35 seems in part based on their notion that, like the other monochrome oil sketches, it must be the model for an etching project never carried out.[11] Perhaps, like many of Rembrandt's biblical narrative drawings that are free inventions in their own right and not necessarily preparatory to a work in another medium, it was created for its own sake rather than for another purpose.

All four evangelists describe Joseph of Arimathea's claiming of Christ's body, his wrapping of the body in fine linen, and its burial in a rock-cut tomb. Here we see the body of Christ swathed in linen, supported under the arms by Joseph of Arimathea, being carefully lowered into the sepulchre. A glowing torch, held by a woman and masked by her hand, throws a spotlight on the principal figures, while the dimmer illumination of a lantern picks out a shadowy cluster of followers on a

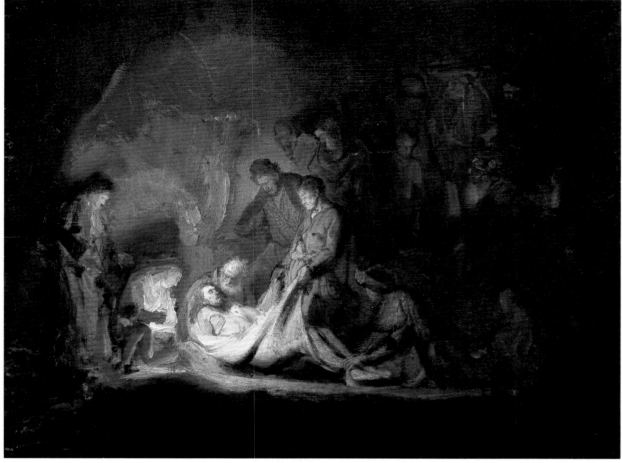

46
The Entombment, 1630s
Oil on panel
Br. 554; Corpus A105
32.1 × 40.3 cm (12⅝ × 15⅞ in.)
Hunterian Art Gallery,
University of Glasgow

ledge at the upper right. The principal figures, those grouped immediately around the body of Christ, are not only more dramatically illuminated but their facial features and expressions are more defined than those of the witnesses in the shadows. This is accomplished with the utmost subtlety, providing an emotional center and point of narrative focus for one of Rembrandt's most eloquent—and seemingly effortless—explorations of the dialogue of darkness and light. CSA

NOTES

1. Schwartz 1985, 67, 72–77, 106–18, 238–9.

2. *Master and Workshop: Drawings and Etchings* 1991, 35–37, no. 5.

3. Schatborn believes this figure to be Simon of Cyrene; see *Master and Workshop: Drawings and Etchings* 1991.

4. Reproduced in Amsterdam/London 2000, 132, no. 22, fig. b.

5. *Corpus* 1982–89 3: 89–100; and Bomford et al. 1988, 66–73.

6. Tümpel 1970, "Introduction."

7. Royalton-Kisch 1992, 53–55, no. 12.

8. See Ernst van de Wetering, "Remarks on Rembrandt's Oil-sketches for Etchings," in Amsterdam/London 2000, 54–55.

9. See *Master and Workshop: Drawings and Etchings* 1991 38–40, no. 6.

10. *The Entombment* painting in the Alte Pinakothek is Br. 560 and Corpus A126.

11. See Schwartz 1985, 117; and *Corpus* 1982–89 3: 65–69.

47

The Incredulity of Thomas

1634

An essay in mystical light, *The Incredulity of Thomas* (no. 47) dramatizes one stunned apostle's moment of recognition that Christ has indeed risen from the dead. While heavenly rays descend from the upper left, a burst of radiance emanating from Christ bathes the surrounding figures in light. This painting is one of Rembrandt's many depictions of the events occurring between Christ's resurrection and his ascension into heaven. He painted the almost square panel in 1634 when he was engaged in executing a number of paintings of Christ's Passion for the court of the stadholder, Fredrik Hendrik, in The Hague. The prestigious project seems to have stimulated work on images with related themes. At the same time Rembrandt was also working with the Amsterdam art dealer Hendrick Uylenburgh, whose Mennonite clientele may have influenced Rembrandt's choice of subject. In developing his composition, Rembrandt departed from artistic tradition to arrive at a highly original solution, rethinking central features even at the last minute.

The story of Thomas is the culmination of the gospel of John, a book written with the stated purpose of converting the reader to belief in Christ as the son of God (John 20:19–31). The evening of the Resurrection, Christ miraculously appeared to his apostles who, in fear of the religious authorities, had gathered in a closed room. The apostle Thomas was, however, absent. When the other apostles reported the wonders they had seen, Thomas replied that he would not believe until he himself had felt Christ's wounds and thrust his hand into the one made in Jesus' side by a Roman soldier's spear. Eight days later, the apostles once more gathered in a closed room, this time with Thomas present. Christ miraculously appeared again and invited Thomas to place his hand on and in his wounds in order to overcome his doubts. Thomas then acknowledged Christ as his Lord and his God.

In Rembrandt's painting, Christ lifts his robe to encourage the skeptical Thomas to thrust his hand into the spear wound. The stunned apostle recoils with a shock of recognition. The dynamic burst of light that penetrates and dispels the darkness signals the moment of revelation. The figures in the room are the ten other apostles (the treacherous Judas having hanged himself in remorse for having betrayed Christ), the Virgin Mary with a hood, and the more sumptuously dressed Mary Magdalene. Though John does not mention the presence of the two women, biblical text and tradition identifies them as the first to have seen the risen Christ.[1] The followers respond to the central event with gestures and expressions of amazement, awe, and piety. Intense emotion, theatrical lighting, and compositions crowded with figures are characteristic of many of Rembrandt's narrative paintings of the 1630s, especially the Passion paintings for Fredrik Hendrik.

Rembrandt's painting technique reinforces the dual nature of Christ as man and god. He applied thin layers of paint in the darker parts of the image. In contrast, the bright parts, especially Christ and his drapery, are rendered in a thicker paint having much more body. Thus, while Christ is the source of immaterial light, he also has the strongest material presence of any figure in the painting.

In depicting this scene, Northern European artists usually showed Christ seizing Thomas's wrist to insert

REDUCED

47

The Incredulity of Thomas, 1634
Oil on panel
Br. 552; Corpus A90
53.1 × 50.5 cm (20⅞ × 19⅞ in.)
The Pushkin Museum of Fine Arts, Moscow

the disciple's hand into the spear wound.[2] X-rays of this painting suggest that Rembrandt began with this same motif but then reworked the figure of Thomas so that he starts back in recognition before the unexpected, miraculous sight.[3] In so doing, Rembrandt may have been adhering more closely to scripture, for John does not in fact mention Thomas actually touching the wounds. Christ underscores the role of sight, saying to Thomas, "because thou hast seen, thou hast believed: blessed are they that have not seen, and yet have believed" (John 20:29). At the lower right, the figure of the young apostle John, the most faithful of the disciples, literally embodies the second half of Christ's statement as he slumbers on through the moment of revelation.

Hendrick Uylenburgh, the Amsterdam art dealer with whom Rembrandt worked at this time, was a Mennonite. The earliest recorded owner of this painting, Maria Rutgers, was the widow of a Mennonite merchant.[4] In the sixteenth century, the Mennonites emerged as a radical offshoot of the Lutherans. They rejected salvation through the baptism of infants in favor of a voluntary declaration of faith by adult believers. The archetypal doubter, Thomas, was finally convinced of the divinity of Christ and publicly affirmed his belief.

Two decades later, Rembrandt would depict a closely related subject in his 1656 etching, *Christ Appearing to the Apostles* (no. 152). Placing the burden of the narrative on a more intense explosion of mystic light, he muted the melodramatic responses of Christ's followers to produce an even more moving and spiritual work of art.
TER

NOTES

1. John 20:14–17 recounts Christ's appearance to the Magdalene. His appearance to his mother is not in the scriptures, but a widespread belief from the early days of Christianity held that he visited her in her home even before he revealed himself to the Magdalene. The story entered the literary canon in Pseudo-Bonaventure's *Meditationes*, composed in the late thirteenth century. See Panofsky, 1953, 262–63.

2. Spicer and Orr et al. 1997, 143–45. For a summary of previous images of the subject, see Bolten 1981, 17–19, note 6.

3. *Corpus* 1982–89, 2: 470–71, 476.

4. *Corpus* 1982–89, 2: 477.

48–49
Christ before Pilate
1634–1636

In the early 1630s Rembrandt received a prestigious commission to paint scenes of Christ's Passion for Stadholder Frederik Hendrik. It appears that the artist attempted to capitalize on this achievement by creating unusually large and elaborate prints, *Christ before Pilate* (no. 49) and *The Descent from the Cross* (fig. 59, p. 108), related to those paintings. Whether initiated by Rembrandt or by a publisher, the making of these prints was clearly intended to emulate the print-publishing juggernaut that had spread the fame and filled the coffers of Peter Paul Rubens during the two previous decades. Rembrandt seems to have prepared for the undertaking with great care, for *Christ before Pilate*, his largest print, is also his only print for which a full-scale model in the form of an oil sketch is known (see no. 48). He also inscribed the bottom of the print, *cum privile*, "with privilege," which claimed that he had copyright protection, perhaps because he sensed the commercial value of his ambitious many-figured composition.[1]

Much admired in the eighteenth century, *Christ before Pilate* fell from favor in the mid-nineteenth century as suspicions arose that someone else had etched much of the image. Connoisseurs have sporadically hazarded opinions about the genesis of the plate. Although no scenario has been conclusively proven, considerable evidence points to collaboration between Rembrandt and Jan (Johannes) van Vliet.[2] This Leiden printmaker's independent etchings were somewhat coarse and pedestrian, but he was capable of producing impressive prints when working in conjunction with Rembrandt. Unfortunately, questions surrounding the execution of the plate have largely overshadowed consideration of the originality of Rembrandt's conception.

The seed of Rembrandt's invention was the account of Christ's trial in the gospel of John (John 18–19). Both the Jewish priests and the Roman procurator Pilate find themselves in a political predicament. The Jewish authorities want to have Christ put to death but do not have the lawful power to execute him. Pilate has the authority to order the execution but believes Christ to be innocent. In the print, both parties contend with political forces. Pilate has to appease an unruly band of heavily armed soldiers who are turning persecution into a sport. They have already crowned the half-naked Christ with thorns, draped him in a royal robe, and mocked him as King of the Jews. The priests have to placate a vast mob in search of a scapegoat.

As a central episode in the New Testament, the story had often been depicted in prints and paintings, but few artists had instilled the scene with so much unbridled energy and theatrical intensity. Rembrandt dramatizes the event as grand opera with a cast of thousands. Christ stands at the apex of a great pyramid of humanity. He is surrounded by soldiers dressed in costumes from an improbable mixture of times and places. Below, the palace courtyard is so crowded that spectators scramble up the imperial monument while soldiers repel those who press toward the dais. In the lower foreground a circle of roguish-looking characters appear to conspire. As viewers, we feel as though we are on the stage, halfway up the steps, watching from the wings. We have a direct view of the central conflict. In their attempt to persuade Pilate to accept the rod of judgment, the priests beg, argue, and bully.[3] As he so often does in the 1630s, Rembrandt emphasizes the physicality of the confrontation, as one man seizes hold of Pilate's mantle. Pilate stands, stooping under the weight of his dilemma. With one hand he attempts to fend off the responsibility being thrust upon him, and with the other he appears to signal Christ's innocence.

From 1634, when he made the oil sketch, until 1636 when the plate reached its published form, Rembrandt worked sporadically on the project. Considerable evidence points to the participation of a collaborator; yet, Rembrandt remained the guiding force and also a hands-on participant. Although the composition remained nearly unchanged from sketch to published print, Rembrandt reassessed countless details along the way. He probably painted the sketch for the specific purpose of providing guidance to another printmaker. The composition is so complex and the figures so expressive that the oil sketch may not have been Rembrandt's first step in the development of his ideas. There may have been one or more preliminary drawings, now lost or perhaps hidden beneath the paint of the sketch.[4] The sketch might even be a monochrome reproduction of a now lost, full-color painting.[5]

Rembrandt made the sketch on a loose sheet of paper using brushes and a palette of paints that produced a wide range of grays and yellows and browns.[6] He also added a few touches of red. The colors that we now see are probably warmer and more yellow than they were originally because the paper has been mounted on canvas and varnished. He placed emphasis on the figures of Pilate and the priests, charging them with emotion and rendering them in great detail. The Hebrew inscription on the headgear of the priest holding the rod has been partially deciphered as referring to the name of God.[7]

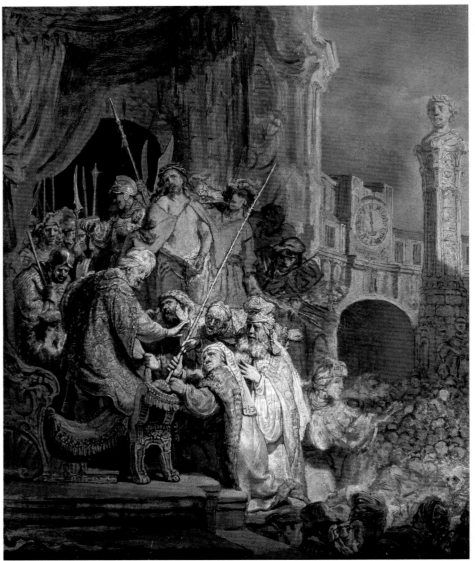

REDUCED

Figures of secondary importance are shown in various degrees of specificity, while almost no details are to be found in the boisterous courtyard mob. Even when broadly indicating form, Rembrandt's trenchant draftsmanship animates the figures.

The execution of the plate differs markedly from the freedom that we associate with Rembrandt's approach to etching. The oil sketch design was traced onto the copper plate by scoring the outlines with a stylus.[8] First-state proofs taken to check the progress of the work were inscribed with *Rembrandt f. 1635* beneath the vaguely indicated clock face, and the area reserved for Pilate and the priests was left unworked and blank.[9] The remain-

48

Ecce Homo (Christ before Pilate),
1634
Oil on paper laid on canvas
Br. 546; Corpus A 89
54.5 × 44.5 cm (21⁷⁄₁₆ × 17½ in.)
The National Gallery, London

der of the plate was brought almost to completion with respect to detail but conveyed as yet little drama in the lighting. Working from the edges to the middle was a practice common to professional engravers, who left the important areas of a print for last in order to avoid damaging them as work progressed, but it was seldom employed for etching.

Although some aspects of the proofs suggest the participation of a professional reproductive printmaker, we should not overlook the degree of creative interpretation required to move from the general indications of the oil sketch to the details of the plate.[10] For example, a figure leaning over the parapet near the center of the image is only vaguely rendered in the sketch but comes into focus as one of Rembrandt's fantasized self-portraits in the proof. Moreover, thoughtful revisions already occurred in the first state. In addition to the suppression of the anachronistic clock, there are significant changes to the figure of Christ. In the oil sketch he somewhat fades into the background, but in the print he is a boldly illuminated presence. More importantly, his gaze has been raised to heaven in accord with his recognition of heavenly rather than earthly authority. Would a reproductive printmaker carrying out Rembrandt's instructions independently take the initiative to make such changes? One of these first state proofs is broadly retouched with brush and oil paint to indicate adjustments in lighting, accentuation of some details, and a reduction in the size of the canopy above Pilate. The second state seen here (no. 49), inscribed *Rembrandt f. 1636 cum privile.* along the lower edge, follows many of the brushed-on directives for oil paint and greatly increases the expressive vigor of the work: the play of light becomes vibrant; innumerable figures—even the small ones in the crowd—are given much more specific features; the tangibility of the architecture increases; and the tepid shading of the sky is replaced by long, arcing strokes that reinforce the tension of the historical moment and anticipate Rembrandt's breadth of style and execution in the 1639 *Death of the Virgin* (no. 70).

During the nineteenth century, the elaborate preparatory and corrective procedures coupled with the engraving-like care lavished on the plate raised doubt about Rembrandt's authorship of what had previously been one of his most highly esteemed plates.[11] In 1890, Dmitri Rovinski suggested that Leiden printmaker Johannes van Vliet had begun work on the plate and that Rembrandt had retouched the figures and the heads.[12] Erik Hinterding's recent watermark research supports Rovinski's broad scenario and fills in some details.[13]

In 1631, Rembrandt began making trips to Amster-

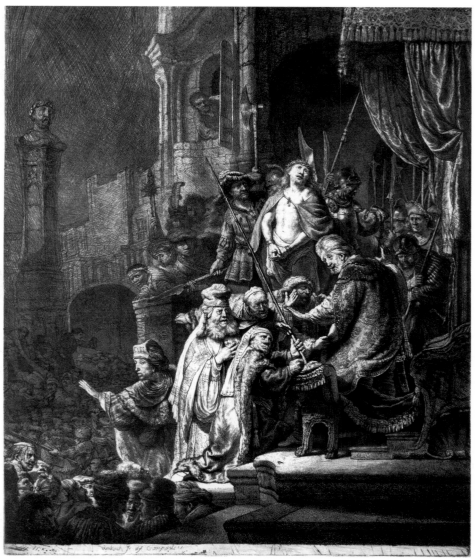

REDUCED

dam to work in Hendrick Uylenburgh's large and productive painting studio.[14] That same year Van Vliet produced the first of eleven prints signed with his own name that reproduced drawings and paintings by Rembrandt.[15] In 1631 and 1633, Van Vliet's and Rembrandt's prints appeared on the same paper, suggesting that Rembrandt's plates were printed in Leiden along with those he and Van Vliet produced under some collaborative arrangement.[16] But by about 1632–33, nearly all of Rembrandt's prints began to appear on different paper from that used by Van Vliet. It appears that by then Rembrandt had made his permanent move to Amsterdam, taking his growing stock of etched copper plates with him. Only

49
Christ before Pilate, 1635–36
Etching and engraving
B. 77, II
54.9 × 44.7 cm (21⅝ × 17⅝ in.)
National Gallery of Art, Washington
Rosenwald Collection

the large-scale prints, *Christ before Pilate* and *The Descent from the Cross*, continued to appear on the same paper as prints made by Van Vliet. *The Descent from the Cross* was made in two versions. The first failed version was drawn with great expressive intelligence but suffered a disastrous mishap in the acid. The second version (fig. 59, p. 108), though more pedestrian and workmanlike than the first, was nonetheless impressive.[17] Uylenburgh published *The Descent*, and it may have been his business instinct that caused Rembrandt to attempt the production of prints that emulated those of Rubens in scale, subject, design, and production methods.[18] Rembrandt may have exerted more control in the production of the first version of *The Descent* and given Van Vliet more latitude in the second. Rembrandt apparently continued to rely on Van Vliet for *Christ before Pilate*. Because impressions of the first state appear on paper used by Van Vliet in Leiden and those of the second and later states appear on paper used by Rembrandt in Amsterdam, Erik Hinterding sees Rembrandt as having directed Van Vliet's work from Amsterdam.[19] While this may be true, the many artistic adjustments made to increase the expressive power of the print in both the first and the second states suggest that Rembrandt may have actively intervened in Van Vliet's work at more frequent intervals than just those represented by the oil sketch, the proof corrected in oil paint, and the final retouching. Given the far more energetic handling of the second state, it appears that Rembrandt extensively reworked the plate to give it greater expressive power and then, having left Uylenburgh's workshop in 1635, published it himself. Van Vliet married a woman from a wealthy family in 1636 and gave up printmaking, apparently to pursue a career as a wine seller. TER

NOTES

1. The copyright "privilege" that Rembrandt claimed is not known to have been granted by the States General, the usual protector of intellectual property at the time. For more on privileges, see Orenstein 1996, 90–94.

2. The most extensive study of the collaboration is Schuckman et al. 1996.

3. Rembrandt's viewers would have immediately understood the meaning of the rod, for a long wand made of ash wood was still grasped by officials handing down a death sentence; see *Master and Workshop: Paintings* 1991, 166.

4. The Rembrandt Research Committee suggested the possibility of a pen and ink underdrawing; see *Corpus* 1982–89 2: 459.

5. Martin Royalton-Kisch in Amsterdam/London 2000, 136–140.

6. Bomford et al. 1988, 44–47. Rembrandt's authorship of the oil sketch was questioned by Eugene Dutuit in 1883. He believed that it contained Rembrandt's indication of the composition but that it was for

the most part completed by another hand; see Dutuit 1883, 1: 126. Dutuit's opinion has met little agreement.

7. *Corpus* 1982–89 2: 467.

8. Royalton-Kisch 1984, 19.

9. The first state of the print is known in three impressions, two in the British Museum, London, and one in the Rijksprentenkabinet, Amsterdam. See reproductions of the London impressions in White 1999, 16. Although he had many ways of building up his images, in no other plate of which early proofs survive did Rembrandt leave a blank, completely unworked area in the middle.

10. White 1969, 39. White later accepted—with a degree of caution—Van Vliet's authorship of the first state of *Christ before Pilate* as well as the two plates of *The Descent from the Cross*. White 1999, 15–18.

11. Gersaint 1751, 70–71, noted the heaviness of the drawing but concluded that the print was highly esteemed. Other cataloguers repeated his conclusion until the mid-nineteenth century.

12. Rovinski 1890, 54–55. In 1877, Francis Seymour Haden had brought Van Vliet's name into consideration but had settled on Jan Lievens. See Schuckman, "Critical History," in Schuckman et al. 1996, 15–19.

13. Hinterding diss. 2001, 85–91.

14. Dudok van Heel, "Rembrandt van Rijn (1606–1669): A Changing Portrait of the Artist," in *Master and Workshop: Paintings* 1991, 54.

15. Schuckman et al. 1996, 40–64.

16. This discussion of papers is based on Hinterding diss. 2001, 85–89.

17. The first publication to closely compare the quality of the two versions was Haden 1879, 27–28, and nos. 2–3.1

18. Uylenburgh's publication of *The Descent from the Cross* (B. 81, II) is well known, but the variants of his publication address that appeared on the plate are not. A long overlooked early state—between those identified as the second and third states in White and Boon 1969—was recorded by Bartsch but overlooked by every subsequent cataloguer. In it, the publisher's address was unsatisfactorily spelled: Amstelodami Henricum Ulenbugensis excudebat (Vienna, Albertina, inv. 1926.1664). In White and Boon's third state, this was changed to: Amstelodami Henrickus Ulenburgensis Excudebat.

19. Hinterding diss. 2001, 90–91.

50–53
Joseph Telling His Dreams
1630S

Four works related to the Old Testament subject of Joseph Telling His Dreams (Genesis 37:2–11) span the decade in which Rembrandt moved his artistic activity and his place of residence from his birth city of Leiden to the more cosmopolitan city of Amsterdam. In this tale of sibling rivalry, the seventeen-year-old Joseph, favorite son of the nomadic patriarch Jacob, recounts to his eleven herdsman brothers, the sons of Jacob's various wives, two symbolic and prophetic dreams. In the first, Joseph dreamed that he and his brothers were tying up

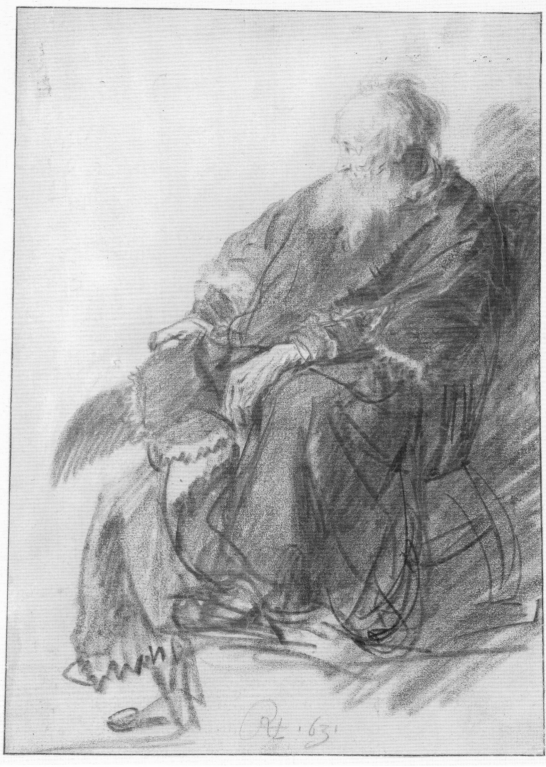

50
Bearded Old Man Seated in an Armchair, 1631
Red and black chalk on pale yellow prepared paper
Ben. 20
23.3 × 16 cm (9³/₁₆ × 6⁵/₁₆ in.)
Private Collection

REDUCED

sheaves of grain in the field and Joseph's sheaf stood upright while the brothers' sheaves bowed down to his. In the second dream the sun and moon (the parents) and eleven stars (the brothers) did reverence to Joseph. While the first dream provoked the brothers' hatred, the second dream, shared with Jacob, was too much even for the father, who reproved Joseph.

Subsequently, Joseph's brothers, consumed with envy, plotted to kill him but decided instead to sell him into slavery. They took his fine "coat of many colors" that his father had given him, sprinkled it with goat's blood, and showed it to Jacob, who, based on this false evidence, assumed that his son had been slain by wild beasts. Unbeknownst to his family, Joseph was in Egypt. There, after a series of misadventures that include further episodes involving the interpretation of dreams, Joseph rose to a position of high authority. He showed prophetic foresight in his management of the grain crops, laying up stores against times of want. Later, due to famine in Canaan, Joseph's brothers traveled to Egypt to seek grain. Ironically, the administrator to whom they obsequiously applied for aid was their own brother Joseph, whom they did not recognize. Joseph, who eventually revealed his identity, became the savior of his grateful family, as foretold in his youthful dreams.

The first step in the evolution of Rembrandt's painted and etched versions of *Joseph Telling His Dreams* was an independent model study in red and black chalk on paper prepared with a wash of pale yellow, representing a bearded old man seen seated in profile with one leg elevated (no. 50).[1] Changes in the position of the sitter's right leg and in the disposition of the draperies are clearly visible. One of several Leiden-period chalk studies of the same patriarchal-looking model, the drawing is monogrammed RHL (Rembrandt Harmensz. [Harmen's son] Leijdensis [of Leiden]) and dated 1631. Fully signed and dated sheets are relatively rare in Rembrandt's drawings. Despite the many visible changes of mind that give this sheet its particular energy, Rembrandt must have regarded this drawing as a finished work. Rembrandt later used this drawing with surprisingly few alterations, first for the figure of Jacob in the oil sketch *Joseph Telling His Dreams* (no. 51), and then for the etching of the same subject (no. 52)

The monochromatic Amsterdam oil sketch, executed on paper that has been mounted on cardboard (no. 51), has a difficult-to-read signature and a partially obliterated date (163...) but it is most likely datable to about 1633–34.[2] With its palette of gray-browns and ochres, it is comparable in its breadth of execution to the London *Ecce Homo* oil sketch on paper of 1634 that served as a

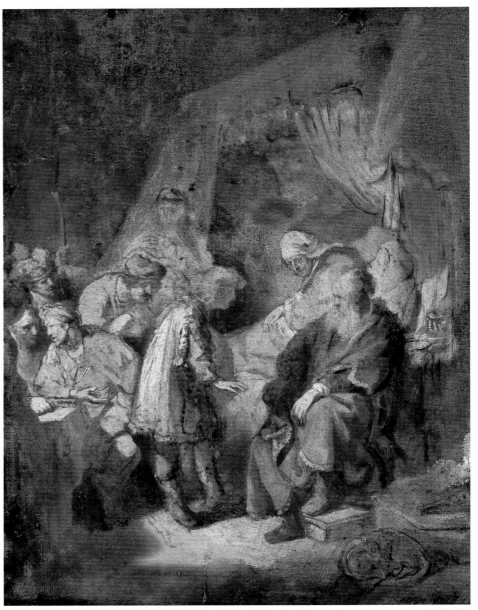

REDUCED

model for an etching of 1635–36 by Rembrandt and his probable collaborator, Johannes van Vliet (nos. 48 and 49). Joseph is seen in profile at center, narrating his dream to his father, Jacob, and to a woman sitting up in bed who must be Rachel, Joseph's mother.[3] According to the book of Genesis, Rachel had already died giving birth to Benjamin, Joseph's younger brother (Genesis 35:16–20). The Bible text is, however, ambiguous here because Jacob refers to Rachel when he reprimands Joseph regarding his dream: "Shall I and *thy mother* and thy brethren indeed come to bow down ourselves to thee

51
Joseph Telling His Dreams, 1633–34
Oil on paper laid on cardboard
Br. 504; Corpus A66
55.8 × 38.7 cm (21¹⁵/₁₆ × 15¼ in.)
Rijksmuseum, Amsterdam

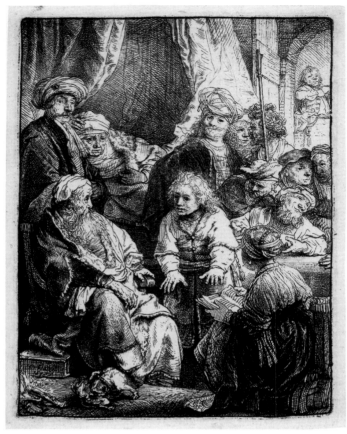

52

Joseph Telling His Dreams, 1638
Etching
B. 37, II
11.1 × 8.4 cm (4⅜ × 3⁵⁄₁₆ in.)
Museum of Fine Arts, Boston
Harvey D. Parker Collection

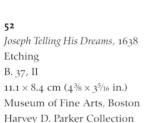

53

Two Women and a Turbaned Figure, 1638
Pen and brown ink, brown wash, white
watercolor
Ben. 168
13.9 × 12.5 cm (5½ × 4¹⁵⁄₁₆ in.)
Private Collection, New York

on earth?" A number of Joseph's brothers crowd in behind him, some apparently discussing the dream that he is relating. Joseph's capelike "coat of many colors" is the brightest accent in the picture, calling attention to his bowing posture that illustrates in pantomime the dream that he is narrating.

It has frequently been speculated that the Amsterdam *Joseph* oil sketch, like the London *Ecce Homo* sketch, was intended as a model for a reproductive etching. It is roughly comparable in size and format to the London painting, although trimmed at the sides.⁴ Unlike the London oil sketch, however, its outlines have not been indented for transfer to a copper plate and no such print

exists. It did, however, serve as the partial model or source of inspiration for the small etching of 1638 (no. 52).

In the etching's crowded composition Joseph is again at the center of things but faces the viewer. Jacob seated at left, Rachel reclining in bed, and a younger woman with an open book seated on a chair at lower right listen attentively to Joseph, who once again makes the pantomimed bowing-down gesture appropriate to his dream narrative. Nine brothers are present, while a tenth, with whom another brother is communicating, is represented only by his fingertips on the tabletop at the right borderline. Huddled together in the right background,

the brothers—one holds a shepherd's staff—respond to Joseph's tale with conspiratorial whispers or a mocking expression (see detail, fig. 18, p. 24). According to the pictorial tradition, it is unusual for a young woman to be present, but she must be Dinah, Jacob's only daughter. The silhouette of a woman is also visible at the left edge of the oil sketch.[5] There is a dog before the fire at the lower left corner, but the dog is attentive only to his fleas. A dog is also visible before the hearth at the lower right in the oil sketch but is curled up asleep rather than acrobatically grooming itself. The dog of the oil sketch closely resembles the one in the Boston drawing of a chained dog in a kennel (no. 54).

Preparatory drawings for Rembrandt etchings are relatively uncommon but, exceptionally, there are two for this small etching. The first is a very cursory compositional sketch in red chalk on the back of a pen drawing in Rotterdam in which Rembrandt was thinking in the broadest possible terms about the relationships of the various figures.[6] The second (no. 53) is a fully developed pen and wash study for key figures not present or fully defined in the oil sketch: the seated woman with the book and the rather pompous-looking brother in the turban who appears directly behind Joseph in the etching and who acts as a visual and emotional foil for Joseph. In this drawing corrected and highlighted with opaque white watercolor, Rembrandt also experimented with different versions of the woman's head covering.

CSA

NOTES

1. Amsterdam/London 2000, 160, fig. a.

2. *Corpus* 1982–89 2: 293–96.

3. Tümpel 1970, no. 14.

4. *Corpus* 1982–89 2: 289–97.

5. Ibid.

6. Giltaij 1988, 60–62, no. 13; Amsterdam/London 2000, 160–61.

54–55

Sleeping Dogs

LATE 1630S–1640

Rembrandt's narrative works, particularly his biblical etchings, are alive with dogs as spectators and participants, as a foil to the spiritual events, or as an aspect of his desire to more firmly ground the extraordinary in everyday reality. The Boston drawing of a chained watchdog curled up asleep in its kennel (no. 54) and the related etching (no. 55) focus exclusively on the animal itself.

In the Boston drawing, executed in pen and brush and gallnut ink, the small watchdog sleeps in a roughly carpentered shed that rests on piled-up wooden blocks in order to raise it above the damp ground. Vigorous shorthand pen and brush marks that describe the dog's hutch and the surrounding board walls or fences provide a frame for the more specific pen description of the slumbering dog's furry coat, head, and muzzle. A touch of opaque white watercolor highlights the dog's nose. Like many Rembrandt drawings of the later 1630s the drawing is executed in gallnut ink, an ink that changes from black to brown over time, that softly bleeds, and that sometimes, due to its acidity, eats through the paper.

The dog in the drawing relates in a general way to the curled-up dog by the fire in the Amsterdam oil sketch of *Joseph Telling His Dreams* of 1633–34 (no. 51) but is very likely later in date, about 1637–40, and more closely related to the undated etching of the identical dog. The latter should, on the basis of comparisons of style and technique with other etchings, probably be dated about 1639–40.

The etching concentrates on the play of light across the texture of the dog's coat and on the cozy fashion in which the sleeping animal nestles into the corner of the plate. The body of the dog is lightly and delicately etched with lines that are literally hair-fine. The plate was originally larger at the left and at bottom and was cut down. In the final state shown here the rectangle of the plate becomes the equivalent of the enclosed boxlike space of the kennel in the drawing.[1] The small size of the plate contributes to the feeling of an intimate glimpse into the animal's private life. A few links of the dog's chain are faintly visible at the lower right and there is a suggestion of a collar around the dog's neck. The depth of shadow in the dog's alcove is reinforced by slanting lines of drypoint at the upper right corner.

Etchings of domestic animals by Dutch painters who were contemporaries of Rembrandt usually appeared in series and typically presented the animals in the context of their characteristic surroundings; see for example

54

Sleeping Watchdog, 1637–40
Pen and brown ink, brown wash
Ben. 455
14.3 × 16.8 cm (5⅝ × 6⅝ in.)
Museum of Fine Arts, Boston
John H. and Ernestine A. Payne
Fund

Pieter van Laer's pioneering series of eight published in Rome in 1636 or Simon de Vlieger's series of ten plates, possibly from the 1640s. De Vlieger's series includes an alert and much heftier watchdog chained to a kennel out of doors in a wide landscape setting.[2] Even Rembrandt's portraitlike etching of *The Hog* of 1643 (no. 76) is given the context, however sketchy, of the seasonal ritual of hog slaughtering. Rembrandt's pictorial isolation of the dog and his evocative description of it is comparable to his careful depiction of a single exotic shell in the small etching of 1650 (no. 145). CSA

2. See Ackley *Printmaking* 1981, 123, nos. 75–76 (van Laer, B./Holl. 7 and 6), and 161, no. 103 (de Vlieger, B. 16). De Vlieger's print of the chained watchdog in the wide landscape setting is B./Holl. 20.

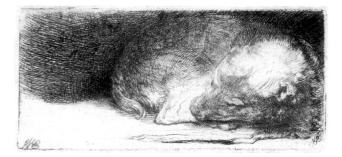

55

Sleeping Puppy, 1639–40
Etching and drypoint
B. 158, II*
3.8 × 8.1 cm (1½ × 3³⁄₁₆ in.)
Museum of Fine Arts, Boston
Katherine E. Bullard Fund in
memory of Francis Bullard

NOTES

1. See Amsterdam/London 2000, no. 37 (with reproductions of states). See Thomas Rassieur's corrective note on the states of the print in the Exhibition List.

56–57

The Holy Family

1630S AND 1640S

Two Rembrandt works, one an etching extremely intimate in scale, the other a large-scale painting, give us a glimpse into the private life of the Holy Family: the infant Jesus, Mary, and Joseph. An interest in the details of the domestic life of the Holy Family had a strong tradition in Netherlandish painting and printmaking from the fifteenth century onwards. The etching (no. 56) is so lacking in traditional symbols of divinity such as haloes that one might mistake it for an ordinary scene of tranquil Dutch domestic life. Mary, seated on a low step, offers her breast to the child, who has apparently fallen peacefully asleep while nursing. She has a box of linens ready to hand at her side. Behind her at right, propped up on end with a shawl over it, is a wicker *bakermat*, a legless basketry couch used in seventeenth-century Holland by nursing mothers. In the left background one sees Joseph, seated in profile reading, presumably from a sacred text. The relaxed domesticity of the scene is best represented by the slipper that has casually dropped from Mary's foot.

The background of the featureless interior is enveloped in a transparent web of shifting shadow, while Rembrandt uses areas of blank white paper to focus light on Mary and the child. The delicate play of light and shadow over Mary's features subtly heightens her musing, reflective expression. One can choose to view her as simply a mother who has fallen into a dreamy trance while nursing her child, or as the mother of the Savior meditating on this particular child's special destiny.

This monogrammed but undated etching, typical of Rembrandt's 1630s etchings in its wiry calligraphic line, looks forward to etchings such as *The Pancake Woman* of 1635 (no. 75). It is, however, usually dated about 1632, the last year in which Rembrandt is known to have used the *RHL* monogram seen here.

While the mundane setting and the suppression of any allusion to the child's divinity might lead a viewer to misinterpret the print as a domestic genre scene, in the 1645 painting (no. 57) the cloudborne flight of angels that miraculously appears in the dim interior leaves no doubt about the identity of this cottage's residents. The heavenly ambassadors descend on a radiance of transcendent light that eclipses the pale flicker of the fire, brightly illuminates the Virgin's face, hand, and book, and spreads a luminous aura around the sleeping infant Christ. Yet the carefully rendered wicker cradle, carpen-

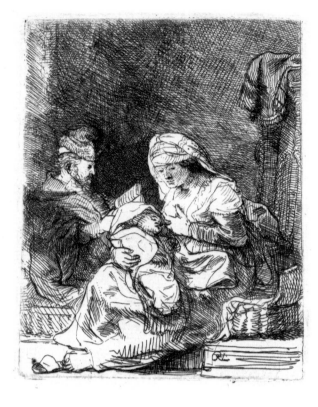

56

The Holy Family, about 1632
Etching
B. 62, only state
9.6 × 7.3 cm (3¾ × 2⅞ in.)
National Gallery of Art, Washington
Print Purchase Fund (Rosenwald
Collection)

ter's tools, foot warmer, and brick hearth would not be out of place in a Dutch interior of the period, and the compelling naturalism of Rembrandt's technique enhances the impression of everyday actuality that informs the work. At the center of the composition—the lightest passage in the dark canvas—the Virgin's head and her gesture are the focus of the picture. The touches of red in her garments and the glowing red of the child's blanket also draw the eye within the somber interior. Anything but the aloof Mother of God associated with traditional devotional images, Mary interrupts her reading to check on the sleeping child, her countenance animated by an expression of loving maternal concern and tender solicitude that underscores her humanity. No wonder that generations of commentators have emphasized the anecdotal appeal of the work and its kinship to the domestic genre subjects that were the specialty of Dutch artists such as Rembrandt's pupil Nicolaes Maes, who translated this very composition into a contemporary scene of a mother caring for her infant.[1]

Christian Tümpel, a minister as well as an art historian, has emended this standard interpretation of the picture because he believes it ignores Christian symbols here disguised as mundane activity. In this view the yoke hewn by Joseph in the present work and in another

painting of the Holy Family dated 1640 evoke Old Testament prophecies that predicted the birth of a Savior who would break the yoke of Israel's burden.[2] According to this interpretation, Mary has just read an allusion to the Savior in her Bible and has lifted the cloth covering the cradle to fondly gaze at the infant Savior and to share him with the viewer. Thus the heavenly light and the glory of small angels—one of which hovers above the infant Jesus with arms extended in a cruciform gesture—can be understood as illuminating a special moment in the story of human salvation.

Quiet scenes of Christ's nativity and infancy dominate Rembrandt's choice of New Testament subjects in the paintings of the years 1640–47. The palette of this painting restricted to earth tones, to reds, and to black and white, as well as the subtlety of the light effects, accord well with Rembrandt's development as a painter in those years. CSA/WWR

NOTES

1. See the Rembrandt and a related Maes painting reproduced side by side in color in Westermann 2001, 53.

2. Tümpel 1994, 245.

58–63

Saskia in Various Roles

1630S

Rembrandt's wife, Saskia, was one of his favorite models, and for a few years one of his most frequent. He made intimate life studies of her in unguarded moments, formal portraits, and works that drew her into his world of fantasy role-playing. To Rembrandt Saskia could be a housewife, an aristocratic beauty, a biblical heroine, a martyred saint, or a classical goddess. It is difficult to say whether viewers beyond the artist's circle of friends and collectors were expected to know that Saskia was the model. It is equally difficult to determine precisely when Rembrandt was portraying Saskia, for as in the case of his self-portraits, her familiar likeness stimulated his invention of imaginary faces and types.

Rembrandt and Saskia probably met in 1633 through Hendrick Uylenburgh, her cousin in whose workshop Rembrandt was active at that time. They were engaged in June 1633, as Saskia approached her twenty-first birthday, and married a year later.[1] Uylenburgh may have hoped that the match would solidify his business relationship with his prize artist. If so, he was to be disap-

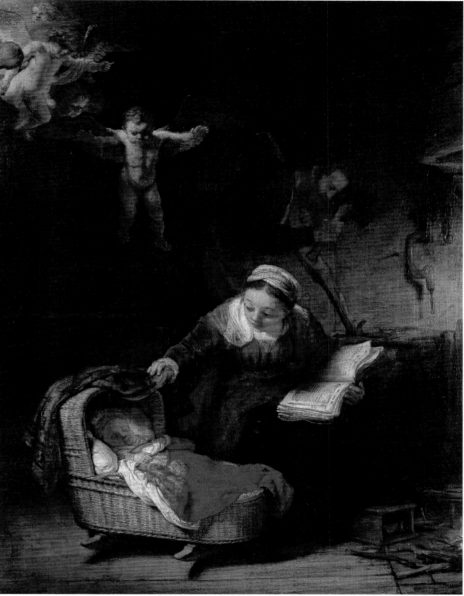

REDUCED

pointed, for Rembrandt acted with increasing independence following the marriage.[2]

Saskia's appearance is documented by Rembrandt's lyrical betrothal portrait, drawn in silverpoint on vellum and inscribed in his hand (fig. 60): "This is drawn after my betrothed when she was 21 years old, the third day after our engagement on 8 June 1633."[3] She was a fleshy beauty with full cheeks and a slight double chin, widely spaced eyes, and a small Cupid's bow mouth.

Even in the absence of the inscribed portrait, one would be inclined to identify Rembrandt's highly origi-

57
The Holy Family with Angels, 1645
Oil on canvas
Br. 570
117 × 91 cm (46 × 36 in.)
The State Hermitage Museum,
St. Petersburg

nal 1636 etching with the title, *Self-Portrait with Saskia* (no. 58). Though the composition fits into no clear pictorial tradition, in seventeenth-century Holland a portrait of a man and woman close in age and shown in close proximity almost inevitably presents a married couple. The image is rather eccentric, for the exaggerated perspective causes Rembrandt, seen in extreme close up in the immediate foreground, to upstage Saskia somewhat on the far side of the table. Having paused in his work, the right-handed artist has a loose, left-handed grasp on his drawing instrument. The marks on his paper suggest that he was in the process of drawing her until we interrupted him. The couple stares out at us. He must, of course, have been looking directly into a mirror. By twenty-first century standards one might criticize Rembrandt for relegating Saskia to a secondary position, but in the seventeenth century her placement would on the contrary have been considered a relatively intimate and prominent one.[4]

In the 1630s and 1640s, Rembrandt developed innovative compositions for painted marriage portraits that showed the wives participating in the activities of their husbands,[5] and that appears to be the case here. Saskia wears an old-fashioned veil and Rembrandt an equally antiquated plumed hat with a slashed brim.[6] These costumes invite the viewer to read the image as something more than mere documentation of everyday appearances. For some learned viewers the portrait might illustrate the sixteenth- and seventeenth-century Dutch maxim: *Liefde baart kunst* (Love gives birth to Art).[7] Rembrandt's eccentric composition allows him to cast Saskia in multiple roles: wife, model, and muse.[8]

In the year of their marriage, Rembrandt took up a very fine needle to etch and drypoint a small, exceedingly delicate study, *Saskia with Pearls in Her Hair* (no. 59). She also wears pearl earrings and a double stranded necklace of pearls. These may be the same adornments that were documented a quarter-century later when financial concerns necessitated appraisals.[9] In these earlier carefree days, Rembrandt studied his wife with loving attention. Minute stippling defines the structure of her facial features and softens the shadows on her full cheek and fleshy chin. The sparkling pearls set off the combed and gathered tresses of her otherwise undisciplined hair. The fringe at her brow catches the light to frame her face in a halo. Her elegant dress has puffed

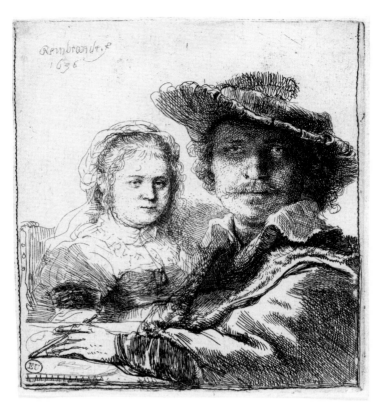

58

Self-Portrait with Saskia, 1636
Etching
B. 19, I
10.4 × 9.3 cm (4⅛ × 3¹¹⁄₁₆ in.)
Museum of Fine Arts, Boston
Harvey D. Parker Collection

sleeves, a split bodice, and is draped with a lace-edged shawl. When executing the lace collars ubiquitous in his 1630s portraits, Rembrandt spared himself the labor of intricate brushwork, creating the illusion of lace by applying black spots to fields of white. Similarly in this etching he left a jagged-edged, white reserve that he peppered with short strokes and squiggles. Out of Rembrandt's tangle of lines and dots, Saskia emerges, every inch the prosperous Amsterdam bride.

More intimate views of Saskia appear in a group of three plates, on each of which Rembrandt etched a few studies of his wife and other female models. He appears to have worked directly on the copper as though sketching with a pen on a sheet of paper. *Three Heads of Women, One Asleep* (no. 60) is typical of these etchings that grow out of the tradition of master artists designing prints as model sheets from which aspiring artists could learn to draw. While the two heads in three-quarter profile may be easily associated with Saskia, the close-fitting headgear and hand of the sleeping woman make the identification less certain. Rembrandt's composition appears casual, but he has in fact taken great care to vary the poses and the lighting in each of the studies and to arrange them artistically on the plate. In contrast to the more formal portrait prints discussed above, here Saskia

Fig. 60. *Saskia Wearing a Straw Hat*, silverpoint on vellum, Ben. 427, 18.5 × 10.7 cm. Staatliche Museen zu Berlin, Preussischer Kulturbesitz, Kupferstichkabinett.

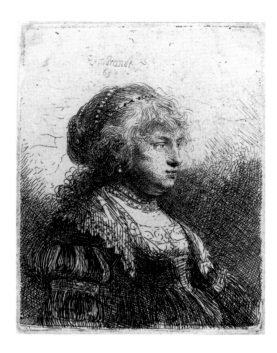

59
Saskia with Pearls in Her Hair, 1634
Etching
B. 347, only state
8.6 × 6.6 cm (3⅜ × 2⅝ in.)
Teylers Museum, Haarlem

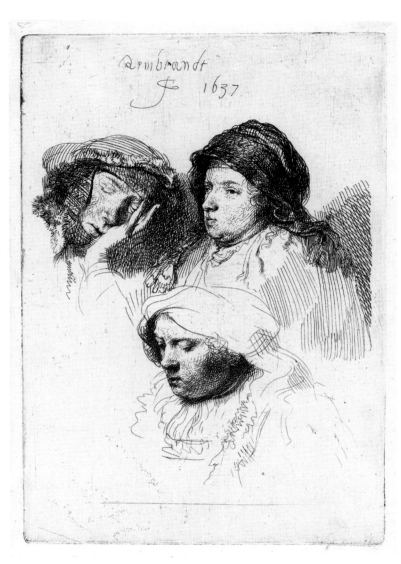

hardly seems to have been aware that Rembrandt was taking her likeness. Perhaps she had grown so accustomed to being observed that she took no notice. He took advantage of these unguarded moments to create remarkably personal images. The heads in Rembrandt's etched sketch plates seem to capture the individuality of the model, a quality distinct from the more stereotyped studies of body parts seen in most of the printed model-sheet series by other artists that preceded them.[10]

In a highly finished etching of 1635, he portrayed Saskia as a grand and noble personage (nos. 61, 62). Though not all critics have agreed that Saskia is the sitter, one might do well to heed the wisdom of the nineteenth-century Rembrandt scholar, Charles Henry Middleton,

who, after wrestling with the issue concluded that "it is an idealized study and not a portrait, and it must be confessed that Rembrandt's genius did not lie in accuracy of likeness."[11] Middleton's observation might very well be applied to all of Rembrandt's role-playing images. Traditionally identified as *The Great Jewish Bride*, the etching features her with long, flowing hair adorned with a diadem, wearing rich clothes of velvet and brocade, holding a scroll, and enthroned in an imposing architectural setting. An alternate interpretation would cast Saskia in the role of Esther, the beautiful Old Testament heroine who bravely interceded with the Persian King Ahasuerus to rescind proclamations ordering the destruction of the Jews (for the subject, see no. 108).[12] The story of Esther

60
Three Heads of Women, One Asleep, 1637
Etching
B. 368, II
14.1 × 9.6 cm (5⁹⁄₁₆ × 3¾ in.)
Museum of Fine Arts, Boston
Gift of the Estate of Lee M. Friedman

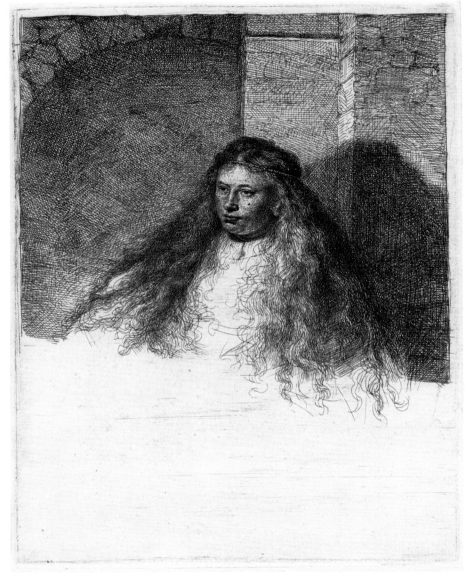

61

The Great Jewish Bride, 1635
Etching and drypoint
B. 340, II
22.1 × 16.8 cm (8^{11}/$_{16}$ × 6^{5}/$_{8}$ in.)
Museum of Fine Arts, Boston
George Nixon Black Fund

REDUCED

was a popular one in the literature and visual arts of seventeenth-century Holland because the Dutch Protestants, having suffered Spanish oppression in the Netherlands, identified with the eighth-century B.C. Jewish diaspora in Persia.

The second-state impression taken from the still incomplete plate of *The Great Jewish Bride* (no. 61) reveals that Rembrandt began with a study of Saskia's head and abundant hair situated in a stone niche and brightly illuminated from the left. The light plays over her glowing face, and her Rapunzelian hair cascades down her shoulders in perfect contrast to the hard, gritty surface of the walls. At this point she is, except for the diadem in her hair, devoid of the attributes that would cast her in a more symbolic or literary role. There still survive about a dozen impressions from the first and second states, in which the lower part of the image remains blank, suggesting that Rembrandt may have been catering to a sophisticated audience with a taste for prints from "unfinished" plates. Yet he already knew how he wanted to develop the image. He had drawn a full-length seated study of Saskia with elaborate costume and scroll, but when setting to work on the copper plate he cropped the drawn composition more tightly.[13]

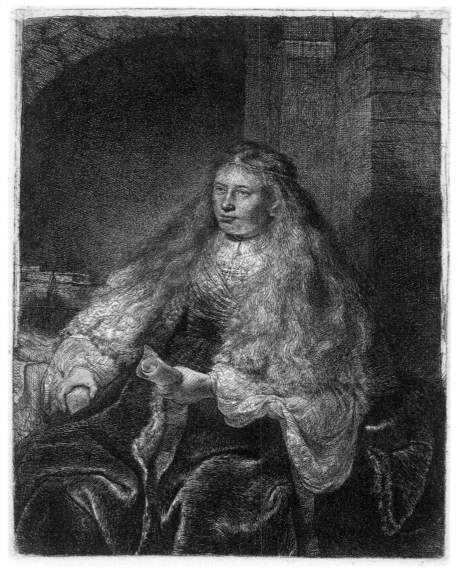

62

The Great Jewish Bride, 1635
Etching
B. 340, IV
22.2 × 16.9 cm (8¹¹/₁₆ × 6⅝ in.)
Courtesy of the Fogg Art Museum, Harvard
University Art Museums, Cambridge,
Massachusetts
Gift of Paul J. Sachs

REDUCED

In the completed state of *The Great Jewish Bride* (no. 62), Rembrandt went much further than the addition of clothing, chair, and scroll. He transformed the lighting from the original, relatively naturalistic scheme, creating dark shadows in the stone niche so that the heroine seems spot-lit, as if upon a stage. The reversal of an etching's lighting scheme from dark-on-light to light-on-dark was habitual for Rembrandt. In this case he took the opportunity to make several changes: he eliminated the looming shadow, increased the depth and elaboration of the niche, and added a stack of books (without burnishing and scraping away already bitten lines).

A smaller etching of Saskia from 1638 (no. 63) again shows her wild mane of hair barely tamed by a diadem. She wears a white shift, the full sleeves gathered at the wrists. Through a translucent veil, her left hand is visible folded over her right. The shift opens slightly to reveal the suggestion of a dress with an elaborate bodice. Her expression is neutral, and her clear eyes peer out without locking onto our gaze. Rembrandt contrasted the wild, wavy strokes of her hair with the neat parallel lines that describe the shadows and folds of her clothing. He modeled her face in short flicks and dots, avoiding harsh lines that would spoil the appearance of her

soft flesh. He also added drypoint accents throughout the image. The impression shown here is among the few printed while the fragile burr remained intact. In the lower right corner, we catch a glimpse of a spiked wheel, an attribute that casts Saskia in the role of St. Catherine of Alexandria.

The flowing hair, diadem, and three-quarter pose so strongly recall *The Great Jewish Bride* that already in the eighteenth century collectors referred to the print as "The Little Jewish Bride." The title has persisted even though more than two hundred years ago the wheel was widely recognized as that of Catherine. Legends tell us that the saint and martyr, a well-educated eighteen-year-old virgin, born of a noble family, upbraided the Emperor Maximinus for his persecution of Christians and for his idolatry. Furious at her impudence, he subjected her to questioning by teams of scholars in hopes of provoking her into an act of apostasy. His tactic failed because she won her inquisitors over to Christianity. When she converted even the Emperor's wife and the general of his troops, Maximinus ordered Catherine's flesh torn from her body on a spiked wheel. Miraculously, the wheel shattered at its first contact with her skin. Infuriated, the Emperor had her decapitated with a sword, only to see her body carried off by angels. Although the circumstances of the stories behind them are quite different, *The Great Jewish Bride*—if she is indeed Esther—and *Saskia as St. Catherine* share not only Saskia's features but also moral lessons about willing self-sacrifice for the sake of principles and fellow believers. TER

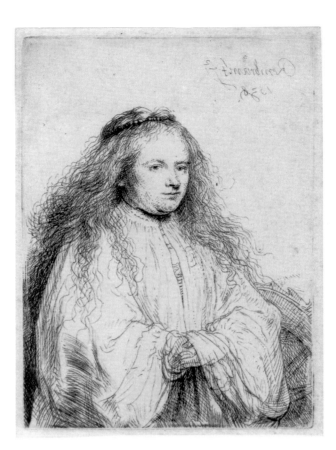

63
Saskia as St. Catherine ("The Little Jewish Bride"), 1638
Etching and drypoint
B. 342 only state
11 × 7.8 cm (4⅝₁₆ × 3¹⁄₁₆ in.)
Hood Museum of Art, Dartmouth College, Hanover, New Hampshire
Gift of Jean K. Weil in memory of Adolf Weil, Jr., Class of 1935

NOTES

1. *Docs.* 1979, 1612/1, 1634/5.

2. Dudok van Heel, "Rembrandt: His life, his wife, the nursemaid, and the servant," in Williams et al. 2001, 23.

3. Berlin, Kupferstichkabinett, Ben. 427; see *Docs.* 1979, 1633/3.

4. The motif of a self-portrait with the artist's wife had two especially prominent antecedents in printmaking history: Israhel van Meckenem's engraving of about 1490 showing himself and his wife, Ida (B. 1), and Aegidius Sadeler's 1600 engraving after Bartolomeus Spranger's flamboyant self-portrait with a memorial to his deceased wife, Christina Muller (Holl. 21: 332). Meckenem's design is truly remarkable for the equal treatment accorded the two sitters, while Spranger's—like Rembrandt's—makes clear whose role is the more prominent one.

5. See, for example, the portrait of the shipbuilder Jan Rijksen and his wife Griet Jans, 1633 (London, Buckingham Palace, Collection of Her Majesty Queen Elizabeth II, Br. 408), and the portrait of the preacher Cornelis Claesz. Anslo and his wife Aeltje Gerritsdr. Schouten, 1641 (Berlin, Gemäldegalerie, Br. 409).

6. White and Buvelot et al. 1999, 162, no. 46.

7. De Jongh 1986, 58.

8. The composition also inspired a later creative printer or publisher to play a joke by masking out Saskia's likeness, replacing it with a portrait of Rembrandt's mother (B. 349); see Hinterding *Copperplates* 1995, 20, no. 11.

9. *Docs.* 1979, 1659/11, 1659/13.

10. For example, see the plates designed and etched by Jacopo Palma the Younger (Bartsch 1797, 16: 288–90, nos. 2–15) and Giuseppe Ribera (Bartsch 1797, 20: 85–86, nos. 15–17).

11. Middleton 1878, 14.

12. Kahr 1966, 228–44. Kahr's identification of the subject of the etching is quite plausible, but her argument about Rembrandt's creative process is unfortunately marred by her attempt to date the plate to 1637. See *The Triumph of Mordecai* (no. 108) for Rembrandt's etching of another aspect of this story.

13. Stockholm, National Museum, Ben. 292. Though usually associated with *The Great Jewish Bride* etching, this drawing might equally well be related to plans for a never executed or now lost painting. In the 1630s, Rembrandt made paintings featuring full-length seated images of women in historical roles: *Minerva* (Berlin, Gemäldegalerie, Br. 466) and an Old Testament heroine (Ottawa, National Gallery of Canada, Br. 494). Kahr identified the latter as Esther, rejecting the more commonly accepted identification of Bathsheba; see Kahr 1966.

64–65

Jacob Caressing Benjamin

1645

The seventeenth-century Amsterdam print publisher Clement de Jonghe owned at least seventy-four copper etching plates of Rembrandt that he had acquired by about 1658. The present plate (no. 65) was listed in the 1679 inventory of his estate as "Father Abraham playing with his son" and has been identified since Bartsch's catalogue of 1797 as "Abraham Caressing Isaac."[1] In recent decades scholars such as Christian Tümpel have pointed out that the subject should more properly be identified as the patriarch Jacob, Isaac's son, with Benjamin, his beloved youngest son by his favorite wife Rachel, who was also the mother of Joseph.[2] The subject is related to the episode in the book of Genesis in which Joseph's brothers request that Benjamin accompany them on their journey to Egypt in order to obtain grain

to alleviate the famine in their land. Jacob refuses to let Benjamin go because he believed that he had already lost one favored son. Joseph, whom the brothers had falsely reported as slain by wild beasts, was, unbeknownst to Jacob, alive and well and occupying a position of high authority in Egypt.

The conception in the etching seen here, with a standing child sheltered between his elderly father's knees, relates to certain Rembrandt or Rembrandt school drawings of the 1630s that represent Joseph telling his dreams. In the drawings the young child standing between the seated Jacob's legs is clearly identifiable as Benjamin.[3] Tümpel has pointed out that one of the devices Rembrandt sometimes favored in conceiving his biblical subjects was removing a figural motif from its original narrative context and isolating it.[4] By choosing to isolate the two figures of Jacob and Benjamin in his etching, Rembrandt concentrates our attention more narrowly on the love of the elderly father for the son and on the trusting innocence of the child. Jacob and Benjamin are

64

Jacob Caressing Benjamin, about 1645
Etching
B. 33, I
11.8 × 9 cm (4⅝ × 3⁹⁄₁₆ in.)
Museum of Fine Arts, Boston. Gift of Eijk and Rose-Marie van Otterloo in honor of Clifford S. Ackley

65

Jacob Caressing Benjamin, 1645
Copper etching plate
B. 33
12 × 9 cm (4¾ × 3⁹⁄₁₆ in.)
Museum of Fine Arts, Boston
William Francis Warden Fund

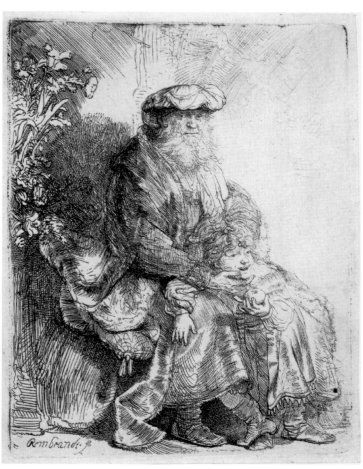

64

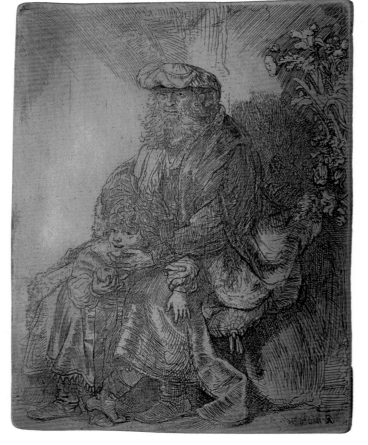

65

shown out-of-doors in a gardenlike setting, bathed in a powerful light that nearly dissolves their forms and casts strong shadows. There is a vague suggestion of a masonry wall behind Jacob and at left a flourishing tangle of tall, variegated flowers. Jacob sits proudly erect and looks at the viewer with a commanding directness as if to say, "look at the treasure that I have here," while Benjamin, secure in his father's love, gazes blissfully off into space. It is above all the silent language of the father's hands that fondle and caress the child's head, and the child's that play with the apple, that most clearly communicate the deep bond of father and son.

The etching is signed but not dated. It is usually dated about 1637 (see *Abraham Casting out Hagar and Ishmael*, dated 1637, no. 66) but its linear vocabulary and pictorial construction are closer in their rational clarity and breadth of form to an etching such as the *Abraham and Isaac* of 1645 (no. 67). In an early impression such as the present one, the printed lines have their full range from extreme delicacy at right to clear and emphatic at left. The shadows are still transparent and have not yet been made heavy and opaque by the reworking of the plate by a later hand.

Even though Rembrandt's original intentions were distorted when the heavier shadows were reworked and the lines lightly rebitten, this plate (no. 65)—like a number of the more simply drawn and etched of the surviving plates—is still quite legible as an image. Such a copper plate was originally simply the means by which the true work of art, the impression on paper, was produced, but today there is a growing tendency to regard them as aesthetic objects in their own right, as Rembrandt drawings in copper. They also have become, whether one likes it or not, gleaming reliquary objects touched by that "saint of art," Rembrandt van Rijn. CSA

NOTES

1. Hinterding diss. 2001, 160–61. The plate is number 25, "Vader Abraham speelend met sijn soon," in De Jongh's inventory. See De Hoop Scheffer and Boon 1971, 8.

2. Tümpel 1970, no. 20.

3. Ibid.

4. Tümpel 1970, Introduction and no. 20.

66–68
Abraham

THREE DECADES

When one reads the book of Genesis, one is aware that the nomadic patriarchs of the Old Testament appear to have communicated directly with God on an almost daily basis. God could give, as in the miraculous conception and birth of a son to aged parents, and God could cruelly test devotion by demanding the sacrifice of that son. Three dramatic episodes from the life of Abraham, traditionally regarded as the founding father of the Jewish people, reveal Rembrandt's differing approach to related themes over three decades in etchings dated 1637, 1645, and 1655.

Abraham's dismissal of his concubine, the Egyptian servant-woman Hagar, and her son Ishmael is a complex domestic drama. Sarah, Abraham's wife, had given her

66

Abraham Casting out Hagar and Ishmael, 1637
Etching and drypoint
B. 30, only state
12.6 × 9.6 cm (4¹⁵⁄₁₆ × 3¾ in.)
Museum of Fine Arts, Boston
Harvey D. Parker Collection

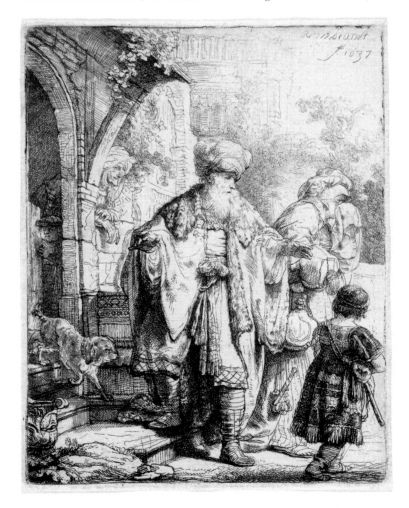

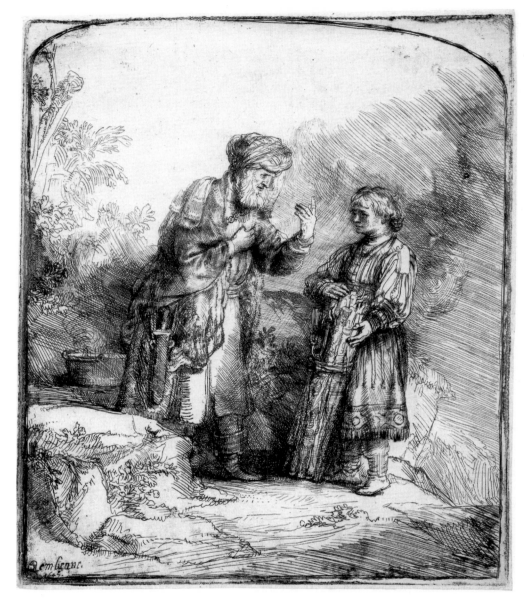

67

Abraham and Isaac, 1645
Etching and drypoint
B. 34, I*
15.7 × 13.3 cm (6³⁄₁₆ × 5¼ in.)
Museum of Fine Arts, Boston
Gift of Eijk and Rose-Marie van Otterloo
in honor of Clifford S. Ackley

maidservant Hagar to Abraham to warm his bed. But when the younger woman bore Abraham a son, Ishmael, things became more complicated. Later, when through God's intervention a son, Isaac, was born to the elderly couple (Sarah was ninety and Abraham, ninety-nine), Sarah became concerned for Isaac's inheritance and asked Abraham to send Hagar and Ishmael away. Abraham was reluctant, but God reassured him, promising that Ishmael would become the father of a great nation (Genesis 21:13–21). Ishmael, who was to become a skilled archer and fierce warrior, is considered to be the founding father of the Arab (Muslim) people.[1]

The elaborate chain of human interaction in Rembrandt's small 1637 etching (no. 66) matches the complexity of the story. There is a dramatic arc of expression and gesture that begins at left with the figure of the triumphantly grinning Sarah looking on with satisfaction from the window; continues through the small Isaac peeping out the door with a sly, gloating expression; descends the steps with the faintly smiling family dog; passes through the emotionally divided figure of Abraham; and ends with the faceless figures of Hagar and Ishmael, already moving away. The weeping Hagar, water flask at her side and bundle under her arm, has her face

buried in her kerchief, while the valiant small figure of Ishmael seems already to be marching determinedly toward his future. As with a number of Rembrandt's biblical narratives, this one takes place on the symbolic threshold of a home.[2] Sarah and Isaac are securely in possession within the house while the pivotal figure of Abraham literally has one foot inside (on the step) and one foot outside (on the ground). His hands reach out in both directions, explicitly representing the anguished division of his loyalties between his two families.

This highly detailed, nuanced psychological drama is staged in a surprisingly small format. Seldom was Rembrandt's etched line so intricately fine as here. The line work is, however, relatively open and fluid rather than tight and pedantic.[3]

God later tested Abraham's faith by demanding that he travel to a far mountaintop and there perform an act of worship and obedience, sacrificing his beloved son, Isaac, as a burnt offering (Genesis 22:1–18). Abraham and Isaac, having arrived at the mountain, left behind the servants and the ass that had carried the supplies and set out for the place of sacrifice, carrying themselves the wood and the fire (here a bucket of coals). Along the way, a puzzled Isaac interrogated his father, asking, "where is the lamb for a burnt offering?" and Abraham replied that God will provide one.

In his 1645 etching (no. 67) Rembrandt concentrates our attention on this charged dialogue between father and son, Isaac pondering and Abraham asserting, pointing heavenward. Abraham is firmly planted, resolute in his faith at the center of the composition, while Isaac's stance is less secure. Abraham looks at his son with great intensity while Isaac gazes straight ahead, his eyes narrowed in thought and not meeting his father's gaze. In the foreground we see an altarlike stone. Rembrandt has apparently condensed the biblical narrative and staged the exchange of question and answer at the place of sacrifice itself rather than at a spot on the way to it. As Tümpel has noted, in his biblical narratives Rembrandt sometimes chose not to illustrate the climactic moment of the story but rather an episode that preceded and anticipates it or one that immediately follows and echoes it.[4]

In an early impression such as this one the figures that dominate the composition have their full bulk, weight, and density, and their costumes their maximum textural richness. This is in part due to fine touches of drypoint burr that register here in all their velvety fullness and which quickly wore away. The mountaintop setting is by comparison lightly and sketchily suggested, with a large patch of blank sky serving as a foil to the figures. The rounded corners of the inner borderline at top serve to focus our attention yet more closely on the central dialogue of father and son.

The book of Genesis tells us that Abraham made all the necessary preparations for the sacrifice and "stretched forth his hand and took the knife to slay his son." At that moment an angel of the Lord called out from heaven and told Abraham not to harm the boy, for Abraham had proven that he was truly God-fearing. Abraham then looked up and saw a ram with its horns caught in a thicket and offered it up as the substitute sacrifice that God had at the last minute provided.

The subject of Abraham interrupted by divine intervention in the act of sacrificing his son has a far stronger pictorial tradition than the foregoing subject of Isaac questioning his father about the absent sacrificial lamb. One of Rembrandt's best-known Biblical paintings of the 1630s, the large-scale painting in the Hermitage dated 1635, presents the subject in sensational stop-action terms.[5] The angel swoops down, seizing the surprised Abraham's right hand. The sacrificial knife falls from Abraham's grip, suspended in air over Isaac's prostrate body. In accordance with the Bible text, Rembrandt in this painting represented Isaac as trussed-up and reclining, like a true sacrificial offering, on the pyre of wood. Abraham's left hand brutally pushes down on Isaac's face, exposing his son's naked throat and bare arched torso to the knife.

By contrast, the figures in Rembrandt's 1655 etching (no. 68) seem suspended in time—locked together in a symbolic embrace—like a sculpture group on a pedestal. The angel firmly grasps both of Abraham's arms, restraining him, but it is not clear whether Abraham, anguished and confused, with half-open mouth and darkened eye sockets, actually sees the angel or only hears the voice of God's messenger.[6] Isaac obediently kneels, unbound, but with hands passively concealed. Isaac's head significantly occupies the very center of the squarish composition. Abraham with a compassionate, protective gesture masks his son's eyes from the sight of the knife. A salver placed to catch the sacrificial blood adds a chilling ritualistic note. Diagonal beams of light from heaven represent the fall of God's blessing on Abraham.

Other elements of the story that precede and follow the central drama are hinted at in the periphery of the image. At right, on the side of the mountain, two servants and the ass gaze off into space, totally unaware of the miraculous event. Below them two tiny foreshortened figures of travelers on a road suggest the precipitous height of the mountain. At left in the shadows we

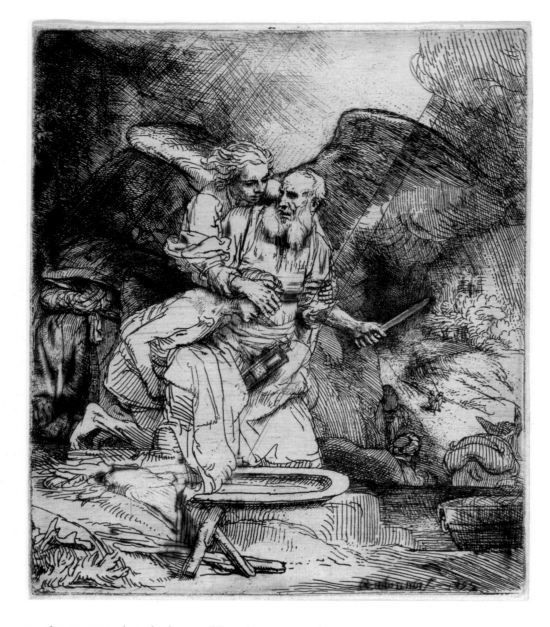

68

Abraham's Sacrifice, 1655
Etching and drypoint
B. 35, only state
15.6 × 13.1 cm (6⅛ × 5³/₁₆ in.)
Museum of Fine Arts, Boston
Harvey D. Parker Collection

see the garments that Abraham and Isaac have removed in preparation for the ritual offering and—tucked into the curve of the angel's wing—the arched back of the substitute sacrifice, the ram with its horns caught in a thicket.

As in so many prints of the mid-1650s, the plate was drawn and etched with great firmness and clarity of line, which was then further enriched by passages of drypoint that lend a washlike softness and density to the shadows. CSA

NOTES

1. See Josephus 1999, 66.

2. Kuretsky 1997, 63.

3. The *Hagar* etching is exceptional in that Rembrandt sold the plate shortly after its creation to a Portuguese painter, Samuel d'Orta, who in a legal deposition sought to hold Rembrandt to an agreement in which after selling the plate, Rembrandt was supposed to retain only two or three impressions of the print, and only for his personal use, not for sale. The implication of the deposition is that Rembrandt had retained more impressions than stated in the agreement. See *Docs.* 1979, 1637/7.

4. Tümpel 1970, Introduction.

5. Corpus A108, Br. 498.

6. Rosenberg 1964, 176.

69–70
The Life and Death of the Virgin
1639–1640

The subject of this Rembrandt painting dated 1640 (no. 69), the Visitation, represents in Catholic literature and imagery the transition from the old Judaic religion of the patriarchs and the prophets to the new era of Jesus and Christianity. As the evangelist Luke relates (Luke 1:5–64), before the angel Gabriel announced to the Virgin Mary, the divine conception in her womb of Jesus, Gabriel had already appeared to an elderly priest of the temple, Zacharias, and announced that he and his aged—and barren—wife, Elisabeth, would conceive a son. Zacharias refused to believe in such a miracle and was in consequence punished by being struck speechless until the moment that the circumcision and naming of his son was complete. His son was John the Baptist, the prophet who foretold the coming of Christ and Christ's mission on earth. At the time of Gabriel's announcement to Mary the angel also informed her that her elderly cousin Elisabeth was six months pregnant with a son. Mary traveled to visit Elisabeth and stayed with her for three months. The moment in the story that Rembrandt has represented here is that of Mary's arrival and of Elisabeth's sudden illumination. When the aged Elisabeth, whose belly is here visibly rounded, first saw Mary, "the babe leaped in her womb." Elisabeth was suddenly and miraculously possessed by the Holy Spirit, represented here by a mysterious dark, low-hovering cloud. Rembrandt shows her embracing her youthful and serenely poised cousin, looking worshipfully up into her face and uttering her divinely inspired cry of recognition, "Blessed art thou among women, and blessed is the fruit of thy womb."

As so often with Rembrandt's biblical narratives the central event is staged on an elevated site in the foreground with the land dropping away behind it. The scene takes place on the steps and terrace of a grand dwelling, more temple than house.[1] Elisabeth and Mary are picked out of the darkness by a divine spotlight while a black maidservant stands on tiptoe to remove Mary's heavy traveling cloak. In the right background we see Joseph with the donkey ascending the hill while at left the aged Zacharias carefully descends the steps, leaning for support on a young boy. The theme of birth is echoed in the peacock family at the lower left. The peacock also has a more symbolic function for it is a traditional Christian symbol of immortality, of Christ and the Resurrection.[2]

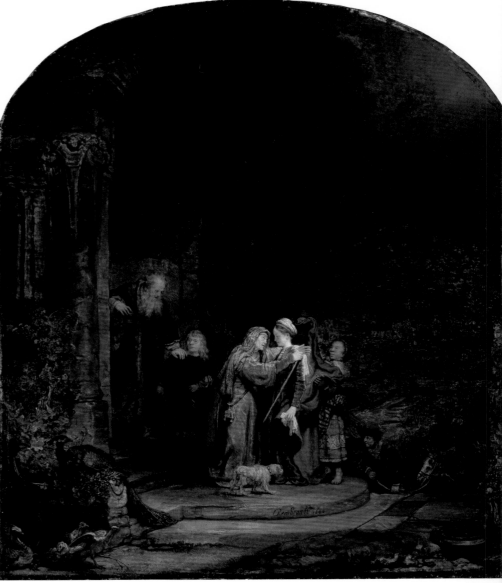

REDUCED

This painting on cedar panel has an arched top, a shape echoed by the ornamental step that forms a grand pedestal for the group of Elisabeth and Mary. The work is in many passages thinly executed, with a palette consisting of a whole spectrum of variations on the themes of green and red, cream yellow and ochre, and gray and black.

The general conception of the subject is indebted in part to Albrecht Dürer's woodcut from his series devoted to the Life of the Virgin (see figs. 61, 62). Rembrandt, the print collector and perhaps sometime art dealer, had purchased nine sets of these woodcuts at auction just two

69
The Visitation, 1640
Oil on panel
Br. 562; Corpus A138
56.6 × 47.8 cm (22 5/16 × 18 13/16 in.)
The Detroit Institute of Arts,
City of Detroit Purchase

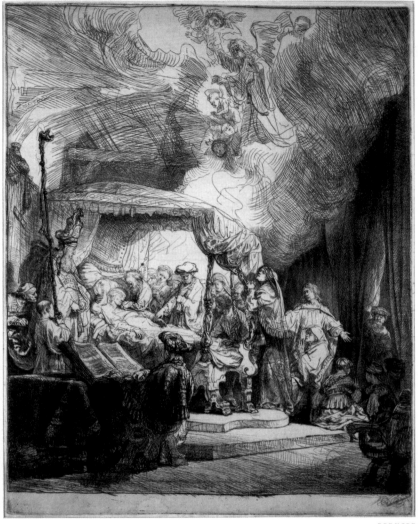

REDUCED

70

The Death of the Virgin, 1639
Etching and drypoint
B. 99, I
40.9 × 31.5 cm (16⅛ × 12⅜ in.)
Rijksmuseum, Amsterdam

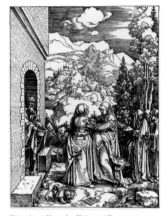

Fig. 61. Albrecht Dürer (German, 1471–1528), *The Visitation,* from the series *The Life of the Virgin,* probably 1504, woodcut, B. 84, 30 × 21.1 cm (11¹³⁄₁₆ × 8⁵⁄₁₆ in.), Museum of Fine Arts, Boston, Maria Antoinette Evans Fund.

years before in 1638.³ Dürer's woodcut, however, is set in ordinary daylight, the architecture is much simpler, and the women are both much more visibly pregnant.

The 1639 *Death of the Virgin* (no. 70) is one of the last etchings in which Rembrandt fully indulges the taste for Baroque pomp characteristic of many of his works of the 1630s. This large-scale etching and drypoint from Rembrandt's own hand differs from the large collaborative etching of *Christ before Pilate* of 1636 (no. 49) in that it is executed with varying degrees of finish, with the freest, most sketchlike passages being reserved for the heavenly vision with its celestial vapors, cherubs, and stately angel with open arms who appears to be waiting to receive the Virgin's soul.

The episode of the Death of the Virgin is based on apocryphal texts and legend rather than on authorized biblical texts and has strong visual precedents in the earlier history of printmaking: see, for example, Martin Schongauer's late-fifteenth-century engraving or Albrecht Dürer's 1510 woodcut from his cycle of the Life of the Virgin, referred to above (figs. 61, 62).⁴ Jacopo de Voragine's thirteenth-century *Golden Legend or Lives of the Saints* informs us that Mary was seventy-two years of age when she died. In many visual representations she is, however, ideally beautiful and even youthful in appearance, and in some versions of the legend she is said merely to have slept rather than to have died and to have been received still living into heaven by her son, Jesus. Legendary accounts surround the Virgin's deathbed with many miracles and heavenly visions, including the miraculous transportation of all of the widely scattered apostles to her bedside.⁵ Here only the two apostles into

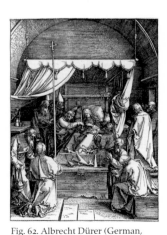

Fig. 62. Albrecht Dürer (German, 1471–1528), *The Death of the Virgin,* from the series *The Life of the Virgin,* 1510, woodcut, B. 93, 29.3 × 20.6 cm (11⁹⁄₁₆ × 8⅛ in.), Museum of Fine Arts, Boston, Maria Antoinette Evans Fund.

whose care Jesus had consigned his mother, Peter and John, appear to be present among a throng of witnesses, mourners, and priestly officiants. At the right, the youthful John with long flowing locks casts wide his arms in a rhetorical gesture of sorrow, while the bald-headed Peter tenderly nurses the expiring Mary through what are evidently her last moments of earthly existence.

Rembrandt upstages even Schongauer's intricately ornamental draperies and furnishings and Dürer's noble architecture with the theatrical splendor of his furnishings and setting. Rembrandt's grand canopied bed is very much part of the visual tradition that the earlier artists had established. This is an impression of the rare first state before the chair in the lower right corner was given firmer definition and greater weight, apparently in order to increase by contrast the illusion of depth in the room. Here many passages of drypoint burr that rapidly wore away contribute their velvety richness of texture to the overall opulence of the scene.

An unusual feature of Rembrandt's conception of the subject is the elaborately garbed figure in fur cape in the left foreground that is seated at a carpet-draped table on which rests a great open book. This elderly personage, who has removed his reading glasses, may have been intended by Rembrandt to be understood as a participant in the religious rites conducted by the grandly robed priest and acolyte to the left of the deathbed, but he also functions in the composition as a kind of witness or chronicler of the event with whom the viewer identifies.

The most unusual aspect of the etching is the intimate realism with which Rembrandt portrays the death scene that lies at the heart of all this grandiloquence. Peter, his features contorted with concern, uses Mary's pillow to support her limp form while attentively holding a cloth to her nose and mouth. A grave-looking doctor takes her pulse.[6] Rembrandt's various drawn and etched studies of women ill in bed or recovering from childbirth (see no. 104) seem to have been put to good use in this touchingly real vignette enclosed in a frame of rhetorical Baroque grandeur. This large print, which is perhaps today an acquired taste when compared with some of Rembrandt's less operatic religious narratives, was very successful in Rembrandt's time and went through four separate printings while the plate was still in Rembrandt's hands.[7] CSA

NOTES

1. See the evocative description of this narrative painting staged by Rembrandt "on the threshold" in Kuretsky 1997, 66–68.

2. See Kuretsky 1997, 67.

3. *Docs.* 1979, 1638/2.

4. Schongauer's engraving is B. 33; Dürer's woodcut is B. 94.

5. Jacobus de Voragine 1900, 4: 234. See also "The Assumption of the Virgin" in *Apocryphal New Testament* 1969, 194–98.

6. Tümpel 1970, no. 127 notes that these realistic details relate more to a tradition of moralizing images of deathbeds, such as the Death of the Rich Man, than to traditional representations of the Death of the Virgin.

7. Hinterding diss. 2001, 98–100.

71–74
Portraits of Learned Men
1646 AND 1647

One of Rembrandt's greatest gifts as a portraitist was his ability to convey a vivid sense of inner spiritual or intellectual life, of "soul." Three highly finished etched portraits of learned men from the 1640s—a deceased Protestant minister, a Jewish physician who was also a man of letters, and a wealthy amateur of art and literature who was a prominent member of Amsterdam's ruling merchant class—demonstrate Rembrandt's special gift for portraying the inner, as well as the outer, man. All three are full-dress portraits that acknowledge the printed portrait conventions of the day but transcend them in various ways.

In seventeenth-century Dutch society, Protestant preachers and ministers were stars celebrated for the eloquence of their public oratory or the sagacity of their moral and ethical guidance. They were portrayed by Rembrandt and his contemporaries in large numbers of paintings and prints. Jan Cornelisz. Sylvius (1563/4–1638) was a preacher of the Dutch Reformed Church who had married into the family of Saskia Uylenburgh, Rembrandt's wife, and had served as the orphaned Saskia's legal guardian. He also baptized two of Rembrandt and Saskia's children who died in infancy. Rembrandt had portrayed him before in a rather quiet etching of 1633, seated at a desk with eyes modestly and meditatively cast down and with hands passively folded on a Bible (fig. 63). The deceased Sylvius of the posthumous 1646 portrait is much more dynamic, actively gesturing with his right hand as he energetically and illusionistically leans forward into our space (no. 71). The fingers of his left hand are inserted into the pages of his Bible, so as to give him more ready reference to the passages which he wishes to consult. Rembrandt thus dramatically drives home the message that Sylvius's moral lessons are still as vital and relevant as ever and that his eloquence has

Fig. 63. *Jan Cornelis Sylvius, Preacher,* 1633, etching and engraving, B.266, I, 16.7 × 14.1 cm (6⁹⁄₁₆ × 5⁹⁄₁₆ in.), Museum of Fine Arts, Boston, Harvey D. Parker Collection.

71

Jan Cornelis Sylvius, 1646
Etching, drypoint, and
engraving
B. 280, I
27.8 × 18.9 cm (10^{15}/$_{16}$ × 7^{7}/$_{16}$ in.)
Museum of Fine Arts, Boston
Gift of William Norton Bullard

survived the grave. Engraved on the tablet below are the eulogistic Latin verses by the humanist scholar Caspar Barlaeus which may be translated, "Thus he decided: that Jesus can be taught more properly through leading a better life than by thundering speech."[1]

The feeling of Sylvius preaching to us from beyond the grave is heightened by the resemblance of the print's format to the carved stone memorial tablets set into the walls of seventeenth-century Dutch churches. The use of the oval frame in printed portraits is a tradition that can be traced back to late sixteenth-century engravings by Hendrik Goltzius and his circle. The idea of the sitter's hand illusionistically projecting through such a frame is seen in earlier portrait engravings by Jan

van de Velde after designs by Frans Hals.[2] But Rembrandt intensifies this fool-the-eye effect by thrusting Sylvius's whole upper body out of the shadowy space within the frame and into the light. The drama of the illumination is subtly enhanced by the transparent shadows cast by Sylvius's right hand, profile, and Bible. The shower of light fills the skillfully foreshortened hand like water flowing into a cup.

The earlier etched Sylvius portrait of 1633 also has a strong sense of light falling onto and singling out the preacher's head and shoulders, but the graphic vocabulary used to achieve it is more conventionally linear. In the 1646 etching Rembrandt not only used a finer mesh of line to achieve an effect of continuous tone, but he

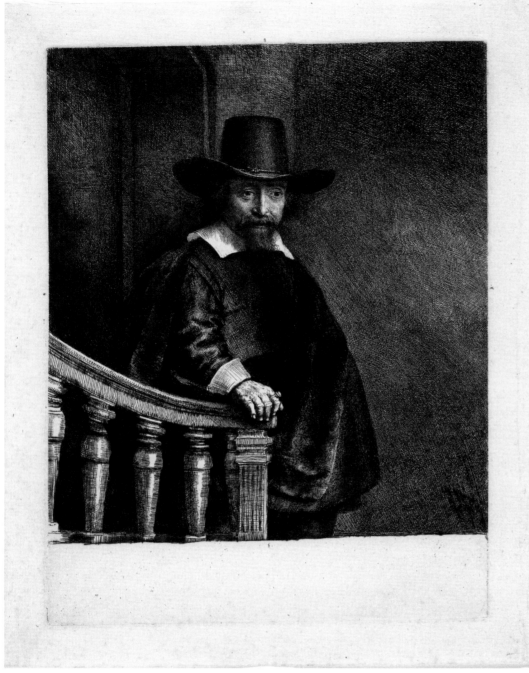

72

Ephraim Bueno (Bonus), Physician,
1647
Etching, drypoint, and engraving
B. 278, II
24 × 17.7 cm (9⁷⁄₁₆ × 6¹⁵⁄₁₆ in.)
Courtesy of the Fogg Art Museum,
Harvard University Art Museums,
Cambridge, Massachusetts
Gray Collection of Engravings Fund

REDUCED

also made deliberate and calculated use of an extreme-
ly fine granular etched tone to subliminally evoke the
play of light over Sylvius's features and to give an authen-
tically stony texture to the frame that bears the profes-
sionally engraved inscriptions. This still-mysterious
granular bitten tone was one that Rembrandt used
repeatedly (see nos. 119, 134). In some instances it
appears to be an accidental effect that Rembrandt took
advantage of (a crackled or too-porous etching ground),
but in other cases such as the present one its use seems

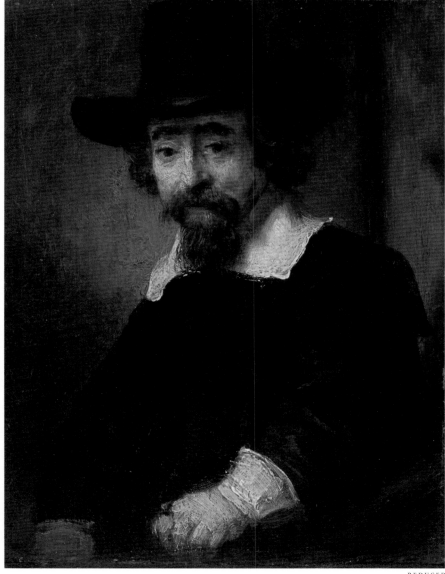

73
Ephraim Bueno, 1647
Oil on panel
Br. 252
19 × 15 cm (7½ × 5⅞ in.)
Rijksmuseum, Amsterdam

REDUCED

carefully calculated.³ Rembrandt apparently laid this tone down over Sylvius's face and then scraped and burnished out the highlights, achieving an ineffably subtle glow of light over Sylvius's features. He gave particular attention to removing the tone from the whites of Sylvius's melancholy eyes, subtly intensifying their expression. It is unclear whether he applied a corrosive paste or intentionally employed a too-porous etching ground to achieve this effect. It is similar to, but not necessarily identical with, the nineteenth-century tonal etching process, sulphur tint, in which a paste composed of oil and flowers of sulphur was applied to the plate to corrosively pit it.⁴

Although we do not know the circumstances behind its execution, this is one of the most official-looking of Rembrandt's several etched portraits and was most likely, like a number of the other etched portraits, commissioned.⁵ The fact that the plate was apparently given to a professional engraver to have the biographical and eulogistic inscriptions engraved backwards in flowing calligraphic script supports this notion.⁶ A number of Rembrandt's etched portrait plates have blank spaces in

the lower margin on which no verses were ever engraved. Impressions of some of these spaces acquired pen inscriptions by early collectors that have subsequently helped to identify the subjects of the portraits. In the Sylvius portrait the relative flatness of the precise engraved inscriptions heightens by contrast the magical tonal illusionism of the image.

Unlike most of his etchings of other subjects, many of Rembrandt's official etched portraits were carefully planned in advance of their execution by means of drawn sketches or sketches in oil (no. 73). Two drawings made in preparation for the Sylvius etching exist. The more developed one in the British Museum already has the foreshortened hand and its cast shadow but does not as yet include the motif of the fingers marking the pages in the Bible.[7]

The Portugese Jewish physician Ephraim Hezekiah Bueno (or in the Latin version, Bonus) was a financial backer of the printing house of Rembrandt's neighbor Rabbi Menasseh ben Israel, for whose mystical book Rembrandt made etched illustrations a few years later (see figs. 72, 73; p. 210). Bueno, who came from a long line of physicians, was also a poet and translator.[8] Here he is seen dressed to go out, perhaps to visit a patient, his hand resting on the banister at the foot of a staircase (no. 72). The shadowy architectural background appears to represent a foyer rather than the out-of-doors. In many respects this is one of Rembrandt's most conventional etched portraits. However, in a fine early impression such as that of the completed second state seen here, it is a virtuoso essay in black on black. It is one of Rembrandt's several "hand-drawn mezzotints" from the 1640s, made when the new copper plate print process of mezzotint (that used a special tool to achieve continuous tones on a copper plate) was still in its primitive developmental stages. Rembrandt's deeply textured, velvety symphony of blacks is composed of an unsystematic web of fine strokes in etching, drypoint, and engraving—that emphasizes the dignified sobriety of Bueno's contemporary dress. The white of the cuff and collar sets off by contrast the doctor's small but obviously strong and capable hand and the soulful expression of the eyes with their distant, reflective gaze. One is, in fact, tempted to characterize this print as the portrait of a pair of eyes—eyes that convey a remarkably vivid and complex sense of interior life. At the bottom of the plate space was reserved for an inscription that was, as was so often the case with Rembrandt's etched portraits, never added.

The Bueno etching is extraordinary in that its preparation consisted not of drawings as with the Sylvius portrait, but of a small oil sketch in color on wooden panel (no. 73). Prior to Rembrandt, Anthony van Dyck and Frans Hals had made use of oil sketches as models for portraits to be engraved by professional printmakers.[9] Rembrandt's oil sketch is, however, not monochromatic but executed in color and is more informal in character than the print, a half-length close-up of the sitter. What becomes a banister in the print may very well be the curved arm of a chair in the painting. There is an architectural element indicated at right in the painting but it is not yet put to the highly formal use that architectural elements are in the print. In the etching, the cone of the crown of the sitter's hat is carefully aligned with the projection of the archway and with the stairpost on which Bueno's hand rests. Rembrandt on one other occasion appears to have used an oil sketch in color as preparation for a black and white portrait etching. The oil sketch of the calligrapher Coppenol in the Metropolitan Museum, New York, served as a model for the larger of Rembrandt's two etched portraits of the celebrated penman (see no. 210 for the "small Coppenol").[10]

When one mentions "Rembrandt and Jan Six" many inevitably think of Rembrandt's moving 1654 three-quarter-length painted portrait of Six that is still in the Six family collection in Amsterdam.[11] But Rembrandt's 1647 etched portrait of the twenty-nine-year-old Six, his patron and very likely his friend, is equally original. It was to have an enormous influence not only on printed but also on painted images in the eighteenth and early nineteenth centuries: for its innovative conception of how to portray a cultivated gentleman of leisure, for its inclusion of the sitter's domestic environment as an essential aspect of the portrait, and as a poetic image of a figure at a window. Whereas the 1654 painted portrait is all fluid brushwork and seeming ease of execution, the 1647 etching—seen here in the fourth and final state—is a virtuoso, labor-intensive production in which the individual mark is subordinated to a broader tonal vision of daylight penetrating a dark interior (no. 74).

Jan Six's grandfather was an aristocratic French Hugenot émigré who formed the family's highly successful cloth-dying and silk-weaving business. His grandson continued in the family business for a time and then gave it up a few years after this portrait was etched. His widowed mother insured that he received the best of educations. He had studied at the University in Leiden, had made the Grand Tour of Europe and was conversant with several languages.[12] He was a also poet and playwright. In the following year, 1648, Rembrandt etched an illustration for Six's tragic verse drama, *Medea* (see no. 138), and in 1652 he drew in Six's friendship album, *Pandora*, two finished drawings, one of the poet Homer recit-

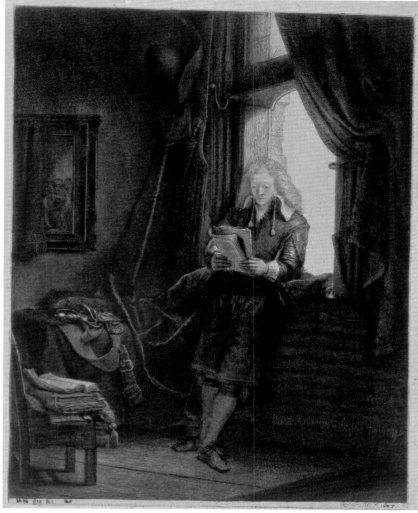

REDUCED

74

Jan Six, 1647
Etching, drypoint, and
engraving on Japanese paper
B. 285, IV
24.8 × 19.6 cm (9¾ × 7¹¹⁄₁₆ in.)
Private Collection

Fig. 64. *Study for Portrait of Jan Six*, about 1647, pen
and brown ink with brown wash, corrected with
white, Ben. 767, 22 × 17.7 cm (8¹¹⁄₁₆ × 6⁵⁄₁₆ in.), Six
Collection, Amsterdam.

ing and one of Six's mother in the guise of Athena, the goddess of wisdom. Both drawings cast a highly flattering light on the family's cultivation and learning.[13] Six seriously collected paintings by Rembrandt[14] and other artists and was extremely proud of his deep personal commitment to arts and letters. When referring in an erudite Latin inscription to his 1654 portrait by Rembrandt he described himself as, "I, Jan Six, who since childhood have worshipped the muses."[15]

Rembrandt's quietly radical etched portrait flatters Six by characterizing him as the cultivated gentleman of leisure totally at ease with himself and deeply immersed in his artistic and intellectual pursuits. We see here no swagger and no self-conscious awareness of the viewer. In addition to the book that Six is perusing, others are

piled up on a chair, and a painting protected by a curtain hangs on the wall. The potential for more active pursuits is hinted at by the aristocratic sword on the table or the hat, satchel, and stick in the corner that suggest country activities such as walking or hunting. But the center of focus here is Six's profound absorption in the text that he is reading. The light of day illuminates the text and the light reflected from the text illuminates Jan Six in a literal and a figurative sense. Jan Six's head and hair irradiated with light are a virtuoso study in the tonal rendering of fairness and blondness, particularly when contrasted to the deep penumbra of shadow that envelops the room.[16] The rendition of Six's facial features and hair is achieved through innumerable fine marks that seamlessly meld with one another and with

the tone of the paper. In the dark interior of Six's study details gradually become more legible the longer we look. Our eyes adjust, as they would in a darkened room.[17] Figures at a window and light entering from a window are, of course, central images not just in Rembrandt's art but also in seventeenth-century Dutch art in general. One need only think of Vermeer's milkmaids and letter readers.

Like the other portraits under discussion here, the Six portrait was carefully planned. There are three surviving drawings for the plate. The two most complete drawings, one of which was used to trace the image onto the copper plate, and the copper plate itself are still in the possession of the Six family.[18] The first of the surviving drawings, a wonderfully energetic full-length pen drawing made with a broad point, probably with a reed pen, is unusually casual in conception (fig. 64, p. 143). Six leans on the windowsill and looks out at us. He has no book or manuscript in his hands. A whippetlike dog leaps up on him. The chair at lower left is an armchair and appears to hold no books. He is more the man of action than of studious contemplation. The second, a cursory sketch in black chalk in the Fodor collection of the Amsterdam Historical Museum, depicts Six's head and upper body. He now appears to be reading, as in the print, but has a tall hat awkwardly perched on his head. The third drawing is a full-length black chalk drawing touched up with pen and indented to transfer the principal elements of the etching to the plate. Such careful transfer of a design to the copper plate is rare in Rembrandt's printmaking and underlines the exceptional and meticulous care Rembrandt exercised in order to please this particular patron.

Fine impressions of the Six portrait, including the completed fourth state shown here, are relatively rare. Through the first three states Rembrandt gradually intensified the light from the window and deepened the shadows of the study interior. In the early stages Six's face is yet more subtly and ethereally rendered. In the final state Rembrandt inscribed the sitter's name and age in small letters in the narrow lower margin: "AE: 29" (the letters AE are an abbreviation for the Latin *aetatis*, "of the age of"). This rather narrow blank lower margin was probably never intended to receive laudatory verses. But in any case no such verses were necessary: the carefully conceived image of gentlemanly ease, cultivation, and enlightenment said it all.[19] CSA

2. See Ackley *Printmaking* 1981, 150, note 1. For a reproduction of Jan van de Velde's engraving of the preacher Acronius after Frans Hals, see Holl. 33–34, no. 384.

3. See Clifford S. Ackley, "The Quest for Printed Tone," in Ackley *Printmaking* 1981, xix–xxvi (with detail of Sylvius's head), and 150–51, no. 97.

4. Cynthia Schneider is more definite about Rembrandt's use of sulphur tinting in her "Introduction" to Schneider 1990, 24, and 79, no. 4. See also Hinterding diss. 2001, 105, note 308. Hinterding is inclined to attribute these effects to the use of a porous etched ground but expresses uncertainty about the degree of intention.

5. Koerner and Zell 1999 present a different position. They consider Rembrandt's etched portraits to have been produced for a limited audience, primarily as gifts intended for a circle of friends.

6. The related etched oval portrait of the preacher Jan Uytenbogaert of 1635 (B. 279) acquired in the fourth state in the lower margin verses by Hugo de Groot, but these were etched rather than professionally engraved, most likely by Rembrandt himself.

7. Ben. 762a and 763; Ben. 763 is in the British Museum. See Amsterdam/London 2000, 225–26, no. 54 for reproductions.

8. Amsterdam/London 2000, 227–31, no. 55.

9. Depauw and Luijten et al. 1999; and Ernst van de Wetering, "Remarks on Rembrandt's Oil Sketches for Etchings," in Amsterdam/London 2000, 36–63.

10. The "large Coppenol," is B. 283; the "small" is B. 282. See also Ernst van de Wetering, "Remarks on Rembrandt's Oil Sketches for Etchings," in Amsterdam/London 2000, 36–63; and Ger Luijten in Amsterdam/London 2000, 354–60, no. 89.

11. Br. 276.

12. See Barbara Welzel in *Master and Workshop: Drawings and Etchings* 1991, 2: 231, no. 23; and Smith 1988, 42–43.

13. See Peter Schatborn in *Master and Workshop: Drawings and Etchings* 1991, 2:109–112, no. 31; and Smith 1988, 43.

14. He owned, for example, the ambitious Rembrandt oil sketch *John the Baptist Preaching*, now in Berlin (Br. 476, Corpus A106). See fig. 32, p. 35 in Ronni Baer's essay on the oil sketches.

15. *Docs.* 1979, 1654/21; cited in Smith 1988, 43.

16. Rembrandt's 1641 etched fantasy portrait *Young Man at a Desk Wearing a Cross and Chain* (B. 261) is a kind of rehearsal for this virtuoso portrayal of fairness and blondness in black and white.

17. See Sophie de Bussiere's sensitive description of the etching in De Bussiere 1986, 143–44.

18. The three surviving drawings are Ben. 749 verso (Amsterdam Historical Museum), Ben. 767 (Six Collection), and Ben. 768 (Six Collection). Reproduced in Amsterdam/London 2000, 239–41.

19. *Docs.* 1979, 1655/8. A notary's document of 1655 testifies to the esteem in which the etched portrait of Six was held. In the document, Rembrandt proposed to purchase a house from the brothers Dirck and Otto van Kattenburch (or Cattenburgh) in exchange for a smaller sum of cash and a larger sum of appraised art by Rembrandt and others. Part of the deal (which was never consummated) was "a portrait of Otto van Kattenburch which the aforementioned Van Rijn shall etch from life, equal in quality to his portrait of Mr. Jan Six, for the sum of [ƒ.]400:0." (Four hundred guilders!—an astonishing sum in the age of the highly expensive "Hundred Guilder Print.")

NOTES

1. See the complete translation of these verses in Amsterdam/London 2000, 225, no. 54.

75–79
Scenes from Everyday Life
1630S–1650S

Rembrandt used his keen observation of the daily life around him to inject new life and reality into traditional biblical and historical narratives, but he also depicted everyday reality for its own sake, whether the life of the street or the activities and customs associated with particular months and seasons. Etchings and drawings from 1635 to about 1651 testify to the special insight he brought to such subjects.

"The Pancake Baker" was already part of an established tradition of imagery by the time Rembrandt made his etching of 1635 (no. 75). Jan van de Velde in the 1620s had engraved a nocturnal version of the subject in which a somewhat sinister-looking pancake woman is eerily illuminated by firelight in a dark interior.[1] We also know from the 1656 inventory of Rembrandt's possessions that Rembrandt owned a painting of a *koekebaker* (cake baker) by the Flemish painter Adriaen Brouwer, who had studied with Frans Hals in Haarlem in the 1620s.[2] Rembrandt's etching takes place out-of-doors in the street. Vendors of hot food are, of course, still familiar sights in city streets today, whether selling hot dogs and pretzels on a New York corner or crêpes in a Parisian park. Rembrandt's etching is related to his many drawn sketches from this time that document the often-rambunctious life of small children and their nurses or mothers.[3] Rembrandt's conception of children was refreshingly robust and vital rather than sentimental in nature.[4]

The Pancake Woman is one of the first etchings in which Rembrandt made expressive use of different degrees of finish. In the first state of *The Pancake Woman* everything— even the old pancake baker herself—consists of scrawling wiry outlines with relatively little shading.[5] In the completed second state seen here, heavy etched shading has transformed the old woman into the weighty hub around which the rowdy animation of the children circulates. In the foreground a sturdy, grimacing child defends his pancake from a dog positively aquiver with greed.[6]

A fattened hog was often the primary source of the provisions that saw a Dutch farm family through the winter. In the traditional cycle of the months specific activities were associated with each month: November was known as *slachtmaand* (slaughtering month).[7] Rembrandt's etching of 1643 is not a standard depiction of such a subject (no. 76). It is first of all a detailed portrait of a particular and very weighty, trussed-up, and teth-

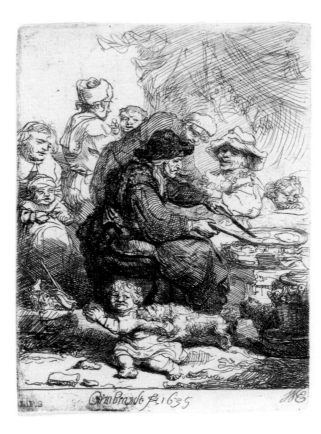

75
The Pancake Woman, 1635
Etching
B. 124, II
10.7 × 7.7 cm (4³⁄₁₆ × 3¹⁄₁₆ in.)
Museum of Fine Arts, Boston
Harvey D. Parker Collection

ered sow. The portraitlike character of the image is intensified not only through the precise characterization of the hog's bristly coat but also through the careful rendering of her eye and its expression.

About this time Rembrandt drew a few pen studies of hogs, including one of a reclining sow with her hind legs tied (Ben. 777; Rothschild Collection, Musée du Louvre). This sheet also includes a carefully rendered detail study of the hog's eye and ear.[8] Appended to the animal's portrait in the background of the etching are lightly sketched anecdotal references that concern the whole family's participation in this occasion. One of the most unusual aspects of the etching is the radically asymmetrical balancing of the fully described, three-dimensional bulk of the hog at the lower left against the large area of totally blank paper at the upper right.

In the left background the father of the family is occupied with preparations for the slaughtering. A basket is looped over his right arm and his right hand holds an axe. With his left hand he grasps a yoke from which the hog's carcass will be suspended. The wooden trough leaning upright against the wall is also a familiar implement in the butchering process. At the left a smiling mother encourages a young baby wearing a head pro-

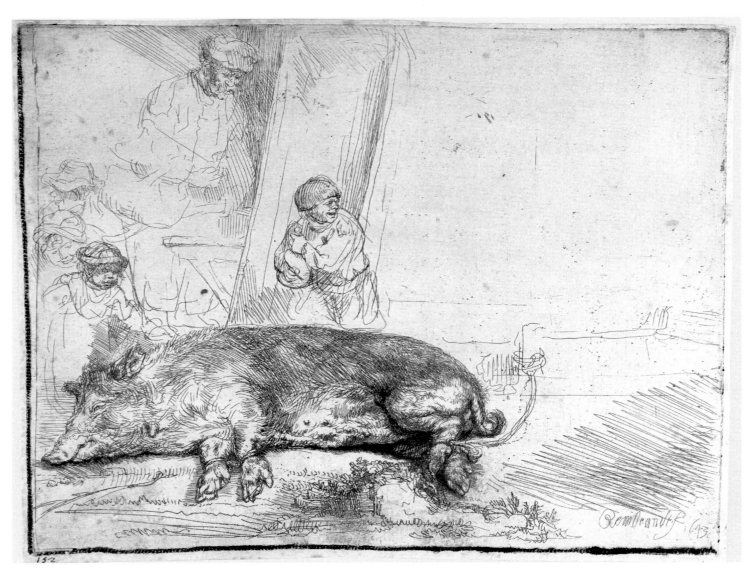

152

tector to take a closer look at the source of their winter meals: the baby reaches out to pat the hog. To the right a grinning boy squeezes an inflated pig's bladder. The boy either holds a straw to inflate the balloonlike bladder or a pin to prick it. The image of young children in association with evanescent bursting bubbles, commonly soap bubbles, was a standard seventeenth century Dutch symbol of *vanitas*, of the brevity of life. Most contemporary Dutch depictions of hogs or hog slaughtering are singularly unsentimental, even brutal; Rembrandt's depiction is a unique blend of objective observation, earthy humor, and a certain pathos.

In seventeenth-century Holland the twelfth night after Christmas, Epiphany, was a celebration of the arrival

of the three Kings or Magi who had followed the star to Bethlehem bearing gifts for the newly born Christ child. Children customarily went from door to door carrying an illuminated star-shaped lantern to represent the miraculous star that had guided the wise men. They also sang carols and begged for alms. It was an occasion not unlike the trick-or-treating from door to door associated with the American celebration of Halloween.

In the large drawing of the subject dating from about 1645–47 (no. 77), a group of children with an illuminated star lantern have halted before the door of a house. From within the house women and children, one a baby in arms, watch the show from behind the closed lower leaf of a Dutch door. While one larger child—his figure

76

The Hog, 1643
Etching and drypoint
B. 157, I
14.5 × 18.8 cm (5^{11}/$_{16}$ × 7^{3}/$_{8}$ in.)
Courtesy of the Fogg Art Museum, Harvard University Art Museums, Cambridge, Massachusetts
Anonymous Fund for the Acquisition of Prints Older than 150 Years

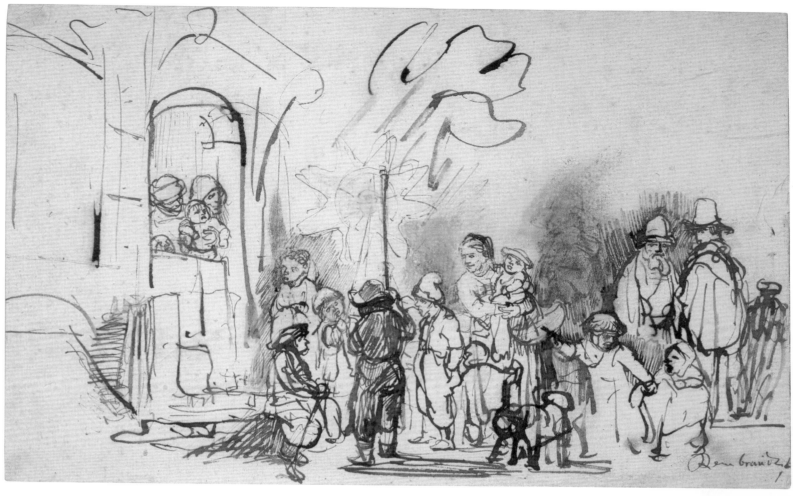

strongly shadowed by the light from the star—holds the pole that supports the star, another smaller child pulls on a cord that causes it to revolve. The motion of the glowing star is indicated by lightly drawn overlapping contour lines.

The drawing is executed with an extremely fluid pen line. Scribbly bundles of pen hatching and patches of ink wash applied with a brush allude in abbreviated fashion to the surrounding darkness. Wash is also used to edit out figures the artist wished to suppress, such as the man to the right of the standing woman holding a small child wearing a head protector. The rapid linework of the drawing is often suggestive rather than fully descriptive: it is difficult to say whether the scrawled lines above the lantern were intended to represent smoke emanating from it or foliage illuminated by it. Given its seemingly casual execution it is somewhat surprising that the draw-

ing is fully signed at lower right with an authentic signature. This signature suggests the very real possibility that Rembrandt regarded this extremely free but ambitious large-scale sketch as a finished work.

A small black chalk sketch (no. 78) from about the same time (1645–48) representing an elderly man with cane and fur-lined cap and cloak not only shows us what some of the figures in the foregoing drawing would look like if drawn in chalk rather than pen, but provides a close comparison and contrast with the Leiden period black chalk drawing of about 1629 of a street figure leaning on a stick (no. 22). The more heavily shaded figure here is compacter, bulkier and more substantial than the figure in the earlier, more calligraphic drawing but the chalk still lends an angular rhythm to some of the contours. We can easily imagine this figure as one of the onlookers in the *Star of the Kings* drawing but it is also the

77

The Star of the Kings, 1645–47
Pen and brown ink with brown wash
Ben. 736
20.4 × 32.3 cm (8¹/₁₆ × 12¹¹/₁₆ in.)
Lent by the Trustees of the British Museum, London

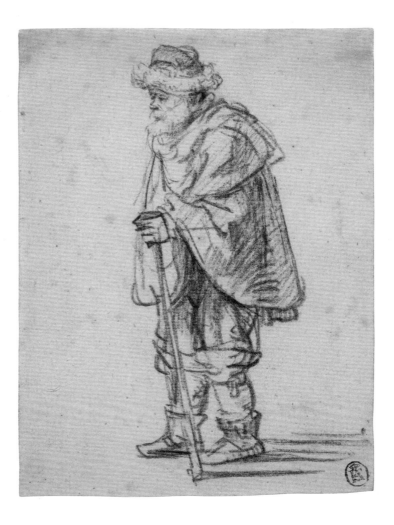

78

Old Man in a Fur Cap, 1645–48
Black chalk
Ben. 724
12.9 × 9.4 cm (5$\frac{1}{16}$ × 3$\frac{11}{16}$ in.)
Private Collection

kind of drawing that might have served as background source material for the figures of the poor and the sick to whom Christ is ministering in the ambitious large etching of about the same date representing *Christ Preaching* (the "Hundred Guilder Print," no. 135). Perhaps its closest relationship is with a black chalk sketch of a family of beggars that has been related to the 1648 etching of *Beggars at the Door* (no. 140). The latter can probably be dated about 1647 because it is the recto of a black chalk study for the 1647 etching of Jan Six (no. 74).[9]

Rembrandt took up the subject of the *Star of the Kings* once again in 1651 in an etching (with drypoint and engraving) more modestly scaled than the drawing discussed above (no. 79). Again the glowing star appears before the half-door of a house, but now individual

figures are nearly swallowed up in the enveloping darkness that is the central image. Jan van de Velde had depicted the subject in the 1620s in a nocturnal engraving after Peter Molyn (fig. 65), but the darkness in Rembrandt's etching is more tangible and more impenetrable. Rembrandt himself had earlier etched a similar nocturnal subject in which a blind hurdy-gurdy man surrounded by children appears at the half-door of a house on which leans a woman with strongly illuminated, rather brutal features (B. 128, 1641, the so-called "Schoolmaster"). In the 1651 etching the velvety web of darkness is quite dense but still somewhat translucent. One can just discern in the distance the dim glow from the windows of other houses and the bright spark of another lantern. The eye is tantalized, convinced that if one

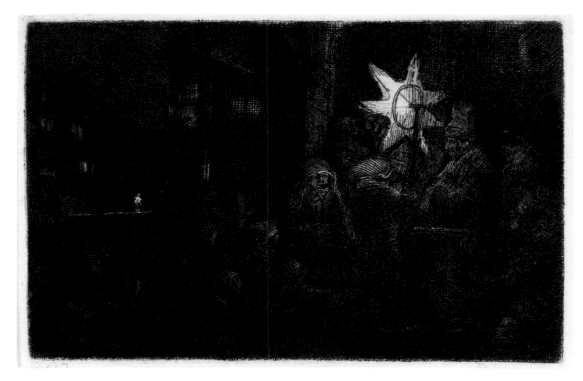

79
The Star of the Kings, 1651
Etching, drypoint, and engraving
B. 113, only state
9.3 × 14.1 cm (3¹¹/₁₆ × 5⁹/₁₆ in.)
Museum of Fine Arts, Boston
Gift of William Norton Bullard

looked long enough, one's vision would finally adjust to the darkness and all would be visible. On another, more metaphorical level the image of the light from the miraculous star barely penetrating the profound darkness can be seen as having a more symbolic or mystical meaning. CSA

NOTES

1. Holl. 33–34: no. 148. See also Ackley *Printmaking* 1981, 102, no. 61.

2. *Docs.* 1979, 1656/12, 1 (there translated as "pastrycook").

3. For these drawings, see nos. 100, 102.

4. A contemporary pen drawing of horizontal format of this subject (Ben. 409; Rijksmuseum; reproduced in Amsterdam/London 2000, 153, no. 28, fig. c) is not a preparatory study for the etching but rather a lively variation on the same theme.

5. First state reproduced in Amsterdam/London 2000, 152 no. 28, (I Amsterdam).

6. Gersaint, the first cataloguer of Rembrandt's etchings, his appetite apparently stimulated by the image, thoughtfully provided a recipe for Dutch pancakes—how one prepares them, and how one eats them. See Gersaint 1751, 105–106, note 120.

7. See Ackley *Printmaking* 1981, 162, no. 104 (Ostade) for this subject.

8. Reproduced in Amsterdam/London 2000, 205, no. 47.

9. Amsterdam Historisch Museum, Ben. 749.

Fig. 65. Jan van de Velde II (Dutch, 1593–1641), *The Star of the Kings, a night piece,* 1620s, engraving, Holl. 149, 20.8 × 16.1 cm (8³/₁₆ × 6⁵/₁₆ in.), Museum of Fine Arts, Boston, Harvey D. Parker Collection.

80–84
Self-Portraits

1630S AND 1640S

With his permanent move to Amsterdam about 1633, Rembrandt's etched self-portraits became more elaborate and, over the course of the decade, diminished in frequency. If in the intense little studies of the Leiden period (nos. 15–17) he had rehearsed expression, lighting, and technique, Rembrandt stepped on stage in full costume before a larger audience in his highly imaginative Amsterdam self-portraits. At first he so completely enveloped himself in his roles—as in the orientalizing fantasy *Self-Portrait (with plumed cap and lowered sabre)* (no. 28)—that his own identity was nearly lost, but he soon achieved an equilibrium in which he was clearly the star playing the part. His interest in presenting himself as a Renaissance courtier, seen in early paintings such as his 1629 self-portrait (no. 14), came to full flower in the medium of etching. These historicizing fantasies culminated in his 1639 *Self-Portrait Leaning on a Stone Sill* (no. 81), after which he never again presented himself so flamboyantly in print.

Given the dozens of known self-portrait paintings and etchings, the number of extant drawings that Rembrandt made of his own likeness is remarkably small. A small red chalk bust from about 1635–38 in the National Gallery, Washington, shows him handsomely outfitted as a Renaissance courtier with lovelock, wide beret, and old-fashioned smocked shirt (no. 80). Though the bust now appears carefully centered on a small piece of paper, the sheet was apparently cut down after Rembrandt's death in order to frame the drawing more tightly.[1] We know that the sheet was larger because the verso bears fragments of trimmed-down sketches for an Entombment of Christ. These sketches are pertinent to Rembrandt's courtly ambition, for he drew them while working out the details of a painting commissioned by Stadholder Frederik Hendrik. In 1636, Rembrandt wrote to Constantijn Huygens, the stadholder's secretary, saying that he was diligently at work on the painting as well as related works.[2] This formal and dignified portrait suggests that Rembrandt may also have spent time daydreaming about the influence such a noble patron might have on his own social status. Whatever Rembrandt's mindset, he executed the drawing in a single medium using crisp, staccato movements of the hand, relieved occasionally by more flowing strokes.

In 1639 Rembrandt began to taste the fruits of success. He had finally delivered the paintings ordered by the

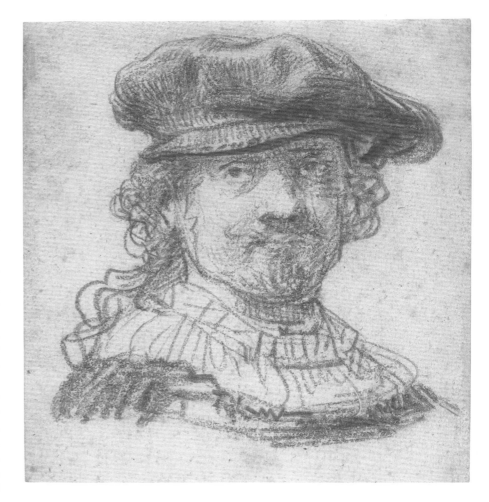

stadholder, had overcome bureaucratic obstacles to receiving payment for the work, and had moved into a grand house large enough to accommodate his family, workshop, gallery, students, collections, and servants (see Chronology). He celebrated his success in an etched self-portrait, now so familiar from its reproduction on posters, book covers, and shopping bags that—like Leonardo's *Mona Lisa*—it is somewhat difficult to see with fresh eyes. It is ironic that such familiarity should affect our response to the *Self-Portrait Leaning on a Stone Sill* (no. 81)—a work of enormous quality and refinement. Here Rembrandt elbows his way into the company of two great single-name artists of the Italian Renaissance: Raphael and Titian. The etching is a direct response to two famous portrait paintings briefly visible in Amsterdam at this time: Titian's so-called *Ariosto* and Raphael's *Baldassare Castiglione*. The Titian—or perhaps a faithful

80

Self-Portrait with a Beret, 1635–38
Red chalk
Ben. 437
12.9 × 11.9 cm (5 1/16 × 4 11/16 in.)
National Gallery of Art, Washington
Rosenwald Collection

81

Self-Portrait Leaning on a Stone Sill, 1639
Etching
B. 21, II
20.5 × 16.3 cm (8 1/16 × 6 7/16 in.)
Museum of Fine Arts, Boston
Anonymous gift and Katherine
E. Bullard Fund in memory of
Francis Bullard

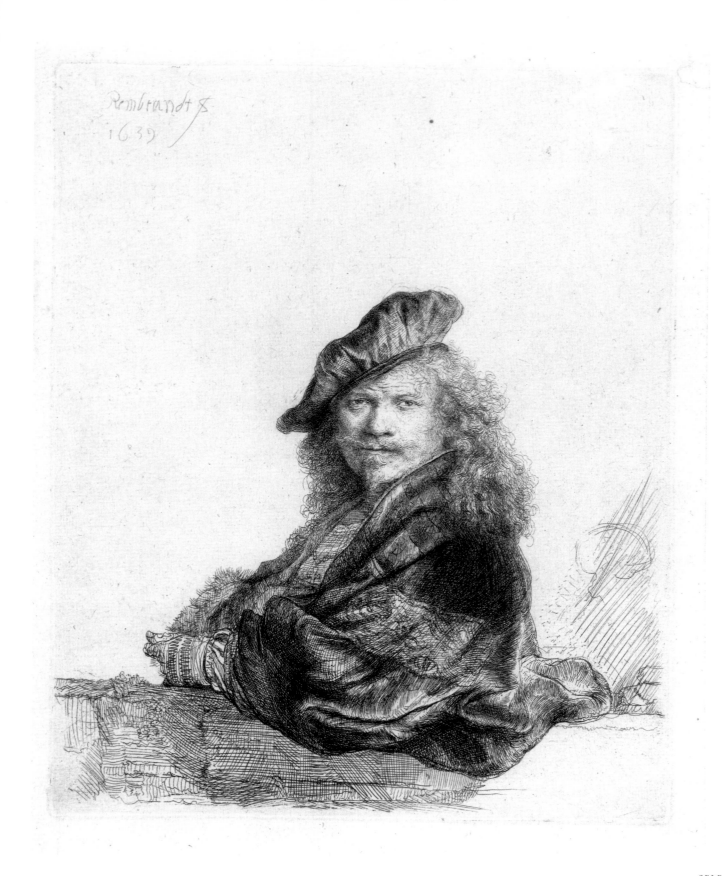

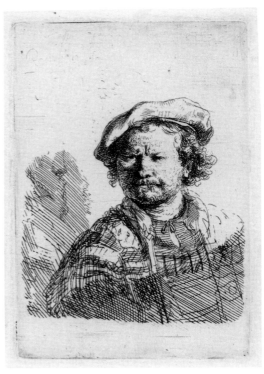

83
Self-Portrait (in a flat cap and embroidered dress), 1642
Copper etching plate
B. 26
9.5 × 6.2 cm (3¾ × 2⁷⁄₁₆ in.)
Courtesy of the Fogg Art Museum, Harvard University Art Museums, Cambridge, Massachusetts
Gift of Robert M. Light in memory of Jakob Rosenberg

82
Self-Portrait (in a flat cap and embroidered dress), 1642
Etching
B. 26, only state
9.2 × 6.1 cm (3⅝ × 2⅜ in.)
Museum of Fine Arts, Boston
Katherine E. Bullard Fund in memory of Francis Bullard

84
Sheet of Studies, 1638–45
Etching
B. 372, only state
7.7 × 6.7 cm (3¹⁄₁₆ × 2⅝ in.)
Museum of Fine Arts
Harvey D. Parker Collection

copy—was in the possession of the international broker of luxuries, Alfonso Lopez. It inspired Rembrandt's conceit of posing behind a stone barrier with an opulent sleeve lapping over the edge. From the Raphael, Rembrandt adopted the upturned collar and outward turn of the head. Rembrandt actually witnessed Lopez's purchase of the Raphael for a breathtaking 3,500 guilders, probably not aware that the Portuguese agent was acting on behalf of Cardinal Richelieu for Louis XIII of France. Rembrandt was so taken by the portrait and the event that he drew a free copy of the painting and noted its price.[3] Some elements of the etching draw on both paintings. For instance, the beret recalls Castiglione's and is set at an angle comparable to that of the hair combed across Ariosto's temple. Yet, despite unmistakable references to the celebrated paintings, the etching is remarkably original. Rembrandt places his face at the very center of the plate. Discarding Castiglione's look of glassy remove and Ariosto's aloof sideward glance, he stares us down with piercing intensity. His full mane of hair may reflect a new fashion just taking hold in 1639.[4] His gloved hand removes him from the workshop and places him at court. Even the etching style expresses Rembrandt's personal refinement. Using a needle so fine that it is often difficult to make out individual lines, he avoided strong contrasts everywhere except in those uncannily intelligent eyes. The soft tonalities may also have been intended as a metaphor for gentlemanly moderation and refinement. Rembrandt would later show himself as an artist at work, but here he is a Renaissance courtier and prominently displays his distinctive single-name signature in the generous open space of the blank background.

Though he sometimes dressed himself ostentatiously in his later self-portrait paintings, Rembrandt never again etched his own likeness with such swagger. He donned a Renaissance slit doublet in his pocket-sized *Self-Portrait (in a flat cap and embroidered dress)* of about 1642 (no. 82), but completely dispensed with the theatrics of his 1630s performances. He portrayed his face here without the mask of idealization. Saskia died in June 1642. Is it too subjective to see in the knit brow and down-turned mouth the face of a man determined to carry on despite his sorrow?

The dramatic raking light recalls his early self-portraits (such as nos. 15 and 16), but here he uses a different linear vocabulary. In depicting his clothing and the shadow on the wall, he used a rational, open system of parallel lines often employed by prominent Renaissance artists such as Mantegna and Raphael. This is an early instance of a graphic language that he used more fre-

quently in later years. The copper plate for this etching is remarkably legible (no. 83). One can almost visualize Rembrandt cupping it in the palm of his left hand while he fluently wielded the needle with his right.

An intriguing curiosity among Rembrandt's prints is his smallest sketch plate, which includes a fragmentary self-portrait, a miniature landscape, a lightly drawn disembodied eye, and a tuft of hair (no. 84). These components are oriented in different directions: the various elements do not form a conventionally coherent composition as in the 1637 sketch plate that features Saskia (no. 104). Attempts to date the etching have ranged from 1638 to 1645. The earlier estimate probably derives from the similarity of the self-portrait fragment to the motif and style of a self-portrait etching signed and dated 1638, *Self-Portrait in a Velvet Cap with Plume,*[5] and the *Self-Portrait Leaning on a Stone Sill* (no. 81).[6] The later date is based on comparison of the landscape style to that of *The Omval* (no. 125) and *The Boathouse* (no. 122).[7] The desire to assign a single date to the plate may, however, be misguided. Rembrandt may initially have begun a self-portrait—or tested some ideas in preparation for one—and then set the copper plate aside. Several years may have elapsed before he picked up the plate again and dashed off the little landscape. The sharp decline in Rembrandt's production of self-portrait etchings after 1640 and the lack of landscapes dated before 1640 lend plausibility to the notion of a gap in time. Only a small number of impressions were printed, and collectors consider the etching a rarity. TER

NOTES

1. Ben Broos in White and Buvelot et al. 1999, 161, no. 45.

2. *Docs.* 1979, 1636/1.

3. Albertina, Vienna, Ben. 451. Rembrandt recorded the painting after seeing it at the dispersal of the collection of Lucas van Uffelen in April 1639; see *Docs.* 1979, 1639/8. The Titian, *Portrait of an Unknown Man,* is now in the National Gallery, London. In the seventeenth century the sitter was believed to be the famous poet Lodovico Ariosto. The Raphael, *Baldassare Castiglione,* is in the Musée du Louvre, Paris. Castiglione was renowned as the author of *The Book of the Courtier,* the work that defined the notion of the cultivated gentleman.

4. Blankert et al. 1997, 128. In 1640, a stormy debate broke out over the propriety of long hairstyles. Despite five years of resistance, the new fashion persisted.

5. *The Self-Portrait in a Velvet Cap with Plume* is B. 20.

6. Filedt Kok 1972, 162.

7. Peter Schatborn in White and Buvelot et al. 1999, 185, no. 61.

Images of Artists

1630S–1650S

Apart from his many portraits of himself in painting, drawing, and print, Rembrandt executed a number of etchings that depict artists at work or that are portraits of artist friends and contemporaries. These images provide us with clues—or raise new questions—regarding Rembrandt's attitudes and ideas about art and artists.

The Artist Drawing from a Model, an unsigned and undated etching of about 1639 (no. 85), is seen here in its rare first state, but even in the second state, in which the upper center and right quarter of the image were elaborately and meticulously finished, three-quarters remained in a sketchlike, "bare outlines" stage. A pen and gallnut ink drawing of the whole composition in the British Museum suggests that Rembrandt did indeed have plans at one stage to complete the image.[1] Nevertheless, although he did not "finish" the plate, which still survives in the collection of the Rembrandt House, recent watermark research indicates that a fairly large number of second-state impressions were printed while the plate was still in Rembrandt's possession, first about 1640 and again about 1652.[2] Unusual as such an incomplete image was at the time, there was a prestigious precedent for the issuing of such an unfinished print in the earlier posthumous publication of two unfinished engravings by Hendrik Goltzius (1558–1617), the celebrated virtuoso of Dutch printmaking who preceded Rembrandt.[3] Rembrandt apparently had reason to believe that there was an audience or a market for such an image, an image that not only gave insight into his working process but also dramatized his surprising range of handling from the roughest, most spontaneous sketch to the most polished, meticulous finish.[4]

In this very fresh impression of the rare first state, the rich burr on the lines makes it clear that Rembrandt initially scratched the image into the plate with drypoint. Martin Royalton-Kisch believes that the visible changes of mind evident here (the different overlapping positions of the model's feet, for example) reinforce the idea that the British Museum drawing (which is not indented for transfer) was intended as a model for mid-stream *completion* of the composition, rather than as a guide for its beginning.[5] In both states of the print the finished areas at top and upper right provide the maximum contrast with the free contour drawing in drypoint below. The former passages are executed in Rembrandt's most meticulous and detailed manner, comparable in finish to

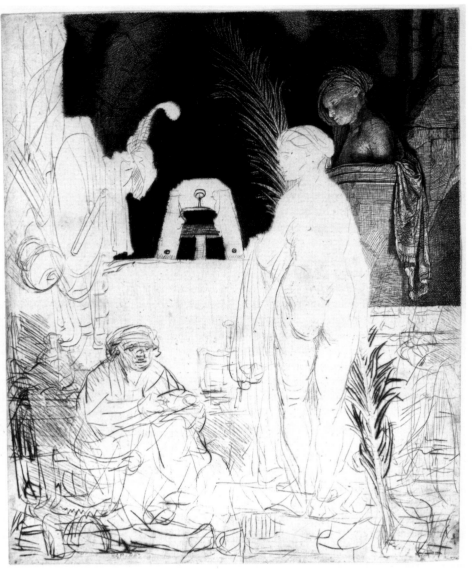

REDUCED

his etched portrait in historical dress of 1639, *The Goldweigher.*[6] In this upper zone objects are not only elaborately shaded and modeled in three dimensions but light from below throws dramatic shadows as well.

The *Artist Drawing* is clearly intended more as an allegory of art rather than as documentation of the appearance of a particular artist's studio, but in characteristic Rembrandt fashion it has elements of both. It is, for example, by no means clear that the artist drawing is intended to be Rembrandt himself, as opposed to a generic "Artist." In the British Museum drawing it is evident that the artist wears quite fanciful headgear, reinforcing the allegorical mood. However, the picturesque

85

The Artist Drawing from a Model,
about 1639
Etching, drypoint, and engraving
with touches of black chalk
B. 192, I
23.2 × 18.4 cm (9⅛ × 7¼ in.)
Lent by the Trustees of the
British Museum, London

assemblage of exotic or antique weapons and artifacts hanging above him—a shield, a quiver, a water gourd, and a club—represent the real props and paraphernalia useful for historical and biblical compositions that are often to be found in contemporary representations of artists' studios. Similar objects were well documented in the 1656 inventory of Rembrandt's possessions.

The model has been given the pose of a sculpture of a classical Venus and holds a palm emblematic of victory. In the second state Rembrandt defined more precisely the plank on which the model stands and thoughtfully placed a dish of coals under it to keep the real flesh-and-blood model warm. A curious detail in the first state is the outline of a vertical screw press, similar to a contemporary linen press, visible in outline between the model's drapery and the large stretched canvas on the easel.[7] Rembrandt subsequently removed this detail in the second state. In the second state additional shading gave new weight and substance to the top of the easel and to the model's pendant drapery. The play with degrees of finish in the print is well represented in both states by the symbolic palm, its lower fronds only sketched in outline and its upper fronds fully shaded. The sculpted bust of a black woman draped with an oriental shawl on the ledge above her provides the maximum contrast to the model's blank, sketchily indicated head.

A small etching of about 1641 representing a young artist drawing by candlelight from a sculpted bust, most likely a plaster cast, raises the subject of the artist's education (no. 86). Rembrandt himself practiced and recommended to his many pupils regular sessions of drawing from live models (see no. 200), but drawing from plaster casts represented a particular stage in a young artist's education. Ideally, the apprentice artist of the seventeenth century initially learned by drawing from flat representations, first prints and then drawings and paintings. The aspiring artist next progressed to the representation of three-dimensional forms, first plaster casts of sculpture antique and modern and finally, the live model.[8] A number of plaster casts of sculpture are listed in Rembrandt's 1656 inventory. Here, having elevated the bust with a cushion and a thick book in order to achieve a more interesting or challenging angle of vision, the young artist intently studies the cast by the candlelight that must have served to dramatize its sculptural volumes. He holds an inkpot in his left hand and rests his drawing on a sheaf of papers, just as Rembrandt does in his 1648 self-portrait, in which he portrayed himself drawing or etching by a window (no. 213). The candlestick is adjustable, implying—as does his working by

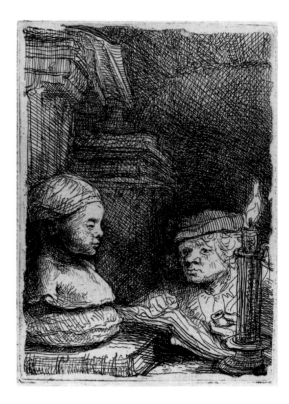

86
A Man Drawing from a Cast, 1641
Etching
B. 130, I
9.4 × 6.4 cm (3¹¹⁄₁₆ × 2½ in.)
Teylers Museum, Haarlem

night—the artist's unflagging diligence. The intimate space of the room, defined by the windowlike shape of the plate itself, is crammed to the ceiling with books. This detail suggests the young artist's devotion to learning. The interior space is veiled in layers of gray shadow formed from transparent nets of etched cross-hatching.

Rembrandt's etching of the Dutch painter of Italianate landscapes Jan Asselyn (about 1614–1652) is the only clearly documented portrait of the relatively short-lived painter (no. 87). It is seen here in the first state, which has at upper left a lightly etched but fragmentary signature and date. The last two digits are missing but the etching is generally dated on the basis of its conception and style about 1647–48, after Asselyn returned to Amsterdam from Rome in 1647.[9] While their art was radically different, Rembrandt and Asselyn were probably acquainted, for Asselyn's brother-in-law was Rembrandt's former pupil Ferdinand Bol.[10]

Rembrandt's portrait of Asselyn is as formal and dignified as his 1647 etched portrait of Dr. Bueno (no. 72). Asselyn is shown as the gentleman-artist, dressed not for the studio but for the street. The conventional pose with hand on hip is reminiscent of the printed artists' portraits earlier designed and etched by Anthony van Dyck. Rembrandt in fact cleverly used the pose

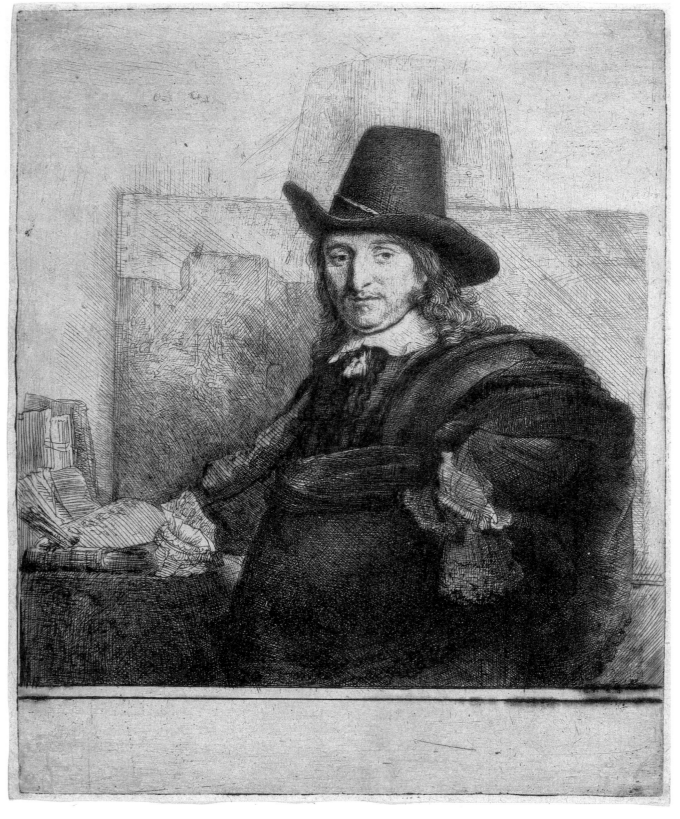

87
Jan Asselyn, Painter,
about 1647
Etching, drypoint, and en-
graving on oatmeal paper
B. 277, I
21.8 × 17 cm (8⁹⁄₁₆ × 6¾ in.)
National Gallery of Art,
Washington
Rosenwald Collection

to conceal by means of ruffled cuff and embroidered glove Asselyn's crippled left hand. In Rome, the members of the rowdy Netherlandish artist's club, the *Bentveughels* ("birds of a feather") had, because of this deformity, given Asselyn the rather cruel nickname of *Krabbetje* ("little crab").

In spite of the formal pose and dress, Rembrandt makes clear reference to Asselyn's profession. On the table on which the artist rests his good right hand we see a palette set out with colors and a bundle of brushes, as well as books that may be either sketchbooks or allusions to the artist's depth of learning. The most telling indication of Asselyn's vocation is, however, the large easel bearing a painting that looms behind the artist, echoing and reinforcing the profile of his hat and the outlines of his stocky figure: painter and work are one. The painting on the easel appears to represent city walls or ruins, as seen in a number of Asselyn's surviving painted foreign views. The easel and its painting are very lightly etched so as to suggest the deep space of the room and so as not to compete too forcibly with the figure of the artist. Asselyn's dark garments are richly toned and textured by a free but densely worked combination of etching, drypoint, and engraving.

Impressions of the first state reveal Rembrandt's new experimentation with varied printing surfaces: golden-toned Japanese paper, vellum, and here, a thin, watermarked oatmeal or *kardoes* (cartridge) paper with prominent colored fibers. All of these unusual supports contributed a unifying painterly warm or gray tone very different from the reflective sparkle of conventional white paper. Some impressions of this state were also printed with a veil of ink left on the surface of the plate in order to further tonally enrich the image.

In the second state the large easel and its painting were largely scraped and burnished away (fig. 66). Broken remnants of the lines remain to enliven the background. It is not clear what occasioned this change. Perhaps the sitter felt that the looming easel upstaged his figure and made him look stumpier rather than more important. A number of impressions of this state, such as the one reproduced here, were, like the first state, printed on warm-toned Japanese paper with a tone of ink, probably with the intention of achieving a better unity between the now-silhouetted figure and the background. Certainly impressions of the posthumous third state, in which the background has been polished clean of all prior work, show a noticeable flattening of the artist's figure, which now reads like a cutout.

In the 1656 etched portrait (no. 88) of the eminent gold and silversmith Jan Lutma (about 1584–1669) the seventy-two-year-old Lutma is seated in the same high-backed chair decorated with lion heads that provides the seating for the portraits of two other elderly sitters, Thomas Haringh (1655, no. 207) and Arnold Tholinx (1656, no. 208). On the draped table to Lutma's left are a hammer and a container of metal punches, tools of his trade. Behind them is a silver drinking bowl in the Dutch biomorphic or "lobate" style of metalwork of which Lutma was one of the greatest practitioners.[11] Lutma holds in his right hand another example of his craftsmanship, perhaps the figural base of an ornamental wine cup or candlestick. In the first state seen here Lutma's lower body is engulfed in shadow deepened in texture by drypoint burr. His head, with its complex expression, is by contrast dramatically illuminated. Lutma's gaze is averted, reflective, his eyes cast down. One has the sense from Lutma's contracted brow and the ambiguous play of shadow over his features that these are the outward manifestations of a powerful interior life. Whether Lutma might be conceiving new designs for metalwork or pondering the struggles of his long artistic career is impossible to say, but one nevertheless has the sense that the physical relaxation of Lutma's body is accompanied by lively mental action.[12] In visually punning fashion, the right-hand lion finial of the chair in which he sits seems to echo, almost caricature, the expression of the "old lion."

In the first state the blank wall behind Lutma seems to reinforce the mood of private introspection. In the signed and dated second state Rembrandt added in the right background a window with a deep embrasure, heightening the sense of a specific setting but diffusing the mood of inwardness that characterized the first state.

The *Goldsmith* etching of 1655 (no. 89) not only provides us with a glimpse into a metalsmith's workshop but also provokes speculation about the relationship between artist and work. The goldsmith's workbench occupies the immediate foreground, functioning for the viewer as a kind of windowsill. It is littered with tools such as anvils and pliers. Behind we see the glow of fire in the forge. The old smith or sculptor tenderly embraces his sculpture of the personified virtue of Charity, as Charity protectively embraces her children. Both the artist's and Charity's head are bowed, inclined toward each other in intimate accord. The small scale of the print increases our sense of eavesdropping on a private communion between artist and work. The sculptor appears to be engaged in fastening the completed sculpture to its scrolled base: it is conceivable that the elderly artisan is experiencing a certain sense of finality, of sadness at the completion of the work. The severe inter-

Fig. 66. *Jan Asselyn*, about 1647, etching, drypoint, and burnishing on Japanese paper, B.277, II, 20.9 × 16.8 cm (8¼ × 6⅝ in.), Museum of Fine Arts, Boston, Harvey D. Parker Collection by exchange.

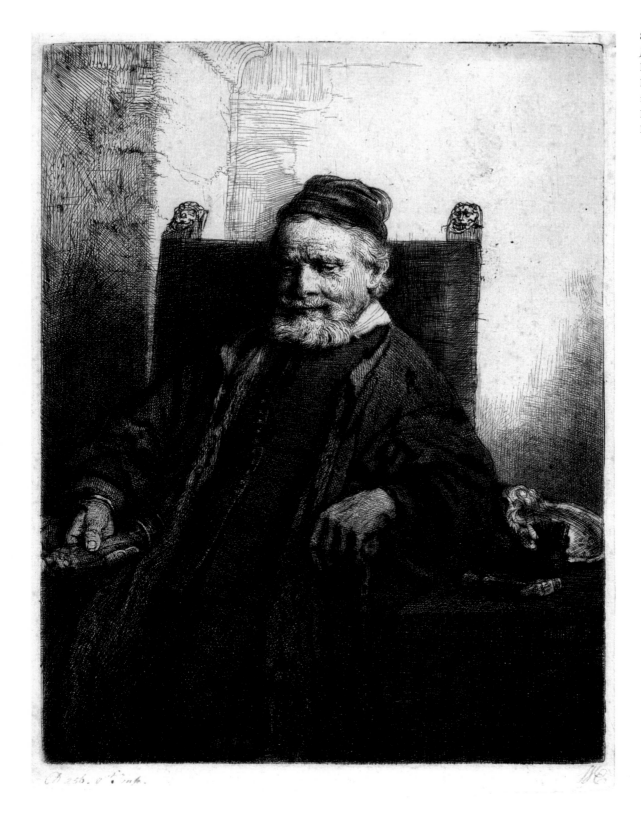

88
Jan Lutma, 1656
Etching and drypoint
B. 276, I
19.9 × 15 cm (7¹³⁄₁₆ × 5⅞ in.)
Museum of Fine Arts, Boston
Harvey D. Parker Collection

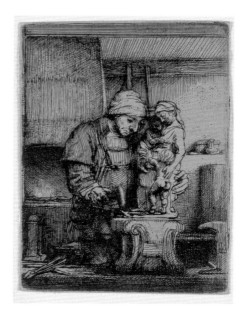

locking right-angle geometries of the workshop's interior intensify by contrast the living organic character of the figures of sculptor and sculpture. Early impressions of the etching are frequently printed, as here, on a warm-toned golden Japanese paper that lends a soft glow of light or metallic sheen to the image of the fire-lit goldsmith's workshop. CSA

NOTES

1. Ben. 423. See reproduction in Amsterdam/London 2000, 178, no. 36, fig. c.

2. Erik Hinterding in Amsterdam/London 2000, 179.

3. See Peter Parshall, "Unfinished Business: The Problem of Resolution in Printmaking," in Parshall et al. 2001, 14–17.

4. See Stacey Sell, "Quicke to Invent and Copious to Expresse: Rembrandt's Sketch Plates," in Parshall et al. 2001, 62.

5. See Royalton-Kisch 1992, 81; and Erik Hinterding in Amsterdam/London 2000, 174–79. See also Peter Parshall, "Unfinished Business: The Problem of Resolution in Printmaking," in Parshall et al. 2001, 22.

6. B. 281.

7. A similar linen press appears in the double-page illustration showing the cross-section of a grand house on fire by Jan van der Heyden. See Jan van der Heyden, *A House in the Herengracht, Burned in the Night of 25th–26th April, 1683* in Jan van der Heyden and Jan van der Heyden the Younger, *Beschryving der Niewlijks uitgevonden en geoctrojeerde Slang-Brand-Spuiten*...(Amsterdam: Jan Rieuwertsz., 1690), 6, plate 2, section E; discussed in Ackley *Printmaking* 1981, 301–2. How the press would have been employed in the context of the artist's studio in Rembrandt's etching is unclear. Perhaps it might have been used to flatten sheets of paper dampened for printing, as suggested also in Slatkes 1973, 250–63.

8. De Jongh and Luijten 1997, 349.

9. White 1969, 152; Erik Hinterding in Amsterdam/London 2000, 231; and Steland-Stief 1971, 13–19.

10. White 1999, 152.

11. A near-identical silver dish composed from grotesque marine forms is today in the collection of the Rijksmuseum, Amsterdam. Reproduced in Amsterdam/London 2000, 332, no. 83, fig. a.

12. Ger Luijten in Amsterdam/London 2000, 332, chooses to relate Lutma's expression to the goldsmith's documented difficulty with his eyes. Von Graevenitz 1973, 296, note 656, cites a document in which Lutma in 1656 stated that due to the intervention of an experienced oculist, he had for some time been cured of his blindness.

89
The Goldsmith, 1655
Etching and drypoint on Japanese paper
B. 123, I
7.7 × 5.7 cm (3¹/₁₆ × 2¼ in.)
The Art Institute of Chicago
The Clarence Buckingham Collection

90
The Young Couple and Death
1639

Leaning on his scythe and swathed in a rotting shroud, Death in his tomb holds his hourglass aloft as if offering an ironic toast to the betrothed lovers who have come to call. Approaching the tomb hand-in-hand, dressed in costumes from a Renaissance romance, the young couple does not recoil from the fearsome sight. Smiling, the young man greets Death with raised hand. The woman appears to offer a flower similar to that held by Saskia in the portrait that Rembrandt had drawn on the occasion of their betrothal (fig. 60, p. 126). He conceals the woman's face and her expression from our view, maintaining a degree of ambiguity and preventing us from fully comprehending the meaning of the scene before us. Are Love and Death for the moment reconciled, or is the couple approaching a fate that they are still too young to recognize? At the beginning of their life together, their story has yet to be written. The memorial tablet above the grave remains blank.

Though thematically unique in Rembrandt's work, his *Young Couple and Death* (no. 90) of 1639 picks up on a major leitmotif of Northern European printmaking, the rivalry between Love and Death. Rembrandt extended that tradition while adding his own twist. When the most celebrated earlier German artists explored the theme, they depicted lovers who are oblivious to Death or who pay no heed to their certain fate. There is an implication of moral failure on the part of lovers too caught up in their earthly pleasures to attend to their spiritual preparation for Death. In the late 1490s, for example, Dürer engraved a poetic image of a young couple promenading in a landscape in which Death, unseen, pops out from behind a tree and brandishes his hourglass.[1] Dürer

alerts us to the woman's imminent fall as she treads on the hem of her dress. Holbein's celebrated book of forty miniature woodcuts, *The Dance of Death*, was first published in 1538.[2] A survey of Death's inevitable embrace of all levels of the social hierarchy, the series includes a noble couple who attempt to ignore Death's enthusiastic drum serenade.[3] Rembrandt's couple confronts Death directly, but their exact relationship to Death remains tantalizingly unclear.

As he created his image, Rembrandt may also have had in mind a more recent print. Nicolaes Braeu's sinister engraving after a design by Jacob Matham (fig. 67), probably from the later 1610s, shows a man drawing his sword to defend a woman from the depredation of Death.[4] Death springs from a fissure in the earth and seizes their garments. Rembrandt, too, shows Death rising from below. Braeu's engraving probably entered Rembrandt's consciousness at an early stage, for its publisher was Jan Pietersz. Berendrecht, who also published Rembrandt's novice effort, *The Circumcision* (no. 7).[5] Rembrandt's sensitive reformulation of the subject avoids the arch theatricality of Matham's design and draws us gently into the scene instead of immediately shocking or repelling us.

It is not widely acknowledged that *The Young Couple and Death* is one of Rembrandt's first plates in which drypoint played a dominant role. Many catalogue descriptions still describe the technique as etching despite a nineteenth-century observation that the plate was executed almost entirely in drypoint.[6] Rembrandt applied so little pressure to the drypoint needle that he could draw undulating curves that approach the fluency of etched lines. The present impression is one of very few printed before the loss of the fine burr that gives the woman's dress the sheen of velvet and silk. The delicacy of the drypoint technique that Rembrandt employed here is particularly apt as a metaphor of the tenderness of love and the frailty of life. In this period costume fantasy, he may indeed have intended to emulate the pale tones of earlier silverpoint drawings or the silvery tonalities of fifteenth- and early sixteenth-century engravings that depicted lovers in various stages of happiness and distress. TER

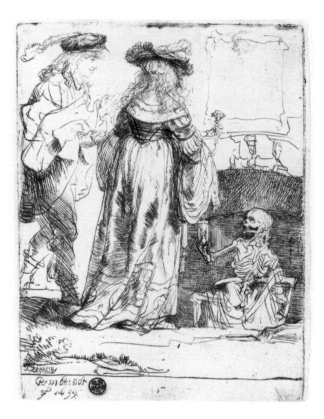

90
The Young Couple and Death, 1639
Drypoint
B. 109, only state
Sheet: 10.8 × 8.1 cm (4¼ × 3³⁄₁₆ in.)
National Gallery of Art,
Washington
Rosenwald Collection

NOTES

1. B. 94.

2. *Les Simulachres et historiées faces de la mort . . .* (Lyon: Trechsel for Frellon, 1538).

3. Holl. (German) XIV–A, 99, 35.

4. Holl. 3: 201, no. 51 as by Gillis van Breen. Hollstein confused the identity of Braeu and Van Breen, an error rectified in Spicer 1991, 275–80.

5. Wyckoff 1998, 152–53.

6. Claussin 1824, 75, identifies the technique as drypoint. Daulby 1796 describes it as being etched with a fine point. Also among those describing the technique as etching are White and Boon 1969, 58.

Fig. 67. Nicolaes Braeu (Netherlandish, active 1597–1602), *A Young Couple and Death*, 1610s, engraving after Jacob Matham, Holl. 111, 28.6 × 20.5 cm (11¼ × 8¹⁄₁₆ in.), Rijksmuseum, Amsterdam.

91–94

Flirtation and Fornication

1640S

Rembrandt was not squeamish about the earthy side of life. The 1640s brought a flurry of prints showing couples in intimate circumstances. By turns tender, humorous, and cynical, he tipped the scales away from the idealization of human behavior, giving greater weight to our failings and foibles. Three of the four etched scenes here reveal his barbed take on the literary and artistic tradition of pastoral love, while the fourth lets us share voyeuristically in a private moment in an elegant bedchamber. Sexually charged prints had been made since the fifteenth century, and Rembrandt owned "erotica by Raphael, Rosso, Annibale Carracci, and Giulio Bonasone."[1]

In the 1620s and 1630s, pastoral poetry came into vogue among the Dutch, and artists were quick to capitalize on the demand for related images.[2] Rembrandt was no exception. In the mid-1630s, he painted two pictures of *Saskia as Flora in Pastoral Dress*.[3] Endowing Flora with opulent gowns, jewelry, staffs, and bouquets of flowers, he portrayed her as a goddess, queen of shepherdesses. However, when he returned to pastoral themes shortly after initiating his series of landscape prints, his approach was markedly different from the Flora paintings. Now his frank and mischievous carnality sets his work apart from that of his Dutch contemporaries.[4]

The shepherd girl in *The Flute Player*, dated 1642, is relatively plain and definitely does not comport herself like a lady (no. 91). She sits hunched over, intent on her wreath of flowers, her legs askew, affording a tempting view for her musical companion. No Adonis, he too is far from the porcelain-skinned, tendril-haired ideal of contemporary pastoral paintings. While his crook and his flute indicate that he is an amorous shepherd, his coarse features and knowing look mark him as a rogue.[5] Owls such as the one perched upon his shoulder were at the time more widely associated with foolishness and ignorance than with wisdom. The suggestive mating of garland and flute requires little explanation. The ewes and rams pressing toward the water are not the only ones

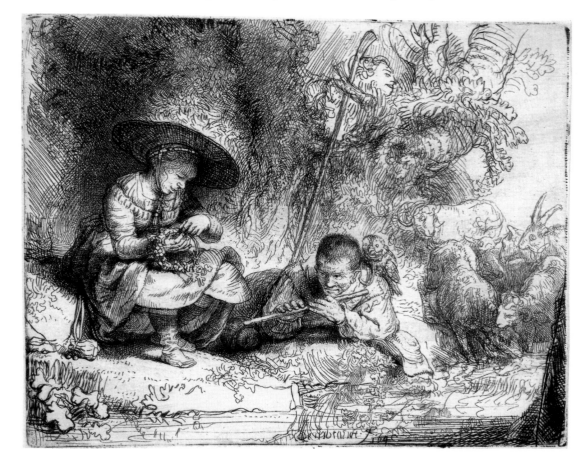

91

The Flute Player, 1642
Etching and drypoint
B. 188, II
11.8 × 14.5 cm (4⅝ × 5¹¹⁄₁₆ in.)
The Art Institute of Chicago
The Clarence Buckingham and
Amanda S. Johnson and
Marion Livingston
Endowments

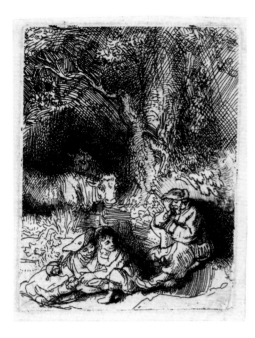

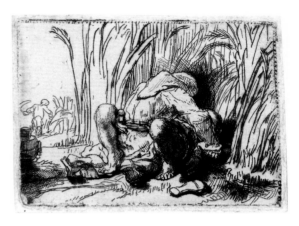

92
The Sleeping Herdsman, 1643–44
Etching and engraving
B. 189, only state
7.9 × 5.8 cm (3⅛ × 2⁵⁄₁₆ in.)
Museum of Fine Arts, Boston
Harvey D. Parker Collection

93
The Monk in the Cornfield, about 1646
Etching and drypoint
B. 187, only state
5.1 × 6.9 cm (2 × 2¹¹⁄₁₆ in.)
The Art Institute of Chicago
The Clarence Buckingham and Amanda S. Johnson
and Marion Livingston Endowments

here with a thirst. But the shepherd may be out of luck, for the girl seems as oblivious to her own charms as she is to his curiosity. Indeed the mouth of her purse is turned away from him, the drawstrings pulled tight. In the background, near the scoop of the shepherd's crook, we see the smiling face of a witness, perhaps a satyr or another herdsman, laughing at the shepherd's frustration.[6] In the etching's final state, Rembrandt removed this comic interloper.

One or two years later, Rembrandt returned to the pastoral mode in a sly little etching called *The Sleeping Herdsman* (no. 92).[7] The scene echoes ancient Greek and Roman tales such as the story of Mercury and Argus but omits all mythological reference.[8] While a bearded old man dozes on a leafy embankment, a young woman and her suitor take advantage of the moment. Rather than sublimating pastoral desire into poetry, song, and emblems of fecundity—the usual strategy of his Dutch literary and visual precursors—Rembrandt explicitly depicted the couple's mutual enjoyment of sexual play. Both smile as, grasping her lover's elbow, she guides his hand toward its goal while turning to check that her elderly guardian is safely asleep. Again a bit player comments on foreground activities, but this time it is an astonished wide-eyed cow that turns the tables by watching the herders.

Another tiny outdoor pastoral scene, *The Monk in the Cornfield* (no. 93), usually dated about 1646, participates in a long artistic tradition that satirizes the unchaste behavior of monks and priests.[9] Hidden from a nearby reaper by the tall grain, the monk kneels and bows his tonsured head to worship at the altar of Venus. Rocking on his knuckles and pressing forward from the tips of his toes, he seems totally enthralled by this earthly rite. Venus, a sturdy milkmaid who has set aside her jug, pulls him to her with her right hand and heel. Prominently placed in the foreground, the monk's prayer book in its leather pouch metaphorically sums up the situation. An engraving of a monk and a nun by the sixteenth-century, reform-minded German, Heinrich Aldegrever, provided Rembrandt's point of departure.[10] And depart he did, playing down the moralizing commentary and distilling the composition to a compact sculptural group. Rembrandt's print is very rare, suggesting that the miniature masterpiece was intended to be shared, like an off-color story, only among close friends.

Despite his use of a remarkably similar pose for its protagonists, *The French Bed*, dated 1646, is far more tender in mood (no. 94).[11] Rembrandt seduces us with the velvety lines created by his drypoint needle. Bathing the lovers in soft light as they recline beneath a canopy on the richly draped, sensuously disheveled bed, he allows us a glimpse of their faces, especially her beatific smile. They have warmed their hearts with a taste of wine from the tall glass standing on the table covered with a splendid cloth. They are alone. The stately architecture of the

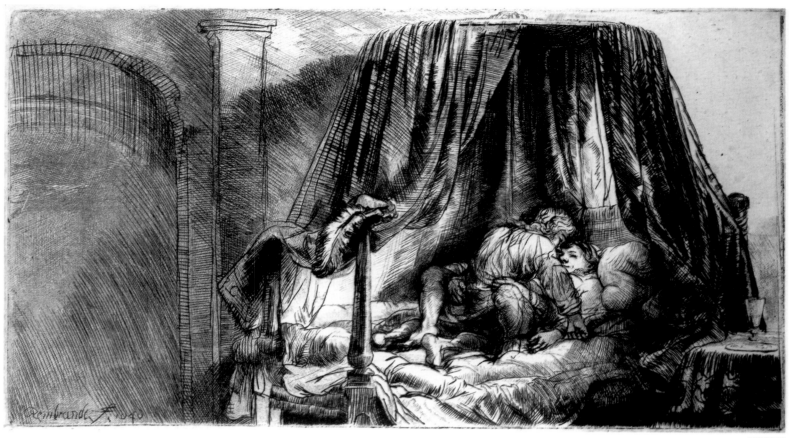

passage leading to their chamber is only vaguely discernible in the dusky light, but one has the sense that the couple enjoys considerable privacy.[12] While the background functions as a kind of stage flat, the lovers and their immediate surroundings are shown in full dimension. Rembrandt has framed the scene so as to crop the bed and has directed our gaze from a slightly elevated perspective, giving us the sense that we stand nearby, unnoticed, witnesses to the intimate moment. In the foreground, a velvety plumed cap metaphorically envelops the top of the bedpost. The careful observer will note the surprising fact that the woman has three arms. She pulls her lover close with two hands but another rests on the bed alongside her leg. Rembrandt felt no obligation to choose a single solution and reaped the benefit of suggested movement by showing both positions of her left arm. Above and beyond the explicit intimacy of the image, he set himself apart from other artists by his willingness to retain his change of mind as part of a process rather than treating it as an error. TER

NOTES

1. *Docs.* 1979, 1656/12, 232: "bouleringhe van Raefel, Roest, Hanibal Crats en Julio Bonasoni."

2. Kettering 1977, 32 provides an extended analysis of the etching's historical context.

3. The two Floras are respectively in the collections of the Hermitage, St. Petersburg (1634, Br. 102), and the National Gallery, London (1635, Br. 103). The identification of the model for the Hermitage painting as Saskia has occasionally been called into question.

4. The timing of these prints invites speculation about the effect of Rembrandt's relationship with Geertje Dircx, his servant-turned-mistress. Perhaps she brightened his mood after Saskia's death in 1642. Moreover, this romance with a woman far beneath his social station may have renewed his appreciation for primal human needs.

5. Hence the print's traditional French title, *L'espiègle* (the rogue), and its traditional Dutch title, *Eulenspiegel* (Owl Glass), the devious protagonist of a popular folk tale. His features are copied from a sixteenth-century woodcut based on a Titian design. See Amsterdam/London 2000, 200–201. The upended crook is tipped with a small metal trowel that could pitch clods of dirt to startle errant sheep.

6. For the most part, this reading follows Kettering's analysis of the details, except that she regards the third face as a sketchy remnant of a discarded first attempt and interprets the image as more sinister in tone. Kettering 1977, 38–40.

94

The French Bed ("Ledikant"), 1646

Etching, drypoint, and engraving

B. 186, III

12.5 × 22.4 cm (4^{15}/$_{16}$ × 8^{13}/$_{16}$ in.)

Rijksmuseum, Amsterdam

7. 1644, the date usually assigned to B. 189, is dependent on its similarity to a small pastoral landscape, B. 220, the only etching dated by Rembrandt in that year.

8. The complex tale from Ovid's *Metamorphoses* centers on Io, a beautiful maiden transformed by the lustful Jupiter into a white heifer to hide her from his wife, Juno. Wise to the trick, Juno placed Io under the protection of the many-eyed Argus. Jupiter sent his messenger, Mercury, to retrieve Io. Artists often showed Argus as an old herdsman lulled to sleep by the flute-playing Mercury as the prize heifer stands nearby.

9. The assigned date is based on the print's similarities to *The French Bed* (no. 94).

10. B. 179; for a reproduction, see New Holl. (German), *Heinrich Aldegrever*, no. 179. See Amsterdam/London 2000, 221–22, for further comparisons.

11. Due to the subject matter of the print, the title is sometimes considered an allusion to Gallic eroticism, as in "French" as a modifier of "letter" and "kiss." However, the French themselves used the title in the eighteenth century, the Dutch preferring the more neutral "Ledikant," meaning "bedstead." Although the type most commonly referred to as a "French bed" supported curtains on a simple rectilinear framework, the term can also be used more generally to distinguish a freestanding curtained bed from the Dutch-style box bed that is enclosed by paneling on three sides. See Thornton 1978, 158–64.

12. Catalogues of Rembrandt's prints usually cite a final state in which the plate has been cut to remove Rembrandt's signature and the gray doorway; however, the impressions so catalogued are simply damaged and lacking this portion of the image.

95–97

Man and Woman

1630S

In his lively *Adam and Eve* etching of 1638 Rembrandt seized the opportunity provided by the fall from primal innocence of humankind's first parents to explore with comic irony the battle of the sexes. The story of Adam and Eve and the loss of innocence is the culmination of the creation story in the book of Genesis. God had created the heavens and the earth but they were empty of life. After the first rainfall, God formed Adam from the "dust of the ground" and put him in charge of the paradisiacal garden of Eden, which contained the Tree of Life and the Tree of Knowledge of Good and Evil. God instructed Adam that he could eat of the fruit of every tree in the garden except the Tree of Knowledge. If he ate of the latter he would die. After God had created the "beasts of the field" and the "fowl of the air" and Adam had named them, God formed Eve from Adam's rib (Genesis 2:7–25). In the story of the Temptation and Fall (Genesis 3:1–27) the serpent, "more subtil than any beast of the field" tempts Eve to eat of the fruit of the Tree of Knowledge of Good and Evil. She in turn convinces

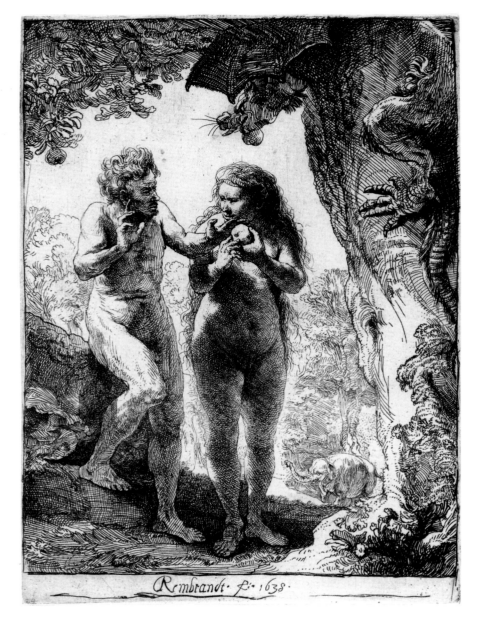

Adam to eat, thus introducing into the world desire, shame, sorrow, discord, and death. As a consequence of their disobedience, Adam and Eve are cast out of paradise. God curses the serpent and condemns it to henceforth crawl on its belly.

Painters and printmakers who preceded Rembrandt in the sixteenth and early seventeenth centuries generally conceived of Adam and Eve as ideals of human physical beauty, the most celebrated example being Albrecht Dürer's 1504 engraving of the *Fall of Man* (fig. 68). Rembrandt's pair are more primitive and earthy. Past the first

95
Adam and Eve, 1638
Etching
B. 28, II
16.3 × 11.6 cm (6⁷⁄₁₆ × 4⁹⁄₁₆ in.)
Museum of Fine Arts, Boston
Harvey D. Parker Collection

flush of youth, they are distinctly naked and dominated by the pull of gravity. Their vulnerable physical appearance, touchingly different from Dürer's superhumans, seems already to reflect the consequences of the transgression they are in the very act of committing.[1]

Eve is clearly the stronger figure. Firmly planted at the center of the composition, she regards Adam with a calculating expression as she enticingly displays the fatal apple. The serpent, Satan, who here takes the form of a winged dragon, is entwined around the Tree and holds another apple ready in its maw should the first one be rejected.[2] Compared with the stalwart and determined Eve, Adam, with hunched shoulders and uncertain stance, is a surprisingly weak and vacillating figure. The dialogue of hands around the pivotal apple says it all: Eve caressingly presents the apple while Adam's hand indecisively hovers above it (see detail, fig. 2, p. 18). The dramatic play of shadow over Eve's backlit lower body both veils and reveals, encouraging thoughts about the rise of human sexual desire and calling attention to the fecund belly that is to be the cradle of the human race. This is the nakedness that was soon to be a source of shame, covered with aprons of fig leaves and garments of animal skins.

Rembrandt was criticized by seventeenth- and eighteenth-century writers on art for having shown the serpent, the Tempter, as a winged dragon rather than as the traditional snake. In our time, however, Christian Tümpel has pointed out that Rembrandt's Satan was inspired by the wingless, lizardlike Satan draped over an archway that aims his spear at Adam and Eve in Dürer's engraving of *Christ's Descent into Limbo*.[3] Rembrandt had acquired the *Small Engraved Passion*, the Dürer series to which this print belongs, in the very year, 1638, that he etched the tragi-comedy of *Adam and Eve*. Tümpel further points out that Rembrandt's conception of a winged and legged Satan is actually consistent with the text from Genesis cited earlier: God only condemned the serpent to slither on its belly in the dust as punishment after it had been responsible for the Temptation and Fall.[4] The etched elephant that appears in the distance below the winged Tempter is the sole representative in Rembrandt's Eden of the varied animal population of the lush, leafy paradise. According to legend, the elephant was a symbol of piety and temperance, virtues that are clearly being violated here. In 1637 Rembrandt had had the opportunity to make black chalk sketches of an elephant that was on exhibition in the Netherlands as an exotic curiosity. These drawings served as a model for Eden's elephant.[5]

The Getty's red chalk drawing of a standing nude woman (no. 96) is usually dated about 1637, in part because of the similarity of the body type with that of Eve in the 1638 etching. She is, however, a sleeker and more idealized figure than Rembrandt's etched earth mother. She wears an elaborate headdress and drapery falls from the crook of her left arm. The spread fingers of one hand frame and present her left breast while behind her back she clutches a snake that twines its body around her thigh. The woman's face has a somewhat inward, reflective expression. She has traditionally been identified as Cleopatra, queen of Egypt, who committed suicide by encouraging an asp to bite her breast.[6]

Since the Italian Renaissance, red chalk had frequently been employed for drawing the nude figure. Samuel van Hoogstraten, Rembrandt's former pupil, recommends the use of red chalk for this purpose in his 1678 treatise.[7] This is a unique surviving example of a red chalk nude in Rembrandt's work. After an initial sketching-in of the figure, Rembrandt worked the drawing up further, adding the headdress and firming up modeling with heavier accents, some made with wetted red chalk. Underlying the red chalk are touches of liquid white that give Cleopatra's flesh greater roundness, smoothness, and a luminous pallor.[8]

The story of the "well-favoured" Joseph's attempted seduction by the wife of Pharoah's captain of the guard, Potiphar, was popular with artists in the seventeenth century as a moralizing subject with titillating overtones, but Rembrandt outdistances them all in his ribald emphasis on female lust and aggression. Joseph's jealous herdsman brothers had sold Jacob's favorite son to slavers who in turn sold him in Egypt to Potiphar. Potiphar was so pleased with Joseph's abilities that he made him chief overseer of his household. Potiphar's wife was also favorably impressed with the fair Joseph and invited him into her bed. Joseph refused, virtuously declaring that he would not betray either his master or his God. She nevertheless persisted, and on an occasion when they found themselves alone, seized hold of his clothing. Joseph fled, leaving his garment behind. The wife turned the situation to her advantage, using Joseph's abandoned clothing as evidence that Joseph had attempted to seduce her. As a consequence, the falsely accused Joseph was flung into prison. Eventually, due to his adeptness in the interpretation of dreams, Joseph was released from prison through Pharoah's intervention and elevated by him to a position of high authority (Genesis 37 and 39–41).

In Rembrandt's 1634 etching of *Joseph and Potiphar's Wife* (no. 97) a rather soft, feminine-looking Joseph repulses with theatrical gestures of repugnance the eager

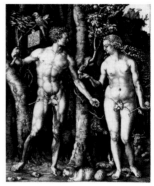

Fig. 68. Albrecht Dürer (German, 1471–1528), *The Fall of Man (Adam and Eve)*, 1504, engraving, B. 1, 25.2 × 19.4 cm (9¹⁵⁄₁₆ × 7⅝ in.), Museum of Fine Arts, Boston, Centennial Gift of Landon T. Clay.

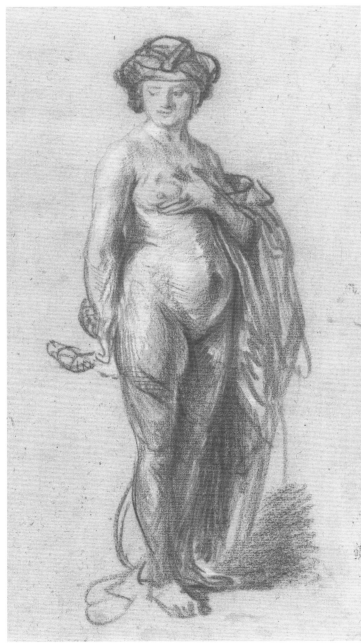

96

Nude with a Snake (Cleopatra), about 1637

Red chalk and white chalk

Ben. 137

24.7 × 13.7 cm (9¹¹/₁₆ × 5⁷/₁₆ in.)

The J. Paul Getty Museum, Los Angeles

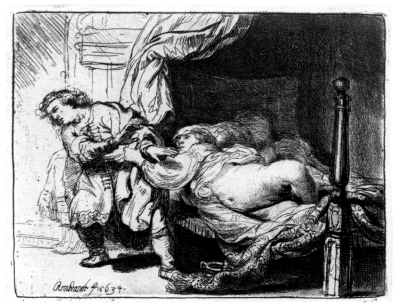

97

Joseph and Potiphar's Wife,
1634
Etching
B. 39, I
9 × 11.5 cm (3⁹/₁₆ × 4⁷/₁₆ in.)
The Pierpont Morgan
Library, New York

advances of Potiphar's wife, who reclines in bed. An expectant expression on her upturned face, she has a firm grip on Joseph's cloak. Her nightgown is hiked up above her waist and her bared lower body, rendered bluntly in explicit detail, stands out startlingly white against the dark alcove of the bed. With intuitive visual symbolism, Rembrandt juxtaposes the shiny upright bedpost with the soft-pillowed depths of the bed. CSA

NOTES

1. For the evolution and interpretation of this image, see White 1999, 38–41; Williams et al. 2001, 155, no. 73, and Martin Royalton-Kisch in Amsterdam/London 2000, 157–59, no. 30.

2. Lucas van Leyden, whose engravings Rembrandt actively collected, on one occasion portrayed the pre-transformation Tempter in an engraving with legs if not wings (Holl. 7). He also in several instances represented Satan (in serpent form) in engravings of the Fall as holding another apple in readiness in his mouth (Holl. 3, 8, 9 and 10).

3. B. 16.

4. Tümpel 1970, no. 1. As Tümpel notes, Houbraken (1719) quoted his master Hoogstraten as having reproved a pupil for following the false lead of Rembrandt, who followed his own instincts rather than the "rules of art" in depicting the serpent as a dragon. See Houbraken 1718–21, 2: 255. For the purchase of Dürer's engraved series, see *Docs.* 1979, 1638/2 (the Gommer Spranger sale at which Rembrandt purchased many prints and drawings).

5. Slatkes 1980, 7–13.

6. Lee Hendrix has proposed that the woman in the drawing may represent Eve rather than Cleopatra. See Williams et al. 2001, 152, no. 71.

7. Van Hoogstraten 1678, 31. In his discussion of what drawing materials are suitable for which kinds of subjects Hoogstraten suggests red chalk on white paper as appropriate for "heads, hands and whole nude figures from life [tronien, handen of geheele naekten na't leeven]."

8. See Lee Hendrix in J. Paul Getty Museum 1997, 78, no. 62.

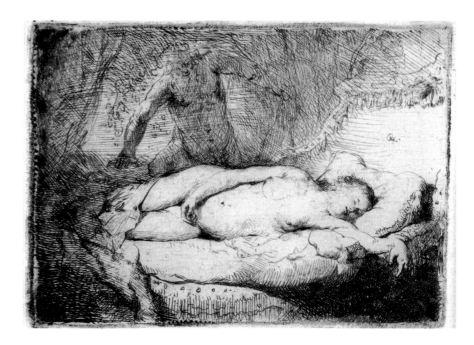

98–99

The Loves of Jupiter

EARLY AND LATE

From the early sixteenth century on, artists seized upon the love lives of the Greek and Roman gods as a convenient, and learned, pretext for depicting the female nude, whether Venus or one of the many feminine love objects of Jupiter's numerous extramarital adventures. Two etched scenes from the king of the gods' love life, one from about 1631 (no. 98) and one from 1659 (no. 99), present us with a uniquely Rembrandtian blend of the comic and the sensuous. Rembrandt early and late conceives of the loves (or voyeurisms and rapes) of the antique gods in very human terms. The subject of both etchings is today generally identified as "Jupiter and Antiope." In classical mythology Antiope was a nymph or, alternately, a daughter of the king of Thebes, whom Jupiter seduced while disguised as a satyr.

The early, undated etching is from about 1631—the same date as Rembrandt's larger etched nude study of the goddess Diana bathing (no. 196). It has over time been variously identified as "Venus and Satyr" or as Danaë, the closely protected king's daughter whom the ever-inventive and wily Jupiter visited in the form of a shower of gold. The nude young woman who is the object of Jupiter's eager attention slumbers in a pool of light in an elaborate bed. A miniscule version of Rembrandt's early *RHL* monogram studs the center of the headboard like an upholsterer's tack. In the shadowy background behind her the naked figure of the excited god clambers through parted draperies into the

bedchamber. Jupiter, somewhat clownish and undignified in appearance, has the thickening torso of an aging athlete and the avid expression of an eager adolescent. Behind him one discerns a rain of molten droplets. Given the latter detail and the fact that Jupiter does not take the form of a satyr, it is quite likely that Danaë rather than Antiope is intended here.[1] The young woman's face and body are an acute, almost caricatural, study of the passive relaxation of deep sleep. The slackness of her facial features and the pillowy softness of her body are accentuated by the puffy organic forms of the bedding and of the shell-like bed on which she reclines. One is reminded of the biomorphic style of ornament so popular with goldsmiths at this time, the so-called lobate (ear-lobe) style. The influence of this taste is also evident in a lively etching of 1612 by the Dutch painter Werner van den Valckert representing the sleeping Venus and Cupid spied upon by satyrs (fig. 69), a print that Rembrandt very likely would have known.

The Rembrandt etching is seen here in an early impression of the second state in which the heavier shadows and the platemark are still inky and strong, intensifying the spotlightlike illumination. In this second state Rembrandt covered the sleeping woman's lower legs with a sheet executed in engraving and drypoint, perhaps because in the first state her naked legs ended so abruptly as to appear almost amputated.

The etching of 1659 (no. 99), one of Rembrandt's last prints, does appear to represent Jupiter in the form of a

98

Jupiter and Antiope, about 1631
Etching, engraving, and drypoint
B. 204, II
8.5 × 11.3 cm (3⁵/₁₆ × 4⁷/₁₆ in.)
Hood Museum of Art,
Dartmouth College, Hanover,
New Hampshire
Gift of Jean K. Weil in memory
of Adolf Weil, Jr., Class of 1935

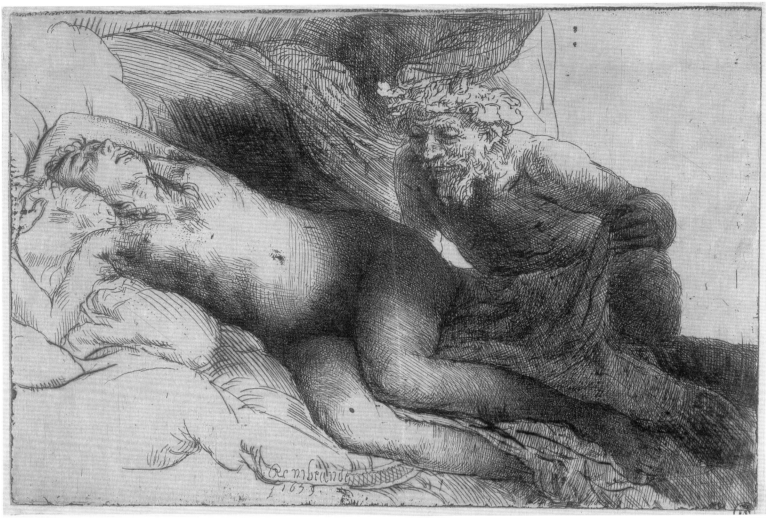

Fig. 69. Werner van den Valckert (Dutch, about 1585–about 1627/8), *Sleeping Venus Surprised by Satyrs*, 1612, etching, Holl. 7, 29.3 × 37.1 cm (11 9/16 × 14 5/8 in.), Museum of Fine Arts, Boston, Gift of Mr. and Mrs. Moses Alpers and Stephen Bullard Memorial Fund.

satyr unveiling and inspecting with a connoisseur's attention the lower body of the innocently sleeping Antiope. It is characteristic for the later Rembrandt that he places us much closer to the principal players than in the early "Danaë" discussed above. We are virtually *in* the bed, an effect magnified by the radical cropping of Antiope's right arm by the left plate edge.

The aging Rembrandt (he was 53) emphasizes the disparity in age between the adolescent Antiope and the visibly aging satyr with the crown of leaves. Antiope's body seems still not fully developed. Sunk deep in the cushions, her sleeping head is seen in rather grotesque foreshortening: one can almost hear her snoring. This experienced satyr is not one of the lusty and vigorous young satyrs familiar from Rubens's and Van Dyck's various paintings of the subject or from the etching of 1592

99

Jupiter and Antiope, 1659
Etching, drypoint, and engraving on Japanese paper
B. 203, I
13.8 × 20.5 cm (5 7/16 × 8 1/16 in.)
Private Collection

by Annibale Caracci.[2] The latter almost certainly served as inspiration for the relationship of the figures in Rembrandt's print.[3] Rembrandt's satyr has a body with softening musculature and his expression blends desire and melancholy. One is tempted to question whether this satyr is still capable of achieving his goal or whether he will be content only to look. If the two are not yet joined in the flesh they are joined by the shadows that link their bodies, shadows deepened and made more velvety by the use of drypoint with burr. Shadow tantalizingly veils Antiope's groin and lends a richer ambiguity to the expression on the aged satyr's face.

This impression, like so many early impressions of this print, is printed on a warm-toned Japanese paper similar to that often used to print early impressions of the four etched nudes of 1658 (see nos. 197 and 198). Rembrandt obviously considered this paper's warm color and sensuous, silky texture useful in achieving a more vivid evocation of skin and flesh. CSA

NOTES

1. The famous painted nude in an elaborate bed of 1636–43 in the Hermitage, St. Petersburg (Br. 474; Corpus A119), is related in conception to the early etching and appears indeed to represent Danaë but omits the shower of gold.

2. B. 17.

3. For Van Dyck's and Rubens's paintings of Jupiter and Antiope, see Larsen 1997, 66–74. For a reproduction of the Caracci print see Amsterdam/London 2000, 362, no. 90, fig. b. Annibale Caracci prints are mentioned twice in Rembrandt's 1656 inventory; see *Docs.* 1979 1656/12, no. 209, a book or album of prints by the three: Carracci, Reni, Ribera; and no. 232, a basket containing erotica (presumably prints) by Annibale and others.

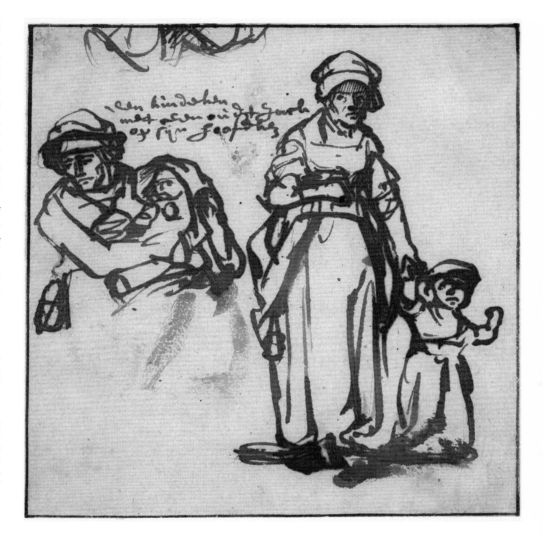

100–104
Sketches of Daily Life

LATE 1630S—EARLY 1640S

Rembrandt in the later 1630s and early 1640s recorded the human activity in the world around him in groups of related drawings, either from direct observation or from well-practiced memory, concentrating on "the life of women with children." The wealthy marine painter and collector Jan van de Capelle (about 1624–1679) owned a portfolio with 135 Rembrandt drawings categorized under this broad title.[1] In Rembrandt's work such drawings frequently took the form of sheets of assorted sketches, including etched sketch plates that exposed a wider audience to the sketch sheet concept.

A sketch sheet with nursemaids (or mothers) and small children is one of a very small number of drawings annotated with an authentic inscription from Rembrandt's hand (no. 100). This sketch sheet of the late 1630s or early 1640s shows two strong-faced minders with their charges, one with a baby in her arms and one walking a small child. The latter caretaker has a firm grasp on one of the child's hands while the infant energetically waves the other about. She appears to direct a stern, rather suspicious glance toward the artist and the viewer. Executed in pen and gallnut ink with touches of brush, one senses that this sheet was drawn directly from life. The inscription by Rembrandt would tend to confirm this, for it is a reminder to himself not to forget a particularly amusing detail: *"een kindeken met een oudt jack op sijn hoofdken"* (a little child with an old jacket on his little head). Apparently Rembrandt felt that his rapidly

100
Studies of a Woman and Two Children,
late 1630s–early 1640s
Pen and brown ink
Ben. 300
13.6 × 13.2 cm (5⅜ × 5³/₁₆ in.)
Private Collection

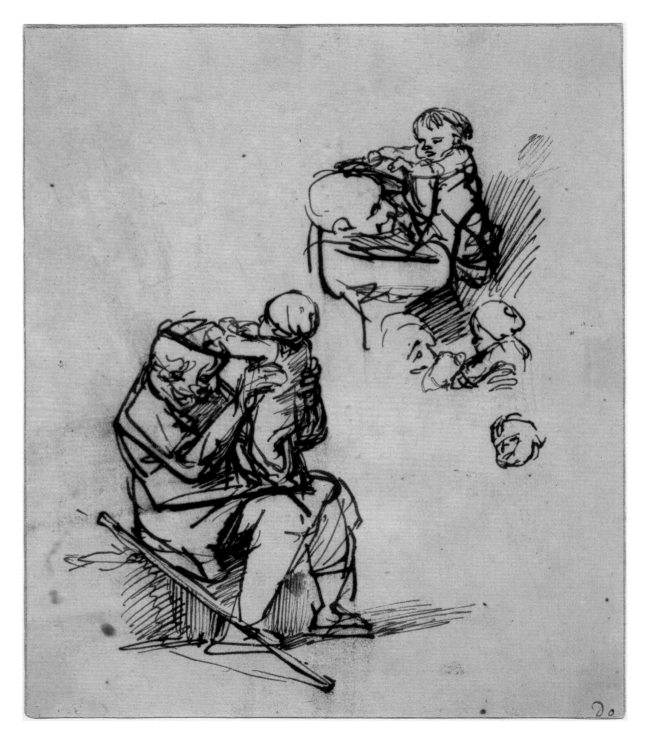

101

Two Studies of a Child Pulling off the Cap of an Old Man, 1639–40
Pen and brown ink, touched with brown wash, on paper washed pale brown
Ben. 659
18.9 × 15.7cm (7⁷/₁₆ × 6³/₁₆ in.)
Lent by the Trustees of the British Museum, London

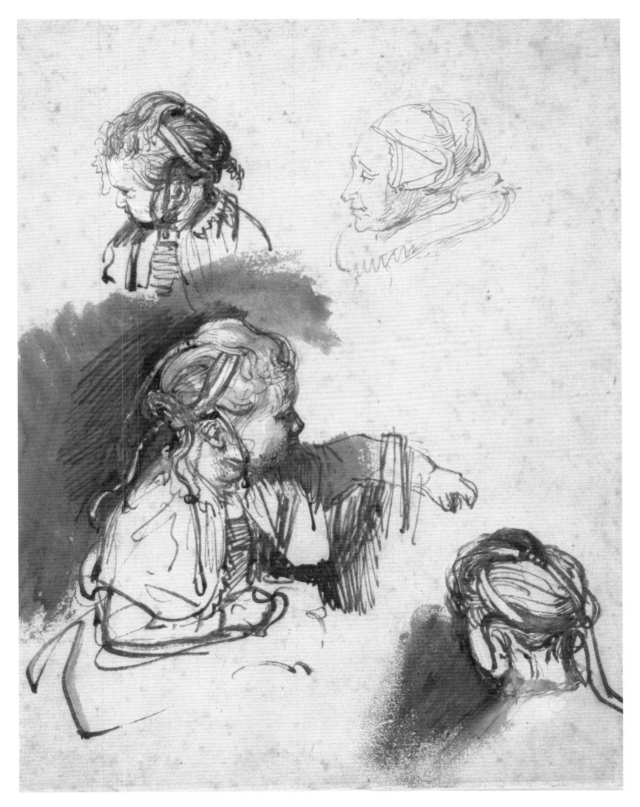

102

Three Studies of a Child and One Study of an Old Woman, 1640–45
Pen and brown ink and brown wash, white watercolor
Ben. A10
21.4 × 16 cm (8⁷/₁₆ × 6⁵/₁₆ in.)
Courtesy of the Fogg Art Museum, Harvard University Art Museums, Cambridge, Massachusetts
Gift of Meta and Paul J. Sachs

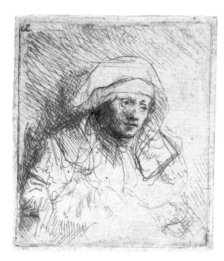

103

Sick Woman with a Large White Headdress, about 1641–42
Etching and drypoint
B. 359, only state
6.1 × 5.1 cm (2⅜ × 2 in.)
National Gallery of Art,
Washington
Rosenwald Collection

scrawled sketch did not provide him with enough information to remember the precise nature of the improvised head covering. The sheet was evidently once larger because at top left one can see the lower remnants of a repetition of the sketch of the nurse holding the baby. Rembrandt's drawings often show signs of having been cut down or cut from larger sheets of studies by later hands. The lines of the drawing are unusually bold, partly because over time the gallnut ink has bled into the surrounding paper, thickening the contour lines.

The British Museum drawing (no. 101) datable to about 1639–40[2] is related to the same "women with children" group as the foregoing drawing, even though in this instance the minder of the rambunctious child is an old man, possibly a grandfather. This sketch sheet executed with pen and gallnut ink confronts us with an almost cinematic 1-2-3 sequence in which the eye follows a path from lower left to upper right and down again: the child standing in the old man's lap lays covetous hands on the old gentleman's cap, yanks it loose, and finally succeeds in removing it. A fourth small study on the sheet is a schematic three-quarter sketch of the baby's head. The bold zigzagging rhythm of the lines intensifies the sense of lively action.

The Fogg study sheet (no. 102) consists of three fully developed pen and wash studies touched with opaque white watercolor depicting the head of the same little girl from different angles, plus a lighter pen profile of the head of an older woman. It is a perfect example of a sheet of seemingly miscellaneous studies in which the separate studies are so beautifully positioned on the page that the drawing gives one the feeling of a complete and finished work. Rembrandt's etched sketch plates from 1636 to 1637 with different views of his wife Saskia's head

and shoulders have a similar sense of casual, but beautifully composed rightness (no. 60). From the eighteenth century to our day—from Watteau to Picasso—the sheet of loosely assorted sketches that has the impact of a finished work became a standard part of an artist's repertoire. While Rembrandt was certainly not the originator of this artistic concept, his frequent use of it in his much-emulated drawings and prints had a decided influence on the artistic conceptions and taste of artists and collectors in succeeding centuries.

One senses in this drawing from about 1640–45 that Rembrandt was above all interested in the elaborate knotted coiffure of the child. It suggests the varied exotic coiffures and headdresses he invented for the female spectators in his many-figured historical and biblical narratives.[3] Here the older woman's staider, more conventional cap and pose provides a nice foil for the views in the round of the child's elaborate hairdo. One is reminded of some of Arnold Houbraken's observations in his 1718 account of the artist's life and art regarding Rembrandt's ways of working: "he was also inexhaustible, be it in regard to facial features and attitudes or in regard to costume," and, "I know nobody who has varied his sketches of one and the same subject in so manifold a fashion," or again, "Many of his pupils told me that he at times sketched a face in ten different ways before he brought it on the canvas, or else might spend a whole day or two in placing a turban to his taste."[4]

One of Rembrandt's most intimately scaled and delicately etched sketches on copper is a study of the bust of a melancholy-looking woman with slumped posture who appears to be wasting away from illness (no. 103). This etching of about 1641–42 has often been identified as a portrait of Rembrandt's wife, Saskia. Saskia gave

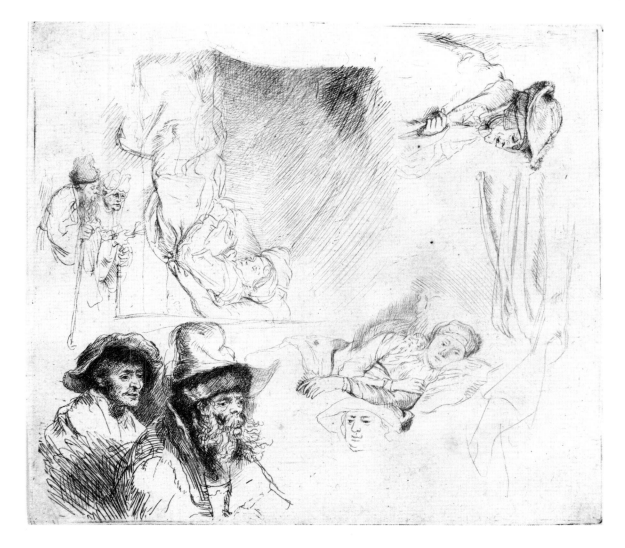

104

Sheet of Studies (with a woman lying ill in bed), about 1641–42
Etching
B. 369, only state
13.5 × 15.1 cm (5⁵⁄₁₆ × 5¹⁵⁄₁₆ in.)
Fogg Art Museum, Harvard University Art Museums, Cambridge, Massachusetts
Gifts for Special Uses Fund, Alpheus Hyatt Fund, William M. Prichard Fund

birth to the couple's only surviving child, Titus, in 1641 and died a few months later in 1642. Many modern scholars are understandably wary of overly personal, biographical associations in connection with Rembrandt's works, fearing that a too subjective or Romantic interpretation might interfere with the quest for the objective truth. But the fact of the matter is that Rembrandt produced a large number of unusual images—not just his self-portraits—that have a strong personal resonance and are difficult to completely disassociate from his personal life. The issue of whether this woman is or is not Saskia does not, however, alter the effectiveness of the metaphor of fading strength being represented by the delicacy and pallor of the etched lines themselves.

The etched *Sheet of Studies* (no. 104) is datable to about 1641–42. This is the most elaborate of Rem-

brandt's etched sketch plates and can be read either vertically or horizontally. In both directions the image is organized around a study of a woman, possibly Saskia again, ill in bed. The lines in these studies are more delicate than the several pen studies of women recuperating in bed from illness or childbirth that Rembrandt made in the second half of the 1630s and in the early 1640s. Around the edges of the plate are distributed with seeming casualness miscellaneous studies of beggars and street people, including on the shorter side of the plate a vignette of an indigent elderly couple with canes in which the man appears to be blind. The woman holds in her hand a wooden clapper that heralds their coming. These sketches combine with the image of the bed-ridden woman to contribute a melancholy unity to the plate as a whole. It has been noted that Rembrandt

subtly linked the "unrelated" sketches visually. The cane of the old woman with the clapper defines the bottom of the sick woman's bed on the shorter side of the plate and, on the longer side of the plate, the bed linen corresponds to the outlines of the head covering of an old woman.[5] CSA

NOTES

1. Jan van de Capelle, one of the most poetic of the seventeenth-century marine painters, was the independently wealthy owner of a paint factory. He had an extensive art collection including an unusually large number of drawings by Rembrandt. The 1680 inventory of his estate lists under the heading, "Drawings," number 17: "Een dito [portfolio] daerin sijn 135 tekeningen synde het vrouwenleven met kinderen van Rembrandt." Also listed are a portfolio with fifty-six "history" drawings by Rembrandt and one with eighty-nine landscape drawings, as well as one with forty-eight "sketches" by Rembrandt and Pynas, and yet another with 188 "sketches, landscapes by Rembrandt." See Bredius 1892, 37–38.

2. Royalton-Kisch 1992, 87, no. 31.

3. Williams et al. 2001, 177, no. 96.

4. Houbraken 1718–21, 1: 256–57 and 261, as translated in Goldscheider 1960, 26–27.

5. See Stacey Sell, "Quick to Invent and Copious to Express: Rembrandt's Sketch Plates" in Parshall et al. 2001, 63.

105–106

Lion Hunts

TWO DECADES

Rembrandt made three etchings depicting equestrian lion hunts. This subject already had a strong visual tradition: following the example of Renaissance tapestry cycles that adorned aristocratic households, sixteenth-century printmakers had produced series of hunt scenes, each plate featuring different and often exotic quarry, such as elephant, hippopotamus, ostrich, lion, or bear. These series were the precedents that Rembrandt must have studied before going his own way.[1] But ignoring all the other types of game, he returned repeatedly to lions.[2] Although we cannot know his reasons for this particular choice, the ferocious conflict between man and savage beast clearly unleashed the primal energy of the draftsman's hand.

Rembrandt probably etched the undated *Small Lion Hunt* in the late 1620s, when he was still struggling to learn the fine points of printmaking (no. 105). *The Large Lion Hunt* is dated 1641, when he was already an accomplished printmaker (no. 106). Though both were drawn in a rapid, sketchy manner, these two etchings are a study in contrasts with respect to lighting, use of line, and professionalism of technique.

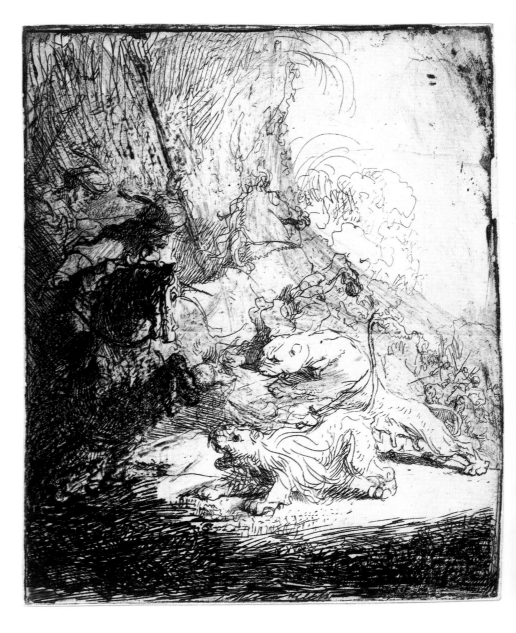

In *The Small Lion Hunt* one cannot predict whether men or lions will prevail. One of the turbaned hunters holds his spear at the ready, but the lions have already proven their ability to unseat the riders. The fallen hunter screams as the lioness pounces, tearing at him with its teeth and claws. Colliding masses of light and dark underscore the drama of the conflict. Rembrandt's impulsive, unsystematic draftsmanship mirrors the mayhem of the scene: he has exchanged the niceties of clarity and order for dynamism verging on chaos. Broken contour lines and slashing strokes give the figures addi-

105

The Small Lion Hunt (with two lions), late 1620s
Etching and abrasion
B. 115, only state
15.4 × 12.1 cm (6 1/16 × 4 15/16 in.)
Lent by the Trustees of the British Museum, London

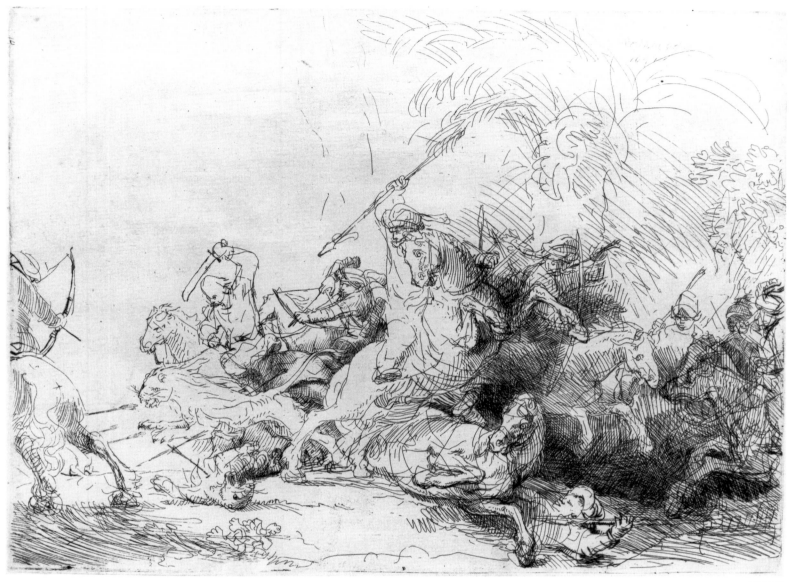

tional speed and fluidity. Rembrandt the etcher is often characterized as experimental, but here he recklessly pushes the limits of the medium. In this early impression we see at first glance the raw effect of the copper plate's inky irregular edges and the random etched blotchiness in the upper right corner. In some areas, such as the horse's chest, he etched and scraped and etched again until the linear structure broke down, producing an uneven pocked and mottled effect. Rembrandt also abraded the surface of the copper plate: an inverted arc of scratches darkens part of the background, allowing the

attacking lioness to stand out more clearly. He toned the lioness's foreleg with scratches that serve to focus our eyes on the rippling highlights of her tensed body. We can trace her strength from her dug-in rear claws, along her lean frame and massive shoulders, past her glaring eyes to the straining flesh of the hunter pierced by her teeth. The same scratches emphasize the power of the foreleg clawing at the man. From these untutored, intuitive attempts at direct mark making, Rembrandt's signature drypoint technique would later emerge in all its richness and subtlety. This inky early impression with

106

The Large Lion Hunt, 1641
Etching and drypoint
B. 114, I
22.5 × 30 cm (8⅞ × 11¹³/₁₆ in.)
The Fitzwilliam Museum,
University of Cambridge

its bold roughness and irregularity also presages the dramatically expressive chiaroscuro that Rembrandt would more deftly employ as a mature artist (see, for example, "The Three Crosses," no. 170, and *Abraham's Sacrifice*, no. 68).

By 1641, Rembrandt had learned to etch freely yet with full control, drawing his plates with seemingly effortless fluidity and grace. He worked quickly on *The Large Lion Hunt*, using loose bundles and tangles of lines that achieve structural clarity without becoming labored or overly decorative. Each stroke retains its lively individuality. The powerful conflicts and clashes of the earlier etching give way to open swirling motion in which horses and lions seem nearly to take flight. Horses with their riders also dart in and out of the frame. With racing figures, light, shadow and line, Rembrandt causes our eyes to flick back and forth across the sheet as though we were witnesses to the wild scene. Although completely different in execution, the background here shares a telling parallel to that in *The Angel Appearing to the Shepherds* (no. 39). In both prints, Rembrandt animated the landscape as though it were responding to the excitement of the event. Here in *The Large Lion Hunt* he opened up broad areas of luminous blank white paper, offering his fluid lines room to play. He also increased the overall visual activity through the use of light passages of etched, and partially burnished, granular tone.

One of the riders has fallen, but so has one of the lions. The other lion is on the run. Rembrandt does not concern himself with unnecessary details: the downed hunter has no lower body. The lions, especially the fleeing one, might invite the question as to whether Rembrandt had ever seen a lion with his own eyes, but the same question could be provoked by his stylized rendering of horses and hunters.[3] Seizing the essence of the movement and action was here Rembrandt's primary concern. This is one of three known impressions of the first state. Before printing the plate in greater quantity in the second state, Rembrandt added some further shading to separate the horses at the right as well as a few other tentative marks in and around the palm tree, evidently choosing to stop before the image lost its spontaneity. TER

NOTES

1. Beets 1915, 2, first noted Rembrandt's study of hunting prints by Antonio Tempesta (1555–1630). Johannes Stradanus (1523–1605) designed an often-reprinted hunting series engraved in 1578 by Philips Galle, as well as one engraved by Johannes Collaert; see New Holl. *Philips Galle* 3: nos. 519–62; and Holl. 4: 213, nos. 173–88. Rembrandt borrowed elements from the deer hunt engraved by Collaert; see reproduction in Amsterdam/London 2000, 191, no. 42, fig. d. Rembrandt may also have known Pieter Soutman's series of etchings after

hunt scenes painted by Rubens for Maximilian I, Duke of Bavaria; see Balis 1986), 111–149.

2. Rembrandt may well have made a fourth lion hunt, for the 1656 inventory of his possessions includes "Een leeuwengevecht" painted by him; *Docs.* 1979, 1656/12, 21. The Dutch can be literally translated as "a lion fight"; see Amsterdam/London 2000, 191.

3. Rembrandt certainly did see a lioness, the proof being a group of beautiful portraitlike drawings (Ben. 774 and 775). It is, however, not yet possible to determine exactly when they were made. Royalton-Kisch 1992, 93–95, suggested a date range of 1638–42. Rembrandt also saw a lion, but probably not until the late 1640s (see no. 148; also Ben. 1211–15).

107–108
The New and Old Testaments
ABOUT 1641

Two etched biblical narratives from the New and Old Testaments dated 1641, or datable to about 1641, illuminate the variations in conception and treatment that Rembrandt was capable of at a given moment in time. *The Baptism of the Eunuch* (no. 107) illustrates an episode of Christian conversion from the ministry of the apostle Philip (Acts 8:26–39). Philip was directed by the divine spirit to the desert south of Jerusalem where he encountered a eunuch, a high official of the court of Queen Candace of Ethiopia. The eunuch, who was returning from Jerusalem, was sitting in his chariot puzzling over a prophetic passage in the Old Testament book of Isaiah. Philip joined him in the chariot and interpreted the text as foretelling the coming of Christ, whose gospel he preached to him. They traveled on, and having arrived at a body of water, the eunuch asked how he could be baptized. He was informed that he must simply profess faith in Jesus as the son of God. He did so and Philip baptized him. Philip was then miraculously spirited away and the eunuch continued on his journey, rejoicing.

The subject was painted several times by Rembrandt's teacher Pieter Lastman and twice by Rembrandt at the very beginning of his career.[1] It clearly appealed to the Dutch Protestant emphasis on the confession of faith and baptism. It also stressed, because it concerned the conversion of a black man, the relevance of the Christian message to all peoples. An additional appeal for artists such as Lastman and Rembrandt was the opportunity to indulge their imaginative skills in inventing exotic costumes, trappings, and paraphernalia. Rembrandt takes full advantage of the opportunity, producing in this etching one of his most extravagant displays of ancient "oriental" splendor set in an invented oasislike landscape.

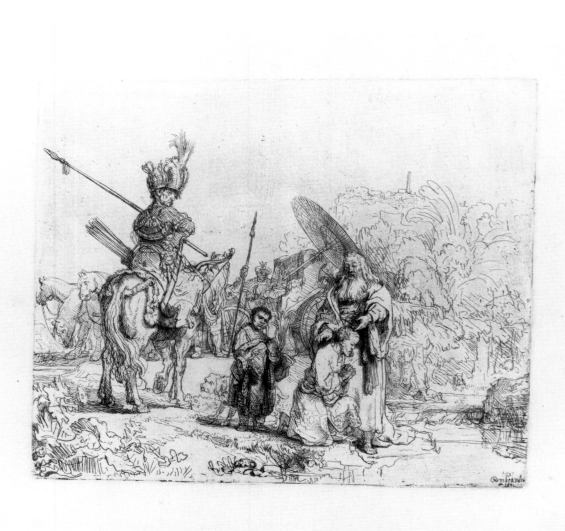

107

The Baptism of the Eunuch,
about 1641
Etching and drypoint
B. 98, I
18.3 × 21.3 cm (7³⁄₁₆ × 8³⁄₈ in.)
The Fitzwilliam Museum,
University of Cambridge

REDUCED

In the period 1640–45 Rembrandt made a number of etchings of varied subject matter that were very light in tonality, and took full advantage of the luminosity of the untouched paper. Such Rembrandt etchings of the forties and later, drawinglike in their suggestive use of line and blank paper, parallel the work of contemporary Italian painters who etched, artists such as Guido Reni.[2] They tend to be essentially linear in character, the open linework having a springy, wiry quality that is sometimes, as here, distinctly ornamental in effect.

In this luminous impression of the first state (before extra shading on the waterfall and the riverbank) the key figures of Philip performing the baptism and of the eunuch who kneels in prayer before him dominate the surrounding scene, as they should. This is in part due to the presence of subtle touches of drypoint burr that rap-idly disappeared but are still visible on this impression. In later impressions commonly encountered, all the lines tend to take on equal value and the expressive and spatial relationships appropriate to the image are somewhat diminished.

In the year of Rembrandt's first dated landscape prints (see nos. 117–122, 125, 127), 1641, landscape plays a prominent role. We are presented with a kind of Eden in the desert, the source of the baptismal water. The mountainous buildup of the landscape behind the figures of Philip and the eunuch also serves, together with the chariot's halolike sunshade, to give increased prominence to their figures.

About the same time that Rembrandt etched *The Baptism of the Eunuch,* he created one of his most elaborately staged and choreographed etched biblical narra-

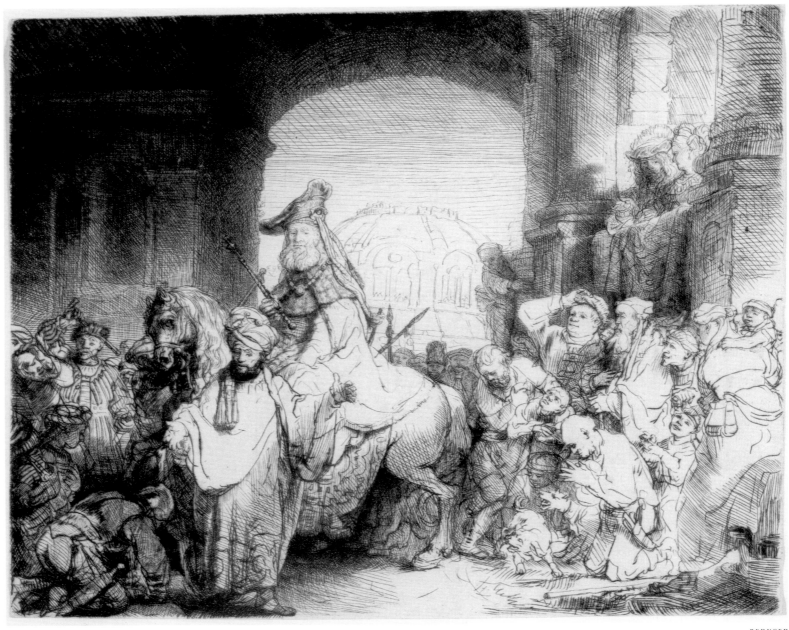

tives, *The Triumph of Mordecai* (no. 108). This intricate and ironic tale of revenge in which the tables are turned on the wicked and scheming is to be found in the Old Testament book of Esther (chapters 2–7). When the orphaned beauty Esther (or Hadassah) became an active candidate for selection as queen to Ahasuerus, king of the Persian empire, her older relative and guardian Mordecai cautioned her not to disclose her Jewish identity. Ahasuerus chose Esther, but in the meantime, he had raised to a

high position a certain Haman, who was deeply offended when Mordecai refused on principle to do reverence to him. Haman in consequence hatched a plot to do away with all the Jews in the kingdom. He also set up a gallows on which to hang Mordecai. Unfortunately for him, Haman was unaware that the king was in fact deeply grateful to Mordecai because Mordecai had uncovered a plot against the king's life. By going about in conspicuous mourning garb (sackcloth and ashes) Mordecai alert-

108
The Triumph of Mordecai, about 1641
Etching and drypoint
B. 40, II*
17.2 × 21.3 cm (6¾ × 8⅜ in.)
National Gallery of Art, Washington
New Century Fund

ed Esther to the plot against her people. Gathering her courage, Esther fasted and then, arrayed in her finest apparel, dared to appear, uninvited, before the king. Dazzled, the king granted her wish that she prepare a banquet for him. Haman was invited as a special guest and at the banquet he asked (referring to himself) how would the king do honor to someone? The king replied (referring to Mordecai) that the person to be honored should be decked out in the royal apparel, mounted on the royal charger, and led through the streets by a herald who would proclaim: "Thus shall it be done to the man whom the king delighteth to honor." Haman, to his chagrin, became Mordecai's herald and proclaimer. At a second banquet given by Esther for the king and Haman, Haman's plot against the Jews as well as Esther's Jewish identity were revealed to the surprised and angry king, and Haman ended up hanging from the gallows intended for Mordecai.

The Triumph of Mordecai is one of Rembrandt's most accomplished and characteristic performances in print, but it owes a clear debt to Lucas van Leyden's major engraving of 1515 on this theme and to Pieter Lastman's 1624 painting of the subject (now in the Rembrandt House, Amsterdam).[3] Lucas's friezelike composition does not have the spatial complexity of Rembrandt's triumphal progress, but details on the right hand side of Rembrandt's composition, such as the man doffing his hat and the kneeling man, are loosely inspired by corresponding passages in the Lucas print. In the Lastman painting the emergence of Mordecai's white horse from a dark gateway is accompanied by dramatic contrasts of light and dark, but Lastman does not interweave light and shadow with the fluid mobility of Rembrandt. Rembrandt borrowed freely from his predecessors throughout his career but always translated his borrowings into his own unique visual language. The architectural backdrop in Rembrandt's etching echoes both of his sources, but the dynamic semicircular space created by the figures as they wheel, turn and jostle each other is Rembrandt's own. At left a soldier with raised whip forces the crowd to kneel while at right hysterically yapping dogs and small children add animation and variety to the diverse crowd of onlookers. Rembrandt added an original detail to this traditional representation, including Esther and Ahasuerus in a tapestry-draped loge at the right as witnesses to the event. The inclusion of Esther and Ahasuerus here is another telling example of Rembrandt's use of dramatic compression, in which he alludes to other moments in a narrative within a single image. Ahasuerus is rendered incognito by the shadow that masks his lower face but his appearance has overtones of Rembrandt himself as seen in his etched fancy dress self-portrait of 1639 (no. 81).[4]

As has been noted, Rembrandt's version of the subject might just as well be entitled *The Fall of Haman* as *The Triumph of Mordecai*.[5] Haman is more than usually conspicuous: facing the viewer, he strides before the mounted Mordecai, arms flung wide in proclamation. But his contorted brow signals his inner confusion. By contrast, Mordecai is composed and serene, elevated above the crowd's hubbub. He closely resembles the distinguished bearded elder in the split fur cap in Rembrandt's etching of 1640 (no. 33).

This is the first etching in which drypoint burr with its velvety dark tones plays a major role in the expressive impact of a Rembrandt print. Drypoint is responsible for the deep, fluid shadows that are intricately interwoven with the lights represented by the untouched white of the paper. In a similar fashion, varying degrees of finish, from sketchlike to densely worked, are contrasted with each other. This elaborate dialogue of light and shadow is quite different in conception from the desert glare of white light and the emphasis on pure line in the contemporary etching of *The Baptism of the Eunuch* discussed above.

This exceptional impression, in which the drypoint burr is unusually fresh, once belonged to the surgeon and etcher Seymour Haden (1818–1910), champion of the nineteenth-century etching revival, brother-in-law of the painter and etcher Whistler, and an enthusiastic but highly opinionated connoisseur of Rembrandt's prints.
CSA

NOTES

1. Tümpel 1970, no. 122, and Tümpel and Schatborn et al. 1991, 54–84. The Rembrandt paintings are the rediscovered paintings in the Rijksmuseum het Catharijneconvent, Utrecht (Corpus A5) and the lost painting engraved by Van Vliet (New Holl. 12).

2. Reni was one of the seventeenth-century Italian etchers represented in Rembrandt's print collection; see *Docs.* 1979, 1656/12, no. 209.

3. Both are reproduced in Amsterdam/London 2000, 195, no. 44, figs. a, b.

4. This image is a good example of one of Rembrandt's ambiguous "semi-self-portraits." Not every scholar chooses to associate this figure with Rembrandt's image.

5. Tümpel 1970, no. 27.

109–115
The Flight into Egypt
1630S–1650S

From the late Middle Ages on, artists were attracted to the theme of the Flight into Egypt and the related subject of the Rest on the Flight, seizing the opportunity provided by the vagueness of the New Testament text (Matthew 2:1–23) to explore details of the domestic life of the Holy Family. In this episode from Christ's early childhood, Christ's parents, alerted by an angel in Joseph's dream, flee with the child into Egypt in order to avoid the persecution of King Herod, who hoped to exterminate the rival infant "King of the Jews" about whose birth the three wise men had informed him. They remained in Egypt until an angel notified them that Herod was dead and that it was now safe to return. However, fearful of the wrath of Herod's son and successor, upon their return they settled in Nazareth in Galilee rather than in Judea where Christ had been born.

Rembrandt had a special devotion to these two related subjects, especially in his etched works, and used them not only to give us intimate glimpses into the daily life of Joseph, Mary, and the infant Jesus, but also to explore the theme of landscape, particularly nocturnal landscape. The evangelist Matthew tells us that Joseph "took the young child and his mother *by night*, and departed into Egypt."

Rembrandt had etched two *Rest on the Flight* and *Flight into Egypt* subjects at the very beginning of his print-making career in 1626–28 (see nos. 8, 9). In 1633 he took up the theme of the Flight again in a small etching (no. 109) that is similar in its combination of miniaturistic scale and high degree of finish to the three small Childhood of Christ etchings of 1630 (nos. 36–38). As in the freely sketched experimental etching referred to above, the Holy Family is seen on the road, ascending a hill with Joseph leading the donkey that carries Mary and the bundled-up Christ Child. On the rump of the pack animal are full saddlebags and a mallet and saw, tools of Joseph's carpenter trade.

This print is one of Rembrandt's early explorations of the use of an etched tone that is bitten into the plate in order to achieve an effect similar to a wash of ink. A mottled bitten tone covers much of the top half of the plate, suggesting the fall of night and the emergence of stars. The "stars" were probably produced by bubbles in acid applied directly to the plate without a protective ground. This etched tone is quite visible on Joseph's upper figure but has been scraped and burnished away in other areas

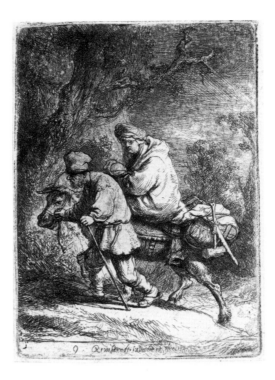

109
The Flight into Egypt, 1633
Etching
B. 52, I
8.9 × 6.2 cm (3½ × 2⁷⁄₁₆ in.)
National Gallery of Art,
Washington
Rosenwald Collection

such as Mary's heavily cloaked back to strengthen the sculptural effect of her figure and to heighten by contrast the feeling of oncoming night.

In the equally small 1644 etching of *The Rest on the Flight* (no. 110) night, represented by a dense web of criss-crossing etched and drypointed lines, has enveloped the exhausted travelers and is only dispelled by the large lantern hanging on a convenient branch. Beneath the lantern we see part of their baggage spread out on the ground: an unbuckled saddle resting on its side, a basket of linens and a large water bottle. Mary wears a wide-brimmed traveling hat and presses one hand to her forehead in a gesture of weariness. She has one breast exposed and the swaddled child in her lap appears to have fallen asleep while nursing. In this impression of the first state the branch that holds the lantern is still unshaded and the donkey that will stick its head and neck in from the right in Rembrandt's third state has not yet made its appearance. In scale and finish this minia-ture nocturne, like the etching just discussed, might also understandably be considered a possible late addition to the group of miniature, etched scenes from the child-hood of Christ that Rembrandt began in 1630. Like many earlier and contemporary printmakers Rembrandt seemed on occasion to be thinking in terms of a *series* of biblical subjects (see also nos. 36–38) but the difference is that he seldom strove for the necessary uniformity of

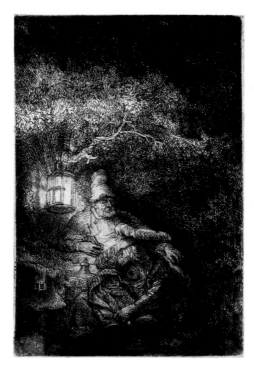

110

The Rest on the Flight (a night piece), 1644
Etching
B. 57, I
9.2 × 5.9 cm (3⅝ × 2⁵⁄₁₆ in.)
Lent by the Trustees of the
British Museum, London

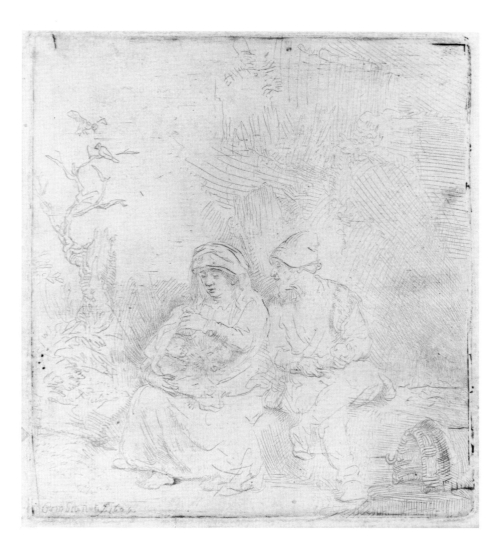

111

The Rest on the Flight (lightly etched), 1645
Etching and drypoint
B. 58, only state
13.1 × 11.6 cm (5³⁄₁₆ × 4⅝ in.)
The Frances Lehman Loeb Art
Center, Vassar College,
Poughkeepsie, New York
Gift of Mrs. Felix M. Warburg
and her children

format and dimensions and in fact never completed or published such series.[1]

The etched *Rest on the Flight* of one year later (no. 111) is wholly different in scale and conception. Lightly drawn and etched, it is one of a small group of Rembrandt etchings in which he intentionally sought the utmost delicacy of line and lightness of tone, an effect not unlike a silverpoint drawing (see the famous silverpoint betrothal portrait of Saskia in Berlin, fig. 60, p. 126). Other etched examples of this lightly drawn, almost evanescent style of etching are the undated bust of a *Sick Woman* (no. 103) from about 1639–42 or, from this very year 1645, *The Penitent St. Peter* and the undated *Old Man in Meditation*.[2] A number of Rembrandt's first landscape etchings of 1641–45 have a similar sketchlike suggestiveness and freedom (see no. 117) but do not share the same ineffable delicacy of line.

Here the Holy Family is seen enjoying a picnic rest stop (at right a saddle rests on the ground) rather than collapsing with exhaustion after their travels. Mary and Joseph are seated companionably side by side. Mary raises the baby's blanket so that Joseph, who is in the act of peeling an apple, can gaze fondly at his son. The landscape setting is deliberately vague, but at upper left a pair of birds visually allude to the theme of family harmony.

The Dublin nocturnal landscape painting of the *Rest on the Flight* (no. 112) is dated 1647. This painting on wooden panel is the latest in date of the seven or eight landscape paintings still attributed by modern scholars to Rembrandt and the only night piece among them.[3] The Holy Family, seated in a rustic shelter under a great tree, is bathed in the warm glow from a herdsman's campfire while the night sky is illuminated by the cooler light

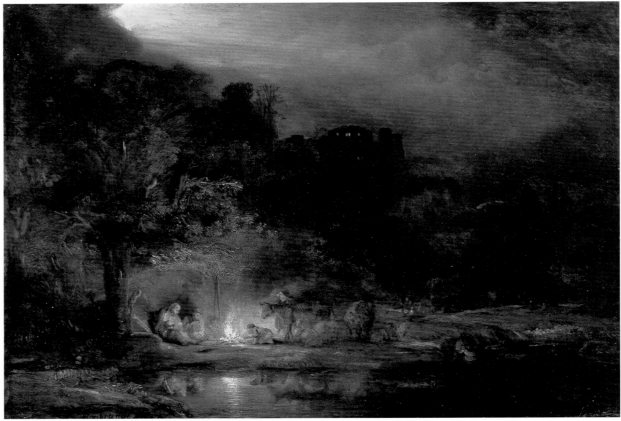

112
The Rest on the Flight into Egypt,
1647
Oil on panel
Br. 576
34 × 48 cm (13⅞ × 18¾ in.)
The National Gallery of Ireland,
Dublin

REDUCED

of the moon concealed behind clouds. The Holy Family seen together with herders and their flocks evokes memories of earlier episodes from Christ's childhood, such as the angel announcing Christ's birth to the shepherds (no. 39) or the shepherds' visit to the stable to pay homage to the newly born Christ child (nos. 153, 161). In fact details of daily life and landscape are so dominant in this painting that it was once thought to represent a gypsy encampment rather than the Holy Family resting on their journey.[4]

Modern scholars writing about this painting all comment on the influence of the work of the German artist active in Rome, Adam Elsheimer (1578–1610). Elsheimer's small painting on copper panel of the Holy Family fleeing by night was owned by the Dutch printmaker Hendrick Goudt, who in 1613 made an engraving of it that was very likely the work that Rembrandt actually knew (fig. 70).[5] Elsheimer, a figure and landscape painter who produced exquisitely refined small-scale cabinet pictures, was much admired by seventeenth century artists for his unique ability to combine in one small painting a variety of realistically rendered and highly

poetic effects of illumination both natural and artificial. Goudt's engraving brilliantly translated into black and white Elsheimer's moonlight, starlight, torchlight, and firelight—all reflected in water. The subsidiary motif of the herders and cattle around the campfire in the Goudt

Fig. 70. Hendrik van Goudt (Dutch, 1580/85–1648) after Adam Elsheimer (German, 1578–1610), *The Flight into Egypt*, 1613, etching and engraving, Holl.3, 36.2 × 41.3 cm (14¼ × 16¼ in.), Museum of Fine Arts, Boston, Katherine E. Bullard Fund in memory of Francis Bullard.

113

The Flight into Egypt (a night piece),
1651
Etching, engraving, and drypoint
B. 53, IV
12.7 × 11.1 cm (5⁵⁄₁₆ × 4⅜ in.)
Museum of Fine Arts, Boston
Harvey D. Parker Collection

Fig. 71. *The Flight into Egypt, a night piece*, 1651, etching, B. 53, I, 12.7 × 11.1 cm (5 × 4⅜ in.), The Metropolitan Museum of Art, New York, Gift of Felix M. Warburg and his Family, 1941.

engraving becomes the central image in Rembrandt's painting. In the depths of his painted landscape Rembrandt included other light sources as well: a spark of light from another campfire and the illuminated windows of an imposing domed building seen in silhouette against the skyline.

In the final state of the 1651 etched *Flight into Egypt* (no. 113) the Holy Family make their way, guided by Joseph's lantern, through an almost impenetrable darkness that seems to have nearly extinguished the "Light of the World." Mary and the child are barely visible and only a faint light remains in the sky. In the first state (fig. 71) Rembrandt was obviously fascinated by the dazzling patterns of light and shadow thrown by the lantern but as he added work to the plate the degree of symbolic darkness grew until it nearly extinguished legibility.[6] Rembrandt followed a similar progression from relative

clarity to stygian gloom as he reworked repeatedly another New Testament etching datable to 1654, *The Entombment* (nos. 155–157).

The most unusual of all of Rembrandt's *Flight into Egypt* prints is one usually dated about 1653. To create this image he reworked a copper plate on which the Dutch painter and printmaker Hercules Segers (about 1589/90–about 1638) had etched in his uniquely eccentric manner a landscape with large figures of Tobias and the angel with the magic fish (no. 114; for the subject see p. 200–201). Segers is the only seventeenth-century Dutch printmaker who one might conceivably claim to have been more unconventional and inventive with printmaking techniques than Rembrandt. Samuel van Hoogstraten, Rembrandt's pupil, wrote of him that he "printed...painting."[7] Segers experimented in his prints with various unusual tonal patterns rather than conven-

tional line, frequently printed with colored inks as well as black ink, printed on cloth as well as paper (sometimes prepared with color before printing), added details or color by hand after printing, and cropped each impression individually. The majority of his rare surviving prints are essentially unique variants rather than editions printed with consistency or uniformity.[8] The *Tobias and the Angel* etching, possibly executed in the 1620s, is known in only two impressions, both printed in greenish ink on white paper.[9] Segers's print is a free variation on a painting by Adam Elsheimer that was probably known to him through another 1613 engraving by Hendrik Goudt.[10] It is executed in a highly original

graphic vocabulary that consists largely of the application with a brush of fine dabs and dashes of resist (when etched these read as negative light marks on a darker field) and fine nets of criss-crossing etched lines. Segers's printing of the image with a pale gray-green ink caused these fanatically fine etched marks to meld together into broad effects of painterly tone and texture. Unfortunately for our knowledge of his technique, none of Segers's plates—including this one altered by Rembrandt—survives.

It was common practice for seventeenth-century publishers to give new life to old copper plates, recycling and updating them by adding more fashionable figures or

114

Hercules Segers (Dutch, about 1589/90–about 1638)
Tobias and the Angel, 1620s
Etching printed in green ink
20.2 × 27.6 cm (7^{15}/₁₆ × 10⅞ in.)
Rijksmuseum, Amsterdam

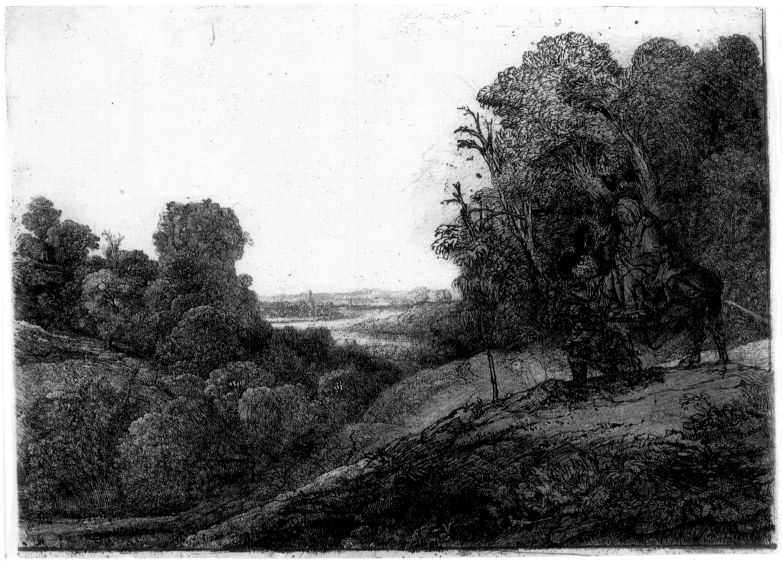

putting a new portrait head on an equestrian portrait.[11] But Rembrandt's revision of Segers's plate should perhaps be regarded more as a personal dialogue—in the face of time and death—with an artist who clearly fascinated Rembrandt rather than as a commercial ploy. His inventory reveals that he owned eight paintings by Segers. The Segers *Mountain Landscape* painting in the Uffizi Gallery, Florence, has passages of overpainting, which appear to be additions by Rembrandt's hand or by someone in Rembrandt's immediate circle.[12] These additions or adjustments alter the scale and mood of the landscape in a manner not unlike Rembrandt's more radical changes to Segers's copper plate.

Rembrandt's revision of the Segers plate was a long creative struggle that continued through some seven states. The fourth state shown here (no. 115) is one of the most satisfactory stages in the reworking of the plate. Rembrandt printed a relatively large number of impressions of this state, a number of them on Japanese paper. Rembrandt has scraped away Segers's large figures of Tobias and the angel and replaced them with the smaller-scale figures of the traveling Holy Family passing in front of a dark clump of trees. The wing feathers of Segers's angel are still faintly visible in the foliage at upper right. In this state the boldly drawn figures of the traveling Holy Family are visually fused with the dark

115

The Flight into Egypt (altered from Hercules Segers), 1653
Etching, drypoint, and engraving
B. 56, IV
21.2 × 28.4 cm (8⅜ × 11³⁄₁₆ in.)
Museum of Fine Arts, Boston
Gift of the Visiting Committee

wood behind them. In later states their figures are made more legible but the total effect of the landscape is less somberly expressive. At left and in the middle distance much of the texture and feeling of Segers's landscape is retained, even though the river has somewhat altered its course and the cauliflower-like character of the trees has been softened by Rembrandt's drypoint shading. Small details of Segers's light-on-dark figures and patterns delineated with wax or varnish resist are still visible in the tiny herder on the hill at left or the tenacious lizard in the right foreground. Rembrandt's bold use of scraping and erasure to remodel the hill over which the Holy Family travel reminds one of the broad sculptural handling of paint in Rembrandt's canvases of the 1650s and 1660s. CSA

NOTES

1. An exception would be the series of book illustrations Rembrandt etched in 1655 for Rabbi Menassah ben Israel's mystical book. See figs. 72, 73, p. 210.

2. *The Penitent St. Peter* is B. 96; *Old Man in Meditation* is B. 147.

3. See Schneider 1990, 47, 51–52.

4. See National Gallery of Ireland 1985, 62–65, no. 24.

5. See Ackley *Printmaker* 1981, 73–75, no. 44.

6. See the state sequence reproduced in White 1999, 71–73, nos. 86–91.

7. Van Hoogstraten 1678, 312.

8. For Segers's technical innovations, see Haverkamp-Begemann 1973 and Ackley 1974, 91–94.

9. Haverkamp-Begemann 1973, no. 1a.

10. Holl. 6, no. 2.

11. Marijn Schapelhouman, "The Flight into Egypt: altered from the plate by Hercules Segers," in Amsterdam/London 2000, 290, no. 71.

12. See Schneider *Landscapes* 1990, 71–72. Not all recent scholars accept the notion that these passages were added by Rembrandt's hand. When the painting was given to the Uffizi in 1839 by artist Maria Cosway it was attributed to Rembrandt. See The Uffizi Gallery (Florence), 1927, 185, no. 1303.

116–128
Landscapes
LATE 1630S–1640S

Beginning in the late 1630s, Rembrandt left the city walls of Amsterdam to record in drawing and print landscapes of fields (many of them polderlands reclaimed from the sea), dikes, farmsteads, and distant glimpses of the city. On his sketching expeditions he walked along dike roads dating from the Middle Ages and followed in the footsteps of artists such as the Amsterdam print publisher Claes Jansz. Visscher (1587–1652), who had drawn and etched many of the same sites earlier in the century.[1] In addition to his many drawings, which range from rough sketches to more carefully worked up or "finished" sheets, Rembrandt produced twenty-six landscape etchings dating from 1641 to 1652, which range in conception from the quick, momentary impression (*Six's Bridge,* no. 127) to an elaborate summation concerning Nature and man's relation to it (*The Landscape with the Three Trees,* no. 121). The earlier landscape group under discussion here consists of four drawings, eight etchings, and one painting dating from the late 1630s to the late 1640s.

A bold calligraphic quill pen and ink drawing of *Two Thatched Cottages* (no. 116) provides an appropriate introduction to Rembrandt's landscapes "from life" executed in the 1640s. This is almost certainly one of Rembrandt's rough notations made on the spot rather than worked up back in the studio. It is one of a group of five pen landscape drawings of picturesque farmhouses that have been variously dated by scholars from the early 1630s to as late as 1650. They relate closely in motif to dated landscape etchings of 1641, such as the *Landscape with Cottage and Haybarn* (no. 118). More recently, on the basis of comparison of the landscape drawings' vigorous zig-zag shading strokes and thick wiry contours with figural drawings similar in style and technique datable to the late 1630s, a dating of about 1635–40 has quite convincingly been suggested.[2] As in others from this group of late-thirties pen landscape drawings, Rembrandt has here added touches of opaque white watercolor (now transparent) to soften or edit out certain contours. Such passages are visible in the thatch along the eaves to the left of the chimney of the foremost cottage. Topographical research has suggested that these cottages are of a type found in the Gooi region southeast of Amsterdam.[3] There are actually three cottages in a row facing a road in the drawing: at far right Rembrandt has sketched in the thatched roof but not the walls of a third cottage. At

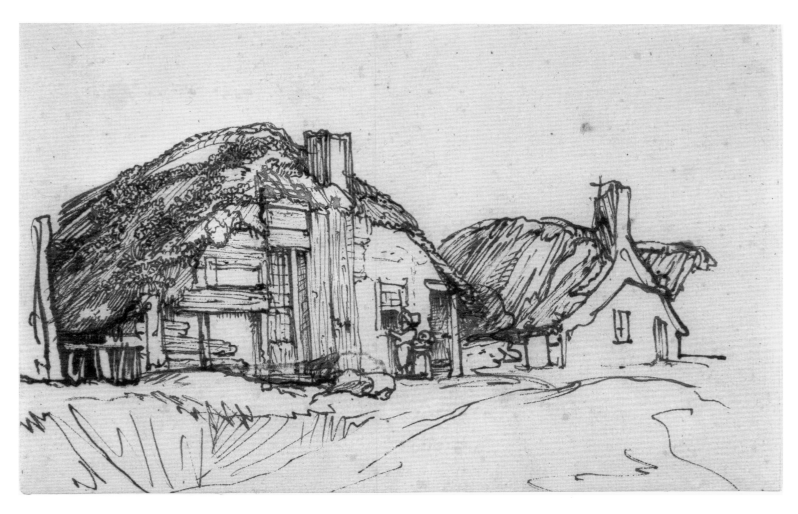

an open window of the first cottage stand two figures, one a child, perhaps beggars soliciting alms.

The undated etching of *Cottages and Farm Buildings with a Man Sketching* (no. 117) variously dated from 1642 to 1645, gives us a vivid sense of Rembrandt's sketching expeditions in the countryside around Amsterdam. An artist with a tall hat is seated on the ground at the right drawing the farmhouse, which has a low living quarters wing and taller attached stable or barn block. He is observed by some rather whimsically drawn goats or sheep. At mid-century, many artists were actively making drawings of similar subjects in the farmlands around Amsterdam, including artists in Rembrandt's circle working in his style such as Philips Koninck.[4] Executed in a fine wiry etched line, the farmhouses might well have been drawn directly on the plate in front of the subject.

The popularity of rural farmhouses as a subject in print goes back to the series of engravings of rural lanes with farmhouses published by Hieronymus Cock in

Antwerp in 1561. These were engraved after drawings by the anonymous Master of the Little Landscapes. Claes Jansz. Visscher issued a set of updated copies of these prints in 1612, attributing them on his title page to Pieter Bruegel.[5] Another series of influential farmhouse prints from the early seventeenth century are those etched by Boetius à Bolswert after Abraham Bloemaert, which were in turn copied and reissued by Visscher in 1620.[6] The Bloemaert designs emphasized the picturesque irregularities of the farm buildings and the ornamental undulation of contours. Rembrandt's farmhouses do not have the undulating organic rhythms of Bloemaert but they do emphasize picturesque dilapidation and farmyard litter: see, for example, the crude out-house at left or the carts and other farmyard debris around the tree at right. Rembrandt's farmhouses hug the earth and often seem to be in the process of returning to it. This impression of *Cottages and Farm Buildings with a Man Sketching* is an unusually strong one with the full range of tonal accents

116

Two Thatched Cottages with Figures at a Window, about 1635–40
Pen and brown ink, corrected with white watercolor
Ben. 796
13.2 × 20.2 cm (5¼ × 7¹⁵/₁₆ in.)
The J. Paul Getty Museum, Los Angeles

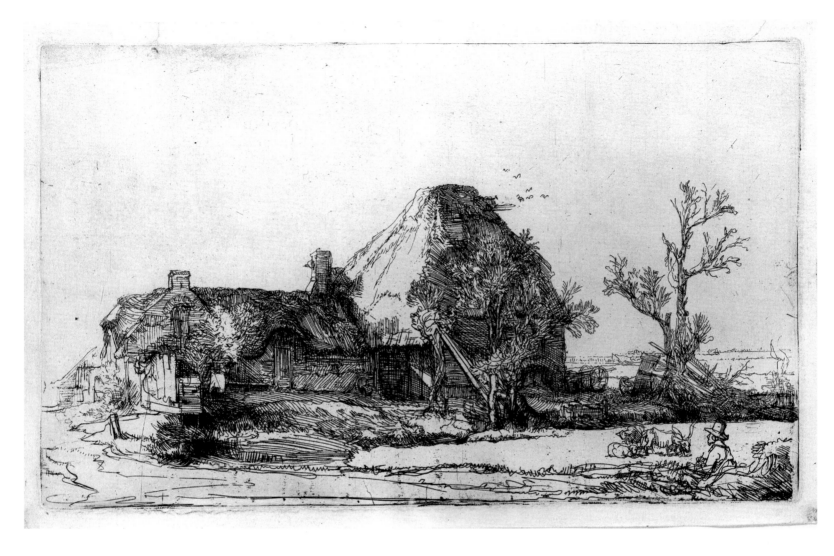

that give the buildings a more solid material presence. The many ordinary impressions of the print have an even middle gray tonality and the blank paper of the sky that provides space, light, and atmosphere has often been trimmed down as if it were considered inessential.

The etching *Landscape with a Cottage and Haybarn* (no. 118) is one of three Rembrandt landscape etchings dated 1641, two of them having a long format appropriate to the horizontal expansiveness of the flat, often man-made, landscape around Amsterdam. They are indebted for their panoramic format to the long etched landscapes of Jan van de Velde (1568–1623) published in Haarlem in the second decade of the century, but the space in Rembrandt's etched landscapes with their radically new, cloudless blank paper skies is much more open, and the linework is less patterned and ornamen-

tal.7 Such islands composed of huddled-together farm buildings and sheltering trees still dot the flat Dutch landscape. But today the roof on the haybarn might be metal or plastic rather than thatch, and, if the farm is located near a main road or rail route, the outlying farm sheds might be covered with spray-can grafitti.

The farm in Rembrandt's etching is indeed an island, a central mass or hub around which open space circulates. The circular motion around the farm island is emphasized by well-worn curving paths and drainage ditches as well as patterns of light and shadow. To the left in the far distance one sees a skyline of city towers and to the right, surrounded by trees, the amusingly named country estate of Kostverloren ("money down the drain"), the extravagant sixteenth-century house that Rembrandt was later to draw in its ruined state (no. 193).

117

Cottages and Farm Buildings with a Man Sketching, about 1642–45
Etching
B. 219, only state
12.9 × 20.9 cm (5¹/₁₆ × 8¼ in.)
The Metropolitan Museum of Art, New York
Gift of Walter C. Baker

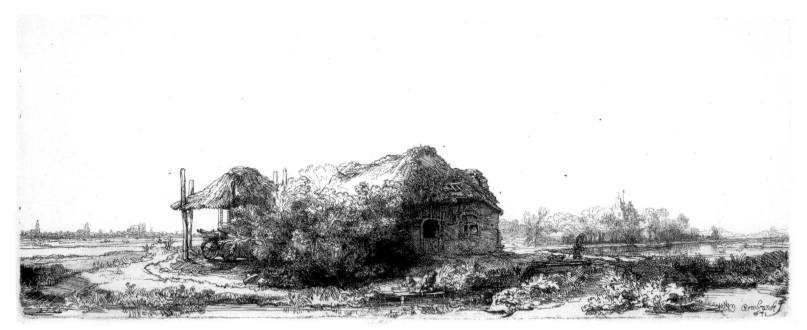

This etched view of Kostverloren corresponds closely (but in reverse) to a Rembrandt drawing in the Duke of Devonshire's collection at Chatsworth of Kostverloren among its trees seen across a bend of the Amstel river.[8] It has been determined that sixteen of the twenty-six Rembrandt etchings are to one degree or another based on actual sites that Rembrandt drew. Rembrandt was not, however, so devoted to recording actual topographical relationships that he bothered to anticipate or correct for reversal in his landscape prints. In this instance the Kostverloren view is based on real topography but there was no farmhouse situated on the site it occupies in the etching.[9]

The landscape is enlivened by signs of human activity that slowly reveal themselves: two children fishing in the ditch, a figure accompanied by a dog crossing a bridge over it, figures dimly perceived at the window and door of the cottage, and a boat moored in the river before Kostverloren. This is a fine early impression in which the drypoint accents that supplement the etched lines have their full effect, helping to define the circulating space and giving depth to the shadow that fuses trees and house and gives the farmhouse island weight and mass.

In 1641 the miller's son finally etched a windmill (no. 119). Even though Rembrandt chose to emphasize the picturesque tumbledown aspects of the mill and the cottage this was in reality a relatively new working mill. It has been identified as a mill situated on one of the city's

defensive bulwarks, the Passeerder. It was popularly known by the bluntly expressive name "The Little Stink Mill" because cod liver oil was used there in the processing of leather in order to soften it.[10] Rembrandt balances the mass of elaborately described structures on the left against total openness and infinite distance on the right. In the middle distance two miniscule figures stand on another of the projecting V-shaped bulwarks of earth that made up Amsterdam's defenses.

The Windmill is one of two landscape etchings dated 1641 in which Rembrandt employed his mysterious granular bitten tone to evoke a misty gray atmosphere.[11] Brushy marks are visible in the sky as well as crackle patterns resulting from the cracking of the etching ground or perhaps of the layer of corrosive paste that Rembrandt may have applied to the plate in order to achieve this fine etched tone. As he did with other etchings (see, for example, *The Angel Departing from the Family of Tobias*, no. 134, also 1641) Rembrandt carefully burnished away the gray bitten tone in certain areas, such as the diagonal struts of the mill, in order to create bright highlights.

The *Small Gray Landscape (house and trees beside a pool)* (no. 120) is Rembrandt's only etched landscape miniature. This twilight landscape shows a cottage beside a pond. In the lighted cottage doorway a figure is visible and in the foreground at the water's edge a bent-over figure appears to be doing laundry. Over the dark mass of the trees the sun is setting. It has usually been dated about 1640 perhaps because of its small size and its ret-

118

Landscape with a Cottage and Haybarn, 1641
Etching and drypoint
B. 225, only state
12.7 × 32 cm (5 × 12⅝ in.)
Museum of Fine Arts, Boston
Katherine E. Bullard Fund in memory of Francis Bullard

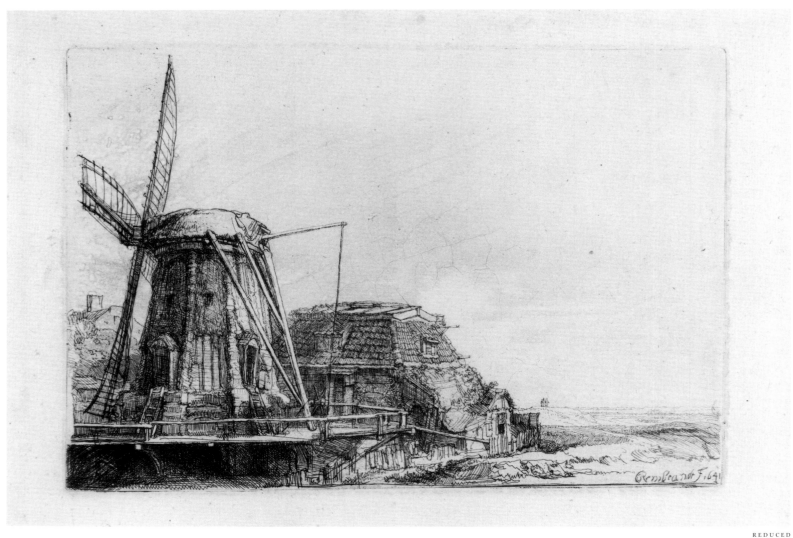

rospective conception of landscape that looks back to the Elsheimer/Goudt style of nocturnal landscape (see the Goudt *Flight into Egypt* after Elsheimer, fig. 70, p. 182) but, as Cynthia Schneider suggests,[12] it also relates stylistically to etchings of the mid-1640s, such as the nocturnal *Rest on the Flight* of 1644 (no. 110), and in mood and conception it resonates with the Dublin painting of the *Rest on the Flight* dated 1647 (no. 112).

While the *Small Gray Landscape* is Rembrandt's smallest landscape etching, *The Landscape with the Three Trees* of 1643 is the largest (no. 121). It can also be designated "The Hundred Guilder Print" among Rembrandt's landscape etchings in that it is an ambitious synthesis of various observations about Nature and humanity's relationship to it. It is the only Rembrandt etched landscape that presents nature as ever changing, as an ongoing process. The intensely dramatic character of the light and shadow in this elaborately worked-out etching is comparable to some of Rembrandt's earlier painted landscapes such as *The Stone Bridge* (Rijksmuseum) from the late 1630s.[13] Both etching and painting take as their subject the native Dutch landscape but transform it through the drama of light and weather. *The Three Trees* is one of three Rembrandt etchings in which the sky is not represented solely by blank paper. The others, the *Small Gray Landscape* (no. 120) and the *Landscape with Trees, Farm Buildings, and a Tower* of about 1650–51 (no. 187) evoke a twilight or sunset mood. The sky in *The Three Trees* occupies almost two-thirds of the image and is the principal source of the sense of dynamism that the landscape conveys. In the upper foreground dark clouds hover and at the left we see the ruler-straight diagonal

119

The Windmill, 1641
Etching
B. 233, only state
14.5 × 20.8 cm (5¹¹⁄₁₆ × 8³⁄₁₆ in.)
Museum of Fine Arts, Boston
Harvey D. Parker Collection

streaks of a passing rain shower.[14] In the distance towering clouds draw up moisture from the earth. The depth of the sky's cloudscape and the alternating bands of cloud-shadow cast over the land contribute greatly to the sense of mobile light and majestic scale. The notion of recording in landscape the passage of time and of nature as ever changing had been eloquently expressed earlier in the landscape paintings of Rubens, with their evanescent rainbows, rainstorms, and simultaneous sunsets and moonrises. The Dutch printmaker Schelte à Bolswert made numerous engravings for Rubens after these paintings.

Though the grand movements of nature are dominant here—the streaming rain and roiling clouds or the wind whipping through the foliage of the stand of trees—one slowly discovers that this is an inhabited or lived-in landscape. In this respect Rembrandt continues the mid-sixteenth century tradition initiated by Pieter Bruegel's painted landscapes and the prints engraved after his drawings in which the landscape teems with varied

human activity. The difference is that, whereas Bruegel and his many followers delineate this bustling human activity with great clarity, Rembrandt half-obscures and conceals the human detail, subordinating it to the larger patterns of nature and allowing us to discover these varied human anecdotes and incidents slowly, over time. In the right foreground a pair of lovers, dimly seen, are concealed in the bushes from all prying eyes save our own, while at left one sees a standing angler and his

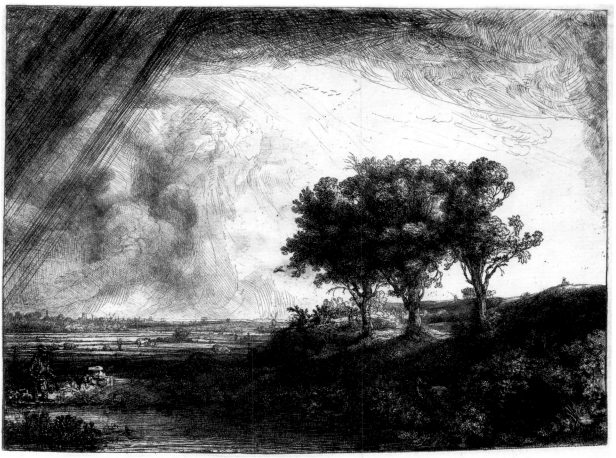

REDUCED

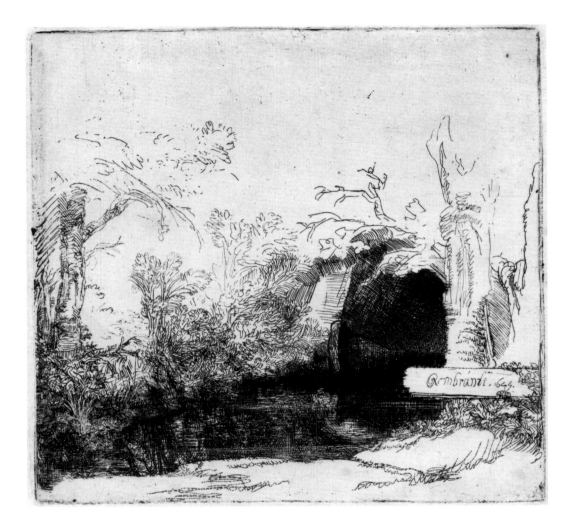

122

The Boat House, 1645
Etching and drypoint
B. 231, I
12.7 × 13.4 cm (5 × 5¼ in.)
The Pierpont Morgan Library,
New York

female companion.[15] Behind the wind-tossed trees, out of which a pheasant flies, we glimpse the roof of a cottage nestled in a dale and above, on the dike, a wagonload of travelers. At the far right the tiny figure of an artist seated on the dike sketches the view beyond the picture's edge. In the middle distance at left cattle attended by herders graze. On the horizon windmills and city buildings are reduced almost to insignificance by the soaring cloudscape.

Complex in conception, the print is also complex in the execution, combining etching, drypoint, and, in the denser passages, most probably engraving. Many of the heavier meshes of deep shadow in the foreground are reminiscent of the velvety web of darkness in the *St. Jerome (in a dark chamber)* of the year before (no. 146), while the somber clouds that frame the top of the composition and the slashes of dark rain at left have been freely scratched in with drypoint. Finer meshes of dry-

point cross-hatching evoke the translucent shadows that model the forms of the rising clouds. A fine granular bitten tone has been applied to the fields in the distance, contributing subtly to the sense of evanescent cloud-shadows moving over the land.

The Boat House etching of 1645 (no. 122) is seen here in its first of three states, the only aesthetically satisfying one. It is an anomaly among Rembrandt's etchings: Rembrandt never etched a title page or frontispiece for a print series, but if he had, it might have looked like this. His signature and the date are prominently displayed on a board at right before the mouth of the boathouse/grotto. The prow of the boat in its shadowy cave and the surface of the dark water are rendered with great density while the surrounding vegetation is sketched in with great freedom and openness. A surprising amount of blank space that does not represent sky is left at the top of the composition. In two further states the boat and its

123

A Clump of Trees with a Drawbridge,
about 1645
Black chalk
Ben. 1256
9.4 × 15.1 cm (3¹¹⁄₁₆ × 5¹⁵⁄₁₆ in.)
Lent by the Trustees of the
British Museum, London

124

*A Clump of Trees in a Fenced
Enclosure,* about 1645
Black chalk
Ben. 1255
9.5 × 15 cm (3¾ × 5⅞ in.)
Lent by the Trustees of the
British Museum, London

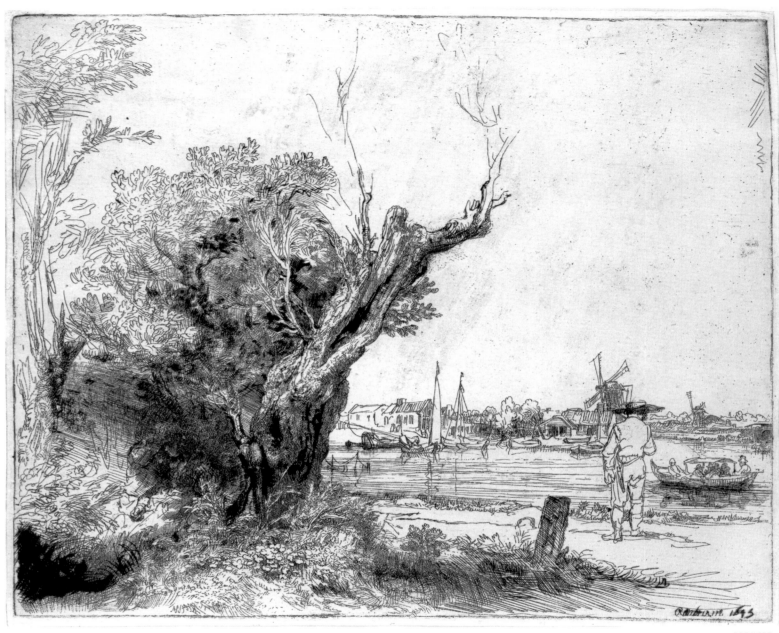

dark cave were reworked. According to the evidence of watermarks, this change occurred during Rembrandt's lifetime (about 1650), but the results are extremely unsatisfactory. Either Rembrandt took on a technical problem that he was unable to successfully deal with or perhaps the plate fell into someone else's hands.

The 1645 *Boat House* etching is closely related in style to a black chalk sketch of upright format representing a canal between bushes and trees (once in Lvov, Ukraine,

now in Wroclaw, Poland).[16] On the basis of comparison with the *Boat House* etching this drawing and a group of some twenty-five related black chalk landscape and urban sketches, which include the two British Museum woodland sketches of horizontal format shown here (nos. 123 and 124), have been dated to the mid-1640s.[17] Many of them, such as the British Museum pair, were most likely once pages in a sketchbook of horizontal format filled with black chalk sketches similar to those used

125

The Omval, 1645
Etching and drypoint
B. 209, I
18.7 × 22.7 cm (7⅜ × 8¹⁵⁄₁₆ in.)
The Art Institute of Chicago
The Clarence Buckingham
Collection

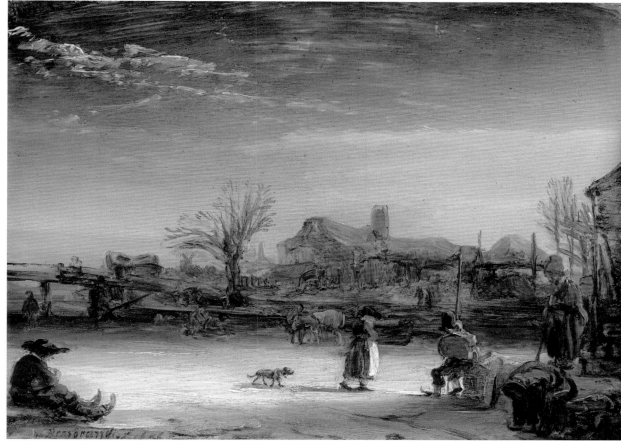

126

Winter Landscape, 1646
Oil on panel
Br. 452
16.6 × 23.4 cm (6⁹/₁₆ × 9³/₁₆ in.)
Staatliche Museen Kassel,
Gemäldegalerie Alte Meister

REDUCED

by the contemporary landscape painter Jan van Goyen (1596–1656). The dense masses of luxuriant springing foliage, as well as hints of farmhouse architecture, are evoked by Rembrandt's rapid chalk strokes with admirable sureness and economy. Here we truly sense Rembrandt making notations directly "from life" that served to prompt his memory when he worked up more finished landscapes in drawing or print in his studio.

Another landscape etching of 1645 *The Omval* (no. 125) is unusual in that it gives more prominence to human activity. Highly original in conception, it is divided into two contrasting spaces: the shadowy enclosed private space of the green bower at the left where a man is crowning his lover with a wreath, and the brighter, open public space on the right where a man standing on the riverside path watches a passing boat filled with passengers seated beneath an awning. The trunk of the gnarled willow is the barrier or mediator between these two spaces, the private and the public. On the left one glimpses a romantic interlude straight out of pastoral

painting and poetry and on the right a realistic slice of contemporary life. The "Omval" is an area named for a spit of land at a bend of the Amstel River outside Amsterdam on which a ruin (*omval* = "fallen down") stood. There was a popular inn nearby and the area had a reputation as a place of recreation and also as a kind of lover's lane.[18] The print is seen here in a wonderfully inky impression of the scarce first state in which the tufts and patches of drypoint burr that enliven and model the foliage and the willow's trunk are particularly strong. In the second state the brim of the hat of the man on the path is shortened a bit on the right and the effect of the burr is diminished.

The small panel painting dated 1646, the *Winter Landscape* (no. 126), is similar in dimensions to Rembrandt's landscape drawings and prints. It is the latest of Rembrandt's seven or eight securely attributed landscape paintings except for the Dublin *Rest on the Flight* painting of the following year (no. 112), and is unique among the landscape paintings in dealing with the native Dutch

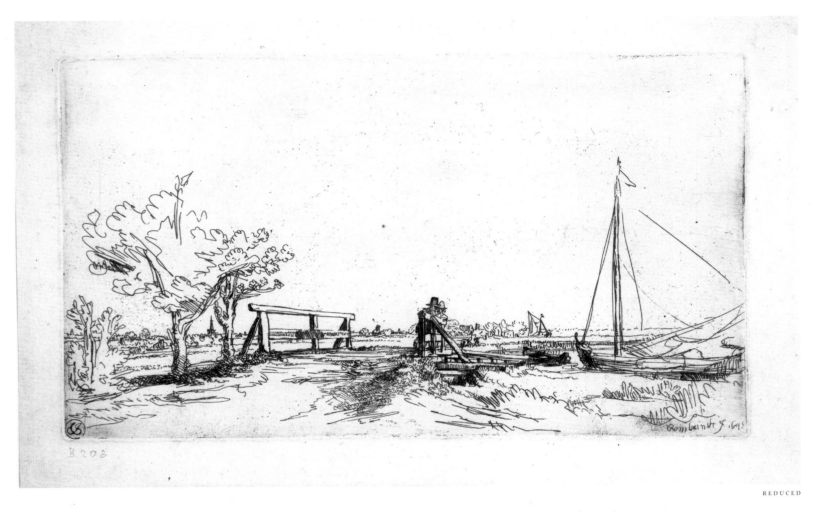

landscape in naturalistic terms.[19] *Winter Landscape* may be one of the four (one unfinished) little landscape paintings "from life" (*naer 't leven*) mentioned in Rembrandt's 1656 insolvency inventory.[20] Given this documentary evidence and the painting's freedom of execution, it has sometimes been suggested that Rembrandt executed it directly from nature. Given the scarcity of documentation for seventeenth-century Dutch painters working out-of-doors and the fact that the painting's conception closely follows that of the earlier winter landscapes painted by Esaias van de Velde (1587–1630), one must remain somewhat skeptical—despite the painting's easily portable size and extreme freshness of execution—about its execution directly before the motif. Rembrandt with his drawn sketches and practiced visual memory must have been perfectly capable of recreating such a feeling of direct, spontaneous execution back in the studio.

Compared to the monochrome sobriety of many winter landscape paintings of the 1640s by contempo-rary Dutch artists, Rembrandt's *Winter Landscape* (no. 126) is relatively bright and colorful. It has the crisp clarity of a sunny winter day. The sky is a luminous steely blue streaked with clouds, and the translucent ice sheet seems to give off light as the sun strikes it. The strong horizontal emphasis resulting from the direction of the brushstrokes in the sky and on the ice are reinforced by the figure of a woman with apron trailed by a dog proceeding in profile from left to right across the ice. There are a number of prominent figures in the scene but little action compared with the hectic festivity of ice-skating scenes by artists such as Hendrik Avercamp from earlier in the century. Many of them have ice skates but are calmly sitting rather than skating. At right a man is bending down to fasten his skates and in the distance a gray horse stands before a sledge, but all is becalmed. In this well-preserved panel the handling of the paint—alternately thick and thin—has a buttery fluidity and a suggestive freedom that parallels Rembrandt's pen and

127

Six's Bridge, 1645
Etching and drypoint
B. 208, III
13 × 22.7 cm (5⅛ × 8¹⁵⁄₁₆ in.)
Museum of Fine Arts, Boston
Gift of Eijk and Rose-Marie van Otterloo in honor of Clifford S. Ackley

128

"Winter Landscape" (*Landscape with a Farmstead*), about 1648–50
Brown ink and brown wash on paper prepared with a light brown wash
Ben. 845
6.7 × 16 cm (2⅝ × 6⁵⁄₁₆ in.)
Courtesy of the Fogg Art Museum, Harvard University Art Museums, Cambridge, Massachusetts
Bequest of Charles A. Loeser

chalk landscape drawings as well as his earlier oil sketches.

In the landscape etching traditionally known since the early eighteenth century as "Six's Bridge" (no. 127) one again has a lively sense of Rembrandt sketching on a copper plate covered with an etching ground in the open air directly before the subject. Gersaint in 1751 recounted a legend connected with the origin of the plate that has tended to reinforce this idea of rapid execution on the spot. He said that Rembrandt often accompanied Jan Six to the country and that he came supplied with plates already covered with etching ground. One day when the time for a meal had been signaled by Six's servant but there was no mustard available for the repast, Rembrandt supposedly bet Six that he could draw the etching on the plate in the time that it took the servant to fetch the mustard from the village. Rembrandt estimated that the errand would take half an hour, and he, of course, won the bet.

Unfortunately for the attractive legend, modern topographical research has confirmed that the bridge was in fact on the property of the then-burgomaster of Amsterdam A. C. Burgh, not on that of the *future* burgomaster Jan Six.[21] But the sense of spontaneous execution in front of the motif remains as vivid as ever. In spite of Rembrandt's rapid execution of this landscape with its bridge over a canal and a distant sailboat that seems to be sailing right through the fields, Rembrandt later made some carefully considered adjustments to the print that can be seen in this beautifully preserved impression of the third and final state. In the first state the hats of the two men leaning on the bridge rail were unshaded. In the second state he added fine shading to one man's hat and in the third, to the other's. These subtle adjustments ensure that the two conversing figures on the bridge provide a focal point for this wonderfully open landscape in which the extensive areas of luminous untouched white paper evoke light and air.

The landscape drawing traditionally known as the "Winter Landscape" (no. 128) epitomizes Rembrandt's tendency to evoke deep atmospheric space and light with a few broken strokes of the pen, light touches of wash, and, above all, the reflective surface of the untouched paper. Rembrandt apparently used a combination of reed pen and quill pen to emphasize the near and the far. The foreground fences are suggested with bold calligraphic strokes of the reed pen that perform their spatial function but also appeal to the modern eye's taste for abstract mark-making. Since Hofstede de Groot's Rembrandt drawing catalogue of 1906 this drawing has often been referred to as a "winter" landscape, but as the trees around the farmhouse seem to have their full foliage it is equally possible that the view is intended to represent a summer's day in the watery polderlands outside of Amsterdam. The current consensus of scholars of Rembrandt drawings is that the drawing should be dated about 1648–50. C S A

NOTES

1. For Rembrandt's predecessors and the sites that he drew, see the introductory essay by Boudewijn Bakker in Bakker et al. 1998, 15–39. This exhibition and catalogue expand on the groundbreaking research about the sites of Rembrandt's landscapes initiated by Lugt 1915 and 1920. The information on the drawings for the landscape entries has been provided by William W. Robinson.

2. The other drawings are Ben. 462, 462a, 795 and 797. For the dating see Carolyn Logan in Liedtke et al. 1995 2: 161–62, 59.

3. Bakker in Bakker et al. 1998, 30.

4. A Rembrandt drawing from a private collection of about 1648–50

shows a draftsman seated on the ground drawing a view of Diemen (reproduced in Bakker et al. 1998, 238).

5. Illustrated in Holl. 38 and 39, nos. 292–317.

6. Partially illustrated in Holl. 3, nos. 324–337. For the Visscher versions, see Holl. 38 and 39, nos. 266–291, partially illustrated.

7. For Jan van de Velde's long landscapes, see Ackley *Printmaking* 1981, 70–72, nos. 42–43.

8. Bakker et al. 1998, 283–84 no. 87, illustrated in black/white and color.

9. Ibid., 284.

10. Bakker et al. 1998, 194–95.

11. The other is B. 228, *Cottages beside a Canal*.

12. Schneider *Landscapes: Drawings and Prints* 1990, 145–46, no. 32.

13. Br. 440. Schneider *Landscapes* 1990, no.1, reproduced in color, plate 6.

14. Some have chosen to read the streaks of rain as bands of shadow. Sudden brief rain showers are, of course, a common occurrence in the Netherlands. Some of the precedents for representing rain in this fashion are the engravings by Schelte à Bolswert after Rubens's landscapes and Jan van de Velde's *Autumn* and month of *February* (Holl. 33 and 34, nos. 32 and 35, illustrated). None of these give the visible streaks of rain the prominence that Rembrandt does.

15. H. Rodney Nevitt, Jr. explores the possible symbolic connection between the concealed lover and the fishing couple, referring to an emblematic tradition in which fishing and lovemaking are equated; see Nevitt 1997.

16. Ben. 817. See Schneider *Landscapes: Drawings and Prints* 1990, 207, no. 58.

17. Ibid.; and Royalton-Kisch 1992, 155–56, nos. 69 and 70.

18. Bakker et al. 1998, 269. See also Nevitt 1997, 170–77.

19. Schneider *Landscapes* 1990, 190–93, no. 7. See also Sutton et al. 1987, 429–432, no. 77.

20. *Docs.* 1979, 1656/12, 68, 69, 291, and 304.

21. White and Boon 1969, 101, no. 208.

129–130

The Raising of Lazarus

1642

In the evangelist John's account of Jesus' miraculous raising of his friend Lazarus from the dead (John 11:1–44), Christ explains to Lazarus's sister, Martha, the broader significance of the miracle before he performs it: through belief in him, the son of God, one shall achieve salvation and eternal life. He says, "I am the resurrection, and the life: he that believeth in me, though he were dead, yet shall he live," and, "whosoever liveth and believeth in

129
The Raising of Lazarus, 1642
Etching and drypoint
B. 72, I
15 × 11.5 cm (5⅞ × 4½ in.)
Museum of Fine Arts, Boston
Katherine E. Bullard Fund in
memory of Francis Bullard

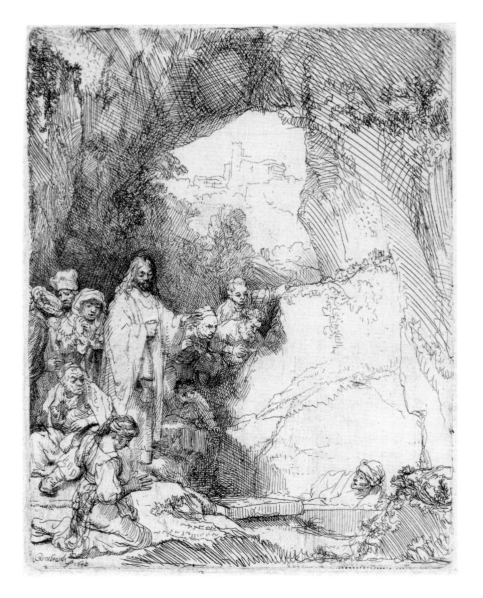

me shall never die." John tells us that Jesus loved Mary, Martha, and their brother Lazarus, followers of Christ residing in Bethany near Jerusalem, and that he wept for Lazarus. Christ's resurrection of Lazarus from the dead was one of his most dramatic miracles and we are told that many witnesses to the event were converted to belief in him. It was also one of Jesus' public acts that most seriously alarmed the reigning religious authorities and led to Christ's subsequent arrest, trial, and crucifixion.

Rembrandt had illustrated the miracle in a painting of about 1630–31 (Los Angeles County Museum of Art) and in a related large, highly finished etching (about 1632), which he had labored over and taken through many states.[1] Both of these interpretations of the story involved a dark cavelike tomb and highly melodramatic gestures, with Christ's arm raised in command as he cries out "Lazarus, come forth." Rembrandt's conception of the subject in his small etching of 1642 is much simpler (no. 129). He locates the miracle out of doors in a landscape flooded with daylight. John's text tells us regarding the grave only that "It was a cave, and a stone lay upon it."[2] Here the stone slab has been moved aside. Rembrandt's understated 1642 interpretation of the subject seems to suggest that for Christ all things are simple, that a miracle is just another everyday event. Christ's gestures and those of the spectators, Mary and Martha and their comforters, are extremely restrained. Lazarus opens his eyes and his mouth gapes with surprise, a wholly different effect from the eerie corpse magnetically drawn upward by Christ's gesture in the earlier painting and print.

The emphasis on landscape, albeit highly imaginary and grottolike, is not surprising because Rembrandt's first dated landscape prints had been etched in the previous year, 1641 (see nos. 118, 119). The blank white paper of the large rockface behind the diminutive figure of the resurrected man effectively suggests Lazarus's return to the radiant light of day and enables us to better focus on his head and shoulders still wrapped in their grave clothes. The light tonality and delicate line of the etching relate it to other religious etchings of 1640–42 such as the 1641 *Baptism of the Eunuch* (no. 107). The underplaying of a dramatic episode from Christ's life and its treatment as an everyday event reminds one of certain Rembrandt Passion etchings from the first half of the 1640s, the sketchlike *Descent from the Cross* (1642, no. 42) and *Christ Carried to the Tomb* (no. 45).

The well-preserved copper plate of the Lazarus print (no. 130) is one of the simply etched linear plates that suffered less from reworking in the workshops of later publishers, who acquired the plates following Rem-

brandt's bankruptcy and death, than did more complicated, heavily worked plates. This early impression of the first state has a fool's cap watermark datable to about 1643 but this plate continued to produce clear, if less subtle impressions for a long time. Erik Hinterding in his research on plates and watermarks has estimated that at least 150 Rembrandt plates were in circulation in the late seventeenth century after they had left Rembrandt's hands.[3] Eighty-one survive today. CSA

NOTES

1. The painting in the Los Angeles County Museum of Art is Br. 538, Corpus A30; the etching is B. 73.

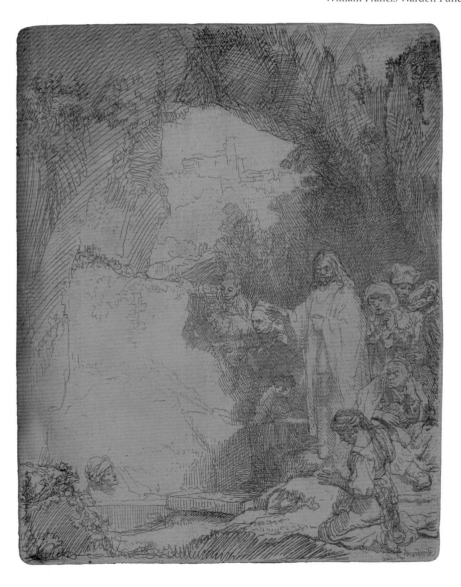

130

The Raising of Lazarus, 1642
Copper etching plate
B. 72
15 × 11.5 cm (5⅞ × 4½ in.)
Museum of Fine Arts, Boston
William Francis Warden Fund

2. Lucas van Leyden, in an ambitious engraving of 1508, had also staged the miracle out of doors in a landscape setting; see New Holl. *Lucas van Leyden*, no. 42.

3. Hinterding *Copperplates* 1995, 8.

131–134

Tobit and Tobias

1640S AND 1650S

This "tale of magic and miracles" is to be found in one of the apocryphal books of the Old Testament, the Book of Tobit (Tobit 2–12). The complicated narrative of Tobit and his son Tobias—the story of a son's loyalty and of blindness healed—was an extremely popular one with Rembrandt and his pupils.[1] Tobit was a pious Jew living in exile in Nineveh, he and his family having been carried off by the invading Assyrians. Tobit had suffered the affliction of being blinded by birdlime that fell into his eyes while he was sleeping. Far away in Ecbatana, Tobit's cousin Raguel also had a problem: a curse. His daughter Sara had attempted marriage seven times but each marriage had been thwarted because a demon, Asmodeus, had slain the bridegrooms before they could lie with Sara and consummate the marriage. God answered the prayers of both men by sending to their aid the angel Raphael disguised as an ordinary man. When Tobit, in despair and preparing for death, sent his son Tobias to

131
Tobias and the Angel Taking Leave of Raguel, early 1650s
Brown ink, touched with white watercolor
Ben. 871
19.4 × 27.3 cm (7⅝ × 10¾ in.)
Rijksmuseum, Amsterdam

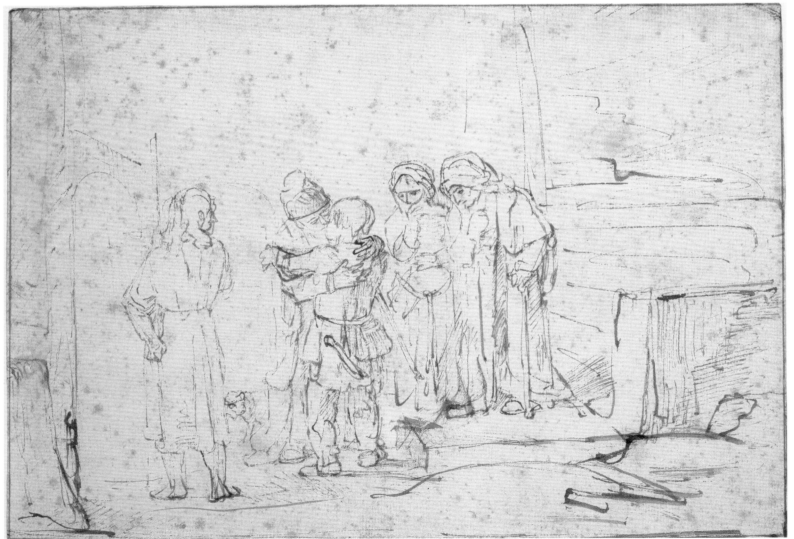

REDUCED

collect a debt he was owed, he hired a man—who was really the incognito angel Raphael—to accompany Tobias and his dog on the journey. At the river Tigris a large fish attacked Tobias while he was washing. Raphael instructed Tobias to catch the fish and to remove its heart, liver, and gall and to preserve them because of their magical properties. Later, their journey brought them to Raguel's house in Ecbatana where Raphael made a match between Tobias and Sara, instructing Tobias to take the precaution of purifying the marriage chamber by burning the fish's heart and liver. The reek of the smoke from the fish's organs drove away the demon Asmodeus and Tobias and Sara were safely united in the marriage bed. When Tobias and his new wife made preparations to return to Nineveh, the grateful Raguel gave Tobias half of his earthly goods. Upon their arrival in Nineveh, the angel instructed Tobias to anoint Tobit's blind eyes with the gall of the fish. The whiteness that had obscured Tobit's sight fell away and Tobit regained his sight. Deeply grateful for these miracles, father and son attempted to repay Raphael with a generous portion of the goods that Tobias had brought with him. The angel refused the gift and finally revealed his true identity, causing Tobit and Tobias to fall on their faces in awe and fear. Informing them that it was the Almighty they must thank and praise, Raphael disappeared.

Tobias and the Angel Taking Leave of Raguel (no. 131), a drawing datable in style to the early 1650s, illustrates a seldom-depicted episode from the Tobit-Tobias story: Tobias with his wife Sara, saying goodbye to his new in-laws.[2] Drawn lightly, often with a dry pen, this fully worked-out biblical composition drawing emphasizes delicate suggestion and nuance rather than bold contrasts. There is a gentle but continuous chain of interlocking movement as the viewer's eye descends the staircase at right, pauses on the landing with the veiled Sara and her elderly mother Edna, takes in the pivotal group of Raguel and Tobias embracing, and proceeds with dog and angel to the open door. All participants turn toward the drawing's emotional center, the warm embrace of Raguel and Tobias, the new father and the new son. Here in the Amsterdam drawing the angel, still incognito, is properly shown as wingless in accordance with the text. In the visual tradition, the angel Raphael was usually shown as winged at all stages of the narrative.

The 1651 etching which shows the blind Tobit shuffling to the door to greet his returning son (no. 132) is one of the most original inventions among Rembrandt's etched biblical narratives as well as—at first glance—one of the simplest. The print is executed in the pure, economical linear vocabulary that characterizes

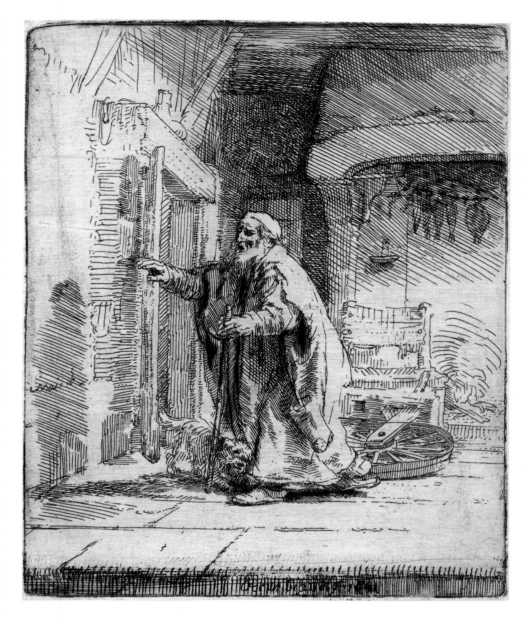

Rembrandt's etching style of the 1650s. He replaces elaborate description with shorthand suggestion: regular parallel shading strokes, impressionistic broken contours, and dotted lines. The idea of showing Tobit completely alone, isolated by his blindness, is Rembrandt's dramatic addition to the visual tradition of the Tobit-Tobias story. Tobit's isolation is comparable to that of the repentant King David kneeling in prayer in the Rembrandt etching of 1652 (no. 160), but for the latter subject there was a strong visual tradition of depicting David alone with his guilty conscience. Rembrandt had

132
The Blindness of Tobit, 1651
Etching and drypoint
B. 42, I
16.1 × 12.9 cm (6⁵⁄₁₆ × 5¹⁄₁₆ in.)
Rijksmuseum, Amsterdam

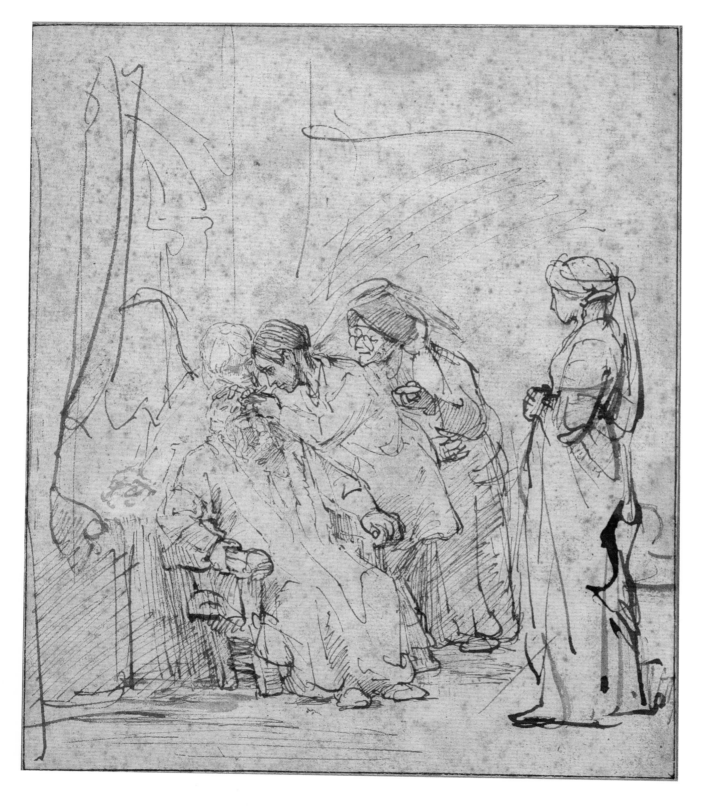

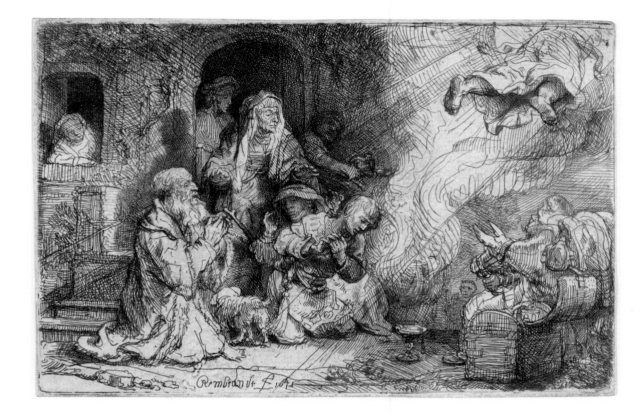

134

The Angel Departing from the Family of Tobias, 1641
Etching and drypoint
B. 43, I
10.3 × 15.4 cm (4¹/₁₆ × 6¹/₁₆ in.)
Museum of Fine Arts, Boston
Katherine E. Bullard Fund in
memory of Francis Bullard

already attempted the subject of the blind Tobit in a small, roughly sketched etching of about 1629 that is primarily known in impressions reworked by another hand.[3] There the image consists primarily of Tobit and the open door. Here the large chair by the hearth suggests that Tobit had been seated by the warmth of the fire, as we see him, for example, in Rembrandt's early painting of 1626 of Tobit and his wife Anna in the Rijksmuseum.[4] In his excitement and clumsy haste to reach the door he has knocked over the spinning wheel with which Anna has sought to earn their living since he was struck blind. He feels his way with cane and extended groping hand. His shadow, projected onto the wall by the firelight, underlines just how far he has strayed from his goal of the open door. In certain versions of the text Tobias's little dog rushes ahead to greet Tobit.[5] Here he seems also to be attempting—like a seeing-eye dog—to steer the blind man in the direction of the door. The fish drying on a line in the fireplace may very well be an oblique visual allusion to the magical healing properties of the fish gall that Raphael and Tobias are bringing. In the early impression of the print shown here a few touches of drypoint burr still visible

in the folds of Tobit's garments lend a subtly heightened sense of sculptural presence to his figure.

The Cleveland pen drawing of *Tobias Healing His Father's Blindness* (no. 133) has been variously dated from the late 1630s to 1645.[6] Executed in a bold calligraphic manner but with a firm sense of spatial construction, it portrays Tobias as a kind of ophthalmologist armed with a scalpel-like tool. He is seen in the very act of alleviating or removing the white film that masks his father's sight.[7] He lifts his father's left eyelid and concentrates his sharply defined profile on the delicate operation with birdlike attention. Tobit presents his upturned face to his son trustingly, but his hands clutch the arms of the chair in anticipation of pain. The chair itself is drawn as if leaning back, emphasizing Tobit's tensed posture. Anna assists her son: holding the dish with the magic fish gall, she looks over his shoulder, peering with avid curiosity through her spectacles. The angel, whose wings symbolically embrace the group, concentrates his glance on Tobias as if to fortify and encourage him. At right Sara as witness clasps her hands in concern and serves as a firmly drawn pillar that helps to define the space of the room. To tone down the effect of Raphael's head and

right arm—possibly in order to make the angel appear more immaterial and otherworldly—Rembrandt applied in those areas opaque white watercolor that has become more transparent over time.

Rembrandt's etching of 1641 (no. 134) makes visible what Tobit and Tobias in the apocryphal text did not see: the newly revealed angel Raphael levitating to God through roiling clouds in a burst of divine light. Ironically, what most viewers of the etching remember about this moment of spiritual revelation is the all-too-material feet of the angel disappearing into the tunnel of light. The apocryphal text mentions only Tobit and Tobias as being present. They did not observe the angel's departure because they had prostrated themselves out of fear. In Rembrandt's 1636 painting of the same subject in Paris Tobit looks at the ground and Anna averts her eyes while the younger couple, awe-struck, observe the angel's flight.[8] Here, in the etching of 1641 it is precisely the other way around: Tobias reverently bows his head and Sara looks away, while the elderly Tobit sees with his newly restored sight and Anna reacts to the miraculous event by dropping her fork-handled cane. Additional witnesses have been added, such as the startled servant to Anna's right who has lost his grip on the elaborate pitcher and tray that he was carrying. Tobias's little dog, however, turns away from the action as if the excitement has passed and it can now return to its home in peace.

In characteristic fashion Rembrandt has alluded in this single image to other moments or aspects of the story. At the far right we see an open trunk filled with treasure and a donkey driver leaning back against his pack animal. These details are clear references to the recent journey of the newlyweds and to the valuable goods that Raguel had given Tobias, a portion of which the grateful Tobit and Tobias had in turn offered as payment to Raphael. The ornate footed cup seen in isolation below the angel's cloud may be part of this treasure or it may represent the cup containing the magical fish gall that healed Tobit's blindness.

This impression of the first state (before Rembrandt added fine touches of shading in the second and final state) captures all the subtle nuances of the light and shadow playing over the earthbound participants. These include passages of fine etched granular tone that resembles a light gray wash. In certain areas this bitten tone has been meticulously and delicately scraped and burnished away to create bright highlights—for example on Anna's wimplelike head scarf and the head of her cane.

CSA

NOTES

1. See Held 1964.

2. Schatborn 1985, 90–91, no. 41, discusses the history of the identification of the subject.

3. B. 153.

4. Br. 486. Corpus A3.

5. See Van der Coelen 1996, 140–41, no. 49.

6. See Peter Schatborn in Master and Workshop: Drawings and Etchings 1991 2:70–72, no. 18; and Sabine M. Kretzschmar in De Grazia and Foster 2000, 166.

7. For the medical-historical details, see Sabine M. Kretzschmar in De Grazia and Foster 2000, 166, and note 4.

8. Br. 503, Corpus A121.

135–137
Christ's Ministry
1640S AND 1650S

Two of Rembrandt's most celebrated etchings represent Christ preaching. Summations of Christ's ministry on earth, they are original inventions on Rembrandt's part and not part of an existing visual tradition. The *Christ Preaching* of about 1648 (no. 135), popularly known since the seventeenth century as "The Hundred Guilder Print," is one of Rembrandt's best-known images in any medium. It is a self-conscious masterpiece, a "just-try-to-surpass-this" challenge thrown down to his contemporaries and to future generations of artists. It falls into the same category as such legendarily ambitious and virtuoso artistic statements in print as Albrecht Dürer's *Master Prints* (the trio of engravings *Saint Jerome in His Study*; *Knight, Death, and the Devil*; and the *Melancholia*) in the early sixteenth century, or, in our time, Pablo Picasso's *Minotauromachia*. A symphonic orchestration of various aspects of Christ's ministry, Rembrandt's etching fluidly interweaves passages of varying degrees of finish and unfinish and broad areas of light and shadow. The Italian Abbot Filippo Baldinucci, in his historical treatise on engraving and etching published in 1686, characterized the range and variety of finish so distinctive—and sometimes puzzling—to seventeenth-century eyes in such a Rembrandt print: "He covered parts of his plate with intense blacks and in other places he permitted the white of the paper to play..."[1] The etching is unsigned and undated, but perhaps Rembrandt deemed no signature necessary, assuming that viewers would realize that only one artist could be capable of such a distinctive feat of literary and visual invention.

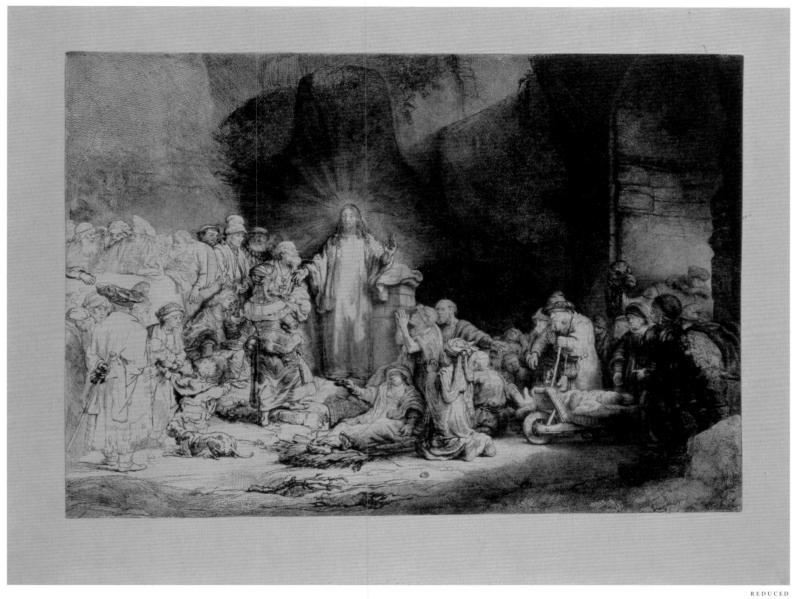

Christ is elevated above the throng of supplicants and questioners, a kind of lighthouse or beacon radiating illumination. The mysterious shadowy promontory that looms behind him serves to further magnify his position as the focus of the multitude's attention. His facial features and halo are drawn without firm contours, made up of loosely associated touches of drypoint that give them a shimmering mobility and indefiniteness, allowing each viewer to discover there his or her own image of Christ's nature. The print illustrates in visual terms various aspects of Christ's teaching as related in the nineteenth chapter of the Gospel of Matthew. At right a crowd

of the sick, crippled, and elderly implore Christ's help: "And great multitudes followed him; and he healed them there" (Matthew 19:2). At the far left are the religious authorities, the Pharisees who engaged Christ in a debate on divorce (Matthew 19:3–12). Two mothers advance from the left, bringing their children to be blessed. Christ's apostle Peter tries to hold them back, but Christ reproves him, declaring, "of such is the kingdom of heaven" (Matthew 19:13–15). Between the two mothers we glimpse a seated, pondering figure who is very likely the rich young man who sought eternal life, but who went away troubled when Christ advised him

135

Christ Preaching ("The Hundred Guilder Print"), about 1648
Etching, drypoint, and engraving on Japanese paper
B. 74, I
27.8 × 38.8 cm (10^{15}/$_{16}$ × 15^{1}/$_{4}$ in.)
Rijksmuseum, Amsterdam

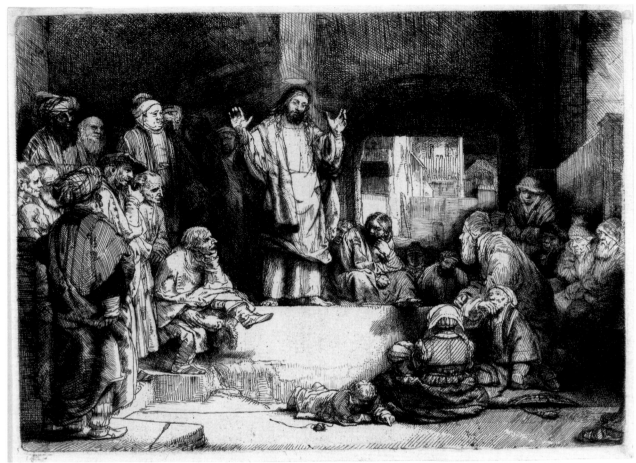

136

Christ Preaching ("La Petite
Tombe"), about 1652
Etching and drypoint
B. 67, only state
15.4 × 20.6 cm (6¹/₁₆ × 8¹/₈ cm)
Museum of Fine Arts, Boston
Gift of William Norton Bullard

REDUCED

to sell all he owned and give the proceeds to the poor.
The camel in the gateway at far right may possibly allude
visually to Christ's statement that it is easier for a camel
to pass through the eye of a needle than for a rich man
to enter heaven (Matthew 19:16–24). The nineteenth
chapter of Matthew closes with Christ's parable-like
statement that in the scheme of eternal salvation, "many
that are first shall be last; and the last shall be first." It is
worth noting in this context that in Rembrandt's picto-
rial sermon the humble, the poor and the afflicted are
often more carefully defined, weightier, and visually
more dominant than the rich and powerful.

The intricate interplay of luminosity and deep but
semitransparent shadow that characterizes the print—a
complex mix of etching, drypoint, and engraving—is per-
haps best symbolized by the shadow play visible on
Christ's robe. To the right and below him an old woman
raises her hands in a prayerful, beseeching gesture. The
transparent shadows of her imploring hands and of her

profile are literally and symbolically projected by the
light onto the bright screen of his robe.

Given its ambitious scope and complexity, analogous
in its baroque pictorial organization to Rembrandt's
celebrated painting of the civic guard of 1642, the *Night
Watch*, it is not surprising that it has frequently been sug-
gested that the etching was executed over a period of
several years, even as long as a decade. There are an
unusually large number of preparatory drawings for the
etching, not just for individual figures but for groups of
figures as well.[2] The traces of earlier work, of Rem-
brandt's changes of mind are clearly visible on the plate.
See, for example, the contours above Christ's head that
indicate that he was originally conceived as taller or indi-
cations that his raised left hand was originally lowered
(the sketchy outlines of its former position are still visi-
ble at waist level on the right side of his robe). Howev-
er, recent watermark research indicates that early
impressions of the completed second state were printed

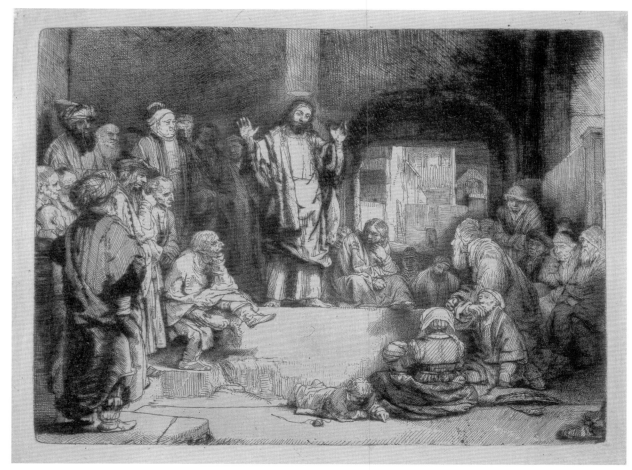

137

Christ Preaching ("La Petite
Tombe"), about 1652
Etching and drypoint on
Japanese paper
B. 67, only state
15.4 × 20.5 cm (6¹/₁₆ × 8¹/₁₆ in.)
Museum of Fine Arts, Boston
Harvey D. Parker Collection

REDUCED

in 1648.³ The related drawings are not inconsistent in style with a dating in the late forties. It is therefore quite possible that Rembrandt's work on the composition and the plate was concentrated in those years rather than extended over a longer period.

The etching is seen here in an impression of the rare first state known in only nine impressions, all printed on golden Japanese paper. In the completed second state additional shading was added to the deep shadows of the background and parallel shading to the neck of the ass at the far right. The first state shows strong drypoint burr on many lines that are relatively free of burr in the second state. The result is that the space of the composition reads rather differently. In the first state there is a stronger sense of a circular flow of space in the foreground between the figure of Christ and the broken branch lying on the ground, as opposed to the greater emphasis on the rising and falling frieze of figures in the middle ground that tends to characterize impressions of

the second state. The contrast between the heavily worked "finished" passages at the right and those defined primarily in outline at the left is also somewhat less in the first state than in the second state. Some of these outline figures consequently take on a more sculptural presence in the first state. It seems likely that Rembrandt intentionally removed some of this burr when developing the second state. As in the many early impressions of the second state printed on silky, warm-toned Japanese paper, the Japanese paper of this first state impression (with unusually generous untrimmed margins) lends a painterly unity of tone and a muted glow of light to the scene as a whole.

The popular nickname by which the etching is commonly known, "The Hundred Guilder Print," seems an ironically materialistic one when associated with such a spiritual subject. It is first mentioned in print with this title by Arnold Houbraken in 1718, but we now know that it was already mentioned in a letter of 1654

addressed to a Flemish bishop as having sold for *over* one hundred guilders (the writer, who admired the print, nevertheless suggested that *thirty* guilders would have been a fairer price!).[4]

The image on this complex and subtle plate rapidly deteriorated in quality, but experienced a kind of abortive resurrection in the eighteenth century when the Boston-born painter John Greenwood sold the seriously worn plate to Captain William Baillie, a London art dealer and amateur printmaker passionately devoted to Rembrandt's work. Baillie faithfully but clumsily reworked the entire plate and about 1775 printed an edition of one hundred impressions. He subsequently cut the plate into four pieces and printed impressions of these out-takes on varied papers, including Japanese papers.[5]

If "The Hundred Guilder Print" consists of a slow dance of swirling movement around the pivotal figure of Christ, the "Light of the World," the smaller, simpler and more tightly organized etching and drypoint of *Christ Preaching* of about 1652 (nos. 136, 137) is all about stillness and fixity.[6] The listeners of varied ages are rapt, totally attentive to Christ's message, with the notable exception of the little child lying on its belly in the foreground—its top neglected—totally engrossed in drawing with its finger in the soil, or the seated old man at right who, eyes closed, appears to be asleep. Christ, though standing on a raised platform, is in closer touch with the crowd than in "The Hundred Guilder Print." A vertical pilaster precisely aligned with his head gives him greater prominence and subtly suggests either (in conjunction with his disklike halo) a descending beam of divine light or, when seen together with his raised hands, the upright of a cross.

As with a number of Rembrandt's other etched religious narratives of the 1650s there is an overall effect of calm, of each element locked firmly into place. When we look through the gateway at right we discover a relatively shallow space rather than a deeply illusionistic one. The view visible through the archway is a nearly abstract geometric composition that serves as an emblem of the architectural rigor that pervades the whole composition. The space that the listeners occupy is, as so often with Rembrandt, more complicated than it first appears, with projections and hollows that conform to or accommodate the figures of individual spectators. The mother seated on the ground holding a baby, in the foreground, for example, is actually seated on a ledge with her legs dangling down into a declivity. Or, the seated man to the left of Christ's platform, plumed cap in hand, has a little step provided to support his foot. While the spectators

are not so sharply differentiated as to type as they are in some earlier Rembrandt narrative compositions, they are artfully varied in tonality. At the left, for example, the round blank white face of a clean-shaven man is contrasted with a swarthy bearded man standing to his left. An eccentric detail is that of the sandaled feet cut off by the lower right edge of the plate, implying that the audience extends well beyond the framing rectangle.

This etching, which has only one state and which in early impressions involves a dialogue between clean etched lines and velvety drypoint lines fringed with rich burr, is seen here in two equally fine impressions, one on white European paper and one on a dark tan Japanese paper. Which impression one prefers is entirely a matter of taste: the white paper impression with its clearly defined forms has a more sculptural, architectural impact, while in the Japanese paper impression the forms appear softer, more fluid and painterly with a warm, almost twilight glow about the scene as a whole. The Japanese paper is less absorbent and the extra ink retained by the drypoint burr bleeds across the surface, producing washlike patches of tone (see, for example, the deep folds in Christ's robe). For those who wish to savor the qualities of the later Rembrandt's experiments with inking, printing, and choice of papers, it is not really a question of preferring one impression over the other but rather of enjoying the comparison, of appreciating Rembrandt's involvement in the creative process and his range of choices. CSA

NOTES

1. Baldinucci 1686, 1: 197–98, as paraphrased in Slive 1953, 105–6.

2. See Royalton-Kisch in Amsterdam/London 2000, 253–58, no. 61 (with reproductions of drawings).

3. Hinterding diss. 2001, 114–19.

4. Royalton-Kisch in Amsterdam/London 2000, 255–58 and note 3.

5. For the history of the plates, see Stampfle et al. 1969, 28–41, no. IV.

6. Gersaint's 1751 title for the print, *La Petite Tombe*, has caused a bit of confusion, having been occasionally misunderstood as "the little tomb" on which Christ supposedly stands, or as "the little one falls down" (the child in the foreground). The title goes back to Clement de Jonghe's inventory, in which it is listed as the *Latombisch plaatjen* (La Tombe's little plate), referring to a member of the La Tombe family who may have commissioned it. See Martin Royalton-Kisch in Amsterdam/London 2000, 281, and notes 5 and 6.

138
Medea and Book Illustration

On October 24, 1647, Jan Six's *Medea* premiered at Amsterdam's foremost theater. The play was an adaptation of the Greek tragedy written in Dutch verse. Six was a rich young literary dilettante who worked in his family's textile dyeing business. He appears to have celebrated his own artistic success by commissioning two prints from Rembrandt. One of these was a virtuoso portrait of Six (1647; no. 74).[1] The other, a summation of Six's tragic drama, appeared as a frontispiece for the anonymous publication (by Six) of the poem the following year (no. 138). This book was one of only three for which Rembrandt's etched plates served as illustrations. Prior to the print's inclusion in the book, however, Rembrandt printed a quantity of loose impressions on special paper, such as this one of the first state on Japanese paper. Six may have used these prints as gifts to his artistically and intellectually inclined peers.

A princess from the eastern shores of the Black Sea, Medea was also one of the few sorceresses in classical mythology. When the handsome hero Jason came to her father's kingdom in quest of the Golden Fleece, she fell madly in love with him and used her magic to help him perform heroic feats, even at the expense of her own family. Together they sailed back to the Greek kingdom of Iolchus, where she tricked the daughters of the usurper of Jason's royal birthright into murdering their own father. Jason was so grateful for Medea's magical powers that he married her, and together they had two children. But soon, Jason's ambition to expand his domain led him to agree to marry Creusa, the daughter of Creon, the king of Corinth. Learning of his plan, Medea protested his ingratitude and infidelity. Her audacity resulted in a sentence of banishment, a terrible fate for a woman who had severed her family ties. In revenge she plotted to ruin the wedding festivities by poisoning Jason's bride and murdering his—and her own—children. This moment is the one Rembrandt chose to illustrate in order to convey the essence of the story.

In the print, the wedding takes place in a grand hall, its high arches and enormous windows looking much more like a Dutch church than an ancient Greek temple. Jason and the elaborately crowned Creusa kneel before an altar, hands joined. Adorned with symbols of power— crowned turban, ermine cape, train, and scepter—Creon looks on. Among the many court attendants are a trumpeter and a harpist. With a ceremonial staff and tall head-

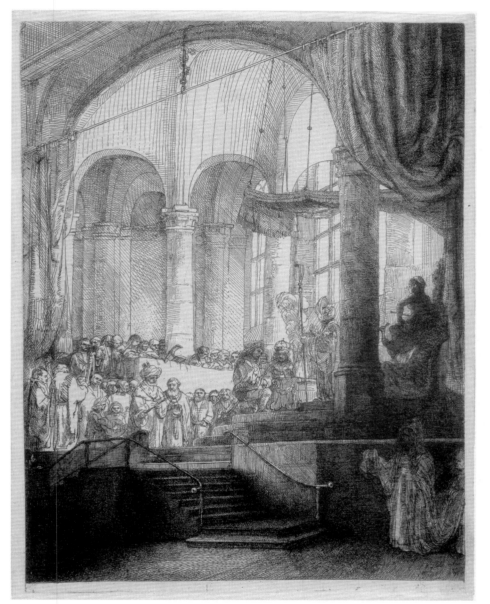

REDUCED

gear, a priest administers the vows. Presiding over the whole affair, the goddess Juno—or her effigy—sits on a high, feather-backed peacock throne. Below, in the foreground, Medea cocks her head, listening to the music of the wedding ceremony. In her left hand is the dagger that will pierce her children's flesh. Her right hand is raised and carries the covered container of lethal poison that will bring about Creusa's death.

Six did not include the wedding in his play. Rembrandt's print is sometimes regarded as an illustration of

138

Medea, or *The Marriage of Jason and Creusa,* about 1648
Etching and drypoint on Japanese paper
B. 112, I
23.9 × 17.8 cm (9⁷/₁₆ × 7 in.)
Museum of Fine Arts, Boston
Harvey D. Parker Collection

an otherwise unrecorded tableau vivant staged between the second and third acts, but this is highly speculative and fails to recognize Rembrandt's creative originality.[2] Not only did Rembrandt invent the wedding scene, but he also found a way to have Medea on stage during the ceremony even though she was, strictly speaking, not in attendance. He took pains to show us that she does not see the ceremony but instead hears the celebration from outside the inner precincts of the temple. He placed Medea down two flights of stairs, around a corner, behind a massive column, and, for good measure, he plunged her symbolically into darkness.

Rembrandt's performance is remarkably disciplined. The rational, systematic draftsmanship reveals space and detail with elegant precision. The varying densities of line create broad zones of light and dark, symbolizing the soon-to-be-inverted fortunes of the players. The great curtains drawn back to reveal the ceremony inform us that Rembrandt presents us with an imaginary performance of a play rather than a depiction of events set in antiquity. The composition emphatically separates the jilted spouse from the festivities and literally aligns her with the notoriously jealous and vengeful Juno, wife of the notoriously unfaithful Jupiter.[3] This telling arrangement can only occur because Rembrandt has firmly established our viewpoint, an option unavailable in live stage performance.

Even before focusing on the complex image, recipients of first state impressions would have regarded it with great curiosity, for more often than not Rembrandt printed them on Japanese paper. This exotic paper had only recently arrived in Amsterdam. Though it would eventually become a hallmark of Rembrandt's later printmaking, he first used it in 1647. The date of *Medea* is open to discussion. In the fourth state, the version that appeared in Six's book, the plate is dated 1648, but given that impressions of the first state still exist in substantial numbers, it is quite possible that they were printed in 1647, perhaps even before the play premiered.[4] Rembrandt may have wished to ensure that his new paper would be seen by appreciative eyes, for he introduced it in prints—the portrait of Six, the portrait of the painter Jan Asselyn (no. 87), and, *Medea*—all probably intended for circulation in rarefied circles.

Unlike the first state, the fourth state was meant for a broader audience. Rembrandt and Six probably collaborated in preparing the plate for use as a book illustration. Rembrandt lengthened Medea's gown in a way that calls more attention to her and added a crown on Juno's head to underscore her status as the queen of the gods.[5] Six apparently composed the four Dutch verses added by a professional engraver of calligraphic inscriptions at the base of the plate:[6]

> Creusa and Jason here pledge mutual fidelity:
> Medea, Jason's wife, unjustly shoved aside,
> Was incited by spite and driven by vengeance.
> Alas, unfaithfulness, how dearly you cost![7]

The other important addition in the fourth state is Rembrandt's signature and the date. Unlike Japanese paper impressions of the first state, the fourth was printed on conventional white European paper. The success of *Medea* as a frontispiece is confirmed by its reuse in deluxe second-edition copies of the play published in 1679. By this time the lower part of the plate had been cut away, removing both Six's verses and Rembrandt's signature. This change may have been an intentional expurgation of Six's association with Rembrandt after the artist's personal and financial history became inappropriate to the poet's rising social and political ambitions.

The other instances of Rembrandt producing book illustrations come early and late in his printmaking career.[8] In 1633, he made an allegorical etching that appeared in Elias Herckmans's *Der Zee-Vaert Lof*, a verse history of seafaring exploits that extended back to Noah and the Ark (fig. 80, p. 255).[9] Commonly known as *The Ship of Fortune*, the undulating Baroque composition is a complex evocation of Augustus's defeat of Marc Antony.[10] Weary of battle, the victor's horse sinks to the ground. The event ushered in a period of peaceful maritime trade: Fortune—or perhaps the disarmed war Goddess Bellona—sets sail. In making the print, Rembrandt seems to have accommodated himself to the style of Willem Basse, the younger and less celebrated artist responsible for most of the illustrations in the book. Yet, Rembrandt still managed to imprint the image with his own personality, not least by using his own likeness as the basis for the image of Janus—the two-faced god whose temple we see being closed to mark the arrival of peace in Rome.

In 1655, Rembrandt made four small prints for Menassah ben Israel's *Piedra Gloriosa*, a mystical tract on the coming of the Messiah written in Spanish.[11] The two shown here are the dynamic *David and Goliath* and the dreamlike *Daniel's Vision of the Four Beasts* (figs. 72, 73). Characteristic of the 1650s, their economical draftsmanship does away with the ornate embellishments of the 1630s and the refinement of the 1640s in favor of direct, concentrated expressiveness. Menassah was a rabbi, publisher, and diplomat, perhaps best remembered today for his efforts to persuade Cromwell to allow the Jews back into England. Rembrandt may have already etched the rabbi's portrait in 1636.[12] The "Glorious Stone" of the book's title refers to Menassah's interpretation of three

Fig. 72. *David and Goliath*, illustration for *La Piedra Gloriosa*, 1655, etching, engraving, and drypoint, B. 36c, I, 10.6 × 7.4 cm (4 3/16 × 2 15/16 in.), Museum of Fine Arts, Boston, Gift of Mrs. Lydia Tunnard in memory of W. G. Russell Allen.

Fig. 73. *Daniel's Vision of the Four Beasts*, illustration for *La Piedra Gloriosa*, 1655, etching, engraving, and drypoint, B. 36d, III, 10.1 × 7.5 cm (4 × 2 15/16 in.), Museum of Fine Arts, Boston, Gift of Mrs. Lydia Tunnard in memory of W. G. Russell Allen.

stones mentioned in the Bible as symbols of the Messiah. Three of Rembrandt's illustrations pertain to these, one being the stone shot by David to slay Goliath (I Samuel 17:49). Rembrandt cleverly used perspective to accentuate Goliath's seeming advantage over the boy whose sling whirs in a circle described by flicks of the etching needle. The fourth plate illustrates Daniel's dream (Daniel 7), in which "there came one like a son of man," the Messiah himself in Menassah's interpretation. The biblical passage is filled with vivid descriptions of hellish beasts (a lion with eagle's wings), earthly beings (a flesh-eating bear with a bone in its mouth) and heavenly glories ("a thousand thousands" serving "the Ancient of days" [the Lord] dressed in white raiment and seated upon a throne) that inspired Rembrandt's own miniaturistic vision. Rembrandt etched all four images on a single copper plate. He printed a number of impressions on Japanese paper and vellum before cutting the copper into four separate plates.[13] Apparently Rembrandt's drypoint wore so quickly in the publication that engraved copies were ordered to replace his plates.[14]

A final, abortive illustration project was undertaken late in life, in 1665, when Rembrandt had not made a new print in four years. Publisher Daniel van Gaesbeecq commissioned him to make a portrait frontispiece for a commentary on Hippocrates written by the physician Jan Antonides van der Linden, who had died the previous year. Rembrandt's son Titus conducted the negotiations for the work, promising that his father would make an *engraving* based on a portrait of the doctor painted by Abraham van den Tempel (Mauritshuis, The Hague).[15] Following his familiar old ways, Rembrandt produced instead an etching heavily augmented by drypoint (fig. 74). Clearly unsuitable for printing in quantity, the plate was never used for the book, and so far as we know, Rembrandt never again etched another plate. TER

NOTES

1. In 1655, when Rembrandt was attempting to buy a house, Otto van Kattenburch, acting through the agency of his brother Dirck, agreed to accept in lieu of four hundred guilders a portrait "etched from life, equal in quality to his portrait of Mr. Jan Six." *Docs.* 1979, 1655/8. For more on Van Kattenburch's and Rembrandt's fruitless negotiation, see Crenshaw 2000, 78–82.

2. Leendertz 1923–24, 68–82, argued that Rembrandt's print depicted a tableau. Some shortcomings of his theory are raised by Stephanie Dickey in Dickey 1986, 261–62.

3. I would like to thank Clifford Ackley for this observation.

4. White and Boon 1969, 59, lists fourteen impressions, and at least four more have appeared on the art market since 1988.

5. Writing in the early eighteenth century, Arnold Houbraken accused Rembrandt of arbitrarily manufacturing extra states so that collectors would feel the need to buy variant impressions of a single plate. In

doing so he made specific reference to "the little Juno with and without the crown"; see Münz 1952 2:214.

6. The Boston Public Library owns impressions of *Medea* in the third and fourth states, each printed on large folded sheets of paper suitable for binding in a book. They were acquired from the Six family collection, which still contains similar examples. These proofs suggest that Six was planning to use the plate as a frontispiece while it was in the third state and that he had the inscription added before the book was published.

7. This translation is a slight modification of that in *Docs.* 1979, 1648/8.

8. Another midcareer print, the so-called *Spanish Gypsy* (B. 120) of about 1642, attracts speculation about its intended use as a book illustration, but no actual use or documentary evidence is known; see White and Boon 1969, 63.

9. Herckmans 1634.

10. Ackley *Printmaking* 1981, 135–36.

11. *Docs.* 1979, 1655/1. Van de Waal 1974, 113–32.

12. B. 269.

13. On other occasions he may have made more than one image on a single copper plate, but apart from a dismembered sketch plate (B. 366), this is the only instance in which complete impressions from a single plate bearing multiple images survive intact.

14. Copies of *La Piedra Gloriosa* containing Rembrandt's plates are quite rare. Until recently only four were known; however, a fifth was auctioned in New York in 2002. Despite their small size, the prints were folded vertically to fit into the tiny book. For illustrations of the rather crude engravings that replaced Rembrandt's plates, see Van de Waal 1974, 132.

15. *Docs.* 1979, 1665/5, 1665/6.

Fig. 74. *Jan Antonides van der Linden*, 1665, etching, drypoint, and engraving, B. 264, II, 17.2 × 10.5 cm (6¾ × 4⅛ in.), Rijksmuseum, Amsterdam.

139–140
Beggars at the Door
1632 AND 1648

Vagabonds, beggars, and street people in Rembrandt's time often justified their existence and their requests for money by plying a minor trade or by providing musical entertainment, selling quack medical potions and poisons to control household vermin, or performing on the fiddle or hurdy-gurdy. All these activities are to be found in Johannes van Vliet's 1632 series of ten etched scenes of mendicants, "Giving is our living" (*By't. geeve Bestaet Ons Leeve*).[1] Two Rembrandt etchings made about fifteen years apart provide a dramatic contrast of style and content between the etchings of the early Amsterdam period and the beginning of Rembrandt's later style of etching.

The Rat-Poison Peddler (or *Rat Catcher*, no. 139) of 1632, a popular image that influenced the look of the rat catcher in the series referred to above by Rembrandt's associate Van Vliet, is one of Rembrandt's furthest excursions into the realm of the picturesque, the caricat-

ural and the grotesque.[2] Seen here in the completed third state, it is a veritable essay on the pleasures of picturesque dilapidation: everything is frayed, broken, shaggy or distinctly irregular in profile. Rembrandt makes use of staged biting of the etched lines in order to achieve a sense of deep atmospheric recession. The pale image of the thatched cottage in the distance echoes the more firmly delineated cottage in the foreground where the rat-poison peddler is attempting to make his sale. The rat catcher is a wonderfully grotesque figure, not only in his irregular silhouette but also in the lovingly described details of his costume and equipment. He holds a pole surmounted by a cage from the top of which a live rat peers down at the potential customer. The corpses of other rats hang by their necks from the cage, testimony to the rat exterminator's effectiveness. Another live rat, sleek and seemingly well fed, rides on the rat catcher's shoulder like a pet parrot. The rat catcher has a shaggy fur cloak flung over his other shoulder and an elaborate sword or knife—a theatrical advertisement of his killing prowess?—hangs from a sash. He offers a packet of ratsbane (red arsenic) to the prospective customer, while his dwarfish assistant, who looks expectantly up at the potential customer, holds a box with a sliding lid that presumably contains further packets of poison. The client decisively pushes away the rat catcher's hand with the back of his own while looking away, perhaps overpowered by the reek of the peddler's victims and the rat catcher himself. In the middle distance prowls—a kind of footnote to the scene in the foreground—a scrawny cat, enemy of rats.

In the *Beggars at the Door* etching of 1648 (no. 140) the basic situation—solicitors at a half-open door in which the owner of the house appears—is the same, but everything else has radically changed. We are closer to the principal figures and all picturesque distractions have been eliminated. Most strikingly, the distant view at the right is represented by blank paper, creating a shallower space and giving increased emphasis to the interaction of beggars and householder. The soliciting figures have a new, almost Bruegel-like solidity and sculptural monumentality, not only individually (see the wonderful barrel-like, bullet-headed baby with curled fists tucked into the backpack) but also as a group.

The line work is much more economical and efficient, less involved with lacy elaboration or varied textural description. The shading strokes are more regularized and systematized, often represented by regular bundles of parallel lines, a linear vocabulary partly inspired by classical Italian draftsmanship (Mantegna and Raphael). In this exceptionally early impression, passages of dry-

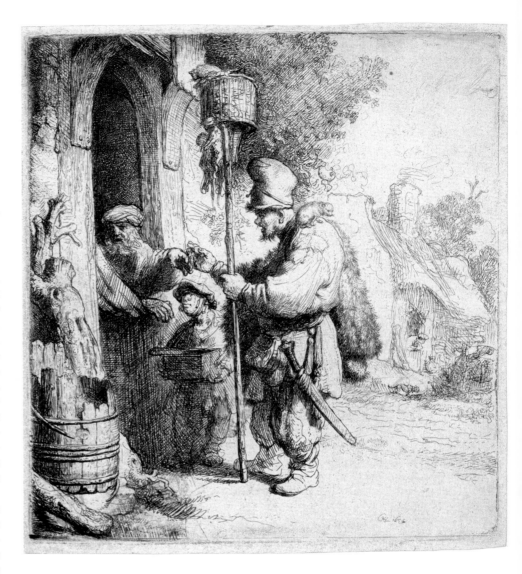

point burr that soon disappeared soften shadows and strengthen the modeling of forms. It is characteristic of Rembrandt's economical later etching style with its deeply bitten lines and clear structure that such plates continued to print quite legibly even after the burr had disappeared.

The beggars here, despite their patches, have a dignity rarely associated with Rembrandt's earlier, more picturesquely tattered beggars. The man of the beggar family, apparently blind, cranks a hurdy-gurdy that is largely concealed by the figure of the boy with his back to us. The latter figure is, as has been noted, a marvel of suggestion in which the body's whole gesture, articulation and firmness of stance is suggested solely through

139
The Rat-Poison Peddler, 1632
Etching and engraving
B. 121, III
14 × 12.5 cm (5½ × 4¹⁵⁄₁₆ in.)
Rijksmuseum, Amsterdam

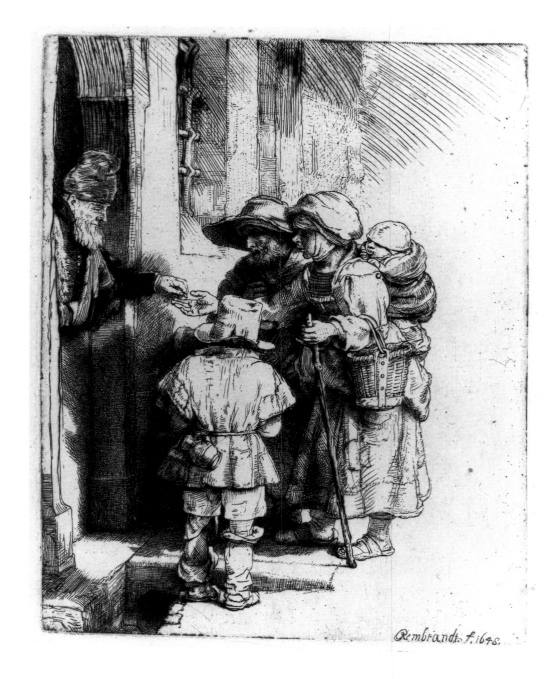

140

Beggars Receiving Alms at the Door of a House, 1648
Etching, drypoint, and engraving
B. 176, I
16.5 × 12.9 cm (6½ × 5⅟₁₆ in.)
The Fitzwilliam Museum, University of Cambridge

the description of the boy's clothing and the way it fits his body: not a hand or facial feature is visible.[3]

As in the rat-catcher etching discussed above, the central event is the transaction between two hands, in this instance the open begging palm of the mother and the alms-giving hand of the benevolent master of the household. The emphasis here is on an act of charity, but charity with clearly defined class divisions: the venerable donor with his velvet cap has his other hand safely tucked away and the thick stone walls and heavy iron grills barring the window, as well as the gutter, clearly underline the social separation between giver and recipients. CSA

NOTES

1. Holl. 41: 73–82.

2. On rat catchers, see Eddy de Jongh on Cornelis Visscher's related but much more dignified engraved rat catcher of 1655 in De Jongh and Luijten 1997, 318–20, no. 66. See also Ger Luijten in Amsterdam/London 2000, 122–25, no. 18.

3. Ger Luijten in Amsterdam/London 2000, 250–53, no. 60.

141–144

Abraham and the Angels

1640S AND 1650S

A small painting, an etching, the copper plate from which the etching was printed, and a drawn copy of an early seventeenth-century Mughal miniature painting shed light on Rembrandt's different creative interpretations of the same Old Testament narrative executed a decade apart. This story of divine visitation and hospitality (Genesis 18:1–15) begins with the ninety-year-old patriarch Abraham seated at the entrance to his tent. He looks up and sees three men. He rushes to greet them and offers them his full hospitality: the washing of their feet, rest in the shade of a tree, a calf slain to provide meat, cakes that he asks his wife Sarah to bake, as well as butter and milk. As the narrative unfolds it becomes evident that one of the mysterious strangers is in fact Jehovah. The Lord asks after Sarah and informs Abraham that the aged Sarah will conceive and give birth to a son (Isaac). The barren Sarah, surprised, laughs out loud at the idea that she should have pleasure in her old age and is reproved by the Lord, who reminds her that with God all things are possible. Frightened, Sarah denies that she had laughed.

Traditionally, the "three men" or divine messengers are represented as winged angels, as in the Lucas van Leyden engraving of about 1513 in which three youthful, scarcely differentiated angels stand close together while Abraham kneels before them in a prayerful attitude.[1] Rembrandt's signed and dated panel painting of 1646 (no. 141) is miniaturistic in scale but executed with a free painterly touch. It has the feel of a finished work rather than of a model for a work to be executed in another medium. Three angels are seated on the ground under a large tree while the kneeling Abraham, holding a bowl and covered pitcher, serves them. A carpet has been spread out for Abraham's distinguished visitors to sit upon. In the right background Sarah eavesdrops from behind the open door of the house. The most original

and surprising aspect of this small painting is that it is conceived as a night scene. The principal angel, the manifestation of God himself, is not only majestically larger than the two angel escorts but is the source of a radiant divine light that illuminates the whole scene. The passages of glowing light on the chief angel's garments also represent the heaviest buildup of pigment on the surface of a painting that is in many areas quite thinly painted (the great tree, for example). The subordinate angels dine while the angel that represents the Lord God gestures authoritatively, announcing the miraculous birth of a son to the old couple.

In Rembrandt's etching of 1656 (no. 142) the guests are again seated on the ground on a carpet, Near Eastern style, but they have been accommodated on the threshold, the porch or terrace, of Abraham and Sarah's house. Abraham, who holds a pitcher, is serving them. He occupies a conspicuously lower position and humbly inclines his head while being addressed by the chief of the visitors. Behind them the thirteen-year-old Ishmael, the child of Abraham and the maidservant Hagar who is soon to be displaced by the birth of Isaac, leans over the parapet to shoot his bow. Ishmael was, of course, to become a skilled bowman and warrior. Within the dark interior, Sarah, smiling to herself, listens behind a half-open door. The most prominent of the three guests, the Lord God himself, is wingless and has a long white beard. He resembles God the Father as portrayed more schematically by Rembrandt the year before in his etched illustration for Daniel's apocalyptic dream in the rabbi Menasseh ben Israel's mystical book (fig. 73, p. 210). He gestures toward his host while holding Abraham's cup of hospitality, imparting the news of the coming miraculous birth. The two angels who accompany God are highly unconventional hybrid creations: a combination of the "men" referred to in the Bible text and traditional angels, they have highly individualized features, heavy beards, receding hairlines, and wings!

The arrangement of the central group and their manner of seating were inspired by Indian miniatures known to or owned by Rembrandt. Rembrandt made drawn copies of a large number of such early seventeenth-century Mughal miniature paintings on paper. Twenty-three of these lively drawn translations, with their fine line and subtly layered washes executed on silky warm-toned Japanese paper, survive. These can be dated to the period 1656–61 and are satisfying works of art in their own right, free copies that ignore the visual stylizations of the originals in order to achieve a more naturalistic rendering of figure and costume. They usually concentrate selectively on the figures, dropping out

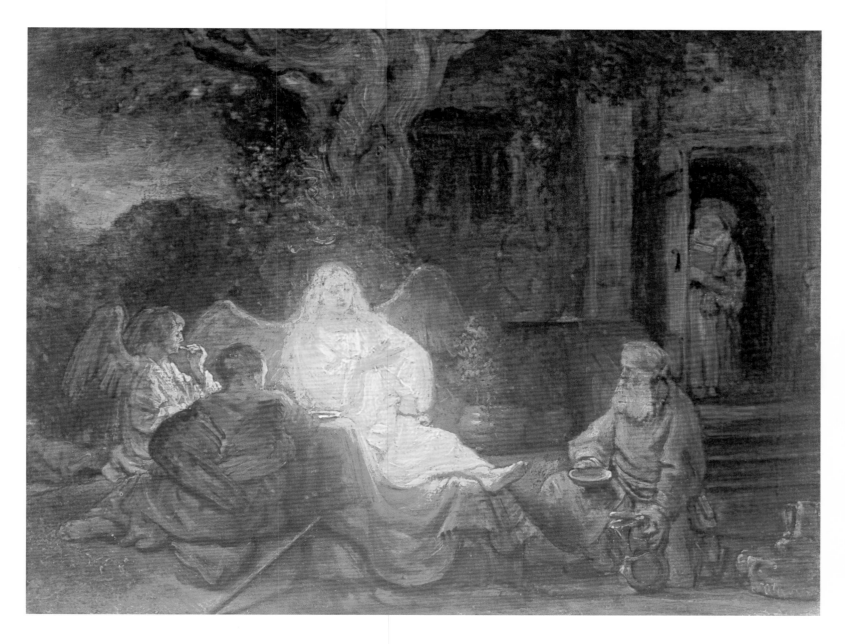

the setting. The drawn copy included here in the collection of the British Museum, London (no. 143) documents a miniature of seated elders that was apparently the closest source of inspiration for the 1656 etching. Several of the original miniatures from Rembrandt's collection, or close versions of them, were later incorporated into the rococo decor of a room in Vienna's Schönbrunn Palace.[2] The drawing is unusual in that it includes a landscape background with a central tree. The tree in the miniature that Rembrandt copied was half obliterated when the painting was fitted into the

eighteenth century décor of the Viennese palace, but is still visible.[3] In Rembrandt's etching the uprights of the house's architecture replace the tree.

Rembrandt's 1656 inventory of his possessions lists an album "full of curious miniature drawings as well as various wood and copper prints of all kinds of costumes."[4] The placing of the miniatures with costume prints underscores the fact that Rembrandt was primarily interested in the Mughal miniatures for their details of costume. From early on in his career Rembrandt sought out details of Near Eastern dress and custom in

141

Abraham and the Angels, 1646
Oil on panel
Br. 515
16 × 21 cm (6⁵⁄₁₆ × 8¼ in.)
Aurora Art Fund, Courtesy of
Stiebel, Ltd.

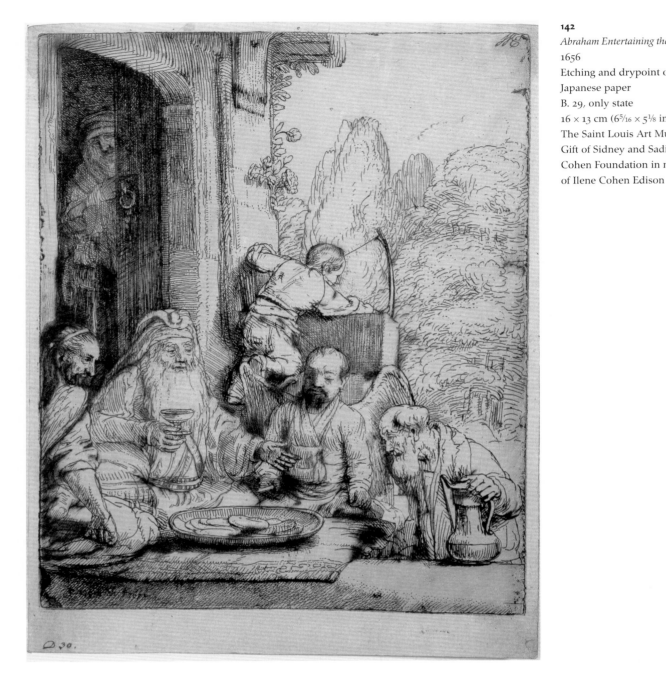

142
Abraham Entertaining the Angels,
1656
Etching and drypoint on
Japanese paper
B. 29, only state
16 × 13 cm (6⁵/₁₆ × 5⅛ in.)
The Saint Louis Art Museum
Gift of Sidney and Sadie
Cohen Foundation in memory
of Ilene Cohen Edison

order to give greater "authenticity" to his scenes from Biblical antiquity.[5] An amusing example of such authenticity is seen in the etching in the flat breads or pita breads that Abraham has set before his visitors. They replace the tray of teacups in the drawing after the miniature.

This impression of the 1656 etching is a particularly early one printed on golden-toned Japanese paper in which the added accents of drypoint burr which rapidly wore (or were scraped) away are particularly strong and rich. The plate (no. 144) seems to have left Rembrandt's possession early on, having been created about the time of his bankruptcy proceedings. It is very likely the only Rembrandt copper etching plate to survive that was not to one degree or another reworked at the hands of later publishers in order to extend its life. The reason for its

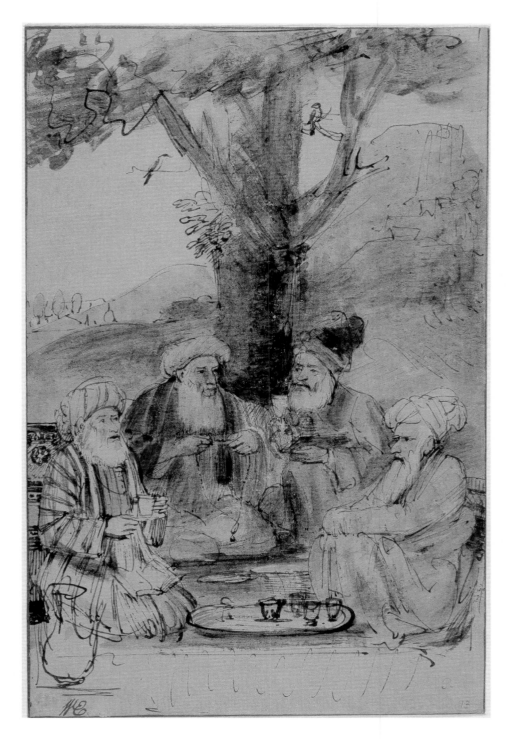

143
Drawing after an Indian Miniature,
1656–61
Pen and brown ink, brown and
gray wash, and white watercolor
with scraping, on Japanese paper
Ben. 1187
19.4 × 12.4 cm (7⅝ × 4⅞ in.)
Lent by the Trustees of the
British Museum, London

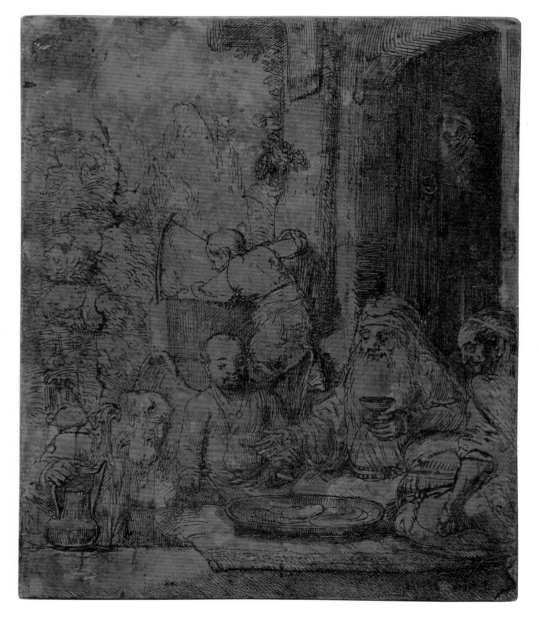

144

Abraham Entertaining the Angels,
1656
Copper etching plate
B. 29
16.2 × 13.3 cm (6⅜ X 5¼ in.)
National Gallery of Art,
Washington
Gift of Ladislaus and Beatrix
von Hoffmann and Patrons'
Permanent Fund

Fig. 75. Attributed to Peeter Gysels (Flemish, 1621–
1690), *River Landscape with Villages and Travelers,* oil on
verso of copper etching plate, 16.2 × 13.3 cm (6⅜ × 5¼
in.). National Gallery of Art, Washington, Gift of
Ladislaus and Beatrix von Hoffmann and Patrons'
Permanent Fund.

relatively pristine condition is that it was acquired by the Flemish painter Peeter Gysels (1621–1690/91), or someone in his circle, and the smooth unworked back of the plate was used as the support for a miniature landscape painting executed in the style of Jan Bruegel (fig. 75).[6] CSA

NOTES

1. Illustrated in New Holl. 15.

2. See Royalton-Kisch 1992, 141–44, no. 62.

3. See reproduction of the miniature in Royalton-Kisch 1992, 142, fig. 62a.

4. *Docs.* 1979, 1656/12, 203.

5. Slatkes 1983.

6. Robison 1997–98, nos. 6–7b.

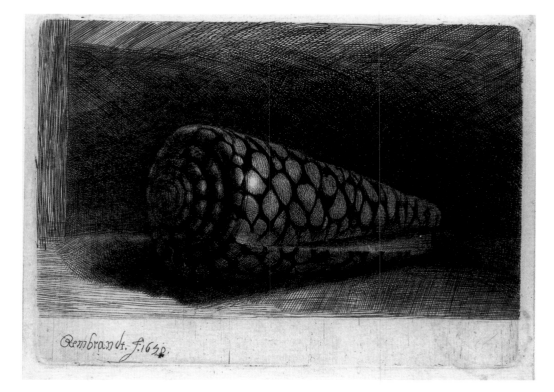

Fig. 76. Giorgio Morandi (Italian, 1890–1964), *Still Life with Pine Cone and Fragment of a Vase*, 1922, etching on Japanese paper, 7.6 × 10.8 cm (3 × 4¼ in.), Museum of Fine Arts, Boston, Gift of Alan and Marianne Schwartz (Shapero Foundation) and the Lee M. Friedman Fund.

145
The Shell

1650

Prior to the Cubist prints of the early twentieth century still lifes were relatively rare subjects in printmaking. Rembrandt's strikingly simple etching *The Shell* (no. 145) was from early on admired and copied and continues to be a favorite source of inspiration for artists. An equivalent for Rembrandt's etching in our own time might be an intimate, small-scale etching by the Italian still-life painter and etcher Giorgio Morandi (fig. 76).

In Rembrandt's time the image was, of course, not just an artistic still life, but closely related to the contemporary interest in the collecting and study of nature's wonders and curiosities. Shells and other sea-growths (*zeegewassen*) were depicted in watercolor miniatures on paper and vellum and in engraved or woodcut plates in scientific publications. The cone shell seen here, the *conus marmoreus*, could be found today in most shell shops at a modest price, but in the seventeenth century it was an exotic, imported rarity valued like a rare tulip bulb. There were special shops in Amsterdam that dealt in these costly natural rarities brought back from all over

the globe by Holland's sea-faring mercantile traders. This shell was the kind of elegant product of God's higher craftsmanship that would have adorned a contemporary collection of art and natural curiosities such as Rembrandt's own.[1] The 1656 inventory of his possessions lists—among works of art, plaster casts of sculpture and antique weapons—a large quantity of natural history specimens, including shells.[2] A few years before, Wenceslaus Hollar (1607–1677), the Czech etcher active in England and Flanders, had published a series of thirty-eight etchings of exotic shells.[3] Hollar's shells are represented as floating in isolation against a blank background and, although meticulously delineated, do not have the specific weight, volume, and vivid suggestion of color and texture that Rembrandt gave to his shell. Rembrandt's etching is a *portrait* of an individual shell enveloped in its own light and atmosphere rather than a generic specimen. The etching presents the shell actual size and Rembrandt has endowed it with a remarkable sense of tangibility.

The etching is seen here in its completed second state in which the shell rests on a plane surface and is embedded in deep shadow. In the rare first state, already signed and dated, the surrounding background is blank but the shell casts a strong shadow.[4] It is already strongly

modeled and the glossy surface of the shell reflects the light. In the second state Rembrandt added a ledge or shelf on which the shell rests and left a blank lower margin that sets off the signature and the date. The shell is wrapped in a deep chiaroscuro not unlike that which envelops the figure in Rembrandt's etching of a reclining female nude seen from the back (1658, no. 199). CSA

NOTES

1. See Roelof van Gelder and Jaap ven der Veen, "Collecting in the Time of Rembrandt," in De Heer et al. 1999, 27–31.

2. See, for example, *Docs.* 1979, 1656/12, 179: "A large quantity of shells, sea-growths/casts from life and other rarities."

3. For comparison, see the Wenceslaus Hollar etching reproduced in Amsterdam/London 2000, 260, no. 62, fig. a.

4. Reproduced in Amsterdam/London 2000, 259, no. 62 (I Amsterdam).

146–149
St. Jerome and St. Francis

1640S AND 1650S

Like the great painter-printmaker of the German Renaissance, Albrecht Dürer, Rembrandt appears to have had a special devotion to St. Jerome, the scholar-saint responsible for the official Latin translation of the Bible, the Vulgate.[1] Three *St. Jeromes* of 1642, 1648, and about 1654, as well as a 1657 etching of *St. Francis in Prayer*, present different incarnations of these iconic saints of the Catholic Church. Rembrandt may first of all have been attracted by the strong visual traditions represented by earlier depictions of these subjects by famous painters and printmakers, and may have felt challenged to create his own personal variations or improvements on them. But he may also have hoped to appeal to the potential market for such images represented by the many Catholic faithful in seventeenth-century Holland or, even more significantly, in the international market.

As we learn more about religion and art in the Dutch Republic of the seventeenth century—particularly in the cosmopolitan center of international commerce, Amsterdam—it becomes clear that Calvinist domination of the culture has been somewhat exaggerated. Dutch society was for the time surprisingly pluralistic with regard to the inclusion and toleration of diverse sects and faiths.[2] Rembrandt, brought up as a Calvinist, had friends and clients who represented the full spectrum of faith and belief: Mennonites, Lutherans, Catholics, Jews. He

etched illustrations for a friend's Jewish mystical text (see figs. 72, 73; p. 210) but also etched a number of images that perpetuate—admittedly with his own individual accent—Catholic traditions of imagery and symbolism (see *The Virgin and Child with the Cat and Snake*, no. 164, and *The Death of the Virgin*, no. 70).[3]

The traditional cataloguer's title of Rembrandt's 1642 etching, *St. Jerome "in a dark chamber,"* is a singularly appropriate one (no. 146). This image is the most profoundly dark one that Rembrandt had thus far produced in printmaking. Because the expressive effect of early impressions of the print depends so much on the condition of the printed surface, fine impressions such as the present one are relatively scarce. The intensity and depth of the shadow in the print is dependent on the undisturbed condition of the dense "fur" of printed marks standing up on the surface of the paper: accidental deposits or rubbing of the surface tend to rob the shadows of their intended depth and texture. This dense unsystematic web of marks made by a combination of etching, drypoint, and engraving also tended to wear rapidly, sometimes making particular details more legible in later impressions but severely diminishing the effect of the print's principal subject, the enveloping velvety darkness.

In the profound darkness of the room, by the minimal light that filters through the window, one can barely decipher the attributes that identify the subject as St. Jerome: the top of a crucifix; a skull; a cardinal's hat seen in profile hanging from the side of the spiral staircase; and finally, Jerome himself seated, sunk in meditation with an open book before him. Jerome's faithful guardian, the lion, reclining on the floor before the table, is scarcely visible.[4] Rembrandt's conception of the saint in his study is strikingly, perhaps intentionally, opposite to that in Dürer's famous engraving of 1514, *St. Jerome in His Study* (fig. 77). In Dürer's print sunlight penetrates and energizes every corner of the elaborately detailed interior space. The room's exaggerated perspective urgently focuses our attention on the saint actively at work at his writing desk. Rembrandt's saint is, on the other hand, turned wholly inward: he rests his head on his hand, eyes closed in prayer or meditation. The space of the room is indeterminate, immeasurable. Only the corkscrewing spiral staircase turning on itself at the center of the room emerges with relative clarity from the enshrouding gloom. The figure of the seated saint is embraced by the stair's spiral and the latter functions as a kind of visual symbol or metaphor for inwardness and the interior life.

The "dark chamber" St. Jerome is one of the climac-

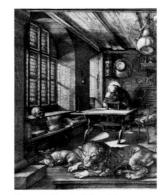

Fig. 77. Albrecht Dürer (German, 1471–1528), *St. Jerome in His Study*, 1514, engraving, B. 60, 24.7 × 18.8 cm (9¾ × 7⅜ in.), Museum of Fine Arts, Boston, Gift of Mrs. W. Scott Fitz and Duplicate Print Fund.

146
Saint Jerome (in a dark chamber),
1642
Etching, drypoint, and
engraving
B. 105, I
15 × 17.6 cm (5⅞ × 6¹⁵⁄₁₆ in.)
Museum of Fine Arts, Boston
Gift of Mrs. Lydia Evans
Tunnard in memory of W. G.
Russell Allen

tic highpoints of Dutch seventeenth-century printmakers' quest for dark printed tones, a quest in which Rembrandt's etched work plays a central role. Rembrandt's intuitive, unsystematic explorations anticipate the contemporary development of the more mechanical, continuous-tone copper plate process of mezzotint.[5] The mezzotint process employed a special tool, a rocker or hatcher, to roughen the surface of a copper plate in order to produce dark continuous tones. The lights were then generally scraped or smoothed out of this roughened surface by a subtractive process. In the very year of the St. Jerome etching, 1642, a military man in Amsterdam, an amateur, Ludwig von Siegen, produced the first prim-

itive mezzotint, a portrait in which the tonal shadows were created with a roulette, a spiked wheel mounted on a handle. The full development of the process took place in Kassel, Germany during the period 1657–61 in the hands of another amateur, Prince Ruprecht, who had spent his childhood at the court in The Hague. The new medium in its fully developed form was not practiced with any great frequency in Holland until the 1670s and 1680s. Rembrandt's extraordinary range and variety with respect to the use of line and tone is dramatized when one realizes that in the same year that he etched the "dark chamber" St. Jerome he also etched the lightly drawn *Raising of Lazarus* (no. 129), in which the subject is

bathed in the sunlight generated by untouched white paper.

St. Jerome spent a four-year period of penitence and prayer living as a hermit in isolation in the Syrian Desert. Italian as well as Northern artists had often represented him as a powerful old man, half-naked, kneeling among the barren rocks of the wilderness while doing penance by beating his breast with a sharp stone. Dürer in his rare drypoint of 1512 (fig. 78) shows him praying before a crucifix, enthroned among rocks with an improvised desk across his lap. Under the nose of his dozing lion we see a pool with rushes and, at right, a shattered stump and a pollard willow.

Rembrandt's "wilderness" in his 1648 etching and drypoint of St. Jerome is a green, welcoming one rather than a desert place of austere penitential rigors (no. 147). Jerome is comfortably seated at an improvised desk carpentered onto the trunk of an aged, twisted tree, traditionally identified as a pollard willow. The stream bordered by rushes at his feet is fed by a sketchily indicated waterfall visible in the distance at upper left.

The etching is rather ostentatiously signed and dated on a board that Rembrandt prominently placed in the foreground of this, the final and completed state. St. Jerome is actively writing, spectacles perched on his nose and cardinal's hat beside him. On the opposite side of the tree his vigilant lion protects his studious solitude.[6] In spite of the admonitory skull facing the saint on the desk, the mood is more that of a sun-bathed summer retreat than of penitential isolation. The aged tree—the dominant figure in a print that is at least as much landscape as devotional image—has put out a flourishing green branch that protects the scholar-saint from the full heat and glare of the sun. Both the weathered tree and the venerable old man are still active and productive.[7] The tree is the sturdy axle around which the whole composition pivots. It is more meticulously rendered, weightier and more substantial than any other part of the image. This print, like the undated *St. Jerome Reading in an Italian Landscape* of the early or mid-1650s (no. 148) is one of those prints in which Rembrandt disconcerted some early critics by using varying degrees of finish or completion in the same print. What would have been acceptable in a drawing was controversial in a published, presumably "finished" print. These variations of finish are still a source of lively discussion among scholars, particularly in relation to some of Rembrandt's unsigned prints. In this fine impression of the second state the drypoint lines have the necessary softness and fullness that contribute a feeling of lushness to the landscape.

The *St. Jerome Reading in an Italian Landscape* (no. 148),

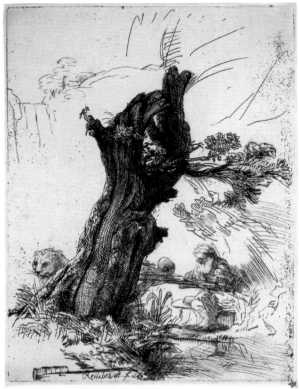

REDUCED

although unsigned and undated, is generally thought to be from the first half of the 1650s, usually about 1654. The sketchily rendered figure of St. Jerome is virtually one with the landscape. Cozily ensconced in the landscape as if in an armchair, sunhat on his head and slipper off, he concentrates on his reading, his privacy insured by his watchful lion. Above Jerome's head Rembrandt has suggested the roof of an improvised shelter by erasing part of the dense mesh of previously etched lines with scraper and burnisher.

"In an Italian landscape," the modifying descriptive phrase of the traditional title, refers to the hilltop with buildings in the distance at right. The churchlike structure and farm buildings seen there resemble those in landscapes of the Venetian painter Titian and his circle from the first half of the sixteenth century. In the 1650s some of Rembrandt's etched and drawn landscapes show clear evidence of his study of landscapes by Titian. His inventory of 1656 lists a large book or album with "almost all the work of Titian," presumably engravings and woodcuts reproducing the designs of the Venetian master.[8] In two instances Rembrandt made at this time drawn copies of landscape drawings by Titian, and in one other instance he retouched a landscape drawing in the style of Domenico Campagnola, an artist

147
Saint Jerome (beside a pollard willow), 1648
Etching and drypoint
B. 103, III*
18.2 × 13.4 cm (7³⁄₁₆ × 5¼ in.)
Museum of Fine Arts, Boston
Katherine E. Bullard Fund in memory of Francis Bullard

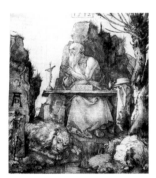

Fig. 78. Albrecht Dürer (German, 1471–1528), *St. Jerome by the Pollard Willow*, 1512, drypoint, B. 59, 20.8 × 18.5 cm (8³⁄₁₆ × 7⁵⁄₁₆ in.), Museum of Fine Arts, Boston, Anna Mitchell Richards Fund.

in Titian's circle.[9] The diagonal division of Rembrandt's upright landscape may have been inspired by an engraving of this subject after Titian by the sixteenth-century Flemish engraver active in Italy, Cornelis Cort, in which a muscular St. Jerome holds an open book on his lap.[10]

In Rembrandt's etching the landscape is diagonally divided by a rushing stream with cascades. Strong touches of drypoint burr on the tree stump, bushes, and lion's mane further accentuate the division between foreground and distant view. As with so many of Rembrandt's etched compositions of the 1650s, the space of the landscape is highly structured rather than deeply illusionistic. The sophistication and complication of the landscape space seems almost to anticipate the later works of Cézanne: many foreground forms are sketchily and lightly defined and tend to recede or flatten out while the distant forms of the hilltop are firmly and weightily defined and visually move forward.

The etching is unusual among Rembrandt's prints in that it was preceded by a freely executed drawing of the whole composition that presents (in reverse) all the main elements of the final composition, particularly the foreground (Kunsthalle, Hamburg).[11] The drawing makes a more conventional distinction between near and far, the foreground being shadowed with wash and the distance lighter and brighter.

The "Italian" St. Jerome was printed by Rembrandt on varied papers that contribute different moods of light and atmosphere to the landscape: white European paper, golden Japanese paper and, here, oatmeal or cartridge (*kardoes*) paper. Oatmeal paper was a less refined packing paper made from the residue left over from the manufacture of finer paper. It contains undigested colored fibers that give it a coarser texture and a grayish or brownish tint. It was often used by artists in seventeenth-century Holland for drawing because it provided a convenient intermediate gray tone that could then be darkened with ink or lightened with opaque white watercolor. It was rarely used by printmakers other than Rembrandt. Here it contributes a muted, cloudy day light to the landscape, whereas impressions on golden Japanese paper seem to glow with afternoon sun.[12]

St. Francis Praying beneath a Tree, a drypoint and etching of 1657 (no. 149) has in the past been mistaken for a representation of St. Jerome in prayer because St. Francis is more customarily represented as miraculously receiving from a hovering seraphic vision of the crucifix the stigmata or wounds of Christ in his hands, feet, and sides. St. Francis is also usually portrayed as more youthful in appearance, whereas Rembrandt has de-

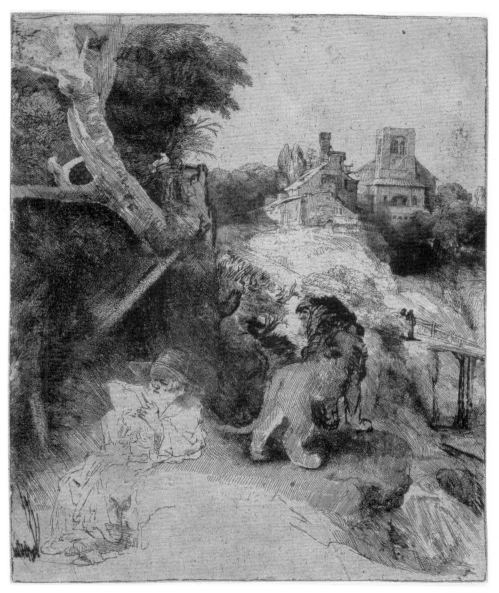

picted him as a venerable elder like St. Jerome. It is only the Franciscan habit that Francis wears, as well as the presence of the companion monk, Brother Leo, kneeling in prayer in the shelter at right, and the Italianate church tower in the distance that confirm the identification of the central praying figure as Francis.[13] Perhaps Rembrandt deemed the Stigmatization *too* Catholic for his audience? On the other hand, the image of St. Francis in prayer was a popular subject during the Catholic Counter-Reformation movement of the seventeenth century, particularly in Spain.

The heroic tree trunk divides the subject into two

148

Saint Jerome Reading in an Italian Landscape, about 1654
Etching, drypoint, and engraving on oatmeal paper
B. 104, II
25.7 × 20.8 cm (10⅛ × 8³⁄₁₆ in.)
Museum of Fine Arts, Boston
Harvey D. Parker Collection

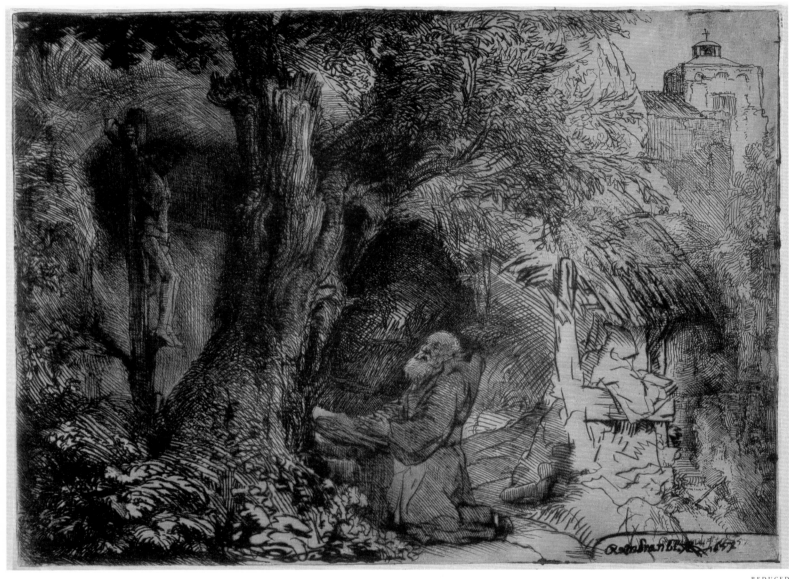

distinct zones: one at right in which Francis kneels absorbed in prayer, his folded hands resting on an open devotional text and the other the grottolike woodland space at left occupied by a nearly life-size crucifix. In an early, richly inked impression of the second state on Japanese paper such as the present one, the shadows that envelop the crucifix create great ambiguity as to whether the almost life-size crucifix should be perceived as a carving, a living figure, or perhaps even a mystical vision.

In his prints that combine etching and drypoint, Rembrandt customarily added supplementary passages of drypoint work to a design that had been initially etched. This is a more practical sequence from a technical point

of view because each time one etches new marks into the plate it must be covered with an etching ground to protect the areas not being etched. In the case of the first state of the St. Francis, however, Rembrandt reversed the usual procedure, first scratching a free drypoint sketch into the plate. This initial state includes all the principal elements of the design, except for the landscape passages along the right edge. The print, in spite of its sketchlike breadth of execution, was already signed and dated in this state. Rembrandt also printed the first state on special supports such as Japanese paper and vellum, suggesting, as has been noted, that this "incomplete" first state was highly valued by Rembrandt and very proba-

149

Saint Francis Praying beneath a Tree, 1657
Drypoint with etching and engraving on Japanese paper
B. 107, II
18 × 23.8 cm (7¹/₁₆ × 9³/₈ in.)
Museum of Fine Arts, Boston
1951 Purchase Fund

bly also by connoisseurs and collectors interested in owning such rare or unusual early working proofs.[14]

In the second state the image was completed in etching in greater detail, apparently without interfering significantly with the rich, fragile burr on the previously executed drypoint lines. In this example of the second state on light cream Japanese paper, Rembrandt enriched the individual impression, as he so often did in the 1650s, by leaving an extra film of translucent ink over most of the image. In certain localized areas, such as Francis's praying figure, he left a heavier film of ink, suggesting a mysterious veil of shadow. In impressions such as this Rembrandt was essentially painting on the plate with printer's ink.[15] CSA

NOTES

1. Between about 1629 and the mid-1650s Rembrandt etched seven or eight St. Jerome plates (B. 100–106). One of these, B. 102, though signed and dated 1635 seems to my eye rather weak in drawing and not wholly characteristic of Rembrandt in its linear vocabulary.

2. On religious diversity, see the essay by Benjamin J. Kaplan, "Confessionalism and Its Limits: Religion in Utrecht, 1600–1650," in Spicer and Orr et al. 1997, 60–71.

3. For the religious affiliation of Rembrandt and his clients and the atmosphere of toleration, see Tümpel 1986, 91, and 129–31. In his essay, "Religious History Painting," in Blankert et al. 1980, 45–54, Tümpel states firmly that our anachronistic distinctions between Protestant and Catholic subjects are not necessarily relevant to Rembrandt's time, in which Protestant and Catholic artists often painted the same religious subjects. He further points out that artists did not necessarily receive commissions strictly according to their faith; they often crossed sectarian lines.

4. Jerome (Eusebius Hieronymus Sophronius, about 340–420) was a real historical figure whose life has been embellished by legend. While he held an official position under an early pope, the cardinal's hat is an anachronistic attribute later considered fitting due to his status as one of the four Fathers of the Latin Church. Jerome, according to legend, was the only one brave enough to pull a thorn from a lion's paw, converting the savage beast into his loyal friend and protector. See Hall 1979, 168–69.

5. For the "quest for printed tone" see the essay of the same title in Ackley Printmaking 1981, xix–xxvi. For mezzotint, see in the same catalogue, nos. 185–86, 189–91, 194, 197–99, and Glossary on page 307 (with illustrations of tools).

6. The lion in the first state is slightly more ferocious-looking, frowns more fiercely, and is less domesticated in appearance than the lion of the final state.

7. Susan Kuretsky 1974, 571–80, explores the visual tradition in northern art that closely associates St. Jerome with a seemingly dead or reborn tree, from the legendary derivation of Jerome's name from the Latin for "holy wood," to the identification of Jerome's tree with Eden's fatal Tree of Knowledge of Good and Evil, and the "tree" of the cross on which Christ gave his life to redeem the sins of humankind.

8. Docs. 1979, 1656/12, 215: "one ditto [book], very large, with almost all the work of Titian."

9. For reproductions of these drawings after Titian (Berlin and Lugt Collection, Paris) see Schneider Landscapes: Drawings and Prints 1990,

156–58, no. 38 (38a and fig.1). The retouched "Campagnola" drawing is Ben. 1369.

10. New Holl. 2: Cornelis Cort, 160, no. 120.

11. Ben. 886. Reproduced in Amsterdam/London 2000, 296, no. 72, fig. a.

12. The oatmeal paper used here has a "wheel" watermark similar to that found in the oatmeal paper used to print the first state of the Asselyn portrait (no. 87), but this sheet is much thicker than that of the Asselyn.

13. Francis of Assisi, founder of the Franciscan monastic order (1384–1440). See Hall 1979, 131–33.

14. See Marijn Schapelhouman in Amsterdam/London 2000, 340–43, no. 85, with reproductions of two impressions of the first state.

15. Dürer's 1512 St. Jerome drypoint (fig. 78, p. 222) is one of the first prints in the history of printmaking in which a printmaker carefully manipulated a film of extra ink on individual impressions of the print.

150

Faust (The Scholar in His Study)

1650S

A mysterious apparition at the window of his study brings an aged scholar to his feet. It projects a beam of light across his dimly lit study and illuminates his gaunt features. He wears a white cap and layers of fur, velvet, and linen to protect himself against the cold. He has been at work, reading and writing. Left hand on the arm of his chair and right hand on his desk, he leans heavily on his knuckles as he rises to train his attention on the shimmering vision. Between the partially drawn half curtains, a radiant halo surrounds a disk with three concentric rings of letters, the centermost of which reads "INRI" (the Latin abbreviation for "Jesus of Nazareth King of the Jews"). The cryptic disk—a transformation of the round, painted panes leaded into many Dutch windows—serves as a head for the shadowy body of a visionary figure. Amid clouds of vapor appear two ghostly hands, one pointing to an indistinct reflection of the cryptic disk in a mirror held by the other. The scholar has been interrupted, but the apparition brings the esoteric knowledge he has been seeking. He experiences a mystical revelation.

We observe the scene from a raised viewpoint. Our eyes glance over minimal suggestions of a globe, a carpet-covered desk, books, and paper. Rembrandt urgently moves our attention past the clutter and into the center of the action. We grasp immediately that the man beholds a vision, but Rembrandt does not allow us to share fully the scholar's understanding of what he sees. Tantalized, we may attempt to decipher the puzzling

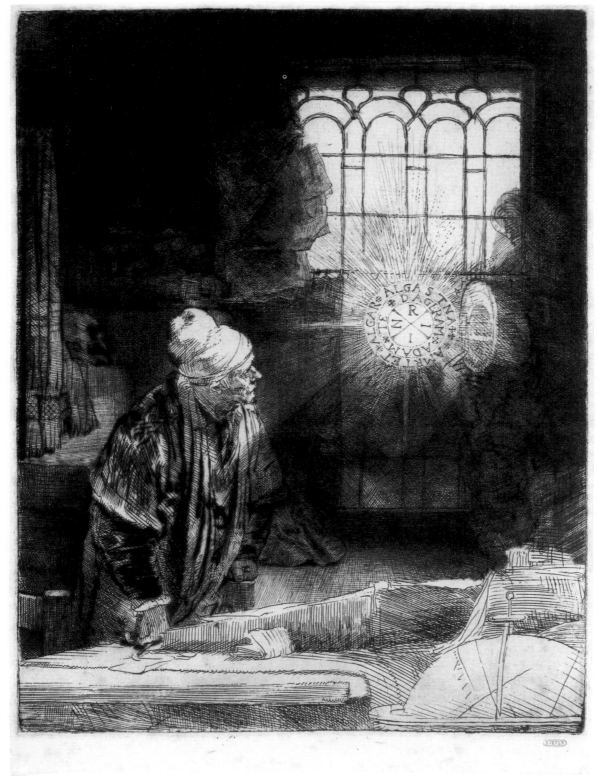

150
Faust (The Scholar in His Study),
about 1652
Etching, drypoint, and engraving
B. 270, I
21 × 16 cm (8¼ × 6⁵⁄₁₆ in.)
Alan and Marianne Schwartz
Collection

inscription, but we may search in vain. Similarly, the interior invites exploration but yields few concrete discoveries. In the sketchily defined foreground, we can identify none of the books, nor can we determine whether the globe is terrestrial or celestial. In the distant corner of the room, we see only shadowy piles of books. Even the clumps of paper that spill out before the light of the tall leaded window tell us nothing of their content. The one obvious meaning-laden detail is the skull strategically placed so as to echo the profile of the old man, a reminder of the inevitability of death and the mystery of what lies beyond.

This image has a long history of interpretation.[1] Its earliest known title is that given in the 1679 inventory of the estate of the print publisher Clement de Jonghe (see nos. 205, 206). There it was called "Practiserende alchimist," usually translated as "practicing alchemist."[2] About 1731, Delft collector Valerius Röver (1686–1739) classified the print as a portrait, calling it "Doctor Faustus."[3] Edme-François Gersaint (1694–1750), author of the first published catalogue of Rembrandt's prints, sensed that "Fautrius" delved into Cabalistic mysteries.[4] Nearly all later interpretations derive from these three.

The interpretation of the print as Faust has two branches. The first identifies him as the protagonist of *Dr. Faustus,* the play by Christopher Marlowe (1564–1593) dramatizing the legend that grew up around the life and mysterious death of the sixteenth-century magician Johann Faust. Some have taken Rembrandt's print as proof that a version of the play was performed in Amsterdam by the mid-seventeenth century.[5] Yet, although his drawings of actors and his illustration of *Medea* (no. 138) provide clear evidence of Rembrandt's interest in the theater, we do not know precisely how he would have come to know Marlowe's tale.

The second branch suggests that the print is a commemorative portrait of Faustus Socinius (1539–1604), the founder of an anti-Trinitarian sect whose adherents— over optimistically—sought refuge in the relatively tolerant religious atmosphere of Amsterdam.[6] The complex argument hinges on the somewhat distant echoes in Rembrandt's print of a 1525 woodcut illustration of a mirror-bearing angel appearing in the study of Martin Luther, one of Socinius' heroes. Rembrandt's relative independence from the Calvinist church and his wide-ranging religious interests make plausible his receptivity to unconventional ideas.[7] As he often did, Rembrandt left this plate unsigned. If this were truly Socinius, it would have been dangerous for the artist to identify himself as the author of the image.

The Jewish Cabalistic interpretation finds support in a 1676 publication on amulets that includes a design close to Rembrandt's in text and form.[8] A 1652 allegorical woodcut of a Cabalistic sunflower reveals that the two outer rings of text contain various names for God.[9] Rembrandt's contact with Jewish mysticism is known from his illustrations for the rabbi Menassah ben Israel's 1655 mystical tract, *La Piedra Gloriosa* (see figs. 72, 73; p. 210). If the old man is Jewish, then the cloth hanging at the left side of the image may be a prayer shawl (*tallith*). While the Cabalistic explanation fits the elements of the image well, one should still exercise caution in using the amulet symbol as the key to a specific interpretation, for Rembrandt may have adopted it simply as an exotic example of esoterica, an emblem of mystery itself.

The alchemical interpretation is perhaps the most flexible. Though alchemy is at root the transformation of base metal into gold, it came to encompass magic and the pursuit of esoteric knowledge. Its practitioners have included Jews, Christians, and heretics of every description.

Were it not so compelling as a purely artistic creation, Rembrandt's print would not have piqued so much curiosity. Since he varied both the paper and the inking from one impression to another, the plate produced a subtle range of effects. The brilliant impression shown here was printed on white European paper. Rembrandt selectively wiped the ink from the plate. He left a film of it over much of the surface, as seen on the sparsely worked foreground, to emphasize the darkness of the room. He wiped the disk and the man's head cleaner, producing focused illumination. The fresh drypoint burr and the ink dragged from it heighten the effect of lustrous fur and velvet. The balance of contrasts and tonality produce a pronounced if irrational and mystical sense of space. The man and the apparition are experienced more vividly because Rembrandt's creativity did not stop with the completion of the copper plate. In some impressions he left even more ink on the plate, obscuring the distant books still visible here.[10]

Recent watermark research confirms that reworking of the plate in the second state occurred after Rembrandt's death.[11] Röver's 1731 inventory states that he had two impressions of *"Doctor Faustus."* Rather than being different states, they may well have been impressions taken on two different types of paper. Those of the *Faust* printed on oatmeal paper are more muted but tend to have more sharply defined areas of burr than the one shown here. Those on Japanese paper tend to glow with silkier transitions between darkness and light. Röver may have appreciated that the different effects were equally valid.

The plate is usually assigned a date of about 1652 and may be compared to *David in Prayer* (no. 160), signed and dated that year. In both, Rembrandt depicts moments of spiritual or metaphysical significance occurring in dimly lit spaces. Not only does his spare description of the objects in the rooms parallel our limited perception in the dark, but it also helps to shift our attention from our physical surroundings to matters of the soul.[12] Watermark research suggests that he probably made the plate by about 1653. While the plate was still in very good condition, some impressions of *Faust* were printed on a paper used repeatedly by Rembrandt for *The Three Crosses* of 1653 (nos. 168–170).[13] TER

NOTES

1. For a summary of interpretations, see Van de Waal 1974, 148–49, 152.

2. Hofstede de Groot *Urkunden* 1906, 408. Van de Waal 1974, 139, reminds us that the Dutch word *prakkizeren* can mean "ponder over" or "think over," so the inventory taker may have seen the image as an alchemist pondering the apparition.

3. By that time Röver had spent more than three decades assembling an unusually complete collection of Rembrandt's prints. His manuscript listing of the 456 impressions then in his possession constitutes the first oeuvre catalogue of Rembrandt's prints. On page 19 of his album were listed two impressions of "Doctor Faustus." See Van Gelder and Van Gelder-Schrijver 1938, 11.

4. Gersaint 1751, 196.

5. Leendertz 1921, 140–41.

6. Van de Waal 1974, 133–81.

7. There is no documentary evidence specifying any clear religious affiliation on the part of Rembrandt. That the church council censured Hendrickje Stoffels but not Rembrandt for their nonmarital sexual union tells us that he was not a member. S. A. C. Dudok van Heel, "Rembrandt van Rijn (1606–1669): A Changing Portrait of the Artist," in *Master and Workshop*: *Paintings* 1991 , 60.

8. The illustrations of the amulet and the disk in Rembrandt's print are almost mirror images of one another; see Grothues 1992, 5.

9. Grothues 1992, 3–9.

10. See Stampfle et al. 1969, 75.

11. Erik Hinterding in Amsterdam/London 2000, 283–85. Prior to Hinterding's research, connoisseurs had long suspected that the clusters of fine parallel lines used to produce a facsimile of drypoint burr in the second state was uncharacteristic of Rembrandt, but they could not prove that it occurred after his death.

12. Rembrandt's unconventional use of sketchiness, and possibly the absence of his signature, led Adam Bartsch to conclude that "Faustus" was unfinished; see Bartsch 1797, xxxiii.

13. Hinterding diss. 2001, 322–23.

151–152
Episodes from the Life of Christ
EARLY AND LATE

Two etched scenes from the life of Christ offer the maximum contrast between the robust physicality characteristic of many of Rembrandt's religious narratives of the 1630s and the quiet spirituality that characterizes many of those from the 1650s. *Christ Driving the Moneychangers from the Temple* (no. 151) is perhaps the most physically energetic episode in Christ's ministry. Christ's cleansing of the place of worship of those who would seek to profit from religion is recounted by all four evangelists (see, for example, John 2:13–16). Jesus made himself a flail of rope and wielded it vigorously to drive from the temple the moneychangers and those who sold cattle, sheep, and doves for sacrificial offerings. Overturning the tables of the moneychangers, he declared that "My house shall be called the House of Prayer: but ye have made it a Den of Thieves." (Luke 19:46).

The Victorians would very likely have considered this image a fine example of what was then known as "muscular Christianity." Christ's upraised fist wielding the scourge or flail occupies the exact center of the composition. From the pivotal figure of Christ two perspectives diverge, one at left leading into the depths of the temple and one at right leading up to the throne of the high priest, where temple authorities look on like spectators at an athletic match.[1]

The figure of Christ is one of Rembrandt's most blatant creative borrowings. It is a reverse copy of the figure of Christ from Albrecht Dürer's print of the same subject from that artist's *Small Passion* series of 1509–11 (fig. 79). As has been noted, the significant difference is that whereas the light in the Dürer radiates from a candle in a wall sconce, Rembrandt's burst of light emanates from the scourging hand itself, transforming this borrowed motif into one of Rembrandt's most original inventions on the theme of divine light.[2]

This crowded scene of sheer pandemonium reveals Rembrandt's lively talent for low physical comedy—from the man being dragged on his back by a runaway calf with rolling eyes and lolling tongue, to the man who tackles an escaping dove, to the dog hysterically yapping at Christ, to the man who lovingly and protectively cradles his moneybag. One is reminded of the terrified shepherds and the stampeding cattle in Rembrandt's etched *Angel Appearing to the Shepherds* of the year before (no. 39).

The 1656 etching of *Christ Appearing to the Apostles* (no.

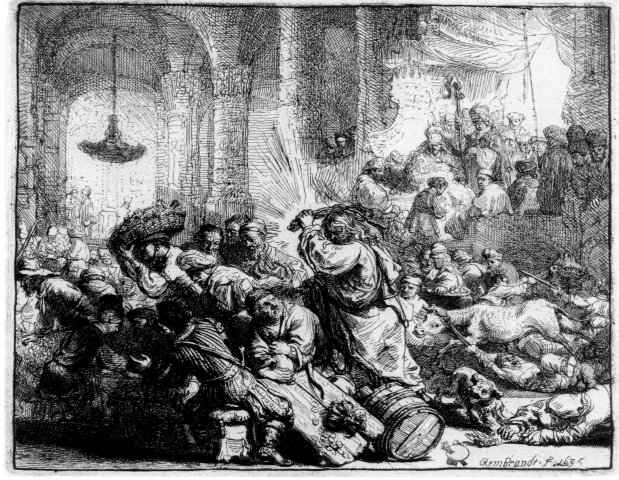

151

*Christ Driving the Moneychangers
from the Temple,* 1635
Etching and engraving
B. 69, I
13.8 × 17.1 cm (5⁷⁄₁₆ × 6¾ in.)
Museum of Fine Arts, Boston
Gift of the Estate of Lee M.
Friedman

REDUCED

152) like the *Supper at Emmaus* (nos. 4–6, 159) illustrates one of Christ's miraculous reappearances to his followers after his resurrection from the dead. The image involves one of the most radical conceptions of the "light of divine revelation" in Rembrandt's work. The combined accounts of the evangelists Luke (Luke 24:33–42) and John (John 20:9–23) tell how, after the resurrected Christ had made himself known to two of his disciples during the supper at Emmaus, the latter brought word of his miraculous reappearance to the other apostles and followers, who were hiding in a closed room in fear of persecution. Jesus suddenly appeared among them, saying "Peace be unto you." Assuming that he must be a ghost they were struck with terror. To prove that he was indeed flesh and blood he commanded them to see and to touch his wounds.

Rembrandt's highly original spiritual interpretation

has resulted in a number of varied identifications of the subject since Gersaint's first published catalogue of Rembrandt's prints in 1751. Gersaint identified it as "Christ Healing the Sick," while Bartsch in 1797 identified it as Christ appearing to the apostles with the doubting one, Thomas, kneeling before him.[3] According to the evangelist John's account (John 20:24–29), Thomas had not been present when Christ appeared to the apostles for the first time and did not believe that they could truly have seen the risen Christ. Jesus miraculously appeared a second time when Thomas was present and persuaded the skeptic of his reality by asking him to touch his wounds (see Rembrandt's 1634 painting of this subject, no. 47). In the nineteenth and early twentieth century the "Doubting Thomas" identification dominated until Christopher White persuasively argued for the present title.[4]

Fig. 79. Albrecht Dürer (German, 1471–1528), *Christ Driving the Money Lenders from the Temple,* from the series *The Small Passion,* 1509–11, woodcut, B. 23, 12.7 × 9.7 cm (5 × 3¹³⁄₁₆ in.), Museum of Fine Arts, Boston, Harvey D. Parker Collection.

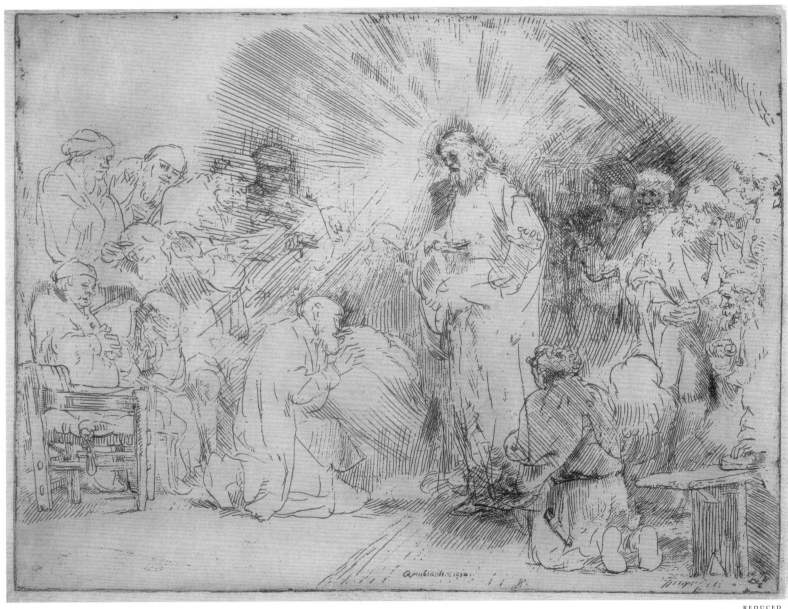

REDUCED

In the etching Christ gestures to the spear wound in his side that he had asked Thomas to probe, but his presence is overwhelmingly spiritual rather than physical. A blinding flash of light, the light of divine revelation, floods the room and disintegrates form. The followers, sketchily indicated, reverently kneel, bow their heads, close their eyes, and turn away. Clouds of vapor billow out from around Christ's feet and he seems to hover rather than stand, more spirit than flesh. The only solid objects that define the room are a chair and a bench. The mood suggests the mystical passage in John's account in

which Christ passes on his mission to his followers: "he breathed on them, and saith unto them, Receive ye the Holy Ghost."

The character of the etched line—broken, dotted, and suggestive rather than explicitly descriptive—parallels the style of some of the religious composition drawings of the 1650s in which Rembrandt used an almost dry pen to achieve a delicate spidery line that melds optically with the blank paper (see nos. 175–179). In the etching Rembrandt apparently further atomized some of the etched rays in the great halo of light by breaking them

152

Christ Appearing to the Apostles,
1656
Etching on Japanese paper
B. 89, only state
16.2 × 20.8 cm (6⅜ × 8³⁄₁₆ in.)
Museum of Fine Arts, Boston
Gift of Miss Ellen T. Bullard

down with a scraper and burnisher. In this impression printed on a white Japanese paper, the silky, shimmering surface subtly enhances the ethereal effect of the image. CSA

NOTES

1. This two-pronged construction of the interior space is similar to that seen in Rembrandt's small etched *Presentation* of 1630 (nos. 1, 37).

2. Tümpel 1970, no. 89.

3. Gersaint 1751, 61–62, no. 76, and Bartsch 1797, 92, no. 89 (*Jésus Christ au milieu de ses disciples*).

4. White 1969, 94–95.

153

The Adoration of the Shepherds

MID-1650S

The evangelist Luke tells us how the shepherds, following the instructions of the angel who had announced to them Christ's miraculous birth, hastened to Bethlehem and "found Mary, and Joseph, and the babe lying in a manger" (Luke 2:16). In his smaller etching from about 1654 depicting the shepherd's visit to the newborn (no. 161) Rembrandt used an oil lamp to illuminate the lucidly drawn scene. In the present large etching (no. 153), a

153
The Adoration of the Shepherds, 1656–57
Etching, drypoint, and engraving
B. 46, IV
14.9 × 19.6 cm (5⅞ × 7¹¹⁄₁₆ in.)
Museum of Fine Arts, Boston
Harvey D. Parker Collection

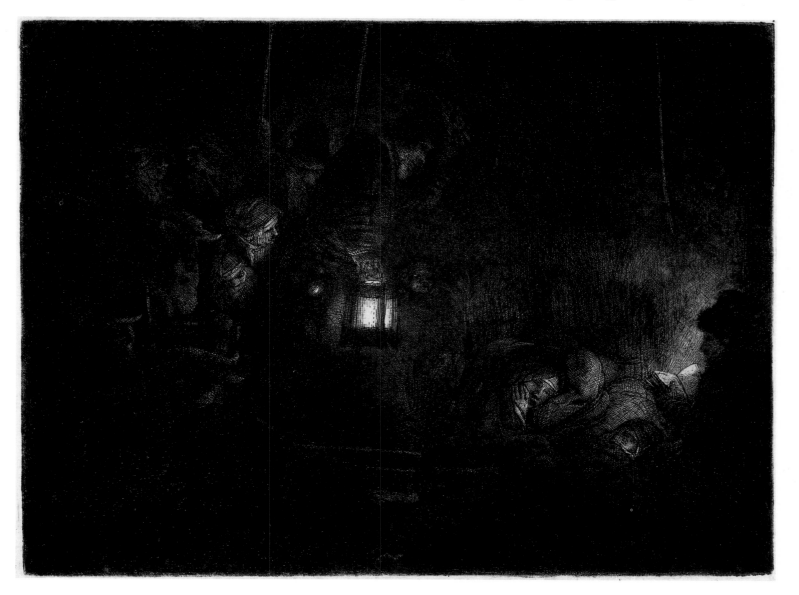

complex blend of etching, drypoint, and engraving seen here in its fourth state, the light from the large lantern carried by the foremost shepherd, who respectfully doffs his hat, and a secondary light source concealed behind the seated figure of Joseph reading the Bible at right, barely penetrate the tangible darkness that grows from state to state in the first five states of the print. The extremely rare first state is fairly bright in the area surrounding the Holy Family but from the second state onward the darkness closes in and it becomes increasingly difficult to decipher the forms of shepherds and cattle. In the profound darkness, the visual and emotional center becomes the lovely face of the Virgin who pulls back the blanket that enfolds her in its warmth in order to better focus her attention on the swaddled, sleeping child.

The undated print has in recent decades generally been dated about 1652, but current watermark research as well as stylistic comparison encourages a dating closer to 1656–57.[1] The plate is similar in its dimensions to two other horizontal format Life of Christ subjects from the 1650s—the Christ Preaching ("La Petite Tombe") of about 1652 (nos. 136, 137) and the Christ Appearing to the Apostles of 1656 (no. 152).[2] It also has approximately the same dimensions as the four plates of the upright Life of Christ group of 1654 (nos. 154–159). Whether these horizontal plates of the 1650s should be regarded as part of a larger Life of Christ series that Rembrandt was developing, together with the vertical format 1654 plates, is an interesting subject for speculation.[3] He never formally issued such a series but his mind and imagination seemed instinctively to be working in a serial direction during these years.

The Adoration of the Shepherds is one of those nocturnal images of the 1650s that Rembrandt repeatedly reworked, deepening the veil of darkness with each state. Other examples are the 1651 Flight into Egypt (no. 113) or The Entombment of 1654 (nos. 155–157). As with a number of Rembrandt's later plates it is often difficult to determine where Rembrandt's rethinking ends and reworking by other hands in the workshops of later publishers begins.[4]

CSA

NOTES

1. See Ger Luijten in Amsterdam/London 2000, 277–80, no. 67.

2. B. 89.

3. I would like to thank Thomas Rassieur for calling to my attention the relationship of size and format between the horizontal and vertical Life of Christ plates of the 1650s.

4. For the first two states, see reproductions in Amsterdam/London 2000, 279, no. 67, fig. c (first state), and 278, no. 67 (second state). For the full range of states see Filedt Kok 1992, 161–71. The fifth state was

printed in a larger number of impressions and is currently regarded as constituting a kind of "edition" of the print by Rembrandt. The watermarks of this state are datable to 1656–57. Thomas Rassieur and the present author suspect that beginning with the sixth of the eight described states, the rather coarse rework of the plate may stem from other hands.

154–159
The Life of Christ
1654

Four etchings of vertical format and exactly similar dimensions represent significant events from the Life of Christ: The Presentation in the Temple (no. 154), The Descent from the Cross (no. 158), The Entombment (no. 155–157), and Christ at Emmaus (no. 159). The second and fourth are dated 1654. The other two, although unsigned and undated, are consistent in style and execution and can securely be assigned the same date. In these later etched religious narratives the symbolic dialogue of darkness and light plays the central expressive role. The movement and gestures of the participants are carefully calculated but are more restrained and contained than the theatrical gesticulations of the actors in the etched Biblical narratives of the 1630s.

As in the smaller 1654 horizontal format Childhood of Christ group of etchings (nos. 161–166) Rembrandt was here clearly thinking serially, even though he never went so far as to issue the prints as a numbered series with title page. He appears early and late instinctively to have worked in a serial direction with certain of his etched religious subjects but never to have followed that impulse to a conventional conclusion. There is tantalizing documentary evidence that Dirck van Cattenburch had left a set of copper plates with Rembrandt toward the end of the artist's life in order that he might etch a Passion series, but there is no evidence that the series was ever executed.[1] Was it a question of Rembrandt's failing strength and weakening eyesight or did such a conventional commissioned project simply have little appeal for him?

The striking composition of The Presentation in the Temple "in the dark manner" is discussed in the first entry in this catalogue (nos. 1–3), but it should be further noted that its composition—with the standing priest calling attention to the seated and kneeling figures below him through the emphatic vertical accent of his staff—closely parallels the relationship of the figures that occupy these positions in the tiny etched Circumcision of 1630 (no. 36)

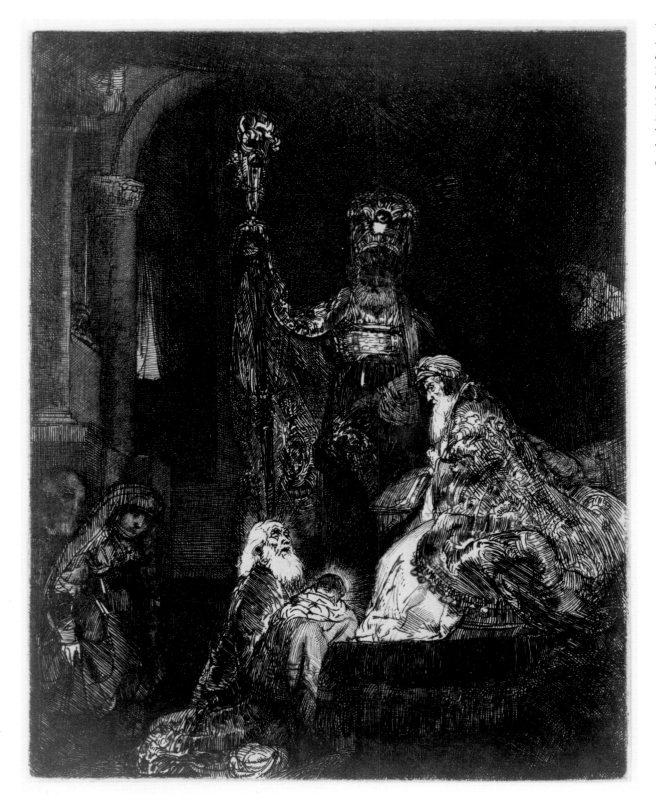

154

Presentation in the Temple (in the dark manner), 1654
Etching, drypoint, and engraving
B. 50, only state
20.9 × 16.2 cm (8¼ × 6⅜ in.)
The Art Institute of Chicago
The Clarence Buckingham Collection

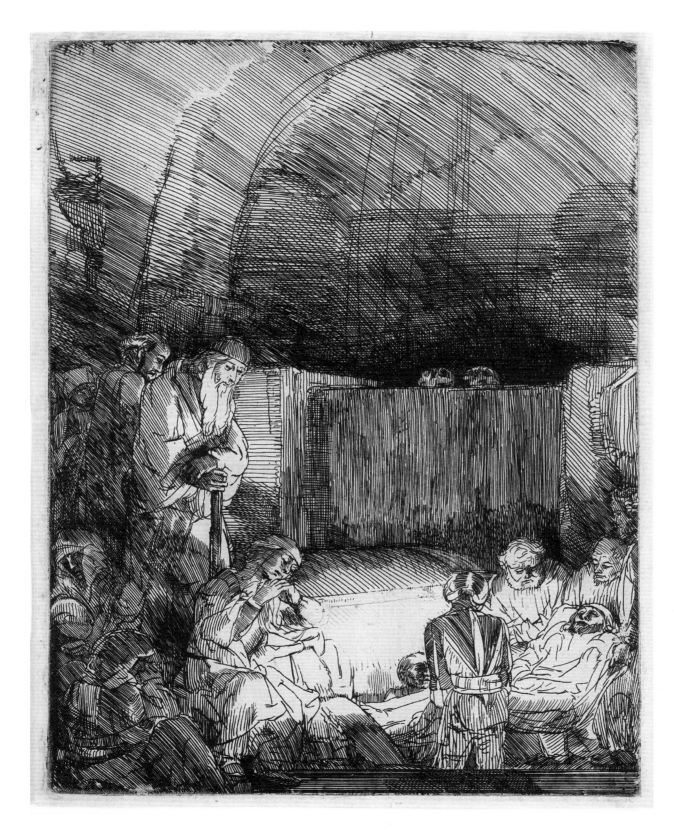

155
The Entombment, 1654
Etching on Japanese paper
B. 86, I
21 × 15.9 cm (8¼ × 6⅜ in.)
The Art Institute of Chicago
The Clarence Buckingham
Collection

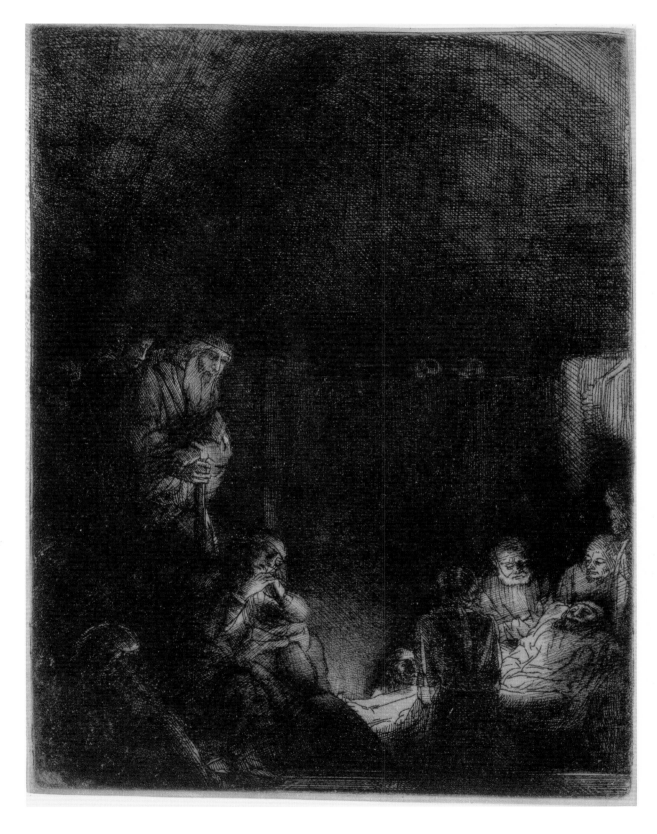

156
The Entombment, 1654
Etching, drypoint, and
engraving on vellum
B. 86, II
20.6 × 15.7 cm (8⅛ × 6³⁄₁₆ in.)
The Art Institute of Chicago
The Clarence Buckingham
Collection

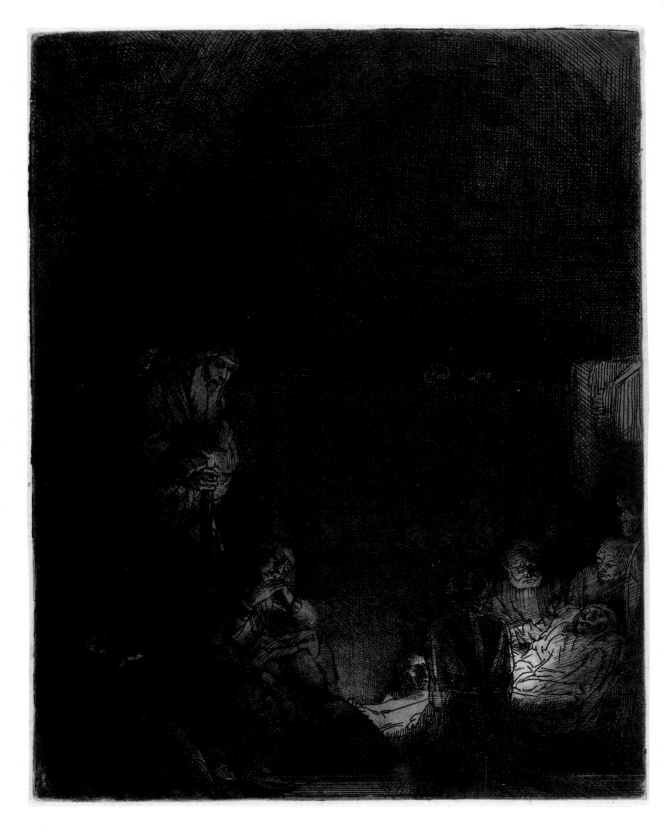

157

The Entombment, 1654
Etching, drypoint, and
engraving
B. 86, II
20.9 × 16.2 cm (8¼ × 6⅜ in.)
Museum of Fine Arts, Boston
Gift of William Norton
Bullard

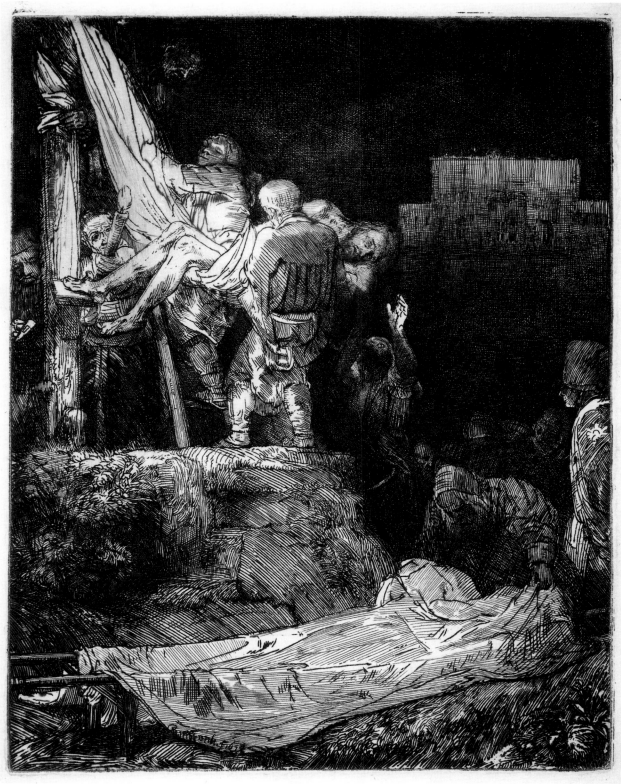

158
The Descent from the Cross by Torchlight, 1654
Etching with drypoint
B. 83, only state
21.2 × 16.5 cm (8⅜ × 6½ in.)
Museum of Fine Arts, Boston
Gift of Eijk and Rose-Marie van Otterloo in honor of Clifford S. Ackley

Here, however, in the mid-1650s the space is much shallower and more compressed and the figures dominate an interior space made mysterious and immeasurable by profound darkness.

In *The Entombment* (for the subject see nos. 45–46) men lower Christ's lifeless body, wrapped in its shroud, into a grave within a cavernous vaulted tomb. At left Christ's sorrowing followers cluster together. Above them on a high ledge rest two skulls. The participants are crowded into the immediate foreground in the lower half of the plate. The action of the lowering of Christ's body is confined to the lower right corner and lower edge of the plate, accentuating the feeling of descent into the grave.

The etching progressed through four states, with Rembrandt at each subsequent stage adding more lines to the plate, deepening the enveloping darkness and further obscuring the figures. The first two states are shown here. The relatively rare first state, seen here in an impression on white Japanese paper (no. 155), is still surprisingly luminous in feeling. The light appears to come from an unseen candle or lantern concealed behind the man standing in the grave with his back to us or—if one chooses to interpret the illumination in a more symbolic or spiritual sense—from the body of Christ itself. The first state of *The Entombment* etching is one of the most elegant, seemingly effortless examples of the lucid, systematic vocabulary of open parallel shading that Rembrandt frequently employed in his etchings of the 1650s. He takes maximum advantage of the unworked areas to give a sense of light springing upward and irradiating the space of the burial vault. The silken shimmer of the surface of the white Japanese paper subtly increases the feeling of luminosity.

In the second state (nos. 156, 157), seen here in two contrasting impressions, the image etched, scratched, and engraved into the plate was exponentially darkened. The first impression of the second state is wiped relatively clean but is a rare impression printed on a sheet of cream-colored vellum. Its warm color contributes a subtle glow of light to the image. It is remarkably well-preserved when one considers the propensity of that sensitive material to warp and shrink (see also the vellum impression of the second state of the *Christ Crucified*, no. 169). A number of impressions of the second, third, and fourth states were further darkened by being printed with a veil of extra printing ink left on the unworked areas of the plate. In the second impression of the second state this veil of extra ink has been partially wiped away from the lower body of Christ before printing (palm or finger prints are visible in this area), giving the effect of a dim or diminishing glow of light. The extinguishing of the light becomes a metaphor for the extinction of life.

The Descent from the Cross (for the subject see no. 42) is one of Rembrandt's most complex interweavings of darkness and light in a black and white image. Ever since the Renaissance, artists had been attracted to this subject not only for its spiritual pathos, but also because it provided a splendid opportunity to inventively display one's command of the human figure in action. The Rembrandt etching is known to print connoisseurs under the traditional descriptive title *The Descent from the Cross "by torchlight."* As with Rubens's altarpiece painting of the subject for Antwerp Cathedral and Rembrandt's own 1633 *Descent* painting for the court in The Hague.[2] Rembrandt heightens the drama of his etched *Descent* by giving it a nighttime setting.[3] The Rubens painting and the 1633 Rembrandt painting were illuminated by divine light falling from heaven but the Rembrandt etching of 1654 is illuminated by equally dramatic, but more realistically justified artificial light sources.

In the etching we are closer to the action than in the Rembrandt painting of 1633 referred to above: we see only the lower part of the cross. Rembrandt in characteristic fashion projects himself into the event, imagining afresh the physical challenge posed by dealing with the dead weight of Christ's body. Within a single image he suggests a chain or sequence of implied actions just performed or about to occur. Christ's body has been lowered on a slide created by a taut cloth wound around the upright of the cross, a workman behind the cross is tapping out the spike that still secures one foot, a hand reaches out of the darkness to assist with the lowering the body and finally, below, parallel to Christ's body, Joseph of Arimathea spreads linen on the stretcher that will bear Christ's body to the tomb.[4] Christ's hanging head and slack upper body are veiled with fine shading—the shadow of death. This eclipsing of life contrasts sharply with the flamelike living hand that reaches up to offer assistance. In the distance the spectral image of a grand building, possibly Pilate's palace, rises from the enshrouding gloom.

In *Christ at Emmaus* (for a discussion of the subject, another impression of the first state and the copper plate see nos. 5, 6) Rembrandt combines the light of day that lends credence to Christ's physical resurrection with the light of divine revelation. The ritual of the Eucharist takes place in a stagelike setting in an upper room accessed by stairs in the immediate foreground. The figure of the curious innkeeper who pauses to look acts as an intermediary between the viewer's everyday

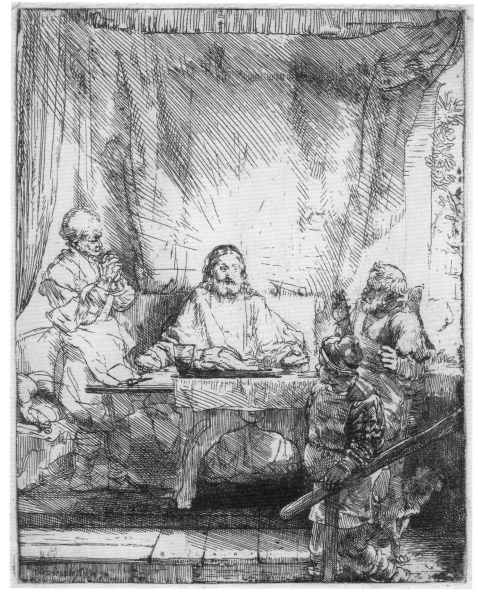

159
Christ at Emmaus, 1654
Etching on Japanese paper
B. 87, I
21.1 × 15.9 cm (8⁵⁄₁₆ × 6¼ in.)
The Art Institute of Chicago
The Clarence Buckingham
Collection

REDUCED

world and the sacred mystery of the symbolic transformation of the bread and the wine. CSA

NOTES

1. See Bredius 1909, 238–40, and White 1999, 254–55. In a legal document of 1671 the artists Allaert van Everdingen and his son Cornelis testified on behalf of the art dealer Dirck van Kattenburch regarding Kattenburch's claim to the painting of Simeon that Kattenburch had commissioned from Rembrandt and that had been left unfinished in Rembrandt's studio at the time of his death (probably the painting now in Stockholm, Br. 600). Cornelis testified that a few months before Rembrandt's death he had visited Rembrandt's studio and that he not

only had discussed the ownership of the painting with Rembrandt, but that the artist also showed him some polished plates that Kattenburch had left him "om daer de passie op te maecken" (on which to execute the Passion).

2. Br. 550.

3. For reproductions of these works see Schwartz 1985, 109–111, nos. 99 and 101; and Tümpel 1986, 132, 138–39.

4. The motif of the bier that will bear Christ's body is an unusual one, but it was anticipated by the fine cloth stretched out at the foot of the Cross to receive Christ's body in Rembrandt's collaborative reproductive print of the subject of 1633 (fig. 30, p. 33).

160

David in Prayer

1652

David, the Old Testament king of Israel, is touchingly human in his dual roles as both hero and fallible sinner. He began his illustrious career as the humble shepherd boy armed only with a sling who slew the Philistine giant Goliath (see fig. 27, p. 30). A gifted musician, he attempted to calm the jealous rages of his predecessor, Saul, with the soothing melodies of his harp.

Rembrandt's 1652 etching represents the repentant David kneeling in prayer on a cushion in his lavishly upholstered bedchamber (no. 160). In the foreground a large harp rests on its side, the key to the identification of this relatively anonymous figure as King David. Behind him a large volume, presumably a book of devotion, lies on a stool.

David's sins were two-fold. He saw the beautiful Bathsheba, the wife of Uriah the Hittite, bathing and took her into his bed. He eliminated her inconvenient husband Uriah by having him placed unprotected in the front lines of battle. David and Bathsheba conceived a child, but God punished David for his transgressions by causing the child to fall ill. In spite of David's supplications and prayers, the child died (2 Samuel 11:2–27). David's other sin involved taking—against God's will—a census of his extended kingdom in order to determine his military potential. God presented the penitent David with a choice of three punishments for this trespass and David chose the briefest, a three-day plague.

David in prayer was represented by Lucas van Leyden twice in prints that Rembrandt may very well have owned: an early engraving (B.28, about 1507) and a later etching (B.29, 1520). Both refer to the census-taking that was punished by a plague (in the first God with an avenging arrow appears in the sky and in the latter an angel appears with three arrows).[1] In both, however, David is represented as kneeling in prayer out-of-doors.

As has been noted, the fact that David in the 1652 etching is seen to be praying, his face shadowed, while leaning on his luxurious bed, most probably indicates that Rembrandt was here alluding to David's sin with Bathsheba and the ill-fated child of that coupling.[2] The most remarkable aspect of the etching is the way in which David's head is conceived as an anonymous profile defined primarily by the shadow of shame or repentance that falls over it. This shadow is drawn economically with the regular parallel strokes that Rembrandt employed so often in the 1650s. The linear

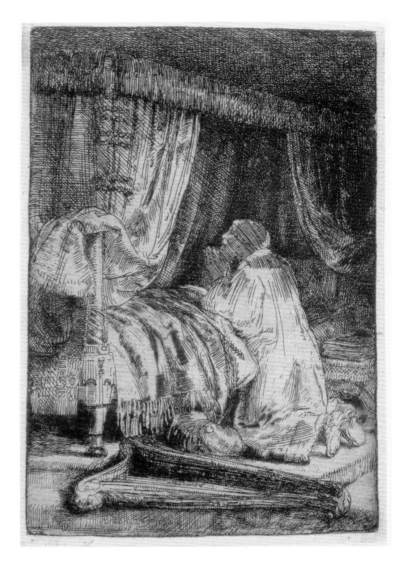

vocabulary is similar to that of the single-figure etching of the blind Tobit of 1651 (no. 132). However in *David in Prayer* the description of the rich bedroom interior symbolically upstages the lonely figure. Printed on a warm-toned cream Japanese paper, this impression is one of the rare ones in which the velvety accents of drypoint burr seldom visible on the impressions on white European paper enrich the description of the seductive softness of the bedding. CSA

160

David in Prayer, 1652
Etching and drypoint on
Japanese paper
B. 41, I
14.2 × 9.5 cm (5⁹⁄₁₆ × 3¾ in.)
Museum of Fine Arts, Boston
Katherine E. Bullard Fund in
memory of Francis Bullard

NOTES

1. Reproduced in New Holl. *Lucas van Leyden*, nos. 28 and 29.

2. For the various interpretations, see Tümpel 1970, no. 25; and Petra Jeroense and Astrid Tümpel in Van der Coelen 1996, 114, no. 32.

161–166
The Childhood of Christ
1654

In 1654 Rembrandt etched a group of six horizontal etchings on the theme of the Childhood of Christ. Five are fully signed and dated and quite similar in size and format (nos. 162–166). The sixth one, *The Adoration of the Shepherds* (no. 161) is slightly taller and squarer in format and is signed but not dated. It is, however, totally consistent with the five other prints in its style of drawing and the proportion of the figures to the space they inhabit.

The evangelist Luke tells us (Luke 2:12–20) how the shepherds—after the angel had announced to them that they would find the newborn savior "wrapped in swaddling clothes and lying in a manger"—traveled to Bethlehem to view the child and went away praising God and wondering at what they had been told and had seen, but that "Mary kept all these things, and pondered them in her heart." Here Joseph extends his arms in a "behold" gesture while Mary lifts her mantle to reveal the swaddled child to the shepherds who press eagerly forward to view the infant Savior. One shepherd politely doffs his cap while another is equipped with a bagpipe to provide a joyful musical accompaniment. At right, in the shadows beyond an overturned wheelbarrow, we see cattle in their stalls.

The Adoration of the Shepherds is traditionally catalogued as the Adoration "with the lamp." The setting is nocturnal but, unlike the other larger etched nocturnal *Adoration of the Shepherds* of the 1650s (no. 153), the manger is flooded with light. Although the literal source of the light is an oil lamp on a bracket, metaphorically we understand the source of the light to be the small child beneath the canopy of his mother's mantle. A blank semicircle of weathered boards subtly suggests a halo or aureole without violating the mood of everyday reality. In the present impression the plate was wiped clean of excess ink in the conventional manner, but Rembrandt also printed a number of impressions in which an uneven veil of ink left on the surface of the plate tempers the light and produces deeper shadows.

The linear vocabulary of this etching and the other five is the economical, suggestive shorthand combined with regular parallel shading that characterizes so many of Rembrandt's etchings of the 1650s. In the first states shown here irregular gaps in the etched line were casually left blank (see the wormlike passage at the upper right edge). Such gaps were possibly the result of a dam of wax that Rembrandt had built up around the edges of

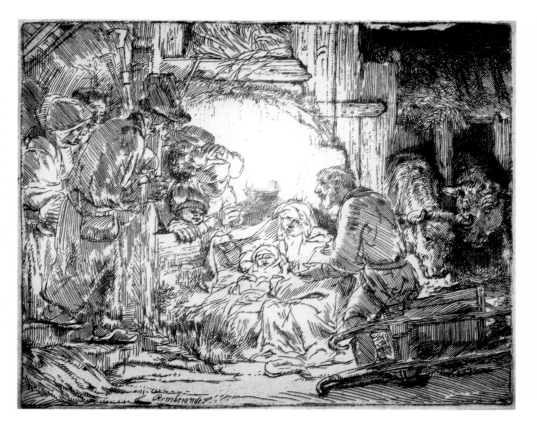

the plate in order to contain the acid during biting, or, more probably at this date, varnish applied to the edges of the copper plate in order to protect them when acid was poured over them. Rembrandt was obviously not concerned about these "defects." Later, when the plate fell into the hands of a publisher with more conventional taste, these blanks were fastidiously filled in with engraved shading.

In his earlier *Circumcision* etchings of about 1626 (no. 7) and 1630 (no. 36) Rembrandt had, in accordance with the conventions of the visual tradition, staged the circumcision of Jesus in a grand temple setting. Despite the fact that, according to the law of Moses, a woman could not enter the Temple so soon (eight days) after giving birth, Mary as well as Joseph is present in these earlier depictions. Placing the rite of circumcision in the humble setting of the stable (no. 162) allowed Mary to be present without violating religious law.[1] The setting also harmonizes better with the down-to-earth emphasis on the daily life of the Holy Family that characterizes the six 1654 "Childhood of Christ" etchings. Here the infant Jesus sits calmly enthroned in Joseph's lap during the operation rather than dramatically wincing or squalling with pain as in the earlier prints. Seated humbly by their

161

*The Adoration of the Shepherds
(with the lamp)*, 1654
Etching
B. 45, I
10.5 × 12.8 cm (4⅛ × 5¹⁄₁₆ in.)
The Art Institute of Chicago
Anonymous gift

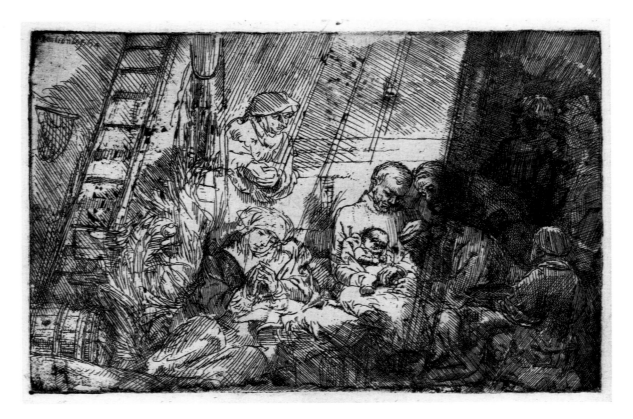

162

The Circumcision in the Stable,
1654
Etching
B. 47, I*
9.5 × 14.5 cm (3¾ × 5¹¹⁄₁₆ in.)
The Fitzwilliam Museum,
University of Cambridge

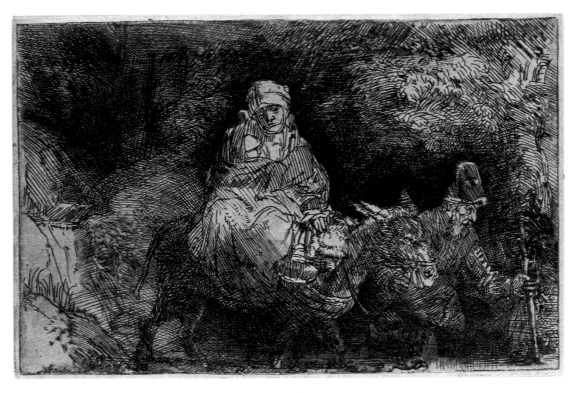

163

*The Flight into Egypt (crossing
a brook),* 1654
Etching and drypoint
B. 55, I
9.7 × 14.6 (3¹³⁄₁₆ × 5¾ in.)
The Metropolitan Museum
of Art, New York
Gift of Felix M. Warburg
and His Family

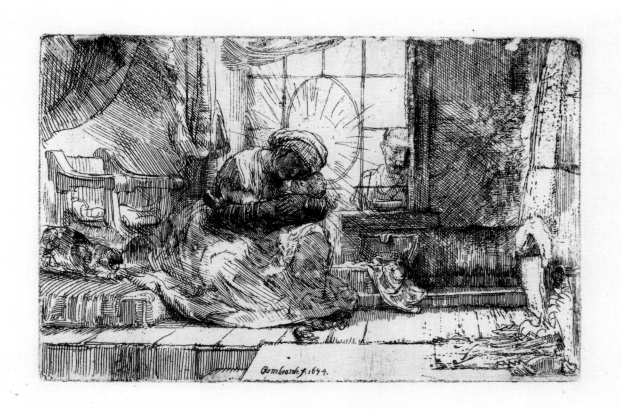

164

The Virgin and Child with the Cat and Snake, 1654
Etching
B. 63, I
9.5 × 14.5 cm (3¾ × 5¹¹⁄₁₆ in.)
Museum of Fine Arts, Boston
Katherine E. Bullard Fund in
memory of Francis Bullard

side on the stable floor, Mary adopts an attitude of prayerful meditation. Counterpoint to the barnyard realism of the setting is provided by the diagonal bands of divine light and enveloping shadow that call attention to the spiritual and symbolic import of the event. As has been noted, the ladder that leans against a post at left not only echoes and reinforces the diagonal patterns of light, but also alludes subtly to the crucifixion and the descent from the cross, future events that were to mark the end of the infant's earthly life.[2]

This fine, exceptionally early impression of the *Circumcision in the Stable* shows, in the beam of light above Joseph, strong random blotches caused by accidental biting of the plate (no. 162). Rembrandt appears to have subsequently diminished these by burnishing in order to increase the effect of radiant light, while leaving similar blotches untouched at left in the area of the ladder. He may also at this time, as has been recently noted, have used burnishing to lighten some of the shadows around the figures in the diagonal band of shadow at right.[3] If these observations are correct, this is yet another example of Rembrandt making extremely subtle adjustments

for expressive reasons while leaving untouched other areas of rough accident that would have offended a professional printmaker or publisher.

Rembrandt's last etched version of the flight of the infant Christ and his parents into Egypt to avoid Herod's jealous persecution (no. 163) shows the weary travelers fording a stream (for Rembrandt's other etched versions of the subject see no. 9 and nos. 109–114). The donkey and Joseph sink knee-deep into the water represented by the lower edge of the plate. The spotlighted group of a stoical Mary with nodding head and child asleep at her breast are set off by the shadows of the dark wood behind them. Fine early impressions of this print, such as the present one, are relatively rare because they depend for their full effect on fine touches of drypoint burr and passages in which acid was applied directly to the exposed plate. Both are very fugitive in effect. Tufts of drypoint burr lend increased depth and texture to the landscape setting while pooling acid describes the surface of the water through which they wade.

The Virgin and Child with the Cat and Snake (no. 164) is an extraordinary combination of slice-of-everyday-life

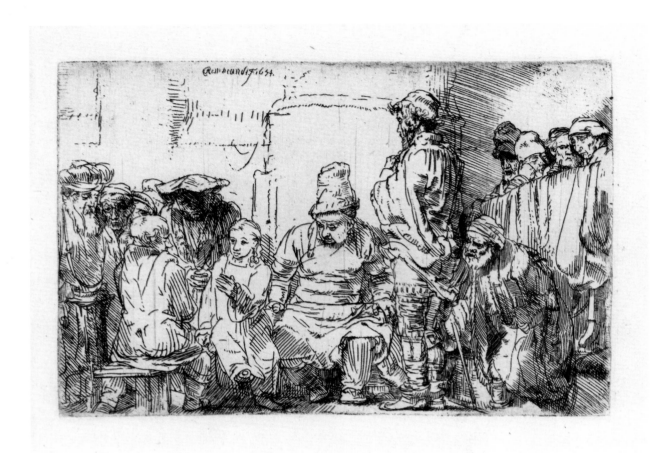

165

Christ Disputing with the Doctors,
1654
Etching
B. 64, only state
9.5 × 14.3 cm (3¾ × 5⅝ in.)
Museum of Fine Arts, Boston
Harvey D. Parker Collection

realism and traditional symbolism associated with the cult of the Virgin Mother. At first glance the etching may seem to be merely a peep into a cozy Dutch interior with fire burning in the hearth at right and tabby cat at left, but it soon becomes evident that this is no ordinary household. The ascending steps in the immediate foreground give the whole scene a stagelike feel. Mary clutches the child in a warm cheek-to-cheek embrace. A good mother, she has a box of linens ready-to-hand at her side, but to her left we see a raised platform with a thronelike chair and above it draperies that suggest a stately canopy—a suitable setting for the Queen of Heaven. The image of Mary and the child seated on the floor suggests the traditional medieval image of the Madonna of Humility, a meaning made all the more explicit by juxtaposition with a "throne" on a dais. Domestic realism coexists with religious symbolism in the eccentric detail of the tensely poised housecat that is about to spring on a snake that Mary has trapped beneath her foot. The serpent beneath the Virgin's foot is a traditional symbol of Satan the Tempter, of Sin and Death, and casts

the Virgin in the role of the New Eve sent to redeem the sin of the first Eve, mother of the human race.[4] The traditional Catholic imagery that pervades this Dutch domestic interior is further underlined when we realize that Rembrandt has modeled the group of the Madonna and Child on an engraving by or after the Italian Renaissance painter Andrea Mantegna (about 1480–85) that undoubtedly was to be found in Rembrandt's extensive collection of earlier prints, including Mantegna.[5]

This extraordinary combination of literal realism and traditional symbolism also extends to the window of the room. The divine radiance emanating from the Virgin's head is punningly echoed by the halo-like leading of the oval windowpane behind her. Outside the window, the excluded Joseph peers wistfully in upon the intimacy of mother and child, symbolizing in ingenious and very literal fashion the traditional separation of Christ's earthly foster father from the inner circle of the divinely conceived child and his mother.

Christ Disputing with the Doctors (no. 165) is the most simply conceived and executed of the 1654 "Childhood

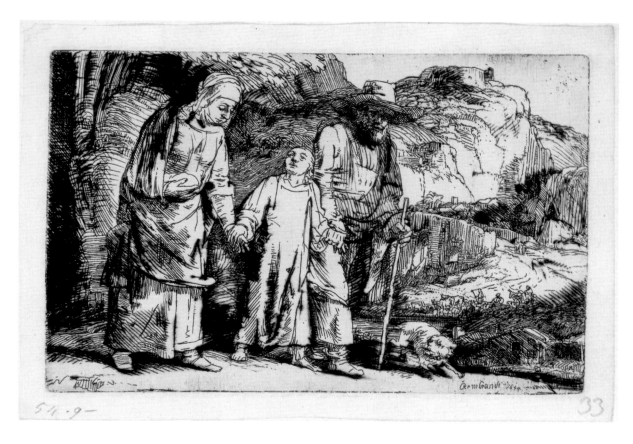

166

*Christ Returning from the Temple
with His Parents,* 1654
Etching and drypoint
B. 60, only state
9.4 × 14.4 cm (3¾ × 5¹¹/₁₆ in.)
Museum of Fine Arts, Boston
Katherine E. Bullard Fund in
memory of Francis Bullard

of Christ" group, seemingly effortlessly drawn and etched in Rembrandt's sparest 1650s linear shorthand with no supplementary drypoint touches. The truant twelve-year-old Jesus—who had left his parents during Passover in Jerusalem in order to debate with the learned doctors in the Temple—is seated on a bench on a raised platform, debating points of religion in a relaxed manner with the rabbis, a full spectrum of character types. He draws our attention not only because he is the youngest and smallest figure, or because he is the focus of the rabbis' attention, but also because he is the most simply rendered. In order to provide the maximum contrast with Christ's virtually unshaded figure, Rembrandt applied the heaviest shading in the etching to the old man with wide-brimmed hat behind Christ. The space is one of the most compressed in all of Rembrandt's 1650s compositions, producing more the feeling of a high relief sculpture rather than the deep illusionistic space that so fascinated Rembrandt in his early etched version of 1630 (no. 38).[6] Here he only hints at the architecture of the temple (the base of a mighty pillar, for example) in the most cursory fashion.

The etching showing the wayward young Christ returning from the temple with his parents (no. 166) depicts them on the road back to Nazareth accompanied by the family dog. Their figures, viewed from below, are integrated with the monumental landscape in a fashion analogous to that seen in the 1650s drawing with the prophet Elisha and the widow (no. 179). The bending tree behind Mary echoes her sorrowful hunched posture and helps to propel the travelers forward, while the form of Joseph's hat is echoed in those of the imposing rocky heights in the right background. This is the most elaborately executed of the 1654 Childhood of Christ group. In early impressions such as the present one, drypoint burr plays a key role, lending a painterly softness and richness to the deeper shadows of the landscape and the folds of the family's clothing.

Luke tells how upset Christ's parents were when, after three days of searching, they finally found him in the temple (Luke 2:48–51). It was difficult for them to fully relate to their son's precocious pursuit of his "Father's business." Here Jesus looks up into Mary's disappointed, cast-down face as if to test her mood or plead with her, while Joseph has a close grip on his son's hand and marches them firmly ahead. The little dog at Joseph's

side, running to keep up, turns its head to take in the family drama. As Luke writes: "And he went down with them, and came to Nazareth, and was subject unto them: but his mother kept all these sayings in her heart." CSA

NOTES

1. See Tümpel 1970, no. 44.

2. See Robinson 1980–81, 165–68. Robinson's lively article is full of enthusiastic observations regarding visual puns in Rembrandt's etchings, many of which the present authors have consciously used or unconsciously used or paralleled in their own observation of the prints.

3. See Martin Royalton-Kisch, "The circumcision in the stable 1654," in Amsterdam/London 2000, 304–6, no. 74.

4. Tümpel 1970, no. 64.

5. For the Mantegna, B. 8, see the reproduction in White *Etcher* 1999, 89, no. 112; and *Docs.* 1979, 1656/12, 200, "The precious book of Andrea Mantegna."

6. Rembrandt had etched a larger, closely related version of the subject in 1652 (B. 65), which is not as well resolved as the present version. The face and figure of the young Christ, who is shown standing, are somewhat vaguely rendered and there is a disproportionate emphasis on the character heads in the gallery at upper right.

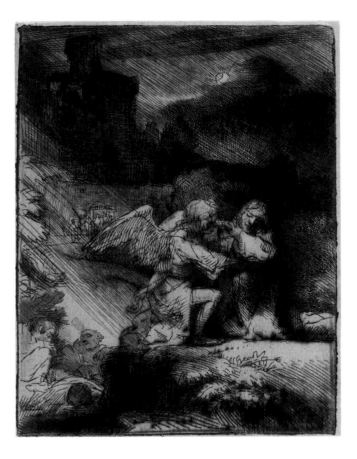

167
The Agony in the Garden,
about 1657
Etching and drypoint
B. 75, only state
11.2 × 8.3 cm (4⁷/₁₆ × 3¼ in.)
Museum of Fine Arts, Boston
Katherine E. Bullard in
memory of Francis Bullard

167

The Agony in the Garden

ABOUT 1657

The smallest of Rembrandt's later biblical prints, the undated etching and drypoint of *The Agony in the Garden* (about 1655–57, no. 167), is also one of the boldest and most powerful. The subject represents one of the most touchingly human episodes in the story of Christ's Passion, a moment of prayer, doubt, and inner struggle that occurs between the Last Supper shared with his apostles and his arrest by the authorities. The evangelists Matthew, Mark, and Luke all relate the story but Luke's is the most dramatic and the most relevant to the present image (Luke 22:37–46). Gathered together for a Passover meal in an upper room, Christ offered his assembled disciples bread and wine, explaining that they symbolized his body and his blood. He predicts that one of them (Judas) will betray him and that another, Peter, will deny him. Christ then retreats with Peter and two other disciples to the garden of Gethsemane to pray. He asks the disciples to keep watch with him but the tired disciples repeatedly fall asleep and Christ reproves them. Alone in prayer he implores his Father, if He is willing, to take away this "cup" (the cup or chalice of Eucharistic sacrifice in which the wine represents Christ's soon-

to-be-shed blood). But if this cannot be, Christ agrees to surrender to his Father's will. There then "appeared an angel unto him from heaven, strengthening him." Luke dramatically describes Christ's agony of resolve: "and his sweat was as it were great drops of blood falling down to the ground." These moments of doubt and inner struggle are followed by the entry of Judas and the authorities into the garden and Christ's arrest, trial, and execution.

Traditionally, the ministering angel was represented as appearing from a cloud and offering the chalice of the Eucharist to the kneeling Christ. Rembrandt, however, translates the biblical passage into more literal, and more human, terms: the angel "strengthens" Christ by physically embracing him.[1] Their interlocked figures are raised up on a pedestal of earth like a sculptural group, illuminated by diagonal rays of heavenly light. The disciples slumber on at the lower left and, in the far distance, the antlike figures of the arresting authorities enter through the gate of the garden.

A contemporary drawing (Hamburg, Kunsthalle)[2] reveals Rembrandt in the process of developing his ideas

for the print. All the main elements of the composition are present but the format is horizontal with an arched top rather than nearly square, and the right-angle stability of the print's composition is not yet present. Also missing is the dramatic nocturnal "dark night of the soul" setting of the etching with the partially eclipsed moon appearing from behind scudding clouds and the dark castle of officialdom looming in the distance.

The print has an underlying armature of etching, but depends for its full evocation of moonlit night and divine illumination on drypoint burr that reads like bold patches of ink wash. After a fine early impression such as the present one, the burr rapidly wore away, taking with it the full dramatic effect of this small but potent image.

Although the composition is constructed with an almost architectural rigor it is executed with great freedom. Like the large drypoints of the 1650s, *Christ Presented to the People* (nos. 173, 174) and *Christ Crucified* ("The Three Crosses," nos. 168–170), as well as certain of the later narrative drawings, it falls into a category that might appropriately be characterized as the "monumental sketch." A sense of order that one might associate with a Renaissance mural by Raphael is combined with a spontaneity of execution and sensitivity to the dialogue of darkness and light that is firmly identified with Rembrandt and his time. CSA

NOTES

1. A painting by the Italian Caravaggio follower Orazio Borgianni in the museum in Braunschweig, a nocturne, also shows the angel physically embracing Christ. Whether Rembrandt actually saw this painting is less relevant than the fact that his tendency to represent the symbolic and spiritual in literal, physical terms is in line with the aesthetic of Caravaggio and his Italian and Dutch followers. The relationship with Rembrandt's print was first noticed by Wilhelm Valentiner, see Tümpel 1970, no. 92. Reproduced in Münz 1952 2:105, no. 225.

2. Ben. 899.

168–171

Christ Crucified

THE 1650S

Two states of a pure drypoint of unprecedentedly large scale, signed and dated 1653 in the third state, and a reed pen drawing of the later 1650s embody the passionate intensity and startling breadth of execution that Rembrandt brought to the subject of Christ's crucifixion during his mature period as a graphic artist. The monumental drypoint of *Christ Crucified*, popularly known as "The Three Crosses" (nos. 168–170) can,

together with the large drypoint plate of similar format and dimensions dated 1655, which represents *Christ Presented to the People* (nos. 173, 174), be regarded as one of a pair. Both, following the subtle adjustments made in their initial states, undergo a dramatic final revision of the plate that radically changes the mood and tenor of the subject. In both there is a deliberate shift from an emphasis in the earlier states on spectators and participants to a heightened symbolic and dramatic emphasis on the figure of Christ in the final revised state.

All four evangelists provide a full account of Christ's crucifixion. It is quite likely that Rembrandt's image in its two versions (the first three states and their revision in the fourth) is inspired by elements of all four texts, but the conception of the subject in the first three states closely parallels a passage from Luke (Luke 23:44–48): "And it was about the sixth hour, and there was a darkness over all the earth until the ninth hour. And the sun was darkened, and the veil of the temple was rent in the midst. And when Jesus had cried with a loud voice, he said, Father, into thy hands I commend my spirit: and having said thus, he gave up the ghost. Now when the centurion saw what was done, he glorified God, saying, Certainly this was a righteous man. And all the people that came together to that sight, beholding the things which were done, smote their breasts and returned."

In the first three states Rembrandt showed a greater concern with anecdotal details of the narrative than in the fourth state in which the "darkness over all the earth" obscures many of the participants and only the image of Christ is truly sharply focused and fully rendered in three dimensions. In the two impressions of the second state shown here, Christ's cross, revealed in a great cone of light, is flanked by the crosses of the two thieves executed with him. To the right of the cross are gathered Christ's family and close followers: Mary Magdalene embraces Christ's feet, Christ's beloved disciple John presses his clenched fists to his head while Mary swoons, supported by another woman. At left we see the executioners: mounted soldiers with spears and, in particular, the dismounted centurion who kneels before the cross, arms outspread in recognition and reverence. In the foreground spectators take their leave, sorrowing or covered with shame and confusion. Women prostrate themselves with grief while a running dog hysterically barks. At the lower right edge of the plate a shadowy cave hollowed out of the rock prefigures the entombment of Christ's body.

Rembrandt had, prior to "The Three Crosses," generally used drypoint in combination with, or as a supplement to, etched line work. While artists such as Albrecht Dürer (see fig. 78, p. 222) had earlier made dry-

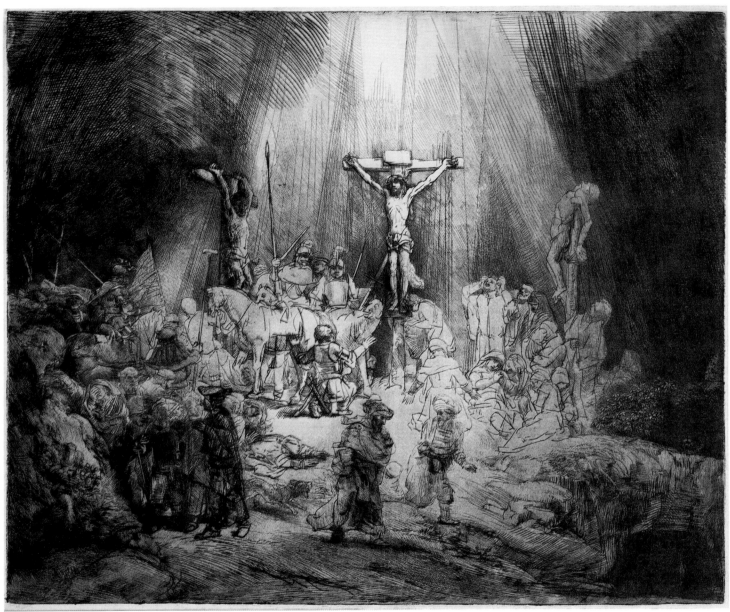

168

Christ Crucified between Two Thieves
("The Three Crosses"), 1653
Drypoint
B. 78, II
38.4 × 45 cm (15⅛ × 17¹¹⁄₁₆ in.)
Museum of Fine Arts, Boston
Katherine E. Bullard Fund in
memory of Francis Bullard and
Bequest of Mrs. Russell W. Baker

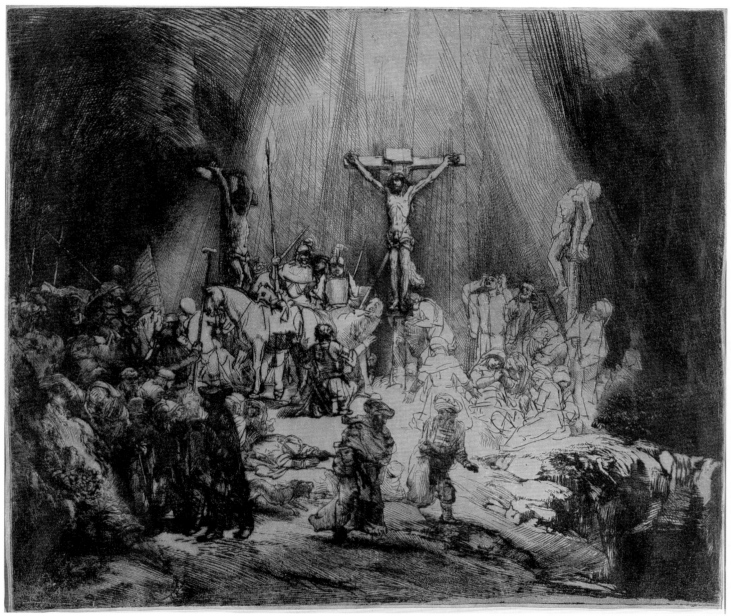

169

Christ Crucified between Two Thieves
("The Three Crosses"), 1653
Drypoint on vellum
B. 78, II
38.1 × 43.8 cm (15 × 17¼ in.)
The Metropolitan Museum of Art,
New York
Gift of Felix M. Warburg and his
Family

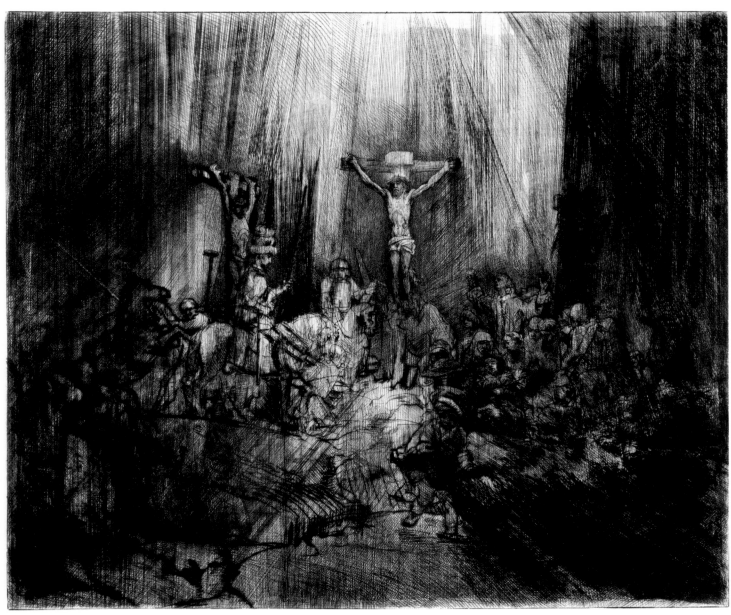

points, no one had ever executed an image in pure dry-point on this scale before. Rembrandt gouged the lines directly into the copper with a sharp point. In the dry-point medium the metal typically puts up considerable resistance to the passage of the point, often resulting in a certain inevitable angularity in the contour drawing. The burr that softens the drypoint lines and produces broad patches of velvety shadow wore rapidly between the first and second states. Rembrandt appears to have sometimes compensated for the diminishment of the

burr in the second state by painting with a tone or veil of ink on the plate before printing. In the Boston impression (no. 168) on white European paper this "painting with tone" produced a muted, twilight atmosphere. A tone of ink, a veil of translucent gray, cloaks much of the scene but is wiped away from the figure of Christ on the cross and from the area immediately around the base of the cross, subtly spotlighting the centurion's conversion. The combination of powerful outlines and the wiping away of the film of excess ink from the crucified Christ

170

Christ Crucified between Two Thieves ("The Three Crosses"), 1653–55

Drypoint

B. 78, IV

38.3 × 45 cm (15$\frac{1}{16}$ × 17$\frac{11}{16}$ in.)

Museum of Fine Arts, Boston

Harvey D. Parker Collection

171
The Raising of the Cross, 1657–58
Pen and brown ink, brown
wash, white watercolor
Ben. 1036
17.9 × 21.1 cm (7¹⁄₁₆ × 8⁵⁄₁₆ in.)
Staatliche Museen zu Berlin,
Preussischer Kulturbesitz,
Kupferstichkabinett

REDUCED

ensures that his luminous figure dominates over the shadowy scene.

The Metropolitan impression (no. 169) is—like fourteen impressions of the first state, one other impression of the second state, and two of the third state—printed on a special support of fine prepared animal skin: vellum.[1] Although vellum had been used as a support for illuminated manuscripts and miniatures during the late Middle Ages, the Renaissance, and later, this precious, expensive material was not commonly used by printmakers in Rembrandt's time. In seventeenth-century Holland vellum was, however, often used as a support for highly finished drawings that were intended to be hung on the wall. With its breadth of execution and bold tonal patterns, "The Three Crosses" carries visually at a considerable distance and is extraordinarily effective on the wall.[2] Vellum responds very differently to the dry-

point burr than does European paper. As one can see in the dramatic Metropolitan impression, vellum is, like Japanese paper, less absorbent and the ink retained by the burr bleeds generously across the surface, creating broad tonal passages. The Metropolitan vellum impression is quite cleanly wiped in the unworked areas of the middle ground, so that, in combination with the unusually rich printing of the dark passages, contrasts are dramatically intensified, particularly when compared with the subtly blended gray tones of the Boston impression.

In the dramatic fourth-state revision of the plate—in every respect the *darker* version—darkness becomes an active force that threatens to extinguish the light of Christ (no. 170). Rays of darkness stream down from above and radiate outward, as if from a point of impact. Never before in a work on this theme had the "darkness over all the land" been so tangible or so violently active a partici-

pant in the tragic event. At right the hailstorm of deeply gouged drypoint lines threatens to engulf Christ's followers and the thief on his cross is totally swallowed up by the darkness. This "black rain," as well as the rays that define the deep well of heavenly light enframing Christ, were undoubtedly drawn in the plate—as were most likely many of the lines in the first three states—with the aid of a straight edge.

Because of the radical shift in conception represented by the fourth state, which seems to anticipate later works by Rembrandt (see, for example, the allegorical *Phoenix* etching of 1658, no. 172), it has often quite understandably been suggested that the fourth state was executed several years later than the first three. Erik Hinterding's watermark research, which has revealed that the European paper used for all states of "The Three Crosses" bears the same watermark and that this large paper was not used for the 1655 *Christ Presented to the People*, has encouraged the idea that the fourth state was executed either consecutively with the first three or no later than 1655. Of course Rembrandt might very well have preserved a supply of "The Three Crosses" large paper for a longer period, but Hinterding argues that is unlikely due to the dispersal of Rembrandt's possessions in the insolvency proceedings of 1656.[3]

In the fourth state, drawing over previous work in drypoint may have necessitated a use of bolder, deeper strokes in order to suppress the previous image. Because this work predicts—even if it does not represent—later stylistic developments, it is hardly surprising that the fourth state has often been assigned a radically later date. It is now clear that Rembrandt did not extensively scrape or burnish away the previous drypoint work, although he may have removed burr from some of the lines. These lines remain present as subliminal ghosts underlying the bolder strokes of the fourth state, contributing to a mood of utter chaos and confusion. New fissures drawn in the earth at the lower left most likely allude to the passage in Matthew's account: "and the earth did quake and the rocks rent." To the left of Christ's cross the figure of the kneeling centurion is still faintly visible as a ghost but new figures of mounted soldiers have replaced the former cavalry. Extraordinarily enough, as has often been noted, the mounted captain with tall hat and spear is based on a figure from a fifteenth-century Italian medal by Pisanello that Rembrandt must have owned.[4] That Rembrandt so blatantly appropriated this image in one of his most seemingly spontaneous later works demonstrates that he, like other omnivorous artists such as Picasso, was willing to use, early and late, whatever he could lay hands on if it suited his expressive purposes.

Few of the foreground figures from the first three states are still legible in the enveloping darkness. One of the two Pharisee-like turbaned figures from the center foreground remains. Redrawn, he now seems to break into a run, plunging into the darkness. In the midst of darkness and chaos only one figure cannot be perceived as a ghost: Christ is the still center from which all else radiates. Only his figure, carefully redrawn, is delicately shaded to give it full sculptural definition. The faint light from his halo is the brightest accent in the reigning darkness.

The episode of the raising of Christ's cross is not to be found in the evangelists' accounts of Christ's crucifixion. The older pictorial traditions focused on the image of Christ being nailed to the cross while the cross was still on the ground. In the seventeenth century, particularly in the wake of Rubens's altarpiece painting of the subject, the Raising of the Cross became a popular devotional subject charged with pathos and robust physical action.[5] Rembrandt painted the subject about 1633 for Frederik Hendrik as part of the commissioned Passion series (Munich, Alte Pinakothek), featuring himself prominently as one of those helping to raise the cross.[6] There is also a very early (1628–29) Rembrandt black chalk drawing of the subject in Rotterdam that shows the influence of Jacques Callot.[7]

The Berlin drawing (no. 171), executed with a reed pen, is usually and convincingly dated about 1657–58. In its rough shorthand and breadth of execution it is the drawn equivalent of Rembrandt's monumental drypoints of 1653–55, "The Three Crosses" and *Christ Presented to the People*. In fact, Rembrandt's vigorous attack on these drypoint plates—partly dictated by the medium itself—may have impacted his later drawing style.[8] The choice of the drawing tool, the reed pen with its blunt, splintery tip, also helped to determine the appearance of the drawing. Rembrandt seems to have taken up the reed pen as early as the 1630s but its use became more frequent from the later 1640s on, when his graphic work was undergoing a noticeable shift in style toward greater breadth, simplicity, and expressive abstraction. Rembrandt's marks made with the reed pen often have the character of rough brush strokes rather than the precision of the quill pen line.

Once again, Rembrandt has used all his empathetic imagination to project himself mentally into the scene, striving to conceive afresh in realistic terms the physical and mechanical challenge posed by the planting in the earth and raising up of the cross. This drawing, like "The Three Crosses" drypoint, exhibits at its boldest Rembrandt's looping and angular shorthand notation of the human figure. The cross and Christ's body are the

agitated nexus of layered, overlapping contours that not only focus our attention on the expressive center of the composition but also suggest movement. One must observe, however, that Rembrandt originally attempted to suppress or edit out with opaque white watercolor some, but not all, of these multiple contours (including the twice-drawn rope looped around the top of the cross that a worker is tugging on) and that, over time, the watercolor covering these marks has become more transparent. The drawing is therefore now slightly more expressionistic in effect than when it left Rembrandt's hands.[9] CSA

NOTES

1. Erik Hinterding in Amsterdam/London 2000, 302, no. 73.

2. Ibid., 304, note 1, states that he has seen an impression of the fourth state that shows traces on the back as having been mounted on linen, presumably in order to hang the print on the wall. Many of the surviving impressions of "The Three Crosses" (Hinterding lists a total of at least ninety-five known impressions from all states of the print) show vertical folds or creasing as the result of their having been pasted into albums of prints. Many years ago I had the opportunity to see in the British Museum Print Room an album of prints (from Cambridge University) collected by the seventeenth-century diarist Samuel Pepys. The "centerfold" of the album was "The Three Crosses," printed on vellum.

3. Ibid., 303; and Hinterding diss. 2001, 131, and note 399.

4. For a reproduction of the medal, see Amsterdam/London 2000, 303, no. 73, fig. c.

5. Tümpel 1970, no. 99.

6. Br. 548. For a reproduction see Schwartz 1985, 108, no. 98.

7. Ben. 6 (recto). See Giltaij *Drawings* 1988, 36–39, no. 2. There is also a copy of this drawing in the collection of the Museum of Fine Arts, Boston (48.1110).

8. For this interesting observation about the possible influence of the monumental drypoints of 1653–55 on Rembrandt's later drawings I am indebted to my colleague Thomas Rassieur.

9. The Berlin drawing catalogue of Elfried Bock and Jakob Rosenberg refers to a copy of the drawing in Turin which reveals that the sheet has been cut down on the right; see Bock and Rosenberg 1931, no. 12013.

172

An Allegory: The Phoenix

1658

Winged putti blare a trumpet fanfare announcing the rebirth of the phoenix, the fabled bird that consumes itself in fire only to rise from its own ashes restored to youth. Above the smoke of a high altar, they hold taut the phoenix's leafy perch. On these gathered fronds of palms symbolizing victory stands the gawky young bird, wreathed by a great corona of mystic light. A crowd gathers around and presses against the weathered monument. One onlooker at left lifts a swaddled baby to afford the child a better view. All look up to receive the streaming rays from above. The commotion has brought a woman to the window of a tall house on the far side of the square. Seemingly unnoticed by the crowd, half-eclipsed by shadow, the fallen figure of a man, or toppled sculpture, lies on the monument's elevated base. This foreshortened figure of youthful appearance sprawls on a rich swath of drapery, perhaps the pelt of a wild animal. Above him on the altar is a crowned shield with an indistinct heraldic design. Carved skulls are visible in profile on the sides of the battered stone monument.

This visionary yet enigmatic image is signed and dated 1658 (no. 172). It has long been recognized as an allegory, but efforts to discover a specific meaning have led to widely divergent interpretations.[1] Some have attempted to link it to political affairs: royalists used the phoenix as a symbol of William III (1650–1702) who, born eight days after smallpox ended the life of his father, stadholder Willem II, represented the best hope for the resurgence of the House of Orange.[2] Others have placed the print in a religious context: Amsterdam's Portuguese Jewish community had used the phoenix as a symbol since 1612 and invoked it again in a book commemorating the victims of a 1655 persecution of their Iberian kinsmen.[3] Such efforts to associate Rembrandt's print with specific contemporary events are problematic due to the widespread use of the phoenix as a symbol.

Much more appealing—if equally speculative—is a more personal interpretation of the print as a reflection of Rembrandt's attitude toward his own changing circumstances.[4] By 1658 Rembrandt had fallen from glory. Humiliated and bankrupt, he had been forced from a grand home into much more modest quarters. He had lost a great art collection as well as some twenty-five years' production of etched copper plates. His illicit liaison with Hendrickje Stoffels had met with rebuke by church officials. Old friends and patrons had turned their backs on him. Yet, he still possessed talent, skill, and fortitude. He continued to paint, teach, and make prints. Could *The Phoenix* be his personal manifesto of perseverance and renewal?

Rembrandt's depiction of the phoenix as an awkward young bird is a departure from visual tradition.[5] The mythical bird was usually shown as having a sharp, curved beak and talons, as well as ostentatious plumage on its head and tail. It puffs out its chest to mark its avian potency. Rembrandt's scruffy hatchling has a stubby tail

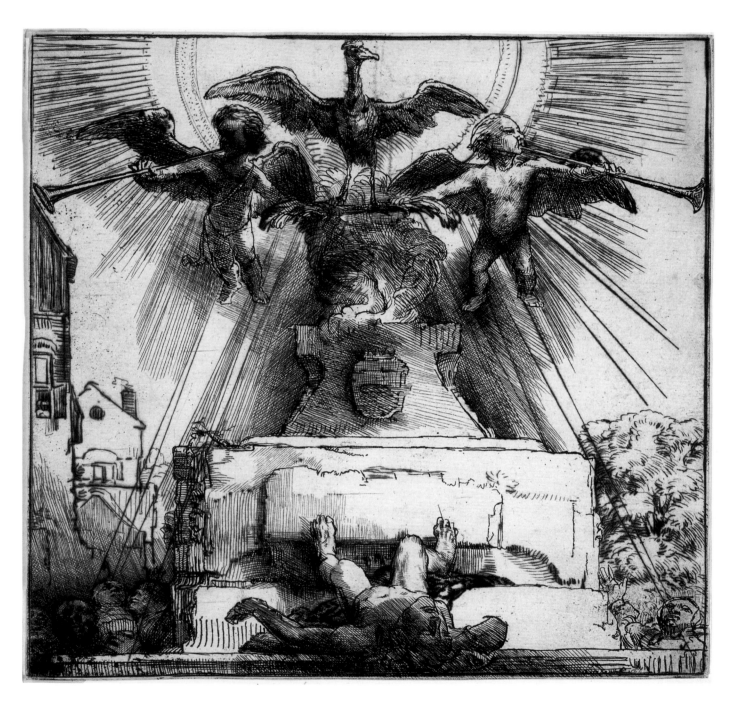

172

An Allegory: The Phoenix, 1658
Etching and drypoint
B. 110, only state
17.9 × 18.3 cm (7 1/16 × 7 3/16 in.)
The Art Institute of Chicago
The Clarence Buckingham and Amanda S.
Johnson and Marion Livingston Endowments

and flaps its wings, still uncertain how to fly. This refor-mulation may well reflect his knowledge of literary sources, for written accounts of the phoenix often men-tion that it begins its new life as a newborn or a small bird. One obvious place for Rembrandt to turn would have been Karel van Mander's chapter on the phoenix in his commentary on Ovid's *Metamorphoses*, which appeared as a companion to his renowned book on the art and history of painting.[6] Van Mander may have sparked Rembrandt's imagination with his description of the new phoenix as a small bird and his repeated men-tion of an altar dedicated to the sun. Other parts of Van Mander's text do not find equivalents in Rembrandt's print. Though we cannot say with certainty that Rem-brandt read Van Mander's commentary, it is possible that he took the inspiration he needed and disregarded aspects that were irrelevant to his own interest in renew-al. If so, this behavior parallels Rembrandt's characteris-tic grab-and-run attitude towards handy visual sources. The mysterious fallen figure in the foreground appears to be inspired by a print designed by Rubens. Though Rembrandt borrowed the pose and foreshortening, he transformed a brutish muscleman into an elegant ideal-ized figure.[7]

Of the fallen figure, Rembrandt reveals only that it had been youthful and perhaps classically handsome but now lies half obscured by shadow. Interpretations of the figure have ranged from personifications of Envy or of Spain defeated to mythical figures such as the titan Hype-rion, father of the sun. Faced with such interpretive con-fusion piled on top of the bewildering array of meanings assigned to the bird, one scholar recently threw up his hands, wryly conceding, "Not all works of art, perhaps, are made for eternity."[8]

Perhaps instead of giving up on the image, however, we should allow *The Phoenix* to be reborn as something new. Viewed simply as an imaginative work of art, the intense, expressive creativity of the print is plain to see in the bold, virtuoso handling of the medium, the explo-sive composition, and the unique combination of ideal-ization and realism so typical of the later Rembrandt. Its qualities are thrown into relief when we compare *The Phoenix* with the allegory that Rembrandt had etched twenty-five years earlier for Elias Herckman's *Der Zee-Vaert Lof* (fig. 80; see comments under no. 138). The undu-lant Baroque composition of 1633 rolls across the page, and our eyes restlessly flit among countless anecdotal details. Having no focal point, the earlier print lacks the concentrated impact of *The Phoenix*. In the later print, Rembrandt distilled his artistic means. He reduced the number of compositional elements to give each one

more power. Perfectly blending etching and drypoint, he accentuated the difference between lines scored along a straightedge and those freely drawn. Similarly, he amplified the effect of the fire, putti, and radiant corona by balancing them against the stability of his angular pyramidal composition. The resulting image bursts with radiant energy, almost hurling the fallen figure into our laps. But Rembrandt stops short of empty bombast by adding an ironic realist twist. At the apex of the blind-ing supernatural vision is its central image, the imma-ture and clumsy young bird. TER

NOTES

1. For a brief summary of theories, see Ger Luijten in Amsterdam/Lon-don 2000, 344–46. For a more extensive if somewhat dated listing, see Cornelissen 1941, 126–29.

2. Emmens 1968, 167–69. For a related usage of the phoenix, see Gov-aert Flinck's 1654 painting, *Allegory to the Memory of the Stadtholder of the Netherlands, Prince Frederick Hendrick of Orange* in the Rijksmuseum, Amsterdam; see Sumowski 1983–95, 2: 1025, 1068, no. 636.

3. Cartensen 1993, 128–31. A Christian interpretation was set forth by Weisbach 1926, 332–34.

4. Schmidt-Degener 1925, 191–208, suggested a personal interpreta-tion but perhaps placed too much emphasis of Rembrandt's aware-ness of posterity. Among contemporary scholars, Ger Luijten in Amsterdam/London 2000 (see note 1 above) rejects it, while Cren-shaw 2000, 246–47, finds it attractive, especially in the contexts of Rembrandt's financial problems and themes of envy and calumny common in seventeenth-century art literature.

5. I would like to thank Clifford Ackley for this observation.

6. Van Mander [1604] 1969, fol. 120r–v.

7. Cartensen 1993, 112, noted the relationship of the figure to Martin van der Goes's engraving after Rubens's *The Miracle of St. Ignatius Loy-ola*. A detail of the Rubens/Van der Goes figure is illustrated in Ams-terdam/London 2000, 344, no. 86, fig. b.

8. Ger Luijten in Amsterdam/London 2000, 346.

Fig. 80. *The Ship of Fortune*, 1633, etching, B. 111, II, 11.1 × 16.7 cm (4⅜ × 6⁹⁄₁₆ in.), Museum of Fine Arts, Boston, Harvey D. Parker Collection.

173–174
Christian Presented to the People



173–174
Christ Presented to the People

1655

Christ Presented to the People (nos. 173–174), signed and dated 1655 in the seventh state, is nearly identical in dimensions and format with the *Christ Crucified* ("The Three Crosses") of 1653 and is often, with justification, regarded as one of a pair with that other ambitious dry-point plate illustrating Christ's Passion. Like "The Three Crosses," *Christ Presented to the People* is a pure drypoint of a scale unprecedented in the prior history of creative printmaking. Also like "The Three Crosses," which was

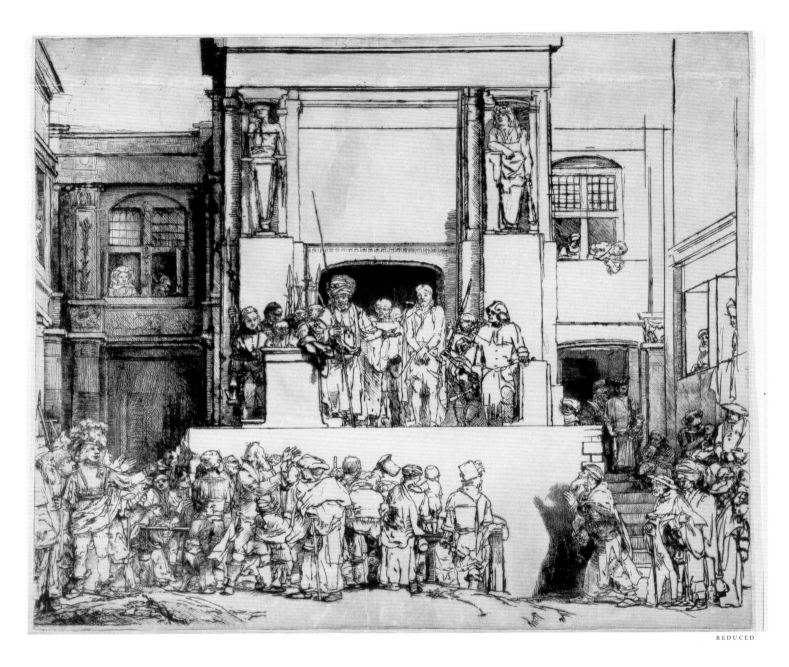

173

Christ Presented to the People, 1655
Drypoint on Japanese paper
B. 76, II
38.3 × 44.9 cm (15¹/₁₆ × 17¹¹/₁₆ in.)
The Saint Louis Art Museum
Museum Shop Fund, Friends Fund, and
funds given in honor of James D. Burke,
Museum Director from 1980 to 1999, by
Mr. and Mrs. Lester A. Crancer Jr., Mr.

and Mrs. Christian B. Peper, the Ruth
Peters MacCarthy Trust, an anonymous
donor, Mr. and Mrs. Oliver Langenberg,
Phoebe and Mark Weil, Mr. and Mrs. Sam
Fox, the Sidney S. and Sadie Cohen Print
Purchase Fund, the Julian and Hope
Edison Print Fund, Margaret Grigg
Oberheide, an anonymous donor, Mr.
and Mrs. Kenneth F. Teasdale, Mr. and
Mrs. John Bachmann, the Anne L.

Lehman Charitable Trust, Anabeth
Calkins and John Weil, Mrs. James Lee
Johnson Jr., Mr. and Mrs. Jerome J.
Sincoff, Mr. and Mrs. Sam Weiss,
Marianne and Martin E. Galt III, and Mr.
and Mrs. Andrew B. Craig III

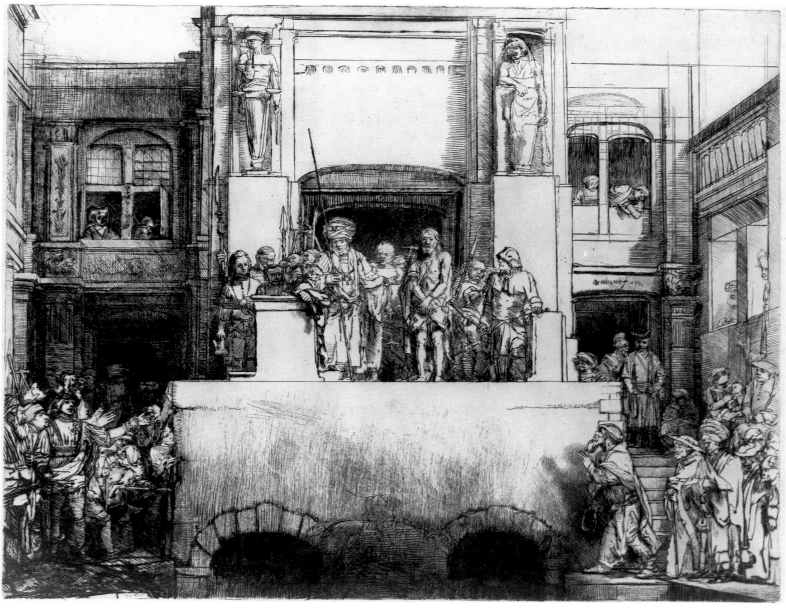

REDUCED

radically revised in the fourth and final state, *Christ Presented to the People* undergoes a major revision in the sixth, seventh, and eighth states that constitutes a dramatic shift in mood and spiritual meaning. This revision may have been partly motivated by the very nature of the medium itself, the tendency of the drypoint burr to rapidly wear away and the necessity of its being frequently redrawn and refreshed, as with "The Three Crosses."[1] It is shown here in impressions of the second state on cream Japanese paper and the eighth and final state on white European paper.

In the collaborative print of *Christ before Pilate* of 1635–36 (no. 49) the large-scale, theatrically gesticulating figures of the foreground dominate over the extravagant architecture. Here the architecture, which represents the crushing weight and authority of the state, symbolically upstages the principal players in the drama. Rembrandt's work of the 1650s is in general characterized by a new clarity, geometry, and balance. The architecture here, rendered with the aid of a straight edge, not only evokes the classicizing taste of the Italian Renaissance but it is also surprisingly symmetrical in its layout.

174

Christ Presented to the People, 1655
Drypoint
B. 76, VIII
35.7 × 45.6 cm (14 1/16 × 17 15/16 in.)
National Gallery of Art, Washington
Rosenwald Collection

Christ—whom we, the viewers, are also invited to judge—and the Roman governor Pilate are framed by a low dark arch located in the very center of the projecting pavilion and stagelike platform that constitutes the place of judgment. One need only think of the radically raking view from the wings in the earlier *Christ before Pilate* print to realize what a surprising shift has taken place in Rembrandt's spatial and theatrical conceptions. Unlike most of the imaginary architecture Rembrandt invented for his Biblical narratives, one might almost succeed in drawing a plan of this architecture. As has frequently been noted, Rembrandt's architecture here echoes the fashionable shift toward a new classicism in Dutch architecture, the most conspicuous example being the monumental new Town Hall of Amsterdam (now the Royal Palace) designed by Jacob van Campen. It was begun in 1648 and ceremoniously dedicated, though still incomplete, in this very year, 1655. The life-size herm sculptures of blind Justice with her scales and Fortitude with lion skin and club that symbolically adorn the pavilion of judgment are similar in motif, if not style, to sculptures by the Flemish sculptor Artus Quellinus on the interior and exterior of the Town Hall.[2]

The subject, which is narrated by all four evangelists, is the culminating moment in the chain of interrogations, trials, and persecutions that followed Jesus' arrest. Pilate, the Roman governor who could find no fault with the prisoner Jesus, turned the responsibility for final judgment over to the people. The turbaned Pilate holds the rod of judgment. To the left of the podium on which Pilate leans we see a young servant with basin and pitcher, a visual reference to Pilate's literal and symbolic washing his hands of the whole troublesome affair (Matthew 27:24, "I am innocent of the blood of this person: see ye to it"). It was the custom in Jerusalem on the feast of Passover, for the Roman rulers to release a prisoner in a gesture of clemency. Pilate asks the people, and the religious authorities who are stirring them up, to choose between two prisoners: Jesus and Barabbas, the leader of a bloody insurrection. The crowd chooses to free Barabbas, the brutal-looking individual with mustache, shaved head, and cockscomb of hair visible between Christ and Pilate, and to condemn Jesus to execution by crucifixion. The presence of Barabbas, so prominent in the evangelists' accounts, is rarely encountered in the visual tradition prior to Rembrandt. Rembrandt emphasizes Christ's humble status as prisoner by showing Christ and Barabbas roped together. Another detail that is rarely to be found in previous visual depictions is the inclusion of a woman who is very likely intended to be Pilate's wife. In the first five states she makes a conspicuous appearance wearing a wimple-like headdress in a window at the upper left. Matthew tells us (Mathew 27:19) that Pilate's wife sent word to her husband that he should have "nothing to do with that just man: for I have suffered many things this day in a dream because of him." In an adjoining window we see the back of a departing soldier, the message bearer.

There was a strong Netherlandish pictorial tradition that emphasized how common humanity condemned Christ, how we all are responsible. This is seen in Lucas van Leyden's engraving of 1510, which Rembrandt undoubtedly knew, in which a large agitated crowd is assembled before the platform in the public square.[3] In the first five states of Rembrandt's print a crowd representative of all ages is assembled before the platform on which Christ is exposed to view. Rembrandt deliberately emphasizes the ordinariness of these eager spectators. Directly below Christ a mother holds up her infant for a better look. This cross-section of the populace is disconcertingly drawn with almost comic affection. At the far left and right the crowd takes on a more official cast, suggesting the priests and religious authorities that egged the populace on to vote for crucifixion. At the left the dandified, pompous figure of a young soldier wearing a hat with outsize ostrich plumes strikes a note of gleeful caricature.

The first five states are represented here by the rare second state. Like other impressions of the first three states it is printed on non-Western or unconventional supports (mostly warm-toned or white Japanese paper and on vellum), in this instance a thick cream Japanese paper. An extra strip of it has been pasted on at the top, because Rembrandt did not have sheets large enough to accommodate the plate before he reduced its height by cutting away a strip of copper in the fourth state. This radical reduction of the plate removed the top course of architecture, or architrave, of the projecting pavilion. As a result of this cropping the central scene is now more tightly framed. The symbolic figures of Justice and Fortitude gain greater prominence and now appear to support the platemark. Cropping by cutting away copper was common in many of Rembrandt's small-scale early prints but relatively rare in his prints of the 1650s.

Through the first five states Rembrandt gradually gave greater completeness, detail and depth of shadow to the architecture. Here in the second state the architecture at the upper right is still sketchy and schematic. Erik Hinterding believes that the first three states are essentially working proofs and that it is only in the fourth

and fifth states that one can truly begin to speak of a completed image.[4]

In the sixth state Rembrandt began to dramatically revise the print, scraping away the crowd in front of the podium. In the seventh state he added at the base of the platform two dark arches framed in rusticated stone, with a brooding sculpted figure between them that resembles an antique river god and which has understandably provoked considerable speculation about its precise meaning.[5] In the eighth and final state seen here he somewhat suppressed and muted the effect of this melancholy and rather distracting figure by scraping away the burr on the lines and adding horizontal shading. The dark arches suggest the arches of prison or dungeon windows seen in earlier representations of the subject.[6] They have also been compared to sewers. Regardless of such specific identifications, the main point remains the remarkable shift in mood. Rembrandt intentionally retained the abraded marks of scraping on the front of the platform. These marks, together with the sinister dark arches and the brooding, now rather ghostly bearded figure fuse together to suggest a dank, dark abyss or nether region that yawns beneath Christ's feet.

In the seventh and eighth state many figures were redrawn. Pilate's wife at the window and the dandified soldier now have a more schematic, less detailed character. The single gesticulating figure of a priest that overlaps the face of the platform at right is now, together with the shadow of his gesture, dramatically isolated.

The figure of Christ was also redrawn in the seventh state. In the first five states he is a stoic, resigned, almost recessive figure. One is reminded of Christ's cryptic, fatalistic "so you say" answers or silent non-answers to Pilate's questioning in the evangelists' narratives. He wears the royal cape that the mocking soldiers have tauntingly draped about his shoulders as "King of the Jews" but not the yet more ironic "crown" of thorns that he wears in the theatrical *Christ before Pilate* print (no. 49) and in many earlier representations of the subject by other artists. In the seventh and eighth state his expression and demeanor remain stoic, humble and resigned, but his more firmly drawn figure has acquired a greater physical presence that accords well with his more conspicuous and dramatic isolation on the edge of the sheer drop into darkness that has opened up before him. CSA

NOTES

1. Erik Hinterding in Amsterdam/London 2000, 320.

2. For the Town Hall, its design, dedication, and decoration, see Fremantle 1959.

3. B. 71. New Holl. *Lucas van Leyden*, no. 71. Also reproduced in Amsterdam/London 2000, 321, no. 78, fig. a.

4. Hinterding in Amsterdam/London 2000, 318.

5. Winternitz 1969, 177–98.

6. See, for example, the Nicolaes de Bruyn engraving of 1618–19, reproduced in Winternitz 1969, 191, no. 3.

175–179
Inventing Religious Compositions
DRAWINGS OF THE 1650S

"The way to become certain and assured in composition is that one should become accustomed to making many sketches and drawing many histories on paper…Sketch and sketch again and play out the history first in your thoughts, and don't give up until you have invented a pleasing composition." Rembrandt's student Samuel van Hoogstraten offered this advice to aspiring artists in his 1678 treatise *Inleyding tot de Hooge Schoole der Schilderkonst* (Introduction to the Noble School of Painting).[1] His words must echo the instruction he received in the master's workshop in the 1640s, even if this passage does not mention his teacher by name.

The biblical compositions in the present group, as well as three others included in the exhibition (*Tobias Healing His Father's Blindness*, Cleveland, no. 133; *Tobias and the Angel Taking Leave of Raguel*, Amsterdam, no. 131; *The Raising of the Cross*, Berlin, no. 171), belong to a separate, but extensive category of Rembrandt's work as a draftsman. He made these drawings to stimulate his inventiveness with composition and emotional expression in the depiction of biblical and other literary narratives—the "histories" of Van Hoogstraten's text—and to provide models for his students, whom he challenged to sketch the same themes. Neither preparatory studies nor finished works intended for the art market, these drawings served primarily as training exercises and pedagogical tools. Significantly, most of them date from about 1640 to the early 1650s, when Rembrandt taught more pupils than at any other stage of his career.[2] Four of the drawings in the exhibition belong to the later, smaller group executed in the second half of the 1650s (*The Raising of Cross*, Berlin, no. 171; *Elisha and the Widow*, Boston, no. 179; *Noah's Ark*, Chicago, no. 178; *Christ Healing Peter's Mother in Law*, Paris, Fondation Custodia, no. 176).

The selection shown here illustrates some of the narrative strategies and expressive devices Rembrandt

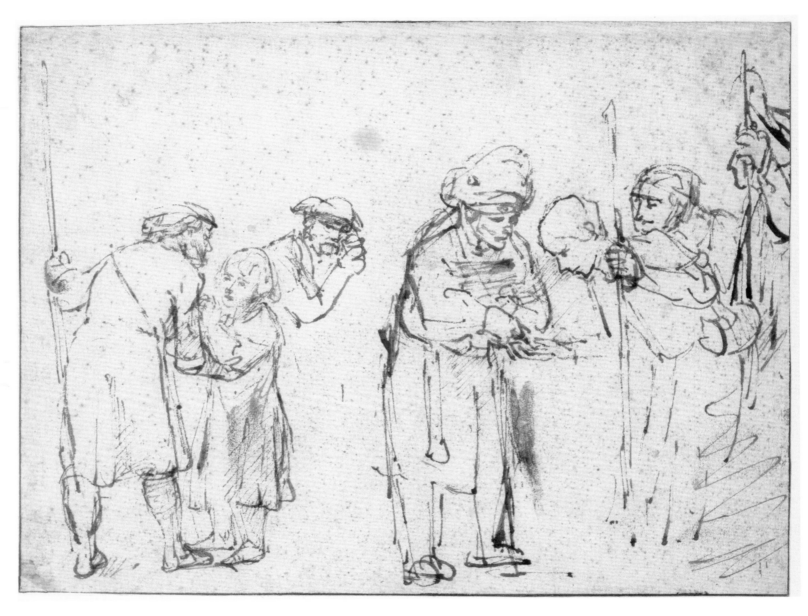

employed in these compositions. When committing his interpretation of a text to paper, his first task was to group the figures. He also outfitted the protagonists with costumes and attributes that identify them as specific individuals and as personages from biblical antiquity. In some cases he indicated a setting or backdrop that located the scene in an interior (*Tobias and the Angel Taking Leave of Raguel*) or in a rugged countryside that he imagined as the landscape of ancient Israel (*The Prophet Elisha and the Widow with Her Sons*). Most remarkably, with an extreme economy of mark-making on a few square millimeters of paper, he conveyed the body language, gestures and facial expressions that vividly characterize the emotions appropriate to the subject. In his 1718 biography of the artist, Arnold Houbraken wrote admiringly: "Connoisseurs are acquainted with hundreds of his pen sketches wherein the passions of the soul in all kinds of situations are so explicitly and artfully shown in the faces that it is admirable. Anger, hatred, sorrow, joy, and so on, everything represented so naturally that one can read the meaning from the very pen strokes themselves."[3] The gestures, facial expressions, narrative devices, and compositional ideas rehearsed in these drawings unquestionably informed the development of Rembrandt's

175

Joseph Sold into Slavery by His Brothers, about 1651–52
Pen and brown ink, wash and white watercolor
Ben. 876
15.8 × 20.5 cm (6¼ × 8¹/₁₆ in.)
Staatliche Museen zu Berlin, Preussischer Kulturbesitz, Kupferstichkabinett

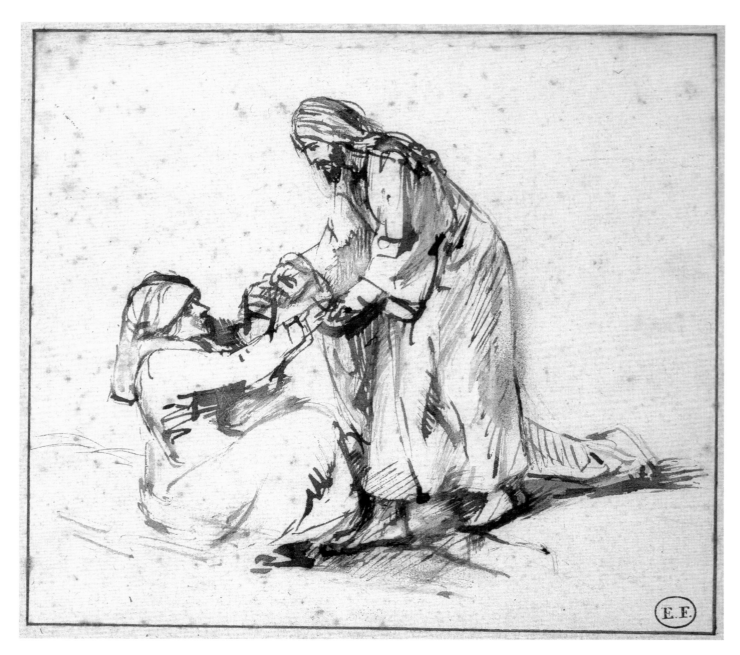

unique gift for biblical illustration that culminated in the great religious etchings of the 1650s.

When praising Rembrandt's prodigious talent for emotional expression, Houbraken must have had in mind drawings such as *Joseph Sold into Slavery by His Brothers*, datable to the early 1650s (no. 175).[4] Rembrandt singled out the moment when Joseph's brothers, jealous of their young sibling's standing with their father, Jacob, sold him as a slave to a passing group of Ishmaelite merchants (Genesis 37:17–28). The long shepherd's staffs

identify the brothers, who were herdsmen. Distinguished from them by his turban and a suggestion of ornamentation on the breast of his garment, an Ishmaelite counts out coins into the hand of one of the brothers. The latter concentrates on the transaction with greedy intensity, which Rembrandt conveyed through the purposeful inclination of his body, the emphatically outlined contour of his angular profile, and the beady eye simulated by a single round blot of ink. He adapted this pose from that of Tobias in *Tobias Healing His Father's*

176

Christ Healing Peter's Mother-in-Law, 1650s
Pen and brown ink, brown wash, and white watercolor
Ben. 1041
17.1 × 18.9 cm (6¾ × 7⁷⁄₁₆ in.)
Collection Frits Lugt, Institut Néerlandais, Paris

Blindness (no. 133), a drawing executed several years earlier.[5] Another brother peers interestedly over his shoulder. Indifferent to the pleading of the childlike Joseph —whose fearful countenance Rembrandt evoked with a few strokes of the pen—a third brother takes the youth by the elbow, ready to deliver him into slavery.

The biblical text sets the scene of *Christ Healing Peter's Mother-in-Law* in the house of Simon, Peter, and Andrew, who, with James and John, witnessed the miracle (Mark 1:29–31). In his drawing of this rarely illustrated subject (no. 176), which dates from the second half of the 1650s, Rembrandt omitted the four apostles and the domestic surroundings, except for the mat where "Simon's wife's mother lay sick of a fever."[6] Isolated and impressive in scale, the two principal protagonists enact the crucial event of the gospel passage: "And he came and took her

by the hand, and lifted her up; and immediately the fever left her." Rembrandt took particular care over this drawing: the facial expressions of both figures are carefully suggested, and he refined the modeling and the relationship of light and shade by smudging the ink with a finger and by applying opaque (now transparent) white watercolor to edit out or tone down certain passages. Thanks to Rembrandt's acute observation of bodily movement he was able to convincingly depict the see-sawing dynamics of their bodies as Jesus helps the woman to her feet. The burden of lifting her is borne by his left arm and her right arm, which are taut and straining, the hands locked together in a firm grasp. She uses her left arm for balance: the arm and wrist are bent and their clasp of Jesus' right hand more tenuous. While persuasively describing the physical effort of raising Peter's

177

Abel Slain by Cain, 1650s
Pen and brown ink
Ben. 860
16.8 × 24.7 cm (6⅝ × 9¾ in.)
Statens Museum for Kunst,
Copenhagen

mother-in-law from the floor, Rembrandt directed Jesus' intense gaze to the woman's eyes, suggesting the spiritual force that cured her fever.

Joseph Sold into Slavery by His Brothers and *Christ Healing Peter's Mother-in-Law* illustrate brief moments in the narrative without incorporating a setting or any reference to previous or subsequent events in the story. In *Abel Slain by Cain*, which dates from the beginning of the 1650s (no. 177),[7] Rembrandt included elements that invoke earlier and later occurrences in chapter 4 of the book of Genesis. The attack itself dominates the composition, but he also depicted the altars where the brothers had offered their sacrifices. On his low, humble altar Abel offered "of the firstlings of his flock and of the fat thereof" (Genesis 4:4), which the Lord approved. On a higher altar Cain placed his offering "of the fruit of the ground" (Genesis 4:3), which the Lord did not approve. In the drawing, the animal seen on Abel's altar is not one of the lambs he offered, but Cain's dog. It is in the process of consuming the remains of Abel's sacrifice—a shocking, but characteristically Rembrandtesque, detail that emphasizes the brazen impiety of the murder.[8] Sketched with summary, broken strokes that effectively suggest a transcendent apparition, God in the sky above witnesses the killing, and his stern, omniscient gaze foreshadows the subsequent events in the narrative: God will confront and punish Cain, cursing him and sending him into exile "East of Eden."

Rembrandt expressed Cain's strength and resolution in the firmly planted left foot, the dark, sinewy contour that runs from the back of his left thigh through his hips, back and shoulder, and in the straight, irresistibly taut line of the arm that grasps his brother's wrist and thrusts the shielding hand aside. We anticipate the violence of the blow because of the heavy outlines that add weight to the jawbone and the energetic strokes that follow the contour of the arm wielding the weapon. Those loose strokes serve no descriptive purpose, other than to suggest the arm's speed and force. That Abel has just dropped his crook, which he might have used in his defense, recalls that Cain took him by surprise when he was unaware of any danger: "And Cain talked with Abel his brother: and it came to pass, when they were in the field, that Cain rose up against Abel his brother, and slew him" (Genesis 4:8). The raised, flailing leg is a motif Rembrandt used early and late in painted and drawn works depicting subjects such as the *Blinding of Samson* and *Jael Killing Sisera*, in which prostrate, helpless male figures writhe spasmodically in response to sudden pain.[9] Contemplating the expression of mortal fear on Abel's face, we can only wonder, with Houbraken, how

such a profound characterization of a transient emotional state could be wrung from the tip of a quill charged with a drop of ink.

To be sure, Rembrandt did not undertake every study of this type in order to plumb the psychological depths of the theme. In the *Noah's Ark* (no. 178) he invented a boldly original composition, in which the mighty ship itself is the central protagonist. God had prescribed to the righteous Noah the exact dimensions and construction of the ship in order that Noah and his family might survive the universal Flood that God sent to destroy the sinful (Genesis 6:14–16). Many artists who illustrated this theme delighted in showing pairs of animals assembled near the ark.[10] Rembrandt omitted the picturesque menagerie and minimized the narrative: the loosely sketched members of Noah's family quietly board with their bundles, a dog, and a hesitant child. At the far left a turbaned man, presumably Noah or one of his sons, seems to urge his reluctant wife to follow the others up the gangplank.

The ark's looming form and sturdy carpentry dominate the drawing's shallow space and enclose the figures and foreground. The ribbed hump of its superstructure rises in the sunlight above the dark hull, which Rembrandt described with translucent brown wash. He delineated the heavy beams and other contours with thick

178

Noah's Ark, 1660
Pen and brown ink, brush and brown wash, and white watercolor
Ben. 1045
19.9 × 24.4 cm (7¹³⁄₁₆ × 9⅝ in.)
The Art Institute of Chicago
The Clarence Buckingham Collection

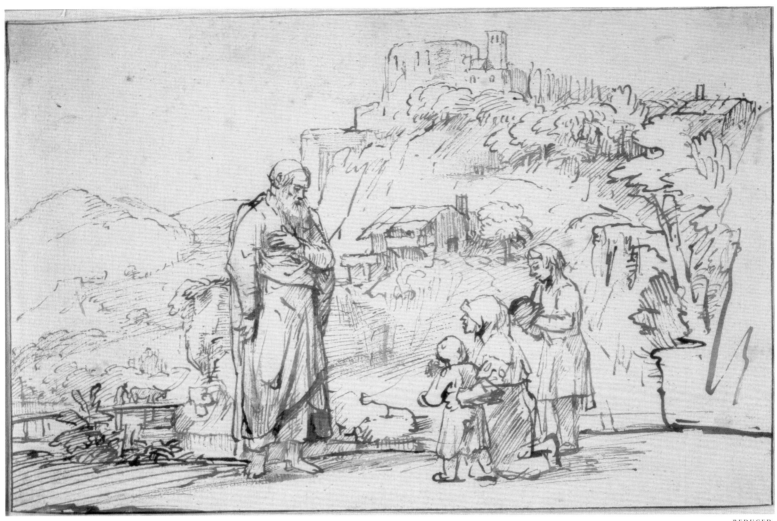

strokes of a reed pen and brush that resemble the bold drypoint outlines of such monumental prints of the mid-1650s as the *Christ Crucified* ("The Three Crosses," nos. 168–170) or the *Christ Presented to the People* (nos. 173, 174).

After the work was complete, or at least far advanced, Rembrandt hastily added irregular framing lines at the top and sides. These decisive strokes comprise a telling critique of his own composition: it should be cropped slightly at the sides and along the peak of the ark's roof. Cropping the drawing to these framing lines would have further powerfully compressed the already highly concentrated design.

The Prophet Elisha and the Widow with Her Sons (no. 179), one of the artist's most perfectly resolved biblical sketches, dates from the middle of the 1650s.[11] It illustrates the first verse of chapter 4 of the Second Book of Kings: "Thy servant my husband is dead; and thou knowest that thy servant did fear the Lord; and the creditor is come to take unto him my two sons to be bondmen." Elisha subsequently establishes that the widow's only possession is a pot of oil. Elisha works a miracle that ensures that the one pot fills many vessels and commands the widow to sell the bounteous oil, enabling her to pay her creditors and save her sons from being sold into bondage. Embracing her younger child, the widow petitions the holy man on her knees, while her older son respectfully glances downward and holds his cap in both hands, a sign of reverence as in other Dutch works of the period.[12] The prophet—his magisterial pose probably based on that of a Roman statue—responds with a profoundly characterized look of compassion.[13] He holds his arm over his breast in a gesture of humble submission that signifies

179
The Prophet Elisha and the Widow with Her Sons, 1650s
Pen and brown ink
Ben. 1027
17.2 × 25.4 cm (6¾ × 10 in.)
Museum of Fine Arts, Boston
Ernest W. Longfellow Fund,
Gift of Jessie H. Wilkinson—
Jessie H. Wilkinson Fund,
Charles H. Bayley Picture and
Painting Fund

his sympathy for the widow's predicament and his intention to intervene to free her from her creditors.[14]

The decisively rendered figures enact the narrative against an elaborately finished backdrop inspired by sixteenth-century Venetian examples. Rembrandt's extensive print collection included "a very large album with nearly all the works [after] Titian," and he copied landscape drawings by Titian and in the style of Domenico Campagnola.[15] Rembrandt adapted the Venetian model—mountainous terrain dotted with castles and farmhouses that evoke a human presence—in other biblical drawings and prints of the 1650s, such as *St. Jerome Reading in an Italian Landscape* (no. 148).[16] His choice of this ideal landscape type, which has little in common with his own naturalistic drawings and prints of the Dutch countryside, establishes the setting as historically and geographically remote. As in narrative etchings such as *Christ Returning from the Temple with His Parents* (no. 166), the calculated interaction of figures and landscape plays a key expressive role in *The Prophet Elisha and the Widow with Her Sons* and in other religious sketches of this period.[17] The landscape forms echo the strong, angular contours of the figures; a cottage bridges the void between the austere prophet and the humble widow; and the precipitous cliff behind Elisha reinforces the prophet's impressive stature and dignified pose. WWR

NOTES

1. Van Hoogstraten 1678, 191–92.

2. See William W. Robinson in Strauss and Felker 1987, 241–57; and Peter Schatborn in Van Berge-Gerbaud 1997, xxvi, for drawings of this type.

3. Houbraken 1718–21 1: 270.

4. Ben. 876. Peter Schatborn in *Master and Workshop: Drawings and Etchings* 1991, 18–19; Ben Broos in Blankert et al. 1997, 368–69.

5. Peter Schatborn in *Master and Workshop: Drawings and Etchings* 1991, 18–19.

6. Ben. 1041. Mària van Berge-Gerbaud in Van Berge-Gerbaud 1997, 51–53.

7. Ben. 860.

8. Rotermund 1963, 1. Garff 1996, 18–19.

9. For a reproduction of *The Blinding of Samson* (Br. 501), see Tümpel, 1986, 160. The drawing *Jael Killing Sisera* is Ben. 622a. The comparison of the Copenhagen drawing, the Oxford drawing, and the Frankfurt painting was made by Peter Schatborn in Schatborn 1985, 101, note 6.

10. See, for example, Roelandt Savery's paintings *The Ark of Noah* and *Before the Flood*, reproduced in Mullenmeister 1988, 314, nos. 243–44.

11. Ben. 1027. Benesch's date of "c. 1657" is perhaps too specific, but the drawing probably belongs in the period 1655–58.

12. In etchings by Claes Jansz. Visscher and Adriaen van Ostade, men and boys hold caps in both hands while praying before a meal. See Sutton 1984, 308.

13. Although it would be difficult—and perhaps beside the point—to identify a specific antique source for this figure, Rembrandt might have known original Roman statues in the Amsterdam collection of the Reynst family. See Logan 1979, 214, plate s100.

14. In Rembrandt's 1645 etching *Abraham and Isaac* (no. 67) Abraham holds one arm across his breast and points heavenward with the other as he justifies to Isaac his submission to God's will.

15. Meijer 1991, 42–43, 134–35; Van Berge-Gerbaud 1997, 46–48.

16. Ben. 909, 944.

17. Ben. 904, 909, 944.

180
Peter and John at the Gate of the Temple

1659

Rembrandt's last etching on a biblical theme (no. 180) illustrates the same episode from the Acts of the Apostles (Acts 3:1–26) that he had attempted as a young novice etcher in an experimental plate of about 1629 (no. 10). The earlier print was clearly a technical failure but nevertheless conceptually a highly expressive dramatization of the story. In the text, Peter and John's healing of the cripple is preceded by the descent of the Holy Spirit on a diverse multitude at the traditional festival of Pentecost, and by the beginning of large-scale conversions by Christ's apostles. The man crippled in his legs from birth accosted the apostles Peter and John at the Beautiful Gate of the Temple and asked them for alms. Peter replied: "Silver and gold have I none; but such as I have I give thee: In the name of Jesus Christ of Nazareth rise up and walk." The cripple walks for the first time and the witnesses to the miracle were filled with wonder. Peter informs them that it is actually Christ, the promised Messiah and Son of God who is responsible for the miracle and he encourages them to repent the sin of Christ's judgement and execution and be converted. Peter and John were subsequently arrested by the religious authorities, who were alarmed by their preaching, but they were compelled to release them because of the admiration aroused by the miracle (Acts 4: 1–22).

The etching and drypoint of 1659 constitutes on Rembrandt's part a rather surprising reversion to the love of spectacle and to imaginative settings that characterizes so many of Rembrandt's biblical narratives of the 1630s, works such as his large-scale collaborative etching of 1636, *Christ Before Pilate* (no. 49), or his 1633 painting of *Daniel and Cyrus before the Idol Bel* (no. 35). Here the grand

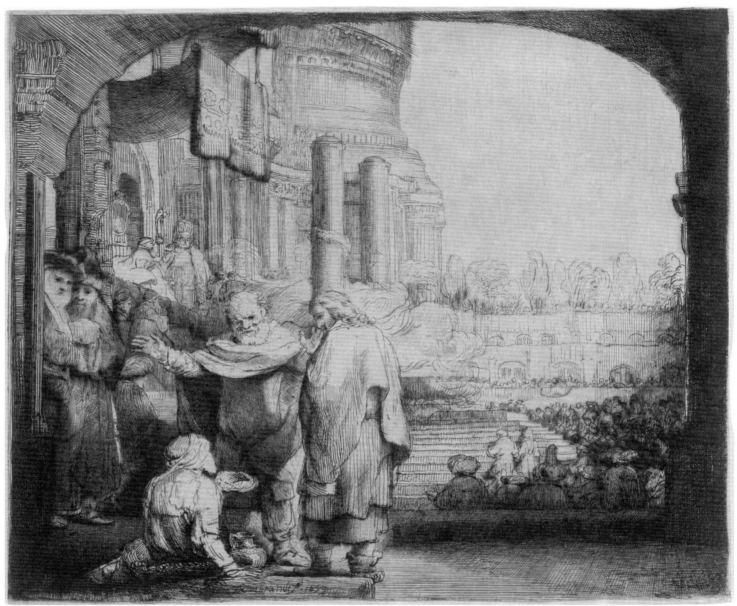

scale and opulent splendor of the temple courtyard visible through the archway of the Beautiful Gate—the throne of the high priest, the two brazen pillars of Solomon's temple,[1] the great basin on a many-stepped platform with its roiling vapors—are played off against the humble garb of the beggar and Christ's apostles. The seductive pomp and ceremony of the established religion is presented as a foil to the more inclusive common humanity of the new faith. The etching is often printed, as here, on Japanese paper with a silken texture that accords well with the sumptuous exoticism of the stag-

ing. Drypoint with burr gives a velvety depth to shadows and a feathery softness to hard edges. The depressed arch employed for the design of the Beautiful Gate was, of course, a favorite motif of Rembrandt's imaginary architecture, as well as a form favored in the framing of his pictures (see the arched top of the *Christ and the Woman of Samaria* etching of the year before, no. 203).

In the early experimental etching, large-scale figures seen close-up dominate the simple setting and the view from below causes us to identify with the point of view of the cripple being healed. In the present version, the

180

Peter and John at the Gate of the Temple, 1659
Etching and drypoint on
Japanese paper
B. 94, II
18.1 × 21.5 cm (7⅛ × 8⁷⁄₁₆ in.)
Courtesy of Fogg Art Museum,
Harvard University Art Museums,
Cambridge, Massachusetts
Gray Collection of Engravings
Fund

symbolism of the grandiose setting nearly overwhelms the central event. There is a curious softening in the drawing of the principal figures that is similar to the unconventional proportions and somewhat awkward articulation of the nude figure in Rembrandt's last major print, *The Woman with the Arrow* of 1661 (no. 201). The construction of the principal figures is in fact relatively clumsy: see the position of John's head and feet in relation to his torso.[2] The etching is fully signed and dated and undoubtedly by Rembrandt. Nevertheless, despite the appeal of its theatrical production values, this etching should perhaps be seen as representing a certain diminishing of narrative focus and of dramatic intensity in Rembrandt's last biblical print. CSA

NOTES

1. For the pillars of Solomon's temple, see Tümpel 1970, no. 119; and *Holy Bible* 1997, 1 Kings 7:15.

2. The Museum of Fine Art's first print curator, Sylvester Rosa Koehler, in Koehler 1887, captured some of the Rembrandt print connoisseur's discomfort with this surprisingly uneven performance: "Note for only one thing, the figure of St. John, muffled up in a cloak like the traditional Italian brigand of the stage, poised in an awkward contortion, and drawn like a bundle of clothing, without any feeling for the human figure."

181–184
Studies of the Male Nude

1640S AND 1650S

A teenage boy with shoulder-length hair, naked except for a loincloth, sits on a low cushioned support (no. 181). We see his gangly legs in profile, one extended and the other folded. His feet are big and awkward, and he does not seem to know quite where to put his hands. His head turns outward but not so far as to meet our gaze. Behind him, beyond some sort of embankment and up a step, stands another somewhat younger adolescent, half-grown and less developed across his chest.[1] His arms are bony. One rests on a cushion atop an indistinct chest-high support; the other hangs at his side. Further in the background we see a lightly etched domestic scene played out before a massive fireplace. A woman crouching down on one knee beckons a toddler who strains toward her in a four-wheeled walker. Nearby lie an abandoned top and the whip with which to spin it.

This peculiar image is the result of observation combined with imaginative free-association. In 1646, Rembrandt organized figure-drawing sessions so that his students could work from nude models. His choice of relatively unprepossessing sitters is remarkable for the time. Traditionally, drawn studies and prints of nude males depicted athletic bodies of sleek Apollo-like or muscular Herculean proportions. Unidealized depictions of the human body were usually reserved for images of the aged and infirm. Rembrandt seems to have enlisted young students or workshop assistants for the exercise. As their fellow students drew on paper, Rembrandt participated too, apparently sketching with a needle on coated copper plates. As he sat down to work, Rembrandt probably held the copper plate exhibited here on his knee, gripping the upper corner with his left hand (no. 182).

One of the students, Samuel van Hoogstraten, has been identified on the basis of his drawings of these same two figures. He sat to Rembrandt's right as they studied each of them. Although Rembrandt combined his sketches, Hoogstraten used two separate sheets of paper.[2] They sketched the seated figure first. Hoogstraten's second drawing informs us that a small obstruction, perhaps a carpet-covered box, blocked the line of sight to the standing adolescent's lower legs. As he did on other occasions, Rembrandt transformed studio furniture or props into a patch of make-believe landscape.[3]

The background vignette was long thought to be an unrelated sketch that Rembrandt casually added to the copper plate, a fairly reasonable assumption considering the sometimes surprising juxtapositions in his other sketch plates.[4] More recently, however, an interpretive connection between the foreground nude studies and the background image of a child learning to walk has come to be widely accepted. Seventeenth-century emblem books—books that matched moralizing texts with metaphorical images—depicted children in walkers as reminders of the importance of constant practice to learning.[5] The background is thus a commentary on the foreground: if an artist wants to learn to draw the human figure, then he must practice diligently. Lacking an accompanying text, the print is not, strictly speaking, an emblem, but it does reveal Rembrandt's involvement in a culture of metaphorical thinking.[6] He probably did not set out to make an allegorical image, but as his thoughts roamed the etching changed accordingly.[7]

Rembrandt was in great demand as a teacher.[8] He had many students, perhaps more than any Netherlandish artist apart from Rubens. They came to him at all stages of artistic development. In 1678 Hoogstraten, who went on to achieve considerable fame for his illusionistic paintings, published his *Inleyding tot de Hooge Schoole der Schilderkonst* (Introduction to the Noble School of Paint-

ing) in which he commented on Rembrandt's art and teaching.[9] While he criticized Rembrandt's inattention to the "Grondregels" (fundamental rules) of art, his advice reflects his teacher Rembrandt's practice and its effect on his students.[10] Hoogstraten warned against drawing continuous contours that outline the figures like black thread and urged students to pay close attention to the shadows right from the beginning.[11] Sketching the boys, Rembrandt lightly indicated contours as broken segments—quite visible in the outstretched foot of the seated model—and pursued a tonal approach allowing his impressionistic study of shadows to determine what parts of the body would be more fully described. In places the light fell so harshly that we see neither contour nor detail—as in the standing figure's forearm resting on the pillow. Where the light was softer, seemingly scattered strokes resolve into fully articulated form. In impressions of the first state, such as the one seen here, Rembrandt's delicate and uneven etching produced transparent shadows. His treatment of both the contours and lighting was so unconventional that when publishers reworked the plates after his death, they filled in the gaps in the outlines and made the shadows more opaque and more schematic.[12]

During the 1646 sessions Rembrandt made two other prints of male nudes, including one of a seated youth seen from the front (no. 183).[13] Now seated atop an improvised posing stand, the model appears to be the same as the one shown seated on a low box in the etching of two boys (no. 181), a notion corroborated in a drawing by Hoogstraten who this time was working to Rembrandt's left.[14] In the present etching Rembrandt portrayed the youth in a more relaxed, harmonious pose. The treatment of the figure is free and spontaneous yet also very sculptural, a quality underscored by the embrace of the curtain, which serves as a shadowy niche to throw the brightly lit figure into higher sculptural relief. Rembrandt's simple but virtuoso technique produced varied, transparent shadows seen to full effect in the fine impression shown here. A relaxed atmosphere and sense of the momentary is evident both in the boy's self-confident ease and in Rembrandt's free, but highly controlled, scribbled indication of the studio wall. Even within a body of etchings as spontaneous as Rembrandt's, these casual strokes convey a rarely equaled sense of carefree pleasure.

In the eighteenth century, a "drawing book of ten to twelve leaves" was attributed to Rembrandt.[15] Later commentators have associated this reference with Rembrandt's etched studies of nudes and his sketch plates.[16] Did Rembrandt gather together his etchings of male and

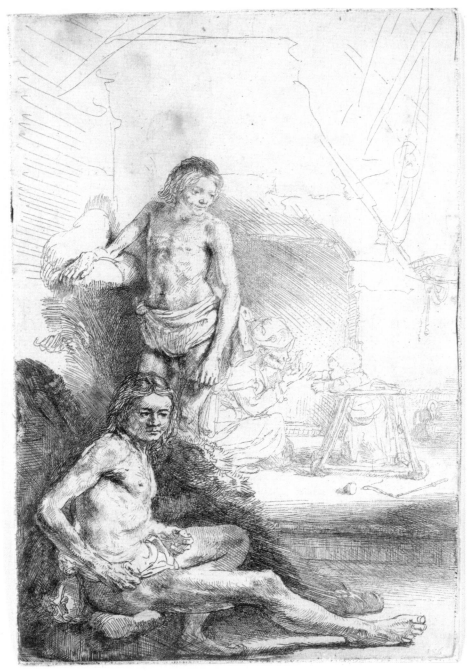

REDUCED

181

Male Nudes Seated and Standing ("The Walker"),
about 1646
Etching
B. 194, I
19.8 × 12.9 cm (7$^{13}/_{16}$ × 5$^{1}/_{16}$ in.)
James M. and Melinda A. Rabb

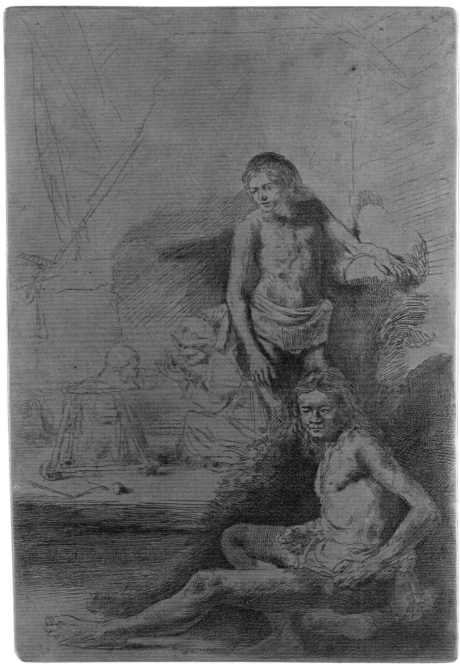

182

Male Nudes Seated and Standing ("The Walker"),
about 1646
Copper etching plate
B. 194
19.8 × 12.9 cm ($7^{13}/_{16}$ × $5^{1}/_{16}$ in.)
James M. and Melinda A. Rabb

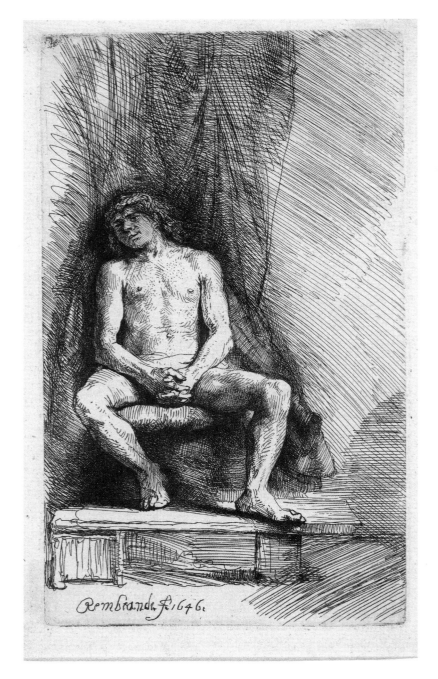

183

Nude Youth Seated before a Curtain,
1646
Etching
B. 193, I
16.5 × 9.7 cm (6½ × 3¹³⁄₁₆ in.)
Courtesy of the Fogg Art Museum,
Harvard University Art Museums,
Cambridge, Massachusetts
Gift of Philip Hofer

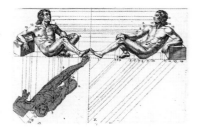

Fig. 81. Crispijn van de Passe II (Netherlandish, 1597–about 1670), Plate from *'t Licht der teken en schilder konst . . .*, 1643–44, engraving (detail), 39 × 27 cm (15³⁄₈ × 10⅝ in.), Museum of Fine Arts, Boston, Gift of W. G. Constable.

female nudes and perhaps the sheets of studies of women's heads to produce a model book for drawing students to copy?[17] Probably not, for no other mention is made of it. Still, it would not be unthinkable for an artist or collector to have assembled these related prints for such a purpose. The result would have been a book radically different from other sixteenth- or seventeenth-

century treatises on figure drawing. More typical books, such as that by the prolific engraver Crispijn van de Passe, the younger (about 1597–1670), used a highly conventional graphic vocabulary to show idealized figures and body parts carefully constructed according to systems of proportion (see fig. 81).[18] Such systems descend from the Vitruvian man with extended arms and legs inscribed in

184
The Bathers, 1651
Etching
B. 195, I
10.8 × 13.6 cm (4¼ × 5⅜ in.)
The Art Institute of Chicago
The Clarence Buckingham
Collection

a circle now familiar from the ubiquitous reproductions of Leonardo da Vinci's famous drawing.[19] In Rembrandt's time the main source of Vitruvian ideals was Albrecht Dürer's *Four Books on Human Proportion*, originally published in 1528 but often republished, including a 1622 Dutch edition. While other artists taught according to theoretical principles of imitation and construction, Rembrandt grounded his lessons in direct visual apprehension.

Rembrandt's naturalistic approach to the human body was remarkably out of step with new directions in Dutch taste. French Classicism was beginning to take hold in the Netherlands during the mid-seventeenth century. The distance between Rembrandt and the younger generation may be seen by comparing prints of similar subjects. A singular print in Rembrandt's oeuvre is *The Bathers*, signed and dated 1651 (no. 184). Combining aspects of genre scenes, landscapes, and sketch sheets, the print captures a quiet moment on a sunny day's visit to a swimming hole. There is no confirmation, but one is tempted to speculate that Rembrandt may have drawn the image in the waxy ground of his etching

plate while resting by the water's edge. The fine vertical polishing scratches seen in early impressions, such as the present one, add a touch of hazy atmosphere appropriate to the subdued mood of the image. A decade or two later, the prolific printmaker Romeyn de Hooghe (1645–1708) included a scene of men bathing in the countryside as part of a series of costume prints showing leisure time activities (fig. 82). De Hooghe's meticulously rendered, idealized figures strike poses that look directly back to the Renaissance, particularly the bathing soldiers in Michelangelo's much copied but never completed fresco, *The Battle of Cascina*.[20] Rembrandt's wonderfully unidealized, somewhat awkward and slightly melancholy figures seem almost to anticipate the later works of Cézanne. TER

Fig. 82. Romeyn de Hooghe (Dutch, 1645–1708), plate 2 from *Capricci, Figures à la Mode,* about 1670, etching, Holl. 360, 16.7 × 12.3 cm (6⁹/₁₆ × 4¹³/₁₆ in.), Private collection.

NOTES

1. Hinterding diss. 2001, 108, sees the image as two sketches of the same youth in two different poses.

2. Van Hoogstraten's drawings: seated figure (Sumowski 1971–75, 5: 2766, no. 1250x), standing figure (Paris, Musée du Louvre; Ben. A55). Two other studies of the standing figure are known. One student was to Rembrandt's left (Vienna, Albertina; Ben. 709), the other to Van

Hoogstraten's right (London, British Museum; Ben. 710). Rembrandt added corrections to the latter student's drawing. For color illustrations of the standing figures, see Amsterdam/London 2000, 215, 217, no. 51. A drawing of Rembrandt leading a different life-study session with a female model shows him surrounded by students (Darmstadt, Hessiches Landesmuseum). For a color illustration, see Williams et al. 2001, 50.

3. See for example, *Woman Bathing Her Feet at a Brook* (no. 197).

4. See sketch plates such as nos. 27, 84, and 104.

5. Emmens 1968, 154–59.

6. Dickey 1986, 258.

7. Rembrandt's drawing on the plate did not occur in an uninterrupted session. As Hinterding diss. 2001, 110, observes, he bit the plate at least twice and adjusted the width of the figures' limbs. Quite possibly, he bit the plate after sketching the two figures and then touched them up when he added the background scene.

8. Egbert Haverkamp-Begemann, "Rembrandt As Teacher," in Haverkamp-Begemann et al. 1969, 21–30.

9. Van Hoogstraten 1678.

10. Schatborn and Ornstein-van Slooten 1984, 9–10

11. Van Hoogstraten 1678, 28–29, "niet met een omtrek, die als een zwarten draet daer om loopt....al van begin af aen, de schaduwen waer te nemen."

12. Hinterding diss. 2001, 111, found that the watermarks of the papers used to print the second state were in all likelihood posthumous.

13. The other etching shows a boy seated on the floor with one leg extended and his head turned away (B. 196).

14. Paris, Bibliothèque Nationale de France; see Sumowski 1971–75, 5: 2780, no. 1256x.

15. Dézallier d'Argenville 1745–52 2: 29.

16. For example, see Emmens 1968, 157–58.

17. For examples of the female nudes see nos. 197–199. For the studies of women's heads, see no. 60.

18. Van de Passe 1643, part 2, plate 10. Collations of Van de Passe's treatise vary. For more on drawing books, see Schatborn 1981, 15–17; and Bolten 1979. One wonders whether Van de Passe's publication might have stimulated Rembrandt to organize the figure drawing classes for his own students.

19. Leonardo da Vinci, *Vitruvian Man* (Venice, Gallerie dell'Accademia). Vitruvius was a first-century Roman author whose writing on architecture and design exerted enormous influence during the Renaissance.

20. Michelangelo worked on the cartoon, about 1504–7, but the fresco for the Palazzo Vecchio never came to fruition. Printmakers disseminated his design in fragmentary form through engravings of details; for example, Marcantonio Raimondi's *Man Putting on His Breeches* (B. 472), and Agostino Veneziano's *Climbers* (B. 423).

185–195
Landscapes
THE 1650S

Seven etchings and three drawings from the early 1650s and one drawing from the late 1650s continue and conclude Rembrandt's exploration of landscape observed and imagined (see nos. 116–128). The etched panoramic landscape of 1651 (no. 151) that looks toward the city of Haarlem on the horizon at left, and a fine country estate with tower among trees in the middle distance at right, has been known since the eighteenth century as the "Goldweigher's Field." It was believed to represent the estate of Jan Uytenbogaert, the tax receiver whom Rembrandt portrayed in Renaissance dress as a goldweigher in an etching of 1639.[1] Twentieth-century scholars have discovered that the country house was in fact Saxenburg, an estate belonging to Christoffel Thijsz., to whom Rembrandt was deeply in debt for payments on his fine house on the Breestraat. The identification of the house as Saxenburg has led to speculation that Rembrandt might have made the print to please or appease Thijsz., but there is unfortunately no concrete evidence to support this attractive theory.

The etching is the ultimate expression of the panorama in Dutch landscape art, the format having evolved naturally from the flat, horizontal character of the Dutch landscape itself. The way was prepared for Rembrandt's paper panorama by the long printed landscapes of Jan van de Velde and Hercules Segers. Rembrandt recorded the same view in a drawing in Rotterdam but it was evidently not made in direct preparation for the print.[2] He drew both from the elevation of the high dunes along the seacoast, but the print—as is usual with Rembrandt—reverses the view. Rembrandt's contemporary Jacob van Ruisdael (1628/9–1682) repeatedly painted views from these dunes toward the distant city of Haarlem. These are always easy to identify due to the distinctive profile of that great ark, Haarlem's church of St. Bavo.

The landscape space, with its somewhat circular sweep and gentle undulations, is highly original in its impact. There are few continuous contours—broken lines, short hatchings, and patches of drypoint burr suggest a space irradiated by diffuse light and dissolved in atmosphere. The accents of drypoint burr that supplement the etched strokes are absolutely essential to the depth and definition of the space, especially its subtle curvature. In later impressions as the burr wore away the space tended to flatten out. The extreme horizontal extension of the space and its curvature at either end

185

Landscape with a View Toward Haarlem ("The Goldweigher's Field"), 1651
Etching and drypoint
B. 234, only state
12 × 31.9 cm (4¾ × 12⁹⁄₁₆ in.)
The Metropolitan Museum of Art, New York
Purchase, Jacob H. Schiff Bequest, by exchange, and Edwin D. Levinson Gift

186

Landscape with the House with the Little Tower, early 1650s
Pen and brown ink and brown wash
Ben. 1267
9.7 × 21.5 cm (3¹³⁄₁₆ × 8⁷⁄₁₆ in.)
The J. Paul Getty Museum, Los Angeles

REDUCED

REDUCED

have led to the suggestion that Rembrandt might have looked at the landscape through an optical device, such as a wide-angle lens.³

A pen and wash drawing comparable to "The Gold-weigher's Field" in the suggestive delicacy with which it employs broken lines, open arrays of dots, and short hatch marks to suggest the shimmer of light and atmosphere is the drawing from the Getty Museum (no. 186). It represents a country house that was situated along the Amstelveen road, *Het Torentje* ("the Little Tower"), nestled among its sheltering trees.⁴ The same house is seen again from another angle with its clustering farm buildings in a long etched landscape of about 1651, *The Landscape with Trees, Farm Buildings, and a Tower* (no. 187). In the etching, we are closer to the subject but, as in the related drawing, the foreground is blank, causing us to concentrate on the massed trees and buildings lined up on the horizon. A lone figure stands at the gate and at left the sky is darkened, suggesting the glow of sunset or lowering storm clouds, a mood heightened by the accompanying dark clump of trees that complements the heavy sky.

This image is perhaps the most self-consciously structured—in the sense of the rational, almost geometric construction of many of Rembrandt's works of the 1650s—of all of Rembrandt's landscape etchings. Originally, in the first two states, as in the drawing of the country house, the tower had a cupola. Here in the third state Rembrandt has scraped and burnished away the round top of the tower, apparently with the intention of giving increased emphasis to the compact, right-angle organization and horizontal extension of the landscape.

The etched *Landscape with the Three Gabled Cottages* of 1650 (no. 188) is a harmonious marriage of etching and drypoint. Based on drawings of houses lining the road that followed the river outside Amsterdam known as the Schinkel, the etching nevertheless rearranges and reorchestrates the relationship of these houses and their surrounding trees.⁵ The new arrangement creates a more compact grouping of cottages and trees along the deeply rutted road so as to emphasize a gradual, but continuous stepping-back into the distance. In this perfectly balanced impression of the third and final state of the print, drypoint with burr is seamlessly interwoven with passages of etching. Drypoint burr is particularly critical for the description of the softness and density of the luxuriant foliage of the trees that frame and embrace the cottages and that lend them increased mass and weight. *The Three Cottages*, like four of Rembrandt's other etched landscapes, is framed at the top with the low arch shape that Rembrandt often favored and which subtly gives increased emphasis to the solid forms of soil, trees, and earth-hugging cottages rather than to the aerial openness of the sky.

A drawing datable to about 1652 also represents, like the foregoing etching, *Houses on the Schinkelweg* (no. 189).⁶ The signboard hanging from one of the buildings indicates that it was most likely a tavern. To the left is pold-

187

Landscape with Trees, Farm Buildings, and a Tower, 1651
Etching
B. 223, III
12.3 × 31.8 (4¹³/₁₆ × 12½ in.)
The Art Institute of Chicago
The Clarence Buckingham Collection

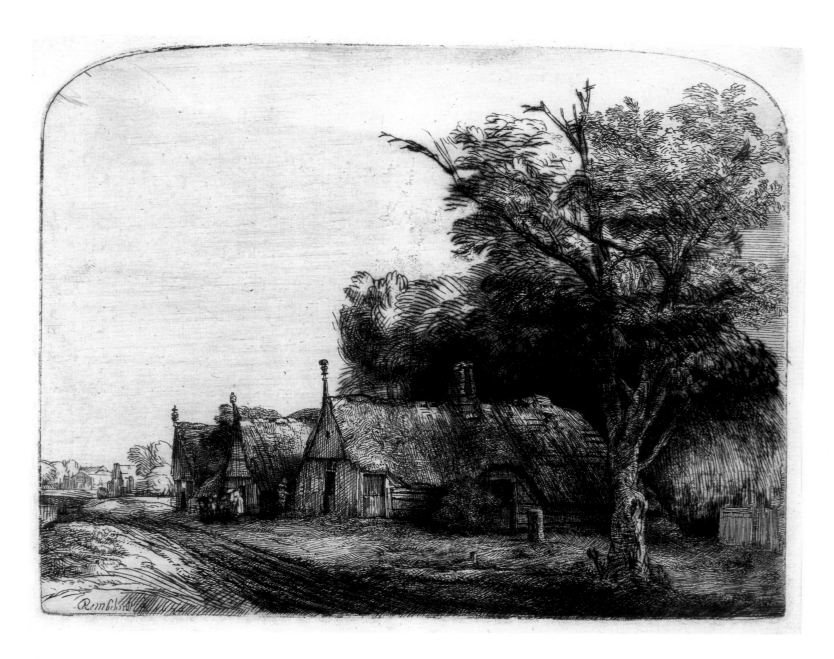

188

Landscape with Three Gabled Cottages
beside a Road, 1650
Etching and drypoint
B. 217, III
16.1 × 20.2 cm (6⁵/₁₆ × 7¹⁵/₁₆ in.)
Alan and Marianne Schwartz
Collection

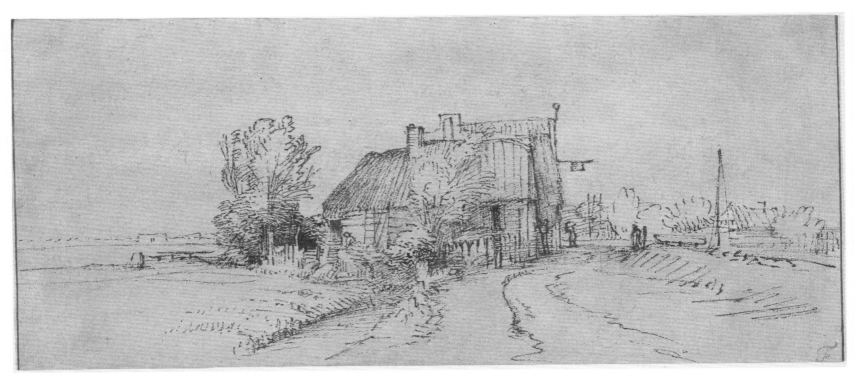

189
*Houses on the Schinkelweg
(Landscape with an Inn)*, about
1652
Pen and brown ink, brown
wash, white watercolor on
paper prepared with gray wash
Ben. 1314
10.9 × 22.1 cm (4⁵⁄₁₆ × 9 in.)
Courtesy of the Fogg Art
Museum, Harvard University
Art Museums, Cambridge,
Massachusetts
Loan from Maida and
George Abrams

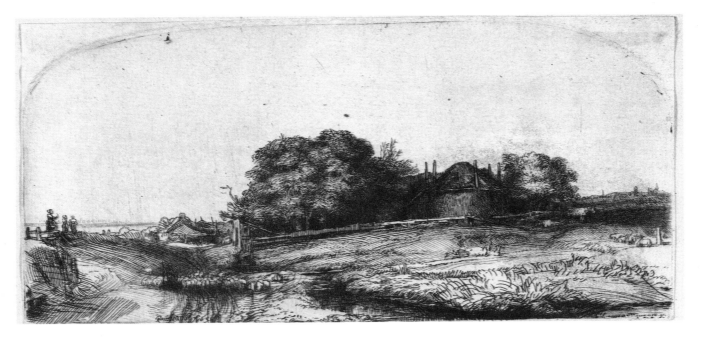

190
*Landscape with a Haybarn
and a Flock of Sheep*, 1652
Etching
B. 224, II
8.2 × 17.4 cm (3¼ × 6⅞ in.)
Courtesy of the Fogg Art
Museum, Harvard University
Art Museums, Cambridge,
Massachusetts
Gift of Arnold Knapp

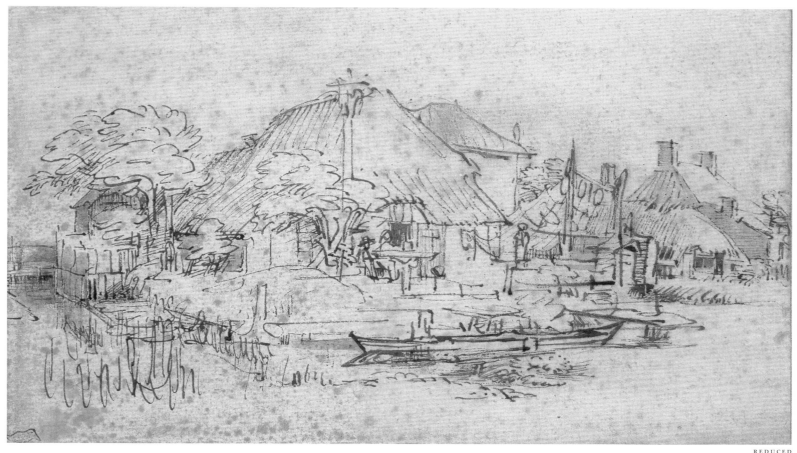

erland and at the right, on the other side of the dike, the Schinkel River with a moored sailboat. A few cursorily indicated figures animate the scene around the central buildings.

The sheet has been prepared with a tone of gray wash that softens contrasts. A number of Rembrandt's landscape drawings are executed on paper that has been prepared with a thin coating of translucent wash. The lines of the drawing are unusually suggestive: a dry, granular pen line melds with the prepared paper, giving a strong sense of solid forms dissolving in atmosphere. Rembrandt's use of parallel strokes in describing the foliage has been compared with the vocabulary of marks in the drawings by the sixteenth-century Venetian artist Titian and his circle that Rembrandt copied at this time.[7]

The etched *Landscape with a Haybarn and Flock of Sheep* of 1652 (no. 190) represents a cottage on the Diemerdijk that Rembrandt had drawn from the other side.[8] Figures stand on the dike and, in the far distance over the water, the city of Amsterdam is faintly visible. This distant view is executed in this second and final state with the most

delicate scratches of drypoint without burr. Heavier passages of drypoint with burr are used throughout the landscape to give increased weight, mass, and form to features such as the bank of the stream in the foreground or the flock of sheep with their herder moving toward us on the road below the dike. One of the liveliest details in all of Rembrandt's etched landscapes is the horse that rolls on its back in the middle of the field at right joyously kicking its legs. Rembrandt's etched landscapes are full of such enlivening anecdotes of human and animal activity, which are executed in an abbreviated shorthand vocabulary of sketchy, economical strokes, and which reveal themselves to the viewer slowly over time. The gradual discovery of these scattered and half-concealed details is one of the long-term pleasures of perusing Rembrandt's landscapes in print and drawing.

The farm property seen in the pen and wash *Farmstead beside a Canal* drawing (no. 191) was sketched by Rembrandt several times in the early 1650s from three different points of view. It is believed to be a site on the Amsteldijk along the Amstel River between the village

191

Farmstead beside a Canal, about 1650–52
Pen and brown ink, brown wash
Ben. 1297
14.9 × 24.8 cm (5⅞ × 9¾ in.)
The Art Institute of Chicago
The Clarence Buckingham Collection

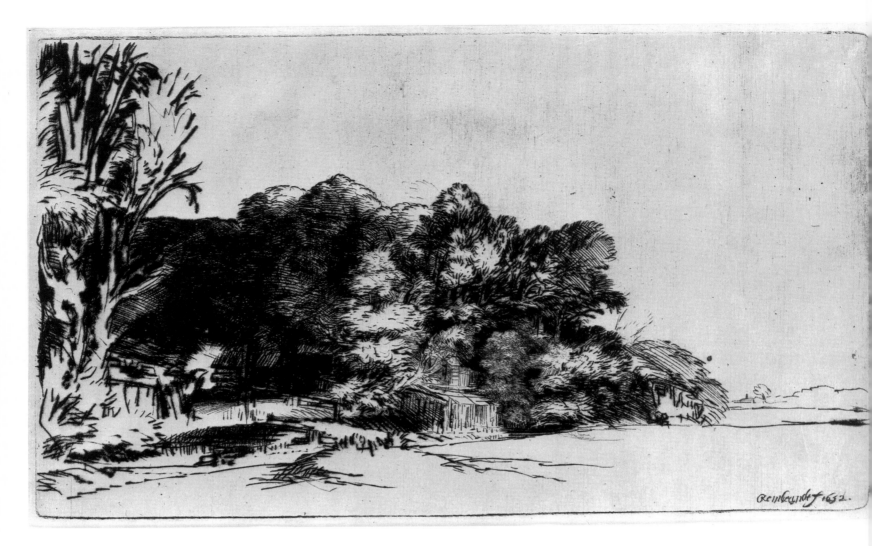

of Ouderkerk and the country house of Kostverloren.[9] The foreground boat and the fishing nets and weirs drying on poles at the right indicate that fishing was an essential part of the activity that sustained the farm. The farmhouse, like the one seen in the 1640s etching with a man sketching (no. 117), is of a type (*Langhuisstolp*) familiar in rural areas around Amsterdam, with a high barn or stalls building (visible here at center) and a lower attached living-quarters wing. In front of the high barn is a dovecote on a tall pole and, lower, a mounted wagon wheel that was used for drying pots and pans (a bucket hangs from it). Before the entrance to the barn and at right sketchily indicated human figures lend animation to the scene. A roofed-over hayrick loaded almost to its limit is visible behind the barn. Rapid calligraphic pen strokes summon up reeds growing in the water and wind-whipped trees.

The *Clump of Trees with a Vista* of 1652 (no. 192) is one of two Rembrandt landscapes of the 1650s executed in pure drypoint only, like the great religious prints of the mid-1650s, the *Three Crosses* and *Christ Presented to the People* (nos. 168–170, 173–174). It represents a farm almost engulfed by its grove of trees. The motif of a farmhouse embedded in trees is anticipated by drawings such as the spontaneous black chalk sketch sheet of the mid-1640s (nos. 123, 124). In the drypoint only a few rough board structures escape the trees' embrace. It is seen here in its completed second state after the plate had been reduced in size at bottom by cutting away a strip of copper. The rare first state consists of only a few minimal strokes that sketchily delineate the central clump of trees and the tall trees that frame the composition at the left.[10] In this richly inked impression of the second state the fullness of the drypoint burr evokes the feathery softness, as well

192

Clump of Trees with a Vista, 1652
Drypoint
B. 222, II
12.3 × 21.1 cm (4^{13}/₁₆ × 8^{5}/₁₆ in.)
The Metropolitan Museum
of Art, New York
The Sylmaris Collection,
Gift of George Coe Graves

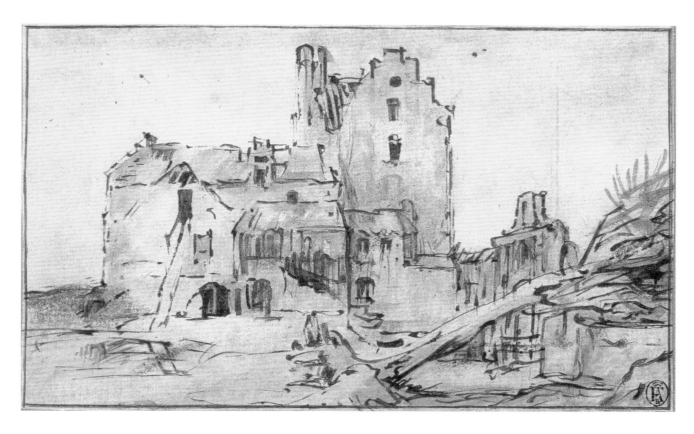

193
Kostverloren Castle in Decay,
about 1652
Pen and brown ink, brown
wash, and white watercolor
Ben. 1270
10.9 × 17.5 cm (4⁵⁄₁₆ × 6⁷⁄₈ in.)
The Art Institute of Chicago
The Clarence Buckingham
Collection

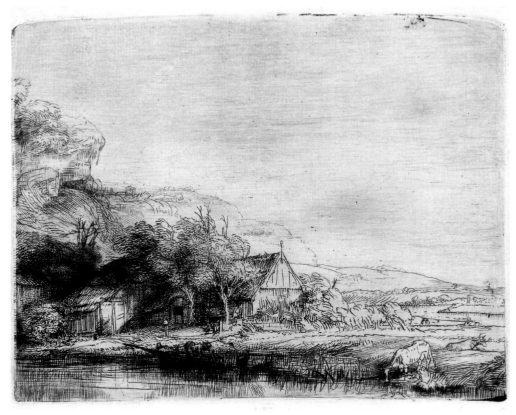

194
Landscape with a Cow Drinking,
about 1652
Etching and drypoint
B. 237, II
10.6 × 13.2 cm (4³⁄₁₆ × 5³⁄₁₆ in.)
Private Collection

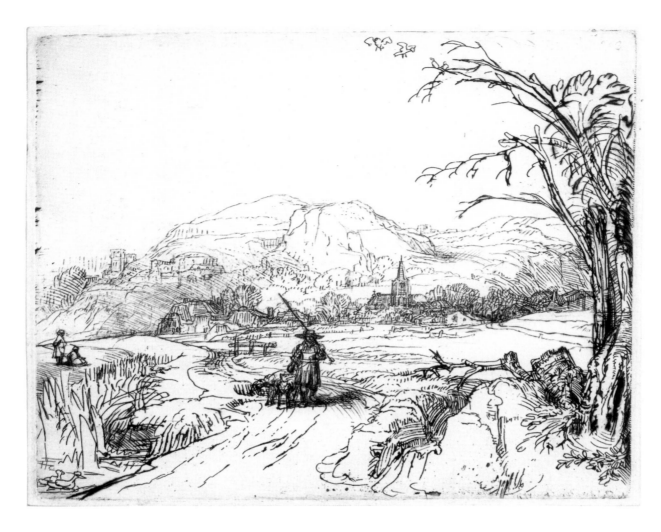

195
Landscape with a Hunter,
about 1653
Etching and drypoint
B. 211, II
12.9 × 15.7 cm (5¹/₁₆ × 6¹/₈ in.)
Private Collection

as the density of the foliage, and a light film of ink makes atmosphere more tangible.

A pen and wash drawing possibly dating from the later 1650s shows the elegant sixteenth-century country house of Kostverloren on the Amstel in ruins (no. 193).[11] The manor figured in Rembrandt's work as early as the 1641 *Landscape with a Cottage and Haybarn* (no. 118) and several of his drawings show Huis Kostverloren rising above the surrounding trees along the banks of the Amstel River. In this late sketch with its blunt, spiky pen lines, the house is starkly exposed and abandoned. At right, an uprooted tree bare of foliage adds to the mood of desolation.

Even when Rembrandt indulges in flights of fantasy and imagination in his etched landscapes of the 1650s he keeps one foot firmly grounded in direct observation of the native Dutch landscape. If we cover the hills and rocky cliffs seen in the background of the *Landscape with*

a Cow Drinking of about 1652 (no. 194), we have a fairly conventional Dutch farm landscape. The cow drinks from the river where a bent-over man busies himself in his moored boat. The print, with its gently arched top, is seen here in an unusually fine impression in which the strong drypoint burr that supplements the etched passages gives the landscape forms their full shadows and substance, and horizontal polishing scratches provide the sky with a thicker atmosphere. In later impressions, after the burr has diminished, the synthetic marriage of observation and fantasy that characterizes this landscape loses its coherence.

The *Landscape with a Hunter* (no. 195) is the most imaginary as well as most constructed in feeling of Rembrandt's etched landscapes. The background with its stately mountains and temple-like building resonate with the nocturnal landscape painting of 1647, *The Rest on the Flight* from Dublin (no. 112). It therefore comes as

a bit of a surprise to discover that the church tower in the distance is that of the village of Ouderkerk outside Amsterdam,[12] demonstrating once again that the persuasiveness of Rembrandt's fantasy and invention is the result of its thorough grounding in his observation of reality.

The man with the brace of dogs and the pole over his shoulder walking toward us on the road that winds into the distance has sometimes been identified as a shepherd, but he is more likely a hunter armed with a special knob-tipped pole that was used to flush rabbits out of their holes.[13] The landscape has been variously dated from the mid-1640s to the early 1650s, but its careful rational construction and its affinity to the invented landscape forms in etched biblical narratives of the 1650s, such as *Christ Returning from the Temple with His Parents* of 1654 (no. 166) incline one to date it in the early to mid-1650s. CSA

NOTES

1. B. 281.

2. Giltaij *Drawings* 1988, 78–79, no. 21, illustrated; and Bakker et al. 1998, 374–79, illustrated in black/white and color. The information on the drawings for this entry was provided by William Robinson.

3. See Bakker et al. 1998, 376, and note 7.

4. Ibid., 314–19.

5. Ibid., 329–36.

6. Ibid., 330–31; and Robinson 2002, 138–39, no. 56.

7. Robinson 2002, 138.

8. Oxford, Ashmolean Museum, Ben. 1227. For an illustration in black/white and color, see Bakker et al. 1998, 219–26.

9. Bakker et al. 1998, 290–97; and Robinson 2002, 136–37, no. 55.

10. See Martin Royalton-Kisch in Amsterdam/London 2000, 285–89, no. 70; an impression of the first state is reproduced on page 286.

11. Bakker et al. 1998, 281–89.

12. Ibid., 244.

13. For the poles used in hunting rabbits, see De Jongh 1986, 262–64.

196–197
Female Nudes

EARLY AND LATE

Rembrandt made nine etchings prominently featuring nude female figures: three in about 1631 and six from 1658 to 1661.[1] In both periods he made etchings in which the model appears to sit on a woodland bank with both feet immersed in the water above her ankles. They are in some respects so similar and in others so different that one suspects that Rembrandt may have intentionally revisited the subject. The larger, nearly square early print casts the model in the role of *Diana*, the chaste mythical goddess of the hunt and of the moon (no. 196). The smaller later one, tall and narrow, assigns the woman no specific role (no. 197).

Diana began with a study of a nude woman drawn in black chalk.[2] As would later be the case with the study of two nude young males (no. 181), Rembrandt may have indulged in a bit of free-association. In the drawing he transformed what must have been the studio interior into a sylvan glade and sketchily indicated a bow and quiver of arrows, attributes of Diana. When he decided to use his study as the basis for a print, he blackened the back of the sheet and traced the outlines onto a copper plate covered with white ground (see "Looking over Rembrandt's Shoulder," p. 49, and note 21, p. 59).

As Rembrandt etched Diana and her surroundings, he made many changes to the image. In the drawing, her bow and quiver of arrows hung above her from an unseen tree. In the etching, a tree trunk is clearly visible, but now the quiver lies near her hands and the bow is absent. Using extremely fine and delicate strokes Rembrandt elaborated the landscape, adding a dense screen of bushes to protect the chaste bather from the intrusion of onlookers—except of course for us, at whom she impassively stares. Voyeurism is a central theme of the Diana myth. Actaeon spied on her and her nymphs while they bathed and was punished by being transformed into a stag that was hunted to death. Rembrandt stops short of placing us in the role of Actaeon, for Diana expresses neither fear nor anger.[3] The rich brocade and jewels of the lustrous mantle spread out on the bank attest to her elevated status as goddess. Rembrandt omits the crescent moon that customarily adorns her headdress. Perhaps the darkened surroundings and suggestion of glowing reflections on the water are meant to allude to moonlight.

Traditionally artists granted the bodies of goddesses immunity to gravity, but not Rembrandt. Diana's weighty breast droops, and her stomach spills into her lap. He mapped every ripple of her unathletic body and noted where her skin had lost its elasticity. Rembrandt depicted his oh-so-mortal model with startling candor. In doing so he showed an affinity for the ideas of Carravaggio, to whom Karel van Mander attributed provocative remarks to the effect that art not made from nature is "a mere bagatelle, child's play or trifle."[4] However, Rembrandt's independent spirit is readily seen in the underlying sympathy that pervades his depiction of

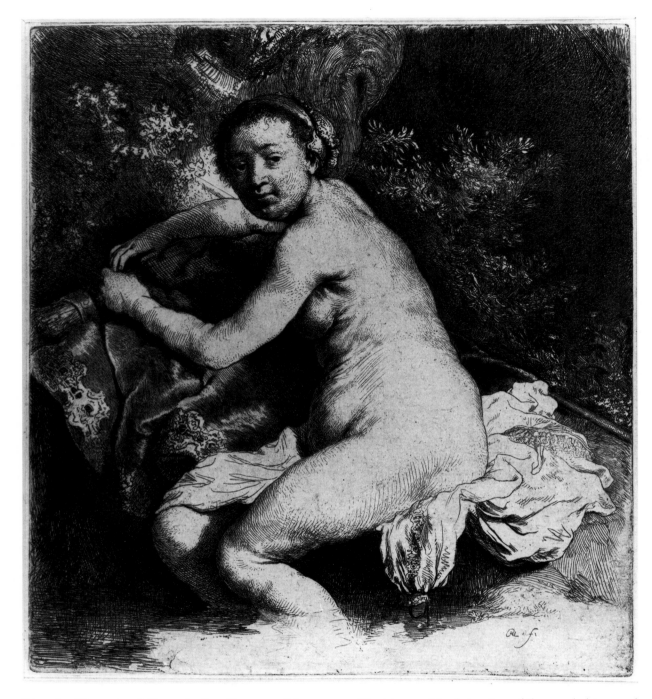

196
Diana at the Bath, about 1631
Etching
B. 201, only state
17.8 × 16 cm (7 × 6⁵⁄₁₆ in.)
Teylers Museum, Haarlem

Diana in all her splendid imperfection. He may well have seen himself as improving upon the achievements of great painters of the human form. To the sumptuously fleshed, living and breathing figures created by the likes of the Carracci in Italy or Rubens in Antwerp—whose art he knew primarily through prints—Rembrandt added greater fidelity to nature.[5]

The biomorphic abstraction of the gnarled tree and rolls of flesh may echo the taste for the curvilinear complexities of the decorative lobate or cartilage style that enjoyed a long period of fashionability in seventeenth-century Holland.[6] The body types seen in paintings of elegant ladies and goddesses suggest that narrow shoulders and large bellies were in vogue.[7] Later observers,

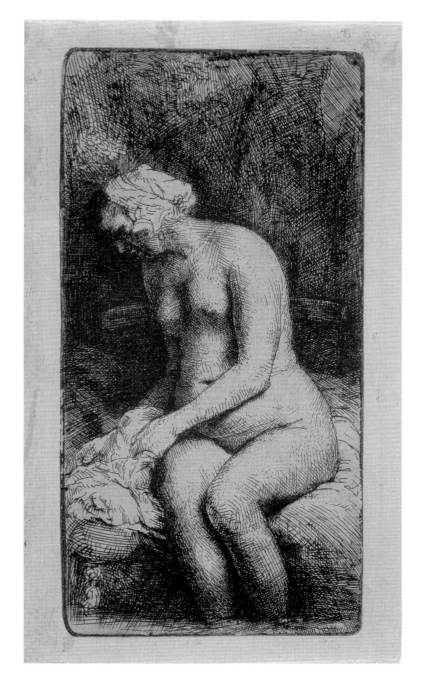

197

Woman Bathing Her Feet at a Brook, 1658
Etching, drypoint, and
engraving on Japanese paper
B. 200, only state
16 × 7.9 cm (6⁵/₁₆ × 3⅛ in.)
Museum of Fine Arts, Boston
Harvey D. Parker Collection

however, saw Rembrandt's nudes as grotesque due to his rejection of classical canons of harmony and proportion. About 1630, few Dutch artists seem to have studied nude models.[8] While the practice became more common by midcentury, the rise of French-influenced classicizing taste dictated that models should have more balanced proportions and that studies would be translated into idealized images. Although for much of his career Rembrandt faced competition from artists such as Jacob van Loo, who produced many paintings of idealized nudes, the first published criticism of his nudes appeared some years after his death.[9] In a 1681 poem, theater critic Andries Pels called Rembrandt "the first heretic of art" and went on to lambaste his depiction of the female

body.[10] Although Pels may have had foremost in his mind another etching of about 1631, the even more starkly unidealized *Naked Woman Seated on a Mound*, some of what he says could apply to *Diana*:[11]

> when he would paint a naked woman, as sometimes happened,
> [he] chose no Greek Venus as his model,
> but a laundress or peat treader from a barn,
> calling his error the imitation of nature,
> all else idle ornament.[12] Sagging breasts,
> deformed hands, yes marks of corset laces
> on the stomach, of garters on the legs,
> all must be rendered or nature would not be satisfied—
> at least *his* nature, which suffered neither rules
> nor reason of proportion in the human limbs.[13]

For all the coarseness decried by Pels, Rembrandt's handling of the etching needle was here remarkably delicate. Unfortunately the fine, closely spaced lines broke down quickly under the stresses of printing. Impressions of the *Diana* with a full range of modeling and clarity of line, such as the one seen here, are seldom encountered.

The unlikely combination of startling realism with undulant Baroque rhythms seen in *Diana* gave way to a subdued study of the fall of light over simplified sculptural volumes in Rembrandt's 1658 etching (no. 197). Here he favored intimate appreciation over voyeuristic intrusion. Meticulous description of every detail has yielded to economical suggestion and the poetry of light and shadow. Instead of starting with a drawing on paper as in the *Diana*, Rembrandt probably drew directly on his coated copper plate while observing the model. Unusually tall and narrow for a close-up study of a seated figure, the proportions of the composition were determined by the use of a scrap of copper trimmed away from the plate used for his etching of *Christ and the Woman of Samaria* (no. 203). The challenge of producing a graceful composition within this unusual format seems to have appealed to Rembrandt. He responded with a harmonious, compact arrangement of form that fits into its surroundings like a sculpture in a niche. In his much sketchier 1646 etching of a seated nude male (no. 183), an element within the composition, the curtain, served as a niche for the figure, but in this more formally conceived, more finished, composition Rembrandt used the whole shape of the etching plate to that end.

The sensuously full-bodied model sat on a cushioned chair, the backrest of which extends to either side of her. As was his habit, Rembrandt seems to have let his mind wander as he worked, and the chair became an embankment strewn with garments and a grand pillow with an extravagant tassel. Whereas Diana met our gaze, this woman turns her head away, her face nearly lost in shadow.[14] Her attention seems focused on the white robe lying by her thigh. Her lower legs disappear into water that has just the faintest glimmer of reflection on its surface. Behind her Rembrandt added a dimly perceived vertical landscape with clustering foliage and perhaps a tree trunk or rocky bank.[15]

Rembrandt's tonal vision subordinated detail to broader perception. His observation of her soft, plump flesh is based on how her body takes the light. His ineffable modulation of tone fully models her form. His skill is apparent in the gentle undulation of form from shoulder to shoulder across her collarbone. Instead of recording the imperfections of her skin, his etching needle made countless tiny dots and flicks to soften the light and deepen the transparent shadows. Rembrandt was acutely aware of the slightest variations in tone. Only in the area of the woman's cap and her large pearl earring did he burnish and polish the plate absolutely smooth. Elsewhere he left the copper surface with a slightly grainy texture. When he wiped the plate, the fine grain held a whisper of ink that softened the light, enhancing the warmth of the woman's skin. The smoothness of the cap area allowed the ink to be cleanly wiped away, producing a bright contrast to her skin and deeply shadowed face.[16] Rembrandt printed the plate on a variety of papers as well as vellum. The present example is a fine early impression on a matte tan Japanese paper that further mutes the light on the woman's skin and deepens the introspective mood of her reverie. TER

NOTES

1. Apart from those discussed here, the early group includes B. 198 and B. 204 (no. 98) and the late group B. 197 (no. 198), B. 199, B. 202 (no. 201), B. 203 (no. 99), and B. 205 (no. 199).

2. Ben. 21, London, British Museum (1895-9-15-1266). See Martin Royalton-Kisch in Amsterdam/London 2000, 98–101; and Royalton-Kisch 1992, 33–35.

3. See Eric Jan Sluijter, "'Horrible nature, incomparable art': Rembrandt and the depiction of the female nude," in Williams et al. 2001, 38. Rembrandt included the Actaeon episode in his painting of *Diana with Her Nymphs* of about 1634 (Anholt, Museum Wasserburg Anholt, Br. 472, Corpus A92).

4. Van Mander [1604] 1969, fol. 191; Sluijter in Williams et al. 2001, 41–42.

5. White 1999, 193–96.

6. Ackley *Printmaking* 1981, 77–78, 204–5, develops this idea with regard to other printmakers. He has also noted in conversation Rembrandt's ownership of a plaster "Diana Bathing" by the lobate-style goldsmith/sculptor Adam van Vianen (*Docs.* 1979 1656/12, item 296).

7. Eric Jan Sluijter in Williams et al. 2001, 39.

8. Schatborn 1981, 19–22.

9. Eric Jan Sluijter frames the competition between idealized and realistic nudes as centering on the problem of their capacity for provok-

ing sexual arousal in a society that tightly regulated morality. In sharp contrast to Jan Emmens, Sluijter sees the awareness of Rembrandt's anti-classical stance as long predating the 1670s; see Sluijter in Williams et al. 2001, 248, note 40; Emmens 1968, 66–71.

10. Pels 1681, 35–36. Pels looked to Jan de Bisschop's criticisms of Dutch painting as a whole as expressed in the introduction to his *Paradigmata*, a 1671 book of prints based on Italian works of art and meant as models for young artists. De Bisschop's book was dedicated to Rembrandt's sometime patron Jan Six. See Bolten 1979, 40–42; and Schatborn 1981, 17. His reference to idle ornament also clearly echoes Caravaggio's words as given by Van Mander.

11. Pels' criticism is usually assumed to have targeted Rembrandt's etching *Naked Woman Seated on a Mound* (B. 198), but he uses the word *schild'ren* which leaves open that possibility that he had in mind a now lost painting.

12. Echoes of Caravaggio's comments in Van Mander.

13. This translation relies on those of Westermann 2000, 320; Borenius as given by Slive 1953, 102; and Hartley 1996, 2.

14. The model may be Rembrandt's lover Hendrickje Stoffels. While noting that there is no conclusive proof of her identity, Volker Manuth finds Hendrickje the most obvious candidate; see Manuth, "'As stark naked as one could possibly be painted...': the reputation of the nude female model in the age of Rembrandt," in Williams et al. 2001, 50. Having been punished already for crossing the bounds of propriety in her relationship with Rembrandt, she perhaps felt no compunction about serving as a nude model.

15. The model, setting, and luxurious fabrics recall his freely brushed 1654 painting of *A Woman Bathing* (London, National Gallery; Br. 437).

16. This subtle use of a polished highlight on a copper plate having a very slightly textured surface produces an effect very similar in appearance to that of selective wiping of the plate. For Rembrandt, the advantage of burnishing would be the repeatability of the effect. Indeed the effect is apparent on nearly all impressions of B. 200. It also appears in *The Descent from the Cross by Torchlight* (B. 83; no. 158) where relatively cleanly wiped impressions consistently show bright highlights on the upstretched hand near Christ's shoulder and on the figure at the far right, both of which appear to be brighter than the flame of the torch at the upper left.

198–201
The Female Nude

1650S AND 1660S

From 1658 to 1661, the female nude was the primary theme in Rembrandt's printmaking. His production of etchings had dwindled, but of his ten plates from this period, six were of women partially or fully undressed. A small number of drawings of nude women survive from this period as well. In some instances, Rembrandt worked alongside his students as when he and earlier pupils had studied male models in 1646 (see nos. 181–184). Although Rembrandt's nudes vary from unadorned realism to tantalizing fantasy, all, including the three prints and the drawing shown here, appear to have been based on direct observation of the model. Their glowing tonal warmth and dreamy sensuality has caused these nudes to be likened to those of Titian, but Rembrandt's are distinguished by their touching reality and vulnerability.

In *The Woman Seated Half-dressed before a Stove* (no. 198), the largest of Rembrandt's printed studies of the human body, we see a semblance of the setting in which modeling sessions occurred.[1] Here a woman has disrobed to the waist and sits near a ceramic tile stove to stay warm. She sits on the edge of an upholstered chair. Her left leg is extended, and her right one bends back at the knee. She leans slightly to her right, supporting herself with her arm. Her hands clutch garments that she has removed. On the floor beside the chair is a foot warmer, an earthenware bowl filled with coals and placed in a wooden housing with a perforated top. Her bare torso is turned partially toward us, but she retains a degree of privacy, her inclined head turned away in profile. Her hair is gathered beneath a large white cap. Rembrandt set off the bright contours of her arm, face, and cap against the shadows of the background. He accentuated the contrast by framing her upper body with the darkened recess of a niche behind her. In the first two states, the left side of the niche was undefined, but here in the third state he settled on an asymmetrical form, arched on the right but square on the left. As Rembrandt worked on the plate, he composed a symphony of forms and tones: angles and curves play off one another, while the handling of light varies from seamless modulation to sharp contrasts between dark and light. Every nuance is lovingly described: the light reflected from her arm brightens ever so slightly the shadow on the darker side of her body. To print the impression shown here, Rembrandt charged the plate with ink and selected heavy, dark cream-colored Japanese paper that suggests the color and texture of the model's flesh and skin. The pensive, meditative mood of the image invites the viewer to linger over it, allowing the full array of Rembrandt's magical spectrum of light and shadow to enter the imagination and work its spell.

Much of this chiaroscuro effect was achieved by means of lightly scratched but closely laid lines of drypoint: in many areas these strokes merge to form areas of pure tone. Rembrandt appears to have considered the plate finished at this point, for today at least two-dozen impressions of the third state are known.[2] By the time the last of these was printed, the drypoint burr had worn, and so the effect of the light had diminished. In the next three states Rembrandt returned to the plate, apparently in an effort to restore its tonal qualities. But

as he worked, he also began to make changes of detail, notably the addition of a damper handle to the stove flue. Eventually he eliminated the woman's cap and showed her with hair pulled back and knotted in a bun. These changes seemed so capricious to Arnold Houbraken that in 1718 he cited them as evidence that Rembrandt had arbitrarily manufactured extra states so that collectors would feel the need to acquire all the variant impressions of a single plate.[3] While the addition of the realist detail of the damper handle may have been a purely compositional choice, the removal of the cap muted the brightest tonal note in the image. Rembrandt's change shifted attention to the woman's face and hence to her interior life.

Rembrandt's most alluring nude may be the *Reclining Woman* who turns her back to the viewer (no. 199). Her dark body lies on a brightly lit, sensuously rumpled sheet. Her bed has a comfortably thick mattress and pillows to cushion her head. As we can see from the billowing folds above her foot, a heavy curtain encloses the far side of the bed. The contour of her body forms a graceful S-curve across the width of the image. Despite the darkness we can distinguish the overlapping edges of the cloth wound into a turban around her head. She has the darkest skin of all Rembrandt's nudes.

For the first hundred years of its existence, the print appears to have been known by neutral—and occasionally graphic—descriptive titles, such as *het slapende Vrouwtje* (The little sleeping woman),[4] *Een naakt slaapend Vrouwtje, leggende met de Billen bloot* (A naked little woman, reclining with a bare bottom),[5] *Une Femme dormant nue, les Fesses au Vent* (A sleeping nude woman, the buttocks exposed),[6] or *Femme nue* (Nude woman).[7] In his highly influential 1797 catalogue of Rembrandt's prints, Adam Bartsch called it *Négresse couchée* (Negress lying down or in bed). With few exceptions, subsequent cataloguers used Bartsch's title or a variant. Karel Boon, in his 1956 catalogue of an exhibition celebrating Rembrandt's 350th birthday, argued that Bartsch's title was misleading, citing the unique impression of the first state in which the body appears considerably paler.[8] Many later commentators have agreed with Boon and lauded the print as a study in half tones.[9]

It is likely that present-day discomfort with the term "negress" plays into the question of whether or not Rembrandt depicted a woman with dark skin. Her head is positioned further back into the recesses of the darkened space than her body; yet, her turban reflects much more light than the skin on her back. Moreover, her skin presents an almost night-and-day contrast with the white sheet along her full length. It seems extremely

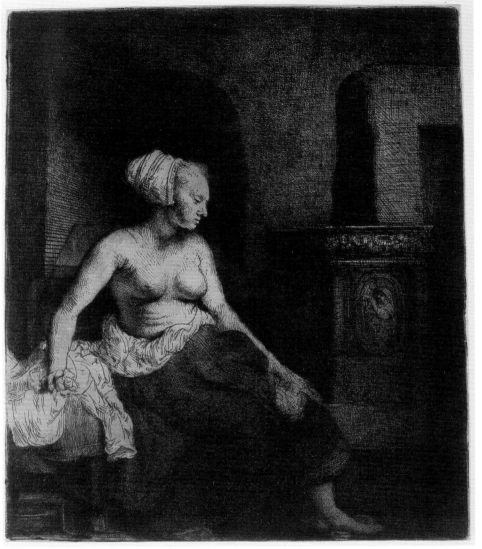

unlikely that light fell on the sheet but not on the model's body. The only place where her skin seems lighter is on the soles of her feet. Rembrandt appears to have been fascinated by the people from distant lands whom he could have seen in the international trading center of Amsterdam. He collected many objects from throughout the world, among them Mughal Indian portrait miniatures.[10] He owned "a Moor cast from life," probably a plaster bust,[11] and on at least one occasion he painted a picture of two Africans.[12] People of apparent African origin appear in several of his prints.[13] Moreover, given Rembrandt's profound interest in the depiction of closely related dark or light tones—black on black and white on white—it is quite possible that the model for this

198

Woman Sitting Half-dressed before a Stove, 1658
Etching, drypoint, and engraving on Japanese paper
B. 197, III
22.8 × 18.7 cm (9 × 7⅜ in.)
Rijksmuseum, Amsterdam

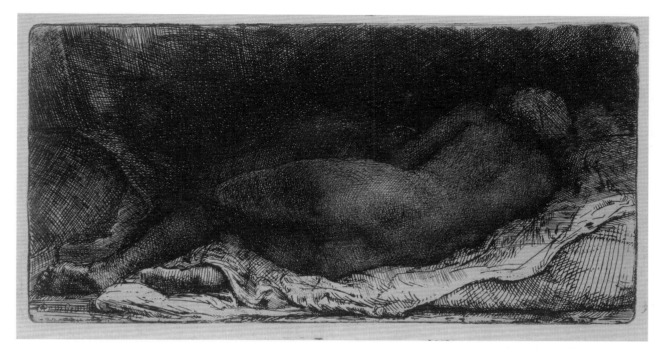

199
Reclining Woman, 1658
Etching, drypoint, and
engraving on Japanese paper
B. 205, II
8.1 × 15.8 cm (3³/₁₆ × 6¼ in.)
The Metropolitan Museum
of Art, New York
H. O. Havemeyer Collection,
Bequest of Mrs. H. O.
Havemeyer

gracefully composed and meticulously executed print did indeed have dark skin. In printing the impression seen here, Rembrandt varied the tones by selectively wiping the ink from the plate. A film of ink slightly darkens the mattress in the lower right corner and beneath her right foot, but he cleaned the plate more thoroughly to produce soft highlights on her thigh and near her waist.

By no means the first artist from the Netherlands attracted to the depiction of nude women with dark skin, Rembrandt joined a tradition that included many artists of stature.[14] Certain Italian and German prints of reclining nude women have been suggested as sources for the composition,[15] but Rembrandt's point of departure may have been closer to home. An elaborate multi-figured allegorical engraving of *Nox* (Night) designed by Karel van Mander includes figures in similar poses, similarly rumpled drapery, and a half-naked sleeping woman with African facial features.[16] Throughout his life, Rembrandt habitually omitted traditional attributes of standard artistic subjects, as in his *Diana* without a crescent moon on her forehead (no. 196), and as a mature artist, he learned to reduce traditionally complicated scenes to their essence. Perhaps we see in this reclining figure, Rembrandt's highly personal, gently erotic interpretation of Night.

In the early 1660s, Rembrandt had few students. Nonetheless, he apparently invited them to join him for some drawing sessions with nude models. Instead of sketching adolescent boys, they now studied mature women. During these sessions Rembrandt sometimes drew on paper, and apparently sometimes etched directly on a copper plate. Although at one time many drawn studies of nude women from this period were attributed to Rembrandt, the last three generations of connoisseurs weeding out copies, forgeries, and the drawings of students working alongside the artist have reduced the accepted number to just four.[17] In the drawing shown here, the woman is completely undressed except for a cap that holds up her hair (no. 200). She sits on a low, lightly upholstered stool, with what seems to be fringed edging. Rembrandt began the drawing with a series of short, straight strokes of his pen to establish the position of the figure. These angular strokes are visible in the woman's hip, legs, feet, and breasts. He also rounded certain features, such as her right calf and ankles. Details such as her toes, eyes, and cap are sketched with rapid yet absolutely precise strokes. With his pen, he completed curves in a few places, such as her right ankle and calf, but he also judiciously chose to use open, broken contours in many places so as to allow the form to dissolve in the light and to avoid making the figure look like a cutout pasted onto a page. He shaded a few small areas with diagonal hatching, and then picked up his brush. With overlapping strokes of brown wash, Rembrandt worked shadows into and around the figure. In very broad passages of parallel strokes, he suggested a partially gathered curtain as well as the complicated play

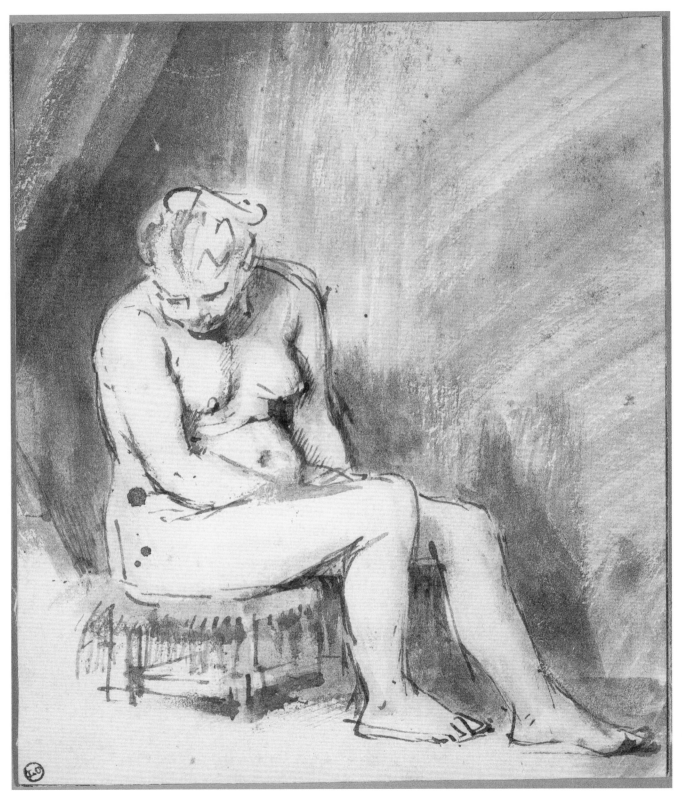

Female Nude Seated on a Stool, about 1661–62
Pen and brown ink, brown wash and white watercolor
Ben. 1122
21.2 × 17.4 cm (8⅜ × 6⅞ in.)
The Art Institute of Chicago
The Clarence Buckingham Collection

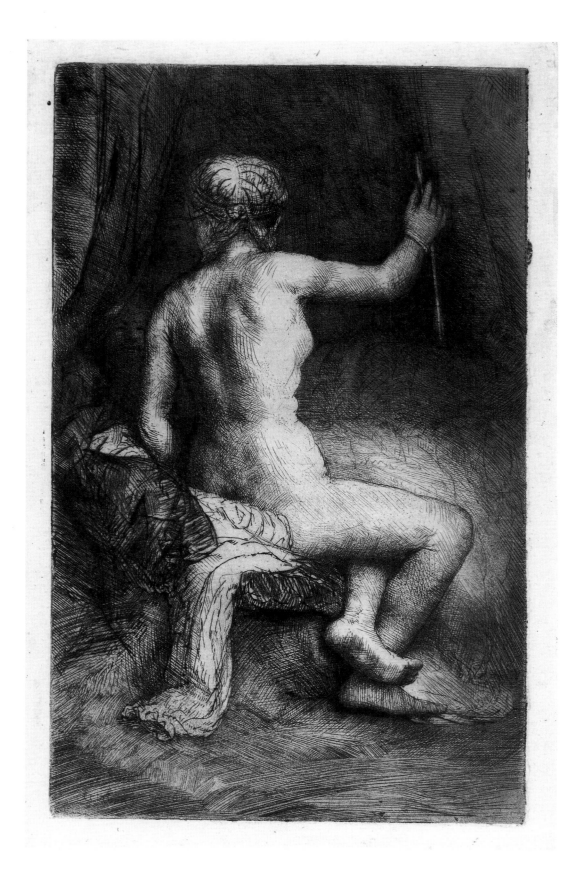

201

The Woman with the Arrow, 1661
Etching, drypoint, and
engraving
B. 202, II
20.4 × 12.5 cm (8¹⁄₁₆ × 4¹⁵⁄₁₆ in.)
Museum of Fine Arts, Boston
Harvey D. Parker Collection

of light across the background. Touches of white watercolor have apparently become somewhat less opaque over time; so, places that were originally brightly illuminated, such as the upper edge of the right thigh, now appear gray instead. Despite its abbreviation of detail, this luminous drawing conveys the living presence of a specific woman at a specific moment in time.

A drawing from the same modeling session and now attributed to Aert de Gelder (1645–1727), the last student on whom Rembrandt exerted a long-term influence, confirms that the woman sat before a bed hung with curtains.[18] Unlike his student, however, Rembrandt transformed the curtain into evanescent light. De Gelder's drawing carefully described the decorative turnings of the legs of the stool, but in his typical fashion Rembrandt was unconcerned with petty detail and concentrated on the broader patterns of light and form before him. The diagonal strokes at right suggest the fall of light on the studio wall, a shorthand similar to the free scribbling in the background of the 1646 male nude (no. 181). Because the woman was willing to pose in the nude for more than one male viewer, she was in all likelihood a prostitute.[19] Even so, Rembrandt instills her image with dignity and allows her her own private space.

In a 1661 session, Rembrandt probably sketched directly on a coated copper plate with his etching needle. He drew the woman from a three-quarter, rear view (no. 201). Other than a bracelet and headband tied at the back, she is completely nude. She sits upright with her ankles crossed on a pillow with a scalloped edge. Her body is softly modeled with a profusion of finely scratched, irregularly crisscrossed strokes. With extensive additions of drypoint and engraving, Rembrandt continued to soften the light throughout the image after biting the plate with acid. The variety of dots, flicks, and strokes reveal that Rembrandt still improvised freely even as his printmaking career drew to a close. In the folds of the drapery, he bore down on his drypoint needle to make emphatic marks. In the foreground, he laid down bundles of fine scratches and then broke up the strokes—perhaps scraping them—so that they would have a more tonal, less linear effect. Here, as he frequently did when printing this plate, he selectively wiped the ink from the copper without fully cleaning any area. The veil of ink is thicker toward the edges of the plate, especially to the upper right. He left less ink on the woman's body as well as on the sheets near her legs, enhancing the sense of her skin's glowing warmth.

When compared to Crispijn van de Passe's engraving based on a drawing of a nude model (fig. 83),[20] the unconventionality of Rembrandt's graphic vocabulary,

the subtle mystery of his light, and his eccentric, independent, but very sensual approach to the female form are all thrown into sharp relief. De Passe's model seems somewhat lifelessly generic, but even with her back to us Rembrandt's seems to have a personality. Both artists' prints grew originally from didactic impulses. While De Passe's lesson was easier to follow, Rembrandt's led into the world of the imagination.

While his students worked to discipline their powers of observation, Rembrandt gave his own fantasy free rein to carry him and his audience far away from his modest post-bankruptcy studio. As we know from a drawing by his little-known student Johannes Raven (1634–1662), the woman wore a white cap.[21] With his drypoint needle, Rembrandt drew instead a classicizing coiffure with headband and hair combed and gathered into braids that fall over her shoulders. The model sat on a chair covered with a sheet located near a bed. Rembrandt blends chair and bed: the woman now sits on the edge of a curtained bed or perhaps inside an exotic tent filled with patterned cushions and bedding. To support her raised arm during the modeling session, the woman grasped a looped cord or sling suspended from above. Rembrandt transformed the loop into her bracelet and the length of cord metamorphosed into a long slender object held in her hand. Though sometimes seen as a crack of light between two curtains, this passage is usually interpreted as an arrow. Deep in the shadows of the bed, we can make out a fleshy face with coal-black eyes and a pudgy nose—shades of the *The Artist in His Studio* painted at the beginning of Rembrandt's career (no. 18). Various suggestions have been made about the identity of this face, among them Cupid taunted by Venus who has taken away his potent arrows.[22] Whoever he became in Rembrandt's imagination, this mysterious figure may have been inspired by a student intently observing the model from another perspective during the original drawing session.

TER

Fig. 83. Crispijn van de Passe II (Netherlandish, 1597–about 1670), plate from *'t Licht der teken en schilder konst . . .*, 1643–44, engraving, 39 × 27 cm (15⅜ × 10⅝ in.), Museum of Fine Arts, Boston, Gift of W. G. Constable.

NOTES

1. Two drawings that show partially or fully disrobed women provide other views of Rembrandt's studio. One by Rembrandt himself shows a woman bare to the waist sitting in a chair in a high-ceilinged studio containing a large easel and other furnishings (Oxford, Ashmolean Museum; Ben. 1161). Dated to about 1654, the drawing probably shows the studio of the grand house that Rembrandt would soon lose in bankruptcy. Another drawing may be a copy of one made by a Rembrandt student of the 1650s–60s (Darmstadt, Hessiches Landesmuseum). It shows a drawing class studying a nude model reclining on a small stage, perhaps a chest of drawers, below a ledge bearing what are probably plaster casts of classical portrait busts. For color illustration, see Williams et al. 2001, 50.

2. Hinterding diss. 2001, 151.

3. Münz 1952, 2: 214. Houbraken also implied that similar motives lay

behind Rembrandt's changes to the figure of Juno in *Medea* (no. 138). For illustrations of the changes to *The Woman Seated by a Stove*, see Amsterdam/London 2000, 348–51, no. 87.

4. Van Gelder and Van Gelder-Schrijver 1938, 12. In about 1731, Röver recorded that on page 26 of his album were two different states of this etching (B. 205).

5. Sale catalogue of the collection of Amadé de Burgy (The Hague: Pieter Gerard van Baalen, 1755), 70, lot 550. The bilingual catalogue appeared in Dutch and French.

6. Ibid., 71, lot 550.

7. Gersaint 1751, 160, no. 197.

8. Boon 1956, 68, no. 117.

9. White 1999, 204–6, fig. 280, illustrates the first state (Paris, Bibliothèque Nationale) and expands upon Boon's argument. White also praises a particular impression of the third state (fig. 281; British Museum) as the only impression that "succeeds completely in suggesting the fully rounded modeling, at the same time as exhibiting perfect control of the half-tones." Unfortunately, the impression to which he refers was printed after the plate was reworked by someone other than Rembrandt and has been subjected to extensive gray wash additions.

10. See Ben. 1187–1206.

11. *Docs.* 1979, 1656/12, item 161.

12 *Docs.* 1979, 1656/12, item 344. A painting of two African men is attributed to Rembrandt (The Hague, Mauritshuis; Br. 310). The reliability of the signature and the date, 1661, has been subject to doubt, so it remains unclear whether this could be the picture cited in the 1656 inventory.

13. "The Hundred Guilder Print" (B. 74; no. 135), *Christ before Pilate* (B. 77; no. 49), "The Three Crosses" (B. 78; nos. 168–170), *The Beheading of John the Baptist* (B. 92), *The Baptism of the Eunuch* (B. 98; no. 107), *The Large Lion Hunt* (B. 114, no. 106), and the so-called *"White Negress"* (B. 357).

14. For example, nude African women appear repeatedly in the work of Hendrick Golztius. He made an allegorical chiaroscuro woodcut showing *Nox*, goddess of the night (B. 237) and designed a series of engravings showing *The Creation* in which two plates feature such a figure as the personification of darkness or night (engraved by Jan Muller, B. 36, 39).

15. Broos 1977, 94.

16. Engraved by Jacob Matham (B. 179).

17. The 1656 inventory lists "Een boeck, vol teeckeninge van Rembrandt gedaen, bestaende in mans en vrouwe; naeckt sijnde" (a book filled with drawings by Rembrandt of nude men and women). *Docs.* 1979, 1656/12, item 239. Benesch 1954–57, catalogued some thirty studies of nude female models that he believed to have been made in the 1650s–60s. Some of these had been questioned earlier, but many remained widely accepted until Peter Schatborn rejected all but four: Ben. 1122, 1123, 1137, and 1142. He assigned others to specific Rembrandt students, particularly Aert de Gelder and Johannes Raven. Peter Schatborn, "Rembrandt's Late Drawings of Female Nudes," in Strauss and Felker 1987, 306–19.

18. Rotterdam, Museum Boymans-van Beuningen, Ben. 1121 (as Rembrandt); see Peter Schatborn, "Rembrandt's Late Drawings of Female Nudes," in Strauss and Felker 1987. For color illustration, see Williams et al. 2001, 51.

19. Volker Manuth, "As stark naked as one could possibly be painted...': the reputation of the nude female model in the age of Rembrandt," in Williams et al. 2001, 47–53.

20. Van de Passe 1643, part 3, plate 30.

21. Amsterdam, Rijksprentenkabinet, Ben. 1146 (as Rembrandt); and London, British Museum, Ben. 1147 (as Rembrandt); see Peter Schatborn, "Rembrandt's Late Drawings of Female Nudes," in Strauss and Felker 1987. For color illustrations, see Williams et al. 2001, 233.

22. See Ackley *Printmaking* 1981, 249, 251, for this and other interpretations.

202–203
Christ and the Woman of Samaria

EARLY AND LATE

The encounter between Christ and the woman of Samaria is an episode from Christ's ministry (John 4:1–44). Jesus had fled Judea because the religious authorities were upset by his success in converting and baptizing new followers. On his way to Galilee he passed through the Samaritan city of Sychar. He stopped there and rested on the ancient well of the patriarch Jacob. A Samaritan woman came to draw water from the well and Christ engaged her in a dialogue about salvation. When

202
Christ and the Woman of Samaria (among ruins), 1634
Etching
B. 71, I
12.4 × 11 cm (4⅞ × 4⁵⁄₁₆ in.)
Museum of Fine Arts, Boston
Katherine E. Bullard Fund in memory of Francis Bullard

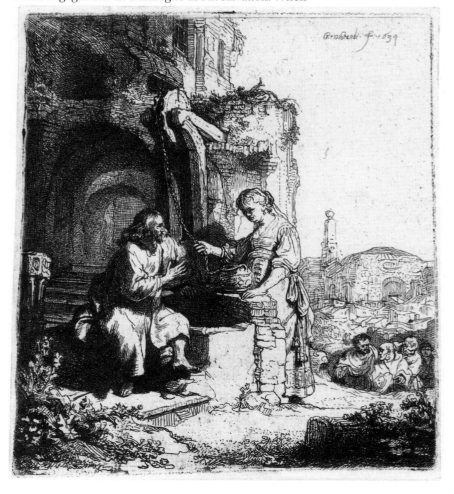

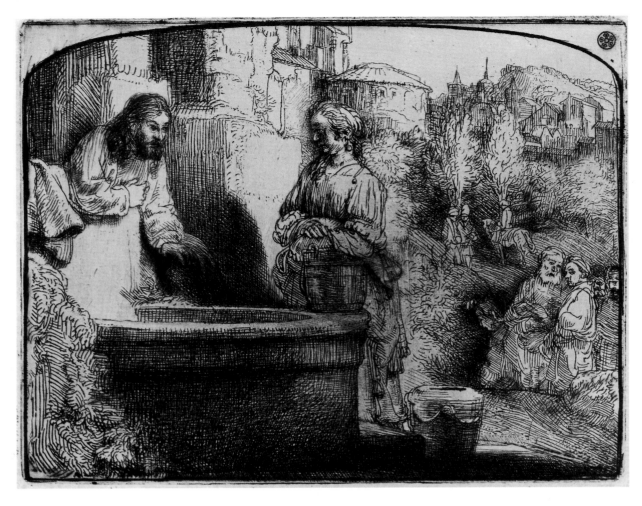

203
Christ and the Woman of Samaria,
1657
Etching and drypoint
B. 70, II
12.5 × 16 cm (4^{15}/$_{16}$ × 6^{5}/$_{16}$ in.)
The Pierpont Morgan Library,
New York
Gift of Mr. and Mrs. Charles
Cunningham, Jr., in honor of
Felice Stampfle

he asked her for water, she was amazed that a Jew—traditionally unfriendly to the Samaritans—would speak to her. Christ further pursues the subject of water, but as a symbol. He explains that the water from Jacob's well only leaves one to thirst again, but declares that "whosoever drinketh of the water that I shall give him shall never thirst" and, that they "shall be in a well of water springing up into everlasting life." The woman expressed her thirst for this miraculous water and Christ told her to go and bring her husband. She claims that she has no husband, but Christ clairvoyantly asserted that she has in fact had five husbands and that her present one is no true husband. The woman was deeply impressed by such insight into her irregular life and declared that Jesus must truly be a prophet. Christ's disciples, who had gone into the city to procure food, return and wonder at the fact that their leader should be preaching to a woman. The woman meanwhile convinces other inhabitants of the city that Jesus is indeed the Messiah. Christ continues

on his way to Galilee, observing that "a prophet hath no honour in his own country." However, a "mere" woman, a citizen of a hostile city and a sinner, had fully understood his message.

Two Rembrandt etchings, one of square format signed and dated 1634 (no. 202) and a larger one of oblong format with arched top signed and dated 1657 and 1658 in consecutive states (no. 203) are so different in conception that a viewer unfamiliar with the evolution of Rembrandt's work might assume that they were by two different artists. Both etchings place the two principal actors, Christ and the Samaritan woman, on opposite sides of Jacob's well on higher ground, while the returning disciples are visible at a lower level at right with the buildings of the city rising behind them in the distance. These parallels once observed, everything else about the two etchings is remarkably different. The spatial movement in the earlier print is circular, spiraling around the solid island formed by the figures of the two principals

and the well. The spaces are also deep and illusionistic: see, for example the stepped and vaulted dark tunnel behind Christ. The etched line is extremely fine and inclines to a curling elaboration. The etching is customarily catalogued under the title of *Christ and the Woman of Samaria (among ruins)*. Rembrandt emphasizes the picturesque antiquity and dilapidation of Jacob's well and its architectural surroundings, possibly alluding to the old order that Christ's new Messianic vision is replacing.

In the etching with drypoint of 1657–58, one of Rembrandt's last biblical etchings, the principal figures are much larger, closer to the viewer and firmly locked into the architectural setting. The figure of the Samaritan woman anchors the composition at its very center. The space as a whole is shallower, and the low arched borderline at top tightly compresses the sculptural figures and the broadly generalized forms of the landscape and the buildings. The linear vocabulary is simpler and the etched lines are thicker and more suggestive in character rather than meticulously descriptive. Compare, for example, the rendering of the clumps of foliage at the lower left in the earlier and later versions of the subject.

Many have discerned in the geometric order of the setting and statuary solemnity of the figures the influence of Renaissance Italian art. We know from the inventory of Rembrandt's possessions made in 1656 that he owned a painting of this subject, then believed to be by the Venetian painter Giorgione (1477–1511), now thought to be a version of a painting by the North Italian painter Moretto da Brescia (1498–1554).[1]

Here the well is more weighty and monumental in form than in the 1634 etching, and Christ and the Samaritan confront each other on the same eye level, Jesus leaning on the well head and the woman resting her folded arms on her bucket. In the 1634 etching Christ is seated in accordance with the Bible text and looks up at the woman. The gestures of Christ and the Samaritan are more open and theatrical when compared with the contained gestures and concentration on facial expression in the later print. In the latter, Christ, gesturing toward himself, leans forward, his eyes intense with conviction while the woman, face shadowed, bows her head in thoughtful reflection.

The later etching has three very different states. In the first, signed and dated 1657 on the well, the plate has a large unworked section at top. When this top piece was cut away it appears to have supplied the copper for the 1658 etched nude with her feet in the water (no. 197).[2] It is an interesting coincidence that in the latter etching the woman is also seen with head bowed in profile and face in shadow.

In the third state that follows the second state shown here, Rembrandt lightened the background between the two principal figures by scraping away the heavier shadows, and darkened further the front of the well with vines added in drypoint. He also defined the masonry blocks of the wellhead and more conspicuously signed and dated the plate 1658 in that area. These changes were perhaps necessary because in the second state seen here the wellhead is sometimes misunderstood as part of Christ's robe. In the present fine impression of the second state, Rembrandt has experimented with creative tonal inking of the plate, leaving a film of ink on the figure of the Samaritan woman, further heightening the intentional contrast between the brightly illuminated visage of Christ and the symbolically shadowed visage of the woman. CSA

NOTES

1. See Tümpel 1970, no. 77. The buildings in the landscapes in the undated *St. Jerome* etching from the 1650s (no. 148) and the *St. Francis* of 1657 (no. 149) have a similar carefully constructed Italianate geometry.

2. First suggested by the print dealer Hollstein as cited in De Bruijn 1939, 15. See Erik Hinterding in Amsterdam/London 2000, 354, no. 88, note 4 (with reproduction, fig. c, of first state of the present print).

204
Flora

ABOUT 1654

In two paintings in the mid-1630s Rembrandt depicted Flora, the Roman goddess of flowers: one a rather shy, pensive brunette Flora (1634), and the other a bolder, more forthcoming red-blond Flora (1635). Each is outfitted in a lavishly brocaded and embroidered gown and generously adorned with blossoms and greenery.[1] Both are seen three-quarter length, with head turned toward the viewer. Rembrandt returned to the theme some twenty years later in another painted *Flora* (no. 204), a mature work of greater simplicity and a new classical serenity. Once again seen three-quarter length, erect and proud, this redheaded Flora of the 1650s is more restrained in conception and less dynamic in pose than the earlier versions. Her slim upright body is presented frontally while her face is turned to the left in cameo-like profile. Profile, clothing, and thoughtful mood evoke the Samaritan woman at the well in the etching of *Christ and the Woman of Samaria* (1658, nos. 202, 203).

In this painting of about 1654, luminosity and color

replace extravagant costumes and theatrical poses. Even the flowers are simpler: instead of the variegated bouquets and garlands of the earlier Floras, a branch of glossy green leaves with a few pink blossoms decorates her hat, while similar blooms are clutched in her extended right hand or cradled in her skirt. Her only ornaments are a pearl necklace and pearl earrings. She wears a pleated, long-sleeved shirt tucked into a golden-yellow skirt. The white shirt, with its voluminous sleeves, is an elegant variation on the shift, an ages old, ubiquitous undergarment. In the seventeenth century, as in the Renaissance, the pleated shift was often used to suggest antique dress.

Rembrandt on the one hand makes his Flora a true goddess, aloof and cool, while on the other he uses her sensuous physical attractions to entice the viewer. Though most of her hair is bound up, a few glossy strands cascade loosely over her shoulders and a glint of moisture seductively adorns her lower lip. In preparing his canvas the artist used a lighter ground than usual, and employed rich warm browns for the background behind the luminous figure.[2] Clear, bright light falls from the upper left, caresses Flora's face and garments, and spills into the blossom-filled lap formed by her gathered-up skirt.

The tangible physical character of the picture's painterly execution connects this goddess more closely to the earth. The lush folds of the sleeves rendered with thick white paint applied with palette knife and brush reminds one of a comment by Adam Bartsch, cataloguer of the artist's prints in 1797, who stated that the artist painted so thickly that he seemed to wish to sculpt (*modeler*) rather than to paint.[3] Bartsch perhaps derived this observation from Houbraken, who in 1718 also referred to the later Rembrandt's paint handling in sculptural terms.[4] The sleeves closely resemble those of the philosopher in the painting of *Aristotle Contemplating the Bust of Homer* of 1653 (Metropolitan Museum of Art, New York).[5] Stylistic similarities between these two paintings have helped to suggest the probable date of *Flora*, 1654.

The restrained elegance of the composition, in combination with the painting's warm, bright colors clearly incorporates Rembrandt's knowledge of Italian Renaissance art. Certain parallels can be drawn between his *Flora* and a painting of the same title by Titian that was in Amsterdam in the 1630s in the possession of the collector and dealer Antonio Lopez (through whose hands the Raphael *Castiglione* and the Titian "Ariosto" paintings also passed; see Rembrandt's response to the latter two paintings in his etched *Self-Portrait Leaning on a Stone Sill*, no. 81).[6] The high-key color scheme, the nobly simplified

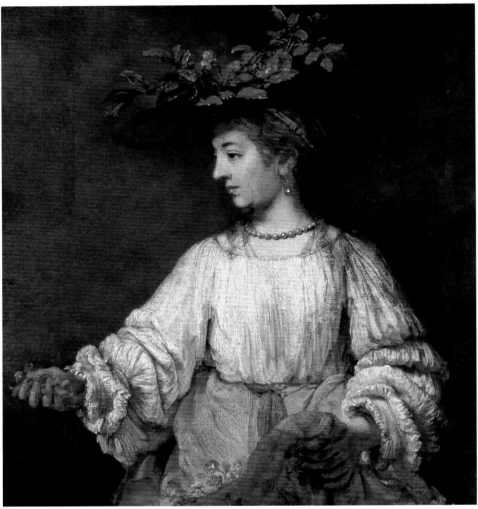

REDUCED

forms, and the particulars of the pose and costume are remarkably similar in the Rembrandt and Titian Flora paintings, though Rembrandt thoroughly adapts and absorbs any borrowings into his own unique pictorial vocabulary. Highly characteristic of the later Rembrandt is the combination of idealization and classical simplicity with a continuing realist vision, most visible in the goddess's sturdy working-woman's hands.

With her free and easy manner and often revealing dress, Flora was traditionally associated with licentiousness, and in Venetian painting, she was often depicted as a prostitute or courtesan. In his seductive Flora painting Titian was traditionally thought to be referring to his mistress. Hendrickje Stoffels, Rembrandt's young common-law wife, mother of his second surviving child, Cornelia, has sometimes been proposed as the model for his *Flora*, as well as for Bathsheba in the painting of 1654

204

Flora, about 1654
Oil on canvas
Br. 114
100 × 91.8 cm (39⅜ × 36⅛ in.)
The Metropolitan Museum
of Art, New York
Gift of Archer M. Huntington,
in memory of his father, Collis
Potter Huntington

(Louvre, Paris, Br. 521). No portrait of Hendrickje has, however, been securely documented, although her name has been associated with a number of Rembrandt works, including several images of women with large dark eyes painted in the 1650s.[7] One must concede that Rembrandt's tendency to play with and transform or idealize his own appearance as well as that of his immediate family circle, such as his son Titus (see nos. 211, 212), often makes it difficult to be precise about such identifications.

Flora is here portrayed as dark-eyed, but, in other aspects, specifically the profile turn of her head and the shape of her large hat, she resembles an earlier, 1634, three-quarter-length portrait of Saskia in the museum in Kassel.[8] Distinctly visible pentimenti in the background of *Flora* indicate that the front of the black, broad-brimmed hat was reduced from its original size and shape, which bore a closer likeness to Saskia's hat in the Kassel painting. It is as if Rembrandt, more than a dozen years after his first wife's death, revisited a portrait of Saskia, changing some aspects of her features to accord with those of his present lover. SWR/CSA

NOTES

1. *Flora*, 1634 (Hermitage Museum, St. Petersburg), reproduced as Br. 102, Corpus A93, and in Williams et al. 2001, no. 26; *Flora*, 1635 (National Gallery, London), reproduced as Br. 103, Corpus A112 and in Williams et al. 2001, no. 36. Despite a general resemblance, neither one is considered to specifically represent Saskia. The subject seems to have been a popular one in his studio as well; see Williams et al. 2001, 104.

2. The ground is yellowish white; see Liedtke et al. 1995 1: 25.

3. Bartsch 1797, xxvii–xxviii.

4. Houbraken 1718–21 1: 269.

5. Br. 478. Stylistic similarities between these two paintings have helped to suggest the probable date of *Flora*, 1654.

6. See Williams et al. 2001, 208, fig. 145. A recent exhibition focused entirely on Rembrandt and Venetian painting; see Clark et al. 2000.

7. Br. 113, 118; see Williams et al. 2001, nos. 125, 127.

8. Br. 101. See Williams et al. 2001, 62, fig. 72.

205–210
Portraits of Men

1650S

Seated portraits of five men—a print seller and publisher who acquired many of Rembrandt's etching plates at the time of the artist's insolvency, an official of the courts of insolvency who oversaw the sale of Rembrandt's pos-

sessions, a physician from the circle of Jan Six, a pharmacist friend of Rembrandt who was an avid collector of works on paper, and a prominent calligrapher etched twice by Rembrandt—provide insight into Rembrandt's approach to printed portraiture in the 1650s. The fact that Rembrandt in his printed portraits often did not etch or engrave the sitter's name in the plate below the image has frequently led to debate about the identity of his sitters. This includes the present portrait of the Amsterdam print and map seller and publisher Clement de Jonghe (nos. 205, 206). Because the plate was not included in the 1679 inventory list of Rembrandt's plates in the publisher's possession at his death, the identification of the sitter as De Jonghe has sometimes been questioned. Erik Hinterding, however, has recently called attention to an impression of the print with an inscription dated 1670 from the hand of the Parisian print dealer Pierre Mariette that firmly identifies the sitter as the Amsterdam print seller. He further points out that the inventory list is apparently not complete and that De Jonghe seems to have reprinted more of Rembrandt's plates than the seventy-four listed in his inventory.[1]

Rembrandt took the portrait of De Jonghe through four states, transforming the conception of the sitter. The changes to the plate in the fifth state and later are now correctly—as confirmed by recent watermark research—regarded as posthumous. The etching is seen here in impressions of the first and third states, revealing how Rembrandt began with a direct, informal notation of the sitter's appearance and then pushed the portrait in a direction that is more formal and more sculptural.

The first state (no. 205), signed and dated 1651, was printed by Rembrandt in considerable numbers (about thirty).[2] It has the feeling of direct reportage. The sitter is uncharacteristically (for Rembrandt) viewed straight on and has a quite neutral expression. Dressed for the street with heavy cloak, gloves and hat, his body is totally relaxed. Except for the deeper shadows of hat, face, and collar the image is very lightly drawn and etched. An extremely subtle, delicate gray tone appears to have been bitten into most of the plate. It has been lightly scraped and burnished in the background and has been carefully burnished away in the whites of De Jonghe's left eye and on his left collar.[3] Etched stipples suggest the texture of the skin of De Jonghe's face.

In the second state Rembrandt added with drypoint, and perhaps engraving, more shading and definition to head and hat.[4] By the third state (no. 206) De Jonghe's appearance has been totally transformed.[5] The very individual rumpled hat of the first state has become a smoothly generalized and quite sculptural object. The

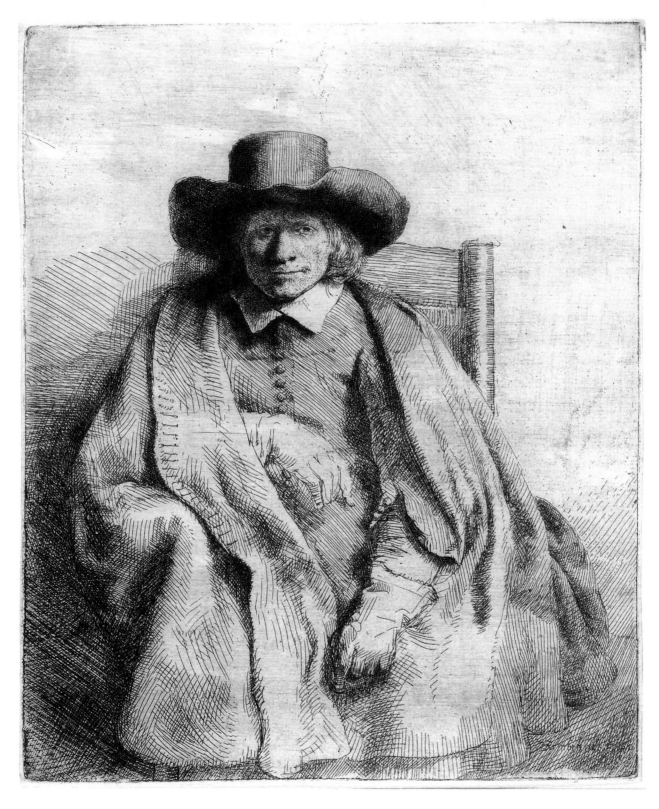

205
Clement de Jonghe, 1651
Etching
B. 272, I
20.6 × 16.1 cm
(8⅛ × 6⁵⁄₁₆ in.)
Museum of Fine Arts,
Boston
Harvey D. Parker
Collection

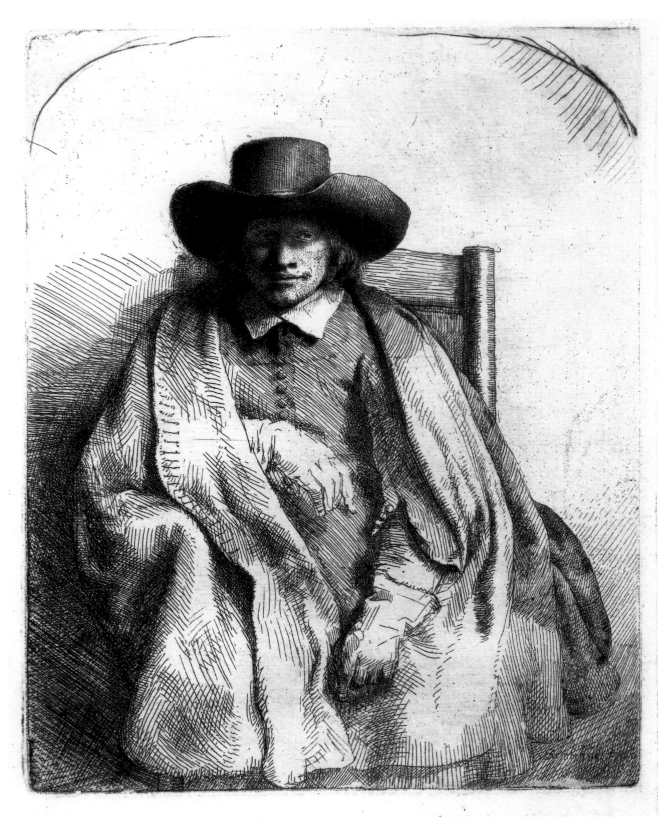

206

Clement de Jonghe, 1651
Etching, drypoint, and
engraving
B. 272, III
20.6 × 16.1 cm (8⅛ × 6⁵⁄₁₆ in.)
Museum of Fine Arts, Boston
William Francis Warden Fund

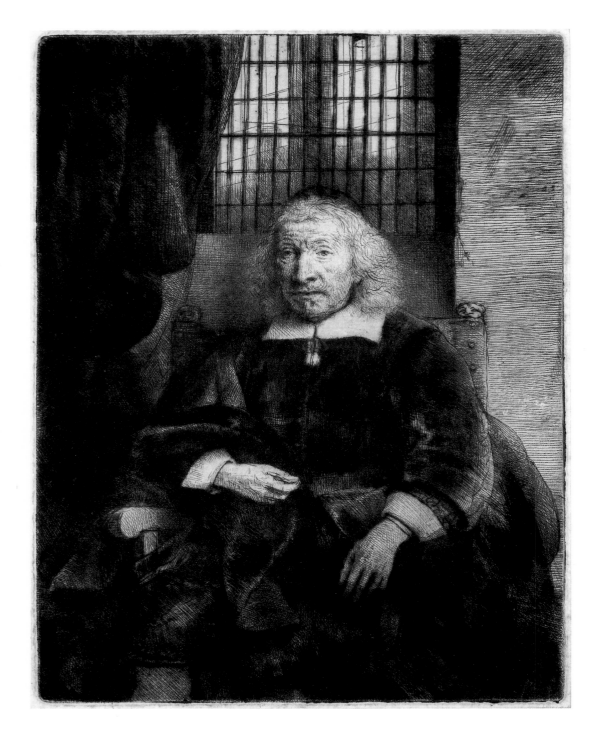

207

Thomas Haringh, about 1655
Drypoint and engraving
B. 274, II
19.5 × 15 cm (7^{11}/$_{16}$ × 5^{7}/$_{8}$ in.)
Museum of Fine Arts, Boston
Gift of Eijk and Rose-Marie
van Otterloo in honor of
Clifford S. Ackley

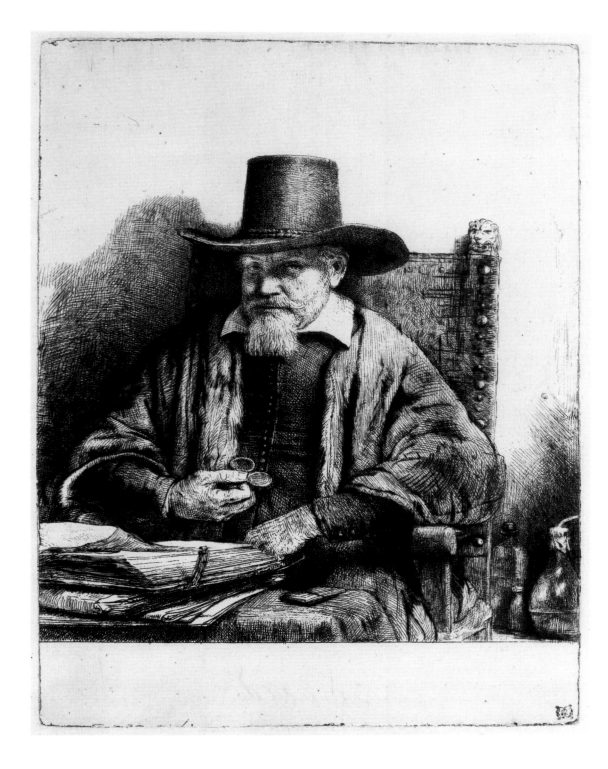

208

Arnold Tholinx, about 1656
Etching, drypoint, and
engraving
B. 284, I
19.8 × 14.9 (7^{13}/$_{16}$ × 5^{7}/$_{8}$ in.)
The Pierpont Morgan Library,
New York

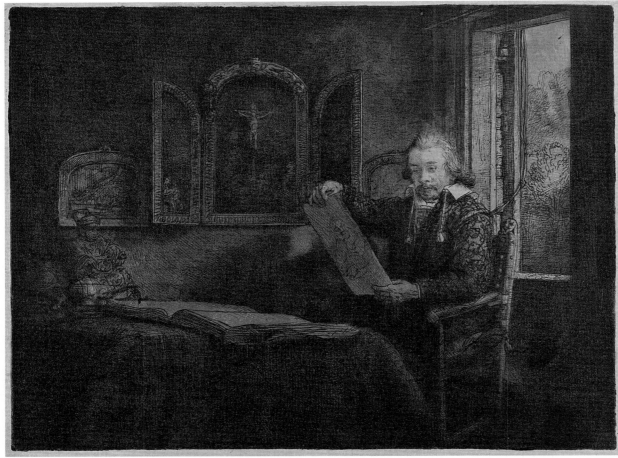

209
Abraham Francen, 1657–58
Etching and drypoint on
Japanese paper
B. 273, IV
15.8 × 20.8 cm (6¼ × 8³⁄₁₆ in.)
The Pierpont Morgan Library,
New York, RvR 373

REDUCED

facial features are more boldly defined but the play of
shadow about the eyes and corners of the mouth intro-
duces a Leonardo-like ambiguity of expression. At the
top of the plate a depressed arch, which will become a
more three-dimensional niche in the fourth state, has
been sketched in with drypoint. The arch not only frames
the sitter but also gives the portrait a more convention-
al or formal character. A particular sitter once seized by
Rembrandt's etching needle in a specific moment in a
specific light has been transformed into a more general-
ized representative of humanity.

Thomas Jacobsz. Haringh (no. 207) was Concierge of
the City Hall and auctioneer for sales under duress of
the property of insolvent citizens. He presided over the
enforced sales of Rembrandt's possessions in the years
1656–58. Haringh, who was about seventy years of age
when Rembrandt made his portrait, was a wealthy col-
lector of antiquities and rarities. It is conceivable that
Rembrandt made his portrait as a favor in conjunction
with the artist's insolvency.[6] Generally dated about 1655,

it is, like the contemporary portrait of "Old" Haringh's
younger cousin Pieter Haringh,[7] entirely executed in
drypoint and engraving. Haringh is seated in the same
armchair with lion-headed finials that one sees in Rem-
brandt's 1656 etched portrait of the goldsmith Lutma (no.
88) and his etched portrait of Dr. Tholinx of about the
same date (no. 208).

Haringh's venerable head is framed and set off by the
deep window embrasure and the shadowy forms visible
through the barred glass. Delicate strokes of drypoint
with little burr define the white clouds of the old man's
hair and the mobile, sensitive features of his face. In this
fine early impression, drypoint touches rich with burr
fuse together into velvety masses of tone in which hard-
ly any line is visible, giving the heavy pendant draperies
flanking the window and Haringh's fine garments their
luxurious depth of texture.

Arnout (or Arnold) Tholinx (no. 208) was a surgeon
who held a high position in Amsterdam medical circles,
that of inspector to the physicians' professional associa-

tion. Like Jan Six, Tholinx married a daughter of the prominent Dr. Nicolaes Tulp, whose now celebrated anatomy lesson Rembrandt had painted in 1632. Rembrandt must have etched his portrait about the same time as his 1656 portrait of the goldsmith Lutma (no. 88). The conception of the Tholinx portrait and the first state of the Lutma portrait are superficially very similar in their set up, but quite different with respect to the characterization of the two sitters and their relationship to the viewer. Lutma is totally lost in thought, turned inward, while Tholinx, his reading glasses held in his right hand, levels on us a penetrating, perspicacious gaze, intensified here in the rare first state by the light reflected from the pages of the open tome on the table before him. In the second state Rembrandt toned down these dramatic lights around the eyes with fine shading. On the floor at right is a still life of stoppered bottles pertaining to Tholinx's medical practice. In the first state, known in only three surviving impressions, the touches of drypoint that supplement the etched passages are at their strongest and enliven the image throughout, adding texture and a suggestion of color. In this same year, 1656, Rembrandt painted a bust-length portrait of Tholinx (Musée Jacquemart-André, Paris).[8]

Abraham Francen (no. 209) was an apothecary who lived all his life in the Jordaan, a poorer and less fashionable district of Amsterdam to which Rembrandt moved in 1658. He was closely acquainted with Rembrandt, stood witness for the artist, helped him with his financial problems, and became the legal guardian for Rembrandt and Hendrickje's daughter Cornelia. He was an art lover of limited means with a special devotion to prints.[9]

Rembrandt's portrait, which is datable to about 1657–58, evolved through at least five states.[10] The plate is densely worked overall and Rembrandt made changes throughout the image from state to state but concentrated most of his attention on the figure of Francen, his seated posture, his chair, and the window. The fourth state shown here is an impression on warm-toned Japanese paper. The fifth state was printed in considerable numbers. Subsequent states, harsher in effect, appear to be posthumous reworkings by other hands albeit, according to the evidence of watermarks, seventeenth-century ones.[11]

The basic conception is reminiscent of the 1647 portrait of Jan Six (no. 74) but horizontal rather than vertical in format.[12] Francen is, however, seated rather than standing at a window and is examining a print or drawing rather than reading. Like the Six etching, the Francen print is as much a portrait of the environment a man

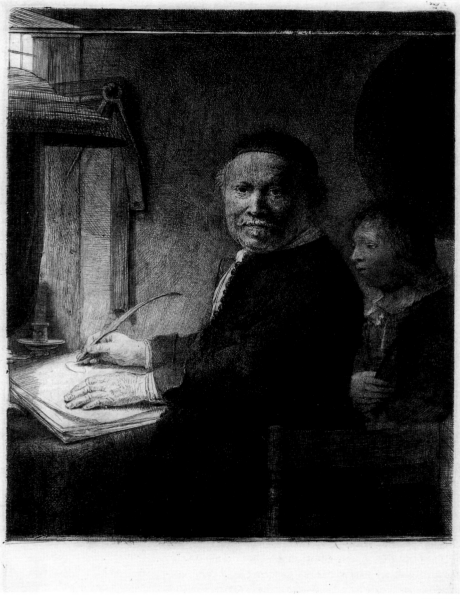

REDUCED

of cultivation has created around himself as of the individual. A large album lies open on the carpet-covered table. The sheet with a half-length figure on it that Francen studies with loving attention probably was preserved loose between the pages of this album. The album has dust flaps with which to protect the contents. On the wall is a painted triptych with wings, the central panel representing the Crucifixion. It is flanked by two small paintings of identical size and format with arched tops. A sign that the collector's taste was not confined to Western art is the Chinese figure on the table. It is accompa-

210

Lieven Willemsz. van Coppenol, Writing Master, about 1658
Etching, drypoint, and engraving
B. 282, III
26.1 × 19 cm (10¼ × 7½ in.)
Museum of Fine Arts, Boston
Harvey D. Parker Collection

nied by a ceramic jar and a skull that reminds the collector of the ultimate vanity of material things. Francen, judging by the rapt expression with which he studies the translucent sheet of paper he holds to the light, is, however, totally committed to those material things compounded of both matter and spirit—works of art. Rembrandt may very well have made Francen's portrait as a gesture of gratitude or friendship. It is especially valuable to us because it provides rare insight into how Rembrandt—that voracious collector—felt about collecting and collectors.

The art of fine writing, pen calligraphy, was greatly venerated in seventeenth-century Holland. It was taught in the business schools and was an essential skill for clerks and secretaries executing official documents.[13] It was also revered as an art in its own right. Lieven Willemsz. van Coppenol, a Flemish-born calligrapher, had been head of Amsterdam's French school. Because of episodes of mental instability, Coppenol left the school and devoted himself solely to his calligraphy. Due to two marriages to wealthy women he was a man of means. Being somewhat publicity-mad, he probably commissioned the two portraits Rembrandt etched of him about 1658. The larger plate is a more conventional and formal portrait, and there are many impressions of it, often printed on Japanese paper. Coppenol several times calligraphed laudatory poems in his own hand on the generous lower margins of impressions that had apparently been left untrimmed for that purpose. This portrait was prepared for with an oil sketch in color (Metropolitan Museum, New York) as Rembrandt had done for the etched portrait of Dr. Bueno (no. 73). An engraved portrait of 1658 undoubtedly commissioned by the self-advertising calligrapher from the brilliant portrait engraver Cornelis Visscher closely resembles Rembrandt's seated formal portrait in conception.[14]

The second Coppenol portrait (no. 210), seen here in the third state, is more informal, showing Coppenol seated in his workroom rather than posing after the manner of Van Dyck. As he pens a perfect circle, token of his skill, his grandson Antonius, hat in hand, reverently looks on. A dark shape on the wall, as well as Coppenol's plump round face, echo the theme of the perfect circle. The plate is densely, somewhat coarsely worked. The room is filled with beautifully graded, tangible chiaroscuro. Rembrandt in fact has emphasized the special lighting conditions required for Coppenol to practice his art: daylight from the window, a candle on a stand with a moveable arm, and a shading canopy with a curtain that can be pulled. A curtain rod running overhead may indicate the possibility of further light control. Tools necessary to his precision-oriented art hang beside the window: set squares and a compass. The persuasively realistic context of the carefully described workroom and the beautifully modulated light is slightly marred by Coppenol's self-conscious pose, as he rather awkwardly turns his head toward the viewer as if to say, "see what I am capable of."

The portrait went through several states. This, the third, may be the last that is wholly from Rembrandt's hand. In the fourth state a painted religious triptych crudely scratched into the plate in drypoint was added to the wall behind Coppenol. When compared with the triptych in the Francen portrait it is difficult to believe that this flat, schematic addition came from Rembrandt's hand. CSA

NOTES

1. Hinterding diss. 2001, 143–47.

2. Ger Luijten, "Clement de Jonghe," in Amsterdam/London 2000, 277.

3. I would like to thank my colleague Thomas Rassieur for sharing this observation in conversation and in his article, "When Things Get Rough for Rembrandt"; see Rassieur 2001, 62.

4. See the reproductions of five states in Stampfle et al. 1969, 56–61, figs. 31–36.

5. An impression of the third state in the Art Institute, Chicago, has on its former mount an admiring inscription in graphite from the hand of James McNeill Whistler (signed with the artist's butterfly monogram): "Without flaw! Beautiful as a Greek marble or a canvas by Tintoret. A masterpiece in all its elements, beyond which there is nothing." Clarence Buckingham Collection (1934.122).

6. For Haringh, see Ger Luijten in Amsterdam/London 2000, 326–28, and De Heer et al. 1999, boxes 4, 23, and 143.

7. B. 275.

8. Br. 281. For Tholinx, see Ger Luijten in Amsterdam/London 2000, 329–332 (with reproductions of both states and painting [fig. a]), and White 1964, 100.

9. For Francen, see De Heer et al. 1999, 142; Erik Hinterding in Amsterdam/London 2000, 338; and White 1964, 115.

10. States I, II, V, and the non-Rembrandt VII are reproduced in Amsterdam/London 2000, 337–40, no. 84.

11. Erik Hinterding in Amsterdam/London 2000, 338–40.

12. It has sometimes been theorized that the Francen portrait, due to its similarity in conception to the Six portrait, was begun as the portrait of Otto van Kattenburch "equal in quality to the portrait of Jan Six" (see *Jan Six*, no. 74, , note 9) but there is no concrete proof of this.

13. For the art of calligraphy in seventeenth century Holland see Ackley *Printmaking* 1981, 48–49, no. 26 (Jan van de Velde I, *Spieghel der Schrijfkonste*).

14. For Coppenol (B. 283), the larger portrait, the preparatory painting (Br. 291), and the Visscher engraving, see Ger Luijten's exceptionally lively entry in Amsterdam/London 2000, 354–60, no. 89.

211–212

Portraits of the Artist's Son, Titus

1650S

Two portraits from the 1650s commonly identified as Rembrandt and Saskia's only surviving child, Titus, one a simple bust-length etched portrait generally dated about 1656, the other a painting signed and dated 1655[1] of a younger boy at his desk, thinking or dreaming, pen in hand, provide us with a glimpse into Rembrandt's inner family circle during the turbulent period of his financial troubles. Titus was born in 1641 and some months later, in 1642, his mother died. Saskia's will left her half of the estate to Titus with Rembrandt having the use of it until Titus came of age or married. If Rembrandt remarried, it was agreed that Titus's half would pass to Saskia's sister Hiskia and the Van Uylenburghs. Rembrandt hired as a nurse for Titus the "trumpeter's widow" Geertje Dircx. The artist gave her gifts of jewelry and Geertje later testified in court that Rembrandt had had intimate relations with her. In 1648, an ailing Geertje made a will in Titus's favor, most likely anticipating that Rembrandt intended to marry her. In 1649 the younger Hendrickje Stoffels had already entered the household, replacing Geertje. Geertje took Rembrandt to matrimonial court for breach of promise and Rembrandt was ordered to pay her an annuity. This extraordinarily awkward and troublesome legal and financial situation continued for years and included Geertje's confinement, with Rembrandt's connivance, to a house of correction in Gouda. It ended only with the unhappy woman's death in 1656.

The sale of Rembrandt's possessions in 1656–58 resulted in the inventory of the contents of the grand house on the Breestraat that Rembrandt had ultimately been unable to afford. The inventory taken at this time reveals under item numbers 298–300 that his son Titus was also an artist, for three paintings by Titus are listed: "Three little dogs from life by Titus van Ryn," "A painted book by the same," and "A head of [the Virgin] Mary by the same."[2] Today the only secure work by Titus the artist is a pen drawing dated 1659 representing a seated figure of Flora holding an urn of flowers.[3] It is a respectable, but somewhat weak, imitation of his father's style of the 1640s.

Rembrandt involved Titus in various ploys in hopes of alleviating or fending off his threatening financial problems. In 1655 he had the fourteen-year-old Titus make a will, anticipating that Titus might predecease him, and, before declaring insolvency, he transferred the

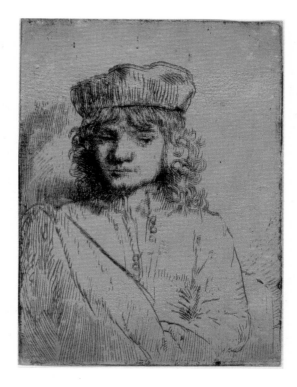

211
The Artist's Son, Titus, 1656
Etching on Japanese paper
B. 11, only state
9.5 × 7 cm (3¾ × 2¾ in.)
Lent by the Trustees of the British Museum, London

title of the house to Titus. In order to help Rembrandt to evade his creditors, Titus and Hendrickje about 1658–60 set themselves up as an art business. Rembrandt, their employee-advisor, received from them room and board and an allowance. Hendrickje died in 1663, but Titus continued to be an agent for his father's art. In 1668 he married Magdalena van Loo, the daughter of a silversmith, who was also a niece of Saskia's sister, Hiskia. A few months later he died. A daughter, Titia, was born after his death.

Just as there is no securely documented portrait of Geertje or Hendrickje, there is no fully documented portrait of Titus. The etched portrait of Titus (no. 211), described by Gersaint and Bartsch in the eighteenth century as a portrait of Rembrandt himself does indeed have his father's distinctive nose. A portrait of Titus (number 57, "Titus conterfeytsel") was included in the 1679 inventory list of the Rembrandt copper plates in the estate of the publisher Clement de Jonghe.[4]

The etching, which survives in only a few impressions, is quite simple in conception and is usually dated to about 1656, the same time as the portraits of the goldsmith Jan Lutma and Dr. Tholinx (nos. 88 and 208). It is executed in the economical vocabulary of parallel shading strokes so familiar in Rembrandt's etchings of the 1650s. Many of the few surviving impressions are printed, as here, on silky, warm-toned Japanese paper, some-

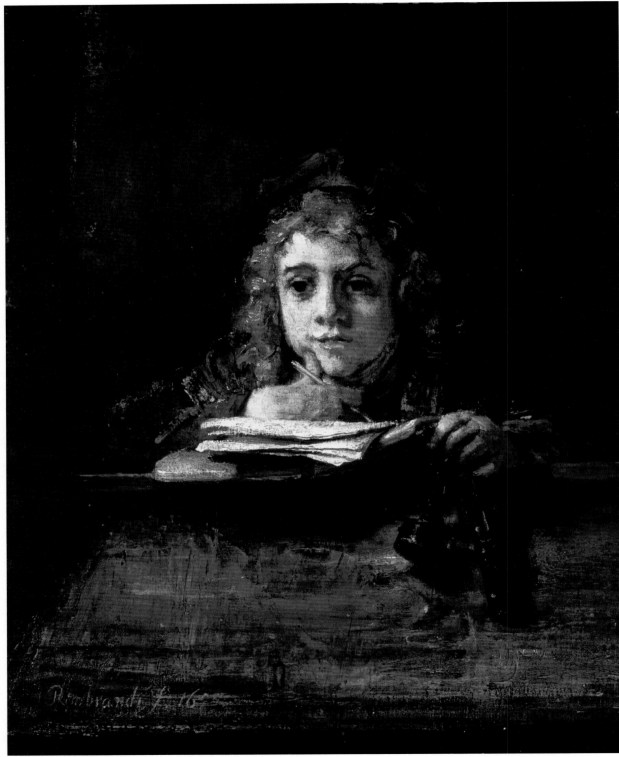

212

Titus at His Desk, 1655
Oil on canvas
Br. 120
77 × 63 cm (30⁵/₁₆ × 24¹³/₁₆ in.)
Museum Boijmans Van
Beuningen, Rotterdam

REDUCED

times with a tone of ink. Several of them also show signs of double-register printing, giving the etched lines a soft, blurred effect. Perhaps the plate was somewhat uneven and moved when undergoing the pressure of the press.

Titus wears a beret, as he does in several of the painted portraits by his father that are believed to portray him. His tunic is partly unbuttoned and he has a heavy cloak draped about him. He eyes are downcast, his expression pensive. Most of the several painted portraits of the young man commonly believed to be Titus represent him as gentle or subdued in temperament. Some of the painted portraits, like many of his father's self-portraits, portray him in fantasy dress (Titus with beret, soft cloak and golden chain now in the Wallace Collection, London) or in a more specific imaginary role (Titus robed and hooded as a Franciscan monk, 1660, Rijksmuseum, Amsterdam).[5] The Rotterdam painting (no. 212) is the most youthful in appearance, which has led some to question the identification. Of course Rembrandt in his own self-portraits was prone to alter his age and physical appearance and it must be acknowledged that teenage boys (Titus was fourteen) often make the transition from child to man with startling rapidity.

This immensely appealing and sensitive portrait is at once an intimate study from daily life, a fool-the-eye bit of illusionism and an astonishing example of the later Rembrandt's bold, sensuous handling of paint. We see the young Titus musing, staring off into space, quill pen in hand, his thumb pressing deeply into his cheek. A sheaf of papers on a thick writing pad or portfolio lies before him. A leather penholder and inkwell dangle from his left hand. It is unclear whether he is thinking about what he is going to *write* or what he is going to *draw*. The relationship to the sitter is not dissimilar to that in Rembrandt's etched *Self-Portrait* of 1648 (no. 213) in which the artist is etching or drawing at a table by a window. The difference is that Rembrandt engages the viewer (or his mirror) directly with his eyes while Titus is lost in thought.

The relatively blank but well-used board front of the desk that prominently displays Rembrandt's signature and date takes up a third of the picture. It is placed so that we identify it with the surface of the canvas, suggesting that the projecting lip of the top of Titus's desk, his papers, and the hand with the inkwell and penholder illusionistically intrude into our space. The almost sculptural tactility of Rembrandt's paint contributes on the one hand to a heightened illusion of three-dimensional form, while on the other the highly visible traces of the paint's manipulation by brush and palette knife insistently remind us that these are in fact distinctive two-dimensional marks from the hand of an artist with a very idiosyncratic way of handling paint. Illusion and artifice are equally balanced. CSA

NOTES

1. In 1985 an examination of the painting by Ernst van de Wetering led to a questioning of the authenticity of the signature and date. It was suggested, due to the boy's youthful appearance, that the painting might actually date from about 1653–54 (see Giltaij *Een gloeiend palet* 1988, 72, no. 22). In his recent Kyoto/Frankfurt exhibition catalogue, Giltaij no longer raises questions about the signature and date (see Giltaij 2003, 162–64, no. 31). He tends to believe that the sitter is Titus and suggests that Titus may be cast in the broader, more generic role of "The Pupil" or "Young Scholar." This view would be comparable to seeing the etching of about 1641 of a young artist drawing from a cast (no. 86) under the broader more emblematic rubric of the "diligent young artist."

2. *Docs.* 1979, 1656/12, items 298–300.

3. Sumowski 1971–75, 9: 4958, no. 2207.

4. De Hoop Scheffer and Boon 1971.

5. Wallace Collection, Br. 123; Rijksmuseum, Br. 306.

213–215
Later Self-Portraits
1648–1659

An etched self-portrait of 1648 (no. 213) shows Rembrandt at work, etching or drawing, seated at a table by a window. Both the etching and a self-portrait drawing datable to about 1648–50 (no. 214) are exceptional in showing the artist in everyday studio dress. A formal painted self-portrait dated 1659 (no. 215) shows the artist dressed in more fanciful but sober costume shortly after the sale of his fine house and its contents. At this time he moved to humbler quarters on the Rozengracht in the less fashionable Jordaan district of Amsterdam.

Rembrandt Drawing at a Window (no. 213) is known in four states.[1] The artist is seated behind a cloth-draped table with daylight entering from the window over his right shoulder.[2] He is engaged in drawing or etching on a sheet or plate that rests on or is cushioned by a sheaf of folded papers or cloth that in turn rests on a slope created by two books of unequal size.[3] With a frown of concentration, he scrutinizes his features in a mirror. To the viewer, however, it may appear that he is studying us with a view to making our portrait. Like the Jan Six portrait etching of 1647 (no. 74), the 1648 *Self-Portrait* is very densely worked. The first state seen here is essentially a working state, known only in a small number of impressions. Rembrandt's method of building up the image by

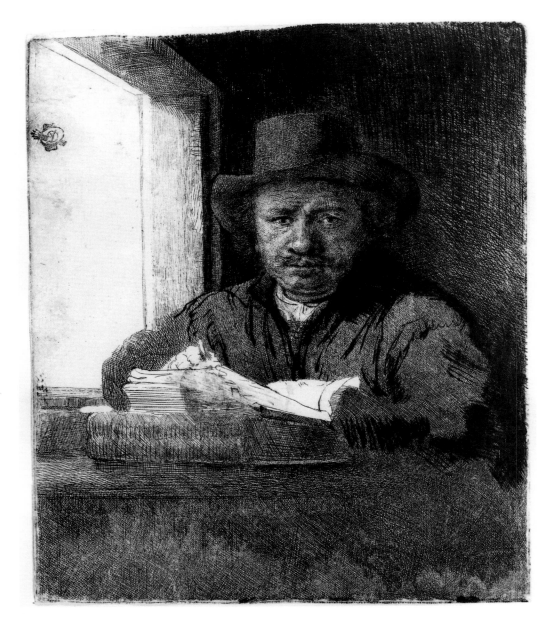

213

Self-Portrait (etching at a window),
1648
Etching, drypoint, and engraving
B. 22, I
16 × 13 cm (6¼ × 5⅛ in.)
The Pierpont Morgan Library,
New York

means of overlapping layers of finely etched meshes of line, which were in turn overlaid with bolder strokes of drypoint rich with burr, is clearly legible here. In the completed second state Rembrandt signed and dated the print on an etched strip of cloth that he added for that purpose to the top of the window opening. He also evened out the irregular top edge of the copper plate and toned down the effect of the accidental etched blot visible on the books that is so conspicuous in the first state.[4] He gave fuller definition in the second state to the artist's head and figure, and to the table and the books, and

deepened the shadows to the right of the table and in the background. Rembrandt continued to add shading to the third and fourth states but the image begins in the third state to diminish in tonal variety. In the fourth state, in which a hilly landscape with trees and buildings is visible through the window, the image begins to seem somewhat too dense and overworked.

Even though the image may in fact be Rembrandt's carefully constructed illusion of realistic reportage, one nevertheless feels, due to the artist's plain workaday clothing and resolute gaze, that we are here confronted

214
Rembrandt in Studio Garb,
1648–50
Pen with brown ink
Ben. 1171
20.3 × 13.4 cm (8 × 5¼ in.)
Museum het Rembrandthuis,
Amsterdam

REDUCED

with "just plain Rembrandt." There is not a trace of the fanciful embellishment of dress or self-aggrandizing wish fulfillment, such as one sees in the celebrated etched self-portrait in Renaissance dress of 1639 (no. 81).

The full-length self-portrait pen drawing from the Rembrandt House collection (no. 214) portrays Rembrandt in studio dress (hat and long smock), as the early inscriptions in Dutch and French cut out and affixed to the drawing's mount indicate ("drawn by Rembrandt van Rhijn of himself as he dressed in his painting studio").[5] His hands-on-hip pose and determined expression confirm the self-assurance and stubbornness one tends to associate with the artist on the basis of lifetime legal documents and early printed accounts of his temperament. Although somewhat unevenly preserved, the drawing's blunt, angular pen strokes (probably reed pen as well as quill pen) and firmly planted stance convey with considerable force the artist's sense of himself as an immovable object.[6] The drawing has been in the past variously dated, but has more recently convincingly been placed about 1648–50, between the 1648 etched self-portrait discussed above and the three-quarter length painting with similar arms akimbo pose in the Kunsthistorisches Museum, Vienna (1652)[7].

The painted *Self-Portrait* from the National Gallery, Washington, signed and dated 1659 (no. 215), echoes in pose the 1639 *Self-Portrait Leaning on a Stone Sill* (no. 81) and the latter's 1640 painted equivalent (National Gallery, London),[8] both of which are indebted for their inspiration to Raphael's portrait of *Baldassare Castiglione* and the Titian "Ariosto" portrait that Rembrandt had seen on the Amsterdam art market. The 1659 painting now rivals the Raphael painting of Castiglione, the perfect courtier, in the elegant restraint with which Rembrandt employs a subdued palette of grays and browns and understated rich dress to set off his face. In the Rembrandt painting everything extraneous or distracting has been muted or suppressed. The clasped hands, for example, are suggested rather than defined. A rich fur cloak is broadly and thinly brushed in. The high collar of a gray tunic of velvety texture flatters the face, editing out some of the artist's jowls. To better define the individual strands and curls within the masses of gray hair that frame the face Rembrandt drew in the wet paint with a point, probably the handle of a brush, a technical trick that is virtually a Rembrandt signature beginning with his early painted self-portraits. The only truly luminous area of the image is the flesh of the artist's face. This face, with its vivid record of life experience and of the effects of the relentless pull of gravity, is a thoroughly lived-in one. The core of this candid presentation of his own

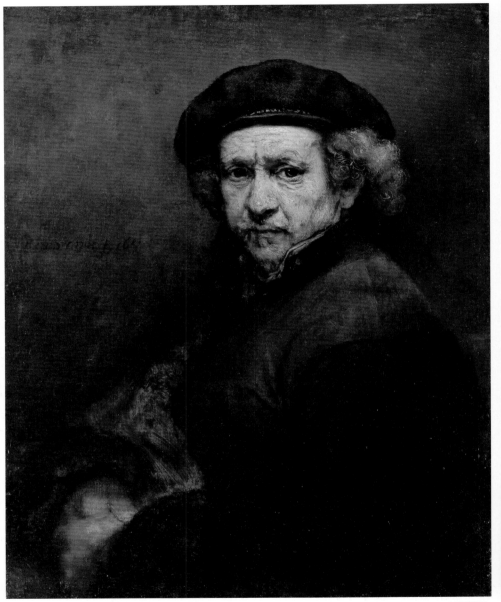

REDUCED

aging image is the steady, dignified, and stoical gaze of the large eyes in their setting of fleshy folds. The flesh is marbled with color, with gray-green passages that hint at the veins beneath the skin. White highlights glisten on the skin's surface. It is, however, the palpable tactility of the paint, manipulated like modeling clay by the brushes, that makes indelibly visible the stresses and strains of a life compounded of creative triumphs and personal and financial reverses. CSA

215

Self-Portrait, 1659

Oil on canvas

Br. 51

84.4 × 66 cm (33¼ × 26 in.)

National Gallery of Art, Washington

Andrew W. Mellon Collection

NOTES

1. All four states as reproduced in Stampfle et al. 1969, 24–27, figs. 6–9. States I, II, and IV are reproduced in Amsterdam/London 2000, 244–46.

2. I have sometimes speculated that the blank window of the first three states was intended to represent not open sky but a scrim of cloth stretched across the window to diffuse the light.

3. Peter Schatborn in White and Buvelot et al. 1999, 186, no. 62, believes the implement in Rembrandt's hand to be an etching needle rather than a drawing implement. The plate or sheet is not visible in the etching.

4. White 1999, 151, interprets the "blob" as an initial attempt at rendering Rembrandt's right elbow. This would be more convincing if there was more evidence on the plate of a previous positioning of the rest of the artist's body.

5. "getekent door Rembrant van Rhijn naer sijn selver / sooals hij in sijn schilderkamer gekleet was." The Mariette inscription is a free translation of the Dutch. See the entry by Ben Broos in Blankert et al. 1997, 354–55, no. 85.

6. Ben Broos in Blankert et al. 1997, 354–55, no. 85, notes that Rembrandt originally showed himself striding forward (see change in his right foot) rather than firmly planted.

7. The Vienna painting, Br. 42, reproduced as fig. 85b in Blankert et al. 1997, 354–55.

8. Br. 34.

216
The Apostle James

1661

Rembrandt's half-length painting of the apostle James in prayer, signed and dated 1661, is one from a larger group of paintings by Rembrandt and his school that date from about 1660 and represent either Christ's apostles or the evangelists. Other paintings dated, like the *James*, 1661, and similar in size and format, include Rembrandt's self-portrait in the guise of the apostle Paul and imaginary portraits of Bartholomew, Matthew, and Simon.[1] In the late sixteenth and seventeenth centuries in the Netherlands artists produced series of the twelve apostles in painting and print that often included a portrait of Christ and sometimes the Virgin Mary.[2] The theme of the twelve apostles offered painters the opportunity to depict a great range of ages and types, from the young and handsome to the old and wizened, in attitudes that ranged from joyous revelation to prayerful contemplation. Some authorities believe that the relatively large number of pictures of similar type, scale, and date from Rembrandt's hand suggest that he was intending to produce such a set of Apostles; others maintain that this is unlikely because it was contrary to his normal practice. The

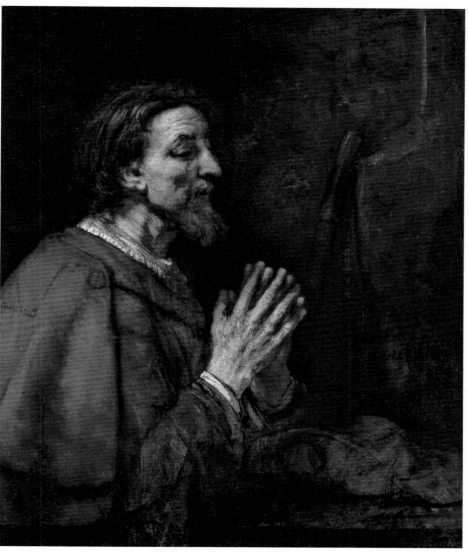

truth seems to lie somewhere in between. Rembrandt made groups of prints related in size and subject, but seldom if ever brought such a "series" to a conventional completion.

Rembrandt's pilgrim (no. 216) was first identified as the apostle James by Hofstede de Groot in 1916.[3] James was the son of Zebedee, a fisherman, and brother of John the Evangelist. Together with Peter, James and John were the disciples closest to Christ and accompanied him during his prayerful vigil in the Garden of Gethsemane. This James is known as James Major or James the Greater to distinguish him from a second apostle named James (the Lesser), who is sometimes described as Jesus' brother. James the Greater was tried

216

James the Apostle, 1661
Oil on canvas
Br. 617
original canvas: 92.1 × 74.9 cm
(36¼ × 29½ in.)
Private Collection

in Jerusalem in A.D. 44 by Herod Agrippa and executed. His martyrdom is the only one reported in the scriptures (Acts 12:12), and it is depicted in medieval fresco and stained glass cycles. Legend tells of his mission to Spain and his burial at Santiago de Compostela, which became the third great pilgrimage site of Christianity after Jerusalem and Rome.[4]

Rembrandt drew on two artistic traditions in his representation of James: as an apostle and as a pilgrim. Traditionally, the apostle was shown as a mature man with a thin beard and dark hair parted in the middle and falling on either side of his face in a fashion similar to that of Christ. He was identified by the presence of the sword of martyrdom. To differentiate him when included in groups or series of saints, James was depicted as a pilgrim, wearing a long protective cloak and a broad-brimmed hat. He carried a staff to assist him in walking and a pilgrim's wallet and water gourd to carry food and water. His emblem or special attribute is the scallop shell, worn on his hat or his cloak.

Here the artist chose a restrained color scheme, primarily a muted range of browns and grays, with enlivening touches of yellow and red. The figure is seen outdoors against a dark background. The middle-aged man of weathered, travel-worn appearance is bareheaded with dark reddish hair and a reddish-golden beard. He is seen half-length in profile to the right, hands joined in prayer. James is dressed in a garment with well-worn sleeves, over which is draped the short cape that traditionally completes the pilgrim's voluminous clothing, providing an extra layer of protection against the elements. It has a patch sewn on it and, on the shoulder, a small scallop shell. The figure is set back from the right edge of the picture, with a rocky formation with small clumps of vegetation growing on it visible in the right background. His staff rests against the rock, its handle, polished from years of use, reflecting a few highlights. At the lower right, on a flat surface, rests his pilgrim's hat, its crown coarsely stitched, its broad brim turned up and bearing another scallop shell. The overall mood of the picture is hushed, sober, and deeply introspective. The hands are prominently featured, clasped in prayer, the long straight fingers tautly splayed out with their tips interlaced.

The paint layers range in thickness from thin to moderate, except for heavier touches of white on cuff and shirt collar and in the pale, luminous colors of the flesh. Gray-blue highlights play over the apostle's thick matted hair. Rembrandt painted the gaunt face and lean, strong hands with a fairly thick impasto, using relatively dry strokes of paint that retain the drawinglike indentations of a stiff brush. Cooler gray underlies and contrasts with the warmer flesh tones, suggesting beard shadow, the veins beneath the skin, and a certain weariness. Soft light falling from above lends a muted glow to the figure of the saint against the austere, somber background.[5]

It is characteristic of the later Rembrandt that he here downplays the picturesque appeal of the pilgrim's costume in order to concentrate our attention on the inner workings of James's spirit. This quietly luminous portrayal of the apostle's total absorption in prayer encourages the viewer who contemplates it to emulate it, assuming a similarly meditative state. SWR/CSA

NOTES

1. Paul, Br. 59; Bartholomew, Br. 615 (Malibu, the J. Paul Getty Museum); Matthew, Br. 614 (Paris, Musée du Louvre); Simon, Br. 616A (Zurich, Kunsthaus; Ruzicka Foundation). For reproductions of these and others by Rembrandt and his school, see Schwartz 1985, 310–14, figs. 351–60. Arthur Wheelock is planning to explore the theme of the apostles and evangelists in an exhibition to be shown at the National Gallery of Art and the Getty in winter 2006.

2. For example, the exuberantly Baroque half-length set painted on panel by Rubens in 1603, still together today in the Prado Museum, Madrid.

3. Cornelis Hofstede de Groot, *A Catalogue Raisonné of the Works of the Most Eminent Dutch Painters of the Seventeenth Century, Based on the Works of John Smith*, vol. 6 (London, Macmillan, 1916), 121, no. 170, as cited in Sutton et al. 1992, 198. See for a further discussion of the James painting, Sutton 1992, no. 121.

4. Hall 1979, 165–66; Smith 1979, 166–67.

5. Strips of canvas that extend the painting at the left edge (2 in.) and to a lesser degree at the top (¾ in.) were added at some later date. These strips of canvas and their later painted additions have been masked out in the illustration here and in the recent reframing of the painting. The canvas with additions measures 37 × 31½ in. The original canvas measures 36¼ × 29½ in.

EXHIBITION LIST

Compiled by Kate Harper and Thomas E. Rassieur

All objects are by Rembrandt, except for no. 114 and the verso of no. 144. The identifying numbers for Rembrandt works in standard catalogues are abbreviated as follows: B. (Bartsch 1797) and H. (Hind 1923) for prints and copper plates; Ben. (Benesch 1973) for drawings; and Br. (Bredius 1937) and Corpus (Corpus 1982–89) for paintings. States of prints are indicated with roman numerals following the Bartsch number. If the states given differ from those of White and Boon 1969, they are marked with an asterisk (*) and explained in a note. Measurements are height before width. For prints, the measurements are those of the platemark, unless otherwise indicated. Watermark (wm.) classifications for prints are those of Ash and Fletcher 1998 and Hinterding diss. 2001, unless otherwise indicated. A dagger (†) indicates that the copper plate for that print still exists. The identifying numbers for collectors are those of Lugt 1921 and 1956. Objects exhibited only in Boston or Chicago are so indicated.

1 The Presentation in the Temple, 1630
 B. 51, II; H. 18
 Etching
 10.2 × 7.8 cm (4 × 3¹/₁₆ in.)
 In plate: RHL 1630

 Provenance: Pierre Mariette (1634–1716, Paris, cf. Lugt 1790), 1674; Richard Gutekunst (1870–1961, Stuttgart, London, Bern, Lugt 2213a); sequestered by the British government in 1914 and sold as penalty for "trading with the enemy" by order of a public trustee through Garland-Smith & Co., London, 2–3 December 1920, as part of lot 185; to Meatyard (London); sold by Sotheby Parke Bernet, New York, 15 February 1980, lot 1034; Artemis-Boerner (New York and London); to MFA, June 2000.

 Museum of Fine Arts, Boston. Katherine E. Bullard Fund in memory of Francis Bullard, 2000.647

2 The Presentation in the Temple, 1639–41
 B. 49, II; H. 162 †
 Etching and drypoint
 21.2 × 29 cm (8³/₈ × 11⁷/₁₆ in.)

 Provenance: Possibly Arthur Pond (about 1705–1758); John Barnard (died 1784, London, Lugt 1419); his bequest to John Kenrick (died about 1798); his sale London, Philipe, 16 April 1798 and following days, lot 63; to Thomas Philipe (died about 1817, London, Lugt 2451); probably John Gibbs (mid-19th century, London, cf. Lugt 1081 and 1125); Henri Vever (1854–1943, Paris, cf. Lugt 2491bis); appeared at auction London, Sotheby's, 30 June 1998, as part of lot 129 but withdrawn; sale, London, Sotheby's, 11 December 1998, lot 75; Artemis-Boerner (New York and London); to MFA, March 2001.

Museum of Fine Arts, Boston. Katherine E. Bullard Fund in memory of Francis Bullard, 2001.140

3 The Presentation in the Temple (in the dark manner), 1654
 B. 50, only state; H. 279
 Etching, drypoint, and engraving
 21 × 16.2 cm (8¼ × 6³/₈ in.)

 Provenance: Franz Rechberger (1771–1841, Vienna, Lugt 2133); Dukes d'Arenberg (Brussels and Nordkirchen, Lugt 567); their sale, London, Christie et al., 14–17 July 1902, probably part of lot 391; Lessing J. Rosenwald (1891–1979, Philadelphia, Lugt 1760b); his gift to the National Gallery of Art, 1951.

 National Gallery of Art, Washington, Rosenwald Collection, 1951.12.1

4 Christ at Emmaus, 1634
 B. 88, only state; H. 121
 Etching
 10.2 × 7.4 cm (4 × 2¹⁵/₁₆ in.)
 In plate: Rembrandt f. 1634

 Provenance: Helmut H. Rumbler (Frankfurt); to MFA, June 2000.

 Museum of Fine Arts, Boston. Katherine E. Bullard Fund in memory of Francis Bullard, 2000.649

5 Christ at Emmaus, 1654
 B. 87, I; H. 282 †
 Etching on Japanese paper
 21 × 15.9 cm (8¼ × 6¼ in.)
 In plate: Rembrandt f. 1654.

 Provenance: Ambroise Firmin-Didot (1790–1876, Paris, Lugt 119); his sale, Paris, Pawlowski, et al. 16 April–12 May 1877, lot 840; Francis Seymour Haden (1818–1910, London, Lugt 1227); his sale London, Sotheby's, 15–18 May 1891, lot 447; to E. F. J. Deprez (London); Paul Davidsohn (born 1839, London and Berlin, Lugt 654); his sale, Leipzig, Boerner, 26–29 April 1921, lot 81; William G. Russell Allen (1882–1955, Boston); to his niece, Lydia Evans Tunnard (1913–1980, New Haven); her gift to MFA, December 1960.

 Museum of Fine Arts, Boston. Gift of Mrs. Christopher Tunnard in memory of W. G. Russell Allen, 60.1543

6 Christ at Emmaus, 1654
 B. 87; H. 282
 Copper etching plate
 21.3 × 16.3 cm (8³/₈ × 6⁷/₁₆ in.)

 Provenance: Probably Clement de Jonghe (1624/25–1677, Amsterdam); Pieter de Haan (1723–1766, Amsterdam); his sale, Amsterdam, Weyers & Castelein, 9 March 1767, lot 30; to Fouquet (probably Pierre, Jr., 1729–1800), for Claude-Henri Watelet (1718–1786, Paris); to Pierre-François Basan (1723–1797, Paris), 1786; inherited by Henry-Louis Basan (died before 1819); to Auguste Jean (died 1820, Paris), 1809–10; inherited by his widow and sold at her death, 1846; to Auguste Bernard (Paris), 1846; inherited by his son Michel Bernard (Paris); to Alvin-Beaumont (Paris), 1906; to Robert Lee Humber (died 1970, Greenville, NC), 1938; inherited by his sons (on loan to the North Carolina Museum of Art, Raleigh); sold to Artemis (London) and Robert M. Light (Santa Barbara), about 1992; from Artemis to The Art Institute of Chicago, 1993.

 The Art Institute of Chicago, The Clarence Buckingham Collection, 1993.181

7 The Circumcision, 1626
 Seidlitz 398, III*; H. 388
 Etching and engraving
 21.5 × 16.8 cm (8⁹/₁₆ × 6½ in.)
 In plate (not in Rembrandt's hand): Rembrant fecit I.P. Berendrech. ex.

 Provenance: Joseph Gulston (1745–1786; Ealing Grove, Middlesex, England, Lugt 2986); probably included in his sales, London, Greenwood, January-March 1786; C. Naumann (active mid-19th century, probably Germany, Lugt 1939); John Witt Randall 1813–1892, Boston, Lugt 2130); given by his sister Belinda L. Randall to Harvard College, 1892; transferred to the Fogg Art Museum.

 Courtesy of the Fogg Art Museum, Harvard University Art Museums, Cambridge, Massachusetts, Gift of Belinda L. Randall from the collection of John Witt Randall, R 823 NA

 *White and Boon describe two states, but there is an intermediate state (Hinterding diss., 514–15). The first state is illustrated in Boon 1963, pl. 1. The second state, in which hatching is added to the upper end of the stair rail and to the baluster beneath it as well as to the drip pan of the sconce, is illustrated in Münz 1952 I, pl. 208. In many areas around the edges, the hatching is also completed to the edge of the plate. In the third state the inscriptions and borderline are added.

8 *The Rest on the Flight into Egypt*, 1626

B. 59, only state; H. 307

Etching
21.7 × 16.5 cm (8⁹⁄₁₆ × 6½ in.)

Provenance: Pieter Cornelis Baron van Leyden (1717–1788, Leiden, cf. Lugt 12); acquired by the Dutch state, 1807; acquired by the Rijksmuseum, Amsterdam, 1816.

Rijksmuseum, Amsterdam, RP-P-OB-120

9 *The Flight into Egypt (a sketch)*, 1626

B. 54, I; H. 17

Etching and engraving
Sheet: 14.6 × 12.2 cm (5¾ × 4¹³⁄₁₆ in.)
wm: Basilisk variant C'.d

Provenance: Pieter Cornelis Baron van Leyden (1717–1788, Leiden, cf. Lugt 12); acquired by the Dutch state, 1807; acquired by the Rijksmuseum, Amsterdam, 1816.

Rijksmuseum, Amsterdam, RP-P-OB-108

10 *Peter and John at the Gate of the Temple*, about 1629

B. 95, only state; H. 5

Etching
22.1 × 16.9 cm (8¹¹⁄₁₆ × 6⅝ in.)
wm: Countermark NA variant A.d.

Provenance: Heneage Finch, Fifth Earl of Aylesford (1786–1859, London & Warwickshire, Lugt 58), acquired by the British Museum, 11 September 1848.

Lent by the Trustees of the British Museum, London, 1848.9.11.50

11 *Samson Betrayed by Delilah*, 1628–30

Br. 489; Corpus A24

Oil on panel
61.3 × 50.1 cm (24⅛ × 19¾ in.)
Signed and dated (possibly not by Rembrandt): RHL 1628

Provenance: Possibly Stadholder Frederik Hendrik (1584–1647, The Hague), 1632 (as by Jan Lievens); possibly King Frederick Wilhelm of Prussia (1688–1740) at Honselaersdijk, early eighteenth century; possibly included in a consignment of paintings sent to Berlin in 1742; probably Berliner Schloss (as by Govert Flinck), 1793; transferred to the Berlin museum by Emperor Wilhelm II of Germany, 1906.

Staatliche Museen zu Berlin, Preussischer Kulturbesitz, Gemäldegalerie, 812 A

12 *Self-Portrait, Bust*, about 1628–29

Ben. 54

Pen and brown ink, brown wash and white watercolor
12.7 × 9.4 cm (5 × 3¹¹⁄₁₆ in.)

wm: section of a crown (like Churchill 274, coat of arms with three cross-beams)

Provenance: Sir Thomas Lawrence (1769–1830, London, Lugt 2445); Samuel Woodburn (1786–1863, London, cf. Lugt 2584); William Esdaile (1758–1837, London, Lugt 2617); sold London, Christie and Manson, 17 June 1840, lot 58 (?): "Rembrandt's portrait, a slight sketch; from Sir Joshua Reynold's collection" to Woodburn (?); Edith Mendelssohn Bartholdy, Leipzig, 1924; Cornelis Hofstede de Groot (1863–1930, the Hague, Lugt 561); his sale Leipzig, Boerner, 4 November 1931, lot 160; Van Diemen; I. de Bruijn-van der Leeuw (Spiez, Switzerland); by whom given given to the Rijksmuseum 1949, with rights to ownership until 28 Nov. 1960.

Rijksmuseum, Amsterdam, RP-T-1961.75

13 *Self-Portrait (bare-headed, roughly etched)*, 1629

B. 338, only state; H. 4

Etching, touched with pen in dark gray ink
17.4 × 15.5 cm (6⅞ × 6⅛ in.)
In plate: RHL 1629 (in reverse)
Inscribed, verso, in black chalk or graphite (early 17th-century hand but probably not Rembrandt's): 2 Wtenbogaert 2 Ulespiegels / 2 [..] solemans [?] printen [?]

Provenance: Pieter Cornelis Baron van Leyden (1717–1788, Leiden, cf. Lugt 12); acquired by the Dutch state, 1807; acquired by the Rijksmuseum, Amsterdam, 1816.

Rijksmuseum, Amsterdam, RP-P-OB-723

14 *Self-Portrait*, 1629

Br. 8; Corpus A20

Oil on panel
89.5 × 73.5 cm (35¼ × 28¹⁵⁄₁₆ in.)
Signed and dated: "RHL...9"

Provenance: Richard Grenville, second Duke of Buckingham and Chandos (1797–1861, Stowe House, Buckinghamshire); probably siezed by his creditors, 1847; sold, Stowe House, 15 September 1848, lot 421; Lord Ward (probably William Ward, first Earl of Dudley from 1860, 1817–1885, Himley Hall and Whitley Court); Sawyer (Hinton St. George) Somerset; sale London, Christie's, 13 July 1895, lot 81; to Tooth (probably Arthur Tooth, London); P. & D. Colnaghi (London); to Isabella Stewart Gardner(1840–1924), February 1896.

The Isabella Stewart Gardner Museum, Boston, P21N6
Boston only

15 *Self-Portrait (frowning, bust)*, 1630

B. 10, II; H. 30

Etching
7.2 × 6 cm (2¹³⁄₁₆ × 2⅜ in.)

Provenance: Possibly Jan Six (1618–1700, Amsterdam); possibly Arnold Houbraken (1660–1719, Dordrecht and Amsterdam); possibly Arthur Pond (about 1705–1758); John Barnard (died 1784, London, Lugt 1419); his bequest to John Kenrick (died about 1798); his sale London, Philipe, 16 April 1798 and following days, part of lot 18; to Thomas Philipe (died about 1817, London, cf. Lugt 2451); Lessing J. Rosenwald (1891–1979, Philadelphia, Lugt 1760b); his gift to the National Gallery of Art, 1943.

National Gallery of Art, Washington, Rosenwald Collection, 1943.3.7051

16 *Self-Portrait (open-mouthed as if shouting)*, 1630

B. 13, II; H. 31

Etching
7.3 × 6.2 cm (2⅞ × 2⁷⁄₁₆ in.)
In plate: RHL 1630

Provenance: Fürst Karl Paar (1772–1819, Vienna, Lugt 2009); inherited by his son; probably sold on the eighth or ninth day of his sale, London, Sotheby's, 13–26 July 1854, part of lot 1409; to Evans; August Artaria (1807–1893, Vienna, Lugt 33); his sale, Vienna, Artaria and Co., 6–13 May 1896, lot 369; George Washington Vanderbilt (1862–1914, Asheville, NC); John Pierpont Morgan (1837–1913, New York), after 1905.

The Pierpont Morgan Library, New York, RvR 14

17 *Self-Portrait in a Cap*, 1630

B. 320, only state; H. 32

Etching
5.1 × 4.6 cm (2 × 1¹³⁄₁₆ in.)
In plate: RHL 1630

Provenance: Walter Francis, 5th Duke of Buccleuch and 7th Duke of Queensberry (1806–1884, London and Dalkeith, Scotland, Lugt 402); his sale, London, Christie's, 19–22 April 1887, lot 1760 or 1761; George Washington Vanderbilt (1862–1914, Asheville, NC); John Pierpont Morgan (1837–1913, New York), after 1905.

The Pierpont Morgan Library, New York, RvR 442

18 *The Artist in His Studio*, about 1628

Br. 419; Corpus A18

Oil on panel
24.8 × 31.7 cm (9¾ × 12½ in.)

Provenance: Morton sale, London, Christie's, 27 April 1850, [probably not sold, as unsold pictures passed to Lady Morton's brother, Baron Churston, and were sold by his descendants in 1925]; by descent to John Reginald Lopes Yarde-Buller, third Baron Churston (1873–1930) by 1925; his sale, London, Christie's, 26 June 1925, lot 14; Robert Langton Douglas (1864–1951, London), probably by 1936; to Mrs. Zoe Oliver Sherman (died 1945, Boston); her gift to MFA,1938.

Museum of Fine Arts, Boston. Zoe Oliver Sherman Fund in memory of Lillie Oliver Poor, 38.1838

19 *An Artist in His Studio*, early to mid-1630s

Ben. 390

Pen and brown ink
20.5 × 17 cm (8¹/₁₆ × 6¹¹/₁₆ in.)

Provenance: Edward Bouverie (1767–1858, Delapré Abbey, Northampton, Lugt 325); his sale, London, Christie's, 20 July 1859, lot 24; Lewis Huth Walters; Dr. Francis Springell [originally Sprinzels] (1898–1974, Prague and Portinscale, Cumberland); his widow; sold London, Sotheby's, 30 June 1986, lot 41.

The J. Paul Getty Museum, Los Angeles, 86.GA.675
Boston only

20 *An Elderly Woman (Rembrandt's mother, head and bust)*, 1628

B. 354, II; H. 1

Etching and drypoint
6.6 × 6.4 cm (2⅝ × 2⁹/₁₆ in.)
In plate: RHL 1628 (2 in reverse)

Provenance: P. & D. Colnaghi (London); to Adolph Weil Jr. (1915–1995, Montgomery, Alabama), 9 July 1971; his widow Jean K. Weil; by whom given to the Hood Museum of Art.

Hood Museum of Art, Dartmouth College, Hanover, New Hampshire; gift of Jean K. Weil in memory of Adolf Weil, Jr., Class of 1935, PR.997.5.115

21 *An Elderly Woman (Rembrandt's mother, seated at a table)*, about 1631

B. 343, II; H. 52

Etching and engraving
14.8 × 13.1 cm (5¹³/₁₆ × 5³/₁₆ in.)
In plate: RHL. f.

Provenance: Heneage Finch, Fifth Earl of Aylesford (1786–1859, London & Warwickshire, Lugt 58); to Samuel Woodburn (1786–1853, London, cf. Lugt 2584); to John Heywood Hawkins (died between 1870 and 1880, London and Bignor Park, Sussex, cf. Lugt 1471); sold through P. & D. Colnaghi (London) to Walter Francis, 5th Duke of Buccleuch and 7th Duke of Queensberry (1806–1884, London and Dalkeith, Scotland, Lugt 402); his sale, London, Christie's, 19–22 April 1887, lot 2075; Horatio Greenough Curtis; Mrs. Horatio Greenough Curtis; her bequest to MFA, June or July 1927, received September 1940.

Museum of Fine Arts, Boston. Gift of Mrs. Horatio Greenough Curtis in memory of her husband, Horatio Greenough Curtis, 27.1395

22 *Standing Beggar*, 1630

Ben. 30

Black chalk, with white watercolor
29.4 × 17 cm (11⁹/₁₆ × 6¹¹/₁₆ in.)

Provenance: Jacob de Vos Jacobsz. (1803–1882, Amsterdam, Lugt 1450); sold Amsterdam, Roos, et al., 22–24 May 1883, lot 412; acquired by the Vereniging Rembrandt, 1889.

Rijksmuseum, Amsterdam, RP-T-1889-A-2046 (R)

23 *Beggar in a High Cap, Leaning on a Stick*, about 1629

B. 162, only state; H. 15

Etching
15.6 × 12 cm (6⅛ × 4¾ in.)
wm: Strasbourg Bend G.a.

Provenance: Pieter Cornelis Baron van Leyden (1717–1788, Leiden, cf. Lugt 12); acquired by the Dutch state, 1807; acquired by the Rijksmuseum, Amsterdam, 1816.

Rijksmuseum, Amsterdam, RP-P-OB-245

24 *The Blind Fiddler*, 1631

B. 138, I; H. 38

Etching
7.8 × 5.3 cm (3¹/₁₆ × 2¹/₁₆ in.)
In plate: RHL 1631

Provenance: Heneage Finch, Fifth Earl of Aylesford (1786–1859, London & Warwickshire, Lugt 58); Baron Jan Gijsbert Verstolk van Soelen (1776–1845, The Hague and Soelen, Lugt 2490); his sale, Amsterdam, De Vries, et al., 26 October 1847 and following days, lot 361 or 363; Teylers Museum, Haarlem.

Teylers Museum, Haarlem, KG 3706

25 *A Beggar Seated on a Bank (Self-Portrait)*, 1630

B. 174 only state; H. 11

Etching
11.5 × 6.9 cm (4½ × 2¹¹/₁₆ in.)
In plate: RHL 1630

Provenance: Joseph R. Ritman (born 1941, Amsterdam); Sotheby's and Artemis (New York and London, Ritman Catalogue, no. 79), 1995; to MFA, September 1997.

Museum of Fine Arts, Boston. Katherine E. Bullard Fund in memory of Francis Bullard, 1997.144

26 *Beggar Seated Warming His Hands at a Chafing Dish*, about 1630

B. 173, II; H. 8

Etching
7.7 × 4.6 cm (3¹/₁₆ × 1¹³/₁₆ in.)

Provenance: Alexander John Godby (1853–1934, Baltimore, Lugt supplement 1119b); his sale, London, Sotheby's, 29–30 January 1935, part of lot 146; to Frits Lugt (1884–1970, Paris and the Hague, Lugt 1028); P. & D. Colnaghi (London); Jorge Miguel Steiner; through C. G. Boerner (Düsseldorf) to MFA, April 1970.

Museum of Fine Arts, Boston. Katherine E. Bullard Fund in memory of Francis Bullard, 1970.316

27 *Sheet of Studies (with head of the artist)*, about 1631–32

B. 363, I; H. 90

Etching
10.1 × 11.4 cm (4 × 4½ in.)

wm: Strasbourg Lily with initial L' variant A.a.

Provenance: Pieter Cornelis Baron van Leyden (1717–1788, Leiden, cf. Lugt 12); acquired by the Dutch state, 1807; acquired by the Rijksmuseum, Amsterdam, 1816.

Rijksmuseum, Amsterdam, RP-P-OB-764

28 *Self-Portrait (with plumed cap and lowered sabre)*, 1634

B. 23, I; H. 110

Etching
19.7 × 16.2 cm (7¾ × 6⅜ in.)
wm: Basilisk variant B'.a.
In plate: Rembrandt f. 1634

Provenance: Pieter Cornelis Baron van Leyden (1717–1788, Leiden, cf. Lugt 12); acquired by the Dutch state, 1807; acquired by the Rijksmuseum, Amsterdam, 1816.

Rijksmuseum, Amsterdam, RP-P-OB-42

29 *Three Studies of Old Men's Heads*, about 1630

B. 374, only state; H. 25

Etching
10.5 × 8.4 cm (4⅛ × 3⁵/₁₆ in.)
wm: fragment

Provenance: Pieter Cornelis Baron van Leyden (1717–1788, Leiden, cf. Lugt 12); acquired by the Dutch state, 1807; acquired by the Rijksmuseum, Amsterdam, 1816.

Rijksmuseum, Amsterdam, RP-P-OB-780

30 *Old Man in a Gorget and Black Cap*, about 1631

Br. 81; Corpus A42

Oil on panel
83.1 × 75.7 cm (32¹¹/₁₆ × 29¹³/₁₆ in.)
Signed: RHL

Provenance: Sale, Amsterdam, 10 June 1767, lot 14; to Ketelaar; M. P. W. Boulton (Tew Park, Oxfordshire); sale, London, 9 December 1911, lot 14; P. & D. Colnaghi and Obach (London); Julius Böhler (Munich); Marczell von Nemes (Budapest); sale Paris, 17 June 1913, lot 60; Julius Böhler (Munich); H. Reinhardt (New York); Evalyne M. Cone Kimball (about 1840–1921, Chicago); her bequest to The Art Institute of Chicago, 1922.

The Art Institute of Chicago, Mr. and Mrs. W. W. Kimball Collection, 22.4467

31 *Bust of an Old Man*, 1633

Br. 633; Corpus A74

Oil on paper laid on panel
10.6 × 7.2 cm (4³/₁₆ × 2¹³/₁₆ in.)
Signed and dated: Rembrandt .1633.

Provenance: Possibly Mrs Van Sonsbeeck, before 1751; sale, Fr. Szarvady, Paris, 21 February 1874, lot 39; V. Boric (Paris), 1881; sale, Paris, 1900; to F. Kleinberger (Paris), 1900; to Baron Emile Janssen (Brussels); his sale, Amsterdam, Frederik Muller,

26 April 1927, lot 94; to M. Knoedler and Co. (New York); Andrew William Mellon (1855–1937, Washington), by 1935; Paul Mellon (1907–1999, Upperville, VA); Arthur Amory Houghton, Jr. (born 1906, Queenstown, MD), by 1955; Richard Feigen and Co. (New York), to Saul Phillip Steinberg (New York) 1986; his sale, New York, Sotheby's, 30 January 1997, lot 39; private collection, Japan.

Private Collection

32 *Seated Old Man*, about 1639

Pen and brown ink, brown wash, white watercolor, scoring
16.4 × 12.9 cm (6^7/$_{16}$ × 5^1/$_{16}$ in.)
Verso, in pen and brown ink, a sketch of a standing woman

Provenance: Chevalier Ignace-Joseph de Claussin (1766–1844, London and Paris, Lugt 485); his sale, Batignolles, Dumesnil-Schroth, 2 December 1844, lot 42; to Guichardot (Paris); F. van den Zande (died by 1855, Paris; Lugt 2680); his sale, Paris, Guichardot, et al., 30 April 1855 and following days, lot 2988; Émile Norblin; his sale, Paris, Blaisot et al., 16–17 March 1860, lot 37; W. Nijman; Richard Ederheimer (born about 1885, New York, Lugt 1711); Savile Gallery (London); acquired by Frits Lugt (1884–1970, Paris and the Hague, Lugt 1028), 28 May 1930.

Collection Frits Lugt, Institut Néerlandais, Paris, 4502
Chicago only

33 *Old Man with a Divided Fur Cap*, 1640

B. 265, I; H. 170

Etching and drypoint
15.2 × 13.8 cm (6 × 5^7/$_{16}$ in.)
In plate: Rembrandt f 1640

Provenance: Cambridge University Library; transferred to Fitzwilliam Museum, 1876.

The Fitzwilliam Museum, University of Cambridge, AD 12.39-214

34 *Four Studies of Male Heads*, mid-1630s

Ben. 339

Pen and brown ink, brown wash
12.6 × 15.8 cm (4^{15}/$_{16}$ × 6^1/$_4$ in.)

Provenance: Jonathan Richardson Sr. (1665–1745, London, Lugt 2183); Thomas Hudson (1701–1779, London, Lugt 2432); John Knight (London); sale, London, Phillips 19 July 1841, lot 120; Charles Sackville Bale (1791–1880, London, Lugt 641); his sale, London, Christie's, 10 June 1881, lot 2427; to [Jeffrey?] Whitehead; P. & D. Colnaghi (London); Jonkheer H. Teixeira da Mattos (Vogelenzang); Franz Koenigs (1881–1941, Haarlem, cf. Lugt 1023a); Paul Cassirer (1871–1926, Amsterdam); sale, London, Sotheby's 20 November 1957, lot 70; P. & D. Colnaghi (London); Mrs. Donald Methuen; sale, London, Christie's 7 April 1970, lot 124; P & D Colnaghi (London); New York, Christie's, 11 January 1994, lot 385; Maida and George Abrams (Boston), 1994.

Courtesy of the Fogg Art Museum, Harvard University Art Museums, Cambridge, Massachusetts, Loan from Maida and George Abrams, ABR 115

35 *Daniel and Cyrus before the Idol Bel*, 1633

Br. 491; Corpus A67

Oil on panel
23.4 × 30.1 cm (9^1/$_4$ × 11^7/$_8$ in.)
Signed and dated: Rembrant f 1633

Provenance: Pieter Croon (Amsterdam), by 1650; Barton Booth (1681–1733); bequeathed to his widow Hester Santlow Booth; by inheritance, to her grandson Edward Eliot; possibly by inheritance to the Earl of St. Germans (Port Eliot, Cornwall), by 1921; offered for sale by The Trustees of the Earl of St. Germans' Heirlooms Settlement, London, Christie's, 15 April 1992, lot 28, but unsold; Thomas Agnew & Sons (London); to the J. Paul Getty Museum, Los Angeles in 1995.

The J. Paul Getty Museum, Los Angeles, 95. PB.15

36 *The Circumcision*, 1630

B. 48 only state; H. 19

Etching and drypoint
9 × 6.4 cm (3^9/$_{16}$ × 2^1/$_2$ in.)
wm: Strasbourg Lily with initials BA

Provenance: Heneage Finch, Fifth Earl of Aylesford (1786–1859, London & Warwickshire, Lugt 58); to Samuel Woodburn (1786–1863, London, cf. Lugt 2584), 1846; Ambroise Firmin-Didot (1790–1876, Paris, Lugt 119); his sale, Paris, Pawlowski, et al. 16 April–12 May 1877, lot 777; Dr. August Sträter (1810–1897, Aachen, Lugt 787); his sale, Stuttgart, Gutekunst, 10–14 May 1898, lot 680; Marsden Jasael Perry (1850–1935, Providence, RI, Lugt 1880); his sale, Stuttgart, Gutekunst, 18–23 May 1908, lot 1148; Gustav von Rath (born 1888, Crefeld, Lugt 2772); C. G. Boerner (Düsseldorf, catalogue 71, 1979, no. 37); C. G. Boerner (Catalogue 88, no. 36) 1987; Joseph R. Ritman (born 1941, Amsterdam); Sotheby's and Artemis (New York and London, Ritman Catalogue, no. 26), 1995; to S. William Pelletier, August 2000.

S. William Pelletier, Athens, Georgia, 2000.8.2.10

37 *The Presentation in the Temple*, 1630

B. 51, II; H. 18

Etching
10.3 × 7.8 cm (4^1/$_{16}$ × 3^1/$_{16}$ in.)
In plate: RHL 1630

Provenance: Unidentified French collection, probably assembled in the 18th century; sold London, Sotheby's, 6 December 1990, lot 112; to Thomas E. Rassieur.

Thomas E. Rassieur Collection

38 *Christ Disputing with the Doctors*, 1630

B. 66, I; H. 20

Etching

10.8 × 7.8 cm (4^5/$_{16}$ × 3^1/$_8$ in.)
wm: Eagle wth Basel Crozier variant D.a.
In plate: RHL 1630

Provenance: Clayton Mordaunt Cracherode (1730–1799, London, Lugt 606); bequeathed by him to the British Museum.

Lent by the Trustees of the British Museum, London, 1973.U.756

39 *The Angel Appearing to the Shepherds*, 1634

B. 44, III; H. 120 †

Etching, engraving, and drypoint
26.2 × 21.8 cm (10^3/$_8$ × 8^5/$_8$ in.)
wm: Strasbourg Lily variant D.a.
In plate: Rembrandt. f. 1634

Provenance: Heneage Finch, Fifth Earl of Aylesford (1786–1859, London & Warwickshire, Lugt 58); to John Heywood Hawkins (died between 1870 and 1880, London and Bignor Park, Sussex, cf. Lugt 1471); his sale London, Sotheby's, 29 April 1850, lot 874; to "Webber" (perhaps Hermann Weber, 1817–1854, Bonn, Lugt 1383); Berlin Kupferstichkabinett (cf. Lugt 1606); George Washington Vanderbilt (1862–1914, Asheville, NC); John Pierpont Morgan (1837–1913, New York), after 1905.

The Pierpont Morgan Library, New York, RvR 65

40 *Christ Carrying the Cross*, mid-1630s

Ben. 97

Pen and brown ink, brown wash
14.5 × 26 cm (5^{11}/$_{16}$ × 10^1/$_4$ in.)
Inscribed: Rembrant

Provenance: Sir John Charles Robinson (1824–1913, London, Lugt 1433); acquired by the Berlin Kupferstichkabinett 1880.

Staatliche Museen zu Berlin, Preussischer Kulturbesitz, Kupferstichkabinett, KdZ 1554

41 *Calvary*, mid-1630s

Ben. 108

Pen and brown ink and brown wash, touched with white watercolor, with section replaced and redrawn by Rembrandt
21.8 × 17.9 cm (8^9/$_{16}$ × 7^1/$_{16}$ in.)

Provenance: Sir Michael Ernest Sadler (1861–1943, Oxford, Lugt 1915c); his sale, London, Sotheby's, 12 December 1928, lot 108; to Jacob H. J. Mellaart (died 1970s, London and Holland), possibly for the Kupferstichkabinett, Berlin.

Staatliche Museen zu Berlin, Preussischer Kulturbesitz, Kupferstichkabinett, KdZ 12954

42 *Descent from the Cross (a sketch)*, 1642

B. 82, only state; H. 199

Etching and drypoint
14.9 × 11.6 cm (5^7/$_8$ × 4^9/$_{16}$ in.)
In plate: Rembrandt. f. 1642

Provenance: Evans (London); to the British Museum.

Lent by the Trustees of the British Museum, London, 1860.7.28.647

43 *Lamentation at the Foot of the Cross*, 1634–35
Ben. 154

Pen and brown ink and brown wash, red and perhaps some black chalk, reworked in monochrome oil paint; sheet made up of cut sections of paper
21.6 × 25.4 cm (8½ × 10 in.)
Inscribed on a remnant of the old mat, in pen and brown ink, by Jonathan Richardson, Junior: Rembrandt has labour'd this Study for the Lower part of his famous Des/:cent from the Cross, grav'd by Picart, & had so often chang'd his mind in/the Disposition of the Clair-Obscur, which was his Point Here, that / my Father & I counted, I think, Seventeen different peices [sic] of Paper.

Provenance: Jonathan Richardson, Sr. (1665–1745, London, Lugt 2184); Jonathan Richardson, Jr. (1694–1771, London, Lugt 2170); Sir Joshua Reynolds (1723–1792, London, Lugt 2364); Richard Payne Knight (1750–1824, London, Lugt 1577); bequeathed by him to the British Museum, 1824.

Lent by the Trustees of the British Museum, London, Oo.9-103

44 *Lamentation at the Foot of the Cross*, 1634–35
Br. 565; Corpus A107

Oil on cut paper, mounted on panel
31.9 × 26.7 cm (12⁹⁄₁₆ × 10½ in.)

Provenance: Collection of J. Barij [Jean or Jacob de Bary?] (Amsterdam), by 1730; Joseph Smith (about 1674–1770, Venice), by 1738; to King George III of England (1738–1820, cf. Lugt 1200), 1762; passed into the collection of the Surveyor of the King's Pictures, Richard Dalton (about 1715–1791, London, cf. Lugt 782), his sale, London, 9–11 April 1791, second day, lot 19; to Grosier for Sir Joshua Reynolds (1723–1792, London, Lugt 2364); his sale, London, 13 March 1795, third day, lot 38; to Sir George Beaumont (1753–1827, Coleorton, Leicestershire) 13 March 1795; his gift to the British Museum for the proposed National Gallery, 1823; transferred to the National Gallery, 1828.

The National Gallery, London, NG 43

45 *Christ Carried to the Tomb*, 1645
B. 84, only state; H. 215

Etching and drypoint
12.9 × 10.7 cm (5¹⁄₁₆ × 4³⁄₁₆ in.)
In plate: Rembrant.

Provenance: Goodman-Walker (Boston); to The Art Institute of Chicago, March 1933

The Art Institute of Chicago, The Clarence Buckingham Collection, 1933.794

46 *The Entombment*, 1630s
Br. 554; Corpus A105

Oil on panel

32.1 × 40.3 cm (12⁵⁄₈ × 15⁷⁄₈ in.)

Provenance: Probably identical with a sketch described in the inventory of Rembrandt's possessions dated 25–26 July 1656; possibly the collection of Robert Strange (1721–1792, London, cf. Lugt 2239), 1769 (his catalogue, London, 1769, no. 59): sold, London, Christie's, 7–9 February 1771, lot 61; Dr. William Hunter (1718–1778, Glasgow); his bequest to University College, Glasgow, 1783.

Hunterian Art Gallery, University of Glasgow, GLAHA 43785

47 *The Incredulity of Thomas*, 1634
Br. 552; Corpus A90

Oil on panel
53.1 × 50.5 cm (20⁷⁄₈ × 19⁷⁄₈ in.)
Signed and dated: Rembrandt. f 1634

Provenance: Maria Rutgers (widow of Ameldonck Leeuw); by descent, her son David Leeuw (1631/2–1703), inventoried 7 February 1653; Anna van Lennep (widow of P. Roeters and granddaughter of David Leeuw), by 1759; her sale, Amsterdam, 30 January 1759, lot 1; to the De Neufville brothers; probably Pieter Leendert de Neufville (Amsterdam); Johann Ernst Gotzkowski (1710–1775, Berlin), by 1764; to Empress Catherine II of Russia (1729–1796, Czarina from 1762, St. Petersburg), 1764; transferred from the imperial collection to the newly created Imperial Hermitage Museum, 1852; transferred from the Hermitage State Museum to the Pushkin Museum, 1964.

The Pushkin Museum of Fine Arts, Moscow, 261.9.

48 *Ecce Homo (Christ before Pilate)*, 1634
Br. 546; Corpus A89

Oil on paper laid on canvas
54.5 × 44.5 cm (21⁷⁄₁₆ × 17½ in.)
Signed and dated: Rembrandt. f. 1634

Provenance: Perhaps identical with the 'Ecce Homo' in grisaille in the inventory of Rembrandt's possessions dated 25–26 July 1656; possibly Jan van de Capelle (1624/6–1679, Amsterdam), 1680 estate inventory no 13; Valerius Röver (1686–1739, Delft), 1738 inventory no. 8; Johan Goll van Franckenstein (Amsterdam), before 1827; to A. Brondgeest, (probably Albertus Brondgeest, 1786–1849, The Hague and/or Amsterdam), 1827; to Thomas Emerson (London); Jeremiah Harman, by 1836; his sale, London, Christie's, 17–18 May 1844, lot 92; to John Smith; to G. Blamire; his sale, London, 7–9 November 1863, lot 57; to Mulvaney; Sir Charles Lock Eastlake (1793–1865, London); Lady Eastlake (Elizabeth Rigby, 1809–1893); under the terms of Sir Charles' will, sold by her executors for a nominal sum to The National Gallery, 1894.

The National Gallery, London, NG1400

49 *Christ before Pilate*, 1635–36
B. 77, II; H. 143

Etching and engraving

54.9 × 44.7 cm (21⁵⁄₈ × 17⁵⁄₈ in.)
wm: Strasbourg Lily variant C.c.a.
In plate: Rembrandt f. 1636 cum privile.

Provenance: Lessing J. Rosenwald (1891–1979, Philadelphia, Lugt 1760b); his gift to the National Gallery of Art, 1943.

National Gallery of Art, Washington, Rosenwald Collection, 1943.3.7175

50 *Bearded Old Man Seated in an Armchair*, 1631
Ben. 20

Red and black chalk on pale yellow prepared paper
23.3 × 16 cm (9³⁄₁₆ × 6⁵⁄₁₆ in.)

Provenance: John Heywood Hawkins (died between 1870 and 1880, London and Bignor Park, Sussex, cf. Lugt 1471); his sale London, Sotheby's, 29 April 1850, lot 1027; William Mitchell (died 1908, London, Lugt 2638); his sale Frankfurt, Prestel, 7 May 1890, lot 84; Moriz von Kuffner (1854–1939, Vienna and Zurich); Stephan von Kuffner (Vienna and Zurich); Von Kuffner family (Zurich); sale London, Sotheby's, 26 November 1970, lot 16; to Alain Delon (born 1934, Paris) as "St. Cyre."; to the current owner.

Private Collection

51 *Joseph Telling His Dreams*, 1633–34
Br. 504; Corpus A66

Oil on paper laid on cardboard
55.8 × 38.7 cm (21¹⁵⁄₁₆ × 15¼ in.)
Signed and dated: R[..]brandt. f: 163[.]

Provenance: Ferdinand Bol (1616–1680, Amsterdam, 1669 inventory); Duc de Tallard, sale Paris 22 March–13 May 1756, lot 157; Nogaret; his sale, Paris, Lebrun, 18 March 1782, lot 51.; Six van Hillegom (Amsterdam, cat.1900, no.124) in 1836; Jhr. Jan Willem Six van Vromade (1857–1926, Amsterdam); his sale, Amsterdam, 29 June 1920, no. II; A. W. Volz (The Hague), from 1928; his bequest to the Rijksmuseum through the Vereniging Rembrandt, 1946.

Rijksmuseum, Amsterdam, A3477

52 *Joseph Telling His Dreams*, 1638
B. 37, II; H. 160 †

Etching
11.1 × 8.4 cm (4³⁄₈ × 3⁵⁄₁₆ in.)
wm: fragment
In plate: Rembrant f 1638

Provenance: Henry F. Sewall (1816–1896, New York, Lugt 1309); purchased by MFA, November 1897.

Museum of Fine Arts, Boston. Harvey D. Parker Collection, P414

53 *Two Women and a Turbaned Figure*, 1638
Ben. 168

Pen and brown ink, brown wash, white watercolor

13.9 × 12.5 cm (5½ × 4¹⁵⁄₁₆ in.)

Provenance: Thomas Dimsdale (1758–1823, London, Lugt 2426); Hamian; Stopford Augustus Brooke (1832–1916, London); his sale London, Sotheby's, 28 May 1924, lot 75; to [Frederick John?] Parsons (died 1935, London, cf. Lugt 2881); Cornelis Hofstede de Groot (1863–1930, the Hague, Lugt 561); his sale Leipzig, Boerner, 4 November 1931, lot 163.

Private Collection, New York

54 *Sleeping Watchdog*, 1637–40

Ben. 455

Pen and brown ink, brown wash
14.3 × 16.8 cm (5⅝ × 6⅝ in.)

Provenance: Lucien Guiraud (Paris); sold Paris, Drouot, 14–15 June 1956, lot 62; to MFA through Maurice Gobin (born 1883, Paris, cf. Lugt 1124a) and William H. Schab (New York).

Museum of Fine Arts, Boston. John H. and Ernestine A. Payne Fund, 56.519

55 *Sleeping Puppy*, 1639–40

B. 158, II*; H. 174

Etching and drypoint
3.8 × 8.1 cm (1½ × 3³⁄₁₆ in.)

Provenance: William Esdaile (1758–1837, London, Lugt 2617); D. G. Arozarena (active late 1850s and early 1860s, South America and Paris, Lugt 109); his sale, Paris, Clément, 11 March 1861 and following days, lot 655; C. G. Boerner (Düsseldorf); to MFA, November 1981.

Museum of Fine Arts, Boston. Katherine E. Bullard Fund in memory of Francis Bullard, 1981.397

*White and Boon describe three states: the full plate (6.4 × 10.5 cm), the reduced plate (4.7 × 9 cm), and the further reduced plate (3.9 × 8.1 cm). T. Rassieur finds no evidence that the plate was reduced in two stages. The sheet of the so-called second state in the British Museum measures 4.7 × 9 cm and has no platemark at the left and bottom edges. The only impression in the Rothschild collection that is larger than 3.9 × 8.1 cm measures 4 × 8.8 cm.—smaller than the purported first reduction. Thus, there appear to be only two discernible states from Rembrandt's lifetime. The plate was reworked at a later date.

56 *The Holy Family*, about 1632

B. 62, only state; H. 95

Etching
9.6 × 7.3 cm (3¾ × 2⅞ in.)
wm: Strasbourg Lily
In plate: RHL.

Provenance: John Postle Heseltine (1843–1929, London, cf. Lugt 1507); John Innes (1852–1929, Glasgow, cf. Lugt 1477a); Charles C. Cunningham, Jr. (born 1934, Boston); National Gallery of Art, 1975.

National Gallery of Art, Washington, Print Purchase Fund (Rosenwald Collection), 1975.5.1

57 *The Holy Family with Angels*, 1645

Br. 570

Oil on canvas
117 × 91 cm (46 × 36 in.)
Signed and dated: Rembrandt f. 1645

Provenance: Sale, Adriaen Bout, The Hague, 1733; Pierre Crozat (Paris), before 1740; François Crozat, Baron du Châtel (Paris), before 1750; Louis-Antoine Crozat, Baron de Thiers (Paris); acquired by the Imperial Hermitage, St. Petersburg, 1772.

The State Hermitage Museum, St. Petersburg, 741

58 *Self-Portrait with Saskia*, 1636

B. 19, I; H. 144 †

Etching
10.4 × 9.3 cm (4⅛ × 3¹¹⁄₁₆ in.)
In plate: Rembrandt. f 1636

Provenance: Edward Vernon Utterson (1775 or 1776–1856, London, Lugt 909); Henry F. Sewall (1816–1896, New York, Lugt 1309); purchased by MFA, November 1897.

Museum of Fine Arts, Boston. Harvey D. Parker Collection, P390
Boston only

Self-Portrait with Saskia, 1636

B. 19, I; H. 144 †
Etching
10.3 × 9.2 cm (4¹⁄₁₆ × 3⅝ in.)
In plate: Rembrandt. f 1636

Provenance: Dethomas (probably Maxime, 1867–1928, Paris, Lugt 669a); Albert Roullier (1858–1920, Chicago, cf. Lugt 170); to Clarence Buckingham (1854–1913, Chicago, Lugt 497) March 1910; to his sisters, Katherine (died 1937, Chicago) and Lucy-Maud (died 1920, Chicago); bequeathed by Katherine Buckingham to The Art Institute of Chicago, 1938.

The Art Institute of Chicago, The Clarence Buckingham Collection, 1938.1797
Chicago only

59 *Saskia with Pearls in Her Hair*, 1634

B. 347, only state; H. 112

Etching
8.6 × 6.6 cm (3⅜ × 2⅝ in.)
In plate: Rembrandt f 1634

Provenance: No recorded provenance

Teylers Museum, Haarlem, KG 3908

60 *Three Heads of Women, One Asleep*, 1637

B. 368, II; H. 152 †

Etching
14.1 × 9.6 cm (5⁹⁄₁₆ × 3¾ in.)
In plate: Rembrandt f 1637

Provenance: Heneage Finch, Fifth Earl of Aylesford (1786–1859, London & Warwickshire, Lugt 58); probably sold to Samuel Woodburn (1786–1853, London, cf. Lugt 2584), 1846; Christian David Ginsburg (1831–1914, Palmer's Green, England, Lugt 1145); possibly included in his sale, London, Sotheby's, 20–23 July 1915, as part of lot 444; possibly to P. & D. Colnaghi (London); Craddock & Barnard (Tunbridge Wells, England); Lee Max Friedman (1871–1957, Boston, cf. 1749a); given to MFA by his estate, 13 November 1958.

Museum of Fine Arts, Boston. Gift of the Estate of Lee M. Friedman, 58.1051

61 *The Great Jewish Bride*, 1635

B. 340, II; H. 127

Etching and drypoint
22.1 × 16.8 cm (8¹¹⁄₁₆ × 6⅝ in.)
wm: Strasbourg Lily with initials BA variant A.b.

Provenance: Nicholas Mossloff (1847–1914, Moscow, Lugt 1802); P. & D. Colnaghi (London); to MFA, October 1934.

Museum of Fine Arts, Boston. George Nixon Black Fund, 34.604

62 *The Great Jewish Bride*, 1635

B. 340, IV; H. 127

Etching
22.2 × 16.9 cm (8¹¹⁄₁₆ × 6⅝ in.)
In plate: R 1635 (in reverse)

Provenance: The British Museum, London; Paul J. Sachs (1878–1965, Cambridge, Lugt 2091); his gift to the Fogg Art Museum.

Courtesy of the Fogg Art Museum, Harvard University Art Museums, Cambridge, Massachusetts, Gift of Paul J. Sachs, M 208

63 *Saskia as St. Catherine ("The Little Jewish Bride")*, 1638

B. 342, only state; H. 154

Etching and drypoint
11 × 7.8 cm (4⁵⁄₁₆ × 3¹⁄₁₆ in.)
In plate: Rembrandt f. 1638 (in reverse)

Provenance: W. Stewart; sold Lucerne, Gilhofer and Rauschburg, 7 August 1936; Felix Somary (1881–1956, Vienna and Zurich); N. G. Stogdon and Artemis (London, Somary catalogue 1985); Adolph Weil, Jr. (1915–1995, Montgomery, Alabama); his widow Jean K. Weil; by whom given to the Hood Museum of Art.

Hood Museum of Art, Dartmouth College, Hanover, New Hampshire; gift of Jean K. Weil in memory of Adolf Weil, Jr., Class of 1935, PR 997.5.114

64 *Jacob Caressing Benjamin*, about 1645

B. 33, I; H. 148 †

Etching
11.8 × 9 cm (4⅝ × 3⁹⁄₁₆ in.)

In plate: Rembrandt. f

Provenance: Walter Francis, Duke of Buccleuch (1806–1884, London and Dalkeith, Scotland, Lugt 402); his sale, London, Christie's, 19–22 April 1887, lot 1885; Joseph R. Ritman (1941, Amsterdam); Sotheby's and Artemis (New York and London, Ritman Catalogue, no. 8), 1995; to Eijk and Rose-Marie van Otterloo (Marblehead, MA), 1999; their gift to MFA, 26 March 2003.

Museum of Fine Arts, Boston. Gift of Eijk and Rose-Marie van Otterloo in honor of Clifford S. Ackley, 2003.113

65 *Jacob Caressing Benjamin*, about 1645

B. 33; H. 148

Copper etching plate
12 × 9 cm (4¾ × 3⁹⁄₁₆ in.)

Provenance: Clement de Jonghe (1624/25–1677, Amsterdam, in his estate inventory, 1679); Pieter de Haan (1723–1766, Amsterdam); his sale, Amsterdam, Weyers & Castelein, 9 March 1767, lot 43; to Fouquet (probably Pierre, Jr., 1729–1800), for Claude-Henri Watelet (1718–1786, Paris); to Pierre-François Basan (1723–1797, Paris), 1786; inherited by Henry-Louis Basan (died before 1819); to Auguste Jean (died 1820, Paris), 1809–10; inherited by his widow and sold at her death, 1846; to Auguste Bernard (Paris), 1846; inherited by his son Michel Bernard (Paris); to Alvin-Beaumont (Paris), 1906; to Robert Lee Humber (died 1970, Greenville, NC), 1938; inherited by his sons (on loan to the North Carolina Museum of Art, Raleigh); sold to Artemis (London) and Robert M. Light (Santa Barbara), about 1992; from R. M. Light to MFA, 1993.

Museum of Fine Arts, Boston. William Francis Warden Fund, 1993.91

66 *Abraham Casting out Hagar and Ishmael*, 1637

B. 30, only state; H. 149

Etching and drypoint
12.6 × 9.6 cm (4¹⁵⁄₁₆ × 3¾ in.)
In plate: Rembrandt f 1637

Provenance: Henry F. Sewall (1816–1896, New York, Lugt 1309); purchased by MFA, November 1897.

Museum of Fine Arts, Boston. Harvey D. Parker Collection, P405

67 *Abraham and Isaac*, 1645

B. 34, I*; H. 214 †

Etching and drypoint
15.7 × 13.3 cm (6³⁄₁₆ × 5¼ in.)
wm: fragment, possibly Strasbourg Lily
In plate: Rembrant. 1645.

Provenance: William Beckford (1760–1844, Fonthill Abbey, Wiltshire, according to the Webster catalogue; Beckford collection dispersed about 1840); John Webster (1810–1891, Aberdeen, Lugt 1554, 1555); his sale, London, Sotheby's, 9 May 1889, lot 24; Captain Gordon Wright Nowell-

Usticke (1894–about 1972, New York and Christiansted, St. Croix); his sale, New York, Parke-Bernet, 30 April–1 May 1968, lot 217; Charles C. Cunningham, Jr. (born 1934, Boston); British Rail Pension Fund; its sale, London, Sotheby's, 29 June 1987, lot 63; C. G. Boerner (Düsseldorf); Joseph R. Ritman (born 1941, Amsterdam); Sotheby's and Artemis (New York and London, Ritman Catalogue, no. 9), 1995; to Eijk and Rose-Marie van Otterloo (Marblehead, MA), 1999; their gift to MFA, 26 March 2003.

Museum of Fine Arts, Boston. Gift of Eijk and Rose-Marie van Otterloo in honor of Clifford S. Ackley, 2003.114

*White and Boon mention that other authors list two states, but they decided to list only one. As the Artemis/Sotheby's catalogue of the Ritman collection points out, the slight reduction at the upper edge of the plate described by Biörklund and Barnard 1968 was also accompanied by burnishing of the foul-bitten area at the left and the addition of a few descending diagonal lines. The present impression precedes these changes.

68 *Abraham's Sacrifice*, 1655

B. 35, only state; H. 283

Etching and drypoint
15.6 × 13.1 cm (6⅛ × 5³⁄₁₆ in.)
wm: unclear fragment
In plate: Rembrandt f 1655 (d and 6 in reverse)

Provenance: Henry F. Sewall (1816–1896, New York, Lugt 1309); purchased by MFA, November 1897.

Museum of Fine Arts, Boston. Harvey D. Parker Collection, P408
Boston only

Abraham's Sacrifice, 1655

B. 35, only state; H. 238

Etching and drypoint on Japanese paper
15.6 × 13.1 cm (6⅛ × 5³⁄₁₆ in.)

Provenance: Jan Chalon (1738–1795, Amsterdam, Paris, and London, Lugt 439); St. John Dent (died about 1884, London and Milton, Hampshire, Lugt 2373); Emil Schröter (died about 1912, Dresden, Lugt 2270); his sale, Stuttgart, Gutekunst, 7–11 May 1912, lot 906; to Keppel (New York); Richard Gutekunst (1870–1961, Stuttgart, London, Bern, Lugt 2213a); sequestered by the British government in 1914 and sold as penalty for "trading with the enemy" by order of a public trustee through Garland-Smith & Co., London, 2–3 December 1920, lot 166; to Reader (London); Alfred Strölin (1871–1954, Lausanne) or perhaps his son Alfred Strölin (1912–1974, Lausanne and Paris); to The Art Institute of Chicago, 1954.

The Art Institue of Chicago, The Clarence Buckingham Collection, 1954.10
Chicago only

69 *The Visitation*, 1640

Br. 562; Corpus A138

Oil on panel
56.6 × 47.8 cm (22⁵⁄₁₆ × 18¹³⁄₁₆ in.)
Signed and dated: Rembrandt. 1640.

Provenance: Hieronymous van der Straten, magistrate and burgomaster of Goes (d. 1662); Prince Eugene of Savoy (1633–1736, Vienna, inv. no. 122); by descent, Maria Ann Victoria of Savoy; purchased, with the bulk of Prince Eugene's collection, by Carlo Emmanuele III of Savoy, King of Sardinia (1730–1773, Turin), 1741; possibly confiscated by French officers during the French occupation of the Piedmont; R. Lerondelle, Paris; taken to England by Sebastien Érrard (1752–1831), 1808; Robert, second Earl of Grosvenor (1767–1845),1812; sold by his grandson Hugh Richard Arthur Grosvenor, second Duke of Westminster (1879–1953), 1913; Baron Alfred Charles de Rothschild (1842–1918, Halton Manor); bought by M. Knoedler & Co. (New York), 1924; acquired by the Detroit Institute of Arts, 1927.

The Detroit Institute of Arts, City of Detroit Purchase, 27.200.

70 *The Death of the Virgin*, 1639

B. 99, I; H. 161

Etching and drypoint
40.9 × 31.5 cm (16⅛ × 12⅜ in.)
wm: Strasbourg Lily variant K.a.a.
In plate: Rembrandt f. 1639.

Provenance: Pieter Cornelis Baron van Leyden, Leiden (1717–1788); acquired by the Dutch state, 1807; acquired by Amsterdam, Rijksmuseum, 1816.

Rijksmuseum, Amsterdam, RP-P-OB-623

71 *Jan Cornelis Sylvius*, 1646

B. 280, I; H. 225

Etching, drypoint, and engraving
27.8 × 18.9 cm (10¹⁵⁄₁₆ × 7⁷⁄₁₆ in.)
wm: Strasbourg Bend variant A.c.
In plate: Rembrandt 1646.

Provenance: Probably Arthur Pond (about 1705–1758); Sir Edward Astley (1729–1802, Norfolk, Lugt 2774); probably included in his sale, London, Langford, 27 March 1760 and following days; Heneage Finch, Fifth Earl of Aylesford (1786–1859, London & Warwickshire, Lugt 58); probably included in his sale, London, Christie's, 17–18 July 1893; Francis Bullard (1862–1913, Boston, Lugt 982); to his sister Katherine Eliot Bullard (1866–1920, Boston); to their brother Dr. William Norton Bullard (1853–1931, Boston); his gift to MFA, April 1923.

Museum of Fine Arts, Boston. Gift of William Norton Bullard, 23.1017
Boston only

Jan Cornelis Sylvius, 1646

B. 280, II; H. 225

Etching, drypoint, and engraving
27.7 × 19 cm (10⅞ × 7½ in.)
wm: Strasbourg Bend variant A.a.a.

Provenance: Alfred Hubert (died 1908, Paris, Lugt 130); his sale, Paris, Danlos, 25–29 May 1909, lot 754; to Obach & Co (London); A. H. Hahlo & Co. (New York); to Clarence Buckingham (1854–1913, Chicago, Lugt 497), March 1912; to his sisters, Katherine (died 1937, Chicago) and Lucy-Maud (died 1920, Chicago); bequeathed by Katherine Buckingham to The Art Institute of Chicago, 1938.

The Art Institute of Chicago, The Clarence Buckingham Collection, 1938.1808
Chicago only

72 *Ephraim Bueno (Bonus), Physician*, 1647
B. 278, II; H. 226
Etching, drypoint, and engraving
24 × 17.7 cm (9⁷/₁₆ × 6¹⁵/₁₆ in.)
wm: IHS variant B.b.
In plate: Rembrandt f. 1647

Provenance: Cabanoff-Rosgousky; Dr. Lippmann (possibly Friedrich Lippmann, 1839–1903, Berlin); to Harvard University, 1882.

Courtesy of the Fogg Art Museum, Harvard University Art Museums, Cambridge, Massachusetts, Gray Collection of Engravings Fund, G4929

73 *Ephraim Bueno*, 1647
Br. 252
Oil on panel
19 × 15 cm (7¹/₂ × 5⁷/₈ in.)
Provenance: Willem Six; possibly sold, Amsterdam, G. Schoemaker, et al., 12 May 1734, lot 89; to Philip van Dijk; Graaf van Wassenaer d' Obdam; his sale, The Hague, P. de Hondt, 19 August 1750, lot 8; Philip van Dijk (The Hague), 1753; Gerret Braamcamp; possibly sold, Amsterdam, P. van der Schley, et al., 31 July 1771, lot 178; to P. Fouget; Jan Lucas van der Dussen (Amsterdam), 1774[?]; William Ponsonby, 2nd Earl of Bessborough (1704–1793); sold (possibly by his son Frederick Ponsonby, 3rd Earl of Bessborough, 1758–1844), London, Christie's, 5 February 1801, lot 38; to Sir W.W. Wynne (possibly Watkin Williams, 1772–1840, Wynnstay, Denbighshire); to N. N. Louden, 1801; Jonkheer Goll van Franckenstein (Amsterdam); possibly sold, Amsterdam, J. de Vries, et al., 1 July 1833, lot 67; to Jan Six; by descent to Jonkheer Jan Willem Six van Vromade, (1857–1926, Amsterdam, on loan to the Rijksmuseum, 1915–20); his sale, Amsterdam, F. Muller, 29 June 1920; Dr. Fritz Mannheimer (1890–1939, Amsterdam); lent by the Stichting Nederlands Kunstbezit, 1948; the Dienst voor 's Rijks Verspreide Kunstvoorwerpen, 1949; transferred to the Rijksmuseum, 1960.

Rijksmuseum, Amsterdam, A3982

74 *Jan Six*, 1647
B. 285, IV; H. 228 †
Etching, drypoint, and engraving on Japanese paper
24.8 × 19.6 cm (9³/₄ × 7¹¹/₁₆ in.)

In plate: IAN SIX. AE. 29 Rembrandt f. 1647:
Provenance: Probably Arthur Pond (about 1705–1758); Sir Edward Astley (1729–1802, Norfolk, Lugt 2774); his sale, London, Langford, 27 March 1760 and following days, possibly lot 80; John Barnard (died 1784, London, Lugt 1419), dated 26 April 1760; his bequest to John Kenrick (died about 1798); his sale London, Philipe, 16 April 1798 and following days, lot 349; to Thomas Philipe (died about 1817, London, cf. Lugt 2451); George Hibbert (1757–1837, London, Lugt 2849); his sale, London, Philipe, 17 April 1809 and following days, lot 250; to Heneage Finch, Fifth Earl of Aylesford (1786–1859, London & Warwickshire, Lugt 58); possibly to Samuel Woodburn (1786–1853, London, cf. Lugt 2584), 1846; James Reiss (1812–1899, Manchester and London, Lugt 1522); his sale, London, Christie's, 6–10 May 1901, lot 738; to Kennedy & Co. (New York, cf Lugt 857); to Henry Harper Benedict (1844–1935, New York, cf. Lugt 2936), October 1914; sold by his heirs, London, Sotheby's, 7 March 1963, lot 62; Otto Schäfer (1912–2000, Schweinfurt); his sale, New York, Sotheby's, 13 May 1993, lot 52; to Artemis (London); to the present owner.

Private Collection

75 *The Pancake Woman*, 1635
B. 124, II; H. 141 †
Etching
10.7 × 7.7 cm (4³/₁₆ × 3¹/₁₆ in.)
In plate: Rembrandt. f. 1635

Provenance: William Esdaile (1758–1837, London, Lugt 2617); Henry F. Sewall (1816–1896, New York, Lugt 1309); purchased by MFA, November 1897.

Museum of Fine Arts, Boston. Harvey D. Parker Collection, P518
Boston only

The Pancake Woman, 1635
B. 124, II; H. 141 †
Etching
10.8 × 7.8 cm (4¹/₄ × 3¹/₁₆ in.)
In plate: Rembrandt. f. 1635

Provenance: Dethomas (probably Maxime, 1867–1928, Paris, Lugt 669a); Albert Roullier (died 1920, Chicago, cf. Lugt 170); to Clarence Buckingham (1854–1913, Chicago, Lugt 497), March 1910; to his sisters, Katherine (died 1937, Chicago) and Lucy-Maud (died 1920, Chicago); bequeathed by Katherine Buckingham to The Art Institute of Chicago, 1938.

The Art Institute of Chicago, The Clarence Buckingham Collection, 1938.1818
Chicago only

76 *The Hog*, 1643
B. 157, I; H. 204
Etching and drypoint
14.5 × 18.8 cm (5¹¹/₁₆ × 7³/₈ in.)
In plate: Rembrandt f 1643
Provenance: Henri Vever (1854–1943, Paris, cf.

Lugt 2491bis); by descent until sold, London, Sotheby's, 30 June 1998, lot 106; to Robert M. Light (Santa Barbara); to the Harvard University Art Museums.

Courtesy of the Fogg Art Museum, Harvard University Art Museums, Cambridge, Massachusetts, Anonymous Fund for the Acquisition of Prints Older than 150 Years, M 23935

77 *The Star of the Kings*, 1645–47
Ben. 736
Pen and brown ink with brown wash
20.4 × 32.3 cm (8¹/₁₆ × 12¹¹/₁₆ in.)
wm: Basel Crozier
Verso (visible only through the backing): sketch of a man
Provenance: Anton Maria Zanetti (1680–1767, Venice); Count Moritz von Fries (1777–1826, Vienna, cf. Lugt 2903); Andrew James; his sale, London, Christie's, 28 April, 1873, lot 73; to Sir George Salting (1835–1909, London, Lugt 2261); his bequest to the British Museum, 1910.

Lent by the Trustees of the British Museum, London, 1910.2.12.189

78 *Old Man in a Fur Cap*, 1645–48
Ben. 724
Black chalk
12.9 × 9.4 cm (5¹/₁₆ × 3¹¹/₁₆ in.)
Provenance: Friedrich August II, King of Saxony (1797–1854, Dresden, Lugt 971); by descent; P & D Colnaghi (London), 1949; Percy Moore Turner (died about 1951, London, cf. Lugt 2003); sold, Amsterdam, Sotheby Mak van Waay, 18 Nov. 1980, lot 50A; to the present owner.

Private Collection

79 *The Star of the Kings*, 1651
B. 113, only state; H. 254 †
Etching, drypoint, and engraving
9.3 × 14.1 cm (3¹¹/₁₆ × 5⁹/₁₆ in.)
Provenance: P. & D. Colnaghi (London); Francis Bullard (1862–1913, Boston, Lugt 982); to his sister Katherine Eliot Bullard (1866–1920, Boston); to their brother Dr. William Norton Bullard (1853–1931, Boston); his gift to MFA, April 1923.

Museum of Fine Arts, Boston. Gift of William Norton Bullard, 23.1015

80 *Self-Portrait with a Beret*, 1635–38
Ben. 437
Red chalk
12.9 × 11.9 cm (5¹/₁₆ × 4¹¹/₁₆ in.)
Provenance: Valerius Röver (1686–1739, Delft, cf. Lugt 2984a); C. F. U. Meek; Lessing J. Rosenwald (1891–1979, Philadelphia, Lugt 1760b); his gift to the National Gallery of Art, 1943.

National Gallery of Art, Washington, Rosenwald Collection, 1943.3.7048

81 *Self-Portrait Leaning on a Stone Sill*, 1639
B. 21, II; H. 168
Etching
20.5 × 16.3 cm (8¹/₁₆ × 6⁷/₁₆ in.)
wm: Countermark PDB' variant A.a.
In plate: Rembrandt f. 1639

Provenance: James Reiss (1812–1899, Manchester and London, Lugt 1522); his sale, London, Christie's, 6–10 May 1901, lot 431; to Loeffler; Geraldine G. Bellinger; her bequest to private collector (Boston); to MFA as partial purchase and partial gift through Robert M. Light (Santa Barbara), February 1982.

Museum of Fine Arts, Boston. Anonymous gift and Katherine E. Bullard Fund in memory of Francis Bullard, 1982.181

82 *Self-Portrait (in a flat cap and embroidered dress)*, 1642
B. 26, only state; H. 157 †
Etching
9.2 × 6.1 cm (3⁵/₈ × 2³/₈ in.)
In plate: Rembrandt f.

Provenance: Baron Ludwig Maximilian Freiherr von Biegeleben (1812–1872, Vienna, Lugt 385); George Biörklund (born 1887, Stockholm, Lugt 1138c); C. G. Boerner (Düsseldorf); to MFA, 13 September 1972.

Museum of Fine Arts, Boston. Katherine E. Bullard Fund in memory of Francis Bullard, 1972.878
Boston only

Self-Portrait (in a flat cap and embroidered dress), 1642
B. 26, only state; H. 157 †
Etching
9.4 × 6.2 cm (3¹¹/₁₆ × 2⁷/₁₆ in.)
In plate: Rembrandt f.

Provenance: John H. Wrenn (1841–1911, Chicago, Lugt 1475); Ethel Wrenn (died 1924); her bequest to The Art Institute of Chicago, 1924.

The Art Institute of Chicago, John H. Wrenn Memorial Collection, 1924.613
Chicago only

83 *Self-Portrait (in a flat cap and embroidered dress)*, 1642
B. 26; H. 157
Copper etching plate
9.5 × 6.2 cm (3¾ × 2⁷/₁₆ in.)

Provenance: Pieter de Haan (1723–1766, Amsterdam); his sale, Amsterdam, Weyers & Castelein, 9 March 1767, lot 69; to Fouquet (probably Pierre, Jr., 1729–1800, for Claude-Henri Watelet (1718–1786, Paris); to Pierre-François Basan (1723–1797, Paris), 1786; inherited by Henry-Louis Basan (died before 1819); to Auguste Jean (died 1820, Paris), 1809–10;

inherited by his widow and sold at her death, 1846; to Auguste Bernard (Paris), 1846; inherited by his son Michel Bernard (Paris); to M. Alvin-Beaumont (Paris), 1906; to Robert Lee Humber (died 1970, Greenville, NC), 1938; inherited by his sons (on loan to the North Carolina Museum of Art, Raleigh); sold to Artemis (London) and Robert M. Light (Santa Barbara), about 1992; Robert M. Light, 1993; his gift to Harvard University Art Museums, 1994.

Courtesy of the Fogg Art Museum, Harvard University Art Museums, Cambridge, Massachusetts, Gift of Robert M. Light in memory of Jakob Rosenberg, 1994.120

84 *Sheet of Studies*, 1638–45
B. 372, only state; H. 155
Etching
7.7 × 6.7 cm (3¹/₁₆ × 2⅝ in.)

Provenance: Cambridge University Library; transferred to Fitzwilliam Museum (inv. no. AD.12.39-49, Lugt 2475), 1876; probably sold London, Sotheby's, 2 April 1878; Henry F. Sewall (1816–1896, New York, Lugt 1309); purchased by MFA, November 1897.

Museum of Fine Arts, Boston. Harvey D. Parker Collection, P732

85 *The Artist Drawing from a Model*, about 1639
B. 192, I; H. 231 †
Etching, drypoint, and engraving with touches of black chalk
23.2 × 18.4 cm (9⅛ × 7¼ in.)

Provenance: Pierre Remy (active second half of the eighteenth century, Paris, Lugt 2173); acquired by the British Museum, 14 December 1895.

Lent by the Trustees of the British Museum, London, 1895.12.14.111

86 *A Man Drawing from a Cast*, 1641
B. 130, I; H. 191 †
Etching
9.4 × 6.4 cm (3¹¹/₁₆ × 2½ in.)

Provenance: De Visser (perhaps A.G. de Visser, active 19th century, the Hague); Teylers Museum, Haarlem.

Teylers Museum, Haarlem, KG 3695

87 *Jan Asselyn, Painter*, about 1647
B. 277, I; H. 227 †
Etching, drypoint, and engraving on oatmeal paper
21.8 × 17 cm (8⁹/₁₆ × 6¾ in.)
wm: Wheel variant A.a.
In plate: Rembr f 16[..]

Provenance: Cornelis Ploos van Amstel (1726–1798, Amsterdam, cf. Lugt 2034); his heirs; through Christian Josi (before 1765–1828, Amsterdam and London, cf. Lugt 573) to Heneage Finch,

Fifth Earl of Aylesford (1786–1859, London & Warwickshire, Lugt 58); John Heywood Hawkins (died between 1870 and 1880, London and Bignor Park, Sussex, cf. Lugt 1471); Walter Francis, 5th Duke of Buccleuch and 7th Duke of Queensberry (1806–1884, London and Dalkeith, Scotland, Lugt 402); his sale, London, Christie's, 19–22 April 1887, lot 2014; Alfred Hubert (died 1908, Paris, Lugt 130); his sale, Paris, Danlos, 25–29 May 1909, lot 751; to Wilhelm A. Gaiser (died about 1916, Stuttgart); Otto Gerstenberg (1848–1935, Berlin, Lugt 2785, 1840c); Harris G. Whittemore (died about 1937, Naugatuck, CT, Lugt 1384a); Lessing J. Rosenwald (1891–1979, Philadelphia, Lugt 1760b); his gift to the National Gallery of Art, 1944.

National Gallery of Art, Washington, Rosenwald Collection, 1944.2.61

88 *Jan Lutma*, 1656
B. 276, I; H. 290 †
Etching and drypoint
19.9 × 15 cm (7¹³/₁₆ × 5⅞ in.)
wm: Foolscap with five-pointed collar variant N.a.b.

Provenance: William Esdaile (1758–1837, London, Lugt 2617); Henry Brodhurst (active 1840s–1870s, Mansfield, England, Lugt 1296); through P. & D. Colnaghi (London) to Danlos and Delisle (Paris), about 1883–84; Henry F. Sewall (1816–1896, New York, Lugt 1309); purchased by MFA, November 1897.

Museum of Fine Arts, Boston. Harvey D. Parker Collection, P1607
Boston only

Jan Lutma, 1656
B. 276, I; H. 290 †
Etching and drypoint
19.7 × 14.9 cm (7¾ × 5⅞ in.)

Provenance: Robert Dighton (about 1752–1814, London, Lugt 727); John H. Wrenn (1841–1911, Chicago, Lugt 1475); Ethel Wrenn (died 1924); her bequest to The Art Institute of Chicago, 1924.

The Art Institute of Chicago, John H. Wrenn Memorial Collection, 1924.626.
Chicago only

89 *The Goldsmith*, 1655
B. 123, I; H. 285 †
Etching and drypoint on Japanese paper
7.7 × 5.7 cm (3¹/₁₆ × 2¼ in.)
In plate: Rembrandt f. 1655

Provenance: William Esdaile (1758–1837, London, Lugt 2617); Nathaniel Smith (about 1740–after 1800, London, Lugt 2296); James Norman (active second half of the eighteenth century, Bomley, Lugt 3024); possibly by descent to Archibald Cameron Norman; Albert Roullier (died 1920, Chicago, cf. Lugt 170); to Miss [probably Katherine] Buckingham, 1915; bequeathed by Katherine Buckingham (died 1937, Chicago, cf. Lugt 497) to The Art Institute of Chicago, 1938.

The Art Institute of Chicago, The Clarence Buckingham Collection, 1938.1761

90 *The Young Couple and Death*, 1639

B. 109, only state; H. 165

Drypoint
Sheet: 10.8 × 8.1 cm (4¼ × 3³/₁₆ in.)
In plate: Rembrandt f. 1639

Provenance: Probably Arthur Pond (about 1705–1758); Sir Edward Astley (1729–1802, Norfolk, Lugt 2774); probably included in his sale, London, Langford, 27 March 1760 and following days; Pierre Remy (active second half of the eighteenth century, Paris, Lugt 2173); Jan Chalon (1738–1795, Amsterdam, Paris, and London, Lugt 439); to his son-in-law, Christian Josi (before 1765–1828, Amsterdam and London, Lugt 573); sold through Thomas Philipe (died about 1817, London, cf. Lugt 2451) to Sir Reginald Pole Carew (1753–1835); his sale, London, Wheatley, 13–15 May 1835; Lessing J. Rosenwald (1891–1979, Philadelphia, Lugt 1760b); his gift to the National Gallery of Art, 1943 .

National Gallery of Art, Washington, Rosenwald Collection, 1943.3.7196

91 *The Flute Player*, 1642

B. 188, II; H. 200

Etching and drypoint
11.8 × 14.5 cm (4⅝ × 5¹¹/₁₆ in.)
wm: Basel Crozier
In plate: Rembrandt. f 1642 (2 in reverse)

Provenance: Alexandre-Pierre-François Robert-Dumesnil (1778–1864, Paris, cf. Lugt 2200); his sale, London, Phillips 12–14 April 1836, lot 185; Richard Dawnay, 10th Viscount Downe (1903–1965, Wykeham Abbey, Scarborough, Lugt 719a); to his son John Christian George Dawnay, 11th Viscount Downe, (1935–2003, Wykeham Abbey); his sale, London, Sotheby's, 7 December 1972, lot 259; L. Lancy (possibly Leslie E., died 1996, Pennsylvania); Helmut Rumbler, Frankfurt (Catalogue 10, 1979, no. 88); Joseph R. Ritman (born 1941, Amsterdam); Sotheby's and Artemis (New York and London, Ritman Catalogue, no. 84), 1995; to The Art Institute of Chicago, 2001.

The Art Institute of Chicago, The Clarence Buckingham and Amanda S. Johnson and Marion Livingston Endowments, 2001.118

92 *The Sleeping Herdsman*, 1643–44

B. 189, only state; H. 207

Etching and engraving
7.9 × 5.8 cm (3⅛ × 2⁵/₁₆ in.)

Provenance: Henry Danby Seymour (1820–1877, London and Trent, Lugt 176); Henry F. Sewall (1816–1896, New York, Lugt 1309); purchased by MFA, 1897.

Museum of Fine Arts, Boston. Harvey D. Parker Collection, P571

93 *The Monk in the Cornfield*, about 1646

B. 187, only state; H. 224

Etching and drypoint
5.1 × 6.9 cm (2 × 2¹¹/₁₆ in.)

Provenance: Possibly Jan Six (1617–1700, Amsterdam); Pierre Remy (active second half of the eighteenth century, Paris, Lugt 2173); probably part of a Rembrandt group acquired from Pierre Aved and passed on by Remy to Thomas Major (1714 or 1720–1799, London); John Barnard (died 1784, London, Lugt 1419); his bequest to John Kenrick (died about 1798); his sale London, Philipe, 16 April 1798 and following days, lot 217; to "C"(possibly Clark); Hermann Weber (1817–1854, Bonn, Lugt 1383); his sale, Leipzig, Weigel, 28 April 1856 and following days, lot 296; Cronstern (Schleswig-Holstein); by descent to family of Graf Plessen (Nehmten, Schleswig-Holstein); their sale, London, Christie's, 10 December 1991, lot 78; to Artemis (London), probably for Joseph R. Ritman (born 1941, Amsterdam); Sotheby's and Artemis (New York and London, Ritman Catalogue, no. 83), 1995; to The Art Institute of Chicago, 2001.

The Art Institute of Chicago, The Clarence Buckingham and Amanda S. Johnson and Marion Livingston Endowments, 2001.119

94 *The French Bed* ("Ledikant"), 1646

B. 186, III; H. 223

Etching, drypoint, and engraving
12.5 × 22.4 cm (4¹⁵/₁₆ × 8¹³/₁₆ in.)
In plate: Rembrandt f. 1646. (both sixes in reverse)

Provenance: Pieter Cornelis Baron van Leyden (1717–1788, Leiden, cf. Lugt 12); acquired by the Dutch state, 1807; acquired by the Rijksmuseum, Amsterdam, 1816.

Rijksmuseum, Amsterdam, RP-P-OB-633

95 *Adam and Eve*, 1638

B. 28, II; H. 159

Etching
16.3 × 11.6 cm (6⁷/₁₆ × 4⁹/₁₆ in.)
In plate: Rembrandt. f. 1638.

Provenance: Henry Danby Seymour (1820–1877, London and Trent (Sherborne, Dorset), Lugt 176); Henry F. Sewall (1816–1896, New York, Lugt 1309); purchased by MFA, November 1897.

Museum of Fine Arts, Boston. Harvey D. Parker Collection, P402
Boston only

Adam and Eve, 1638
B. 28, II; H. 159
Etching
16.2 × 11.6 cm (6⅜ × 4⁹/₁₆ in.)
In plate: Rembrandt. f. 1638.

Provenance: Adolf Schwarz (Amstelveen); Robert M. Light (Santa Barbara); to The Art Institute of Chicago, 1987.

The Art Institute of Chicago, Gift of Marjorie Blum Kovler Foundation Collection and the Harry and

Maribel G. Blum Foundation Collection, 1987.247
Chicago only

96 *Nude with a Snake (Cleopatra)*, about 1637

Ben. 137

Red chalk and white chalk
24.7 × 13.7 cm (9¹¹/₁₆ × 5⁷/₁₆ in.)

Provenance: Fournet (Paris); Mrs. Otto Gutekunst (London); Villiers David (London); his sale, Christie's, London, July 7, 1981, lot 120.

The J. Paul Getty Museum, Los Angeles, 81.GB.27

97 *Joseph and Potiphar's Wife*, 1634

B. 39, I; H. 118 †

Etching
9 × 11.5 cm (3⁹/₁₆ × 4⁷/₁₆ in.)
wm: Strasbourg Lily
In plate: Rembrandt. f. 1634.

Provenance: J. E. de Wit (died about 1895, Portland, ME); probably purchased after his death by C. J. Davis (Portland, ME).

The Pierpont Morgan Library, New York, RvR 56

98 *Jupiter and Antiope*, about 1631

B. 204, II; H. 44

Etching, engraving, and drypoint
8.5 × 11.3 cm (3⁵/₁₆ × 4⁷/₁₆ in.)
In plate: RHL.

Provenance: August Artaria (1807–1893, Vienna, Lugt 33); his sale, Vienna, Artaria and Co. 6–13 May 1896, lot 721; probably Alfred Strölin (1871–1954, Lausanne); his son Alfred Strölin (1912–1974, Lausanne and Paris); his sale, Bern, Klipstein & Kornfeld, 7 June 1961, lot 81; sold London, Sotheby's, 19 November 1982, lot 585; Adolph Weil, Jr. (1915–1995, Montgomery); his widow Jean K. Weil; her gift to the Hood Museum of Art.

Hood Museum of Art, Dartmouth College, Hanover, New Hampshire; gift of Jean K. Weil in memory of Adolf Weil, Jr., Class of 1935, PR.997.5.97

99 *Jupiter and Antiope*, 1659

B. 203, I; H. 302

Etching, drypoint, and engraving on Japanese paper
13.8 × 20.5 cm (5⁷/₁₆ × 8¹/₁₆ in.)
In plate: Rembrandt f 1659.

Provenance: Josef Camesina de Pomal (1765–1827, Vienna, Lugt 429); Artaria and Co. (Vienna); Friedrich August II, King of Saxony (1797–1854, Dresden, Lugt 971); Queen Marie; Prince Georg (later King); Prince Johann-Georg; sold Leipzig, Boerner, 14–15 November 1933, lot 689; sold, London, Sotheby's (auction 125), 1963, lot 125; Otto Schäfer (1912–2000, Schweinfurt); his sale, New York, Sotheby's, 13 May 1993, lot 39.

Private Collection

100 *Studies of a Woman and Two Children*, late 1630s–early 1640s

Ben. 300

Pen and brown ink
13.6 × 13.2 cm (5⅜ × 5³⁄₁₆ in.)
wm: fragment, Strasbourg Lily with letters PR below, at top center, identical to Schatborn 1985, cat. no. 27 (about mid-1640s); similar to Ash/Fletcher 1998, variant E'.a. (1637–1654); Churchill no. 378 (1636).
Inscribed by Rembrandt: een kindeken met een oudt jack op sijn hoofdken ("a little child with an old jacket on his head")

Provenance: Dr. Christian David Ginsburg (1831–1914, Palmer's Green, Middlesex, Lugt 1145); possibly included in his sale, London, Sotheby's, 20–23 July 1915; Victor Koch (London); Heinrich Eisemann (possibly 1889–1972, Zurich and London); Stefan Zweig (1881–1942, Vienna, London, and Rio de Janeiro); his brother, Alfred Zweig (died about 1979, New York); sold, New York, Sotheby Parke Bernet, 30 May 1979, lot 81; to the present owner.

Private Collection

101 *Two Studies of a Child Pulling off the Cap of an Old Man*, 1639–40

Ben. 659

Pen and brown ink, touched with brown wash, on paper washed pale brown
18.9 × 15.7cm (7⁷⁄₁₆ × 6³⁄₁₆ in.)

Provenance: Thomas Lawrence (1769–1830, London, Lugt 2445); to William Esdaile (1758–1837, London, Lugt 2617); his sale, Christie's, 17 June 1840, lot 50; to Hodgson; Andrew James; his sale, Christie's 28 April 1873, lot 112; to Sir George Salting (1835–1909, London, Lugt 2261); his bequest to the British Museum, 1910.

Lent by the Trustees of the British Museum, London, 1910.2.12.185

102 *Three Studies of a Child and One Study of an Old Woman*, 1640–45

Ben. A10

Pen and brown ink and brown wash, white watercolor
21.4 × 16 cm (8⁷⁄₁₆ × 6⁵⁄₁₆ in.)
wm: Posthorn

Provenance: Thomas Dimsdale (1758–1823, London, Lugt 2426); probably sold by his heirs to Samuel Woodburn (1786–1853, London, cf. Lugt 2584); Marsden Jasael Perry (1850–1935, Providence, RI, Lugt 1880); Duveen Brothers (New York); to Meta and Paul J. Sachs (1878–1965, Cambridge, Lugt 2091); their gift to the Fogg Art Museum, 1949.

Courtesy of the Fogg Art Museum, Harvard University Art Museums, Cambridge, Massachusetts, Gift of Meta and Paul J. Sachs, 1949.4

103 *Sick Woman with a Large White Headdress*, about 1641–42

B. 359, only state; H. 196

Etching and drypoint
6.1 × 5.1 cm (2⅜ × 2 in.)

Provenance: Dukes d'Arenberg (Brussels and Nordkirchen, Lugt 567); Lessing J. Rosenwald (1891–1979, Philadelphia, Lugt 1760b); his gift to the National Gallery of Art, 1951.

National Gallery of Art, Washington, Rosenwald Collection, 1951.10.480

104 *Sheet of Studies (with a woman lying ill in bed)*, about 1641–42

B. 369, only state; H. 163

Etching
13.5 × 15.1 cm (5⁵⁄₁₆ × 5¹⁵⁄₁₆ in.)

Provenance: Charles Delanglade (born 1870, Marseille, Lugt 660); William H. Schab (New York); to the Fogg Art Museum, 1962.

Courtesy of the Fogg Art Museum, Harvard University Art Museums, Cambridge, Massachusetts, Gifts for Special Uses Fund, Alpheus Hyatt Fund, William M. Prichard Fund, M 13972

105 *The Small Lion Hunt (with two lions)*, late 1620s

B. 115, only state; H. 180

Etching and abrasion
15.4 × 12.1 cm (6¹⁄₁₆ × 4¹⁵⁄₁₆ in.)
wm: Serpent variant A.a.

Provenance: Joseph Maberly (1783–1860, London and Cuckfield, Sussex, Lugt 1845); his sale, London, Sotheby, 26–30 May 1854; part of lot 525; to Walter Benjamin Tiffin (1795–1877, London, cf. 2609) for the British Museum.

Lent by the Trustees of the British Museum, London, 1851.5.30.3

106 *The Large Lion Hunt*, 1641

B. 114, I; H. 181

Etching and drypoint
22.5 × 30 cm (8⅞ × 11¹³⁄₁₆ in.)
In plate: Rembrandt f 1641

Provenance: Cambridge University Library; transferred to Fitzwilliam Museum, 1876.

The Fitzwilliam Museum, University of Cambridge, AD 12.39-14

107 *The Baptism of the Eunuch*, about 1641

B. 98, I; H. 182 †

Etching and drypoint
18.3 × 21.3 cm (7³⁄₁₆ × 8⅜ in.)
In plate: Rembrandt. f 1641

Provenance: Cambridge University Library; transferred to Fitzwilliam Museum, 1876.

The Fitzwilliam Museum, University of Cambridge, AD 12.39-30

108 *The Triumph of Mordecai*, about 1641

B. 40, II*; H. 172

Etching and drypoint
17.2 × 21.3 cm (6¾ × 8⅜ in.)
wm: Words, variant ZZ.zz

Provenance: Edward Hippisley (his sale, London, Sotheby's, 23 May 1848, lot 137); Francis Seymour Haden (1818–1910, London, Lugt 1227); his sale, London, Sotheby's, 15–19 June 1891, lot 436; to Frederick Keppel (1845–1912, New York, cf. Lugt 1023); Henry Studdy Theobald (1847–1934, London, Lugt 1375); his sale, Stuttgart, Gutekunst, 12–14 May 1910, lot 590; to Muller [possibly Frederik Muller & Cie]; Joseph R. Ritman (born 1941, Amsterdam); Sotheby's and Artemis (New York and London, Ritman Catalogue, no. 18), 1995; to the National Gallery of Art, 1998.

National Gallery of Art, Washington, New Century Fund, 1998.25.2

*White and Boon describe only one state, but T. Rassieur found in the Bibliothèque Nationale, Paris, an early impression printed before the addition of drypoint shading on the hand of the woman grasping the basket at far left (diagonals) and on the tail of the horse (verticals above the leg). The Paris impression is also before a number of short strokes in various directions on the lower left leg and foot of the twisting man to the right of the horse. The Washington impression was apparently printed shortly after these changes, for the burr of the strokes on the man's leg is unusually pronounced.

109 *The Flight into Egypt*, 1633

B. 52, I; H. 105

Etching
8.9 × 6.2 cm (3½ × 2⁷⁄₁₆ in.)
In plate: Rembrandt. inventor et fecit. 1633

Provenance: Lessing J. Rosenwald (1891–1979, Philadelphia, Lugt 1760b); his gift to the National Gallery of Art, 1951.

National Gallery of Art, Washington, Rosenwald Collection, 1951.10.475

110 *The Rest on the Flight (a night piece)*, 1644

B. 57, I; H. 208 †

Etching
9.2 × 5.9 cm (3⅝ × 2⁵⁄₁₆ in.)

Provenance: Felix Slade (1790–1868, London, Lugt 2290); his bequest to the British Museum, 1868.

Lent by the Trustees of the British Museum, London, 1868.8.22.663

111 *The Rest on the Flight (lightly etched)*, 1645

B. 58, only state; H. 216

Etching and drypoint
13.1 × 11.6 cm (5³⁄₁₆ × 4⅝ in.)
In plate: Rembrandt. f. 1645.

Provenance: Felix M. Warburg (1871–1937, New

York); his widow and their children; their gift to Vassar College, 1941.

The Frances Lehman Loeb Art Center, Vassar College, Poughkeepsie, New York, Gift of Mrs. Felix M. Warburg and her children, 1941.1.63

112 *The Rest on the Flight into Egypt*, 1647

Br. 576
Oil on panel
34 × 48 cm (13⅞ × 18¾ in.)
Signed and dated: Rembrandt f. 1647

Provenance: Richard Colt Hoare (1758–1838, Stourhead); by descent to Sir Henry Hoare (London); his sale, Christie's, London, 1 June 1883, lot 68; to The National Gallery.

The National Gallery of Ireland, Dublin, NGI 215

113 *The Flight into Egypt (a night piece)*, 1651

B. 53, IV; H. 253 †
Etching, engraving, and drypoint
12.7 × 11.1 cm (5⁵⁄₁₆ × 4¾ in.)
In plate: Rembrandt f. 1651 (6 in reverse)

Provenance: Henry F. Sewall (1816–1896, New York, Lugt 1309); purchased by MFA, November 1897.

Museum of Fine Arts, Boston. Harvey D. Parker Collection, P440

114 Hercules Segers (Dutch, 1589/90–1638)
Tobias and the Angel, 1620s

Etching printed in green ink
Sheet: 20.2 × 27.6 cm (7¹⁵⁄₁₆ × 10⅞ in.)

Provenance: Pieter Cornelis Baron van Leyden (1717–1788, Leiden, cf. Lugt 12); acquired by the Dutch state, 1807; acquired by the Rijksmuseum, Amsterdam, 1816.

Rijksmuseum, Amsterdam, RP-P-OB-796

115 *The Flight into Egypt* (altered from Hercules Segers), 1653

B. 56, IV; H. 266
Etching, drypoint, and engraving
21.2 × 28.4 cm (8⅜ × 11³⁄₁₆ in.)
wm: Strasbourg Lily variant C.a.

Provenance: John Heywood Hawkins (died between 1870 and 1880, London and Bignor Park, Sussex, cf. Lugt 1471); his sale London, Sotheby's, 29 April 1850, lot 877; to John Webster (1810–1891, Aberdeen, Lugt 1554–55); possibly included in his sale London, Sotheby's, 9 May 1889; P. & D. Colnaghi (London); A. A. Hahlo & Co. (New York); to MFA, June 1916.

Museum of Fine Arts, Boston. Gift of the Visiting Committee, M26200

116 *Two Thatched Cottages with Figures at a Window*, 1635–40

Ben. 796
Pen and brown ink, corrected with white watercolor
13.2 × 20.2 cm (5¼ × 7¹⁵⁄₁₆ in.)

Provenance: Possibly Nicolaes Anthonis Flinck (1646–1723, Rotterdam); William Cavendish, second Duke of Devonshire (1665–1729, Chatsworth, cf. Lugt 718); by descent to Andrew Cavendish, the eleventh Duke (born 1920, Chatsworth); sold on behalf of the Chatsworth Settlement, Christie's, London, July 3, 1984, lot 61; art market, New York.

The J. Paul Getty Museum, Los Angeles, 85.GA.93

117 *Cottages and Farm Buildings with a Man Sketching*, 1642–45

B. 219, only state; H. 213
Etching
12.9 × 20.9 cm (5¹⁄₁₆ × 8¼ in.)
wm: Strasbourg Lily with initials LC variant A.a.b.

Provenance: Joseph Daniel Böhm (1794–1865, Vienna, Lugt 272); D. G. Arozarena (active late 1850s and early 1860s, South America and Paris, Lugt 109); his sale, Paris, Clément, 11 March 1861 and following days, lot 705; Artaria & Co. (Vienna, Lugt 90); Walter Cummings Baker (1893–1971); his gift to The Metropolitan Museum of Art, 1962.

The Metropolitan Museum of Art, New York. Gift of Walter C. Baker, 62.664.1

118 *Landscape with a Cottage and Haybarn*, 1641

B. 225, only state; H. 177
Etching and drypoint
12.7 × 32 cm (5 × 12⅝ in.)
wm: fragment of Strasbourg Lily
In plate: Rembrandt f 1641

Provenance: Ernst Theodore Rodenacker (about 1840–before 1894, Dantzig, Lugt 2438); probably sold to P. & D. Colnaghi (London, though possibly sold by Boerner, Leipzig, 15 June 1897); Atherton Curtis (1863–1943, New York and Paris, Lugt 94) and his first wife Louise Burleigh Curtis (born 1869–1910); his second wife and widow, Ingeborg Flinch; sold Bern, Gutekunst & Klipstein, 28 April 1955, lot 110; to C. G. Boerner (Düsseldorf); C. G. Boerner (catalogue 100, no. 46), 1993; private collection (Tokyo); with Pace Prints (New York); to MFA, June 2000.

Museum of Fine Arts, Boston. Katherine E. Bullard Fund in memory of Francis Bullard, 2000.645

119 *The Windmill*, 1641

B. 233, only state; H. 179
Etching
14.5 × 20.8 cm (5¹¹⁄₁₆ × 8³⁄₁₆ in.)
wm: Countermark LB variant A.a.
In plate: Rembrandt f 1641

Provenance: Henry F. Sewall (1816–1896, New York, Lugt 1309); purchased by MFA, 1897.

Museum of Fine Arts, Boston. Harvey D. Parker Collection, P614

120 *Small Gray Landscape (house and trees beside a pool)*, about 1640

B. 207, only state; H. 175
Etching
3.8 × 8.3 cm (1½ × 3¼ in.)

Provenance: Probably Comte de Fries, Baron Jan Gijsbert Verstolk van Soelen (1776–1845, The Hague and Soelen, Lugt 2490); his sale, Amsterdam, De Vries, et al., 26 October 1847 and following days, lot 498; Teylers Museum, Haarlem.

Teylers Museum, Haarlem, KG 3772

121 *The Landscape with the Three Trees*, 1643

B. 212, only state; H. 205
Etching, drypoint, and engraving
21.3 × 27.8 cm (8⅜ × 10¹⁵⁄₁₆ in.)
wm: Foolscap with five-pointed collar variant A.a.b.
In plate: Rembrandt f 1643

Provenance: Henry Osborne Havemeyer (1847–1907, New York); his widow, Louisine Waldren Elder Havemeyer; her bequest to The Metropolitan Museum of Art, 1929

The Metropolitan Museum of Art, New York, H. O. Havemeyer Collection, Bequest of Mrs. H. O. Havemeyer, 29.107.31

122 *The Boat House*, 1645

B. 231, I; H. 211
Etching and drypoint
12.7 × 13.4 cm (5 × 5¼ in)
In plate: Rembrandt. 1645.

Provenance: Heneage Finch, Fifth Earl of Aylesford (1786–1859, London & Warwickshire, Lugt 58); John Heywood Hawkins (died between 1870 and 1880, London and Bignor Park, Sussex, cf. Lugt 1471); Walter Francis, 5th Duke of Buccleuch and 7th Duke of Queensberry (1806–1884, London and Dalkeith, Scotland, Lugt 402); his sale, London, Christie's, 19–22 April 1887, lot 1975; George Washington Vanderbilt (1862–1914, Asheville, NC); John Pierpont Morgan (1837–1913, New York), after 1905.

The Pierpont Morgan Library, New York, RvR 324

123 *A Clump of Trees with a Drawbridge*, about 1645

Ben. 1256
Black chalk
9.4 × 15.1 cm (3¹¹⁄₁₆ × 5¹⁵⁄₁₆ in.)
wm: fragment

Provenance: Count General Antoine-François Andreossy (1761–1828, France); his sale, Paris 13 April 1864 and following days, lot 394 (with Ben. 1255); to Ambroise Firmin-Didot (1790–1876, Paris, Lugt 119); his sale, Paris, Danlos et al., 16 April 1877 and following days, lot 79 (with Ben. 1255); William

Mitchell (1820–1908, Australia and London); his sale, Frankfurt, Prestel, 7 May 1890 lot 90 (with Ben. 1255); to E. F. J. Deprez and Otto Gutekunst (London) for the British Museum.

Lent by the Trustees of the British Museum, London, 1890.5.12.161

124 *A Clump of Trees in a Fenced Enclosure*, about 1645

Ben. 1255

Black chalk
9.5 × 15 cm (3¾ × 5⅞ in.)
wm: fragment of a crowned shield

Provenance: Count General Antoine-François Andreossy (1761–1828, France); his sale, Paris 13 April 1864 and following days, lot 394 (with Ben. 1256); to Ambroise Firmin-Didot (1790–1876, Paris, Lugt 119); his sale, Paris, Danlos et al., 16 April 1877 and following days, lot 79 (with Ben. 1256); William Mitchell (1820–1908, Australia and London); his sale, Frankfurt, Prestel, 7 May 1890 lot 90 (with Ben. 1256); to E. F. J. Deprez and Otto Gutekunst (London) for the British Museum.

Lent by the Trustees of the British Museum, London, 1890.5.12.160

125 *The Omval*, 1645

B. 209, I; H. 210

Etching and drypoint
18.7 × 22.7 cm (7⅜ × 8¹⁵⁄₁₆ in.)
In plate: Rembrant. 1645

Provenance: Dukes d'Arenberg (Brussels and Nordkirchen, Lugt 567); possibly in their sale, Christie et al., London, 14–17 July 1902, as part of lot 423; to Obach (London); William H. Schab (New York); to The Art Institute of Chicago, 1951.

The Art Institute of Chicago, The Clarence Buckingham Collection, 1951.229

126 *Winter Landscape*, 1646

Br. 452

Oil on panel
16.6 × 23.4 cm (6⁹⁄₁₆ × 9³⁄₁₆ in.)
Signed and dated: Rembrandt f. 1646

Provenance: Possibly Lodewijk van Erprecum (Amsterdam, his inventory of 4 November, 1692, lists "een winterje van Rembrandt"); Landgraf Wilhelm VIII of Hesse, 1682–1760, possibly acquired in 1752 through Gerard Hoet (Kassel collection inventory of 1749, no. 768, p. 68); Landgräfliche Collection, Hessen-Kassel, until 1803 (1783 inventory, no. 128, p. 75); Electoral Collection, Hessen-Kassel, 1803–06; Musée Napoléon, Paris, 1807–15; Electoral Collection, Hessen-Kassel, 1816–66 (1816 inventory, no. 469); Kassel Gallery, after 1866; Gemäldegalerie, Schloss Wilhelmshöhe, Staatliche Kunstsammlung, after 1967.

Staatliche Museen Kassel, Gemäldegalerie Alte Meister, GK 241

127 *Six's Bridge*, 1645

B. 208, III; H. 209

Etching and drypoint
13 × 22.7 cm (5⅛ × 8¹⁵⁄₁₆ in.)
In plate: Rembrandt f. 1645

Provenance: Christian Josi (born before 1765–1828, Amsterdam and London, Lugt 573); his sale London, Christie's, 18 March 1829 and following days, second day, lot 79; to Chevalier Ignace-Joseph de Claussin (1766–1844, Paris and London, cf. Lugt 485); John Webster (1810–1891, Aberdeen, Lugt 1554–55); his sale London, Sotheby's, 9 May 1889, lot 94; to A. Danlos (Paris); Paul Davidsohn (born 1839, London and Berlin, Lugt 654); his sale Leipzig, Boerner, 26–29 April 1921, lot 174; sold Leipzig, Boerner, 25–27 May, 1925, lot 1143; to Gilhofer & Ranschburg for Felix Somary (1881–1956, Vienna and Zurich); with Artemis and N. G. Stogdon, 1985 (catalogue no. 32); Joseph R. Ritman (born 1941, Amsterdam); Sotheby's and Artemis (New York and London, Ritman Catalogue, no. 93), 1995; to Eijk and Rose-Marie van Otterloo (Marblehead, MA), 1999; their gift to MFA, 26 March 2003.

Museum of Fine Arts, Boston. Gift of Eijk and Rose-Marie van Otterloo in honor of Clifford S. Ackley, 2003.116

128 "Winter Landscape" (*Landscape with a Farmstead*), about 1648–50

Ben. 845

Brown ink and brown wash on paper prepared with a light brown wash
6.7 × 16 cm (2⅝ × 6⁵⁄₁₆ in.)

Provenance: Count General Antoine-François Andreossy (1761–1828, France); probably included in his sale, Paris 13 April 1864 and following days; Ambroise Firmin-Didot (1790–1876, Paris, Lugt 119); possibly included in his sale, Paris, Danlos et al., 16 April 1877 and following days; Frieherr Max von Heyl zu Herrnsheim (1844–1925, Darmstadt, Lugt 2879); his sale, Stuttgart, Gutekunst, 25 May 1903, lot 246; Charles A. Loeser (1864–1928); his bequest to the Fogg Art Museum, 1932.

Courtesy of the Fogg Art Museum, Harvard University Art Museums, Cambridge, Massachusetts, Bequest of Charles A. Loeser, 1932.368

129 *The Raising of Lazarus*, 1642

B. 72, I; H. 198 †

Etching and drypoint
15 × 11.5 cm (5⅞ × 4½ in.)
wm: Foolscap with five-pointed collar variant A.a.
In plate: Rembrandt f. 1642 (2 in reverse)

Provenance: Carl Benjamin Brüsaber (1815–1876, Hamburg, Lugt 309); probably included in his sale, Berlin, Sagert, 28 April 1873 and following days; Emil Schröter (died about 1912, Dresden, Lugt 2270); his sale, Stuttgart, Gutekunst, 7–11 May 1912, lot 937; Nasrudin Gallery (Boston); to MFA, November 1976.

Museum of Fine Arts, Boston. Katherine E. Bullard Fund in memory of Francis Bullard, 1976.744

130 *The Raising of Lazarus*, 1642

B. 72; H. 198

Copper etching plate
15 × 11.5 cm (5⅞ × 4½ in.)

Provenance: Nicolaes Visscher (Amsterdam); Claude-Henri Watelet (1718–1786, Paris); to Pierre-François Basan (1723–1797, Paris), 1786; inherited by Henry-Louis Basan (died before 1819); to Auguste Jean (died 1820, Paris), 1809–10; inherited by his widow and sold at her death, 1846; to Auguste Bernard (Paris), 1846; inherited by his son Michel Bernard (Paris), 1906; to Alvin-Beaumont (Paris), 1906; to Robert Lee Humber (died 1970, Greenville, NC), 1938; inherited by his sons (on loan to the North Carolina Museum of Art, Raleigh); sold to Artemis (London) and Robert M. Light (Santa Barbara), about 1992; from R. M. Light to MFA, 24 March 1993.

Museum of Fine Arts, Boston. William Francis Warden Fund, 1993.92

131 *Tobias and the Angel Taking Leave of Raguel*, early 1650s

Ben. 871

Brown ink, touched with white watercolor
19.4 × 27.3 cm (7⅝ × 10¾ in.)
wm: Strasbourg Lily

Provenance: Karl Eduard von Liphart (1808–1891, Bonn and Florence, Lugt 1687); his grandson Reinholt Freiherr von Liphart (active late nineteenth century, Dorpat, Lugt 1758); his sale, Leipzig, Boerner, 26 April 1898, lot 300; to "G. v.d. Eeckhout"; Cornelis Hofstede de Groot (1863–1930, the Hague, Lugt 561); by whom given (with rights to ownership to 14 April 1931) to the Rijksmusem, 1906.

Rijksmuseum, Amsterdam, RP-T-1930-18

132 *The Blindness of Tobit*, 1651

B. 42, I; H. 252

Etching and drypoint
16.1 × 12.9 cm (6⁵⁄₁₆ × 5¹⁄₁₆ in.)
wm: fragment of Foolscap with five-pointed collar
In plate: Rembrandt f. 1651

Provenance: Mrs. De Bruijn-van der Leeuw; her bequest to the Rijksmuseum, 1962.

Rijksmuseum, Amsterdam, RP-P-1962-18

133 *Tobias Healing His Father's Blindness*, about 1640–45

Ben. 547

Pen and brown ink, and white watercolor
21.1 × 17.7 cm (8⁵⁄₁₆ × 6¹⁵⁄₁₆ in.)
wm: fleur de lys

Provenance: Chevalier Ignace-Joseph de Claussin (1766–1844, Paris and London, cf. Lugt 485); his sale Paris, Schroth, 2 December 1844, lot 53; to

George Jacob Johan van Os (Paris and Amsterdam); his sale, Paris, Roussel & Defer, 20–22 January 1851, lot 179; possibly Pierre Defer (1798–1870, Paris, Lugt 739); his son-in-law Henri Dumesnil (1823–1898, Paris, Lugt 739); his sale Paris, 10–12 May 1900, lot 87; to Joseph Reinach (1856–1921, Paris); possibly Mme. Pierre Goujon; to Wildenstein and Co. (New York); to Cleveland Museum of Art, 1969.

The Cleveland Museum of Art, J. H. Wade Purchase Fund, 1969.69
Chicago only

134 *The Angel Departing from the Family of Tobias*, 1641

B. 43, I; H. 185 †

Etching and drypoint
10.3 × 15.4 cm (4¹/₁₆ × 6¹/₁₆ in.)
wm: fragment (three lobes)
In plate: Rembrandt f. 1641

Provenance: David Tunick (New York); Joseph R. Ritman (born 1941, Amsterdam); Sotheby's and Artemis (New York and London, Ritman Catalogue, no. 21), 1995; to MFA, March 2001.

Museum of Fine Arts, Boston. Katherine E. Bullard Fund in memory of Francis Bullard, 2001.139

135 *Christ Preaching ("The Hundred Guilder Print")*, about 1648

B. 74, I; H. 236

Etching, drypoint, and engraving on Japanese paper
27.8 × 38.8 cm (10¹⁵/₁₆ × 15¼ in.)

Provenance: Pieter Cornelis Baron van Leyden (1717–1788, Leiden, cf. Lugt 12); acquired by the Dutch state, 1807; acquired by the Rijksmuseum, Amsterdam, 1816.

Rijksmuseum, Amsterdam, RP-P-OB-601

136 *Christ Preaching ("La Petite Tombe")*, about 1652

B. 67, only state; H. 256

Etching and drypoint
15.5 × 20.7 cm (6¹/₈ × 8¹/₈ in.)

Provenance: Francis Bullard (1862–1913, Boston, Lugt 982); to his sister Katherine Eliot Bullard (1866–1920, Boston); to their brother Dr. William Norton Bullard (1853–1931, Boston); his gift to MFA, April 1923.

Museum of Fine Arts, Boston. Gift of William Norton Bullard, 23.1011
Boston only

Christ Preaching ("La Petite Tombe"), about 1652

B. 67, only state; H. 256
Etching and drypoint
15.5 × 20.7 cm (6¹/₈ × 8¹/₈ in.)

Provenance: Dethomas (probably Maxime, 1867–1928, Paris, Lugt 669a); Albert Roullier (died

1920, Chicago, cf. Lugt 170); to Clarence Buckingham (1854–1913, Chicago, Lugt 497), March 1910; to his sisters, Katherine (died 1937, Chicago) and Lucy-Maud (died 1920, Chicago); bequeathed by Katherine Buckingham to The Art Institute of Chicago, 1938.

The Art Institute of Chicago, The Clarence Buckingham Collection, 1938.1749
Chicago only

137 *Christ Preaching ("La Petite Tombe")*, about 1652

B. 67, only state; H. 256

Etching and drypoint on Japanese paper
15.4 × 20.5 cm (6¹/₁₆ × 8¹/₁₆ in.)

Provenance: Henry F. Sewall (1816–1896, New York, Lugt 1309); purchased by MFA, November 1897.

Museum of Fine Arts, Boston. Harvey D. Parker Collection, P454

138 *Medea* or *The Marriage of Jason and Creusa*, about 1648

B. 112, I; H. 235

Etching and drypoint on Japanese paper
23.9 × 17.8 cm (9⁷/₁₆ × 7 in.)

Provenance: Possibly Alfred Morrison (1821–1897, London & Fonthill, cf. Lugt 144, 151); Henry F. Sewall (1816–1896, New York, Lugt 1309); purchased by MFA, November 1897.

Museum of Fine Arts, Boston. Harvey D. Parker Collection, P503

139 *The Rat-Poison Peddler*, 1632

B. 121, III; H. 97

Etching and engraving
14 × 12.5 cm (5½ × 4¹⁵/₁₆ in.)
wm: Countermark HN variant a.a.
In plate: RHL 1632 (3 and 2 in reverse)

Provenance: Mrs. De Bruijn-van der Leeuw; her bequest to the Rijksmuseum, 1962.

Rijksmuseum, Amsterdam, RP-P-1962-59

140 *Beggars Receiving Alms at the Door of a House*, 1648

B. 176, I; H. 233 †

Etching, drypoint, and engraving
16.5 × 12.9 cm (6½ × 5¹/₁₆ in.)
In plate: Rembrandt. f. 1648.

Provenance: Cambridge University Library; transferred to Fitzwilliam Museum, 1876

The Fitzwilliam Museum, University of Cambridge, AD 12.40-37

141 *Abraham and the Angels*, 1646

Br. 515

Oil on panel

16 × 21 cm (6⁵/₁₆ × 8¼ in.)
signed and dated: Rembrandt f. 1646

Provenance: Ferdinand Bol (1616–1680, Amsterdam); Jan Six (1617–1700, Amsterdam); his sale, Amsterdam, 6 April 1702, lot 40; Benjamin West (1728–1820, London); his sale, London, Christie's, 23–24 June 1820, lot 58; J. Haldiman; Richard Saunderson, 1836; Sir Thomas Baring (1772–1848, London); Stanley (perhaps Edward and Mary Dorothy or their son Capt. E. A. V., Quantock Lodge, Somerset); Frederik Muller & Co. (Amsterdam); A. Janssen (Amsterdam); Catalina von Pannwitz (Heemstede, later New York); private collection (England); Aurora Art Trust, 1986.

Aurora Art Fund, Courtesy of Stiebel, Ltd.

142 *Abraham Entertaining the Angels*, 1656

B. 29, only state; H. 286 †

Etching and drypoint on Japanese paper
16 × 13 cm (6⁵/₁₆ × 5¹/₈ in.)
In plate: Rembrandt f. 1656.

Provenance: Jan Chalon (1738–1795, Amsterdam, Paris, and London, Lugt 439); to his son-in-law, Christian Josi (before 1765–1828, Amsterdam and London, Lugt 573); sold through Thomas Philipe (died about 1817, London, cf. Lugt 2451) to Sir Reginald Pole Carew (1753–1835); his sale, London, Wheatley, 13–15 May 1835, lot 34; William Esdaile (1758–1837, London, Lugt 2617); by 1837; probably Alfred Strölin (1871–1954, Lausanne); his son Alfred Strölin (1912–1974, Lausanne and Paris); his sale, Bern, Klipstein & Kornfeld, 7 June 1961, lot 11; private collection; Artemis/Boerner (New York); St. Louis Art Museum, 1999.

The Saint Louis Art Museum. Gift of Sidney and Sadie Cohen Foundation in memory of Ilene Cohen Edison, 104.1999

143 *Drawing after an Indian Miniature*, 1656–61

Ben. 1187

Pen and brown ink, brown and gray wash, and white watercolor with scraping, on Japanese paper
19.4 × 12.4 cm (7⁵/₈ × 4⁷/₈ in.)

Provenance: Jonathan Richardson, Sr. (1665–1745, London, Lugt 2184); his sale, London, Cock, 11 February 1747 (1746 old style) and following days, 18th night, part of lot 70, at first withdrawn and then sold with two other portfolios; Arthur Pond (about 1705–1758); sale, London, Langford, 8th day, May 3rd, 1759, lot 65; "four Chinese men seated under a tree, drinking tea"; Ralph Willet (engraved when in his collection by S. Watts, 1767); his sale, London, Philipe, 13 June 1808 and following days, lot 463; to Allen; Thomas Dimsdale (1758–1823, London, cf. Lugt 2426, according to Lawrence Gallery catalogue); Sir Thomas Lawrence (1769–1830, London, Lugt 2445, described in his MS inventory, case 1, drawer 2, 54, 85: "Four Turks sitting under a Tree drinking Coffee", pen and bistre on India paper); William Esdaile (1758–1837, London, Lugt 2617); his sale, London, Christie's, 17 June 1840, lot 115; to Samuel Woodburn (1786–1853, London, cf. Lugt 2584);

sale, Christie's, 7 June 1860, lot 770; to [Jeffrey?] Whitehead; John Charles Robinson (1824–1913, London); John Malcolm of Poltalloch (1805–1893, Poltalloch, Argyleshire, and London, Lugt 1489); his son John Wingfield Malcolm (1833–1902); sold to The British Museum, 1895.

Lent by the Trustees of the British Museum, London, 1895.0915.1275

144 *Abraham Entertaining the Angels*, 1656

B. 29; H. 286

Copper etching plate
16.2 × 13.3 cm (6⅜ × 5¼ in.)
verso oil painting: attributed to Peeter Gysels (Flemish, 1621–1690), *River Landscape with Villages and Travelers*

Provenance: Acquired 1946 by private collection (Yorkshire, England); sale, London, Christie's, 26 June 1997, lot 94; to the National Gallery of Art, Washington.

National Gallery of Art, Washington, Gift of Ladislaus and Beatrix von Hoffmann and Patrons' Permanent Fund, 1997.85.1.a/b

145 *The Shell*, 1650

B. 159, II; H. 248

Etching, drypoint, and engraving
9.7 × 13.2 cm (3¹³⁄₁₆ × 5³⁄₁₆ in.)
In plate: Rembrandt. f. 1650.

Provenance: Pieter Cornelis Baron van Leyden (1717–1788, Leiden, cf. Lugt 12); acquired by the Dutch state, 1807; acquired by the Rijksmuseum, Amsterdam, 1816.

Rijksmuseum, Amsterdam, RP-P-OB-242

146 *Saint Jerome (in a dark chamber)*, 1642

B. 105, I; H. 201 †

Etching, drypoint, and engraving
15 × 17.6 cm (5⅞ × 6¹⁵⁄₁₆ in.)
In plate: Rembrandt f 1642

Provenance: Ambroise Firmin-Didot (1790–1876, Paris, Lugt 119); his sale, Paris, Danlos, et al., 16 April–12 May 1877, lot 862; William G. Russell Allen (1882–1955, Boston); to his niece, Mrs. Lydia Evans Tunnard (1913–1980, New Haven); her gift to MFA, January 1962.

Museum of Fine Arts, Boston. Gift of Mrs. Lydia Evans Tunnard in memory of W. G. Russell Allen, 61.1363

147 *Saint Jerome (beside a pollard willow)*, 1648

B. 103, III*; H. 232

Etching and drypoint
18.2 × 13.4 cm (7³⁄₁₆ × 5¼ in.)
wm: Foolscap with five-pointed collar
In plate: Rembrandt. f 1648

Provenance: Chevalier Ignace-Joseph de Claussin (1766–1844, Paris and London, Lugt 485); Paul

Mathey (1844–1929, Paris, Lugt 2100b); his sale, Paris, Delteil, 9 April 1924; Henri-Jean Thomas (Born 1872, Lugt 1378); his sale, Paris, Rousseau, 22 June 1951, lot 64; Richard H. Zinser (about 1883–1983, Forest Hills); sold by his descendants through Nicholas G. Stogdon (Oxford) to MFA, June 2002.

Museum of Fine Arts, Boston. Katherine E. Bullard Fund in memory of Francis Bullard, 2002.137

*White and Boon describe two states, but T. Rassieur observed an intermediate stage between them (impressions in the British Museum and in the Collection Frits Lugt, Paris, both printed on Japanese paper). In this state Rembrandt had not yet added the following: diagonal shading on Jerome's left shoulder outside of the collar of his cloak, a few diagonal strokes in the shawl above his right thumb, a cluster of very fine diagonal strokes at the left end of the lower board beneath Jerome's right hand, about four fine diagonal strokes above the strong diagonal extending from his left shoulder to above his neck, and a few very fine vertical strokes to his left temple. The exhibited impression has these additions.

148 *Saint Jerome Reading in an Italian Landscape*, about 1654

B. 104, II; H. 267

Etching, drypoint, and engraving on oatmeal paper
25.7 × 20.8 cm (10⅛ × 8³⁄₁₆ in.)
wm: Wheel (probably similar to variant A.a.)

Provenance: Cabinet Brentano-Birckenstock (founded 1765 by Johannn-Melchior Birckenstock (1738–1809, Vienna and Frankfurt, Lugt 345); sold following the death in 1869 of Antonia, Birckenstock's only daughter, wife of Franz Brentano, Frankfurt, Prestel, 16 May 1870, lot 1338; bought by Marseille Holloway (died about 1910, London, Lugt 1875); Henry F. Sewall (1816–1896, New York, Lugt 1309); purchased by MFA, November 1897.

Museum of Fine Arts, Boston. Harvey D. Parker Collection, P496
Boston only

Saint Jerome Reading in an Italian Landscape, about 1654

B. 104, II; H. 267

Etching, drypoint, and engraving
26 × 20.9 cm (10¼ × 8¼ in.)
wm: Strasbourg Bend D'.a.a.

Provenance: Princes Waldburg-Wolfegg (Wolfegg, Lugt 2542); sale, Leipzig, Boerner, 14–15 May 1934, lot 537; to Alfred Strölin (1871–1954, Lausanne); Richard H. Zinser (about 1883–1983, Forest Hills); to The Art Institute of Chicago, 1941.

The Art Institute of Chicago, The Clarence Buckingham Collection, 1941.1048
Chicago only

149 *Saint Francis Praying beneath a Tree*, 1657

B. 107, II; H. 292

Drypoint with etching and engraving on Japanese paper
18 × 23.8 cm (7¹⁄₁₆ × 9⅜ in.)
In plate (superimposed over his signature from the first state): Rembrandt f. 1657 (d in reverse)

Provenance: Count Moritz von Fries (1777–1826, Vienna, cf. Lugt 2903); Baron Jan Gijsbert Verstolk van Soelen (1776–1845, The Hague and Soelen, Lugt 2490); his sale, Amsterdam, De Vries, et al., 26 October 1847 and following days, probably lot 293; Weber and Van der Kolck, Brussels; Dukes d'Arenberg (Brussels and Nordkirchen, Lugt 567); William H. Schab (New York); to MFA, May 1951.

Museum of Fine Arts, Boston. 1951 Purchase Fund, 51.703
Boston only

Saint Francis Praying beneath a Tree, 1657

B. 107, II; H. 292

Drypoint with etching and engraving on Japanese paper
18 × 23.8 cm (7¹⁄₁₆ × 9⅜ in.)
In plate (superimposed over his signature from the first state): Rembrandt f. 1657 (d in reverse)

Provenance: Six; Pierre Remy (active second half of the eighteenth century, Paris, Lugt 2136); De Kat (possibly Huize Groenhof, Soestdijk); Johann Paul Friedrich Kalle (1804–1875, Cologne and Bonn, Lugt 1021); sold Frankfurt 1850; Dr. August Sträter (1810–1897, Aachen, Lugt 787); his sale, Stuttgart, H. G. Gutekunst, 10–14 May 1898, lot 740; Richard H. Zinser (about 1883–1983, Forest Hills); to The Art Institute of Chicago, 1954.

The Art Institute of Chicago, The Clarence Buckingham Collection, 1954.1190
Chicago only

150 *Faust (The Scholar in His Study)*, about 1652

B. 270, I; H. 260 †

Etching, drypoint, and engraving
21 × 16 cm (8¼ × 6⁵⁄₁₆ in)

Provenance: Henri Vever (1854–1943, Paris, Lugt 2491bis); by descent until sold, London, Sotheby's, 30 June 1998, lot 118; to Robert M. Light (Santa Barbara); to Alan and Marianne Schwartz (Detroit).

Alan and Marianne Schwartz Collection

151 *Christ Driving the Moneychangers from the Temple*, 1635

B. 69, I; H. 126 †

Etching and engraving
13.8 × 17.1 cm (5⁷⁄₁₆ × 6¾ in.)
wm: Strasbourg Bend variant A.c.
In plate: Rembrandt. f. 1635

Provenance: Robert Dighton (about 1752–1814, London, Lugt 727); probably with Frederick Keppel & Co. (New York, cf. Lugt 1023); Tracy Dows (born 1871, New York, Lugt 2427); to Frederick Keppel & Co., February 1911; S. S. Rosenstamm (1860– about 1919, New York, Lugt 2839); his sale,

New York, American Art Galleries, 27 January 1920, lot 75; Lee Max Friedman (1871–1957, Boston, cf. Lugt 1749a); given to MFA by his estate, 13 November 1958.

Museum of Fine Arts, Boston. Gift of the Estate of Lee M. Friedman, 58.1052

152 *Christ Appearing to the Apostles*, 1656

B. 89, only state; H. 237

Etching on Japanese paper
16.2 × 20.8 cm (6⅜ × 8³⁄₁₆ in.)
In plate: Rembrandt. f. 1656.

Provenance: Francis Bullard (1862–1913, Boston, Lugt 982); to his sister Katherine Eliot Bullard (1866–1920, Boston); to their cousin Ellen Twistleton Bullard (1865–1959, Boston); her gift to MFA, November 1925.

Museum of Fine Arts, Boston. Gift of Miss Ellen T. Bullard, 25.1146
Boston only

Christ Appearing to the Apostles, 1656

B. 89, only state; H. 237

Etching 16.3 × 21.2 cm (6⁷⁄₁₆ × 8⅜ in.)
wm: Countermark HP
In plate: Rembrandt. f. 1656.

Provenance: Franz Rechberger (1771–1841, Vienna, Lugt 2133), 1801; Dukes d'Arenberg (Brussels and Nordkirchen, Lugt 567); William H. Schab (New York); to The Art Institute of Chicago, 1951.

The Art Institute of Chicago, The Clarence Buckingham Collection, 1951.228
Chicago only

153 *The Adoration of the Shepherds*, 1656–57

B. 46, IV; H. 255 †

Etching, drypoint, and engraving
14.9 × 19.6 cm (5⅞ × 7¹¹⁄₁₆ in.)
wm: fragment of Strasbourg Lily

Provenance: Franz Rechberger (1771–1841, Vienna, Lugt 2133); Henry F. Sewall (1816–1896, New York, Lugt 1309); purchased by MFA, November 1897.

Museum of Fine Arts, Boston. Harvey D. Parker Collection, P428
Boston only

The Adoration of the Shepherds, 1656–57

B. 46, IV; H. 255 †

Etching, drypoint, and engraving
14.9 × 19.7 cm (5⅞ × 7¾ in.)

Provenance: August Artaria (1807–1893, Vienna, Lugt 33); his sale, Vienna, Artaria, 6–13 May 1896, lot 442; to Artaria; Marsden Jasael Perry (1850–1935, Providence, RI, Lugt 1880); his sale, Stuttgart, Gutekunst, 18 May 1908 and following days, lot 1145; Keppel (New York); to Clarence Buckingham (1854–1913, Chicago, Lugt 497) March 1909; to his sisters, Katherine (died 1937, Chicago) and Lucy-Maud (died 1920, Chicago); bequeathed

by Katherine Buckingham to The Art Institute of Chicago, 1938.

The Art Institute of Chicago, The Clarence Buckingham Collection, 1938.1735.
Chicago only

154 *Presentation in the Temple (in the dark manner)*, 1654

B. 50, only state; H. 279

Etching, drypoint, and engraving
20.9 × 16.2 cm (8¼ × 6⅜ in.)
wm: Foolscap with seven-pointed collar variant B.b.

Provenance: John Heywood Hawkins (died between 1870 and 1880, London and Bignor Park, Sussex, Lugt 1471); Wilhelm Eduard Drugulin (1825–1879, Leipzig, Lugt 2614); his sale 25 November 1865, lot 1454; to C. G. Boerner, Leipzig; George Ráth (1828–1904, Budapest, Lugt 1206); his sale, Vienna, Posonyi, 11 January 1869, lot 779; B. N. Tchicherine, 1870; sold Leipzig, Boerner, 11–13 November 1930, lot 896; to Alfred Strölin (1871–1954, Lausanne); sold Bern, Gutekunst & Klipstein, 6 June 1939, lot 235; Alfred Strölin (1871–1954, Lausanne); to The Art Institute of Chicago, 1950.

The Art Institute of Chicago, The Clarence Buckingham Collection, 1950.1508

155 *The Entombment*, 1654

B. 86, I; H. 281

Etching on Japanese paper
21 × 15.9 cm (8¼ × 6⅜ in.)

Provenance: Keppel (New York); to Clarence Buckingham (1854–1913, Chicago, Lugt 497), March 1909; to his sisters, Katherine (died 1937, Chicago) and Lucy-Maud (died 1920, Chicago); bequeathed by Katherine Buckingham to The Art Institute of Chicago, 1938.

The Art Institute of Chicago, The Clarence Buckingham Collection, 1938.1756

156 *The Entombment*, 1654

B. 86, II; H. 281

Etching, drypoint, and engraving on vellum
20.6 × 15.7 cm (8⅛ × 6³⁄₁₆ in.)

Provenance: Edward Rudge (1763–1846, Evesham, Worcestershire, cf. Lugt 900); by descent to John Edward Rudge; his sale, London, Christie's, 16–17 December 1924, lot 114; Eldridge Reeves Johnson (1867–1945, Merion, PA, and Camden, NJ); his sale, New York, Parke-Bernet, 3–4 April 1946, lot 154; Captain Gordon Wright Nowell-Usticke (1894–about 1972, New York and Christiansted, St. Croix); his sale, New York (Parke-Bernet), 30 April–1 May, 1968, lot 315; Charles C. Cunningham, Jr. (born 1934, Boston); Norton Simon (1907–1993, Pasadena); Joseph R. Ritman (born 1941, Amsterdam); Sotheby's and Artemis (New York and London, Ritman Catalogue, no. 50), 1995; to The Art Institute of Chicago, 1997.

The Art Institute of Chicago, The Clarence Buckingham Collection, 1997.419

157 *The Entombment*, 1654

B. 86, II; H. 281

Etching, drypoint, and engraving
20.9 × 16.2 cm (8¼ × 6⅜ in.)
wm: fragment of Foolscap with five-pointed collar

Provenance: Possibly Ernst Peter Otto (1724–1799, Leipzig, Lugt 895); to his widow; to their son-in-law Mr. Clauss; possibly included in the third Otto sale, Leipzig, Weigel, 17 May 1852 and following days; Wilhelm Koller (died 1871, Vienna, Lugt 2632); probably included in his sale, Vienna, Posonyi, 5 February 1872 and following days; Francis Bullard (1862–1913, Boston, Lugt 982); to his sister Katherine Eliot Bullard (1866–1920, Boston); to their brother Dr. William Norton Bullard (1853–1931, Boston); his gift to MFA, April 1923.

Museum of Fine Arts, Boston. Gift of William Norton Bullard, 23.1013

158 *The Descent from the Cross by Torchlight*, 1654

B. 83, only state; H. 280 †

Etching with drypoint
21.2 × 16.5 cm (8⅜ × 6½ in.)
wm: Foolscap with seven-pointed collar
In plate: Rembrandt. f 1654 (a in reverse)

Provenance: C. G. Boerner (Düsseldorf, catalogue 69, no. 43), 1978; Joseph R. Ritman (born 1941, Amsterdam); Sotheby's and Artemis (New York and London, Ritman Catalogue, no. 48), 1995; to Eijk and Rose-Marie van Otterloo (Marblehead, MA), 1999; their gift to MFA, 26 March 2003.

Museum of Fine Arts, Boston. Gift of Eijk and Rose-Marie van Otterloo in honor of Clifford S. Ackley, 2003.115
Boston only

The Descent from the Cross by Torchlight, 1654

B. 83, only state; H. 280 †

Etching and drypoint
21.6 × 16.4 cm (8½ × 6⁷⁄₁₆ in.)
wm: Foolscap with five-pointed collar variant G.a.
In plate: Rembrandt. f 1654 (a in reverse)

Provenance: C. G. Boerner (Düsseldorf, catalogue 73, no. 83), 1980; private collection, U.S.A., 1985–2000; Boerner/Artemis (London and New York); to The Art Institute of Chicago, 2001.

The Art Institute of Chicago, Restricted gift of Anne Searle Bent, 2001.121
Chicago only

The Descent from the Cross by Torchlight, 1654

B. 83, only state; H. 280 †

Etching and drypoint on Japanese paper
20.9 × 15.6 cm (8¼ × 6⅛ in.)
In plate: Rembrandt. f 1654 (a in reverse)

Provenance: Probably Arthur Pond (about 1705–1758); Sir Edward Astley (1729–1802, Norfolk,

Lugt 2775); probably included in his sale, London, Langford, 27 March 1760 and following days; Jan Chalon (1738–1795, Amsterdam, Paris, and London, Lugt 439); to his son-in-law, Christian Josi (before 1765–1828, Amsterdam and London, Lugt 573); sold through Thomas Philipe (died about 1817, London, cf. Lugt 2451) to Sir Reginald Pole Carew (1753–1835); his sale, London, Wheatley, 13–15 May 1835; Sir Godfrey Nicholson (1901–1991, Winterbourne, Berkshire); Artemis (London); private collection, Switzerland; Boerner/Artemis (London and New York); to The Art Institute of Chicago 2001.

The Art Institute of Chicago, Claudia S. Cassell, Richard Franke, Mr. and Mrs. Robert Hixon Glore, Louise Landau, Randall Rademaker, and Print & Drawing and Purchase funds; Stanley Field, Suzanne Lord Folds, Everett D. Graff, Hannan, Henry M. Huxley, William McCallin McKee, and Print and Drawing Capital Campaign endowments; through prior acquisitions of Stanley Field, Katharine Kuh and Miss Ellen N. Lamotte, 2001.120
Chicago only

159 *Christ at Emmaus*, 1654
B. 87, I; H. 282 †
Etching on Japanese paper
21.1 × 15.9 cm (8⁵⁄₁₆ × 6¼ in.)
In plate: Rembrandt f. 1654.

Provenance: Pierre Mariette (1634–1716, Paris, Lugt 1788), 1682; Otto Gerstenberg (1848–1935, Berlin, Lugt 2785, 1840c); probably to P & D Colnaghi (London) and Harlow & MacDonald (New York), 1922; Richard H. Zinser (about 1883–1983, Forest Hills); to The Art Institute of Chicago, 1944.

The Art Institute of Chicago, The Clarence Buckingham Collection, 1944.605

160 *David in Prayer*, 1652
B. 41, I; H. 258 †
Etching and drypoint on Japanese paper
14.2 × 9.5 (5⁹⁄₁₆ × 3¾ in.)
In plate: Rembrandt f. 1652

Provenance: Cronstern (Schleswig-Holstein); by descent to family of Graf Plessen (Nehmten, Schleswig-Holstein); their sale, London, Christie's, 10 December 1991, lot 41; to Helmut Rumbler (Frankfurt); to MFA, October 1994.

Museum of Fine Arts, Boston. Katherine E. Bullard Fund in memory of Francis Bullard, 1994.279

161 *The Adoration of the Shepherds (with the lamp)*, 1654
B. 45, I; H. 273 †
Etching
10.5 × 12.8 cm (4⅛ × 5¹⁄₁₆ in.)
wm: Foolscap with seven-pointed collar variant D.b.
In plate: Rembrandt. f.

Provenance: Johann Carl Diedrich Hebich

(1818–1891, Hamburg, Lugt 1250); probably included in his sale, Stuttgart, Gutekunst, 15–16 November 1880; Alfred Strölin (1871–1954, Lausanne); anonymous gift to The Art Institute of Chicago, 1952.

The Art Institute of Chicago, Anonymous gift, 1952.19

162 *The Circumcision in the Stable*, 1654
B. 47, I*; H. 274 †
Etching
9.5 × 14.5 cm (3¾ × 5¹¹⁄₁₆ in.)
In plate: Rembrandt f. 1654 (d in reverse)

Provenance: Cambridge University Library; transferred to Fitzwilliam Museum, 1876.

The Fitzwilliam Museum, University of Cambridge, AD 12.39-93

*White and Boon describe two states, the second of which is probably posthumous. Martin Royalton-Kisch (Amsterdam/London 2000, 304–306) separates the first state into two phases: the first being, as in the present impression, prior to burnishing that removed the spots in the diagonal shading in the upper background, as well as burnishing that straightened the shoulder line of the bare-headed man standing in the shadows to the right and lightened the shadows near his arm. Of these changes, the most obvious is the removal of the background spots.

163 *The Flight into Egypt (crossing a brook)*, 1654
B. 55, I; H. 276 †
Etching and drypoint
9.7 × 14.6 cm (3¹³⁄₁₆ × 5¾ in.)
wm: fragment
In plate: Rembrandt f. 1654

Provenance: Felix M. Warburg (1871–1937, New York); his widow and their children; their gift to The Metropolitan Museum of Art, 1941.

The Metropolitan Museum of Art, New York, Gift of Felix M. Warburg and His Family, 1941, 41.1.45

164 *The Virgin and Child with the Cat and Snake*, 1654
B. 63, I; H. 275 †
Etching
9.5 × 14.5 cm (3¾ × 5¹¹⁄₁₆ in.)
wm: Foolscap with seven-pointed collar variant D.b.
In plate: Rembrandt. f. 1654.

Provenance: Sale London, Sotheby's, 30 November 1989, lot 154; to Raymond E. Lewis (Larkspur Landing, CA); to MFA, December 1990.

Museum of Fine Arts, Boston. Katherine E. Bullard Fund in memory of Francis Bullard, 1990.599
Boston only

The Virgin and Child with the Cat and Snake, 1654
B. 63, I; H. 275 †
Etching on Japanese paper

9.1 × 14.3 cm (3⁹⁄₁₆ × 5⅝ in.)

Provenance: Robert M. Light (Santa Barbara); to The Art Institute of Chicago, 1982.

The Art Institute of Chicago, Everett D. Graff Endowment and Print and Drawing Club Fund, 1982.448.
Chicago only

165 *Christ Disputing with the Doctors*, 1654
B. 64, only state; H. 277 †
Etching
9.5 × 14.3 cm (3¾ × 5⅝ in.)
In plate: Rembrandt. f. 1654.

Provenance: Henry F. Sewall (1816–1896, New York, Lugt 1309); purchased by MFA, November 1897.

Museum of Fine Arts, Boston. Harvey D. Parker Collection, P451

166 *Christ Returning from the Temple with His Parents*, 1654
B. 60, only state; H. 278
Etching and drypoint
9.5 × 14.4 cm (3¾ × 5¹¹⁄₁₆ in.)
In plate: Rembrandt f 1654.

Provenance: Unidentified French collection, probably assembled in the 18th century; sold Sotheby's, London, 6 December 1990, lot 114; Joseph R. Ritman (born 1941, Amsterdam); Sotheby's and Artemis (New York and London, Ritman Catalogue, no. 33), 1995; to MFA, June 2001.

Museum of Fine Arts, Boston. Katherine E. Bullard Fund in memory of Francis Bullard, 2001.272
Boston only

Christ Returning from the Temple with His Parents, 1654
B. 60, only state; H. 278
Etching and drypoint
9.4 × 14.4 cm (3¹¹⁄₁₆ × 5¹¹⁄₁₆ in.)
In plate: Rembrandt f 1654.

Provenance: Dethomas (probably Maxime, 1867–1928, Paris, Lugt 669a); Albert Roullier (died 1920, Chicago, cf. Lugt 170); to Clarence Buckingham (1854–1913, Chicago, Lugt 497), March 1910; to his sisters, Katherine (died 1937, Chicago) and Lucy-Maud (died 1920, Chicago); bequeathed by Katherine Buckingham to The Art Institute of Chicago, 1938.

The Art Institute of Chicago, The Clarence Buckingham Collection, 1938.1801.
Chicago only

167 *The Agony in the Garden*, about 1657
B. 75 only state; H. 293
Etching and drypoint
11.2 × 8.3 cm (4⁷⁄₁₆ × 3¼ in)
In plate: Rembrandt f. 165[.]

Provenance: Francis Seymour Haden (1818–1910, London, Lugt 1227); his sale London, Sotheby's, 15–18 May 1891, lot 464; to Bouillon; probably with Kennedy & Co. (New York); Henry Harper Benedict (1844–1935, New York, Lugt 2936); sold by his widow; sold, New York, Sotheby Parke-Bernet, 10 May 1973; to MFA.

Museum of Fine Arts, Boston. Katherine E. Bullard in memory of Francis Bullard, 1973.288
Boston only

The Agony in the Garden, about 1657

B. 75, only state; H. 293

Etching and drypoint on Japanese paper
11 × 8 cm (4⁵/₁₆ × 3⅛ in.)
In plate: Rembrandt f. 165[.]

Provenance: Adam Gottlieb Thiermann (died about 1860/61, Berlin, Lugt 2434); sold by his widow to the Berlin Kupferstichkabinett (Lugt 1606); Stonehill (New York); to The Art Institute of Chicago (through J. [probably Jean] Goriany, New York), 1941.

The Art Institute of Chicago, The Clarence Buckingham Collection, 1941.1046.
Chicago only

168 *Christ Crucified between Two Thieves ("The Three Crosses")*, 1653

B. 78, II; H. 270

Drypoint
38.4 × 45 cm (15⅛ × 17¹¹/₁₆ in.)
wm: Strasbourg Bend variant D'.a.a.

Provenance: Dukes d'Arenberg (Brussels and Nordkirchen, Lugt 567); their sale, Christie et al., London, 14–17 July 1902, lot 399; to Kennedy (New York); Albert Blum (1882–1952, Switzerland and Short Hills, NJ, Lugt 79b); August Laube (Zürich); to MFA, November 1977.

Museum of Fine Arts, Boston. Katherine E. Bullard Fund in memory of Francis Bullard and Bequest of Mrs. Russell W. Baker, 1977.747

169 *Christ Crucified between Two Thieves ("The Three Crosses")*, 1653

B. 78, II; H. 270

Drypoint on vellum
38.1 × 43.8 cm (15 × 17¼ in.)

Provenance: Felix M. Warburg (1871–1937, New York); his widow and their children; their gift to The Metropolitan Museum of Art, 1941.

The Metropolitan Museum of Art, New York, Gift of Felix M. Warburg and His Family, 41.1.31

170 *Christ Crucified between Two Thieves ("The Three Crosses")*, 1653–55

B. 78, IV; H. 270

Drypoint
38.3 × 45 cm (15¹/₁₆ × 17¹¹/₁₆ in.)
wm: Strasbourg Lily variant I.a. and IHS variant A.d.a.

Provenance: Henry F. Sewall (1816–1896, New York, Lugt 1309); purchased by MFA, November 1897

Museum of Fine Arts, Boston. Harvey D. Parker Collection, P19573
Boston only

Christ Crucified between Two Thieves ("The Three Crosses"), 1653–55

B. 78, IV; H. 270

Drypoint and engraving
38.2 × 44.8 cm (15¹/₁₆ × 17⅝ in.)
wm: Arms of Amsterdam (?)

Provenance: Richard H. Zinser (about 1883–1983, Forest Hills); to The Art Institute of Chicago, 1954.

The Art Institute of Chicago, The Clarence Buckingham Collection, 1954.9
Chicago only

171 *The Raising of the Cross*, 1657–58

Ben. 1036

Pen and brown ink, brown wash, white watercolor
17.9 × 21.1 cm (7¹/₁₆ × 8⁵/₁₆ in.)

Provenance: Private collection; to Berlin Kupferstichkabinett, 1925.

Staatliche Museen zu Berlin, Preussischer Kulturbesitz, Kupferstichkabinett, KdZ 12013

172 *An Allegory: The Phoenix*, 1658

B. 110, only state; H. 295

Etching and drypoint
17.9 × 18.3 cm (7¹/₁₆ × 7³/₁₆ in.)
In plate: Rembrandt f.1658

Provenance: Pierre Remy (active second half of the eighteenth century, Paris, Lugt 2173); probably part of a Rembrandt group acquired from Pierre Aved and passed on by Remy to Thomas Major (1714 or 1720–1799, London); John Barnard (died 1784, London, Lugt 1419); his bequest to John Kenrick (died about 1798); his sale London, Philipe, 16 April 1798 and following days, lot 159; Edward Rudge (1763–1846, Evesham, Worcestershire, cf. Lugt 900); by descent to John Edward Rudge; his sale, London, Christie's, 16–17 December 1924, lot 139; to P. & D. Colnaghi (London); Leonard Gow (1859–1936); his sale London, Christie's, May 31, 1937, lot 195; to Frits Lugt (1884–1970, Paris, cf. Lugt 1028); probably Alfred Strölin (1871–1954, Lausanne); his son Alfred Strölin (1912–1974, Lausanne and Paris); his sale Bern, Klipstein & Kornfeld, 7 June 1961, lot 56; Richard H. Zinser (about 1883–1983, Forest Hills); sold by his descendants through Nicholas G. Stogdon (Oxford) to The Art Institute of Chicago, 2001.

The Art Institute of Chicago, The Clarence Buckingham and Amanda S. Johnson and Marion Livingston Endowments, 2001.122

173 *Christ Presented to the People*, 1655

B. 76, II; H. 271

Drypoint on Japanese paper
38.3 × 44.9 cm (15¹/₁₆ × 17¹¹/₁₆ in.)

Provenance: William Cavendish, second Duke of Devonshire (1665–1729, Chatsworth, cf. Lugt 718); by descent to Andrew Cavendish, the eleventh Duke (born 1920, Chatsworth); sold on behalf of the Chatsworth Settlement, London, Christie's, 5 December 1985, lot 183; to Frederick Mulder (London); to David Thomson (Toronto); through Artemis (London) to Joseph R. Ritman (born 1941, Amsterdam); Sotheby's and Artemis (New York and London, Ritman Catalogue, no. 44), 1995; to The Saint Louis Art Museum, 1999.

The Saint Louis Art Museum. Museum Shop Fund, Friends Fund, and funds given in honor of James D. Burke, Museum Director from 1980 to 1999 by Mr. and Mrs. Lester A. Crancer Jr., Mr. and Mrs. Christian B. Peper, the Ruth Peters MacCarthy Trust, an anonymous donor, Mr. and Mrs. Oliver Langenberg, Phoebe and Mark Weil, Mr. and Mrs. Sam Fox, the Sidney S. and Sadie Cohen Print Purchase Fund, the Julian and Hope Edison Print Fund, Margaret Grigg Oberheide, an anonymous donor, Mr. and Mrs. Kenneth F. Teasdale, Mr. and Mrs. John Bachmann, the Anne L. Lehman Charitable Trust, Anabeth Calkins and John Weil, Mrs. James Lee Johnson Jr., Mr. and Mrs. Jerome J. Sincoff, Mr. and Mrs. Sam Weiss, Marianne and Martin Galt III, and Mr. and Mrs. Andrew B. Craig III, 1.1999

174 *Christ Presented to the People*, 1655

B. 76, VIII; H. 271

Drypoint
35.7 × 45.6 cm (14¹/₁₆ × 17¹⁵/₁₆ in.)
wm: Arms of Bern variant A'.a.
In plate: Rembrandt f 1655.

Provenance: Lessing J. Rosenwald (1891–1979, Philadelphia, Lugt 1760b); his gift to the National Gallery of Art, 1945.

National Gallery of Art, Washington, Rosenwald Collection, 1945.5.109

175 *Joseph Sold into Slavery by His Brothers*, about 1651–52

Ben. 876

Pen and brown ink, wash and white watercolor
15.8 × 20.5 cm (6¼ × 8¹/₁₆ in.)

Provenance: Alphonse Wyatt Thibaudeau (about 1840–about 1892, Paris and London, Lugt 2473); Barthold Suermondt (1818–1887, Aachen, Lugt 415); possibly included in his sale, Frankfurt, Prestel, 5 May 1879 and following days; Berlin Kupferstichkabinett.

Staatliche Museen zu Berlin, Preussischer Kulturbesitz, Kupferstichkabinett, KdZ 1119

176 *Christ Healing Peter's Mother-in-Law*, 1650s

Ben. 1041

Pen and brown ink, brown wash, and white watercolor
17.1 × 18.9 cm (6¾ × 7⁷⁄₁₆ in.)

Provenance: Simon Fokke (1712–1784, Amsterdam); Count Moritz von Fries (1777–1826, Vienna, cf. Lugt 2903); E. Faesch (Lugt 846); F. van den Zande; Wilhelm von Bode (1845–1929, Berlin); Max Lieberman (1847–1935, Berlin); Mrs. Kurt Riezler (Max Lieberman's daughter Käthe, born 1885, White Plains,); Schaeffer Galleries (New York,); Frederik Johannes "Frits" Lugt (1884–1970, Maartensdijk, Paris, Lugt 1028), 1942.

Collection Frits Lugt, Institut Néerlandais, Paris, 5794
Boston only

177 *Abel Slain by Cain*, 1650s

Ben. 860

Pen and brown ink
16.8 × 24.7 cm (6⅝ × 9¾ in.)

Provenance: Sir Thomas Lawrence (1769–1830, London, Lugt 2445); William Esdaile (1758–1837, London, Lugt 2617); Ch. S. Bale (1791–1880, London Lugt 640); Charles Fairfax Murray (1849–1919, London); Count De Robiano (perhaps Eugène, born 1848, Braine-le-Château); his sale, Amsterdam, Muller-Mensing, 15–16 July 1926, lot 417; donation from the New Carlsburg Foundation, 1926.

Statens Museum for Kunst, Copenhagen, 10094
Boston only

178 *Noah's Ark*, 1660

Ben. 1045

Pen and brown ink, brush and brown wash, and white watercolor
19.9 × 24.4 cm (7¹³⁄₁₆ × 9⅝ in.)
wm: The Arms of Amsterdam

Provenance: Marie-Guillaume-Thérèse de Villenave (1762–1846, Paris, Lugt 2598); his sale, Paris, Alliance des Arts (Lugt 62), 1–7 December 1842; probably F. van den Zande (cf. Lugt 2680); sale, Paris, Hotel des Commissaires-Priseurs, 30 April 1855, lot 3041 or 2; Marquis de Biron; sale Paris, 9–11 June, 1914, lot 50; Paul Mathey (1844–1929, Paris, cf. Lugt 2100b); Alfred Strölin (1871–1954, Lausanne) or perhaps his son Alfred Strölin (1912–1974, Lausanne and Paris); to The Art Institute of Chicago, 1953.

The Art Institute of Chicago, The Clarence Buckingham Collection, 1953.36

179 *The Prophet Elisha and the Widow with Her Sons*, 1650s

Ben. 1027

Pen and brown ink
17.2 × 25.4 cm (6¾ × 10 in.)

Provenance: August Artaria (1807–1893, Vienna, Lugt 33); Josef Carl von Klinkosch (1822–1888, Vi-

enna, Lugt 577); probably included in his sale, Vienna, Wawra, 15 April 1889 and following days; Johann II, Prince of Liechtenstein (1858–1929, Vienna); Felix Somary (1881–1956, Vienna and Zurich); Rosenberg & Stiebel (New York); Charles C. Cunningham, Jr. (born 1934, Boston); Robert M. Light (Santa Barbara); to MFA, June 1980.

Museum of Fine Arts, Boston. Ernest W. Longfellow Fund, Gift of Jessie H. Wilkinson—Jessie H. Wilkinson Fund, Charles H. Bayley Picture and Painting Fund, 1980.271

180 *Peter and John at the Gate of the Temple*, 1659

B. 94, II; H. 301 †

Etching and drypoint on Japanese paper
18.1 × 21.5 cm (7⅛ × 8⁷⁄₁₆ in.)
In plate: Rembrandt f. 1659

Provenance: Possibly Hugo Helbing (Munich, Lugt 1314); Hans Freiherr von und zu Aufsess (1801–1872, Aufsess and Nuremberg, Lugt 2749); Guy Mayer; to the Fogg Art Museum, 1951.

Courtesy of the Fogg Art Museum, Harvard University Art Museums, Cambridge, Massachusetts, Gray Collection of Engravings Fund, G8849

181 *Male Nudes Seated and Standing* ("The Walker"), about 1646

B. 194, I; H. 222 †

Etching
19.8 × 12.9 cm (7¹³⁄₁₆ × 5¹⁄₁₆ in.)

Provenance: Alexandre-Pierre-Francois Robert-Dumesnil (1778–1864, Paris, Lugt 2200); possibly in his sale, London 12–14 April 1836; William Benoni White (London, Lugt 2592); Adalbert Frieherr von Lanna (1836–1909, Prague, Lugt 2773); his sale, Stuttgart, 11–22 May 1909, lot 2634; Henry Study Theobald (1847–1934; London, Lugt 1375); his sale Stuttgart, Gutekunst, 12–14 May 1910, lot 656; to Richard Gutekunst (1870–1961, Stuttgart, London, Bern, Lugt 2213a); sequestered by the British government in 1914 and sold as penalty for "trading with the enemy" by order of a public trustee through Garland-Smith & Co., London, 2–3 December 1920, lot 123; to P. & D. Colnaghi (London); sold New York, Sotheby Parke Bernet, 10 May 1973, lot 174G; Robert M. Light (Santa Barbara); to James M. and Melinda A. Rabb (Boston).

James M. and Melinda A. Rabb

182 *Male Nudes Seated and Standing* ("The Walker"), about 1646

B. 194; H. 222

Copper etching plate
19.8 × 12.9 cm (7¹³⁄₁₆ × 5¹⁄₁₆ in.)

Provenance: Pieter de Haan (1723–1766, Amsterdam); his sale, Amsterdam, Weyers & Castelein, 9 March 1767, lot 53; to Fouquet (probably Pierre, Jr., 1729–1800), for Claude-Henri Watelet (1718–1786, Paris); to Pierre-François Basan (1723–1797, Paris),

1786; inherited by Henry-Louis Basan (died before 1819); to Auguste Jean (died 1820, Paris), 1809–10; inherited by his widow and sold at her death, 1846; to Auguste Bernard (Paris), 1846; inherited by his son Michel Bernard (Paris); to Alvin-Beaumont (Paris), 1906; to Robert Lee Humber (died 1970, Greenville, NC), 1938; inherited by his sons (on loan to the North Carolina Museum of Art, Raleigh); sold to Artemis (London) and Robert M. Light (Santa Barbara), about 1992; from R. M. Light to James M. and Melinda A. Rabb (Boston).

James M. and Melinda A. Rabb

183 *Nude Youth Seated before a Curtain*, 1646

B. 193, I; H. 220

Etching
16.5 × 9.7 cm (6½ × 3¹³⁄₁₆ in.)
wm: Paschal Lamb variant A.b.
In plate: Rembrandt. f. 1646

Provenance: Philip Hofer (1898–1984; Cambridge); his gift to the Fogg Art Museum.

Courtesy of the Fogg Art Museum, Harvard University Art Museums, Cambridge, Massachusetts, Gift of Philip Hofer, M13472

184 *The Bathers*, 1651

B. 195, I; H. 250 †

Etching
10.8 × 13.6 cm (4¼ × 5⅜ in.)
wm: fragment of a Foolscap
In plate: Rembrandt. f 1651 (the 5 corrected from a 3)

Provenance: Pierre Remy (active second half of the eighteenth century, Paris, Lugt 2173); Louis Godefroy (1885–1934, Paris, Lugt 2971a); his sale, London, Sotheby's, 29 June 1937, lot 122; E. Brupbacher-Bourgeois; C. G. Boerner (Düsseldorf, catalogue 73, no. 40), 1980; Joseph R. Ritman (born 1941, Amsterdam); Sotheby's and Artemis (New York and London, Ritman Catalogue, no. 87), 1995; to The Art Institute of Chicago, 1997.

The Art Institute of Chicago, The Clarence Buckingham Collection, 1997.418

The Bathers, 1651

B. 195; H. 250

Copper etching plate
11.2 × 13.9 cm (4⁷⁄₁₆ × 5½ in.)

Provenance: Clement de Jonghe (1624/25–1677, Amsterdam, in his estate inventory, 1679); Pieter de Haan (1723–1766, Amsterdam); his sale, Amsterdam, Weyers & Castelein, 9 March 1767, lot 54; to Pieter Yver (1712–1787, Amsterdam); Claude-Henri Watelet (1718–1786, Paris); to Pierre-François Basan (1723–1797, Paris), 1786; inherited by Henry-Louis Basan (died before 1819); to Auguste Jean (died 1820, Paris), 1809–10; inherited by his widow and sold at her death, 1846; to Auguste Bernard (Paris), 1846; inherited by his son Michel Bernard (Paris); to Alvin-Beaumont (Paris), 1906; to Robert Lee Humber (died 1970, Greenville, NC), 1938; inherited by his sons (on loan to the North Carolina

Museum of Art, Raleigh); sold to Artemis (London) and Robert M. Light (Santa Barbara), about 1992; to the present owner.

Private collection, Chicago
Chicago only

185 *Landscape with a View Toward Haarlem ("The Goldweigher's Field"), 1651*

B. 234, only state; H. 249

Etching and drypoint
12 × 31.9 cm (4¾ × 12⁹⁄₁₆ in.)
wm: Paschal Lamb variant A.a.b.
In plate: Rembrandt 1651.

Provenance: Pierre Mariette (1634–1716, Paris, cf. Lugt 1790), 1672; Possibly Alfred Morrison (1821–1897, London & Fonthill, Lugt 144).

The Metropolitan Museum of Art, New York, Purchase, Jacob H. Schiff Bequest, by exchange, and Edwin D. Levinson Gift, 45.20

186 *Landscape with the House with the Little Tower, early 1650s*

Ben. 1267

Pen and brown ink and brown wash
9.7 × 21.5 cm (3¹³⁄₁₆ × 8⁷⁄₁₆ in.)

Provenance: Paul Jodot (Paris); Otto Gutekunst (London); Baron Robert von Hirsch (1883–1977, Frankfurt and Basel); his sale, London Sotheby's, 21 June 1978, lot 35; art market, New York.

The J. Paul Getty Museum, Los Angeles, 83.GA.363

187 *Landscape with Trees, Farm Buildings, and a Tower, 1651*

B. 223, III; H. 244

Etching
12.3 × 31.8 cm (4¹³⁄₁₆ × 12½ in.)

Provenance: Carl Julius Kollman (1820–1875, Dresden, cf. Lugt 1584); Marsden Jasael Perry (1850–1935, Providence, RI, Lugt 1880); his sale, Stuttgart, Gutekunst, 18–23 May 1908, lot 1291; General Brayton Ives (1840–1914, New York); his sale, New York, American Art Association, 6–14 April 1915 (the 13th), lot 751; to Albert Roullier (died 1920, Chicago, cf. Lugt 170); to Miss [probably Katherine] Buckingham; bequeathed by Katherine Buckingham (died 1937, Chicago, cf. Lugt 497) to The Art Institute of Chicago, 1938.

The Art Institute of Chicago, The Clarence Buckingham Collection, 1938.1775

188 *Landscape with Three Gabled Cottages beside a Road, 1650*

B. 217, III; H. 246

Etching and drypoint
16.1 × 20.2 cm (6⁵⁄₁₆ × 7¹⁵⁄₁₆ in.)
wm: Foolscap with five-pointed collar similar to variant C.a. with countermark UD
In plate: Rembrandt f. 1650

Provenance: French private collection; Helmut Rumbler (Frankfurt); to Alan and Marianne Schwartz (Detroit).

Alan and Marianne Schwartz Collection

189 *Houses on the Schinkelweg (Landscape with an Inn), about 1652*

Ben. 1314

Pen and brown ink, brown wash, white watercolor on paper prepared with gray wash
10 × 22.8 cm (3⁵⁄₁₆ × 9 in.)
Wm: Arms of Burgundy and Austria with the Golden Fleece

Provenance: Nicolaes Anthonis Flinck (1646–1723, Rotterdam, Lugt 959); William Cavendish, second Duke of Devonshire (1665–1729, Chatsworth, Derbyshire, cf. Lugt 718); by descent to Andrew Cavendish, the eleventh Duke (born 1920, Chatsworth, Derbyshire); sold on behalf of the Chatsworth Settlement, London, Christie's, 6 July 1987, lot 15; to Maida and George Abrams (Boston).

Courtesy of the Fogg Art Museum, Harvard University Art Museums, Cambridge, Massachusetts, Loan from Maida and George Abrams, 25.1998.58

190 *Landscape with a Haybarn and a Flock of Sheep, 1652*

B. 224, II; H. 241

Etching
8.2 × 17.4 cm (3¼ × 6⁷⁄₈ in.)
wm: fragment of Foolscap
In plate: Rembrandt f. 1652 (d in reverse)

Provenance: "J.W." (unidentified seventeenth-century collector, Lugt 1551b); Arnold Herman Knapp (1869–1956, New York); his gift to the Fogg Art Museum.

Courtesy of the Fogg Art Museum, Harvard University Art Museums, Cambridge, Massachusetts, Gift of Arnold Knapp, M 12901

191 *Farmstead beside a Canal, about 1650–52*

Ben. 1297

Pen and brown ink, brown wash
14.9 × 24.8 cm (5⁷⁄₈ × 9¾ in.)

Provenance: Jan Pietersz. Zoomer (1641–1724, Amsterdam, Lugt 1511); Baron Jan Gijsbert Verstolk van Soelen (1776–1845, The Hague and Soelen, Lugt 2490); probably included in his first sale, Amsterdam, De Vries, et al., 22 March 1847 and following days; Jacob de Vos (1803–1882, Amsterdam, Lugt 1450); his sale, Amsterdam, Roos, 22–24 May 1883, lot 393; Francis Seymour Haden (1818–1910, London, Lugt 1227); his sale London, Sotheby's, 15–19 June 1891, lot 571; to Frederick Keppel (1845–1912, New York, cf. Lugt 1023); Alfred Strölin (1871–1954, Lausanne) or perhaps his son Alfred Strölin (1912–1974, Lausanne and Paris); to The Art Institute of Chicago, 1953.

The Art Institute of Chicago, The Clarence Buckingham Collection, 1953.37

192 *Clump of Trees with a Vista, 1652*

B. 222, II; H. 263

Drypoint
12.3 × 21.1 cm (4¹³⁄₁₆ × 8⁵⁄₁₆ in.)
wm: Countermark HW variant A.a.
In plate: Rembrandt f 1652 (d in reverse)

Provenance: George Coe Graves (about 1873–1932); his gift to the Metropolitan Museum of Art, 1920.

The Metropolitan Museum of Art, New York, The Sylmaris Collection, Gift of George Coe Graves, 1920, 20.46.4

193 *Kostverloren Castle in Decay, about 1652*

Ben. 1270

Pen and brown ink, brown wash, and white watercolor
10.9 × 17.5 cm (4⁵⁄₁₆ × 6⁷⁄₈ in.)
wm: Foolscap

Provenance: Friedrich August II, King of Saxony (1797–1854, Dresden, Lugt 971); Willem J. R. Dreesmann (1885–1954, Amsterdam); sale, Amsterdam, F. Muller, 22–25 March 1960, lot 26; Richard H. Zinser (about 1883–1983, Forest Hills); to The Art Institute of Chicago, 1961.

The Art Institute of Chicago, The Clarence Buckingham Collection, 1961.49

194 *Landscape with a Cow Drinking, about 1652*

B. 237, II; H. 240 †

Etching and drypoint
10.6 × 13.2 cm (4³⁄₁₆ × 5³⁄₁₆ in.)
wm: fragment of Foolscap

Provenance: De Kat (possibly Huize Groenhof, Soestdijk); Dr. August Sträter (1810–1897, Aachen, Lugt 787); his sale, Stuttgart, H. G. Gutekunst, 10–14 May 1898, lot 821; Werner Weisbach (1873–1953, Berlin and Basel, Lugt 2659a); his sale Bern, Gutekunst & Klipstein, 11 March 1954; C. G. Boerner (Düsseldorf), 1959; Otto Schäfer (1912–2000, Schweinfurt); his sale, New York, Sotheby's, 13 May 1993, lot 72; to Hill-Stone (New York); to the present owner.

Private Collection

195 *Landscape with a Hunter, about 1653*

B. 211, II; H. 265

Etching and drypoint
12.9 × 15.7 cm (5¹⁄₁₆ × 6⅛ in.)

Provenance: Baron Dominique Vivant-Denon (1747–1825, Paris, cf. Lugt 779–80); his sale, Paris, Duchesne, 12 February 1827, but not sold; retained by his nephew [Vivant-Jean or Dominique-Vivant?] Brunet-Denon; sold to Samuel Woodburn (1786–1853, London, cf. Lugt 2584), March 1829; Francis Seymour Haden (1818–1910, London, Lugt 1227); his sale London, Sotheby's, 15–18 May 1891, lot 437; to Meder (1857–1934, Vienna); Joseph H. Seaman; his sale, New York, Parke-Bernet, 1–2 December 1948, lot 181; to Richard Zinser (about

1883–1983, Forest Hills); sold by his descendants through Nicholas G. Stogdon (Oxford) to current owner.

Private Collection

196 *Diana at the Bath*, about 1631

B. 201, only state; H. 42

Etching

17.8 × 16 cm (7 × 6⁵/₁₆ in.)

wm: Double-Headed Eagle variant A.a.a.

In plate: RHL. f.

Provenance: Arkady Nicolayevitch Alferoff [or Olferoff] (1811–1872, Bonn, Lugt 1727); his sale, Munich, Maillinger, 10–13 May 1869, lot 616; possibly Wilhelm Eduard Drugulin (1825–1879, Leipzig, Lugt 2614).

Teylers Museum, Haarlem, KG 3767

197 *Woman Bathing Her Feet at a Brook*, 1658

B. 200, only state; H. 298 †

Etching, drypoint, and engraving on Japanese paper

16 × 7.9 cm (6⁵/₁₆ × 3¹/₈ in.)

In plate: Rembrandt f.1658

Provenance: Henry F. Sewall (1816–1896, New York, Lugt 1309); purchased by MFA, November 1897.

Museum of Fine Arts, Boston. Harvey D. Parker Collection, P584

Boston only

Woman Bathing Her Feet at a Brook, 1658

B. 200, only state; H. 298 †

Etching

15.9 × 7.9 cm (6¹/₄ × 3¹/₈ in.)

In plate: Rembrandt f. 1658

Provenance: Edward Rudge (1763–1846, Evesham, Worcestershire, cf. Lugt 900); by descent to John Edward Rudge; his sale, London, Christie's, 16–17 December 1924, lot 200; Bernard Houthakker (born 1884, Amsterdam, Lugt 1272); to The Art Institute of Chicago, 1938.

The Art Institute of Chicago, The John H. Wrenn Memorial Collection, 1938.60.

Chicago only

198 *Woman Sitting Half-dressed before a Stove*, 1658

B. 197, III; H. 296

Etching, drypoint, and engraving on Japanese paper

22.8 × 18.7 cm (9 × 7³/₈ in.)

In plate: Rembrandt f. 1658

Provenance: Pieter Cornelis Baron van Leyden (1717–1788, Leiden, cf. Lugt 12); acquired by the Dutch state, 1807; acquired by the Rijksmuseum, Amsterdam, 1816.

Rijksmuseum, Amsterdam, RP-P-OB-256

199 *Reclining Woman*, 1658

B. 205, II; H. 299 †

Etching, drypoint, and engraving on Japanese paper

8.1 × 15.8 cm (3³/₁₆ × 6¹/₄ in.)

In plate: Rembrandt f. 1658.

Provenance: Francis Seymour Haden (1818–1910, London, Lugt 1227); his sale London, Sotheby's, 15–18 May 1891, lot 465; to A. Danlos (Paris); Henry Osborne Havemeyer (1847–1907, New York); his widow, Louisine Waldren Elder Havemeyer; her bequest to The Metropolitan Museum of Art, 1929

The Metropolitan Museum of Art, New York, H. O. Havemeyer Collection, Bequest of Mrs. H. O. Havemeyer, 29.107.28

200 *Female Nude Seated on a Stool*, about 1661–62

Ben. 1122

Pen and brown ink, brown wash, and white watercolor

21.2 × 17.4 cm (8³/₈ × 6⁷/₈ in.)

Provenance: Louis Corot (active nineteenth century, Nimes, Lugt 1718); Alfred Strölin (1871–1954, Lausanne) or perhaps his son Alfred Strölin (1912–1974, Lausanne and Paris); to The Art Institute of Chicago, 1953.

The Art Institute of Chicago, The Clarence Buckingham Collection, 1953.38

201 *The Woman with the Arrow*, 1661

B. 202, II; H. 303

Etching, drypoint, and engraving

20.4 × 12.5 cm (8¹/₁₆ × 4¹⁵/₁₆ in.)

wm: fragment of Strasbourg Lily

In plate: Rembrndt f. 1661 (d in reverse)

Provenance: Henry F. Sewall (1816–1896, New York, Lugt 1309); purchased by MFA, November 1897.

Museum of Fine Arts, Boston. Harvey D. Parker Collection, P587

Boston only

The Woman with the Arrow, 1661

B. 202, II; H. 303

Etching, drypoint, and engraving

20.5 × 12.4 cm (8¹/₁₆ × 4⁷/₈ in.)

Provenance: Cabinet Brentano-Birckenstock (founded 1765 by Johannn-Melchior Birckenstock (1738–1809, Vienna and Frankfurt, Lugt 345); sold following the death in 1869 of Antonia, Birckenstock's only daughter, wife of Franz Brentano, Frankfurt, Prestel, 16 May 1870, lot 1357; to Maillinger (probably Josef, Munich); Carl Schlösser (1827–1884, Elberfeld, Lugt 636); his sale Frankfurt, Prestel, 7 June 1880 and following days, lot 561; sold, Bern, Klipstein and Kornfeld, 1961; to The Art Institute of Chicago.

The Art Institute of Chicago, The Clarence Buckingham Collection, 1961.346

Chicago only

202 *Christ and the Woman of Samaria (among ruins)*, 1634

B. 71, I; H. 122 †

Etching

12.4 × 11 cm (4⁷/₈ × 4⁵/₁₆ in.)

wm: Double-Headed Eagle, similar to variant A.a.

In plate: Rembrandt f. 1634

Provenance: Hermann Weber (1817–1854, Bonn, Lugt 1383); his sale, Leipzig, Weigel, 28 April 1856 and following days, probably lot 158; Dr. August Sträter (1810–1897, Aachen, Lugt 787); his sale, Stuttgart, Gutekunst, 10–14 May 1898; Richard Gutekunst (1870–1961, Stuttgart, London, Bern, Lugt 2213a); Henry Harper Benedict (1844–1935, New York, Lugt 2936); sold by his widow; R. E. Lewis, (Belvedere, CA); to MFA, September 1999.

Museum of Fine Arts, Boston. Katherine E. Bullard Fund in memory of Francis Bullard, 1999.267

203 *Christ and the Woman of Samaria*, 1657

B. 70, II; H. 294 †

Etching and drypoint

12.5 × 16 cm (4¹⁵/₁₆ × 6⁵/₁₆ in.)

In plate: Rembrandt f. 1657

Provenance: Probably Arthur Pond (about 1705–1758); Sir Edward Astley (1729–1802, Norfolk, Lugt 2774); probably included in his sale, London, Langford, 27 March 1760 and following days; Jan Chalon (1738–1795, Amsterdam, Paris, and London, Lugt 439); to his son-in-law, Christian Josi (before 1765–1828, Amsterdam and London, Lugt 573); sold through Thomas Philipe (died about 1817, London, cf. Lugt 2451) to Sir Reginald Pole Carew (1753–1835); his sale, London, Wheatley, 13–15 May 1835; Richard Dawnay, 10th Viscount Downe (1903–1965, Wykeham Abbey, Scarborough, Lugt 719a); to his son John Christian George Dawnay, 11th Viscount Downe, (1935–2003, Wykeham Abbey); his sale, London, Sotheby's, 26 November 1970, lot 73; to Boerner (Düsseldorf); Charles C. Cunningham, Jr. (born 1934, Boston); his and his wife's gift to The Pierpont Morgan Library, 1977.

The Pierpont Morgan Library, New York, Gift of Mr. and Mrs. Charles Cunningham, Jr., in honor of Felice Stampfle, 1977.10

204 *Flora*, about 1654

Br. 114

Oil on canvas

100 × 91.8 cm (39³/₈ × 36¹/₈ in.)

Provenance: George John, 2nd Earl of Spencer (1758–1834; Althorp House, Great Brington, Northamptonshire), about 1822; in possession of the Spencer family until 1916; sold by Duveen (New York and London); Mrs. Collis P. Huntington (Arabella Duval Yarrington de Werison or Worsham, 1852–1924, New York and Los Angeles), about 1920; to (or perhaps owned jointly with) her son Archer Milton Huntington (about 1871–1955, New York); his gift to The Metropolitan Museum of Art, 1926.

The Metropolitan Museum of Art, New York, Gift of Archer M. Huntington, in memory of his father, Collis Potter Huntington, 26.101.10

205 *Clement de Jonghe*, 1651

B. 272, I; H. 251 †

Etching
20.6 × 16.1 cm (8⅛ × 6⁵⁄₁₆ in.)
wm: countermark RC
In plate: Rembrandt f. 1651

Provenance: Heneage Finch, Fifth Earl of Aylesford (1786–1859, London & Warwickshire, Lugt 58); Arkady Nicolayevitch Alferoff [or Olferoff] (1811–1872, Bonn, Lugt 1727); his sale, Munich, Maillinger, 10–13 May 1869, lot 621; William Pitcairn Knowles (1820–1894, Rotterdam and Wiesbaden, Lugt 2643); probably included in one of his two sales, Frankfurt, Prestel, 26 November 1877 and following days or 5 May 1879 and following days; Edward Smith, Jr. (second half of the 19th century, London, Lugt 2897); his sale, London, Sotheby's, 20 November 1880; Henry F. Sewall (1816–1896, New York, Lugt 1309); purchased by MFA, November 1897.

Museum of Fine Arts, Boston. Harvey D. Parker Collection, P642
Boston only

Clement de Jonghe, 1651

B. 272, I; H. 251 †

Etching
20.7 × 16.1 cm (8⅛ × 6⁵⁄₁₆ in.)
wm: Paschal Lamb variant A.a.a.
In plate: Rembrandt f. 1651

Provenance: Pierre Mariette (1634–1716, Paris, Lugt 1788), 1673; Galichon; Francis Seymour Haden (1818–1910, London, Lugt 1227); his sale London, Sotheby's, 15–18 May 1891, lot 420; to Stevens; Robert Hoe (1839–1909, New York); his sale, New York, American Art Galleries, 18–25 February 1911, lot 3524; to Frederick Keppel (1845–1912, New York, cf. Lugt 1023); to Clarence Buckingham (1854–1913, Chicago, Lugt 497), July 1911; to his sisters, Katherine (died 1937, Chicago) and Lucy-Maud (died 1920, Chicago); bequeathed by Katherine Buckingham to The Art Institute of Chicago, 1938.

The Art Institute of Chicago, The Clarence Buckingham Collection, 1938.1752
Chicago only

206 *Clement de Jonghe*, 1651

B. 272, III; H. 251 †

Etching, drypoint, and engraving
20.6 × 16.1 cm (8⅛ × 6⁵⁄₁₆ in.)
wm: Paschal Lamb variant B'.a.a.
In plate: Rembrandt f. 1651

Provenance: S. Kalmann (active late 19th century, Berlin, Lugt 1622b); his sale Leipzig, Boerner, 12 May 1906, lot 524; Rudolph Ritter von Gutmann (1880–1966, Vienna and Vancouver, Lugt 2770);

William H. Schab (New York); to MFA, 8 January 1948.

Museum of Fine Arts, Boston. William Francis Warden Fund, 48.5
Boston only

Clement de Jonghe, 1651

B. 272, III; H. 251 †

Etching with drypoint
20.8 × 16.2 cm (8³⁄₁₆ × 6⅜ in.)
wm: Paschal Lamb variant B'.a.b.
In plate: Rembrandt f. 1651

Provenance: Baron Dominique Vivant-Denon (1747–1825, Paris, cf. Lugt 779–80); his sale, Paris, Duchesne, 12 February 1827, but not sold; retained by his nephew [Vivant-Jean or Dominique-Vivant?] Brunet-Denon; sold to Samuel Woodburn (1786–1853, London, cf. Lugt 2584), March 1829; Baron Jan Gijsbert Verstolk van Soelen (1776–1845, The Hague and Soelen, cf. Lugt 2490); his sale Amsterdam, J. de Vries, et al., 26 October 1847 and following days, lot 606; John Webster (1810–1891, Aberdeen, Lugt 1554, 1555); John H. Wrenn (1841–1911, Chicago, Lugt 1475); his sale, London, Sotheby et al., 9 May 1889, lot 131; Julius Rosenberg (1845–1900, Copenhagen, cf. Lugt 1519); Mrs. Stephen Y. Hord (Lake Forest); to The Art Institute of Chicago, January 1934.

The Art Institute of Chicago, The Clarence Buckingham Collection, 1934.122
Chicago only

207 *Thomas Haringh*, about 1655

B. 274, II; H. 287

Drypoint and engraving
19.5 × 15 cm (7¹¹⁄₁₆ × 5⅞ in.)

Provenance: Possibly Jan Pietersz. Zomer (1641–1724, Amsterdam, cf. Lugt 1511); Antonio Maria Zanetti (1680–1757, Venice); Zanetti's descendants; Baron Dominique Vivant-Denon (1747–1825, Paris, cf. Lugt 779–80); his sale, Paris, Duchesne, 12 February 1827, but not sold; retained by his nephew [Vivant-Jean or Dominique-Vivant?] Brunet-Denon; sold to Samuel Woodburn (1786–1853, London, cf. Lugt 2584), March 1829; Thomas Wilson (died about 1865, London and Adelaide, cf. Lugt 2580); Walter Benjamin Tiffen or Samuel Woodburn; Sir Thomas Baring (1772–1848, London); his sale, London, Christie's, 23–27 May 1831, lot 68; Baron Jan Gijsbert Verstolk van Soelen (1776–1845, The Hague and Soelen, cf. Lugt 2490); his sale Amsterdam, J. de Vries, et al., 26 October 1847 and following days, lot 617; Henry James Brooke (1771–1857, Clapham Rise, cf. Lugt 1324–25); his sale, London, Sotheby's, 23 May 1853 and following days, lot 721; to Hermann Weber (1817–1854, Bonn, Lugt 1383); his sale Leipzig, Weigel, 28 April 1856 and following days, lot 391; to Cronstern (Schleswig-Holstein); by descent to family of Graf Plessen (Nehmten, Schleswig-Holstein); their sale, London, Christie's, 10 December 1991, lot 98; Joseph R. Ritman (born 1941, Amsterdam); Sotheby's and Artemis (New York and London, Ritman Catalogue, no. 108), 1995; to Eijk and

Rose-Marie van Otterloo, (Marblehead, MA) 1999; their gift to MFA, 26 March 2003.

Museum of Fine Arts, Boston. Gift of Eijk and Rose-Marie van Otterloo in honor of Clifford S. Ackley, 2003.117

208 *Arnold Tholinx*, about 1656

B. 284, I; H. 289

Etching, drypoint, and engraving
19.8 × 14.9 cm (7¹³⁄₁₆ × 5⅞ in.)
wm: Strasbourg Lily variant E.zz.

Provenance: Grose (possibly Francis Grose, about 1731–1791, London); John Barnard (died 1784, London, Lugt 1419); his bequest to John Kenrick (died about 1798); his sale London, Philipe, 16 April 1798 and following days, lot 348; to Bryant; George Hibbert (1757–1837, London, Lugt 2849); his sale, London, Philipe, 17 April 1809 and following days; Sir Reginald Pole Carew (1753–1835); his sale, London, Wheatley, 13–15 May 1835; Baron Jan Gijsbert Verstolk van Soelen (1776–1845, The Hague and Soelen, Lugt 2490); his sale, Amsterdam, De Vries, et al., 26 October 1847 and following days, lot 657; John Heywood Hawkins (died between 1870 and 1880, London and Bignor Park, Sussex, cf. Lugt 1471); Walter Francis, 5th Duke of Buccleuch and 7th Duke of Queensberry (1806–1884, London and Dalkeith, Scotland, Lugt 402); his sale, London, Christie's, 19–22 April 1887, lot 2028; George Washington Vanderbilt (1862–1914, Asheville, NC); John Pierpont Morgan (1837–1913, New York), after 1905.

The Pierpont Morgan Library, New York, RvR 399

209 *Abraham Francen*, 1657–58

B. 273, IV; H. 291 †

Etching and drypoint on Japanese paper
15.8 × 20.8 cm (6¼ × 8³⁄₁₆ in.)

Provenance: Count Moritz von Fries (1777–1826, Vienna, cf. Lugt 2903); Franz Rechberger (1771–1841, Vienna, Lugt 2133); Baron Jan Gijsbert Verstolk van Soelen (1776–1845, The Hague and Soelen, Lugt 2490); his sale, Amsterdam, De Vries, et al., 26 October 1847 and following days, probably lot 611; Henry Brodhurst (active 1840s–1870s, Mansfield, England, Lugt 1296); through P. & D. Colnaghi (London) to Danlos and Delisle (Paris), about 1883–84; George Washington Vanderbilt (1862–1914, Asheville, NC); John Pierpont Morgan (1837–1913, New York), after 1905.

The Pierpont Morgan Library, New York, RvR 373

210 *Lieven Willemsz. van Coppenol, Writing Master*, about 1658

B. 282, III; H. 269

Etching, drypoint, and engraving
26.1 × 19 cm (10¼ × 7½ in.)

Provenance: Johann Paul Friedrich Kalle (1804–1875, Cologne and Bonn, Lugt 1021); probably included in his sale, Frankfurt, Prestel,

22 November 1875 and following days; Henry F. Sewall (1816–1896, New York, Lugt 1309); purchased by MFA, November 1897.

Museum of Fine Arts, Boston. Harvey D. Parker Collection, P660

211 *The Artist's Son, Titus*, 1656

B. 11, only state; H. 261

Etching on Japanese paper
9.5 × 7 cm (3¾ × 2¾ in.)

Provenance: Clayton Mordaunt Cracherode (1730–1799, London, Lugt 606); his bequest to the British Museum.

Lent by the Trustees of the British Museum, London, 1973 U.1071

212 *Titus at His Desk*, 1655

Br.120

Oil on canvas
77 × 63 cm (30⁵⁄₁₆ × 24¹³⁄₁₆ in.)
Signed and dated: Rembrandt f. 1655

Provenance: Thomas Barnard (1728–1806), bishop of Limerick; his son Andrew Barnard (about 1762–1807, The Cape of Good Hope) and his wife Lady Anne Lindsay (1750–1825, London); then by descent in the Lindsay family; David Alexander Edward Lindsay, 10th Earl of Balcarres and 27th Earl of Crawford (1871–1940, Haigh Hall, Wigan), 1913; acquired by the Stichting Museum Boymans in 1940 with the support of Vereniging Rembrandt and 120 friends of the museum.

Museum Boijmans van Beuningen, Rotterdam, St 2
Boston only

213 *Self-Portrait (etching at a window)*, 1648

B. 22, I; H. 229 †

Etching, drypoint, and engraving
16 × 13 cm (6¼ × 5⅛ in.)

Provenance: Thomas Worlidge (1700–1766, Bath and London, Lugt 2586), by 1757; probably included in his sale, London, Langford, 25 March 1767, and following days; probably Clayton Mordaunt Cracherode (1730–1799, London, cf. Lugt 606); probably part of his bequest to the British Museum (London); probably stolen by and recovered from Robert Dighton (about 1752–1814, London, Lugt 727), 1806; British Museum (London),

deaccessioned between 1883 and 1910; Henry Studdy Theobald (1847–1934, London, cf. Lugt 1375); his sale, Stuttgart, Gutekunst, 12–14 May 1910, lot 581; to Meder, probably for Amsler & Ruthardt (Berlin); Otto Gerstenberg (1848–1935, Berlin, Lugt 2785); to P. & D. Colnaghi (London) and Harlow & Co (New York), 1922; from the latter to The Pierpont Morgan Library, 1923.

The Pierpont Morgan Library, New York, RvR 27

214 *Rembrandt in Studio Garb*, 1648–50

Ben. 1171

Pen with brown ink
20.3 × 13.4 cm (8 × 5¼ in.)
wm: unidentified

Inscribed on a strip pasted to the paper: "getekent door Rembrant van Rhijn naer sijn selver / sooals hij in sijn schilderkamer gekleet was"; on the cardboard mount: "Rembrant avec l'habit dans lequel / il avoit accoutume de peindre".

Provenance: Pierre Crozat (1661–1740, Paris); sold Paris, 10 April 1741, lot 871; John Postle Heseltine (1843–1929, London, cf. Lugt 1507); his sale, Amsterdam, Muller, 27 May 1913, lot 1; August Janssen (Amsterdam); J. Goudstikker. Gift to the Rembrandthuis, 1919.

Museum het Rembrandthuis, Amsterdam, 246
Boston only

215 *Self-Portrait*, 1659

Br. 51

Oil on canvas
84.4 × 66 cm (33¼ × 26 in.)
signed and dated: Rembrandt f. 1659

Provenance: George (Brudenell), 3rd Duke of Montagu and 4th Earl of Cardigan (1712–1790), by 1767; by inheritance to daughter Lady Elizabeth Montagu (1743–1827), wife of Henry, 3rd Duke of Buccleuch (1746–1812, Montagu House, London); John Charles Montagu-Douglas-Scott, 7th Duke of Buccleuch (1864–1935, London); P. & D. Colnaghi (New York), 1928; M. Knoedler (New York); to Andrew W. Mellon (1855–1937, Pittsburgh and Washington), January 1929; deeded to The A.W. Mellon Educational and Charitable Trust (Pittsburgh), 28 December 1934; to the National Gallery of Art, 1937.

National Gallery of Art, Washington, Andrew W. Mellon Collection, 1937.1.72

216 *The Apostle James*, 1661

Br. 617

Oil on canvas
original canvas: 92.1 × 74.9 cm (36¼ × 29½ in.)
signed and dated: Rembrandt f. 1661

Provenance: Probably sale of the heirs of Caspar Netscher (1639–1684, The Hague), The Hague, A. Schoutman, et al., 15 July 1749, lot 122; MacKenzies of Kintore; Sir J. Charles Robinson (London); Consul Edmund Friedrich Weber (Hamburg, catalogue 1872, no. 213); Charles Sedelmeyer Gallery (Paris, catalogue 1895, no. 29); Maurice Kann (Paris), 1901; Duveen Gallery (Paris); Reinhardt Galleries (New York), 1913; John North Willys (1873–1935, Toldeo); Isabel van Wie Willys (formerly Mrs. John N. Willys); her sale, New York, Parke-Bernet, 25 October 1945, lot 16; to Billy Rose (1899–1966, New York); Oscar B. Cintas (1887–1957, Havana and New York); Mr. and Mrs. Stephen Carlton Clark (Stephen 1882–1960, Susan van der Poel born 1888, Cooperstown, NY), by 1955; the current owner.

Private Collection

CHRONOLOGY

Compiled by Joanna Karlgaard and Thomas E. Rassieur

1589

Rembrandt's parents, Harmen Gerritsz. van Rijn (1569–1630) and Neeltgen (Cornelia) Willemsdr. van Zuytbrouck (1568–1640), marry in Leiden. They are comfortably middle class. Historically a center of religion and scholarship, Leiden is in the early stages of rapid population growth centered on its textile industry.

1606

July 15—Rembrandt Harmensz. van Rijn born in Leiden. The ninth of ten or more children.

about 1613–19

Presumably attends the Latin school in Leiden.

1620

Enrolls in the University of Leiden but never studies there.

about 1621–23

Three-year apprenticeship in Leiden with Jacob Isaacsz. van Swanenburgh (1571–1638), painter of dramatically illuminated hell scenes.

1624

Six-month apprenticeship in Amsterdam with Pieter Lastman (1583–1633), painter of biblical, mythological, and historical subjects.

1625

Working as an independent master in Leiden. Paints *Stoning of St. Stephen* (Lyon, Musée des Beaux-Arts, Corpus A1), his earliest known dated painting.

about 1626

Begins to make etchings (see nos. 7–10).

Engaged in friendly rivalry with painter Jan Lievens (1607–1674), with whom he possibly shared studio space.

1628

First dated etchings, studies of a woman traditionally identified as his mother (see nos. 20, 21).

Takes on the first of his pupils, Gerrit Dou (1613–1674) and Isaac Jouderville (1613–1648). Over the years he will have over fifty students.

about 1628–29

Constantijn Huygens (1596–1687), connoisseur of the arts and private secretary to the stadholder Frederik Hendrik (1584–1647) at the court in The Hague, writes admiringly in his unpublished memoirs of Rembrandt's and Lievens's art.

1629

Paints and etches his earliest dated self-portraits (Munich, Alte Pinakothek, Corpus A19, and nos. 13, 14).

1630

Harmen van Rijn, Rembrandt's father, dies. Collaboration with printmaker Jan van Vliet begins.

1631

Apparently begins to establish ties with Amsterdam art trade.

Paints *Nicolaes Ruts* (New York, Frick Collection, Corpus A43), first known portrait of an Amsterdam patron.

Hendrick Uylenburgh (1584–1661), prominent Amsterdam art dealer, owes Rembrandt 1,000 guilders.

about 1631

Rembrandt makes his first etchings of nude models, including *Diana at the Bath* (no. 196).

1631–34

In Uylenburgh's Amsterdam workshop, primarily active painting portraits of middle-class scholars, preachers, artisans, and small businessmen but also biblical and mythological subjects.

Printmaking activity continues, apparently in Leiden.

1632

Paints *The Anatomy Lesson of Doctor Nicolaes Tulp* (The Hague, Mauritshuis, Corpus A51), his first large group portrait.

1633

Rembrandt's painted *Self-Portrait with Beret and Gold Chain* recorded in the collection of King Charles I of England as a gift from Sir Robert Kerr, ambassador to the Netherlands.

Pieter Lastman, Rembrandt's former teacher, dies.

On the occasion of their betrothal Rembrandt makes a silverpoint drawing on vellum of Saskia Uylenburgh (1612–1642, cousin of Hendrick Uylenburgh).

about 1633

Completes two paintings on the theme of Christ's Passion for stadholder Frederik Hendrik: *The Raising of the Cross* and *The Descent from the Cross* (Munich, Alte Pinakothek, Corpus A65 and A69).

1634

Becomes a citizen of Amsterdam and joins the Guild of St. Luke (the city's guild of painters).

Marries Saskia Uylenburgh.

1635

Rents house in the Nieuwe Doelenstraat, a fashionable address.

Apparently now working independently of Hendrick Uylenburgh.

First child, son Rombertus (named after Saskia's father), born.

1636

Rombertus dies.

Corresponds with Huygens about the *Passion* series for Frederik Hendrik and completes another picture for it.

Ferdinand Bol (1616–1680) becomes a pupil.

1637

Moves to rented house on Binnen-Amstel.

1638

Daughter Cornelia born and dies in infancy.

Unsuccessfully sues members of Saskia's family to counter slanderous accusations that she was squandering her parents' legacy.

1639

Buys a magnificent house for 13,000 guilders on the Sint-Anthonisbreestraat (today the Rembrandt House Museum) from Christoffel Thijs (1603–1680) and Pieter Belten II (1606–1639). Makes down payment of 3,250 guilders and agrees to pay five percent interest on the balance.

Etches *Self-Portrait at a Stone Sill* (no. 81), his last self-portrait etching until 1648.

Again corresponds with Constantijn Huygens about Passion paintings for Frederik Hendrik. Seeks payment and completes two further pictures for the series.

1640

Second daughter Cornelia born and dies in infancy.

Rembrandt's mother dies.

Samuel van Hoogstraten (1627–1678) becomes a pupil.

1641

Son Titus born—only child of Rembrandt and Saskia to survive infancy.

First dated landscape etchings, including *Landscape with a Cottage and Haybarn* (no. 118) and *The Windmill* (no. 119).

Jan Jansz. Orlers (1570–1646) publishes the first brief biography of Rembrandt in a book about Leiden.

Philips Angel (1617/18–1664), painter and art critic, praises Rembrandt's painting *The Wedding of Samson* in a lecture to artists in Leiden. The text is published the following year as *Lof der Schilderkunst* (In Praise of Painting).

1642

Saskia dies.

Completes the large-scale group militia portrait *The Nightwatch* (Amsterdam, Rijksmuseum, on loan from the City of Amsterdam, Corpus A146).

about 1642
Geertje Dircx (1610/15–after 1656) employed as a nurse for Titus and becomes Rembrandt's mistress.

1643
Etches *Landscape with the Three Trees* (no. 121).

1646
Frederik Hendrik pays Rembrandt 2,400 guilders for two further Passion paintings of the infancy of Christ.

1647
Rembrandt estimates that at the time of Saskia's death their joint estate—the house and its contents—was worth 40,750 guilders.

Etches portrait of Jan Six (1618–1700, no. 74), one of his most significant and socially prominent patrons.

about 1647
Obtains a supply of Japanese paper.

Hendrickje Stoffels (about 1625–1663) is employed as a live-in servant and becomes Rembrandt's new mistress.

1648
Rembrandt etches his self-portrait as a working artist (no. 213).

Geertje Dircx makes a will in January, leaving her possessions to Titus van Rijn.

about 1648
Completes *Christ Preaching* (no. 135), known since the seventeenth century as "The Hundred Guilder Print."

1649
Geertje Dircx sues Rembrandt for breach of marital promise. The Chamber of Marital Affairs orders him to pay her an annual allowance of 200 guilders, slightly more than Rembrandt had previously offered.

1650
Rembrandt pays to have Geertje committed to the Spinning House (woman's house of correction) in Gouda.

1652
Last dated landscape prints, including *Clump of Trees with a Vista* (no. 192).

Makes two drawings for the *album amicorum* (friendship album) of Jan Six.

1653
Christoffel Thijs demands that Rembrandt pay the 8,470.16-guilder debt, interest, and taxes still owed for the Sint-Anthonisbreestraat house. Rembrandt borrows heavily to pay off the debt, and his financial problems continue.

Executes his large drypoint *Christ Crucified* ("The Three Crosses," nos. 168, 169).

1654
Hendrickje denied communion by the Reformed Church Council when found to be pregnant with Rembrandt's child.

Cornelia born out of wedlock to Hendrickje. She is Rembrandt's only daughter to survive infancy.

1655
Radically transforms his large drypoint *Christ Presented to the People* (nos. 173, 174).

Geertje Dircx is released from the Spinning House.

Rembrandt auctions art from his collection and perhaps his own work as well. The results are unknown.

Attempts to buy a smaller house, but the deal falls through.

1656
Transfers ownership of his house to Titus.

Applies for and receives a declaration of bankruptcy.

Inventory made of his possessions not sold the previous year. This listing reveals him to have been a voracious collector of works of art, weapons, and curios both natural and man-made.

1656–58
Rembrandt's possessions sold in a series of six auctions yielding a disappointing 5,044 guilders, 4 stuivers.

about 1658
Moves (with Hendrickje, Titus, and Cornelia) to a much smaller rented house on the Rozengracht, in the Jordaan section of Amsterdam, where he lives for the rest of his life.

1658
Titus's ownership of the house voided. The Chamber of Insolvent Estates auctions the house for 13,600 guilders, but the buyer does not pay.

Hendrickje and Titus begin to act as Rembrandt's employers and sell his work.

1659
Rembrandt makes his last religious print, *Peter and John at the Gate of the Temple* (no. 180).

about 1659
The house re-auctioned for 12,000 guilders, but again the buyer does not pay.

Arent (or Aert) de Gelder (1645–1727) becomes one of Rembrandt's last pupils.

1660
Hendrickje and Titus formalize their art-dealing partnership, thus relieving Rembrandt of all financial responsibility.

about 1660
The house auctioned a third time. The buyers pay 11,218 guilders.

1661
Rembrandt makes his last print of a nude, *The Woman with the Arrow* (no. 201).

about 1661
Begins to paint *The Conspiracy of the Batavians under Claudius Civilis*, a large-scale mural canvas for the new Amsterdam Town Hall.

1662
The Conspiracy of the Batavians under Claudius Civilis is returned to Rembrandt from the Town Hall. Paintings by his students Govert Flinck and Ferdinand Bol figure prominently in the final decorative scheme.

Paints *The Syndics of the Drapers' Guild of Amsterdam*.

Receives major commissions for portraits and other works, some from the wealthy Trip family.

Sells Saskia's grave.

1663
Hendrickje dies (probably a victim of the plague) and is buried in a rented grave in the Westerkerk.

1665
Rembrandt makes his last print, a commissioned posthumous portrait of the physician Johannes Antonides van der Linden (fig. 74, p. 211). The publisher rejects the plate as not suitable for extended printing.

1666
Rembrandt gives Titus full power of attorney.

1667
Florentine duke Cosimo de'Medici (1642–1723) visits Rembrandt.

1668
Titus marries and dies seven months later. He is buried in the Westerkerk.

1669
Titus's daughter Titia born.

Rembrandt paints three self-portraits.

Rembrandt dies on October 4th and is buried four days later in a rented grave in the Westerkerk.

MATERIALS AND TECHNIQUES

Deborah La Camera, Rhona Macbeth, and Kimberly Nichols

Paper and Alternative Supports for Prints

European paper. Handmade paper formed on a paper mold consisting of a wooden frame with widely spaced wooden ribs that support a screen of closely spaced parallel wires. The paper mold is dipped into a vat containing fibers beaten from linen and cotton rags suspended in water. In the process of lifting the mold from the vat, paper fibers settle onto the wire screen as the water drains off. Because fewer paper fibers are deposited along the wires of the mold, the finished sheet bears the pattern of the mold. This screen pattern of parallel "laid lines" is best seen in transmitted light, and it gives the paper its name, laid paper. The Dutch did not begin making fine white papers until shortly after Rembrandt's death. European papers were imported from Switzerland, Germany, Italy, and France throughout his lifetime. **Watermarks** are formed by attaching wire designs (coats of arms, figures, letters, etc.) to the screen of the paper mold. Fewer paper fibers collect over the wire designs during sheet formation, resulting in thinner areas visible in transmitted light. Study of a sheet's watermark can provide useful information about the paper's date and manufacture.

oatmeal (or cartridge) paper. Dutch = *kardoes*. A coarse, light-brown, or grayish European paper produced from the remnants of the papermaker's vat and characterized by the presence of unbleached and undigested fibers. It was sold as a packing paper but was not less expensive than fine writing or printing papers. Rembrandt experimented with the tonal and textural effects that could be achieved by its use (see *St. Jerome Reading in an Italian Landscape*, no. 48, and *Jan Asselyn, Painter*, no. 87). Oatmeal paper is sometimes confused with the fibrous Indian papers more rarely used by Rembrandt (not included here).

Japanese paper. Handmade paper composed from the inner bark fibers of the gampi, mitsumata, and mulberry plants; it is typically named after the plants from which it is made. Though Japanese papers do not possess a watermark, they may exhibit faint mold impressions from the bamboo screens on which the sheets are formed. They vary from delicate, thin, semitranslucent sheets to thick, sturdy, dense sheets and are highly regarded for their strength and smooth, absorbent surfaces that receive ink well. Gampi paper has a characteristic lustrous sheen and ranges in color from pale greenish yellows to warm yellows and deep golds. Another Asian paper with a cool whitish tone, sometimes referred to as Chinese paper, may be a Japanese paper known as Gasenshi, made in imitation of Chinese calligraphy paper (see *Christ Appearing to the Apostles*, no. 102). Imported by the Dutch East India Company, Japanese papers appear in Rembrandt's work beginning in 1647.

vellum. Often used interchangeably with "parchment" to refer to the fine prepared skins of animals, usually sheep, cow, and goat. Vellum in the strictest sense refers to the finest quality parchment made specifically from the skins of young calves. It was exploited for its smooth, absorbent surface, which when used for printing produced rich lines and luminous effects (see *Christ Crucified* ["The Three Crosses"], no. 169, and *The Entombment*, no. 157).

Printmaking Terms and Techniques

impression. Any single print taken from a printing plate.

state. Any stage in the development of a printed image during which impressions are pulled. States change only with additional working of the plate (addition or removal of lines and marks).

proof (or trial proof). Any impression pulled before work on the plate is complete.

intaglio. Printmaking processes in which the image is printed from ink-retaining incised or etched lines or grooves in a polished metal **plate**, typically copper. An incompletely polished plate may retain fine scratches, referred to as **polishing scratches**. The image is excavated in the plate surface by biting with acid or incising with a sharp-pointed tool. Unwanted lines or grooves in the plate can be reduced by **scraping** the metal with a sharp knife-like instrument, known as a scraper, and **burnishing** or smoothing-out the area with a rounded steel tool or burnisher. When the plate is ready to be printed, ink is forced into the incised lines with a **dauber** and excess ink is **wiped** from the surface of the plate. **Plate tone** or surface tone may be obtained, accidentally or deliberately, by incompletely wiping the printing plate so as to leave a film of ink on the surface. Plate tone may be used to create variations in lighting or atmospheric effects. In printing, dampened paper is placed on the surface of the plate together with a felt blanket for padding and the resulting sandwich is passed through a roller-bed press. The pressure of printing forces the paper fibers down into the grooves and draws out the ink. **Plate marks** are the indentations formed by the edges of the metal plate as it is pressed into the paper during printing. Plate marks often serve as indicators of intaglio printing processes (engraving, drypoint, etching, and mezzotint).

etching. An intaglio printmaking process in which the lines are created by **biting** or etching the copper plate with acid. The polished surface of the plate is covered with a thin layer of **ground**, an acid-resistant coating comprised of waxes, gums, and resins. The image is drawn through the ground with a metal point or **etching needle**, uncovering the metal surface of the plate. The plate is then exposed to acid, which etches the uncovered metal. Early on, Rembrandt applied wax to the perimeter of his printing plates to act as a dam to contain the acid as it was poured onto the plate. Later he may have poured the acid over the inclined plate. The longer the metal is in contact with the acid and the stronger the acid solution, the more deeply and broadly bitten the grooves become and the darker the line will print. Conversely, lines can be made to print lighter than others by **stopping out,** a method whereby an acid-resistant substance or varnish is applied to areas of the etched plate to prevent lines from being further bitten. Rembrandt occasionally achieved special tonal effects by brushing acid directly onto the exposed surface of the plate (see *The Flight into Egypt*, nos. 110 and 113). He also employed a mysterious tonal process referred to as **etched granular tone** or **granular bitten tone**. The method resulted in a fine pitting of the surface of the plate which, when inked, transferred tiny specks of ink to the paper, producing a delicate granular pattern (see *Jan Cornelis Sylvius*, no. 71). Accidental overheating can result in fine cracks in the ground, allowing acid to penetrate the ground and etch a crackle pattern into the plate.

drypoint. An intaglio printmaking process in which a line is scratched directly into the copper printing plate with a needle. The needle is held like a pencil and pulled across the surface of the plate, rather than pushed as in engraving. Through the action of incising the metal, the needle throws up fine metal fragments, which form a ridge called **burr** along the edges of the furrow. The raised burr retains ink and yields a characteristic blurred, velvety effect when printed. The fragile burr wears down quickly under the pressure of printing and the repeated wiping of the plate, and produces relatively few high-quality impressions.

engraving. An intaglio printmaking process in which a **burin**, or graver, is used to incise lines into a polished copper plate. The burin is a square shaft of steel with one end obliquely cut to a diamond-shaped tip and set into a wooden handle. Holding the burin in the palm of the hand, the engraver forces the sharp tool against the plate while turning the plate with the other hand in the direction of the lines. The burin gouges out slivers of metal to create a neat V-shaped furrow as it is pushed across the surface of the plate. Rembrandt utilized engraving as a supplement to etching rather than as an independent medium.

mezzotint. A subtractive intaglio printmaking process in which a continuous tone is produced by scoring the plate with a rocker, a serrated steel blade with a wide curved

edge set into a handle. The rocker is worked across the plate, roughening the surface as desired. The roughened plate retains ink, creating a dark, velvety continuous tone when printed. Light areas are then scraped and burnished from the roughened surface of the printing plate.

Drawing Materials

chalk. A drawing medium derived from naturally occurring composites of clay and colored minerals. **Red chalk** (sanguine) gains its color from iron oxide or hematite. The proportion of iron oxide to clay content determines the specific hue of the chalk, ranging from a very pale red to a burnt brownish orange. **Black chalk** is a composite of carboniferous shale and clay. Though its relatively friable nature lends itself well to broad effects, it is also capable, as in Rembrandt's drawings, of rendering more precise lines.

gall nut ink (or iron gall ink). Ink produced by mixing ground nut galls of oak trees with iron sulfate, followed by the addition of gum arabic as a binding medium. When first mixed, the ink has a purple-black or violet gray color, which gradually darkens to nearly black upon exposure to air. With further aging, the color continues to transform, shifting from cool black to a warm brown hue. Due to the inherent acidity of iron-gall ink, fracturing or perforation of paper is often a consequence of aging (see *Sleeping Watchdog*, no. 54).

India ink (or black ink, Chinese ink). Ink composed of the soot created from burning oils, resins, or resinous woods, or the charcoal of many kinds of woods mixed with a gum or resin. The mixture is hardened and then molded into a dry ink stick ready to be watered down for use (see *Self-Portrait Bust*, no. 12).

ink wash. A solution of ink and water applied with a brush to create broad areas of light and shade.

opaque white watercolor. Rembrandt occasionally enhanced the modeling of mass and volume by applying opaque white watercolor to create highlights on his drawings (see *Sleeping Watchdog*, no. 54). However, he more often used the opaque white medium to correct or edit out lines that he wished to soften or suppress. The medium often becomes more transparent with age, revealing the covered ink lines (see *Two Thatched Cottages with Figures at a Window*, no. 116, and *Three Studies of a Child and One Study of a Woman*, no. 102).

prepared paper. Rembrandt prepared some of his sheets of drawing paper with a pale wash applied with a brush to create an overall tone or tint (see *Houses on the Schinkelweg*, no. 189).

quill pen. A traditional writing or drawing implement fashioned from the large, hollow outer wing feathers of a goose, swan, raven, or crow. The large, primary flight feathers of the bird are plucked, scraped, and hardened by plunging into hot ashes or sand, prior to being cut into a bifurcated pen nib. The quill was valued for its versatility with regard to the width of the point into which it could be cut, and the capacity of the flexible tip to produce sweeping, calligraphic lines.

reed pen. A common ancient writing instrument cut from hollow-barreled grass, including canes and bamboo. The fibrous structure of the reed lends itself best to a blunt nib, which produces short, powerful strokes that resemble brushstrokes more than conventional pen lines. A reed pen can create dense bands of ink when full, or mottled trails when semi-dry (see *The Raising of Cross*, no. 171, and *Noah's Ark*, no. 178).

by Deborah La Camera and Kimberly Nichols

Painting Terms and Techniques

easel. Stand to hold a painting during its execution. In the seventeenth century the most common type of easel was a relatively simple, very stable tripodlike structure. This type of easel had two slightly splayed front legs that were joined by a cross bar and a third leg that was hinged backwards to make the tripod. The front legs had evenly spaced holes into which movable pegs were fitted. The painting could either rest directly on these pegs, or a narrow shelf could be added and the painting placed onto that. For examples of two slightly different seventeenth-century easels, see the small oil painting of *The Artist in His Studio* (no. 18), and the drawing of the same subject (no. 19).

grinding stone (or grinding slab). A flat surface, usually a slab of granite or porphyry, on which the artist's paints would be prepared by hand. Dry pigments were combined with a chosen medium (usually a drying oil), and ground together, using a muller (a dome-shaped stone with flat bottom), until they had acquired the properties of a usable paint. In the seventeenth century, a grinding stone, often mounted to a heavy block of wood, was a standard piece of equipment in a painter's studio (see the oil painting of *The Artist in His Studio*, no. 18, and the drawing, no. 19, of the same subject).

palette. A smooth nonporous surface, most commonly a hand-held wooden board with thumbhole, used for setting out and mixing paints. For examples of seventeenth-century palettes, see the painting of *The Artist in His Studio* (no. 18). The artist holds one palette in his left hand, while two others, of slightly different size and design, are clearly visible hanging on the wall behind him.

palette knife (or painting knife). A knifelike implement with a handle and a blunt metal blade that was either straight-edged or tapered to a rounded point. Initially used as a tool for preparing the oil paint and transferring it to the palette prior to painting. By the middle of the seventeenth century, artists, most notably Rembrandt, were employing the palette knife as a painting tool, using it to apply and manipulate paint, and thereby achieve rich and varied surface effects. For an example of such expressive paint application, see the painting of *Flora*, no. 204.

maulstick (or mahlstick). From Dutch for "painting stick." A wooden rod with one end tipped with a small soft round ball of cloth or leather. The maulstick would be held in the hand that was not actively painting while the padded end would lean against the easel or the painting support, thereby providing a stable place for the artist's hand to rest while painting fine details. For an example of a maulstick, see the painting of *The Artist in His Studio* (no. 18), and also the drawing of the same subject (no. 19).

panel. A painting support made from one or more wooden planks. In the seventeenth-century Netherlands, oak was the most common type of wood chosen for panel painting. For example, in the painting of *The Artist in His Studio* (no. 18), itself painted on a small oak panel, the painting on the easel is clearly on a wooden support.

canvas. A painting support made from a woven fabric or cloth. Originally these cloths would have been intended for other uses, such as ship's sails, mattress covers, etc. The fabric was adapted for use as a painting support by stretching it over a wooden framework called a strainer.

strainer. A wooden framework with fixed (nonexpandable) corners. The strainer was commonly used for stretching canvas prior to the introduction of the keyable stretcher in the mid-eighteenth century.

stretcher. A wooden framework with expandable corners, used for stretching canvas. The keyable stretcher was designed so that its overall size could be expanded by utilizing triangular wedges (keys) placed into slots at its inner corners. "Stretcher" is a term often wrongly used when what is meant is a fixed strainer.

ground. An overall preparatory layer or coating applied to the support to create a more appropriate surface for receiving the paint. These layers could be white or colored, and thus could be used to set the prevailing tone or tint for the subsequent paint layers. Double grounds, where two separate layers (frequently of different colors) were applied were also common.

imprimatura (or primer). A thin layer of paint applied over the ground layer to adjust its overall color or tone.

underdrawing. A preliminary drawing or sketch, made directly on the ground or priming layer, prior to the application of the overlaying paint layers.

oil. The oils used in making oil paint are *drying oils*, like those made from linseeds or poppy seeds, which will dry naturally when exposed to air and light.

impasto. Paint so thickly applied that it stands up from the painting's surface in relief.

pentimento. Italian for "repentance" or "correction." A change made by the artist during the process of painting. These changes can become more visible over time due to an increase in the transparency of the upper layers of paint.

modello. Italian for "model." A highly detailed drawing, or monochrome painting, created by the artist prior to making the final work (e.g., a print or a painting).

oil sketch. A freely executed study carried out in oil paint. Although an oil sketch can have a preparatory relationship with a more finished work, it can also be created as an independent work of art.

grisaille (and brunaille). French for "gray in gray painting" and "brown in brown painting." A monochrome painting usually carried out in shades of gray and/or brown.

tondo. Italian for "circle." A circular painting.

The Structure of a Rembrandt Painting

Wooden panels, stretched canvases, and copper panels are by far the most common supports found on seventeenth-century Dutch paintings. Rembrandt, in his early career in Leiden, seems to have painted almost exclusively on oak panels, although a few small paintings on copper (not in the exhibition) exist from this period. While continuing to paint on wooden supports throughout his career, after moving to Amsterdam (1631–33) Rembrandt increasingly chose to paint on canvas.

As the properties of rough unsealed wood or canvas fabric do not make for a satisfactory painting surface, they were prepared by the application of a ground layer. In the case of a wooden panel, a layer of animal glue and then a thin white ground of animal glue and chalk would be applied and scraped smooth. Lastly a thin coat of oil (usually mixed with a small amount of pigment) would be applied to help seal and tone the absorbent white ground layer. The process for preparing a canvas was somewhat different. The fabric would be stretched over a wooden strainer and then sized with animal glue. Then one or two ground layers, pigments mixed in an oil medium, would be applied. In Rembrandt's early paintings on canvas there is usually a double ground, consisting of a lower layer of red ochre and an upper layer of lead white and black.

Painting would begin with a monochrome sketch, usually in transparent brown or grayish brown oil paint applied directly to the ground. The composition was first set down in freely brushed contours and then was developed further by laying down broad tones of light and dark, with the same thin brown or gray paint. After this "dead-coloring" stage, the painting would be finished with color applied over the monochrome design. Paint would be applied both thickly and thinly so that in some places the dead-coloring would be completely covered, while in others it would show through.

Finally, after the paint was dry a varnish would be applied. This clear coating was added after all other work was completed, and although its optical properties served to enhance the appearance of the oil paint, it was primarily a protective layer.

by Rhona MacBeth

REFERENCES

Compiled by Kate Harper

ABBREVIATIONS FOR FREQUENTLY CITED WORKS

Ackley *Printmaking* 1981
Ackley, Clifford S. 1981. *Printmaking in the Age of Rembrandt*. Exh. cat. Boston: Museum of Fine Arts.

Amsterdam/London 2000
Hinterding, Erik, Ger Luijten, and Martin Royalton-Kisch et al. 2000. *Rembrandt the Printmaker*. Exh. cat. Amsterdam: Rijksmuseum; London: British Museum Press; Zwolle: Waanders.

***Corpus* 1982–89**
Bruyn, Josua, Bob Haak, Simon Levie, P. J. J. van Thiel, and Ernst van de Wetering. 1982–89. *A Corpus of Rembrandt Paintings*. 3 vols. The Hague: Nijhoff Press.

***Docs.* 1979**
Strauss, Walter L., and Marjon van der Meulen, eds. 1979. *The Rembrandt Documents*. New York: Abaris Books.

Hinterding *Copperplates* 1995
Hinterding, Erik. 1995. *The History of Rembrandt's Copperplates, with a Catalogue of Those that Survive*. Zwolle: Waanders.

Hinterding diss. 2001
Hinterding, Erik. 2001. *Rembrandt als Etser: Twee Studies naar de Praktijk van Productie en Verspreiding*. Ph.D. diss., University of Utrecht.

***Master and Workshop: Drawings and Etchings* 1991**
Bevers, Holm, Peter Schatborn, and Barbara Welzel, eds. 1991. *Rembrandt: The Master and His Workshop: Drawings and Etchings*. Exh. cat. New Haven: Yale University Press in association with National Gallery Publications.

***Master and Workshop: Paintings* 1991**
Brown, Christopher, Jan Kelch, and Pieter van Thiel, eds. 1991. *Rembrandt: The Master and His Workshop: Paintings*. Exh. cat. New Haven: Yale University Press in association with National Gallery Publications.

Ackley, Clifford S. 1974. "Review of *Hercules Segers: The Complete Etchings*, by E. Haverkamp-Begemann." *Print Collector's Newsletter* 5 (September–October): 91–94.
———. 1981. *Printmaking in the Age of Rembrandt*. Exh. cat. Boston: Museum of Fine Arts.
———. 1994–96. "The Mature Rembrandt as an Etcher." *Bulletin of The University of Michigan Museums of Art and Archaeology* 11: 53–69.
Albach, Ben. 1979. "Rembrandt en het Toneel." *Kroniek van het Rembrandthuis* 31, no. 2: 2–32.
Alpers, Svetlana. 1983. *The Art of Describing: Dutch Art in the Seventeenth Century*. Chicago: University of Chicago Press.
———. 1988. *Rembrandt's Enterprise: The Studio and the Market*. Chicago: University of Chicago Press.

Amsterdam Historisch Museum. 1965. *Arm in de Gouden Eeuw*. Exh. cat. Amsterdam: Amsterdam Historisch Museum.
Angel, Philips. 1642. *Lof der Schilder-konst*. Leiden.
The Apocryphal New Testament, Being the Apocryphal Gospels, Acts, Epistles, and Apocalypses. 1969. Trans. Montague Rhodes James. Oxford: Clarendon Press.
Ash, Nancy, and Shelley Fletcher. 1998. *Watermarks in Rembrandt's Prints*. Washington, D.C.: National Gallery of Art.
Bakker, Boudewijn, Mària van Berge-Gerbaud, Erik Schmitz, Jan Peeters. 1998. *Landscapes of Rembrandt: His Favourite Walks*. Bussum, The Netherlands: Thoth; Amsterdam: Gemeentearchief; Paris: Fondation Custodia.
Baldinucci, Filippo. 1686. *Cominciamento, e progresso dell'arte dell'intagliare in rame, colle vite di molti de'più eccellenti maestri della stessa professione*. Florence.
Baldwin, Robert. 1985. "On Earth We Are Beggars, as Christ Himself Was." *Konsthistorisk Tidskrift* 54: 122–35.
Balis, Arnout. 1986. *Landscapes and Hunting Scenes*. Corpus Rubenianum Ludwig Burchard, vol. 18. London: Harvey Miller.
Balzé, R. 1880. *Ingres, son école, son enseignement du dessin*. Paris.
Barnes, Susan J., and Arthur K. Wheelock, eds. 1994. *Van Dyck 350*. Exh. cat. Washington, D.C.: National Gallery of Art; Hanover, N.H.: University Press of New England.
Bartsch, Adam. 1797. *Catalogue raisonné de toutes les estampes qui forment l'oeuvre de Rembrandt, et ceux de ses principaux imitateurs*. 2 vols. Vienna: Blumauer.
Bartsch, Adam. 1803–21. *Le Peintre-graveur*. 21 vols. Vienna.
Bätschmann, Oskar. 1997. *The Artist in the Modern World: The Conflict Between Market and Self-expression*. Cologne: Dumont.
Bauch, Kurt. 1960. *Der frühe Rembrandt und seine Zeit: Studien zur geschichtlichen Bedeutung Seines Frühstils*. Berlin: Gebr. Mann.
Baudouin, Frans. 1991. *Pietro Paulo Rubens*. 1977. Reprint. New York: Harry N. Abrams.
Beets, N. 1915. "Herscheppingen." In *Feest-bundel Dr. Abraham Bredius aangeboden den achttienden*, ed. Commissie van voorbereiding en redactie. Amsterdam: Gebroeders Binger.
Benesch, Otto. 1954–57. *The Drawings of Rembrandt*. 6 vols. London: Phaidon Press.
———. 1973. *The Drawings of Rembrandt*. 6 vols. Enlarged and ed. Eva Benesch. London: Phaidon Press.
van Berge-Gerbaud, Mària. 1997. *Rembrandt et son école: Dessins de la Collection Frits Lugt*. Paris: Fondation Custodia.
Berger, Harry. 2000. *Fictions of the Pose: Rembrandt against the Italian Renaissance*. Stanford, Calif.: Stanford University Press.
Berson, Ruth. 1996. *The New Painting: Impressionism 1874–1886. Documentation*. Vol. 1. San Francisco: Fine Arts Museums.

Bevers, Holm, and Christiane Weibel, eds. 1998. *Heinrich Aldegrever*. The New Hollstein German Engravings, Etchings, and Woodcuts, 1400–1700. Rotterdam: Sound and Vision Interactive. Compiled by Ursula Mielke.
Bialler, Nancy, Adrian T. Eeles, Richard Godfrey, and Katharina Mayer Haunton, eds. 1995. *A Collection of Etchings by Rembrandt Harmensz. van Rijn formed by Joseph R. Ritman*. London and New York: Artemis and Sotheby's sale catalogue.
Biörklund, George, with the assistance of Osbert H. Barnard. 1968. *Rembrandt's Etchings, True and False: A Summary Catalogue in a Distinctive Chronological Order and Completely Illustrated*. Stockholm and New York: George Biörklund.
Blankert, Albert, et al. 1980. *Gods, Saints and Heroes: Dutch Painting in the Age of Rembrandt*. Exh. cat. Washington, D.C.: National Gallery of Art.
———. 1997. *Rembrandt: A Genius and His Impact*. Exh. cat. Melbourne: National Gallery of Victoria; Sydney: Art Exhibitions Australia; Zwolle: Waanders.
Bloy, Colin H. 1967. *A History of Printing Ink, Balls, and Rollers, 1440–1850*. London: Evelyn Adams and Mackay.
Bock, Elfried, and Jakob Rosenberg. 1931. *Die Niederländischen Meister, beschreibendes verzeichnis sämtlicher zeichnungen*. 2 vols. Frankfurt am Main: Prestel-Verlag.
Boime, Albert. 1971. *The Academy and French Painting in the Nineteenth Century*. London: Phaidon.
Bolten, Jaap, ed. 1981. *Rembrandt and the Incredulity of Thomas: Papers on a Rediscovered Painting from the Seventeenth Century*. Leiden: Aliotta and Manhart.
Bolten, Jacob. 1979. *Het noord-en zuidnederlandse Tekenboek 1600–1750*. Ter Aar, the Netherlands.
Bomford, David, Christopher Brown, and Ashok Roy. 1988. *Art in the Making: Rembrandt*. Exh. cat. London: National Gallery Publications.
Boon, Karel. 1956. *Rembrandt, etsen*. Exh. cat. Amsterdam: Rijksmuseum; Rotterdam: Museum Boymans.
Bosse, Abraham. 1645. *Traicté des manières de graver en taille douce sur l'airin, par le moyen des eaux fortes, et des vernix durs et mol.... Paris.
van Breda, Jacobus. 1997. "Rembrandt's Etchings on Oriental Papers: Papers in the Collection of the National Gallery of Victoria." *Art Bulletin of Victoria* 38: 25–38.
Bredius, Abraham. 1892. "De Schilder Johannes van de Capelle." *Oud Holland* 10: 26–40.
———. 1909. "Uit Rembrandt's laatste levensjaar." *Oud Holland* 27: 238–40.
———. 1937. *The Paintings of Rembrandt*. Vienna: Phaidon Press; London: George Allen and Unwin Limited.
———. 1969. *The Complete Edition of the Paintings of Rembrandt*. 3rd ed. Ed. Horst Gerson. London: Phaidon Press.
Bredius, Abraham, and N. de Roever. 1890. "Rembrandt, nieuwe bijdragen tot zijne levensgeschiedenis." *Oud Holland* 8: 173–86.

Bremmer, Jan, and Hermann Roodenburgh, ed. 1991. *A Cultural History of Gesture: From Antiquity to the Present Day.* Cambridge, England: Polity Press.

Brettel, Richard R. 2001. *Impression: Painting Quickly in France, 1860–1890.* New Haven and London: Yale University Press.

Broos, B. P. J. 1975–76. "Rembrandt and Lastman's Coriolanus: The History Piece in Seventeenth-Century Theory and Practice." *Simiolus* 8, no. 4: 199–228.

———. 1977. *Index to the Formal Sources of Rembrandt's Art.* Maarsen: Gary Schwartz.

Brown, Alexander. 1660. *The Whole Art of Drawing, Painting, Limning and Etching, Collected Out of the Choicest Italian and German Authors: To Which Is Added Exact Rules of Proportion for Drawing the Heads of Men, Women, and Children and of What Bigness Soever.* London: Printed for Peter Stint and Simon Miller: Brown, 1660.

ter Bruggen, Gerard. 1616. *Verlichtery Kunst-Boeck.* Amsterdam: Herman Allertsz Koster.

de Bruijn, I. 1939. "De Namen van Rembrandt's Etsen." *Oud Holland* 56: 15.

Brusati, Celeste. 1995. *Artifice and Illusion: The Art and Writing of Samuel van Hoogstraten.* Chicago and London: University of Chicago Press.

de Bussierre, Sophie. 1986. *Rembrandt: Eaux-Fortes.* Paris: Musée du Petit Palais, Collection Dutuit.

Campbell, Colin. 1980. "Rembrandts etsen *Het sterfbed van Maria* en *De drie bomen.*" *Kroniek van het Rembrandthuis* 32, no. 2: 2–33.

Cartensen, H.T. 1993. *Empire als Bildsprache: überlegungen zum jüdischen Einfluss auf Rembrandts kunst.* Ph.D. diss., Ammersbeck bei Hamburg.

Chapman, H. Perry. 1990. *Rembrandt's Self-Portraits: A Study in Seventeenth-Century Identity.* Princeton, N.J.: Princeton University Press.

Chipp, Herschell B., ed. 1968. *Theories of Modern Art: A Source Book by Artists and Critics.* Berkeley and London: University of California.

Chong, Alan, Michael Zell, and Hilliard Goldfarb et al. 2000. *Rembrandt Creates "Rembrandt": Art and Ambition in Leiden, 1629–31.* Exh. cat. Boston: Isabella Stewart Gardner Museum; Zwolle: Waanders.

Chu, Petra ten-Doesschate, ed. 1987. *Im Lichte Hollands: Holländische Malerei des 17. Jahrhunderts aus dem Sammlungen des Fürsten von Liechtenstein und aus Schweizer Besitz.* Exh. cat. Basel: Öffentliche Kunstsammlung Basel.

Churchill, William Algeron. 1935. *Watermarks in Paper in Holland, England, France, etc., in the Seventeenth and Eighteenth Centuries and Their Interconnection.* Amsterdam: Hertzberger.

Clark, Kenneth. 1966. *Rembrandt and the Italian Renaissance.* New York: New York University.

Clark, Kenneth, David Rosand, and Frederick Ilchman. 2000. *Rembrandt and the Venetian Influence.* Exh. cat. New York: Salander O'Reilly Galleries.

Claussin, Ignace Joseph. 1824. *Catalogue raisonné de toutes les estampes qui forment l'oeuvre de Rembrandt, et des principales pièces de ses élèves, composé par les sieurs Gersaint, Helle, Glomy et P. Yver.* Paris: Firmin Didot.

van der Coelen, Peter. 1996. *Patriarchs, Angels, and Prophets: The Old Testament in Netherlandish Printmaking from Lucas van Leyden to Rembrandt.* Exh. cat. Amsterdam: Rembrandt House.

Cohen, Janie, and Isadora Rose-de Viejo. 2000. *Etched on the Memory: The Presence of Rembrandt in the Prints of Goya and Picasso.* Exh. cat. The Netherlands: V and K

Publishing; Amsterdam: The Rembrandt House Museum; Lund Humphries.

Cornelissen, J. D. M. 1941. "Twee allegorische etsen van Rembrandt." *Oud Holland* 58: 111–134.

Couprie, L. D. 1994. "De jonge Rembrandt in zijn atelier, 1629." *Leids Jaarboekje* 69–96.

Crenshaw, Paul. 2000. *Rembrandt's Bankruptcy.* Ph.D. diss., New York University.

Daulby, Daniel. 1796. *A Descriptive Catalogue of the Works of Rembrandt and of his Scholars, Bol, Livens, and Van Vliet, compiled From the original Etchings and from the Catalogues of De Burgy, Gersaint, Helle and Glomy, Marcus, and Yver.* Liverpool: J. McCreery.

Degas, Edgar. 1947. *Degas Letters.* Ed. Marcel Guérin. Trans. Marguerite Kay. Oxford: Bruno Cassirer.

Depauw, Carl, Ger Luijten et al. 1999. *Anthony van Dyck as a Printmaker.* Exh. cat. Antwerp: Antwerpen Open; Amsterdam: Rijksmuseum; New York: Rizzoli.

Dethloff, Diana. 2003. "Sir Peter Lely's Collection of Prints and Drawings." In *Collecting Prints and Drawings in Europe, c. 1500–1750,* ed. Christopher Baker, Caroline Elam, and Genevieve Warwick. Hants, England and Burlington, Vermont: Ashgate.

Dézallier d'Argenville, A. N. 1745–52. *Abrégé de la vie des plus fameux peintres avec leurs portraits gravés en taille-douce, les indications de leurs principaux ouvrages, quelques réflexions sur leurs caractères, et la manière de connoître les dessins et les tableaux des grands maîtres.* Paris: De Bure l'ainé.

Dickey, Stephanie Sowa. 1986. "'Judicious Negligence': Rembrandt Transforms an Emblematic Convention." *Art Bulletin* 68: 253–62.

———. 1994. *Prints, Portraits, and Patronage in Rembrandt's Work around 1640.* Ph.D. diss., New York University.

———. 2001. "Van Dyck in Holland: The *Iconography* and Its Impact on Rembrandt and Jan Lievens." In *Van Dyck 1599–1999: Conjectures and Refutations,* ed. Hans Vlieghe. Turnhout, Belgium: Brepols.

Drossaers, S. W. A. 1930. "Inventaris van de meubelen van het Stadhouderlijk Kwartier met het speelhuis en van het huis in het Noordeinde te 's-Gravenhage." *Oud Holland* 45: 241–76.

Dutuit, Eugène. 1883. *L'oeuvre complet de Rembrandt.* Paris: Lévy.

Ekkart, R. E. O., and Eva Ornstein-van Slooten, eds. 1986. *Oog in oog met de modellen van Rembrandts Portret-Etsen / Face to Face with the Sitters for Rembrandt's Etched Portraits.* Exh. cat. Amsterdam: Rembrandt House.

Ekkart, R. E. O. et al. 1979. *Jan Lievens, ein Maler im Schatten Rembrandts.* Braunschweig: Herzog Anton Ulrich-Museum.

Emmens, Jan. 1964. *Rembrandt en de regels van de kunst.* Utrecht: Haentjens Dekker and Gumbert.

———. 1968. *Rembrandt en de regels van de kunst.* Reprint. Utrecht: Haentjens Dekker and Gumbert.

Fehl, Philipp. 1997. *Sprezzatura and the Art of Painting Finely: Open-ended Narration in Paintings by Apelles, Raphael, Michelangelo, Titian, Rembrandt, Vermeer, and Ter Borch.* Groningen: Gerson Lectures Foundation.

Fehrenbach, Frank, ed. 1997. *L'Europa e l'arte italiana.* Venice: Marsilio.

Filedt Kok, Jan Piet. 1972. *Rembrandt Etchings and Drawings in the Rembrandt House.* Maarssen: Gary Schwartz.

———. 1992. "Bij een aanwinst. De tweede staat van Rembrandts ets *De aanbidding der herders: een nachtstuk.*" *Bulletin van het Rijksmuseum* 40, no. 2 (Summer): 161–71.

Filedt Kok, Jan Piet, Wouter Kloek, and Willy Halsema-Kubes, eds. 1986. *Kunst voor de beeldenstorm: Noordnederlandse kunst 1525–1580.* Exh. cat. Amsterdam: Rijksmuseum.

Fremantle, Katharine. 1959. *The Baroque Town Hall of Amsterdam.* Utrecht: Haentjens, Dekker.

Fried, Michael. 1996. *Manet's Modernism, or The Face of Painting in the 1860s.* Chicago and London: University of Chicago Press.

Gallerie di Firenze. 1952. *Bozzetti delle Gallerie di Firenze: Catalogo.* Exh. cat. Florence: Palazzo Strozzi.

Garff, Jan. 1996. *Drawings by Rembrandt and Other Seventeenth-Century Dutch Artists in the Department of Prints and Drawings.* Copenhagen: Royal Museum of Fine Arts.

Geiser, Bernhard. 1986. *Picasso: Peintre-Graveur: Catalogue raisonné de l'oeuvre gravé et des monotypes 1932–34.* With notes and commentary by Brigitte Baer. Bern: Kornfeld Editions.

van Gelder, J. G. 1939. "Hollandsche Etsrecepten vóór 1645." *Oud Holland* 56: 113–24.

van Gelder, J. G., and N. F. van Gelder-Schrijver. 1938. "De 'memorie' van Rembrandt's prenten in het bezit van Valerius Röver." *Oud Holland* 55: 1–37.

Gersaint, Edmé-François. 1751. *Catalogue raisonné de toutes les pièces qui forment l'oeuvre de Rembrandt.* Paris.

Gibson-Wood, Carol. 2003. "A Judiciously Disposed Collection': Johnathan Richardson Senior's Cabinet of Drawings." In *Collecting Prints and Drawings in Europe, c. 1500–1750,* ed. Christopher Baker, Caroline Elam, and Genevieve Warwick. Hants, England and Burlington,Vt.: Ashgate.

Giltaij, Jeroen. 1988. *The Drawings by Rembrandt and His School in the Museum Boymans-van Beuningen, Rotterdam.* Rotterdam: Museum Boymans-van Beuningen.

———. 1988. *Een gloeiend palet: Schilderijen van Rembrandt en zijn school / A Glowing Palette: Paintings of Rembrandt and His School.* Exh. cat. Rotterdam: Museum Boymans-van Beuningen.

———. 2003. *Rembrandt "Rembrandt."* Exh. cat. Frankfurt am Main: Städelsches Kunstinstitut und Städische Galerie, Edition Minerva.

Goldberg, Edward. 1983. *Patterns in Late Medici Art Patronage.* Princeton, N.J.: Princeton University Press.

Goldfarb, Hilliard. 1988. *A Humanist Vision: The Adolf Weil, Jr., Collection of Rembrandt Prints.* Hanover, N.H.: Dartmouth College, Hood Museum of Art.

Goldner, George R. 1988. *Catalogue of the Collections: European Drawings.* Vol. 1. Malibu, Calif.: The J. Paul Getty Museum.

Goldner, George R., and Lee Hendrix. 1992. *Catalogue of the Collections: European Drawings.* Vol. 2. Malibu, Calif.: The J. Paul Getty Museum.

Goldscheider, Ludwig. 1960. *Rembrandt: Paintings, Drawings, Etchings.* London: Phaidon Press.

von Graevenitz, Antje Maria. 1973. *Das Niederländische Ohrmuschel-Ornament: Phänomen und Entwicklung dargestellt an den Werken und Entwürfen der Goldschmiedefamilien van Vianen und Lutma.* Bamberg: Rudolf Rodenbusch. Originally a Ph.D. diss., University Ludwig-Maximillian, Munich.

de Grazia, Diane, and Carter E. Foster, eds. 2000. *Master Drawings from the Cleveland Museum of Art.* Exh. cat. Cleveland: Cleveland Museum of Art.

Grossmann, F. 1952. "Bruegel's 'Woman Taken in Adultery' and Other Grisailles." *Burlington Magazine* 94: 218–229.

Grothues, Bernard. 1992. "Faust is een kabbalist: Een nieuwe verklaring van de zogenaamde Faust van Rembrandt." *Kroniek van het Rembrandthuis* 44: 3–10.

Haak, Bob. 1969. *Rembrandt: His Life, His Work, His Time.* New York: Harry N. Abrams.

Haden, Francis Seymour. 1879. *The Etched Work of Rembrandt: A Monograph.* London: MacMillan.

Hall, James. 1979. *Dictionary of Subjects and Symbols in Art.* Rev. ed. New York: Harper & Row.

Hartley, Craig. 1996. *Rembrandt and the Nude.* Cambridge, England: Fitzwilliam Museum.

Haskell, Francis. 1980. *Patrons and Painters.* New Haven and London: Yale University Press.

Haverkamp-Begemann, Egbert. 1967. "Purpose and Style: Oil Sketches of Rubens, Jan Breughel, Rembrandt." In *Stil und Überlieferung in der Kunst des Abendlandes. Akten des 21. Internationalen Kongresses für Kunstgeschichte in Bonn 1964.* Vol. 3. Berlin: Gebr. Mann.

———. 1973. *Hercules Segers: The Complete Etchings.* Amsterdam: Scheltema and Holkema.

Haverkamp-Begemann, Egbert, et al. 1969. *Rembrandt after Three Hundred Years: An Exhibition of Rembrandt and His Followers.* Exh. cat. Chicago: Art Institute of Chicago.

Heawood, Edward. 1969. Reprint. *Watermarks: Mainly of the Seventeenth and Eighteenth Centuries.* Monumenta Chartoe Payraceae Historium Illustrantia Series, vol. 1. Hilversum: Paper Publishers Society. Original edition, 1950.

de Heer, Ed, Roelof van Gelder, and Jaap van der Veen et al. 1999. *Rembrandt's Treasures.* Exh. cat. Amsterdam: Rembrandt House; Zwolle: Waanders.

Held, Julius. 1961. "Flora, Goddess and Courtesan." In *De Artibus Opuscula XL: Essays in Honor of Erwin Panofsky,* ed. Millard Meiss, vol. 2. New York: New York University Press.

———. 1963. "The Early Appreciation of Drawings." *Acts of the Twentieth International Congress in the History of Art* 3: 72–95.

———. 1964. *Rembrandt and the Book of Tobit.* Northampton, Mass.: Gehenna Press.

———. 1980. *The Oil Sketches of Peter Paul Rubens: A Critical Catalogue.* 2 vols. Princeton, N.J.: Princeton University Press.

———. 1991. *Rembrandt Studies.* Rev. ed. Princeton, N.J.: Princeton University Press.

Herckmans, Elias. 1634. *Der Zee-Vaert Lof.* Amsterdam: Jacob Pietersz Wachter.

Hind, Arthur M. 1921. "Notes on the History of Soft Ground Etching and Aquatint." *Print Collector's Quarterly* 8: 377–405.

———. 1923. *A Catalogue of Rembrandt's Etchings Chronologically Arranged and Completely Illustrated.* 2d ed. 2 vols. London: Methuen and Company.

Hinterding, Erik. 1993–94. "The History of Rembrandt's Copperplates with a Catalogue of Those That Survive." *Simiolus* 22, no.4: 253–315.

Hockney, David. 2000. *Secret Knowledge: Rediscovering the Lost Techniques of Old Masters.* New York: Viking Studio.

Hofstede de Groot, C. 1906. *Handzeichnungen Rembrandts.* Haarlem: Bohn.

———. 1906. *Die Urkunden über Rembrandt: Neu Herausgegeben und Commentirt.* The Hague: Nijhoff.

———. 1925. "Rembrandt's *Painter in His Studio.*" *Burlington Magazine* 47: 265.

Hollstein, F. W. H. 1949–2001. *Dutch and Flemish Etchings, Engravings, and Woodcuts, c. 1450–1700.* 58 vols. to date. Amsterdam: M. Hertzberger, 1949–87; Roosendaal: Koninklijke van Poll, 1988–94; Rotterdam: Sound and Vision, 1995–2001.

———. 1954–. *German Etchings, Engravings, and Woodcuts, c. 1450–1700.* 62 vols. to date. Amsterdam: M. Hertzberger 1954–87; Rosendaal: Koninklijke van Poll, 1988–94; Rotterdam: Sound and Vision, 1995–.

The Holy Bible Containing the Old and New Testaments: King James Version with Apocrypha. 1997. Ed. Robert Carroll and Stephen Prickett. Oxford: Oxford University Press.

Honig, Elizabeth. 1998. *Painting and the Market in Early Modern Antwerp.* New Haven and London: Yale University Press.

Hoogewerff, G. J., and J. Q. van Regteren Altena. 1928. *Arnold Buchelius, "Res Pictoriae": aantekeningen over kunstenaars en kunstwerken, uitgegeven en toegelicht, 1583–1639.* The Hague: Nijhoff.

van Hoogstraten, Samuel. 1678. *Inleyding tot de hooghe schoole der schilderkonst: anders de zichtbaere werelt.* Rotterdam: François van Hoogstraten.

de Hoop Scheffer, D., and K. G. Boon. 1971. "De inventaris-lijst van Clement de Jonghe en Rembrandts etsplaten." *Kroniek van het Rembrandthuis* 25: 1–17.

Houbraken, Arnold. 1718–21. *De groote schouburgh der Nederlantsche konstschilders en schilderessen, waar van'er veele met hunne beeltenissen ten toneel verschynen, en welker levensgedrag en konstwerken beschreven worden: zynde een vervolg op het SchilderBoek van K. v. Mander.* 3 vols. Amsterdam.

Huygens, Constantijn. 1987. *Mijn jeugd.* Trans. C. L. Heesakkers. Amsterdam: Em. Querido's Uitgeverij B.V.

Institut Néerlandais, Paris. 1977–78. *Rembrandt and His Century: Dutch Drawings of the Seventeenth Century from the Collection of Frits Lugt, Institut Néerlandais.* Paris: Institut Néerlandais.

Jacobus de Voragine. 1900. *The Golden Legend or the Lives of the Saints.* Trans. William Caxton. London: J. M. Dent.

Jobert, Barthélémy. 1998. *Delacroix.* Princeton: Princeton University.

de Jongh, Eddy. 1986. *Portretten van echt en trouw: Huwelijk en gezin in de Nederlands kunst van de zeventiende eeuw.* Exh. cat. Haarlem: Frans Halsmuseum; Zwolle: Waanders.

de Jongh, Eddy, and Ger Luijten, eds. 1997. *Mirror of Everyday Life: Genreprints in the Netherlands 1550–1700.* Trans. Michael Hoyle. Exh. cat. Amsterdam: Rijksmuseum with Snoeck-Ducaju.

Josephus, Flavius. 1999. *The New Complete Works of Josephus.* Trans. William Whiston, with a commentary by Paul L. Maier. Rev. ed. Grand Rapids, Mich.: Kregel Publications.

The J. Paul Getty Museum. 1997. *Masterpieces of the J. Paul Getty Museum: Drawings.* Los Angeles: The J. Paul Getty Museum.

Junius, Franciscus. 1991. *The Literature of Classical Art: The Painting of the Ancients and a Lexicon of Artists and Their Works.* 2 vols. Ed. Keith Aldrich, Philipp Fehl, and Raina Fehl. California Studies in the History of Art Series, no. 22. Berkeley and Los Angeles: University of California Press. Volume 1 was originally published as *De Picturum Veterum, libri tres* (Amsterdam: Johannes Blaeu, 1637).

Kahr, Madlyn. 1966. "Rembrandt's Esther: A Painting and an Etching Newly Interpreted and Dated." *Oud Holland* 81: 228–44.

Kemp, Martin, ed. 1989. *Leonardo on Painting.* New Haven and London: Yale University Press.

Kettering, Alison McNeil. 1977. "Rembrandt's Flute Player: A Unique Treatment of the Pastoral." *Simiolus* 9, no. 1: 19–44.

Koehler, Sylvester Rosa. 1887. *The Etched Work of Rembrandt and of Artists in His Circle, Together with Engravings, Etchings, etc., from Paintings and Sketches by Him, Principally from the Collection of Mr. Henry Sewall.* Exh. cat. Boston: Museum of Fine Arts.

Koerner, Joseph and Michael Zell. 1999. *Lifeworld: Portrait and Landscape in Netherlandish Prints, 1550–1650.* Cambridge, Mass.: Harvard University Art Museum Publications.

Kuretsky, Susan Donahue. 1974. "Rembrandt's Tree Stump: An Iconographic Attribute of Saint Jerome." *Art Bulletin* 56: 571–580.

———. 1997. "Rembrandt at the Threshold." In *Rembrandt, Rubens, and the Art of Their Time: Recent Perspectives,* ed. Roland E. Fleischer and Susan Clare Scott, 60–105. University Park: Pennsylvania State University.

Kuspit, Donald. 2000. *The Rebirth of Painting in the Late Twentieth Century.* Cambridge, England: Cambridge University Press.

Lammertse, Friso. 2002. "Van Dyck's Apostles Series, Hendrick Uylenburgh and Sigismund III." *Burlington Magazine* 144 (March): 140–46.

Larsen, Erik. 1997. "Rubens und Van Dyck: 'Jupiter und Antiope.'" *Pantheon* 55: 66–74.

Laurentius, Th. 1996. *Etchings by Rembrandt: Reflections of the Golden Age; An Investigation into the Paper Used by Rembrandt.* Amsterdam: Van Rossum; Zwolle: Waanders.

Leeflang, Huigen, ed. 2000. *Cornelis Cort.* 2 vols. The New Hollstein Dutch and Flemish Etchings, Engravings, and Woodcuts 1450–1700. Rotterdam: Sound and Vision Publishers in cooperation with the Rijksprentenkabinet Rijksmuseum, Amsterdam. Compiled by Manfred Sellink.

Leendeertz, P. 1921. "Nederlandsche Faust-Illustraties." *Oud Holland* 39: 130–48.

———. 1923–24. "Rembrandt's Faust en Medea." *Oud Holland* 41: 68–82.

Leesberg, Marjolein. 1993–94. "Karel van Mander as a Painter." *Simiolus* 22, nos. 1–2: 5–57.

Lehrs, Max. 1908–34. *Geschichte und kritischer Katalog des deutschen, niederländischen und französischen Kupferstichs im XV. Jahrhundert.* Vienna: Gesellschaft für vervielfältigende Kunst.

Liedtke, Walter A. et al. 1995. *Rembrandt/Not Rembrandt in the Metropolitan Museum of Art: Aspects of Connoisseurship.* 2 vols. New York: Metropolitan Museum of Art.

Limouze, Dorothy, and Susan Donahue Kuretsky. 1995. *The Felix M. Warburg Print Collection: A Legacy of Discernment.* Poughkeepsie, N.Y.: Vassar College, Francis Lehman Loeb Art Center.

Logan, Anne-Marie. 1979. *The "Cabinet" of the Brothers Gerard and Jan Reynst.* Amsterdam, Oxford, and New York: New Holland Publishing.

Loughman, John, and John Michael Montias. 2000. *Public and Private Spaces. Works of Art in Seventeenth-Century Dutch Houses.* Zwolle: Waanders.

Lugt, Frits. 1915. *Wandelingen met Rembrandt in en om Amsterdam.* Amsterdam: P. N. Kampen.

———. 1920. *Mit Rembrandt in Amsterdam : die Darstellungen Rembrandts vom Amsterdamer Stadtbilde und von der unmittelbaren Landschaftlichen Umgebung, mit einem*

Zusatz über einige in Utrecht und Gelderland entstandene Zeichnungen. Berlin: B. Cassirer.

———. 1921. *Les Marques de collections de dessins & d'estampes.* Amsterdam: Vereenigde Drukkerijen.

———. 1956. *Les Marques de collections de dessins & d'estampes, Supplément.* The Hague: Martinus Nijhoff.

Luijten, Ger, ed. 1993. *Maarten van Heemskerck.* 2 vols. The New Hollstein Dutch and Flemish Etchings, Engravings, and Woodcuts 1450–1700. Rosendaal: Koninklijke van Poll, in cooperation with the Rijksprentenkabinet Rijksmuseum, Amsterdam. Compiled by Ilja M. Veldman.

Luijten, Ger, ed. 1996. *Lucas van Leyden.* 2 vols. The New Hollstein Dutch and Flemish Etchings, Engravings, and Woodcuts, 1450–1700. Rotterdam: Sound and Vision Publishers in cooperation with the Rijksprentenkabinet Rijksmuseum, Amsterdam. Complied by Jan Piet Filedt Kok with the assistance of Bart Cornelis and Anneloes Smits.

Maclaren, N., and Christopher Brown. 1991. *The Dutch School: National Gallery Catalogue, 1600–1900.* Revised and enlarged by Christopher Brown. London: National Gallery Publications.

van Mander, Karel. [1604] 1969. *Het Schilder-Boeck waer in voor eerst de leerlustighe Jeught den grondt der edel vry schilder-const in verscheyden deelen wort voorghedraghen.* Reprint, Utrecht: Davaco.

———. [1604] 1973. *Den grondt der edel vry schilder-const.* 2 vols. Ed. Hessel Miedema. Utrecht: Haentjens Dekker & Gumbert.

———. [1604] 1994–99. *The Lives of the Illustrious Netherlandish and German Painters, from the First Edition of the Schilder-boeck (1603–04).* 6 vols. Ed. Hessel Miedema. Trans. Derry Cook-Radmore. Doornspijk: Davaco.

Manuth, Volker. 1993–94. "Denomination and Iconography: The Choice of Subject Matter in the Biblical Painting of the Rembrandt Circle." *Simiolus* 22, no. 4: 235–52.

Manuth, Volker, and Marieke de Winkel. 2002. *Rembrandt's "Minerva in Her Study" of 1635: The Splendor and Wisdom of a Goddess.* New York: Otto Naumann.

Martin, John Rupert. 1977. *Baroque.* New York and San Francisco: Harper & Row.

Meijer, Bert. 1991. *Amsterdam en Venetië: een speurtocht tussen Ij en Canale grande.* 's Gravenhage: SDU.

———. 1991. *Rondom Rembrandt en Titian.* Exh. cat. Amsterdam: Rembrandt House.

Metzger, Bruce M., and Michael D. Coogan, eds. 1993. *The Oxford Companion to the Bible.* New York and Oxford: Oxford University Press.

Michel, Émile. 1894. *Rembrandt, His Life, His Work, and His Time.* 2 vols. London: W. Heineman.

Middleton, Charles Henry. 1878. *A Descriptive Catalogue of the Etched Work of Rembrandt van Rhyn.* London: John Murray.

Mullenmeister, Kurt. 1988. *Roelant Savery: Kortrijk 1576–1639 Utrecht, Hofmaler Rudolf II in Prag: die Gemälde mit kritischem Oeuvrekatalog.* Freren: Luca Verlag.

Münz, Ludwig. 1952. *Rembrandt's Etchings: Reproductions of the Whole Original Etched Work.* 2 vols. London: Phaidon Press.

National Gallery of Ireland. 1985. *Masterpieces From the National Gallery of Ireland.* Exh. cat. Dublin: National Gallery of Ireland.

Nevitt, H. Rodney, Jr. 1997. "Rembrandt's Hidden Lovers." *Nederlands Kunsthistorisch Jaarboek* 48: 163–91.

The New Hollstein Dutch and Flemish Etchings, Engravings, and Woodcuts, 1450–1700. 1993–. 12 vols. to date. Roosendaal: Koninklijke van Poll in cooperation with the Rijksprentenkabinet, Rijksmuseum, Amsterdam, 1993–94; Rotterdam: Sound and Vision in cooperation with the Rijksprentenkabinet, Rijksmuseum, Amsterdam, 1996–. See Leeflang 2000, Luijten 1993, Luijten 1996, and Sellink 2001 for the individual volumes from the series referred to in the text.

The New Hollstein German Engravings, Etchings, and Woodcuts, 1450–1700. 1996–. 4 vols. to date. Rotterdam: Sound and Vision, 1996–. See Bevers and Weibel 1998 for the individual volume from the series referred to in the text.

Nichols, Larry. 1992. "The 'Pen Works' of Hendrick Goltzius." *Bulletin of the Philadelphia Museum of Art* (Winter): 1–57.

Orenstein, Nadine M. 1996. *Hendrick Hondius and the Business of Prints in Seventeenth-Century Holland.* Studies in Prints and Printmaking, vol. 1. Rotterdam: Sound and Vision.

———. 2001. "Scratches, Speckling, and Crooked Lettering: Rembrandt's Messy Aesthetic." *Georgia Museum of Art Bulletin* 21: 5–39.

Panofsky, Erwin. 1953. *Early Netherlandish Painting: Its Origins and Character.* Cambridge: Harvard University Press.

Parshall, Peter, Stacey Sell, and Judith Brodie. 2001. *The Unfinished Print.* Exh. cat. Washington, D.C.: National Gallery of Art in association with Lund Humphries.

van de Passe, Crispijn. 1643. *La Prima Parte della luca del depingere et disegnare.* Amsterdam: Jan Jansz.

de Pauw-de Veen, Lydia. 1969. *De Begrippen "Schilder," "Schilderij," en "Schilderen" in de Zeventiende Eeuw.* Brussels: Paleis der Académiën.

Pels, Andries. 1681. *Gebruik, en misbruik des toneels.* Amsterdam: Albert Magnus.

de Piles, Roger. 1699. *Abrégé de la vie des peintres avec des réflexions sur leurs ouvrages, et un traité du peintre parfait, de la connaissance des desseins et de l'utilité des estampes.* Paris.

Pouncey, Philip, and John A. Gere. 1962. *Italian Drawings in the Department of Prints and Drawings in the British Museum: Raphael and His Circle.* 2 vols. London: British Museum, 1962.

Rassieur, Tom. 2001. "When Things Get Rough for Rembrandt." *Georgia Museum of Art Bulletin* 21: 41–76.

Redon, Odilon. 1986. *To Myself: Notes on Life, Art, and Artists.* Trans. Mira Jacob and Jeanne L. Wasserman. New York: Braziller.

Reed, Sue Welsh, and Richard Wallace. 1989. *Italian Etchers of the Renaissance and Baroque.* Exh. cat. Boston: Museum of Fine Arts.

Riggs, Timothy Allen. 1972. *Hieronymus Cock (1510–1570): Printmaker and Publisher in Antwerp at the Sign of the Four Winds.* Ph.D. diss., Yale University.

Robinson, Franklin. 1980–81. "Puns and Plays in Rembrandt's Etchings." *The Print Collector's Newsletter* 11, no. 5: 165–68.

Robinson, William W. 1991. *Seventeenth Century Dutch Drawings: A Selection from the Maida and George Abrams Collection.* Exh. cat. Lynn, Mass.: H. O. Zimman.

———. 2002. *Bruegel to Rembrandt: Dutch and Flemish Drawings from the Maida and George Abrams Collection.* Exh. cat. Cambridge, Mass.: Harvard University Art Museums; New Haven and London: Yale University Press.

Robison, Andrew. 1997–98. *Building a Collection.* Exh. cat. Washington, D.C.: The National Gallery of Art.

Roethlisberger, Marcel. 1993. *Abraham Bloemaert and His Sons: Paintings and Prints.* 2 vols. Doornspijk: Davaco.

Rosand, David. 2002. *Drawing Acts: Studies in Graphic Expression and Representation.* New York: Cambridge University Press.

Rosenberg, Harold. 1990. "The American Action Painters." In *Abstract Expressionism, A Critical Record,* ed. David and Cecile Shapiro. Cambridge: Cambridge University Press. First published in *Art News* 51, no. 8 (December 1952): 22–23.

Rosenberg, Jakob. 1964. *Rembrandt: Life and Work.* Rev. ed. London: Phaidon Press.

Rossacher, Kurt. 1968. "Oil Sketches of the Baroque—A Collector's Creed." In *Image and Imagination: Oil Sketches of the Baroque, Collection Kurt Rossacher.* Exh. cat. Los Angeles: Los Angeles County Museum of Art; Kansas City, Mo.: Nelson Gallery, Atkins Museum; Toledo, Ohio: Toledo Museum of Art; Providence, R.I.: Museum of Art, Rhode Island School of Design; Minneapolis: Minneapolis Institute of Arts.

Rotermund, Hans-Martin. 1963. *Rembrandts Handzeichnungen und Radierungen zur Bibel.* Stuttgart.

Rovinski, D. 1890. *L'oeuvre gravé de Rembrandt: reproduction des planches originales dans tous leurs états successifs, 1000 phototypies sans retouche.* St. Petersburg.

Rowlands, John. 1979. *Hercules Segers.* New York: George Braziller.

Royalton-Kisch, Martin. 1984. "Over Rembrandt en van Vliet." *Kroniek van het Rembrandthuis* 36: 3–23.

———. 1992. *Drawings by Rembrandt and His Circle in the British Museum.* London: British Museum Press.

Rub, Timothy, et al. 1998. *A Gift to the College: The Mr. and Mrs. Adolf Weil Jr. Collection of Master Prints.* Exh. cat. Hanover, N.H.: Dartmouth College, Hood Museum of Art, in conjunction with Abaris Books.

von Sandrart, Joachim. 1678. *Teutsche Academie der Bau-, Bild- und Mahlerey-Künste.* Nuremberg.

Scallen, Catherine B. 1990. *Rembrandt and Saint Jerome.* Ph.D. diss., Princeton University.

Schama, Simon. 1999. *Rembrandt's Eyes.* New York: A. A. Knopf.

Schatborn, Peter. 1981. *Dutch Figure Drawings from the Seventeenth Century.* Exh. cat. The Hague: Government Publishing Office.

———. 1985. *Drawings by Rembrandt, His Anonymous Pupils and Followers in the Rijksprentenkabinet, Rijksmuseum, Amsterdam.* Rijksmuseum: Amsterdam.

———. 1995. "A 'New' Rembrandt Drawing." In *Shop Talk: Studies in Honor of Seymour Slive,* ed. Cynthia P. Schneider, William W. Robinson, and Alice I. Davies. Cambridge, Mass.: Harvard University Art Museums.

Schatborn, Peter, and Eva Ornstein-van Slooten. 1984. *Rembrandt as Teacher.* Exh. cat. Amsterdam: Rembrandt House.

Schatborn, Peter, and Marieke de Winkel. 1996. "Rembrandts portret van de acteur Willem Ruyter." *Bulletin van het Rijksmuseum* 44: 382–93.

Schmidt-Degener, Frederick. 1925. "Over Rembrandts vogel Phoenix." *Oud Holland* 42: 191–208.

Schneider, Cynthia P. 1990. *Rembrandt's Landscapes.* New Haven and London: Yale University Press.

———. 1990. *Rembrandt's Landscapes: Drawings and Prints.* Exh. cat. Washington, D.C.: National Gallery of Art; Boston, London, and Toronto: Bullfinch Press / Little Brown.

Schneider, Hans. 1932. *Jan Lievens: Sein Leben und seine Werke*. Haarlem: Bohn.

Schneider, Hans, with a supplement by R. E. O. Ekkart. 1973. Reprint. *Jan Lievens: Sein Leben und seine Werke*. Amsterdam: B. M. Israel. Original edition by Schneider without Ekkart's supplement, Haarlem: De Erven F. Bohn, 1932.

Schuckman, Christiaan, Martin Royalton-Kisch, and Erik Hinterding. 1996. *Rembrandt and Van Vliet: A Collaboration on Copper*. Amsterdam: Rembrandt House.

Schwartz, Gary. 1985. *Rembrandt: His Life, His Paintings*. London: Phaidon Press.

———, ed. 1977. *All the Etchings of Rembrandt Reproduced in Original Size*. London: Oresko Book Limited.

von Seidlitz, Woldemar. 1895. *Kritisches verzeichnis der Radierungen Rembrandts: Zugleich eine Anleitung zu deren Studium*. Leipzig: E. A. Seemann.

Sellink, Manfred, ed. 2001. *Philips Galle*. 4 vols. The New Hollstein Dutch and Flemish Etchings, Engravings, and Woodcuts 1450–1700. Rotterdam: Sound and Vision Publishers. Compiled by Manfred Sellink and Marjolein Leesberg.

Sheriff, Mary D. 1990. *Fragonard: Art and Eroticism*. Chicago and London: University of Chicago.

Six, Jan. 1909. "Gersaints lijst van Rembrandt's Prenten." *Oud Holland* 27: 65–110.

———. 1918. "Rembrandt's 'Eendracht van het land.'" *Onze Kunst* 33: 141–58.

Slatkes, Leonard. 1973. "Review of White, 1969, and White and Boon, 1969." *Art Quarterly* 36: 250–63.

———. 1980. "Rembrandt's Elephant." *Simiolus* 11: 7–13.

———. 1983. *Rembrandt and Persia*. New York: Abaris Books.

Slive, Seymour. 1953. *Rembrandt and His Critics, 1630–1730*. The Hague: M. Nijhoff.

———. 1970–74. *Frans Hals*. 3 vols. New York: Phaidon.

Smith, David. 1982. *Masks of Wedlock: Seventeenth Century Dutch Marriage Portraiture*. Ann Arbor, Michigan: UMI Research Press.

———. 1988. "'I Janus': Privacy and the Gentlemanly Ideal in Rembrandt's Portraits of Jan Six." *Art History* 11, no. 1 (March): 42–63.

Smith, William. 1979. *The New Smith's Bible Dictionary*. Rev. ed. New York: Doubleday-Galilee.

Spicer, Joaneath. 1991. "Nicolaus Breau and Gillis van Breen: Two Printmakers or One?" *Print Quarterly* 8, no. 3 (September): 275–80.

Spicer, Joaneath, and Lynn Federle Orr et al. 1997. *Masters of Light: Dutch Painting in Utrecht During the Golden Age*. Exh. cat. Baltimore: Walters Art Gallery; San Francisco: Fine Arts Museum; New Haven and London: Yale University Press.

Stampfle, Felice. 1991. *Netherlandish Drawings of the Fifteenth and Sixteenth Centuries and Flemish Drawings of the Seventeenth and Eighteenth Centuries in the Pierpont Morgan Library*. New York: Pierpont Morgan Library.

Stampfle, Felice et al. 1969. *Rembrandt: Experimental Etcher*. Exh. cat. Boston: Museum of Fine Arts; New York: Pierpont Morgan Library.

Steland-Stief, Anne Charlotte. 1971. *Jan Asselijn nach 1610 bis 1652*. Amsterdam: Van Gendt, 1971.

van Straten, Roelef. 2002. "Rembrandt's 'Earliest Prints' Reconsidered." *Artibus et Historiae* 23, no. 45: 167–77.

Stratton, Suzanne. 1986. "Rembrandt's Beggars: Satire and Sympathy." *The Print Collector's Newsletter* 17, no. 3 (July–August): 77–81.

Strauss, Walter, and Tracie Felker, eds. 1987. *Drawings Defined*. New York: Abaris.

Sumowski, Werner. 1979–. *Drawings of the Rembrandt School*. 10 vols. Ed. and trans. Walter L. Strauss. New York: Abaris Books.

———. 1983–95. *Gemälde der Rembrandt-Schüler*. 4 vols. Landau: Edition PVA, 1983–95.

Sutton, Peter. 1984. *Masters of Seventeenth-Century Dutch Genre Painting*. Exh. cat. Philadelphia: Philadelphia Museum of Art.

Sutton, Peter, et al. 1992. *Prized Possessions: European Paintings from Private Collections of Friends of the Museum of Fine Arts, Boston*. Boston: Museum of Fine Arts.

———, 1987. *Masters of Seventeenth Century Dutch Landscape Painting*. Exh. cat. Boston: Museum of Fine Arts.

van Thiel, Pieter J. J. 1999. *Cornelis Cornelisz van Haarlem: A Monograph and Catalogue Raisonné*. Trans. Diane L. Webb. Doornspijk, The Netherlands: Davaco.

Thornton, Peter. 1978. *Seventeenth-Century Interior Decoration in England, France, and Holland*. New Haven: Yale University Press for the Paul Mellon Centre for Studies in British Art.

Tümpel, Astrid, and Peter Schatborn et al. 1991. *Pieter Lastman: leermaster van Rembrandt/Peter Lastman: The man who taught Rembrandt*. Exh. cat. Amsterdam: Rembrandt House; Zwolle: Waanders.

Tümpel, Christian. 1969. "Studien zur Ikonographie der Historien Rembrandts: Deutung und Interpretation der Bildinhalte." *Nederlands Kunsthistorisch Jaarboek* 20: 107–98.

———. 1970. *Rembrandt legt die Bibel aus. Zeichnungen und Radierungen aus dem Kupferstichkabinett der Staatlichen Museen Preussischer Kulturbesitz, Berlin*. Exh. cat. Berlin: Verlag Bruno Hessling.

———. 1986. *Rembrandt: All Paintings in Color*. Antwerp: Fonds Mercator; New York: Harry Abrams.

———. 1991. *Het Oude Testament in de Schilderkunst van de Gouden Eeuw*. Exh. cat. Zwolle: Waanders.

———. 1994. *Im Lichte Rembrandts: des Alte Testament im goldenen zeitalter der niederländischen Kunst*. Munich: Klinkhart & Biermann.

Turner, Jane, ed. 1996. *Dictionary of Art*. 34 vols. New York: Grove.

Uffizi Gallery. 1927. *The Uffizi Gallery: Catalogue of the Paintings*. Florence: Uffizi Gallery.

Vignau-Wilberg, Thea, with contributions by Peter Schatborn. 2002. *Rembrandt auf Papier: Werk und Werkung. Rembrandt and His Followers: Drawings from Munich*. Exh. cat. Munich: Hirmer Verlag.

Vogelaar, Christian et al. 1991. *Rembrandt and Lievens in Leiden: A Pair of Young and Noble Painters*. Exh. cat. Leiden: Stedelijk Museum De Lakenhal; Zwolle: Waanders.

Vosmaer, C. 1877. *Rembrandt: Sa vie et ses oeuvres*. The Hague: Nijhoff.

van de Waal, H. 1974. *Steps Towards Rembrandt: Collected Articles 1937–72*. Amsterdam: North Holland.

Weisbach, Werner. 1926. *Rembrandt*. Berlin: De Gruyter.

Werenskiold, Marit. 1984. *The Concept of Expressionism. Origin and Metamorphoses*. Trans. Ronald Walford. Oslo: Universitetsforlaget.

Westermann, Mariët. 1999. "Fray en Leelijck: Adriaen van de Venne's Invention of the Ironic Grisaille." *Nederlands Kunsthistorisch Jaarboek* 50: 220–57.

———. 2000. *Rembrandt*. London: Phaidon Press.

———. 2001. *Art and Home: Dutch Interiors in the Age of Rembrandt*. Exh. cat. Denver: Denver Art Museum; Newark, N.J.: The Newark Museum; Zwolle: Waanders.

van de Wetering, Ernst. 1997. *Rembrandt: The Painter at Work*. Amsterdam: Amsterdam University Press.

van de Wetering, Ernst, and Bernard Schnackenburg, et al. 2001. *The Mystery of the Young Rembrandt*. Exh. cat. Kassel: Staatliche Museen; Amsterdam: Rembrandt House; Wolfrathausen: Edition Minerva.

Wheelock, Arthur K. 1995. *Dutch Paintings of the Seventeenth Century: Collection of the National Gallery of Art Systematic Catalogue*. New York and Oxford: Oxford University Press.

White, Christopher. 1964. *Rembrandt and His World*. New York: Viking Press.

———. 1969. *Rembrandt as an Etcher: A Study of the Artist at Work*. University Park: Pennsylvania State University Press.

———. 1999. *Rembrandt as an Etcher: A Study of the Artist at Work*. 2d ed. New Haven and London: Yale University Press.

White, Christopher, and Karel G. Boon. 1969. *Rembrandt's Etchings*. 2 vols. Amsterdam: A. L. van Gendt.

White, Christopher, and Quentin Buvelot et al. 1999. *Rembrandt by Himself*. Exh. cat. London: National Gallery Publications; The Hague: Royal Cabinet of Paintings, Mauritshuis; New Haven: Yale University Press.

Williams, Julia Lloyd, et al. 2001. *Rembrandt's Women*. Exh. cat. London, and New York: Prestel.

Winternitz, Emanuel. 1969. "Rembrandt's 'Christ Presented to the People'—1655: A Meditation on Justice and Collective Guilt." *Oud Holland* 84, nos. 2–3: 177–98.

Wittkower, Rudolf. 1967. "Introduction." In *Masters of the Loaded Brush: Oil Sketches from Rubens to Tiepolo*, ed. Rudolf Wittkower. Exh. cat. New York: Knoedler and Company.

Worp, J. A. 1891. "Constantyn Huygens over de Schilders van zijn Tijd." *Oud Holland* 9: 106–36.

Wurfbain, M. L. 1976. *Geschildert tot Leyden anno 1626*. Exh. cat. Leiden: Stedelijk Museum de Lakenhal.

Wyckoff, Elizabeth A. 1998. *Innovation and Popularization: Printmaking and Print Publishing in Haarlem During the 1620s*. Ph.D. diss., Columbia University.

Zell, Michael. 2000. "Encountering Difference: Rembrandt's Presentation in the Dark Manner." *Art History* 23, no. 4 (November): 496–521.

———. 2002. *Reframing Rembrandt: Jews and the Christian Image in Seventeenth-Century Amsterdam*. Berkeley, Los Angeles, and London: University of California.